P9-DBI-538

200 Years of American Sculpture

200 Years of American Sculpture

David R. Godine, Publisher,
in association with the
Whitney Museum of American Art

Tom Armstrong

Wayne Craven

Norman Feder

Barbara Haskell

Rosalind E. Krauss

Daniel Robbins

Marcia Tucker

730.973
T93

FRONTISPIECE: World's Columbian Exposition, Chicago, 1893. (See Fig. 81, p. 55.)

RIGHT: Alexander Calder. *Big Red,* 1959. (See Fig. 254, p. 174.)

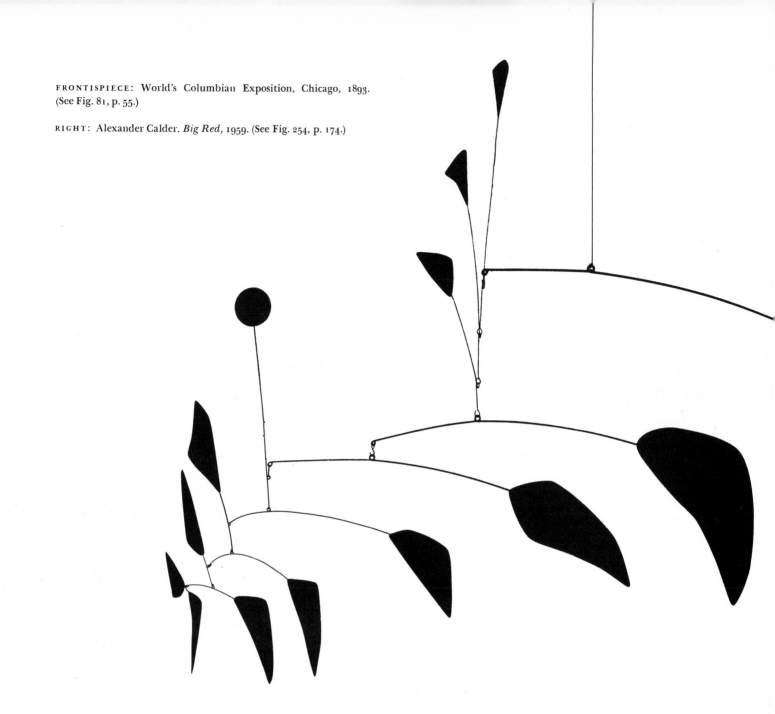

Copyright © 1976, Whitney Museum of American Art
945 Madison Avenue, New York, N.Y. 10021

All rights reserved. No part of this publication may be reproduced, stored in a retrieval system, or transmitted, in any form, or by any means, electronic, mechanical, photocopying, recording or otehwise, without the prior permission of the publisher.

Permission to reproduce illustrations from the book must be obtained in writing from the Whitney Museum of American Art, N.Y.

LCC NO. 75–41717 HC LCC NO. 76–1762 SC
ISBN NO. 0–87923–185–8 HC

This publication was organized at the Whitney Museum of American Art by Doris Palca, *Head, Publications and Sales,* Margaret Aspinwall, *Editor,* Jennifer Russell, *Curatorial Assistant, 18th- and 19th-Century Art,* Anita Duquette, *Rights and Reproductions,* Clair Zamoiski and Cherene Holland.

The book was coordinated at David R. Godine, Publisher, by Yong Hee Last.

A soft-cover edition (containing a checklist of the exhibition) is distributed by the Whitney Museum of American Art, New York.

Design by Lance Hidy, Cambridge, Massachusetts
Design assistant, Carol Goldenberg
Composition by Wrightson Typographers, Boston, Massachusetts
Printed by Case-Hoyt, Rochester, New York
Bound by W. F. Zahrndt & Son, Inc., Rochester, New York

200 Years of American Sculpture was a Bicentennial exhibition organized by the Whitney Museum of American Art, New York, shown from March 16 to September 26, 1976. The exhibition was sponsored by the Chase Manhattan Bank and the National Endowment for the Arts. Educational programs were made possible by The Mary Sisler Foundation. The installation was designed by Venturi and Rauch, Architects and Planners, Philadelphia.

Tom Armstrong, *Director* of the Whitney Museum, served as director of the exhibition, assisted by Pamela Adler, *Exhibitions Coordinator.*

Manufactured in the United States of America.

Contents

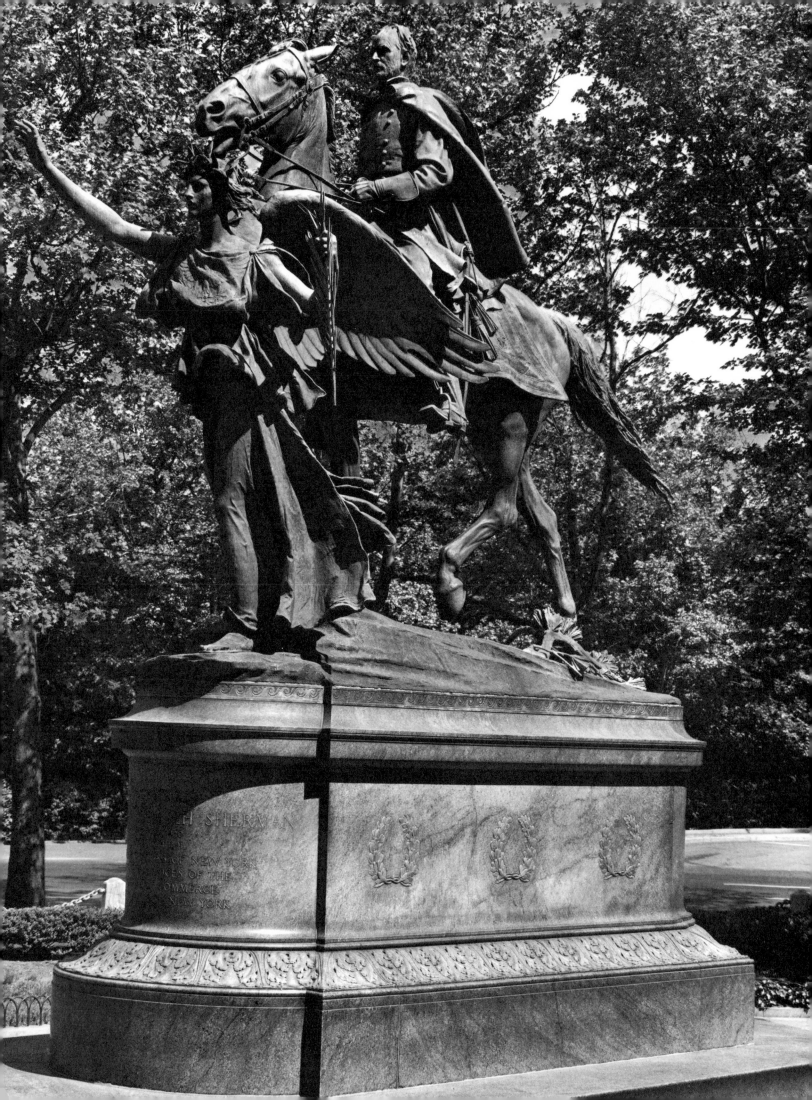

200 Years of American Sculpture

Sponsored by the Chase Manhattan Bank
and the National Endowment for the Arts
Organized by the Whitney Museum of American Art

THE CHASE MANHATTAN BANK is pleased to join the National Endowment for the Arts in supporting the presentation by the Whitney Museum of American Art of the first comprehensive survey of American sculpture. The nation's bicentennial year is an especially appropriate time to review America's cultural achievements. Art inevitably reflects the spirit of the times in which it was created, and a careful look at the history of American sculpture reveals that this country's carvers and sculptors consistently produced works which mirror the richness and diversity of American life.

Although considerable critical and scholarly attention has been devoted to painting, architecture and the decorative arts in the United States, it is only recently that American sculpture has become a separate subject of serious study for art historians and museum specialists. In the past few years a growing body of literature has appeared and we are hopeful that this book and the accompanying exhibition will initiate further research into this fascinating and somewhat neglected facet of American art, as well as provide inspiration to those working within the medium of sculpture today.

We are deeply grateful to the Whitney Museum of American Art for its vision in recognizing the need for this book and exhibition, to the curators and distinguished scholars who have studied and selected these objects for our appreciation, and to the lenders for their unselfishness in sharing outstanding works of art with the public. This contribution at the time of the nation's anniversary celebration provides a unique insight into the history of the United States through the art of sculpture.

David Rockefeller
Chairman of the Board
Chase Manhattan Bank

OPPOSITE: Augustus Saint-Gaudens. *General William Tecumseh Sherman*, unveiled 1903. Bronze, 15½ feet high; granite base, 24 feet, 4 inches high. Grand Army Plaza, New York. Photograph by Bob Zucker.

Foreword

THE DECISION BY THE WHITNEY MUSEUM OF AMERICAN ART to celebrate the nation's Bicentennial with a special exhibition and book was made after consideration that such an endeavor, commemorating this historic occasion, should provide new scholarship in a subject not fully surveyed previously. American sculpture was chosen as our topic because it has been overlooked in the study of American art. It was also decided that observations about present accomplishments should be presented as a preamble for future developments. Sculpture seemed a particularly appropriate topic to recognize during the forty-fifth anniversary year of the Whitney Museum which was founded by a sculptor, Gertrude Vanderbilt Whitney. Not only was Mrs. Whitney a talented artist in the tradition of classical sculpture, she was the greatest patron of American art at the time the Museum opened in 1931. Her pioneering efforts to recognize and present the public with creative achievements in American art were the genesis of the Whitney Museum and the background of this tribute to American sculpture which carries forward her intentions.

The last two hundred years of American art history can be separated into definite periods in which various trends persist until innovation brings about new directions. No single individual could provide the same intensity of interest and scholarship for each phase of American sculpture during these dynamic years of growth, so it was decided to ask specialists identified with specific periods to examine American sculpture through their particular orientation to the subject. This resulted in varied approaches to fundamental questions of art which, in addition to reinforcing the diversity of the subject, provide individual scholarly attitudes as a basis for further investigations. The process of curatorial selection has made it inevitable that artists have been omitted whose contributions are as important as those discussed.

The book begins with a description of the sculpture of the aboriginal inhabitants of the country by Norman Feder, author of *American Indian Art, Art of the Eastern Plains*

OPPOSITE: Mark di Suvero. *Ik Ook*, 1971–72. Steel, 24 x 24 x 33 feet. Collection of the artist, courtesy of R. Bellamy. Shown in Conservatory Garden, Central Park, New York (the gates to the garden, originally from the Vanderbilt home, at Fifth Avenue and 58th Street (see fig. 156), were donated to the City by Gertrude Vanderbilt Whitney); one of twelve sculptures installed on sites in the five boroughs of the City of New York as an extension of the Mark di Suvero exhibition at the Whitney Museum of American Art, November 13, 1975, to February 8, 1976. Photograph by Pedro E. Guerrero.

Indians, North American Indian Painting, and guest curator and author of the catalogue of *Two Hundred Years of North American Indian Art* presented at the Whitney Museum in 1971. By 1776 the great art of these peoples had been diminished because of a number of circumstances which Mr. Feder describes. However, there were still instances when outstanding sculptural form was produced by these native Americans. They are represented through important examples which serve as a prologue to our cultural heritage.

Sculpture in America by Wayne Craven, the Henry Francis du Pont Professor of Art History at the University of Delaware, has become a standard text on the subject, and Professor Craven has enumerated for us the major accomplishments of American sculptors of the 18th and 19th centuries with emphasis on their training and the relation of their art to the social and political history of the period. As a complement to his essay, I have presented a selected group of examples of folk sculpture to indicate the aesthetic importance of this concurrent development in American art. As Curator and Associate Director of the Abby Aldrich Rockefeller Folk Art Collection from 1967 to 1971, I became aware that the relationship of folk art to other art of the same period has never been explored. In an effort to make this review of American sculpture as comprehensive as possible, it seemed appropriate to include American folk art in a general survey—for the first time.

Developments in American sculpture from the Centennial to the Depression are significantly unified to provide a chapter in our cultural history. It is a particularly dynamic period as artists emerge from the dominance of European influences and begin to establish the foundation for our country's special contribution to 20th-century art. Daniel Robbins, former Director of the Fogg Art Museum and now visiting professor at Dartmouth College, analyzes this important transitional phase. His scholarship in the early development of modernism serves as a background for his essay in which he describes the varied activity of the period and the changes in American art which evolved as American sculpture approached the threshold of unique creativity in the 20th century.

That each scholar has chosen to elaborate on a special aspect of the history of sculpture in a distinct manner augments and vitalizes the factual background of the subject. Rosalind Krauss, Associate Professor of Art History at Hunter College of the City University of New York and author of *Terminal Iron Works: The Sculpture of David Smith,* identifies the dramatic evolution in American sculpture during the period 1930–50, with innovations in form and techniques as seen in the achievements of a selected number of major artists. The progress of the survey of *200 Years of American Sculpture* proceeds, therefore, from Norman Feder's discussion of the decline of aboriginal art to Wayne Craven's review of academic art in the 18th and 19th centuries, emphasizing the use of materials and development of the processes of sculpture, and my presentation of contributions in folk art, to Daniel Robbins's summary of the work of a large number of artists in the first three decades of the 20th century whose accomplishments he associates with certain thematic considerations, to Rosalind Krauss's concentration on American artists who emerged as international innovators.

Since the Whitney Museum was founded, it has supported 20th-century American art, particularly the work of sculptors, more than any other institution. Accordingly, it seemed appropriate to provide this book with a statement about recent American sculpture, for reassessment by future generations. The Curators of the Whitney Museum, Barbara Haskell and Marcia Tucker, assumed this task and selected a group of artists to represent the most challenging themes in contemporary sculpture which have emerged in the last two decades. This is the most critical aspect of the exhibition and book and in many ways the most provocative. For the public, it is the period of American art most difficult to understand and controversial: much of the art originates from invention without precedent.

Because developments during the last twenty years are reviewed by two authors, the sculptors included in the separate essays are listed here to clarify why each curator concentrates on the work of specific artists. Barbara Haskell's essay focuses on the work of Larry Bell, Ronald Bladen, John Chamberlain, Walter De Maria, Mark di Suvero, Dan Flavin, Robert Grosvenor, Eva Hesse, Donald Judd, Ellsworth Kelly, Sol LeWitt, John Mason, Claes Oldenburg, Kenneth Price, Robert Rauschenberg, Lucas Samaras, George Segal, Richard Serra, William Wiley and Christopher Wilmarth. Marcia Tucker's essay is primarily about the work of Carl Andre, Richard Artschwager, Michael Heizer, Robert Irwin, Jasper Johns, Edward Kienholz, Barry Le Va, Robert Morris, Bruce Nauman, Tony Smith, Robert Smithson, Keith Sonnier, Sylvia Stone, George Sugarman, Anne Truitt, Richard Tuttle, H. C. Westermann and Peter Voulkos.

The understanding of art is enhanced through an appreciation of the documents associated with it and the photographs and other archival resources which substantiate the narrative history of art. Paul Cummings, Editor of the *Archives of American Art Journal* and author of *A Dictionary of Contemporary American Artists,* has assisted the authors to illustrate their statements with drawings, photographs and other documents related to the sculptors' lives and works. Another of the book's major documentary features, prepared especially to assist students, is the section containing concise biographies and bibliographies for each of the 140 sculptors included in this survey. This section was prepared by Libby W. Seaberg, Librarian of the Whitney Museum, with the assistance of Cherene Holland. Through their efforts, it is one of the most complete references for the study of the subject.

The diversity of American sculpture, as reflected in the critical essays of this book, is strengthened by a quality often dismissed in contemporary life—the eccentricity of creative talent. America and its art were built upon the accomplishments of individuals in a democratic society. This book represents the creative results of the vision and imagination of artists in a country whose strength, since its independence on July 4, 1776, has been based upon respect for the contribution of each individual.

Tom Armstrong
Director
Whitney Museum of American Art

Aboriginal Art

Norman Feder

SCULPTURE TRADITIONS in the United States extend back in time well before 1776. Farmers plowing in their fields, construction crews digging for building foundations and professional archaeologists are continually unearthing new evidence which indicates that the aborigines of the period before contact with the white man were both skillful and prolific in producing sculptural forms in difficult mediums. As a result of the painstaking excavations and analyses of the archaeologist, we do know a limited amount about the cultures and artistic traditions of these pre-contact peoples. However, our knowledge is limited because of several factors which include the scarcity of perishable materials found in the archaeological excavations, the problems involved in systematically moving and sifting through large quantities of earth in the hope of recovering a few artifacts, and the fact that these aboriginal people did not leave any written records. Materials recovered archaeologically are usually of the harder nonperishable types such as stone, antler, shell and clay. Wood, fiber, horn and skin are only preserved in special circumstances such as an extremely arid cave or an area continually soaked with fresh water. The small quantity of prehistoric wood carvings which have managed to survive indicate that wood was probably a common sculptural medium in the period before 1776. Wood was certainly a common material for carving

after metal knives were introduced by the European explorers and traders. We do have a few examples of wood sculpture recovered from early Pueblo cultures in the arid Southwest, usually as a cave deposit; but the major finds of wood sculpture are from the Spiro Mound in Oklahoma (Fig. 3), the Key Marco site in Florida and at the Nootkan village of Ozette on the northwest coast of the state of Washington. The Ozette site is a five-hundred-year-old Nootkan village that was abruptly covered by a mud slide which preserved several wood-plank houses and their entire contents. The Ozette village is still in the process of being excavated and the report on the material uncovered has not as yet been published, but the carved-wood items found are ample proof that the Pacific Northwest Coast people had a well-developed wood-carving technology dating back at least five hundred years.

Stone carvings from archaeological sites are more common than wood and are found over a large portion of the United States. They occur in soft and hard stones, and in the form of bowls, smoking pipes and figures (Fig. 6). The various mound cultures (Adena-Hopewell and Mississippian) stretching from the Ohio-Illinois area down through the southeastern states produced some amazing ceremonial pipes and figure carvings. The Southwest is noted for a large number of human and animal stone sculptures which are usually fairly crude. And the Northwest Coast area has a long tradition of carved utensils, bowls and clubs of elaborate form and fine finish. California is noted for the small soapstone figures from the Channel Islands, and the Plains and eastern area produced some fine stone pipe bowls.

OPPOSITE: 1, 2. Two of four house posts, Tlingit, Yakutat, Alaska, early 19th century. Carved and painted wood, 102 and 104 inches high. Canadian Ethnology Service, National Museum of Man, National Museums of Canada, Ottawa (cat. nos. VII–A–344a, VII–A–343).

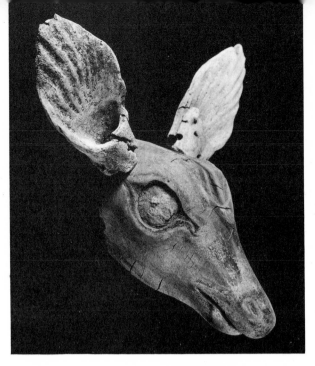

ABOVE LEFT: 3. Deer mask, 13th–17th century, found at Spiro Mound, Le Flore County, Oklahoma. Wood with shell inlaid in eyes and mouth, 11⅜ inches high. Museum of the American Indian, Heye Foundation, New York (cat. no. 18/9306).

ABOVE CENTER: 4. Deer head, 11th–17th century, found at Key Marco, Florida. Wood with traces of paint, 10¾ inches long. The University Museum, University of Pennsylvania, Philadelphia (cat. no. 40707).

FAR RIGHT: 5. Five spoons, Karok, Yurok and Hupa, northern California. Elk antler; largest spoon, 6¾ inches high. The Denver Art Museum, Denver, Colorado (cat. nos. Qka-17, Qyu-21, Qka-19, Qhu-7, Qka-18).

RIGHT: 6. Effigy pipe or "Lucifer Pipe," 13th–17th century, found at Spiro Mound, Le Flore County, Oklahoma. Red sandstone, 8 inches high. Stovall Museum of Science and History, University of Oklahoma, Norman (cat. no. B99-2).

With the influx of Europeans by exploration, the fur trade and land settlement in the New World, we find a general decline in aboriginal sculptural production. This decline was caused by the tremendous impact of introduced trade goods, technology, disease and ideas spreading over the wide area of North America in a short time due to the expansion of the fur trade. The introduction of the horse and the gun increased mortality in intertribal warfare, and some tribal units were virtually wiped out or displaced by white expansion and conquest. Epidemics of diseases new to the Indians, such as smallpox, measles and influenza, probably had the greatest effect on reducing populations. Old religions were often abandoned in favor of Christian forms imported by missionaries, and as the old religions died the need for religious sculpture died with them. Economies changed from the normal hunting-gathering or farming types to a dependence on trader-supplied food and utensils. In spite of the general decline in sculptural production in most areas of the United States, there are a few areas, notably the Southwest and the Northwest Coast, where sculptural production actually grew during the past two hundred years due to the increased wealth and superior tools which accompanied white contact. It should be noted that some cultural traditions were on the decline even before Indian contact with the white man due to the natural processes of cultural change and intertribal warfare. Such is the case with the Ohio-Illinois mound cultures whose complex ceremonial art had all but disappeared by the period of first white contact.

The eastern seaboard along with portions of the West Coast and the Southwest were the areas first subjected to European settlement, and many of the Indian populations in these sections of the country were annihilated by the combined effects of disease and conquest. The coastal region of California south of San Francisco was almost devoid of distinct tribal units by the beginning of the 19th century, but away from the coast and in parts of northern California the Indians fared a little better. The major sculptural works of the California region were the small animal carvings in soapstone produced on the Channel Islands and adjacent coast in the pre-contact period. The only other carvings of note are some of the decorative spoons and purses made of elk antler by the Yurok, Karok, Hupa, Pomo, and related groups in the northern part of the state (Fig. 5).

The East Coast area was unfortunately directly in the path of the major European settlement patterns. By the start of the American Revolution in 1775, the thirteen original colonies were already well established and, to make room for increasing numbers of European immigrants, the Indians (already decimated) were forced to move farther and farther west. With each move they encountered other Indian groups who resented incursions into their territory and fought to keep them away. The result is that little Indian sculpture has been produced on most of the Atlantic seaboard during the last two hundred years because the Indians native to the area were either annihilated, forced to move west or so greatly reduced in number that all traces of their aboriginal culture was lost. The major exception is the tribes of the Iroquois confederacy (Cayuga, Oneida, Onondaga, Mohawk, Seneca and Tuscarora) and a few remnant groups of Delaware, who continued to make face masks for religious ceremonies. The Iroquois still make face masks for their False Face ceremonies related to curing disease (Figs. 7, 8), and up to about the end of the 19th century a migrant group of Delaware in the vicinity of Dewey, Oklahoma, continued to carve the support posts for their Big House rites (Fig. 9).

The native tribes of Florida suffered the same fate as the Indians of southern California, being almost wiped out by early Spanish conquest and newly introduced diseases. The few survivors joined groups of migrant Creeks from Georgia to become the present-day Seminole tribes. A quantity of wood sculpture from pre-contact times has survived in Florida, notably in the artifact-rich site of Key Marco (Fig. 4). Scattered wood carvings have been recovered from other isolated Florida sites, and recent excavations at Fort Center have unearthed even more examples of impressive wood carvings.

The sedentary Pueblo people of the southwestern states of Arizona and New Mexico were not as severely

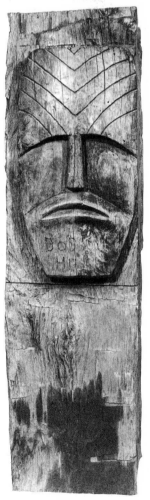

ABOVE RIGHT: 7. Mask ("Old Broken Nose"), Seneca, 1937. Carved and painted basswood with horsehair; 36 inches high, including hair. Cranbrook Institute of Science, Bloomfield Hills, Michigan (cat. no. 3754).

ABOVE LEFT: 8. Mask, False Face Society, Onondaga, 1860. Carved and painted basswood with horsehair, 12 inches high. Museum of the American Indian, Heye Foundation, New York (cat. no. 21/6509).

RIGHT: 9. House post, Delaware, Copan, Oklahoma, c. 1874. Carved wood with traces of paint, 46 inches high. Philbrook Art Center, Tulsa, Oklahoma (cat. no. 3296).

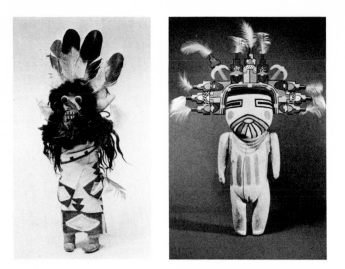

ABOVE LEFT: 10. Kachina doll, Zuni, early 20th century. Wood, feathers, cloth; 18 inches high. The American Museum of Natural History, New York (cat. no. 50.1/9165).

ABOVE RIGHT: 11. Kachina doll, Hopi, Oraibi, Arizona, 1880–1900. Polychromed wood with feathers, 25 inches high. Museum of the American Indian, Heye Foundation, New York. (cat. no. 3709).

BELOW: 12. War God, Zuni, late 19th–early 20th century. Carved wood with traces of paint, 25⅝ inches high. The Brooklyn Museum, New York; Museum Collection Funds (cat. no. 04.252).

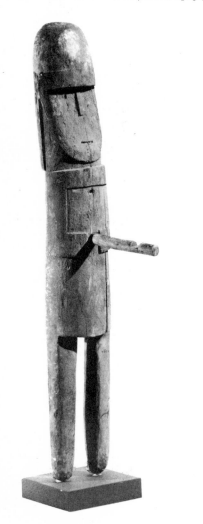

affected by early Spanish occupation as were California and Florida. These people seemed to have been able to absorb Catholicism and Spanish rule while still maintaining their native religion with its attendant ceremonies and ritual equipment. Disease took its toll among the Pueblo people as it did everywhere, and they were also subjected to raids by warlike Comanche, Apache and Navajo. In 1680 the Pueblo people revolted against Spanish occupation, forcing the Spanish out of their territory and destroying the missions. The Spanish returned twelve years later and reconquered the Pueblos, and a passive acceptance has continued to the present. After the Pueblo revolt most of the Pueblo villages relocated to new sites. Some have since been abandoned, like Pecos, or largely abandoned, like Nambe and Pojoaque, and still others largely Mexicanized, like the southern Pueblos of Isleta del Sur and Socorro del Sur. Large numbers of carved-stone fetish figures are known from the Pueblos, particularly from the Keresan groups. These are usually in quite crude humanoid form and can be up to three feet high. Smaller fetish carvings in hard stone, shell or turquoise are known from almost all of the Pueblo villages. Many take the form of water animals such as the frog or turtle, although bird and animal forms are also common. In addition a wide variety of carvings in both wood and stone are produced for shrine offerings, for use on altars inside the Kiva ceremonial houses and as prayer sticks (Pl. 4). The well-known Zuni War Gods are examples of shrine offerings placed in an outdoor shrine on a mountain adjacent to the Zuni village (Fig. 12). The best known carvings of the Pueblo peoples are the Kachina dolls of the Hopi and Zuni, but they are also made at other Pueblos. The Hopi dolls are made from the soft root of the cottonwood tree in the form of specific deities (Kachina). These dolls are given as gifts to children and hung from house rafters. The children, by playing with the dolls and seeing them in their own and neighboring homes, learn to identify the many deities and to learn the attributes of each. Kachina dolls are still being made in quantity both as traditional gifts for children and for sale to collectors and tourists. The earliest collected examples are slightly more than one hundred years old, but similar dolls have been recovered in old cave deposits which may indicate an earlier origin. The Zuni dolls differ from the Hopi examples in that they are made of pine with movable arms and legs, and the clothing is often attached rather than painted (Figs. 10, 11). In addition Zuni dolls are not normally manufactured for tourist sale.

Modeled clay figures and containers have a long tradition among the Pueblo tribes, but during the past one hundred or so years these have been produced mainly for sale to tourists. The Zuni formerly produced ceremonial

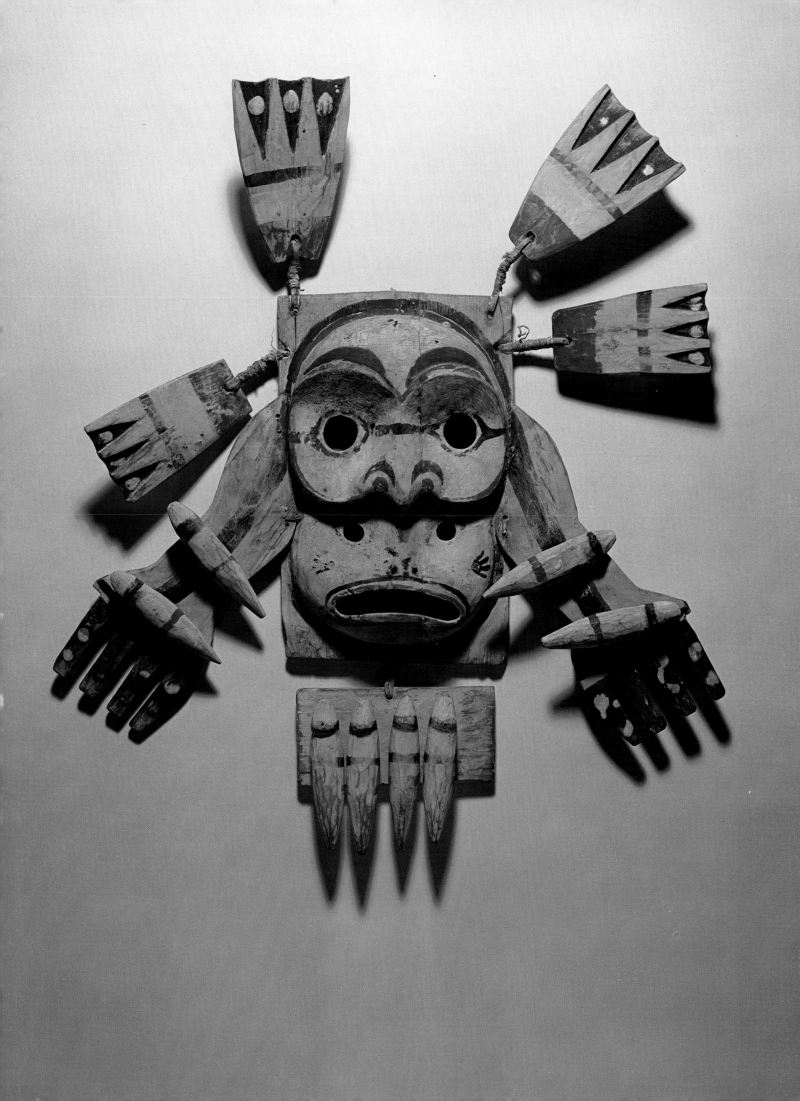

PRECEDING PAGE: PLATE 1. Mask, Eskimo, Lower Yukon, Alaska, 19th century. Painted wood, 23 x 21 x 2 inches. Collection of James Economos.

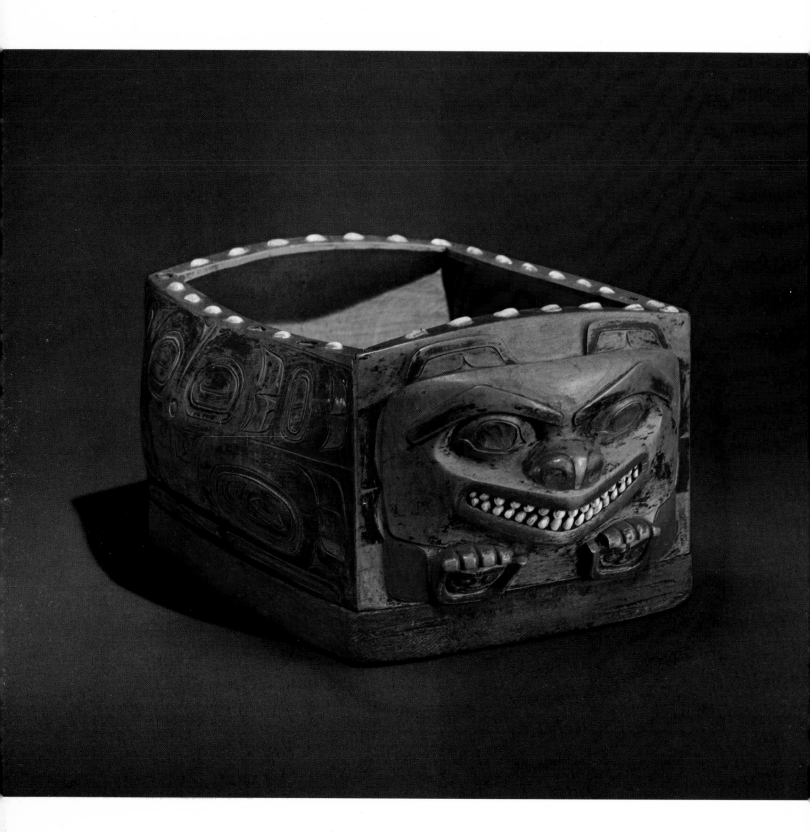

PLATE 2. Bowl in bear form, Chilkat Tlingit, collected before 1887. Carved and painted wood inlaid with abalone shell, opercula teeth; 15 inches wide. The American Museum of Natural History, New York (cat. no. 19/1086).

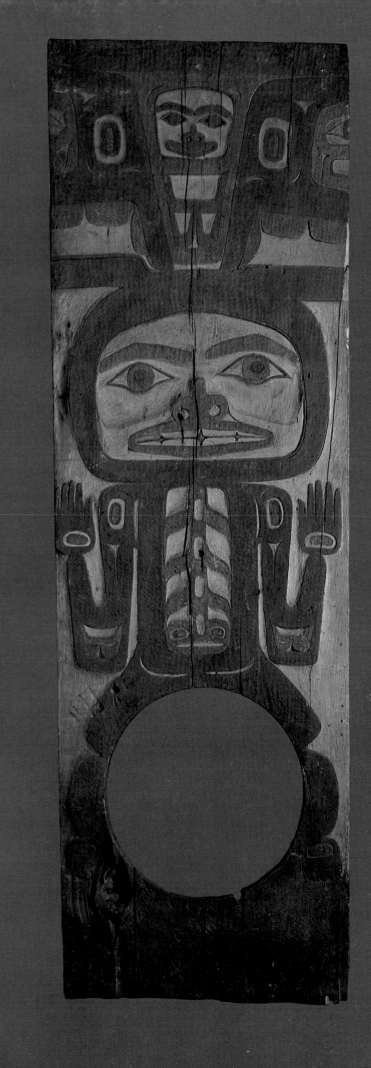

PLATE 3. Center plank of partition screen, Haida, collected c. 1900. Five carved and painted cedar planks, 132 x 150 x 1½ inches (overall). Canadian Ethnology Service, National Museum of Man, National Museums of Canada, Ottawa (cat. no. VII–B–1527).

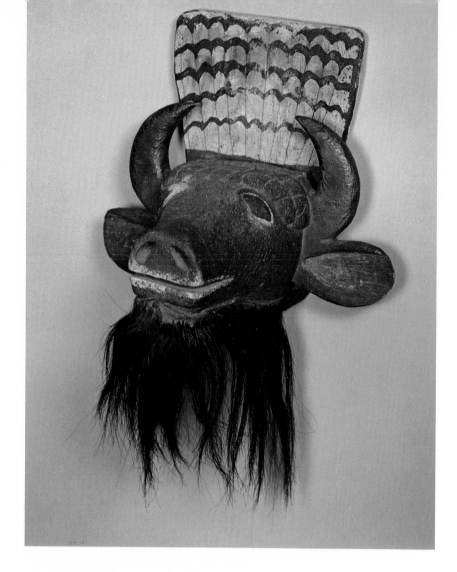

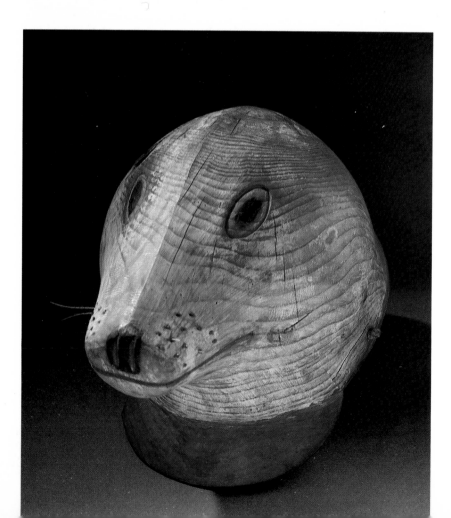

PLATE 4. Altar carving, Zuni, possibly 19th century. Cottonwood, paint, horsehair; 10¾ x 11¼ inches. Taylor Museum of the Colorado Springs Fine Arts Center (cat. no. 1549).

PLATE 5. Seal decoy hat, Kodiak Island, Alaska, collected 1867–68. Wood with white, red and black pigment; rawhide chin strap; 10 inches high. Peabody Museum of Archaeology and Ethnology, Harvard University, Cambridge, Mass. (cat. no. 69–30–10/64700).

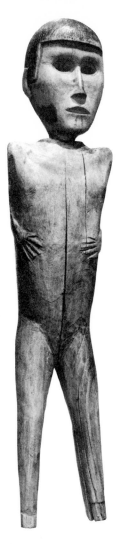

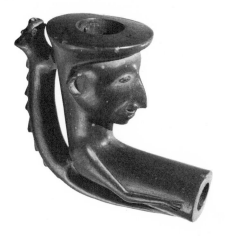

LEFT: 13. Mide doll, Ojibwa (or Chippewa), collected at Minocqua, Wisconsin. Carved wood, 16½ inches high. Milwaukee Public Museum, Milwaukee, Wisconsin (cat. no. 55324).

RIGHT: 14. Pipe bowl, possibly Midwest or Great Lakes region, c. 1800. Catlinite, 3½ inches long. Peabody Museum of Archaeology and Ethnology, Harvard University, Cambridge, Massachusetts (cat. no. 99–12 10/53106).

RIGHT: 15. Mortar, Wishram-Wasco, c. 1840–60. Carved oak burl, 11 x 12 x 12½ inches. Collection of Mr. and Mrs. Alan Backstrom.

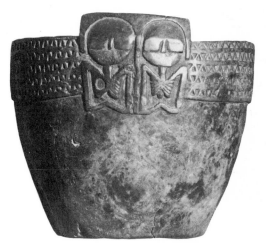

ceramic bowls with modeled frogs, and at Taos Pueblo crude modeled clay animal fetishes are still being made.

The historic Indians of the Great Lakes area carved a wide variety of small-scale wood objects for both religious and secular use. Secular items included spoons with carved figures on the handles; food bowls, often of beautifully grained burls; loom heddle frames; awl handles, often carved of bone or antler; handles for crooked knives; mirror frames; cradle boards; quirt handles; saddles (Fig. 16); war clubs, and pipe bowls and stems. The outstanding item of sacred sculpture was the small humanoid doll used in the ritual of the Grand Medicine Society, but similar dolls were used for magical stunts and as love charms (Fig. 13). In addition many of the normally secular items, such as pipe bowls, could be used for religious ceremonies and when so used were often more elaborately decorated. Little stone carving was done in the Great Lakes region, though pipe bowls were commonly carved from a soft red stone known as catlinite (Fig. 14). Catlinite, also known as pipestone and named after the artist, George Catlin, who first described the quarries, is obtained mainly from one quarry at Pipestone, Minnesota. It was the favorite pipe-bowl material

throughout most of the Plains as well as the Great Lakes area and a common trade item as far west as the plateau area of Washington. The Chippewa and Santee Sioux of the Upper Mississippi River region have been utilizing catlinite to produce carvings for sale to tourists for almost a hundred and fifty years. They make such things as ashtrays, letter openers, paperweights and even lamps in addition to a large number of smoking pipes.

In pre-contact times the Great Plains area was sparsely settled by groups clustered on the major rivers and practicing some agriculture in addition to bison hunting. With the introduction of the horse and the gun, and reinforced by pressure of eastern Indians being pushed west to accommodate European settlers, many of the tribes of the eastern prairies moved out into the Plains and became nomadic bison hunters. As nomads, Plains people tended to limit their material possessions to essential items which could be transported by horse: food, clothing, military and religious equipment, plus the portable tent known as a tipi. Pottery was known to the semi-sedentary tribes of the eastern prairies but was discarded in favor of metal containers obtained from the traders. In general bulky or heavy items were avoided

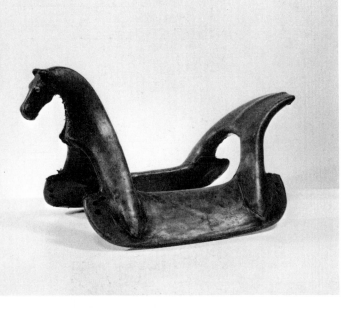

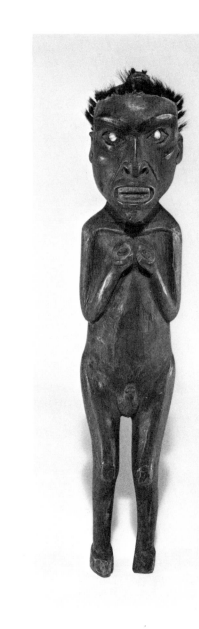

ABOVE LEFT: 16. Saddle, Menominee, collected 1903. Hide over carved wood, 23 inches long. The American Museum of Natural History, New York (cat. no. 50/4848).

ABOVE CENTER: 17. Dance stick, Hunkpapa Sioux, Standing Rock Reservation, North Dakota, c. 1860. Carved wood with feather, 34½ inches high. Museum of the American Indian, Heye Foundation, New York; Bequest of DeCost Smith (cat. no. 20/1295).

because of the difficulty of transportation. Plains Indians therefore created relatively little in the form of sculptural art. Smoking pipes of catlinite were common, but all other sculptural forms were rare. In the eastern Plains, because of the influence from the Great Lakes, we find copies of most of the Great Lakes sculptural forms but in lesser quantity. A few specialized Plains sculptural types evolved for use as emblems of military societies or as contents of medicine bundles. Some Sioux groups developed the stick carved with a horse head for use like a hobby horse while dancing (Fig. 17). Other typically Plains items include stone war clubs with animal forms carved in the stone and horn spoons with figures carved as part of the handles.

The area most prolific in sculptural production was the Pacific Northwest Coast including the coast of Washington and southeastern Alaska. Here tall totem poles, carved wooden boxes, canoes, large plank houses with carved corner posts and painted fronts, plus a wide variety of masks were made. Almost everything used by these people, including spoons and bowls, was lavishly decorated (Fig. 15). Stone carving in this region was common in pre-contact times, and wood carving here also had its roots in prehistory. Rather than declining with white contact, however, these arts seemed to undergo a florescence. The introduction of metal knives for carving certainly helped, but the major impetus came from the increased opportunity to acquire wealth. Most of the sculptural art produced on the Northwest Coast was used in connection with the potlatch. A potlatch was spon-

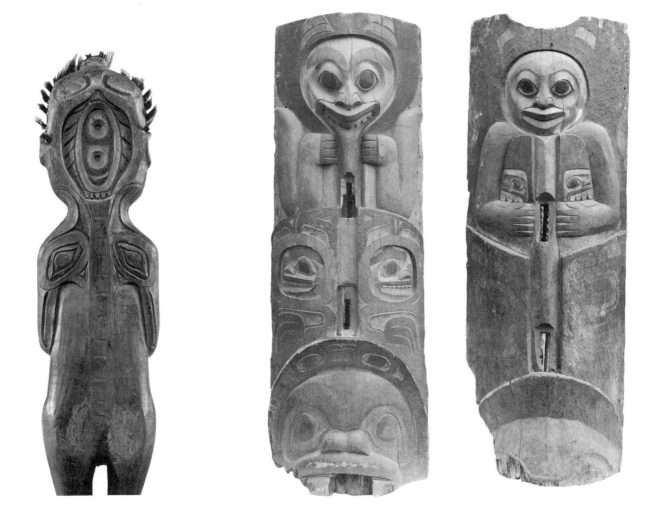

OPPOSITE AND ABOVE: 18a, b. Figure of a shaman with a shark on his back, Chilkat Tlingit, collected before 1887. Carved and painted wood, human hair, abalone shell; 17¾ inches high. The American Museum of Natural History, New York (cat. no. 19/308).

19, 20. Two of four house posts, Tlingit, Yakutat, Alaska, early 19th century. Carved and painted wood, 99 and 92 inches high. Canadian Ethnology Service, National Museum of Man, National Museums of Canada, Ottawa (cat. nos. VII–A–344b, VII–A–345).

sored by an individual to validate an inherited prerogative, such as the use of a name or a crest animal. An essential element of all potlatches was the distribution of wealth to the guests as payment for their services as witnesses. An individual gained prestige by validating as many prerogatives as possible and making lavish payments to witnesses. Therefore the more wealth a person could acquire, the more potlatching he could do, and the more prestige he would assume for himself. The fur trade and chances for employment in white settlements gave the Indians the opportunity to acquire wealth resulting in increased potlatching and an accompanying need for carvings. A wide variety of masks, staffs, rattles, drums and props were required for the dances and ceremonies associated with the potlatch. Payments to wit

nesses often included carved headdresses or spoons and bowls, and food for guests was usually served from elaborately decorated containers (Pl. 2). Even the well-known totem poles were erected to enhance the prestige of the owner, and as each new totem pole was set up it had to be validated with a potlatch. The same was true of a new house which contained carved posts or a decorated screen (Figs. 1, 2, 19, 20; Pl. 3).

In addition to the sculpture created for potlatches, items utilized by the shaman (medicine man) in curing disease, finding missing items or predicting the outcome of some event constituted a second major reason for artistic production (Fig. 18 a,b). Shamanistic sculpture included special masks, rattles, drums and a variety of carved ivory and bone charms (Fig. 21).

Although wood was the dominant medium for Northwest Coast sculpture, carvings in horn, antler, ivory, stone and shell were also common (Fig. 22). Spoons were often made from either sheep or goat horns, and large sheep horns were fashioned into bowls. Copper and soft iron (wrought iron) were carved much like wood into beautiful fighting knives by the Alaskan Tlingit.

The Indians of the Washington coast were similar to the Alaskan Tlingit and Haida with their economies based on seafood, but they produced a smaller number of carved objects. Washington Indians were more concerned with acquiring personal guardian spirits to insure them good health and luck in fishing than with acquiring prestige through the potlatch. Masking was known in parts of Washington, and some small totem pole-like figures were produced. In southern Washington, along the Columbia River, masking seems to have been unknown, but there spoons and bowls were carved of wood or sheep horn in a distinctive style.

North of Yakutat, Alaska, the various Eskimo groups have left a vast legacy of prehistoric carving in ivory and antler and a limited production in stone and wood. The ivory carvings were usually quite small due largely to the size of the raw material, but they took a large variety of forms from small human and animal figures to buckles, buttons, needle cases and snow knives. Much of the early Eskimo ivory carving seems to have had no utilitarian function. In the historic period, ivory carving was continued but largely as production for a tourist market. The major sculpture produced by the Eskimo was in the form of wooden masks made by or for shamans. These were often made in sets of ten or more different mask types to be used in pantomime dances reenacting the shaman's travels through the spirit world. Eskimo masks are some of the most inventive and powerful examples of sculpture found anywhere in the primitive world (Pl. 1). Although Eskimo peoples extend over a vast area from Alaska to Greenland, masking is largely restricted to the west coast of Alaska. The most imaginative masks are produced in the area from Norton Sound south to the Kuskokwim River.

The natives of the Aleutian Islands and of Kodiak Island produced some interesting sculpture in the form of masks, visors and helmets in the early historic period (Pl. 5), but these people suffered the same fate as the southern Californians and were early decimated as a result of white contact.

The situation in Hawaii is unfortunately similar to that of the Aleutian and Kodiak Islanders. In common with the rest of Polynesia, Hawaii had a rich tradition of carving in the pre-contact period, mainly in wood, but also in stone and whale or walrus ivory. We know this from the accounts of the Cook expeditions of 1768–80 and from the few surviving examples of wood sculpture. In 1819 the old religions were denounced by the ruler, Kamehameha II, as a result of missionary influence, and most of the known idols were destroyed. The less than one hundred and fifty examples which have survived were either collected before this date or have been recovered in caves and archaeological excavations. Hawaii, in the pre-contact period, had developed an extreme class system with powerful chiefs and priests who were worshipped almost as deities. Ancestor worship was common because power was inherited and cumulative. The chiefs, of course, inherited power and the commoners did not. The larger carved wooden figures were placed around the temple grounds as guardian figures, and smaller figures served as household deities (Figs. 23a, b). Some utilitarian bowls and drums were decorated with carved figures. Whale and walrus ivory were carved into necklace pendants and worn by the nobility, and a few stone carvings in human form have been recovered archaeologically.

The general picture of the past two hundred years of aboriginal art in the United States is one of rapid change due to the impact of contact with the white man. In most instances, the effect of white encroachment on the natives was to discontinue their traditional artistic production. In some cases this happened almost immediately, as when a tribal group abandoned their old religion in favor of Christianity. In other cases the aboriginal art forms were gradually altered and influenced by new tools and materials. Although vestiges of older forms still exist among the conservative Pueblos and to some extent in other areas, the general picture is that Indian art, if produced at all today, has altered so drastically in form that it is hardly recognizable as an aboriginal form.

A large body of impressive sculpture is known from the pre-1776 period, indicating a long history of artistic production in pre-contact times. However, it should be remembered that "pre-contact" as used here represents a period of five thousand or more years in contrast to the two-hundred-year period covered by this survey. During these last two hundred years, the major sculptural areas have been centered in Alaska among both the Eskimo and Tlingit, among the Pueblo peoples in the Southwest and among the Iroquois in upper New York State.

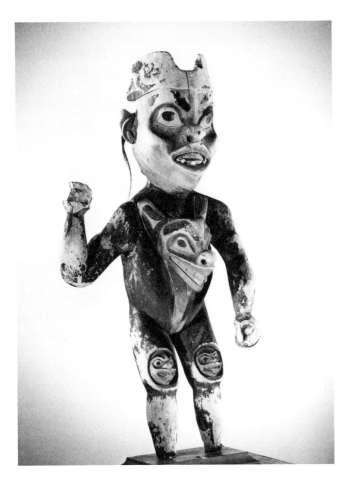

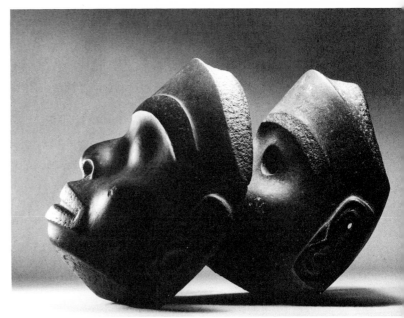

ABOVE LEFT: 21. Shaman's grave figure guardian, Tlingit, collected at Yakutat, Alaska, before 1887. Carved and painted wood, human hair, opercula teeth; 23½ inches high. The American Museum of Natural History, New York (cat. no. 19/378).

ABOVE RIGHT: 22. Masks, Northwest Coast (mask at left, Tsimshian, collected 1879). Basalt, each 9 inches in diameter. Left: Canadian Ethnology Service, National Museum of Man, National Museums of Canada, Ottawa (cat. no. VII–C–329); right: Musée de l'Homme, Paris (cat. no. 81.22.1).

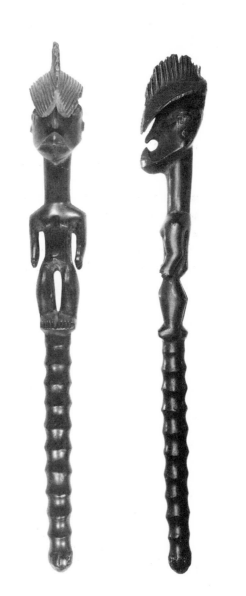

RIGHT: 23a, b. Post figure, Hawaii, probably before 1829. Carved wood, possibly sandalwood; 16 inches high. Roger Williams Park Museum, Providence, Rhode Island (cat. no. E 3099).

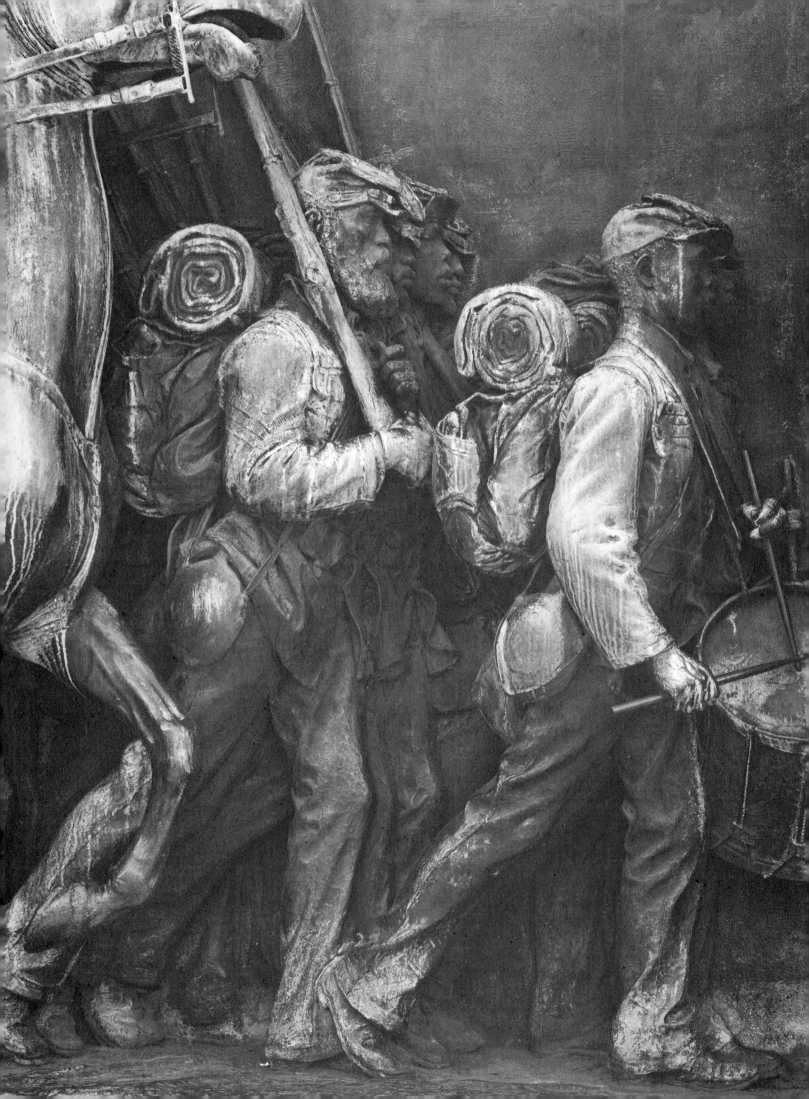

Images of a Nation in Wood, Marble and Bronze

American Sculpture from 1776 to 1900

Wayne Craven

THE SCULPTURAL LEGACY which the new nation inherited from its Colonial predecessors was far from a rich one and in fact, in 1776, sculpture as an art form was still in the hands of artisans and craftsmen. Stone carvers engraved their motifs of skulls and crossbones and other Protestant icons of death into the gray slabs that we still see standing today in old burial grounds (Fig. 24). Some skilled craftsmen made intricately carved wooden ornamentations for furniture or architectural decorations, while others carved wooden shop signs and ships' figureheads. Although they often achieved expression and formal excellence in their generally primitive style, they remained artisans skilled in the craft of carving and constituted a group distinct from what we normally think of as "sculptors" in today's use of the word. On the rare occasion when a fine piece of sculpture was desired, Americans turned to foreign sculptors, as in the 1770s when the cities New York and Charleston, South Carolina, commissioned the Englishman Joseph Wilton to make marble statues of William Pitt. Wilton also made a lead equestrian image of King George III which was erected in New York in 1770 and torn down by zealous patriots six years later. A few marble memorials with carved busts, urns or other decorations were produced in England and brought to the Colonies to be set in the walls of churches — as in King's Chapel in Boston. But sculpture as a high art, practiced by men who knew both the artistic theory of their Renaissance-Baroque-Rococo predecessors and the

various technical procedures of modeling, casting and carving rich three-dimensional forms, was not known among the native school in 1776. Indeed, for many years thereafter America had two groups from which to choose — either the local craftsmen or the imported talent of European sculptors.

The 18th century was not one in which powerful sculptural conceptions were developed. The one really famous sculptor of the period — Jean Antoine Houdon — was no match, in his handling of robust plastic forms, for Michelangelo or Bernini. Therefore, that which our native school inherited from contemporary European sculpture was not sculpture at its fullest realization. Add to this the timidity with which the unschooled artisan — originally trained as a stonemason, carpenter or cabinetmaker — attacked the medium from which he was to make his image, and one understands more fully the development of sculpture (or, more accurately, carving) in post-Revolutionary War America.

Nevertheless, American wood-carvers flourished during the Federal Period, led by such men as the Skillins, Samuel McIntire and William Rush (Fig. 27). They were continually called upon to make a wide variety of carvings — from decorative work for furniture, architecture and ships to the curious shop signs such as the manacled prisoner that is believed to have stood outside the Kent County Jail, East Greenwich, Rhode Island, after it was carved sometime in the 1780s or '90s (Fig. 28). The little figure, wearing the tattered attire of a late 18th-century seaman, may well have been intended as a warning to sailors coming ashore that the community on Narragansett Bay would tolerate no misconduct. Most

OPPOSITE: Augustus Saint-Gaudens. Detail of *Robert Gould Shaw Memorial*, 1884–97. Bronze, 11 x 14 feet (overall). Beacon Hill, Boston. Photograph by Richard Benson from *Lay This Laurel*, Eakins Press Foundation. (See Fig.92.)

ABOVE LEFT: 24. Burial ground, Concord, Massachusetts, with gravestone of Mr. Jonathan Haywood, Jr., died December 15, 1776, at age twenty-nine.

ABOVE: 25. Skillin Shop. *Keystone Head*, 1786–88. Wood, 15 inches high. The Rhode Island Historical Society, Providence.

BELOW LEFT: 26. Skillin Shop. *Hebe*, c. 1800. Painted pine, 58 inches high. The Metropolitan Museum of Art, New York; Rogers Fund, 1967.

BELOW: 27. Unknown artist. *Four Figures*, c. 1800. Wood, 25 inches high. Collection of Mr. and Mrs. George M. Kaufman.

port towns had their carvers such as the Skillin brothers, John and Simeon, Jr., of Boston, sons of the carver, Simeon, Sr. In the late 18th and early 19th century the Skillin Shop produced garden figures for Elias Hasket Derby, furniture ornamentation for many of the leading cabinetmakers of New England, and architectural decorations — such as the *Keystone Head* that was made for the arch in a Palladian window of the John Brown House, built in Providence, Rhode Island, in 1786 (Fig. 25). This painted head, with sand added to the paint to simulate stone, is stylistically nearly identical to that of the figure of *Hope,* of about 1790, which is also attributed to the Skillin Shop and is in the Henry Francis du Pont Winterthur Museum. In these pieces the more primitive style of the elder Skillin (died 1778) may dominate, for after the turn of the century we find carved figures attributed to the Skillin Shop which have more supple forms and bear traces of a knowledge of the marble creations of the Neoclassical movement by such artists as the Italian sculptor Antonio Canova. The *Hebe* that is attributed to the Skillin Shop, for example, suggests that the carver probably knew an engraving of Canova's statue of the same subject, of 1801, which is now in the Hermitage in Leningrad (Fig. 26). The Skillins' *Hebe* was painted

gray with streaks of red, again to simulate stone, and was perhaps intended to decorate a garden or parlor.

In nearby Salem, Samuel McIntire also produced an occasional wood carving, although the list of pieces attributable to him is today much reduced from what was previously believed. There appears to be no doubt, however, about the bust of Governor John Winthrop which originally belonged to the Reverend William Bentley (Fig. 29). The latter recorded in his diary under date of May 12, 1798, that he had loaned McIntire a miniature portrait of Winthrop from which to carve a bust; it was completed in nine days, Bentley was delighted with it, and bequeathed it to the American Antiquarian Society in 1819. This little bust of the first governor of Massachusetts survives as a choice example of the wood-carvers' art of the late 18th century, but with only the quasi-primitive work of other carvers to guide him McIntire had difficulty translating the two-dimensional miniature into three-dimensional sculptural form; the resulting flatness and lack of depth of carving is shared with much of the work of the carvers of this period.

William Rush was one of the few wood-carvers of the Federal Period to make a successful transition from craftsman to sculptor. After serving his apprenticeship to

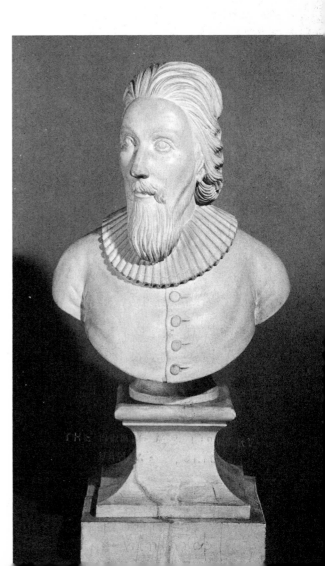

LEFT: 28. Unknown artist. *Kent County Jail Sign,* c. 1780–1800. Wood, 34 inches high. The Rhode Island Historical Society, Providence.

RIGHT: 29. Samuel McIntire. *Governor John Winthrop,* 1798. Wood, 16 inches high. American Antiquarian Society, Worcester, Massachusetts.

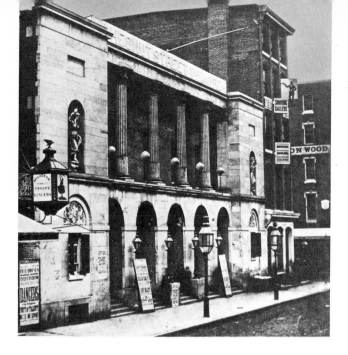

ABOVE: 30. Chestnut Street Theatre, Philadelphia, destroyed in 1855. *Comedy* and *Tragedy*, carved wood figures by William Rush, stand in niches. Reproduced by permission of Clarkson N. Potter, Inc., from Frederick Fried, *Artists in Wood*, 1970.

BELOW LEFT: 31. William Rush. *Comedy*, 1808. Pine, 101¾ inches high. Edwin Forrest Home; Courtesy of the Philadelphia Museum of Art.

BELOW RIGHT: 32. William Rush. *Tragedy*, 1808. Pine, 101¾ inches high. Edwin Forrest Home; courtesy of the Philadelphia Museum of Art.

the Philadelphia carver Edward Cutbush, Rush went into business for himself about the time of the Revolutionary War, and in the last two decades of the century seems to have specialized in making decorations for ships, particularly figureheads; none of this pre-1800 work survives but records exist that give the exotic names of the great prow ornaments.

By 1808 Rush had grasped the idea that there was a difference between artisan-carving and rich sculptural form. That year he carved the two powerful images of *Comedy* and *Tragedy* which were placed in the exterior niches of the New Theatre on Chestnut Street, designed by Benjamin Henry Latrobe (Figs. 31, 32). The building burned in 1820 but Rush's figures were saved and set up in the niches designed for them in William Strickland's new Chestnut Street Theatre (Fig. 30). They were carved from pine and painted, probably to imitate stone, and large hollows were cut into the backs to prevent checking, or the splitting of the wood as it dried out. They are heroic in conception and suggest that Rush, in spite of his legacy from the native wood-carvers' school, was attempting to create in the more fully developed style of the European Neoclassical movement. The bold play of light and shade in powerful dynamic masses reveals that Rush had come to a full realization of sculptural form.

Comedy and *Tragedy* were soon followed by Rush's more celebrated *Water Nymph and Bittern*, the original of which was carved in pine, painted white, and placed in the center of the fountain in front of Latrobe's Water Works in Philadelphia, shown in John Lewis Krimmel's *Fourth of July in Centre Square* (Pl. 6). The wooden image did not long survive under such conditions, and in 1854 the weathered and rotting original was removed and a bronze casting was made from it (Fig. 34). In this piece Rush achieved a remarkable feeling for corporeal form; since the figure was to have the spray of the fountain fall upon it, he quite appropriately created a "wet drapery" effect, for which he was chastised by many of his fellow Philadelphians for revealing too blatantly the well rounded female forms. The problem of the nude or any work that revealed too much the form of the body would be one that American artists and patrons alike would agonize over for many years to come.

The important thing here, however, was that Rush had made the transition from carver to sculptor, and he went on to create numerous other excellent monumental figures in wood—such as the vigorous life-size image of George Washington, which he carved in 1814 and exhibited at the Pennsylvania Academy the following year (Fig. 42). Rush continued to progress in the mid-1820s with such works as *Justice* and *Wisdom* (Figs. 35, 36) and

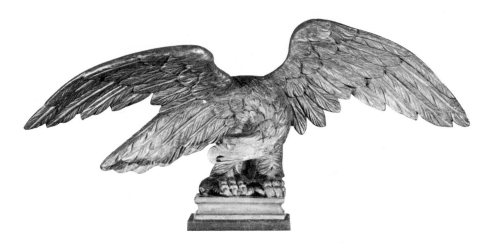

ABOVE: 33. William Rush. *Eagle*, c. 1805. Gilded wood, 37 inches long. Pennsylvania Academy of the Fine Arts, Philadelphia; Gift of B. I. de Young, 1947.

LEFT: 34. William Rush. *Water Nymph and Bittern*, cast 1854 from wood original, made c. 1809 for fountain in Centre Square, Philadelphia (see Pl. 6). Bronze, 91 inches high. The Commissioners of Fairmount Park, Philadelphia.

BELOW LEFT: 35. William Rush. *Justice*, c. 1824. Painted pine, 96 inches high. Philadelphia Museum of Art; on deposit from the Commissioners of Fairmount Park.

BELOW RIGHT: 36. William Rush. *Wisdom*, c. 1824. Painted pine, 96 inches high. Philadelphia Museum of Art; on deposit from the Commissioners of Fairmount Park.

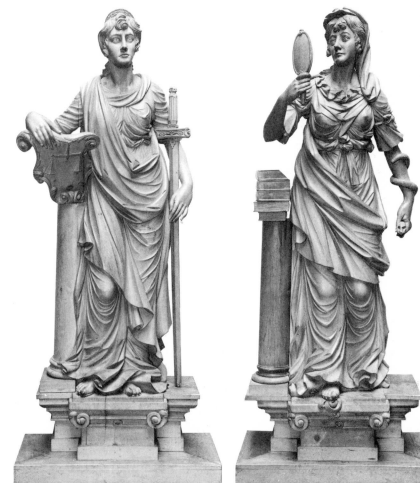

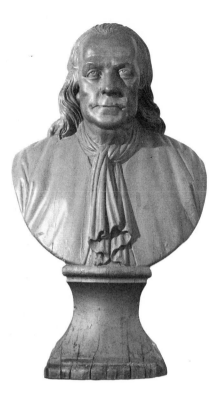

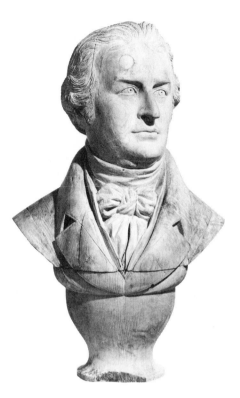

LEFT: 37. William Rush (attributed). *Benjamin Franklin, c. 1785–90.* Wood, 34 inches high. The Historical Society of Delaware, Wilmington.

RIGHT: 38. Unknown artist. *Chancellor Robert R. Livingston,* c. 1810–20. Wood, 24¼ inches high. The New-York Historical Society; The Abbott-Lenox Fund.

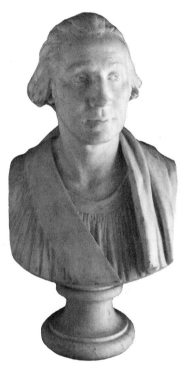

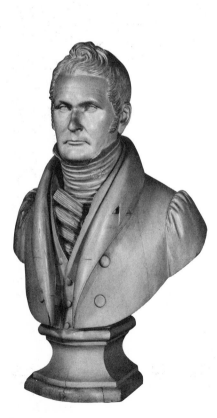

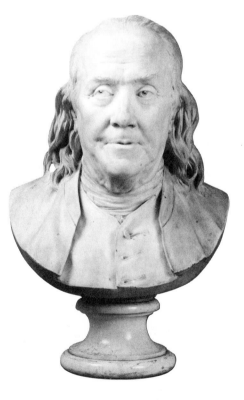

ABOVE: 39. Jean Antoine Houdon. *George Washington,* c. 1790. Marble, 24 inches high. Private collection.

LEFT: 40. Charles J. Dodge. *Jeremiah Dodge,* c. 1825–30. Wood, 27½ inches high. The New-York Historical Society; Bequest of Fanny C. Marquand.

RIGHT: 41. Jean Antoine Houdon. *Benjamin Franklin,* 1779. Marble, 20⅞ inches high. Photograph courtesy of Sotheby Parke Bernet Inc., New York.

his *Schuylkill Freed* and *Schuylkill Chained,* creating his own version of neoclassical sculpture for America by basing his imagery on classical or neoclassical prototypes which he blended with the vigor of the American wood-carvers' art.

Rush is also remembered for the several eagles he carved as symbols of the new nation (Fig. 33). These were probably based on the imperial eagle of the Napoleonic era, but they possess a distinctly American quality.

Rush also created numerous portraits in wood and eventually even modeled busts in terra-cotta. The Historical Society of Delaware owns a bust of Benjamin Franklin, which they have attributed to Rush, that serves as a choice example of the wood-carvers' art about the turn of the century (Fig. 37). The vitality of this kind of work is further seen in two later examples — *Chancellor Robert R. Livingston* by an anonymous carver, about 1810–20, and *Jeremiah Dodge,* carved by Charles J. Dodge about 1825–30 (Figs. 38, 40). But William Rush died in 1833 and thereafter the native

school of carvers turned mainly to cigar-store figures, circus-wagon figures and the like, while the mainstream of American sculpture was continued through her own artists such as Horatio Greenough, Hiram Powers and Thomas Crawford, or foreign sculptors such as Houdon, Canova or Chantrey.

Three years after the signing of the Declaration of Independence, Jean Antoine Houdon created his bust of Benjamin Franklin, then the American minister in Paris for the purpose of negotiating an alliance with France (Fig. 41). In 1785, the year Houdon produced his bust of Thomas Jefferson, Franklin returned to America, accompanied by Houdon who came to make studies for his full-length marble portrait of George Washington, which was commissioned for the Virginia State Capitol in Richmond (Fig. 43). These exquisite portraits were soon joined by Houdon's busts of Washington (Fig. 39), John Paul Jones, Robert Fulton and Joel Barlow, which encouraged numerous other commissions and stimulated the art of sculpture in the new nation.

42. William Rush. *George Washington,* 1814. Painted pine, 73 inches high. Independence National Historical Park Collection, Philadelphia.

43. Jean Antoine Houdon. *George Washington,* 1788–92. Marble, 74 inches high. Virginia State Capitol, Richmond.

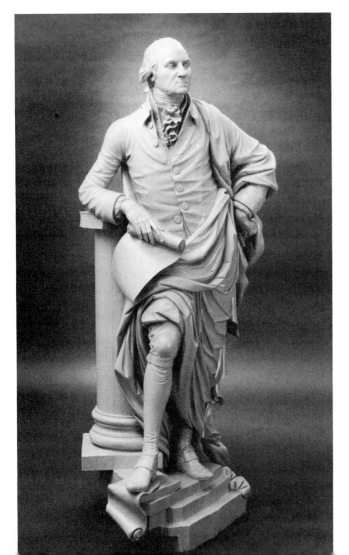

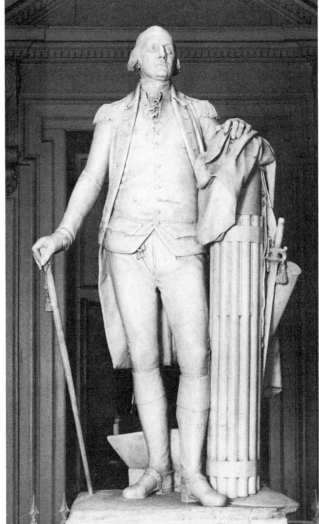

The Italian Giuseppe Ceracchi (1751–1802) came to America in the 1790s and made Italianate likenesses of George Washington, while other Italians, Giuseppe Franzoni (died 1815) and Giovanni Andrei (1770–1824), were imported in 1806 to provide the marble architectural embellishments for the new United States Capitol. In Rome in 1818 Antonio Canova, the most famous sculptor of his day, began his marble statue of Washington, commissioned for the new North Carolina State Capitol building in Raleigh. The celebrated old Italian created an image of "The Father of His Country" in the form of a Roman general (Fig. 44); it arrived amid much fanfare in 1821 and, although it was destroyed in the Capitol fire of 1830, it contributed enormously to the establishment of sculpture as a fully developed form of art in America. In New England, Sir Francis Chantrey's full-length marble portrait of Washington (1826) for the Massachusetts State House further encouraged Americans to consider sculpture seriously, whereas before it had been mainly thought of as the decorative carving of artisans.

During this period from about 1778 to 1826, serious consideration was rarely given to native-born talent when important commissions were contemplated. The records of these commissions clearly reveal that before the 1830s America had no confidence in its own talent to produce sculpture of distinction. But then the situation changed suddenly as Horatio Greenough, Hiram Powers and Thomas Crawford came upon the scene. Almost immediately after these men decided to become sculptors, however, they departed for Italy because America was no place to learn to be a sculptor. This could only be done at what they considered to be the fountainhead of all great sculpture — from Roman antiquity and the Renaissance to the contemporary Neoclassical movement.

Horatio Greenough left his native Boston in 1825 to go to Italy, where he would spend most of the rest of his career, first briefly in Rome and then more permanently in Florence. He absorbed the aesthetic principles of Neoclassicism at their source and willingly became a part of the sizable expatriate community of Americans who found more inspiration abroad than at home. Greenough produced several portrait busts and a few ideal pieces in marble before his great opportunity came. It is a milestone in the history of American sculpture that Congress, in 1832, turned to a native son for the execution of an extremely important commission — the great marble image of Washington that was to be placed beneath the dome of the rotunda of the United States Capitol. American sculpture was to come of age with this commission (Figs. 45a–c).

Like Canova, Greenough conceived his image of Wash-

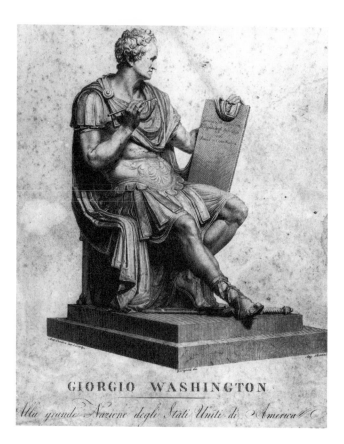

44. Antonio Canova. *George Washington*, 1818–21. Engraving, 17 x 21 inches (framed). Photograph courtesy of the State Department of Archives and History, Raleigh, North Carolina.

45a-c. Horatio Greenough. *George Washington*, 1832–41. Marble, 136 inches high. National Collection of Fine Arts, Smithsonian Institution, Washington, D.C.

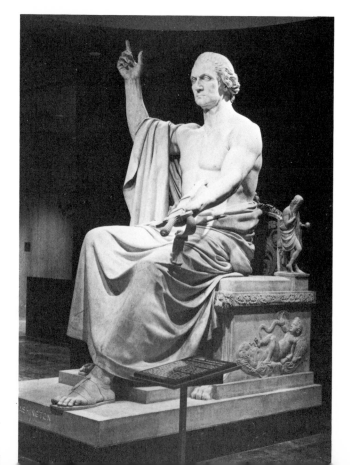

ington in the guise of a great classical personage; in fact, he took as his model an archaeologist's reconstruction of the long-lost but world-famous statue of Zeus by the 5th-century B.C. Greek sculptor Phidias. To Greenough's mind no higher honor could be bestowed upon Washington than portraying him in a way that endowed him with all the noble virtues of antiquity. But back home most Americans failed to comprehend the iconography, and after Greenough's Jovian *Washington* was unveiled in 1841 it drew more censure than praise. Nevertheless, the precedent had been established, and in the second quarter of the 19th century those Americans who aspired to be sculptors almost unanimously looked to neoclassicism as the determinant style in their work. Men such as Greenough rarely turned to truly American subject matter and seldom considered the possibility of a thoroughly American style. Consequently, Greenough's subsequent work consisted of pieces like *Abdiel* and *Castor and Pollux* (Figs. 46, 47). The *Abdiel,* commissioned in 1838 by Professor Edward E. Salisbury of Yale, was inspired formally by the Apollo Belvedere, although its subject is derived from the episode of the good angel departing from the rebel angels in the Fifth Book of Milton's *Paradise Lost.* The *Castor and Pollux* is likewise a blending of a theme from great literature (in this case classical mythology) with formal inspiration from classical art (possibly the processional relief from the Parthenon or the

designs of the English sculptor John Flaxman). To the end, Greenough remained committed to the neoclassical style in sculpture and contributed greatly to its transplantation into American culture.

Hiram Powers gave up his career as a Yankee mechanic in Cincinnati in the late 1820s to become a sculptor of international fame. Encouraged by the wealthy Cincinnatian Nicholas Longworth, Powers went to Washington, D. C., in the mid-1830s to seek portrait commissions, and the most famous result of this trip was the grave but striking marble portrait bust of Andrew Jackson in the Metropolitan Museum of Art. A naturalism of great verve was employed — appropriate to the taste of the subject but enjoying also the sanction of ancient Roman portraiture. Powers soon left for Italy, settling in Florence in 1837, where he was befriended by Horatio Greenough, already well established there. The following year Powers made his beautiful and sensitive bust of Greenough which stands as one of the most exquisite portraits produced by any 19th-century American sculptor (Fig. 48). Powers's portrait busts were soon the rage and over the years he produced dozens of them, revealing in their simple, honest naturalism all of the sensitivity or the banality that the subject inspired.

Powers nonetheless was anxious to take up the challenge of an ideal subject, and in the end he became one of the most respected artists of his era in that genre. He

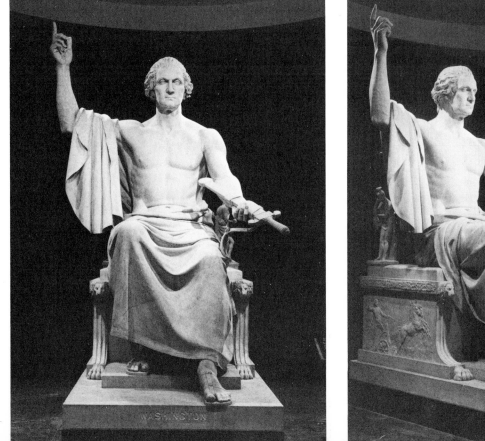

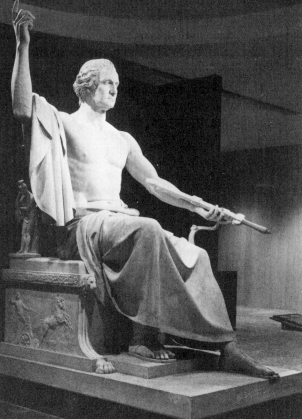

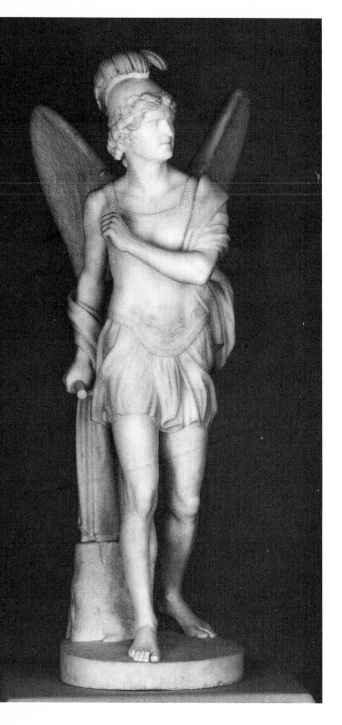

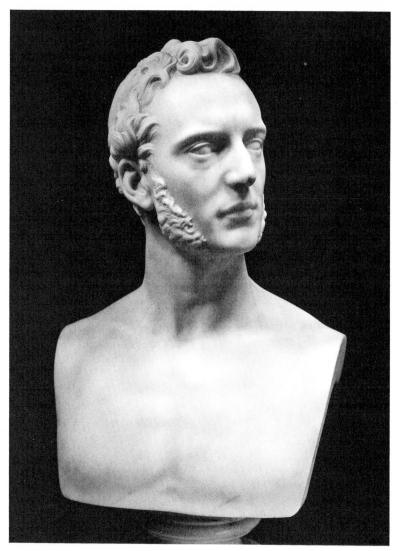

ABOVE: 46. Horatio Greenough. *Abdiel*, 1839. Marble, 40¾ inches high. Yale University Art Gallery, New Haven, Connecticut; Bequest of Edward E. Salisbury.

ABOVE RIGHT: 47. Horatio Greenough. *Castor and Pollux*, 1847–51. Marble, 34½ x 45 inches. Museum of Fine Arts, Boston.

RIGHT: 48. Hiram Powers. *Horatio Greenough*, 1838. Marble, 25½ inches high. Museum of Fine Arts, Boston.

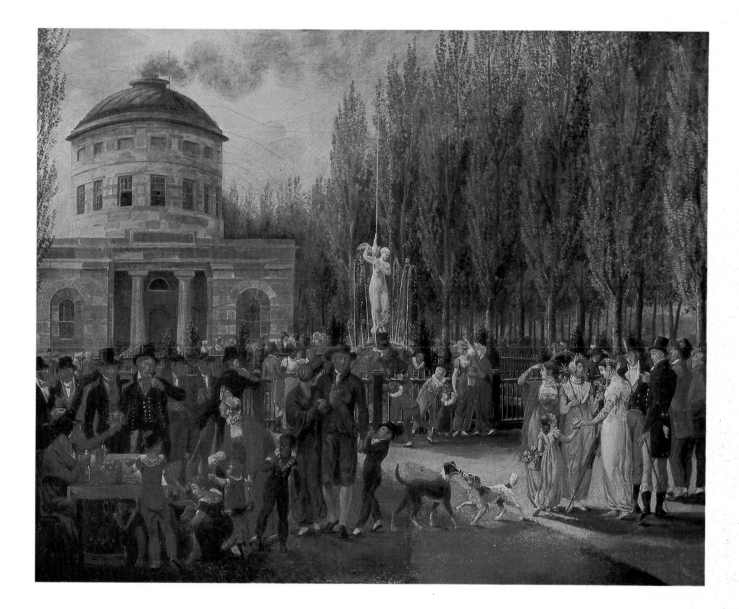

PLATE 6. John Lewis Krimmel. *Fourth of July in Centre Square,*
C. 1810–12. Oil on canvas, 23 x 28¾ inches. Pennsylvania Academy
of the Fine Arts, Philadelphia; Academy Purchase, 1845. (See
Fig. 34, p. 31.)

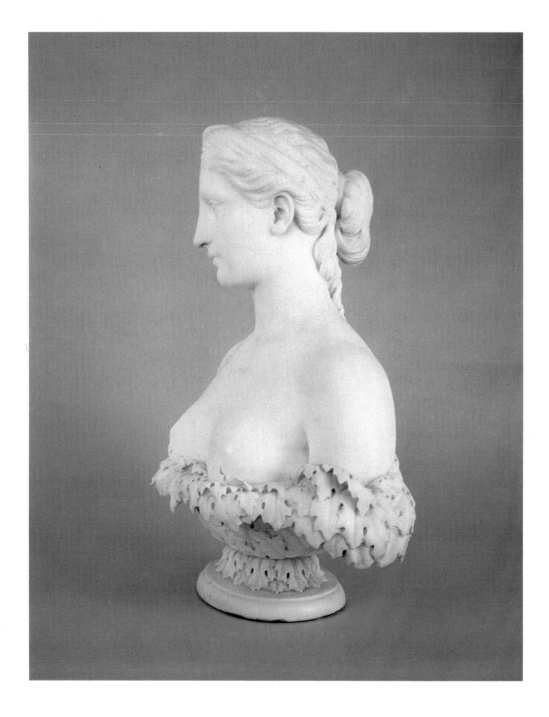

PLATE 7. Hiram Powers. *Proserpine,* 1844. Marble, 24^{15}⁄$_{16}$ inches high. Cincinnati Art Museum, Cincinnati, Ohio; Gift of Reuben R. Springer.

PLATE 8. Tompkins H. Matteson. *Erastus Dow Palmer in His Studio,* 1857. Oil on canvas, 29¼ x 36½ inches. *Infant Flora* at far right (see Fig. 64, p. 48). Albany Institute of History and Art, Albany, New York.

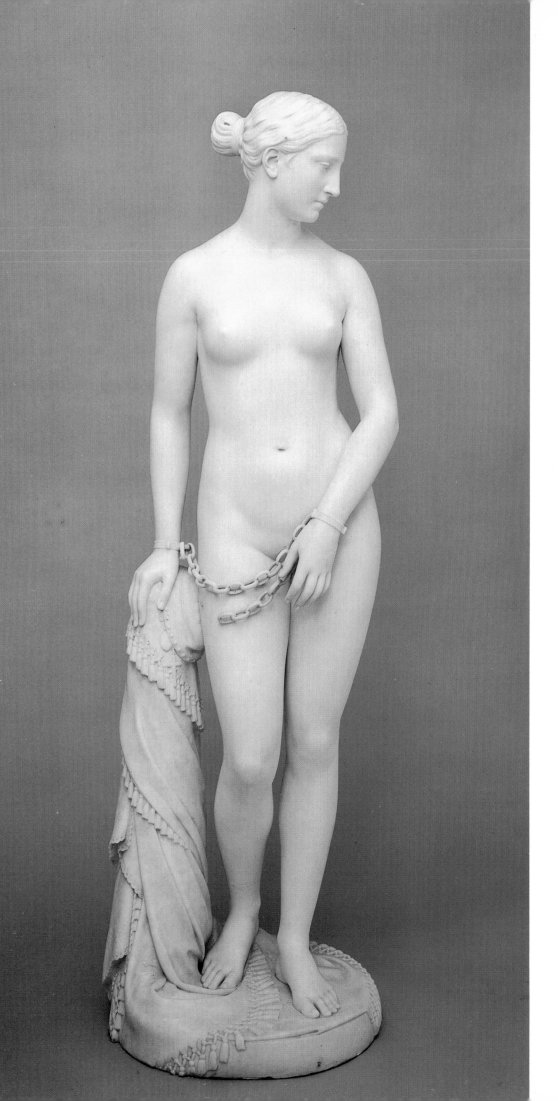

PLATE 9. Hiram Powers. *The Greek Slave,* 1847. Marble, 65½ inches high. The Newark Museum, Newark, New Jersey. (See p. 48.)

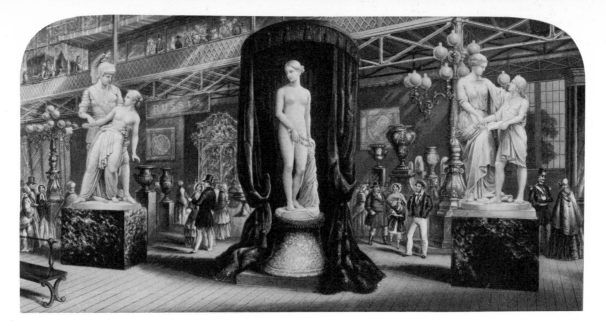

49. George Baxter. *The Genius of the Great Exhibition Number 3.* Combination of wood block and steel plates with oil-colored inks on paper (Baxter's Process), 5⁷⁄₃₂ x 9¹³⁄₁₆ inches. *The Greek Slave* stands at center in draped booth at the Crystal Palace in London in 1851. The Metropolitan Museum of Art, New York; The Elisha Whittelsey Collection, The Elisha Whittelsey Fund, 1955.

made several ideal busts, such as *Proserpine* or *Persephone,* which were reproduced in marble by his Italian artisan-assistants (Pl. 7). The original dates from 1839-40, but it was so popular that as many as one hundred replicas were produced over the years that followed. The lovely countenance has a classical reserve in its expression and quite appropriately the subject wears a wreath of wheat in her hair (she was the daughter of Demeter, mythological goddess of agriculture), while around her shoulders and breasts is a wreath of acanthus leaves, symbol of immortality (obtained as the daughter of Zeus and Demeter and as the wife of Pluto, god of the netherworld). Although the inspiration is classical, the piece represents a 19th-century interpretation of classical aesthetics. This applies equally to Powers's greatest triumph, the internationally celebrated *Greek Slave* (Pl. 9 & p. 48).

Inspired by the recent Greek struggle for freedom from Turkish domination, *The Greek Slave* bears a formal debt to the Venus de' Medici, in Florence, which Powers knew well there; in fact he owned several photographs of it. *The Greek Slave* was an immediate success in his studio and in London where the original was purchased by an Englishman (Fig. 49). So famous was it to become that Powers would produce six marble versions altogether; four of these are now in public collections in the United States: Corcoran Gallery (second version), Newark Museum (third version), Yale University Art Gallery (fifth version) and The Brooklyn Museum (sixth version).

The Greek Slave first came to America in 1847, sent on tour by Powers, and it caused both a sensation and a dilemma which arose from America's inexperience in confronting the nude figure in a work of art. At first shocked by this nudity, Victorian American morality was soon mollified by the literary explanation and interpretation that always accompanied the figure. Even preach-

ers gave their approbation, explaining essentially this: that the woman had been stripped bare by heathen Turks, but that her Christian virtue was so powerful as to turn away every vulgar and profane stare; furthermore, they reasoned, her nudity was clearly beyond her control, and they thereby found it acceptable. Americans flocked to see her wherever she toured, providing Powers a handsome profit and making him an instant celebrity in American art. America came out of its first national confrontation with the nude surprisingly unscathed and undemoralized; but still, in many places on the tour, separate viewing hours were arranged for men and women for the sake of moral propriety.

Powers made several other ideal busts and statues which found favor in America, but he remained an expatriate in Italy; in fact, he never returned to his native land. His inspiration was in Italy, and so were the beautiful white marble of Carrara and the Italian artisans who did almost all of the actual carving in marble after the artist had completed his original in clay; also, models who would pose in the nude were plentiful and inexpensive there.

Thomas Crawford had been trained in a New York stone yard before going to Rome in 1835, where he was to gain acclaim as a maker of public monuments in both marble and bronze. The marble figures for the pediment of the Senate wing of the United States Capitol (1855) and the bronze images for the Washington Monument in Richmond (1850–57) are probably his best known works of this type. But he also produced a number of ideal images of classical inspiration, such as the little marble *Genius of Mirth* of 1843 (Fig. 53). This piece is typical of that kind of 19th-century art which was meant to amuse rather than move the soul through the profundity of its subject.

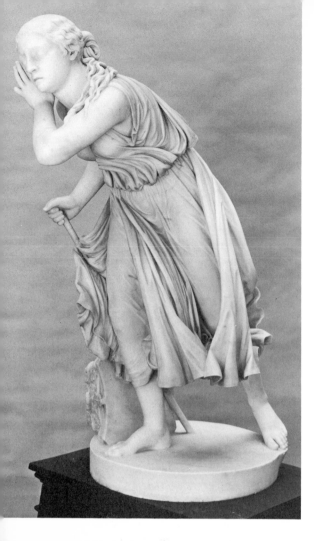

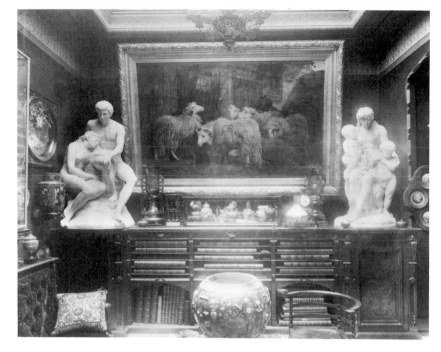

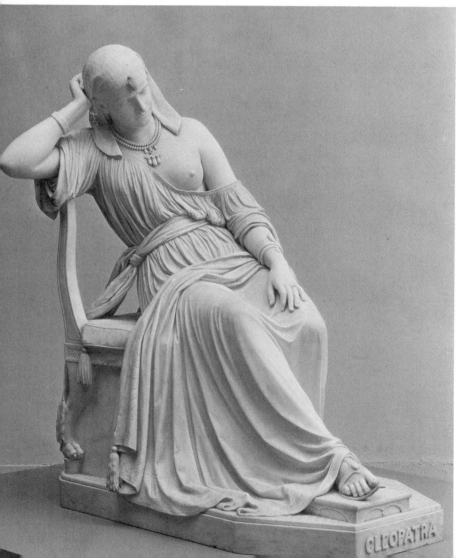

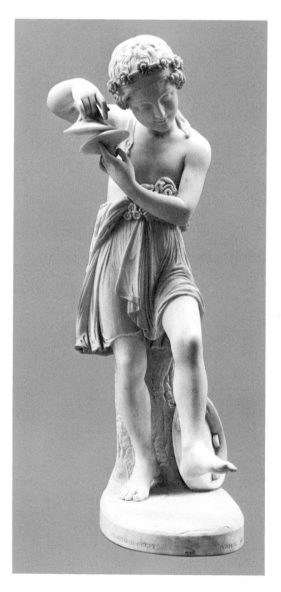

OPPOSITE:

ABOVE LEFT: 50. Randolph Rogers. *Nydia, the Blind Girl of Pompeii,* n.d. Marble, 54 inches high. Pennsylvania Academy of the Fine Arts, Philadelphia; Gift of Mrs. Bloomfield Moore, 1895.

ABOVE RIGHT: 51. The "Last Hour" gallery in Henry C. Gibson's house at 1612 Walnut Street, Philadelphia, where his large collection of painting and statuary was installed. Joseph A. Bailley's life-size marble sculptures, *The Expulsion* (left) and *First Prayer* (right), flank Auguste Friedric A. Schenck's *The Last Hour.* Gibson bequeathed his collection to the Pennsylvania Academy in 1892. Photograph courtesy of the Archives of the Pennsylvania Academy of the Fine Arts, Philadelphia.

BELOW LEFT: 52. William Wetmore Story. *Cleopatra,* 1869. Marble, 56 inches high. The Metropolitan Museum of Art, New York; Gift of John Taylor Johnston, 1888.

BELOW RIGHT: 53. Thomas Crawford. *The Genius of Mirth,* 1843. Marble, 46 inches high. The Metropolitan Museum of Art, New York; Gift of Mrs. Annette W.W. Hicks-Lord, 1897.

A second generation of American sculptors followed Greenough, Powers and Crawford to Italy to take up the expatriate life there. The community of American sculptors in Rome became sizable in the 1850s and 1860s. Thomas Crawford was there until 1857 when his fatal illness set in; Richard Greenough, Horatio's younger brother, and William Wetmore Story arrived in 1848, Edward Bartholomew in 1850, and Randolph Rogers and Chauncey B. Ives established their studios in Rome in 1851. Harriet Hosmer arrived a year later and then came Paul Akers in 1855, for a few years before his tragic premature death. William Rinehart settled in Rome in 1858 and latecomer Franklin Simmons was there by 1867. Most of these Americans entered into the glittering cosmopolitan life of the Eternal City, creating marble portrait busts and statues and ideal images of gods, goddesses, biblical personages and literary figures — all in response to the increasing demand for such sculpture in halls of government, parlors and libraries in Europe and America (Fig. 51). Among the most obvious symbols of Victorian wealth and culture were the marble bust of the self-made industrialist or the ideal parlor statue of a delicate Clytie, a ponderous Cleopatra or an impish Puck.

At the center of this expatriate community, installed in his apartment in the Palazzo Barberini, was William Wetmore Story, sophisticated Boston lawyer-turned-sculptor. Although Story engaged in portraiture his main interest was in images of dramatic heroines from literature and antiquity — such as his *Medea* or the *Libyan Sibyl* or the celebrated *Cleopatra* (Fig. 52). The latter, in large measure, became the archetype of this kind of marmorean art of the 19th century — especially after Nathaniel Hawthorne spread its fame by praising it in a long passage in his *Marble Faun,* published in 1860. Three versions are known to exist, the original having been made in 1858; the example owned by the Metropolitan Museum of Art dates from 1869, the year after the versatile Story published a long poem titled "Cleopatra" which stands as a wonderful example of Victorian passions. The sculptor's subject was a powerful queen of an exotic land of antiquity, notorious for her love affairs with great men; all of this stimulated the sensibilities of the Romantic age, which were further moved by the profound mood of the ill-fated heroine who at the moment reflects on her epic past, her downfall, and her imminent death from the bite of an asp.

International acclaim came to Story when Pope Pius IX requested permission to send the *Cleopatra* and the *Libyan Sibyl* to London in 1862 to the International Exposition to represent the Papal state. Story received word of their extraordinary success from his dear friend, Robert Browning; later, another friend, Henry James, wrote that such work did not present its unbounded appeal in its plastic form, but in "the sense of the romantic, the anecdotic, the supposedly historic, the explicitly pathetic. It was still the age in which an image had, before anything else, to tell a story...."[1] James astutely comprehended that marble sculpture by Story and his contemporaries was to be judged more for the literary, historical and even theatrical associations that it evoked than by the rich beauty of sculptural form itself.

Rivaling Story's *Cleopatra* as a symbol of its era and paralleling it in its dependence upon literary and historic associations was Randolph Rogers's *Nydia, the Blind Girl of Pompeii* (Fig. 50). This piece, first produced in marble in 1856, was so popular that over fifty marble replicas were produced upon commission by the Italian artisans in Rogers's studio. It has the double advantage of being based on a famous ancient statue, the Hellenistic *Old Market Woman* which Rogers knew in the Vatican, and on a then equally famous novel, Bulwer-Lytton's *Last Days of Pompeii,* first published in 1834. It represents the virtuous young blind girl making her way alone through the perilous streets of Pompeii at the moment when Vesuvius erupted in 79 A.D. One may well imagine the sentimentality with which Victorians viewed the statue and read the passage from the novel: "Poor girl! her courage was beautiful to behold! ... The boiling torrents touched her not.... Weak, exposed, yet fearless ... she was the very emblem of Psyche in her wanderings; of Hope, walking through the Valley of the Shadow; a very emblem of the Soul itself — lone but comforted, amid the dangers and snares of life!"

William Rinehart from Baltimore also created marble images of classical themes which were very popular in their day — such as *Hero* and *Leander,* inspired by an

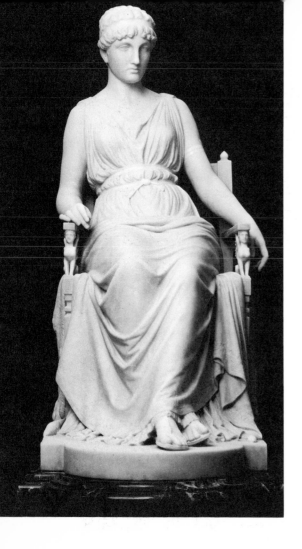

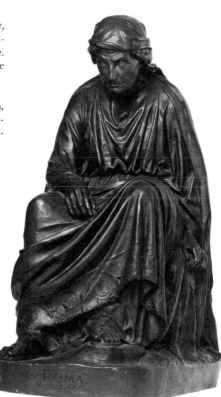

LEFT: 54. Franklin Simmons. *Penelope*, c. 1880. Marble, 36 inches high. Portland Art Museum, Portland, Maine. Gift of the City of Portland from the Estate of Franklin B. Simmons, 1921.

RIGHT: 55. Anne Whitney. *Roma*, 1869, cast 1890. Bronze, 27 inches high. Wellesley College Museum, Wellesley, Massachusetts.

ancient myth and by Lord Byron's poem of the same theme (Pls. 11, 12). Hero, a priestess of Aphrodite, lived on the western shore of the Hellespont, while her lover, Leander, resided at Abydos on the eastern shore; nightly he would swim the straits to be with her, guided by the light of the lamp she always provided. Then one stormy night, the wind blew the lamplight out, he drowned, and his beloved Hero, in her anguish, threw herself into the water to join him once more, in death. Waves lap at the base of each piece while Hero, her lamp already lit, peers hopefully into the darkness; Leander is pensive as he contemplates entering the water, aware of the danger he faces. Formally, Rinehart drew upon Michelangelo's *David* for his *Leander* and the head of *Hero* strongly resembles the head of the Venus de Milo.

Less well known today but famous in his own time for similar work was Franklin Simmons, originally from Maine but after 1867 an expatriate in Rome. His heroic maidens, goddesses and personifications of ancient places were very popular. His *Penelope* is one of the finest examples of his work but again demonstrates the dependency of American sculptors in Italy on themes that had practically nothing to do with contemporary American life (Fig. 54). Here, Penelope sits patiently, awaiting the return of far-wandering Ulysses.

Because the ideal bust was less expensive than the full-length marble statue, it enjoyed an even greater popularity. Among American expatriate sculptors Hiram Powers was probably the most successful in this genre — with his Ginevras, Persephones and numerous other pieces. Many exquisite works were created by other sculptors as well, however, and one could cite, for example, Harriet Hosmer's *Daphne* (Fig. 56). According to classical mythology this beautiful daughter of a river god was admired by Apollo whose amorous intentions were thwarted when, to protect her virtue, Daphne's mother changed her into a laurel tree; hence the wreath of laurel at the base of the bust. Hosmer was a perky, spritely addition to the expatriate scene, although her strong-willed independence often brought censure from other members of the community, many of whom were never convinced that sculpture was an art for women. She supported herself with innumerable marble replicas of her impish *Puck*, who sits upon a toadstool, and its counterpart, *Will-o'-the-Wisp*. But she also accepted the challenge of the heroic female image, as in her large *Zenobia, Queen of Palmyra* (1857), now at the Wadsworth Atheneum, and her *Beatrice Cenci* (c. 1855) at the Mercantile Library in St. Louis.

Actually, there were several American women who became a part of the expatriate group in Rome and Florence, whom Henry James called a "white, marmorean

flock." In addition to Harriet Hosmer there was Anne Whitney, Margaret Foley, Louisa Lander, Emma Stebbins and Edmonia Lewis. Anne Whitney's bronze *Roma* is a personification of the Eternal City represented as an old, stoop-shouldered beggar-woman who sits pondering the disasterous state of Italy before its unification (Fig. 55).

While the ideal bust was a favorite subject, it was usually the portrait bust that kept the sculptor financially solvent and allowed him or her to work on fancy pieces. Somewhere between the two types would come Henry Kirke Brown's *La Grazia,* a beautiful marble image that is both a portrait of a specific person and an ideal conception in the classical mode (Fig. 57). Brown spent four years in Italy, from 1842 to 1846, during which time he came very much under the spell of antiquity, and an ancient Greek prototype of the 5th century B.C. may well be envisioned for his *La Grazia;* in fact, this bust belongs more with those idealizations such as Powers's *Proserpine* and Hosmer's *Daphne* than with actual portraiture such as we find in Chauncey B. Ives's marmorean likenesses of Daniel Wadsworth or Mrs. William Gage Lambert (Figs. 58, 60). Marble portraits of Americans by Powers, Ives and others employed an uncomplicated naturalism in which there was little attempt to idealize the subject's features. This naturalism not only had the approbation of a practical-minded, materialistic clientele of American merchants and businessmen, but it also could claim an aesthetic basis in the portraiture of republican Rome. Thus American sculptors could turn either to ideal Greek prototypes for inspiration in their images of goddesses or the like, or to ancient Roman portraiture for an often severely naturalistic style in portraying their contemporaries in stone. A sculptor could even extend the allusion of endowing contemporary Americans with those ancient and noble Roman virtues by draping a toga about the shoulders, as in Ives's bust of Daniel Wadsworth. While the head remains unidealized, the mantle of republican virtue is nevertheless cast about his shoulders, creating the dichotomy of presenting an ideal within the image without actually idealizing.

The phenomenon of expatriate sculptors in Italy is a fascinating chapter in the history of 19th-century American art, but there were those artists, of course, who remained at home — those who did not feel it was necessary to go abroad. Among these one finds John Frazee, Erastus Dow Palmer and Hezekiah Augur, all of whom worked in marble.

Frazee came up the ranks in a New York stone yard, virtually without formal training of any kind. He concentrated on portrait busts, beginning around 1824, executed in a bold naturalism of verve and vigor. The striking head of Andrew Jackson, now in the Princeton

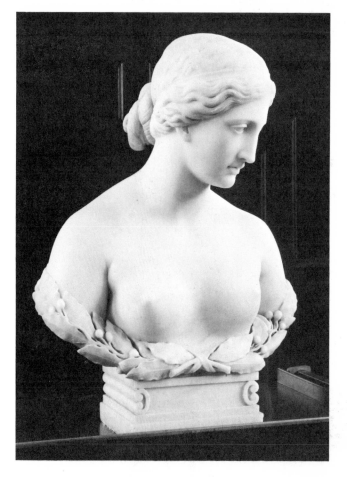

56. Harriet Hosmer. *Daphne,* 1854. Marble, 27 inches high. Washington University Gallery of Art, St. Louis, Missouri.

57. Henry Kirke Brown. *La Grazia,* 1845. Marble, 20½ inches high. The New-York Historical Society.

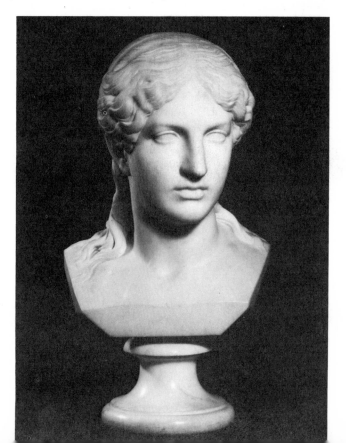

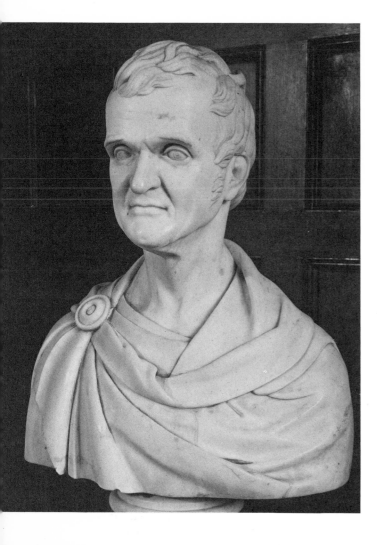

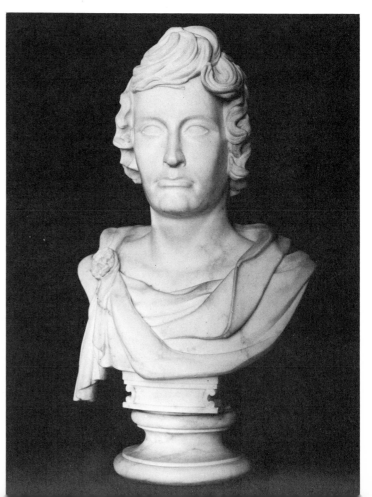

OPPOSITE:
ABOVE LEFT: 58. Chauncey B. Ives. *Daniel Wadsworth*, 1841. Marble, 21 inches high. Wadsworth Atheneum, Hartford, Connecticut; Bequest of Daniel Wadsworth.

ABOVE RIGHT: 59. John Frazee. *Andrew Jackson*, 1834. Plaster of Paris, 13 inches high. The Art Museum, Princeton University, Princeton, New Jersey.

BELOW LEFT: 60. Chauncey B. Ives. *Mrs. William Gage Lambert*, 1848. Marble, 28½ inches high. The New-York Historical Society.

BELOW RIGHT: 61. Hezekiah Augur. *Alexander Metcalf Fisher*, 1825-27. Marble, 22⅞ inches high. Yale University Art Gallery, New Haven, Connecticut; Gift of the Colleagues of Alexander Metcalf Fisher, Class of 1813.

University Art Museum, is a splendid example of this naturalism that seemed to come so easily to American sculptors who were engaged in portraiture (Fig. 59). In its forcefulness, both aesthetically and as a character-filled likeness, it compares favorably with the more famous portrait bust of Jackson by Powers in the Metropolitan Museum of Art.

Frazee's *Jackson* is in plaster, the intermediate stage between the original clay modeled by the sculptor and the ultimate conclusion of its translation into marble. Frazee, of course, trained as an artisan stonecutter, could translate his work into marble himself, and did so, whereas the expatriates saw this as a tedious and laborious task that was better left to their Italian artisan studio assistants.

Hezekiah Augur, like Frazee, Powers, E. D. Palmer and many other American sculptors of this era, came into the field of sculpture from one of the manual or mechanical arts — in Augur's case, he was first a carver of ornamental furniture parts and then inventor of a lace-making machine. He remained of local importance in the area around New Haven and never became a national figure, although his marble images of *Jephthah and His Daughter,* probably his best known work, toured several American cities in the 1830s and were much admired. In his portrait bust of Yale Professor Alexander Metcalf Fisher of about 1825-27, one finds something of the bold vigor of the wood-carver merged with the international style of neoclassicism that Augur knew even in New Haven, so very far from its source in Rome (Fig. 61).

Of those who rejected expatriation in Italy the best known is Erastus Dow Palmer who began his career as a carpenter in the Utica and Albany area of New York. After attempting cameo cutting in the mid-1840s he turned to sculpture, virtually without benefit of formal training. By 1850 he was carving ideal works in marble

and by 1856 he was able to mount a sizable exhibition of his ideal marble pieces at the Church of Divine Unity in New York City. A painting of 1857 by Tompkins H. Matteson shows Palmer at work with several assistants in his Albany studio where a number of his works are visible (Pl. 8).

Although Palmer on occasion drew upon classical subjects and themes — as in his *Infant Flora, Infant Ceres* or a relief of *Sappho* — he is better known for pieces which are more closely connected with America itself. His most famous piece is *The White Captive*, a life-size marble figure of a young frontier girl who has been abducted by Indians, bound and stripped of her clothing (Figs. 62, 63). This is clearly a piece brought forth as a thoroughly American response and counterpart to Powers's *Greek Slave* which only about ten years before had made its triumphal tour of the United States. Aside from its being in white marble, there is practically nothing that is Italianate neoclassicism in this statue. We see here a typically American girl in face and figure, without the dependence on the Venus de' Medici that we observe in *The Greek Slave*. The same may be said of Palmer's *Indian Girl (The Dawn of Christianity)* of 1856, in the Metropolitan Museum of Art, which may be seen in the center of Matteson's painting of Palmer's studio. Romantic Victorian morality and religious sentiment are here expressed through an image of an American Indian girl who examines a small cross and, so the story goes, thereby experiences conversion from savage heathen to the spiritual enlightenment that Christianity offers.

Palmer was drawn to the sweet innocence of children and on occasion used his little daughter for his model, as in his *Infant Ceres* (1849, unlocated). This strain of Victorian sentimentality may also be seen in his *Infant Flora* and the *Little Peasant (The First Grief)*, the latter showing a young girl lost in sad thoughts over the empty bird nest she holds before her (Figs. 64, 65). This is sentimental genre art, quite possibly inspired by Palmer's observing his daughter in a similar dolorous situation.

Marble sculpture at home and abroad allowed a wide span of expression, from portraiture to ideal subjects that ranged from the drama of ancient heroic women to the quiet commonplace images of children at their leisure. Americans burst upon the scene of marble sculpture rather abruptly in the 1820s and rose to a respected membership in the Neoclassical movement that was centered in Italy in the middle third of the century. But after about the time of the Philadelphia Centennial Exposition of 1876 the great era of marble sculpture had passed. Already by the early 1850s that medium had been challenged by another — bronze — which sculptors such as Brown, Ward, Ball, Saint-Gaudens and MacMonnies seemed to favor over marble.

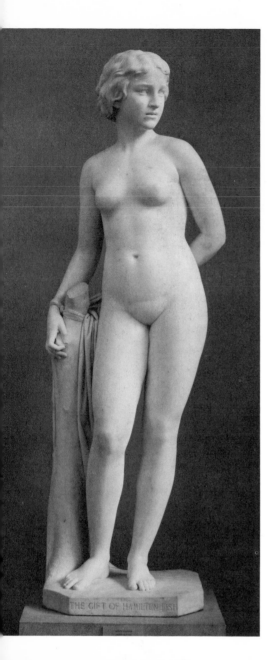

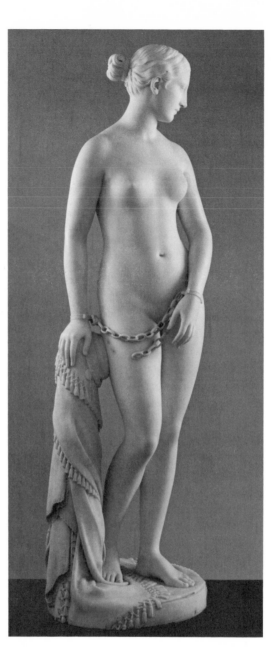

FAR LEFT: 62. Erastus Dow Palmer. *The White Captive,* 1859. Marble, 66 inches high. The Metropolitan Museum of Art, New York; Gift of Hamilton Fish, 1894.

LEFT: Hiram Powers. *The Greek Slave,* 1847. (See Pl . 9.)

BELOW LEFT: 63. Erastus Dow Palmer. *Maquette for the White Captive,* 1857. Plaster, 19¾ inches high. Albany Institute of History and Art, Albany, New York.

BELOW CENTER: 64. Erastus Dow Palmer. *The Infant Flora,* 1857. Marble, 17 inches high. Walters Art Gallery, Baltimore, Maryland. (See Pl. 8.)

BELOW RIGHT: 65. Erastus Dow Palmer. *Little Peasant (The First Grief),* 1859. Marble, 47 inches high. Albany Institute of History and Art, Albany, New York.

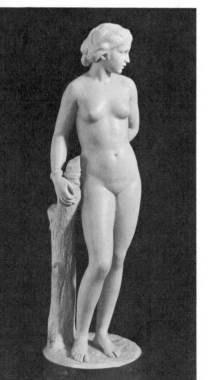

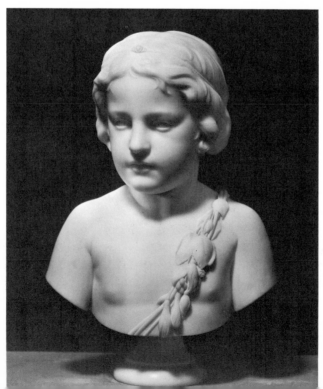

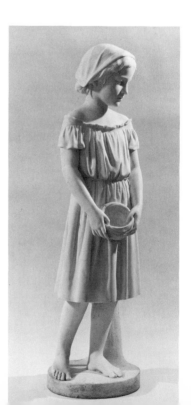

Bronze foundries had existed in the United States for the casting of cannons and utilitarian objects prior to 1850, but only after that date did artists working here begin to create for the medium of bronze and develop foundries and the necessary skills for the purposes of sculpture. In an amazing feat of American ingenuity and self-confidence Clark Mills, an architectural plasterer-turned-sculptor who had never attempted anything more ambitious than a plaster bust, undertook the designing and modeling of his rearing equestrian statue of Andrew Jackson which he cast in a foundry he built himself in Bladensburg, outside Washington. Later a reduced version was made, but the heroic and vigorous original was erected in Lafayette Park across from the White House in 1853 (Figs. 67, 68). This statue and the noble equestrian statue of George Washington by H. K. Brown, erected in Union Square, New York, in 1856, demonstrated clearly that a "bronze age" of American sculpture had arrived.

Henry Kirke Brown returned from Rome in 1846 and settled in New York, evidently already determined not to live as an American expatriate in Italy. Moreover, he rejected neoclassicism in favor of a thoroughly naturalistic style which he considered appropriate for American art. He no doubt hoped that his equestrian *Washington* (Fig. 66) would follow in the line of the ancient Roman bronze equestrian of Marcus Aurelius and Donatello's Renaissance masterpiece, the *Gattamelata* in Padua, but the basis of his style was to be a naturalism that grew out of the cultural forces in America itself, rather than one borrowed from Europe. The vitality of this

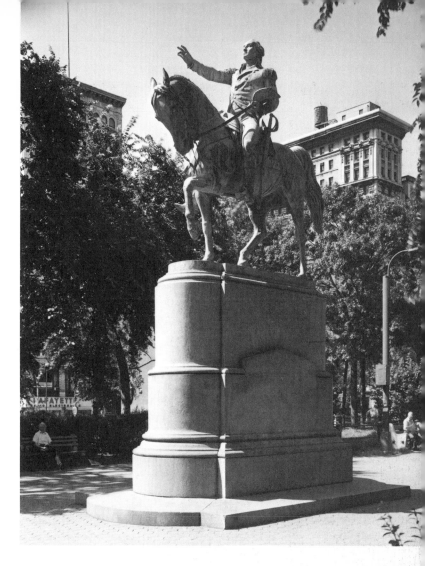

66. Henry Kirke Brown. *George Washington*, 1853–56. Bronze, 13½ feet high. Union Square Park, New York.

67. Clark Mills. *Andrew Jackson*, 1855. Bronze, 24 inches high. The New-York Historical Society.

68. Clark Mills. *Major General Andrew Jackson*, 1848–53. Bronze, approximately 108 inches high. Lafayette Park, Washington, D.C. Photograph by Lee Friedlander.

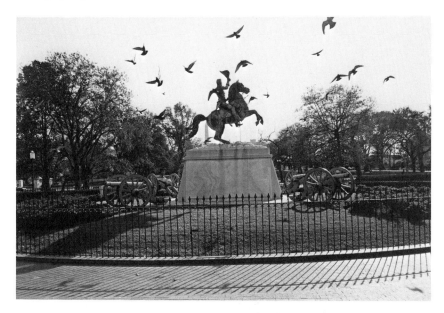

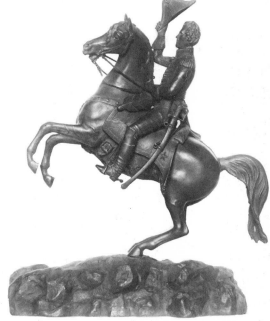

LEFT: 69. Thomas Ball. *Henry Clay, 1858*. Bronze, 30½ inches high. Addison Gallery of American Art, Phillips Academy, Andover, Massachusetts.

ABOVE: 70. John Quincy Adams Ward. *Roscoe Conkling*, c. 1892. Bronze, 23½ inches high. The New-York Historical Society.

naturalism is evident in his bronze bust of General Winfield Scott (Pl. 10), created in connection with the commission for the equestrian statue erected in Scott Circle in Washington. Avoiding sham, pretention and idealization or any flattery of his subject, Brown made a virtue of reality in this bust.

Thomas Ball did the same in his beautifully modeled statuette of Henry Clay (Fig. 69). Like Brown's equestrian *Washington*, the *Clay* was cast at Ames Foundry in Chicopee, Massachusetts, which pioneered in the casting of bronze sculpture in America. Within this aesthetic of naturalism there is a dynamic energy that seems appropriate for self-confident men of accomplishment who guided the destiny of America in the mid-19th century. The vitality of this naturalism — less refined in bronze than in the marble busts previously discussed — is at the heart of American bronze portraiture at its best, as we may see in John Quincy Adams Ward's head of Roscoe Conkling, well-known politician of his day, of about 1892 (Fig. 70). This tour de force of naturalism reflects the materialism of Conkling's kind and it rivals similar portraiture of the 15th-century Italian Renaissance. It is also the verve of this naturalism that gives such animation to the bronze head of Ralph Waldo Emerson which Daniel Chester French modeled in 1879 (Pl. 13). For a portrait of Emerson — by whom art, nature and reality

were blended into a philosophical system — any style other than naturalism would have been grossly inappropriate.

These sculptors applied this same naturalism to full-length bronze statues for memorials to the nation's great men. Brown, Ward, Ball and countless others populated American parks, plazas and halls of business and government with commemorative figures in a movement for memorial monuments that culminated in the art of Augustus Saint-Gaudens and Daniel Chester French.

French's *Minute Man* was commissioned by his home town of Concord, Massachusetts, in 1873 (Fig. 71). At that time the young sculptor had not yet attempted a full-length, over-life-size figure, and possibly that is why he looked for assistance to a cast of the Apollo Belvedere that was available at the Boston Athenaeum. But the result transcended a mere paraphrasing of an antique prototype and became a highly original solution to the challenge of the commission. The *Minute Man* was cast at the Ames Foundry in Chicopee from the bronze of old cannons that the government made available for the purpose. It was unveiled on April 19, 1875, but young French was not present at the ceremony for he had already gone to Florence, Italy, where he would study for a year and a half in the studio of his countryman Thomas Ball. The statuette of *The Concord Minute Man of 1775*

71. Daniel Chester French. *Minute Man*, 1873–75. Bronze, approximately 84 inches high. Concord, Massachusetts.

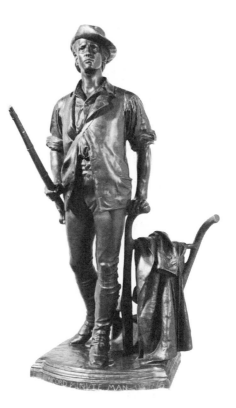

72. Daniel Chester French. *The Concord Minute Man of 1775*, 1889. Bronze, 32½ inches high. Art Gallery, Ball State University, Muncie, Indiana; Gift of F. C. Ball.

is a replica of a reduction made by French in 1889 for the U.S.S. *Concord* (Fig. 72). The Concord *Minute Man* was the beginning of the unparalleled success of Daniel Chester French's half-century career as a sculptor. He rose to the very pinnacle of his profession, excelling not only in memorial portrait statues but also in figures (usually female) personifying the goals and virtues of America in that great age of the late 19th century (Fig. 185).

Another example of monuments to the nation's historic past that were popular during this period would be Augustus Saint-Gaudens's *The Puritan,* the original heroic-scale bronze of which was erected in Springfield, Massachusetts, in 1887; a small version dates from 1899 (Pl. 18). In this piece Saint-Gaudens made an imaginary portrait of Deacon Samuel Chapin, attempting to realize in it all of the religious zeal and vigor of our New England forebears.

Stylistically, *The Puritan* reveals that American sculptors such as Saint-Gaudens, once they rejected Italian neoclassicism and the medium of marble, turned away from Florence or Rome and toward Paris where such masters as Carpeaux and Dalou had developed a new manner of representing form that was exquisitely appropriate for bronze. In the new Parisian manner the surfaces came alive and rippled with activity, in marked

contrast to the smooth, controlled surfaces and contours of neoclassical marbles. Saint-Gaudens had gone to Paris in 1867 and had spent three years there, working part of that time in the studio of François Jouffroy, then one of the foremost sculptors of his day. While in Paris the young American absorbed the French manner of creating surfaces that sparkled as lights and shadows played across every particle, giving a heretofore unknown spontaneity to sculptured form. Deep, bold shadow areas and lively highlights increased the plasticity of the form; sculpture ceased to be dependent upon literary associations (so often the case in marble ideal pieces) and sculptors began to perceive the true beauty and rich potential of three-dimensional form.

As much as any other 19th-century American sculptor, and far more than most, Augustus Saint-Gaudens grasped the significance of plastic form. After a brief visit to Rome in 1870 he returned to New York in 1872, and thereafter American sculpture would be much the richer through the example of his many extraordinary works. Even John Quincy Adams Ward who had worked in the drier naturalism of mid-century turned readily to the new French element that had been brought back to America by Saint-Gaudens. Not the least remarkable of Saint-Gaudens's accomplishments was, of course, the fa-

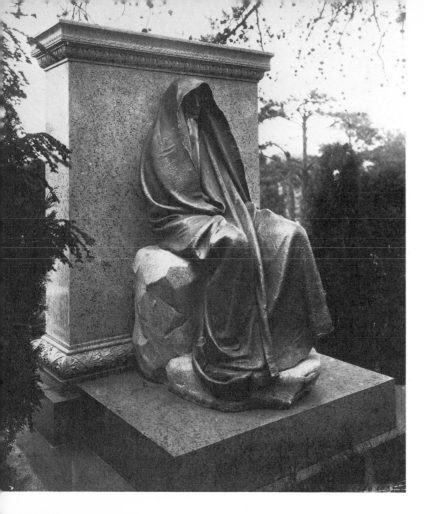

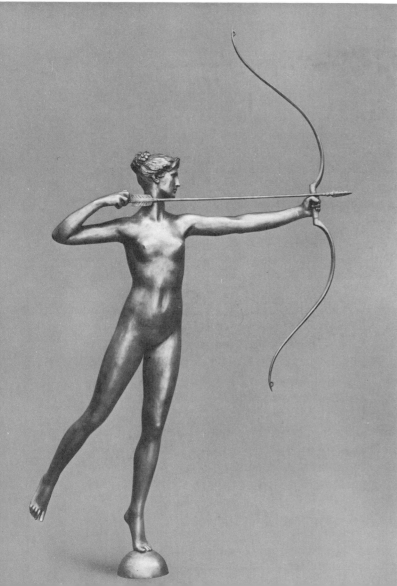

mous *Adams Memorial* of 1886–91 in Rock Creek Cemetery, Washington, D.C., which stands as a monument in its own right to the final triumph of plastic form in American sculpture (Fig. 73).

That Saint-Gaudens could combine an elegance with this quality of rich plastic form is seen in the graceful figure of *Diana* (Fig. 74). The original eighteen-foot-high statue was designed by 1891 as a weathervane for the dome of McKim, Mead and White's Madison Square Garden in New York. It proved too large and was replaced by a thirteen-foot reduction; the larger version was exhibited at the 1893 World's Columbian Exposition in Chicago. When Madison Square Garden was destroyed in 1925, the *Diana* was acquired by the Philadelphia Museum of Art. The version owned by the Metropolitan Museum of Art is a nine-foot reduction cast in Germany in 1928. Saint-Gaudens, who seldom worked with the nude figure, has given a new and personal interpretation to a classical subject; the result is an image that is classical in spirit but original in conception.

The beauty of Saint-Gaudens's art is also to be found in the portrait reliefs he created — as in that of William Merritt Chase (Fig. 75). Saint-Gaudens knew how to use the full range of sculptural effects, from the linear beauty of low relief to the well rounded and highly plastic forms of high relief. He made many such portraits which have a special beauty derived from the total mastery of relief sculpture, in which he undoubtedly drew inspiration from the reliefs he had seen in Florence by the great Renaissance sculptor Donatello.

The Parisian influence may be seen in the work of other American sculptors, as in the very sensitive head of J. Alden Weir by Olin Levi Warner (Fig. 78). Weir, the painter, and Warner, the sculptor, each had his studio in the Benedict Building in New York in 1880 when this portrait was modeled. Warner had studied in Paris about the same time that Saint-Gaudens was there, and he too worked in the studio of Jouffroy at the Ecole des Beaux-Arts. He also admired the work of Jean Baptiste Carpeaux and Jean Antonin Mercié, and he thoroughly absorbed the Parisian manner of rich modeling, giving his surfaces the flickering liveliness that we see in his portrait of Weir. Warner's talent was slow to be appreciated in America, unlike that of Saint-Gaudens or

ABOVE LEFT: 73. Augustus Saint-Gaudens. *Adams Memorial*, 1886–91. Bronze, 72 inches high. Rock Creek Cemetery, Washington, D.C.

LEFT: 74. Augustus Saint-Gaudens. *Diana*, cast in 1928 from cement model for 1893 version. Gilt bronze, 112 inches high. The Metropolitan Museum of Art, New York; Purchase, Rogers Fund, 1928.

ABOVE LEFT: 75. Augustus Saint-Gaudens. *William Merritt Chase*, 1888. Bronze, 21½ x 29½ inches. American Academy of Arts and Letters, New York.

ABOVE RIGHT: 76. Newspaper illustration mocking Frederick Mac-Monnies's *Bacchante and Infant Faun. Boston Post*, May 30, 1897. Frank W. MacMonnies Papers, Archives of American Art, Smithsonian Institution, Washington, D.C.

RIGHT: 77. Frederick MacMonnies. *Bacchante and Infant Faun*, 1894. Bronze, 34 inches high. Philadelphia Museum of Art; Gift of Mr. and Mrs. Clarence E. Hall.

French. Finally, he received the important commission for bronze doors for the new and grand Library of Congress, but his premature death in a carriage accident occurred before he could finish the project.

Frederick MacMonnies's work also bears a strong Parisian flavor. After serving as studio assistant to Augustus Saint-Gaudens he went to France in 1884 and entered the sculpture class of Jean Alexandre Falguière at the Ecole des Beaux-Arts. Before traveling to Chicago to work on the sculptures for the World's Columbian Exposition of 1893, MacMonnies had established his own studio in Paris and soon enjoyed a modest reputation. However, his *Nathan Hale* of 1890, for City Hall Park, New York, was criticized for its impressionistic treatment of form, a criticism that testifies to the extent to which he had absorbed the Parisian manner of modeling. His next major effort was even more controversial — the life-size dancing nude figure of a gleeful *Bacchante and Infant Faun* (1893), of which he made a smaller version in 1894 (Fig. 77). MacMonnies presented the life-size statue to

ABOVE: 78. Olin Levi Warner. *J. Alden Weir,* 1880. Bronze, 22½ inches high. Corcoran Gallery of Art, Washington, D.C.

ABOVE RIGHT: 79. Frederick MacMonnies. *Young Faun and Heron,* c. 1890. Bronze, 27¾ inches high. The Metropolitan Museum of Art, New York; Gift of Edward D. Adams, 1927.

LEFT: 80. Frederick MacMonnies. *Barge of State* or *Triumph of Columbia,* World's Columbian Exposition Chicago, 1893. Staff material; destroyed. Photograph courtesy of Chicago Historical Society.

OPPOSITE: 81. World's Columbian Exposition, Chicago, 1893 (demolished). Master plan by Daniel H. Burnham. Agriculture Building by McKim, Mead and White; Colonnade by Charles B. Atwood; Hall of Machinery by Peabody and Stearns; and fountain, *Barge of State,* by Frederick MacMonnies. Photograph courtesy of Avery Library, Columbia University, New York.

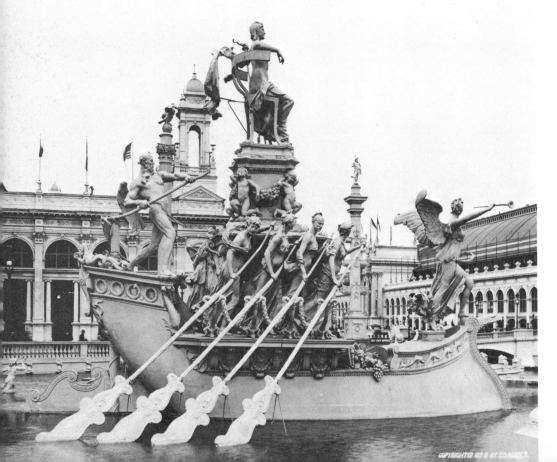

the architect Charles F. McKim who installed it in the neo-Renaissance palace he had designed as the Boston Public Library, but the wantonness of the impish nude young girl was considered scandalous by proper Bostonians and it had to be withdrawn (Fig. 76). The architect then presented it to the Metropolitan Museum of Art in 1897.

In Paris, MacMonnies had also created another group in which a classical subject was rendered, stylistically, in a most unclassical manner — the *Young Faun and Heron* of about 1890 (Fig. 79). The *Bacchante* was too much a real nude girl and too little an allegorical abstraction for the taste of many, thereby uncomfortably removing the thin veil that separates real life and art; the *Young Faun* who holds the great heron by the neck likewise was recognized as a real-life nude male rather than a classical abstraction, which bothered some Americans. Carpeaux or Mercié or Falguière would undoubtedly have liked the *Young Faun,* and the sculptor exhibited it at the Paris Salon of 1890.

MacMonnies returned to the United States in time to join what Saint-Gaudens called the greatest gathering of artists since the Italian Renaissance — this was at Chicago in preparation for the World's Columbian Exposition of 1893. There MacMonnies was given one of the choice commissions, the *Barge of State,* or *Triumph of Columbia,* for the fountain at the head of the grand lagoon — a commission that allowed a full play of Beaux-Arts imagery and iconography (Fig. 80). Classical in its representation of a theme through personifying figures and of a style that had come directly from Paris and the ateliers of the Ecole des Beaux-Arts, it is a superb example of the type of sculpture created for the great exhibitions of the 19th century. The *Barge of State* was guided by Father Time, who stood at the tiller, and propelled by eight maidens representing the Arts and Industries; Columbia, perched on her elaborate throne and holding high a torch, rode triumphant while Victory stood at the prow. The piece complemented perfectly the exuberant neo-Baroque and highly decorative, even festive, architecture that surrounded it (Fig. 81).

Like all of the decorative sculptures for the Exposition, the *Barge of State* was made of staff material — a composition of plaster and straw which was quickly worked and inexpensive, though unfortunately not durable when exposed to the elements; as a result almost nothing of

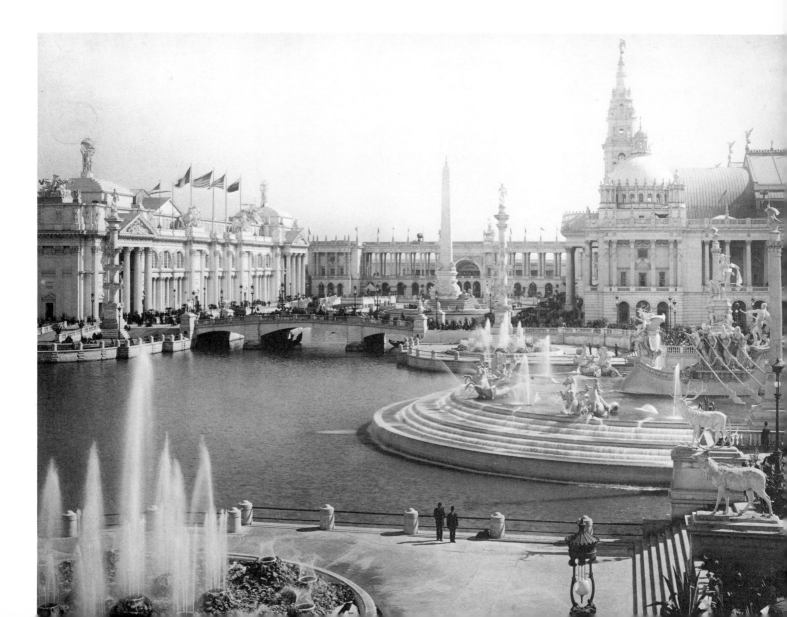

ABOVE: 82. Workmen building armature for sculpture to decorate Administration Building for the Columbian Exposition; photograph taken April 13, 1892. Photograph courtesy of the Chicago Historical Society.

ABOVE RIGHT: 83. Sculptural armature in Fig. 82 here covered with staff material, reproducing sculptor's model at left; photograph taken April 13, 1892. Photograph courtesy of Chicago Historical Society.

BELOW: 84. Studio in Horticultural Building, August 24, 1892; finishing touches being put on staff figures for World's Columbian Exposition, Chicago, 1893. Photograph courtesy of Chicago Historical Society.

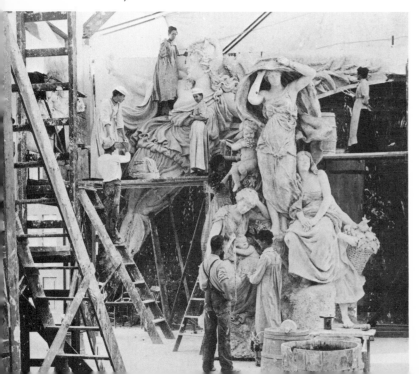

these staff creations has survived, but photographs do record not only their appearance but also their construction. In Figure 82 we may observe the enlargement process of such work: the sculptor's small model is seen at the left and workmen have built the most haphazardly constructed type of armature imaginable out of wood and chicken wire for the finished piece. Figure 83 shows the piece largely completed, again with the small model beside it. Note the size of the dividers, at the lower right, employed in the enlargement process, for they are approximately the size of the man nearby. Figure 84 shows another group of staff figures being enlarged to architectural scale, and the interesting thing here is the number of women employed, evidently in the finishing of the surfaces and details.

The great expositions held in America — in Chicago in 1893, in Buffalo in 1901, in St. Louis in 1904, and in San Francisco in 1915 — represent the apogee of the Beaux-Arts style, and a proud, confident and chest-thumping America on such festive occasions afforded a nearly unbounded opportunity for sculpture. Probably never before and never since has sculpture in America enjoyed such a spectacular display.

PLATE 10. Henry Kirke Brown. *General Winfield Scott*, c. 1858, cast 1966. Bronze, 28¾ inches high. National Portrait Gallery, Smithsonian Institution, Washington, D.C.

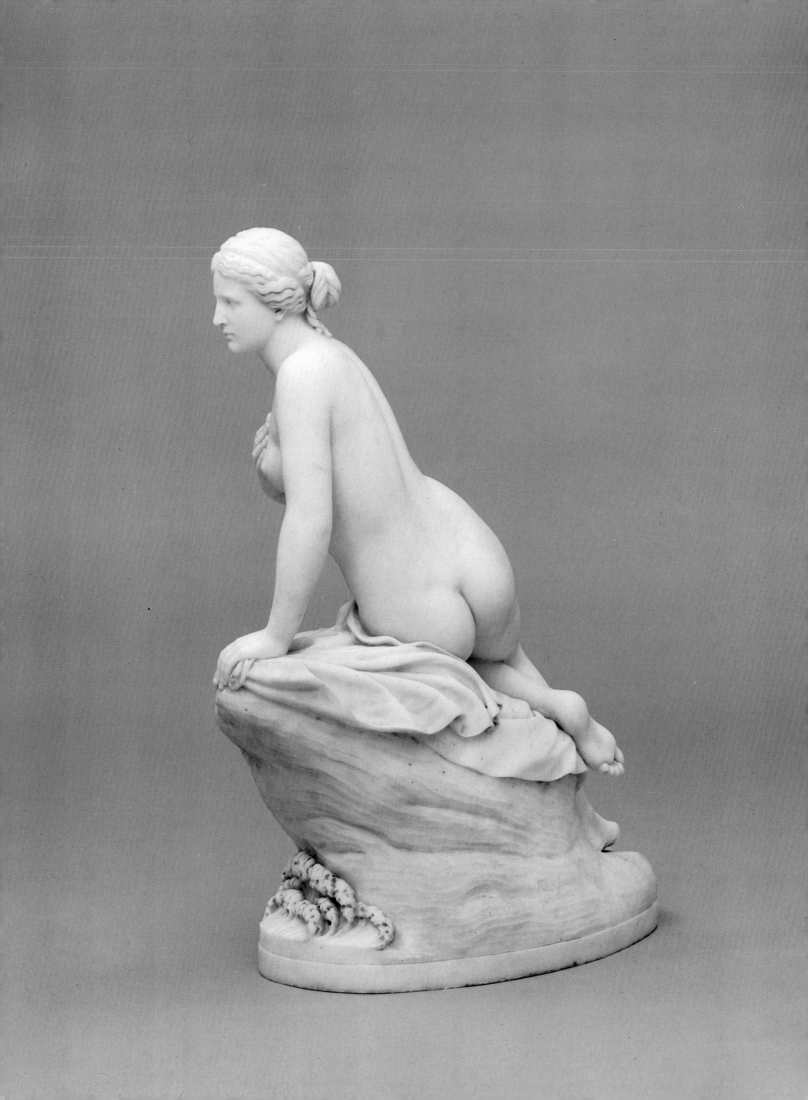

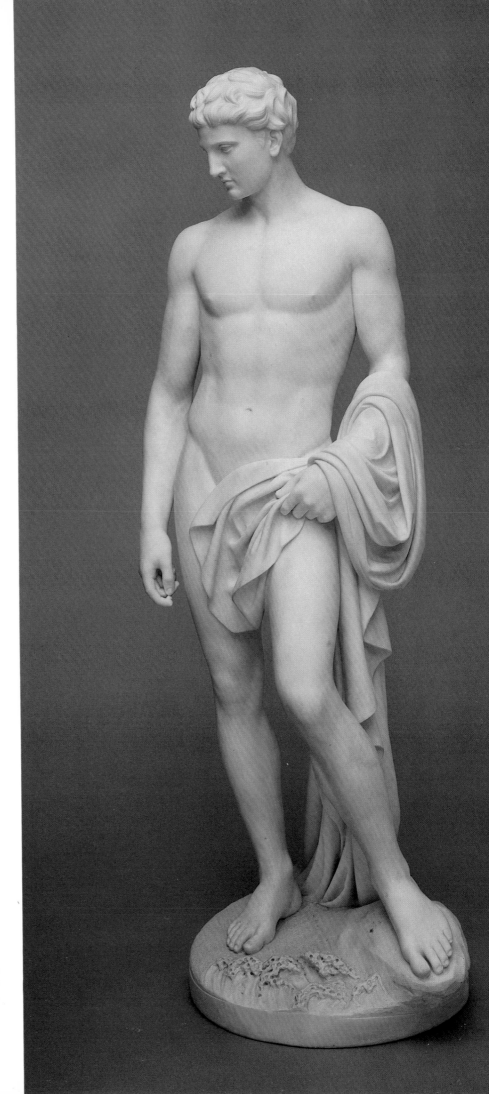

OPPOSITE: PLATE 11. William Rine-hart. *Hero*, 1869. Marble, 34 inches high. Pennsylvania Academy of the Fine Arts, Philadelphia; Bequest of Henry C. Gibson, 1892.

PLATE 12. William Rinehart. *Leander*, c. 1858. Marble, 42 inches high. The Newark Museum, Newark, New Jersey.

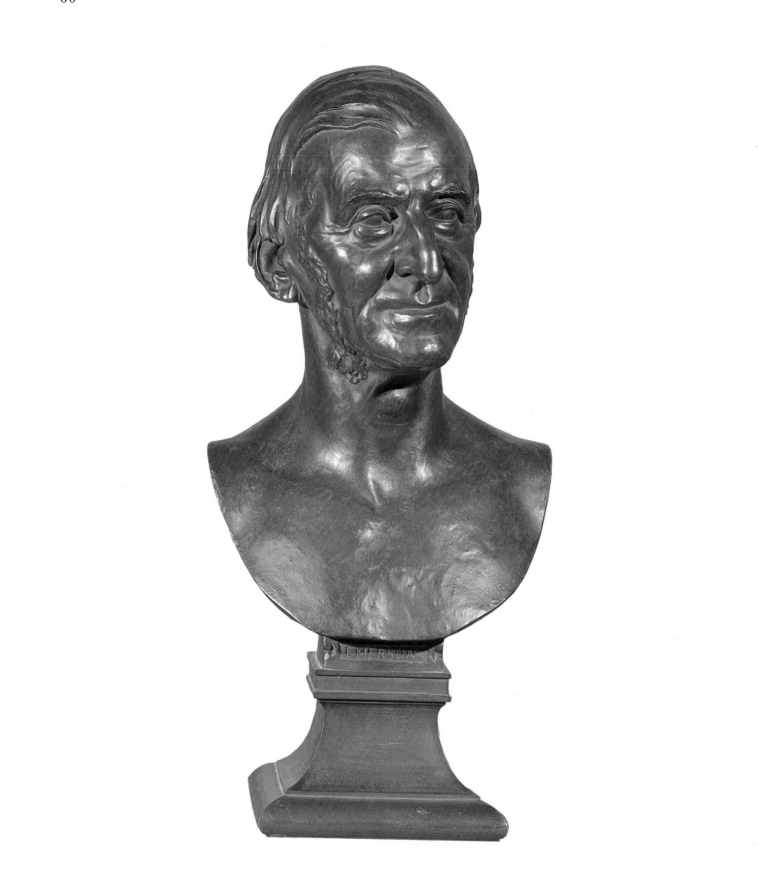

PLATE 13. Daniel Chester French. *Ralph Waldo Emerson*, 1879, cast 1901. Bronze, 22½ inches high. National Portrait Gallery, Smithsonian Institution, Washington, D.C.

Earlier, the Civil War had offered numerous opportunities for sculptors either in representations of abolitionist themes or in portraits of the statesmen and military men who were the subjects of memorials. Thomas Ball created his *Emancipation Group,* showing Abraham Lincoln inviting a Negro slave to rise as a free man, and John Quincy Adams Ward expressed similar sentiments in his bronze statuette titled *Freedman.* Large bronze versions of Ball's *Emancipation Group* were erected in Washington (1875) and Boston (1877); a small version had been modeled as early as 1865 and cast in bronze in 1873 (Fig. 87). Ward's *Freedman* is a sincere expression of antislavery sentiment that is represented in realistic terms rather than neoclassical or some other type of symbolic personification (Fig. 86). In the quarter-century that followed the Civil War, Ward became one of the foremost sculptors of commemorative bronze portraits, his bold naturalistic style enjoying such popularity that he frequently had to decline important commissions. Figure 85 shows him seated in his studio around 1885, working on the model of the monument to President Garfield that would be erected in Washington in 1887. One of his finest accomplishments was his heroic portrait of

ABOVE: 85. Photograph of John Quincy Adams Ward in his studio, mid-1880s, with his model for the Garfield Memorial, Washington, D.C. Archives of American Art, Smithsonian Institution, Washington, D.C.

BELOW: 86. John Quincy Adams Ward. *Freedman,* 1863. Bronze, 19½ inches high. American Academy of Arts and Letters, New York.

BELOW RIGHT: 87. Thomas Ball. *Emancipation Group,* 1865, cast 1873. Bronze, 34½ inches high. Montclair Art Museum, Montclair, New Jersey; Gift of Mrs. William Couper, 1913.

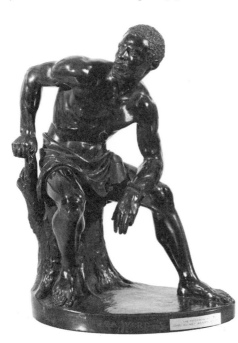

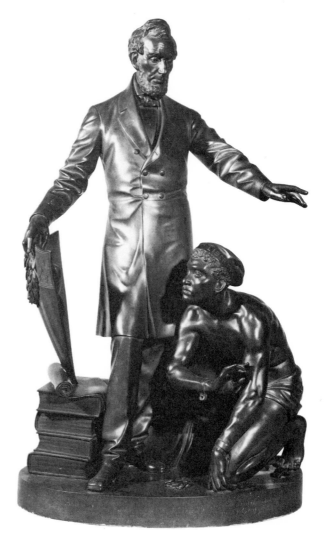

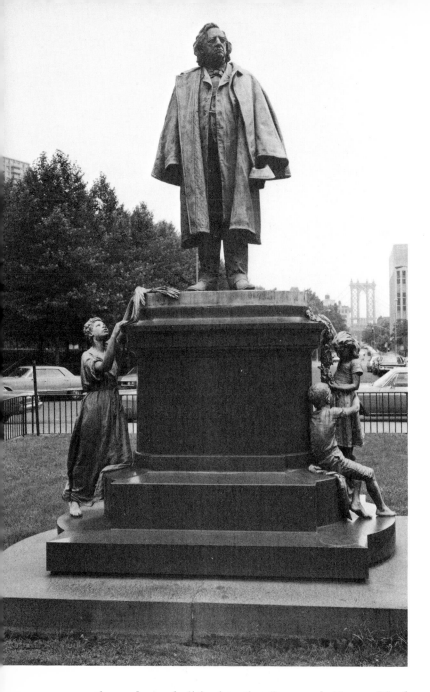

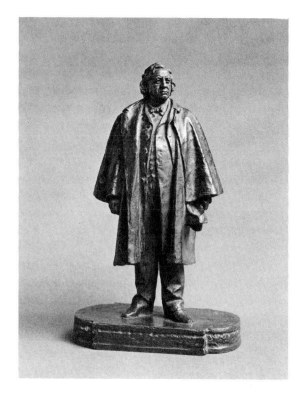

LEFT: 88. John Quincy Adams Ward. *Henry Ward Beecher*, 1889, cast 1890. Bronze, 96 inches high. Cadman Plaza, Brooklyn, New York. Photograph by Jerry L. Thompson.

ABOVE: 89. John Quincy Adams Ward. *Henry Ward Beecher*, n.d. Bronze, 14¼ inches high. Collection of Charles Parks.

the ardent abolitionist, the Reverend Henry Ward Beecher, erected in Brooklyn in 1891 (Fig. 88), which Ward reproduced in exquisite small versions (Fig. 89). In these bronze portraits Ward was committed to naturalism, a commitment he inherited from his early master, Henry Kirke Brown.

There was, of course, a great demand for portrait statues of the central figure of the Civil War, Abraham Lincoln. Two of the finest of these are the standing bronze figures created by Augustus Saint-Gaudens for Chicago (1887) and by Daniel Chester French for Lincoln, Nebraska (1912), each showing the Great Emancipator grave and pensive at the moment he has risen to deliver his Gettysburg Address. Reductions of both these popular figures were also cast in bronze (Figs. 90, 91). Saint-Gaudens was probably the unexcelled master of the Civil War memorial, creating such masterpieces as the *Admiral David Glasgow Farragut Memorial* (1881) in Madi-

son Square Park (Fig. 93), and the equestrian *General William Tecumseh Sherman* (1903; p. 6) in Grand Army Plaza, both in New York. One of the highest achievements of 19th-century American sculpture is his *Robert Gould Shaw Memorial,* erected in Boston in 1896 (Fig. 92). Rarely, if ever, has the sensitivity of the faces of Shaw and his Negro troops been equaled, nor has the impellent march of these troops in this innovative composition been surpassed (Figs. 94a–e and p. 26). Sculpturally, it is exceptionally rich in its plastic values that range from bold three-dimensional forms to delicate relief. The artist's sensitivity in rendering facial expression is clearly evident in the bronze head of Shaw (Fig. 95).

Early in his career John Rogers was noted for his anecdotal genre groups, and he created several pieces in the 1860s of Civil War subjects. One of the most moving is that called *The Fugitive's Story* which shows a young

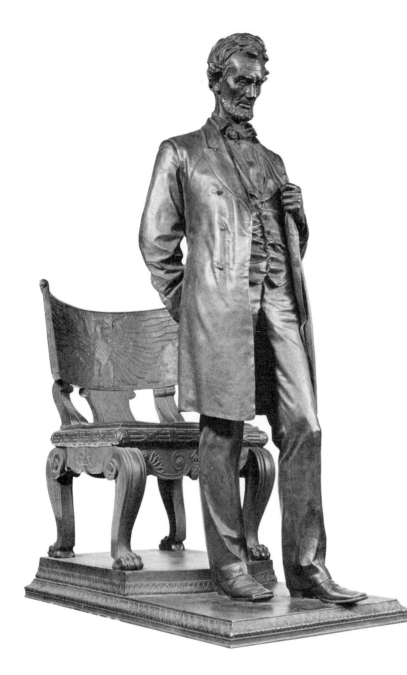

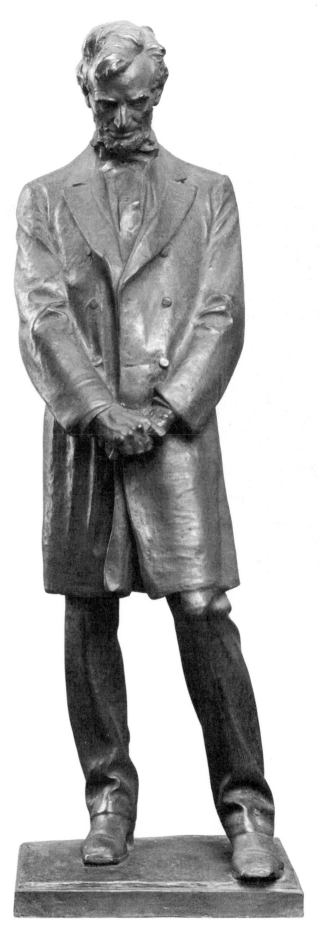

ABOVE: 90. Augustus Saint-Gaudens. *Standing Lincoln*, 1886, cast 1912. Bronze, 40 inches high. The Newark Museum, Newark, New Jersey.

RIGHT: 91. Daniel Chester French. *Standing Lincoln*, 1912. Bronze, 38 inches high. Whitney Museum of American Art, New York.

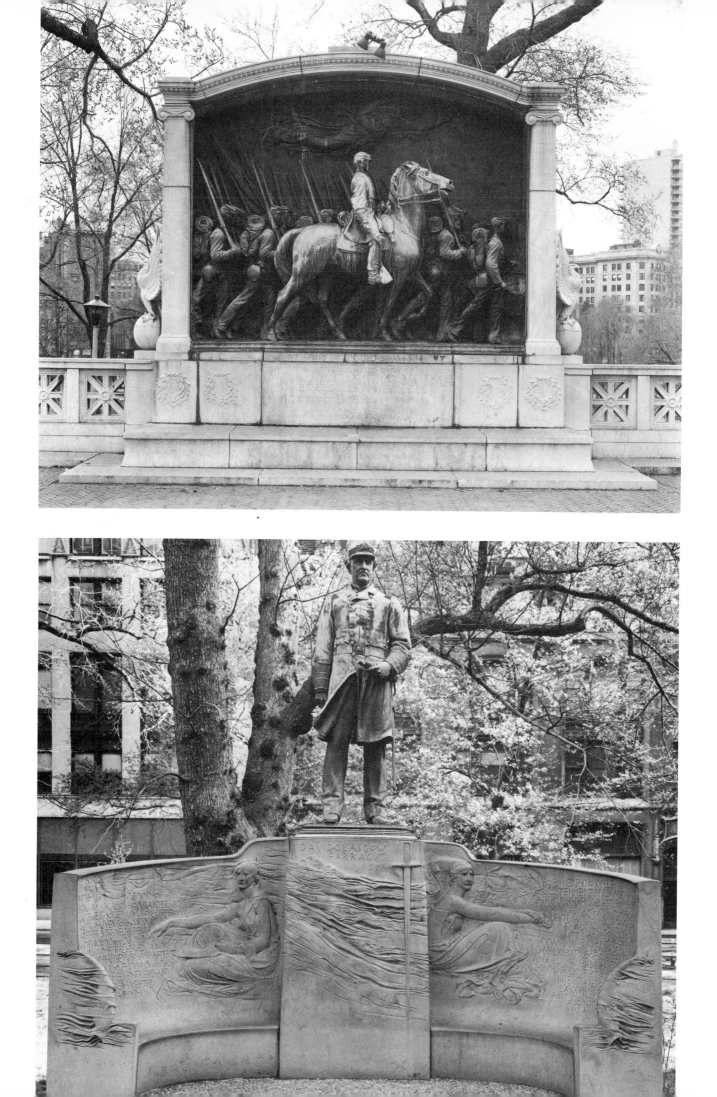

ABOVE: 94a-d. Augustus Saint-Gaudens. *Heads of Black Soldiers*, 1884–97, cast 1964/65. Bronze, 5¾, 5¾, 6 and 7½ inches high. U.S. Department of the Interior, National Park Service; Saint-Gaudens National Historic Site, Cornish, New Hampshire.

ABOVE RIGHT: 94e. Augustus Saint-Gaudens. *Head of Drummer Boy*, 1884–97, cast between 1949 and 1959. Bronze, 6 inches high. U.S. Department of the Interior, National Park Service; Saint-Gaudens National Historical Site, Cornish, New Hampshire.

RIGHT: 95. Augustus Saint-Gaudens. *Head of Robert Gould Shaw*, 1884–97, cast 1908. Bronze, 10 inches high. U.S. Department of the Interior, National Park Service; Saint-Gaudens National Historic Site, Cornish, New Hampshire.

OPPOSITE:
ABOVE: 92. Augustus Saint-Gaudens. *Robert Gould Shaw Memorial*, 1884–97. Bronze, 11 x 14 feet. Beacon Hill, Boston. Photograph by Richard Benson (see p. 26).

BELOW: 93. Augustus Saint-Gaudens. *Admiral David Glasgow Farragut Memorial*, 1877– 81. Bronze, 8½ feet high; stone base, 7 x 17½ feet, recarved in granite, 1930s. Madison Square Park, New York.

Negro mother holding her infant and telling her story of escape from bondage to three of the foremost abolitionists of the day, John Greenleaf Whittier, Henry Ward Beecher and William Lloyd Garrison, all of which are fine portrait studies (Fig. 96).

As the memories of the great civil calamity faded Rogers turned to homey scenes of commonplace American life, often depicted with touches of good-natured humor. His *Checkers up at the Farm* (1875) was a particular favorite and it is estimated that 5000 copies of it were sold (Fig. 97). He also took subjects from American history and literature, such as his *"Why don't you speak for yourself, John?,"* representing John Alden standing timidly before Priscilla, a group that dates from 1885; it was probably inspired by Longfellow's poem "The Courtship of Miles Standish," published in 1853.

The Rogers Groups, as they were called, were enormously popular from approximately 1865 to 1890; mass produced and pictorially representing the American scene, they may be described as the sculptural counterpart to Currier and Ives lithographs. Rogers established a factory for the production of his groups in New York City where the originals he had modeled in clay were reproduced in plaster by workmen from molds of Rogers's own design. They were painted a soft tan color. Some groups were produced in the thousands and were widely distributed for sale throughout the country; they sold for ten to twenty-five dollars and could even be purchased through a catalogue which Rogers published (Fig. 98).

The Civil War also provided an opportunity for American sculptors to create equestrian monuments. We have already mentioned earlier examples of this most challenging type of sculpture — the *Jackson* by Mills and the *Washington* and *Scott* by Brown. To this list should be added Thomas Ball's bronze equestrian *Washington* (1861) for Boston and Ward's *Major General George H.*

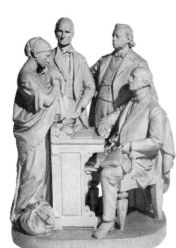

96. John Rogers. *The Fugitive's Story,* 1869. Painted plaster, 21¾ inches high. The New-York Historical Society.

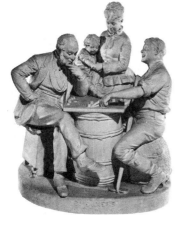

97. John Rogers. *Checkers up at the Farm,* 1875. Painted plaster, 20 inches high. The New-York Historical Society.

98. Title page from *Descriptive Catalogue and Price List of Group Statuettes from the Studio of Mr. John Rogers,* published by Rogers Statuary Company, 1895, New York. The Metropolitan Museum of Art, New York.

Thomas (1878) for Washington, D.C., and Saint-Gaudens's *Shaw* and *Sherman* memorials, among the finest equestrian statues of the 19th century. One of the most sophisticated examples of this type of monument was the one created by Paul Wayland Bartlett — the *Lafayette,* which was erected in the courtyard of the Louvre in Paris in 1908, a commission paid for by the pennies and nickels contributed by American school children as a reciprocal gift for the Statue of Liberty. The bronze reduction of it contrasts the refinement of the elegant Lafayette, the French aristocrat who had come to America to offer his services in the Revolutionary War, with the bold power of the war-horse he rides as he leads his troops into battle (Fig. 99). Bartlett had spent many years in France where he acquired the lively Parisian manner of

modeling. This, together with his comprehension of sculptural form, may be seen in the little study he made for an equestrian monument of *Washington at Valley Forge* (Fig. 100). His virtuosity in creating instantaneous and spontaneous thoughts in beautiful sculptural form may also be seen in the four small studies of seated figures (Fig. 101). Because of their sheer beauty as sculptural form, these pieces find a special appreciation in the eyes of 20th-century connoisseurs. The beauty of this basic sculptural form, however, was all too often obscured when the trappings of the Beaux-Arts style were applied to finished works, as in the group of personifying figures Bartlett made for the pediment of the House of Representatives of the U.S. Capitol (1909–16) or those for the facade of the New York Public Library (1915).

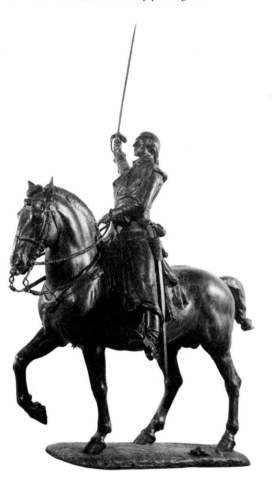

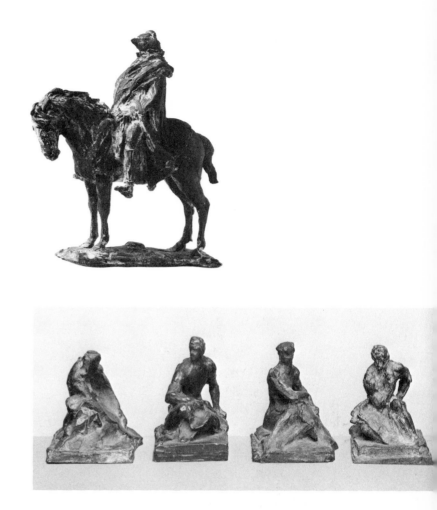

99. Paul Wayland Bartlett. *Equestrian Lafayette,* n.d., cast 1959. Bronze, 41½ inches high. Columbia Museum of Art, Columbia, South Carolina; Gift of Mrs. Armistead Peter III.

TOP: 100. Paul Wayland Bartlett. *Washington at Valley Forge,* n.d., cast 1927. Bronze, 8¼ inches high. Corcoran Gallery of Art, Washington, D.C.

ABOVE: 101. Paul Wayland Bartlett. *Seated Male Figures,* n.d. Bronze, 3½, 3½, 3¾ and 4 inches high. North Carolina Museum of Art, Raleigh; Gift of Mrs. Armistead Peter III.

One of Bartlett's most famous pieces was the *Bohemian Bear Tamer* which brought him his first taste of international critical acclaim in 1887 when he exhibited it at the Paris Salon (Fig. 102). By this time the themes of the American Indian and the American West had become popular. John Quincy Adams Ward had earlier made his *Indian Hunter* which extolled the stealth and alertness of the indigenous American when he was on the trail of game; it was erected in Central Park, New York, modeled after a small version of 1860 (Figs. 104, 105). Other American sculptors — such as Hermon MacNeil and Cyrus Dallin — also took the now noble red man as their subject, and endowed him with a grave, sagacious dignity. For showing him in action no one proved more capable than Charles Russell as his bronze group titled *Buffalo Hunt* illustrated (Fig. 106). By the end of the 19th century the Indian menace had been completely subdued, and, no longer fearful of his savage hostility,

Americans could look upon him in a kinder light, as a noble primitive hero of great anthropological interest.

Russell's counterpart was Frederic Remington who took the American cowboy as his subject. Remington was himself a cowboy, a sheep rancher and an illustrator of the western scene for several magazines, especially *Harper's Weekly,* in the 1880s and '90s. By virtue of his keen eye for details and his insistence on accuracy, Remington was a most successful journalist-illustrator; this same characteristic carried over into his sculpture when he finally turned to that medium in 1895. That year he produced his first western bronze, *The Bronco Buster,* of which more than two hundred copies were cast by the Roman Bronze Works of New York City (Fig. 107). Remington knew his subject so intimately that he could give all the color of the wiry, raw-boned cowboy and his costume, the horse and its trappings, and the wild, noisy commotion of the breaking of a wild bronco. There is a

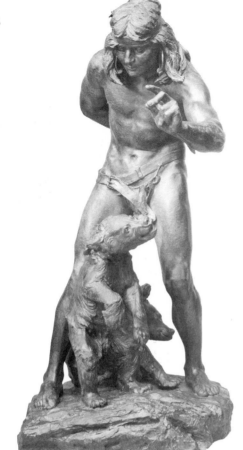

roughness to his style, an unsophisticated directness in the making of his image, that seems totally appropriate to his subject. Remington's insistence upon authenticity in every detail caused him to form a large collection of western paraphernalia in his studio and home (Fig. 103). Remington himself loved the carefree life of the cowboy and one can sense this in his *Comin' Through the Rye* of about 1902 (Fig. 108). Here a group of rowdy cowhands come shooting and yelping as they ride into town after a long period of lonely days and nights on the plains. These are indeed lively portrait studies of the jubilant, hell-bent cowpokes and also of their galloping ponies.

ABOVE: 102. Paul Wayland Bartlett. *Bohemian Bear Tamer*, 1887. Bronze, 68½ inches high. The Metropolitan Museum of Art, New York; Gift of an association of gentlemen, 1891.

RIGHT: 103. Frederic Remington standing before a fireplace decorated with some of his western collection, 1905. Remington Art Museum, Ogdensburg, New York.

BELOW: 104. John Quincy Adams Ward. *Indian Hunter*, c. 1865, cast 1866. Bronze, 120 inches high. Central Park, New York.

BELOW RIGHT: 105. John Quincy Adams Ward. *Indian Hunter*, 1860. Bronze, 17 inches high. American Academy of Arts and Letters, New York.

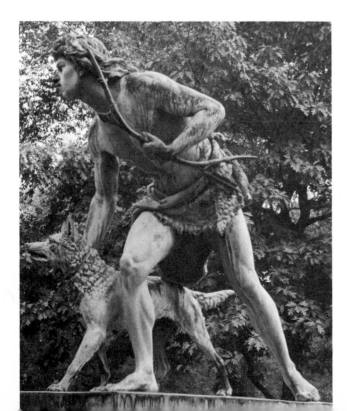

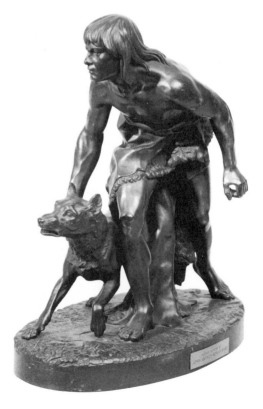

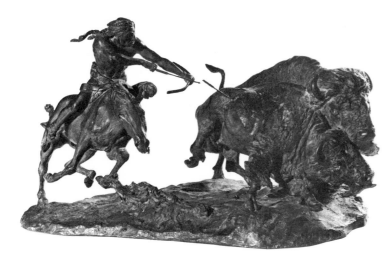

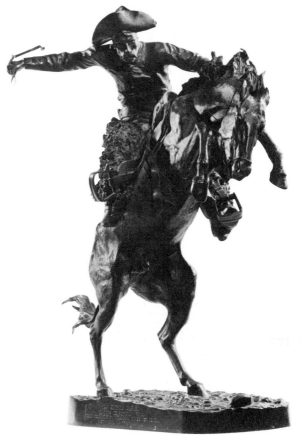

ABOVE: 106. Charles M. Russell. *Buffalo Hunt*, 1905. Bronze, 10 inches high. Amon Carter Museum, Fort Worth, Texas.

ABOVE RIGHT: 107. Frederic Remington. *The Bronco Buster*, 1895. Bronze, 23¼ inches high. Amon Carter Museum, Fort Worth, Texas.

BELOW: 108. Frederic Remington. *Comin' Through the Rye (Off the Range)*, c. 1902. Bronze, 27⅜ inches high. The Metropolitan Museum of Art, New York; Bequest of Jacob Ruppert, 1939.

BELOW RIGHT: 109. Solon H. Borglum. *Lassoing Wild Horses*, 1898. Bronze, 33 inches high. National Cowboy Hall of Fame, Oklahoma City, Oklahoma.

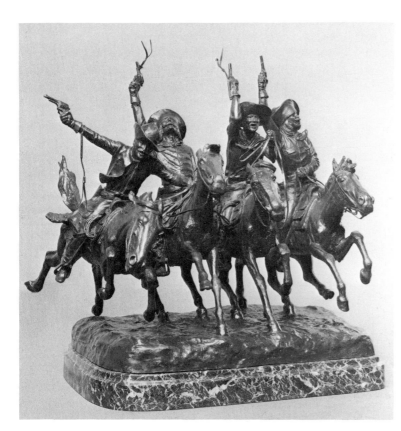

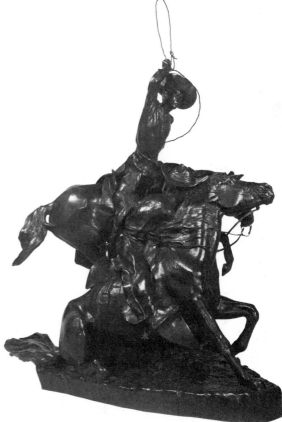

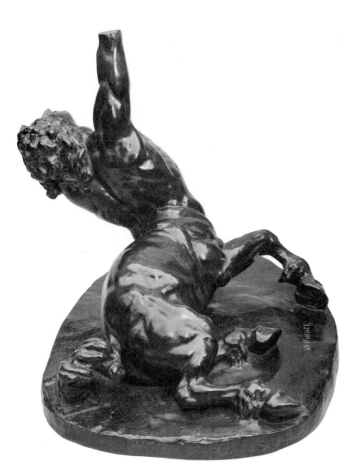

110. William Rimmer. *The Dying Centaur*, c. 1871, cast 1906. Bronze, 21½ inches high. The Metropolitan Museum of Art, New York; Gift of Edward Holbrook, 1906.

111. Gutzon Borglum. *Mares of Diomedes*, 1904. Bronze, 62 inches high. The Metropolitan Museum of Art, New York; Gift of James Stillman, 1906.

Gutzon Borglum frequently took western themes as the subjects for his sculpture. Pieces such as the *Mares of Diomedes* gained him great acclaim and reveal the rich modeling, lively surfaces and dynamic composition that he acquired during his years of study in Paris (Fig. 111). But this is a case of the Parisian manner applied to an American subject and spirit, and A. T. Gardner's analysis of the *Mares of Diomedes* is worth quoting here: "The classical title and the nude rider cannot disguise the fact that the real subject . . . is a cowboy stampeding a herd of broncos. The allusion to Greek mythology was an afterthought that transformed a cowpoke into Hercules and his ponies into the mythical, flesh-eating mares of the Bistonian king Diomedes."[2] Today, Borglum is best remembered for his colossal sculptural projects carved from the sides of mountains, as at Stone Mountain near Atlanta, Georgia, or the four great presidential portraits at Mount Rushmore in South Dakota. Gardner also wrote of Borglum that his "outspoken opinions and the gigantic scale of his sculptural projects set him apart from his contemporaries and give him a unique place in the history of American art."[3]

In the last half of the 19th century there were several sculptors who defy classification because of their individuality and the personal direction their work took. William Rimmer was one of these, an enigmatic figure who believed his shadowy ancestry included descent from the royal line of French kings. After an unsuccessful attempt at a career as a largely self-taught physician, Rimmer turned to sculpture and created some of the most exciting art of the century. He also became a teacher of great importance, especially through his anatomy classes and lectures in New York and New England. He had no training as a sculptor and his full-length figure of the *Falling*

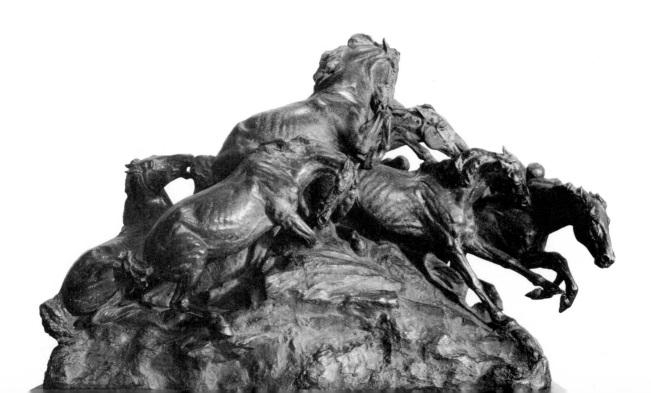

Gladiator (original plaster in the National Collection of Fine Arts) repeatedly fell over in his studio because he did not know about using an armature to support the clay model. Nevertheless, his work is charged with expressive content in a romantic fervor that is akin to, but predates, that of Rodin. His *Dying Centaur* exhibits this quality as well as a powerful feeling for modeled sculptural form (Fig. 110). But Rimmer was little admired in his day and commissions seldom came his way.

Charles Grafly of Philadelphia, who was an important influence through his long years of teaching at the Pennsylvania Academy of the Fine Arts, falls quite nicely into the main current of American sculpture as far as his beautiful portrait busts are concerned, or even with pieces such as the *Aeneas and Anchises,* a classical subject representing Aeneas's escape from Troy, carrying his aged father on his back while his young son follows at his side (Fig. 112). It is rendered in the richly modeled forms of the Parisian manner. But as popular as Grafly's portraits and academic pieces were, some of his work left his contemporaries bewildered because of its very personal use of symbolism — as in his *In Much Wisdom,* a standing nude woman holding a serpent and a mirror, time-honored attributes of wisdom that were nevertheless not immediately recognizable (Fig. 113). That he frequently turned to exotic sources such as ancient Egyptian art is seen in the hat worn by the figure; but his sources were often as obscure as they were exotic and were little understood by those who saw his sculpture. The acclaim that came to Grafly was not from art such as this, but from his portraits, his academic work and his teaching.

Thomas Eakins, also a Philadelphian and a teacher of Grafly, fails to fit into any of the regular groups or movements because he was primarily a painter who occasionally indulged in sculpture, often to assist him in developing his paintings. For example, there are the little figures he modeled in wax when he was working on his picture *William Rush Carving the Allegorical Figure of the Schuylkill,* or the sprightly horses he modeled for his painting *The Fairman Rogers Four-in-Hand;* all of these, pictures and models, are to be seen in the Philadelphia Museum of Art. Conversely, his lovely and delicate reliefs *Spinning* and *Knitting* (1881–83) are derived from earlier watercolor pictures; these oval reliefs are among the few sculptures which Eakins actually made on commission, in this case as fireplace decorations for James P. Scott of Philadelphia who, however, chose to refuse them (Figs. 114, 115). The relief panel *Arcadia* is beautifully modeled and represents a curious departure by the artist from the themes of real life; indeed Thomas Eakins would seldom leave the real world in his paintings to attempt flights of fancy into the idyllic world of Arcadia (Fig. 116). But one can only wish he had done so more often.

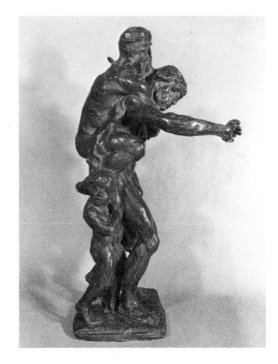

112. Charles Grafly. *Aeneas and Anchises,* 1893, probably cast between 1906 and 1929. Bronze, 27⅞ inches high. Delaware Art Museum, Wilmington.

113. Charles Grafly. *In Much Wisdom,* 1902. Bronze, mosaic tiles; 63½ inches high. Pennsylvania Academy of the Fine Arts, Philadelphia; Gilpin Fund Purchase, 1912.

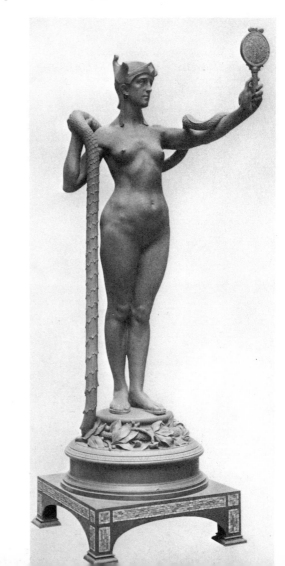

Alexander Milne Calder, father of Alexander Stirling Calder and grandfather of Alexander Calder, came to Philadelphia from Aberdeen, Scotland, in 1868. Like Grafly, he was a student of Eakins at the Pennsylvania Academy of the Fine Arts. In 1872 Calder was engaged to design and model the sculptures for Philadelphia's City Hall including the 37-foot statue of William Penn, to surmount the building. Figure 117 shows the plaster model in Calder's studio, ready for casting in bronze; the artist stands with folded arms, dwarfed by the model.

With Edmund Austin Stewardson of Philadelphia we return to the main flow of French-influenced bronze sculpture in America. Stewardson studied at the Pennsylvania Academy under Thomas Eakins before going to Paris where he worked with Chapu and Allar. His first major effort was *The Bather*, modeled in 1889–90 and in the latter year shown in plaster at the Salon where it received much praise (Fig. 118). It is beautiful in its simplicity, and apparently the sculptor never intended it to be anything more than it is—a study of a young nude girl seated, with arms in a very characteristic gesture of fixing her hair. It demonstrates a fine feeling for sculptural form and the play of defracted lights and shadows across the surfaces is a delight to the eye. One can only speculate on what such a talented young artist might

TOP: 114. Thomas Eakins. *Spinning*, 1881–83. Bronze, 18 x 14½ inch oval. Pennsylvania Academy of the Fine Arts, Philadelphia; Gift of Edward H. Coates, 1887.

ABOVE: 115. Thomas Eakins. *Knitting*, 1882–83. Bronze, 18¾ x 15 inch oval. Philadelphia Museum of Art; Given by Mrs. Thomas Eakins and Miss Mary A. Williams.

BELOW: 116. Thomas Eakins. *Arcadia*, 1883. Bronze, 12 x 24 inches. Collection of James Wyeth.

117. Photograph of Alexander Milne Calder standing next to 37-foot plaster statue of William Penn, 1888–90. The statue was cast in bronze and in 1894 placed on top of Philadelphia's City Hall. Photograph courtesy of the Archives of the Pennsylvania Academy of the Fine Arts, Philadelphia.

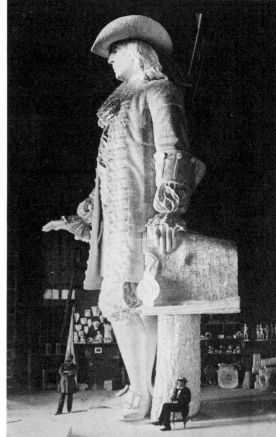

have accomplished had he not drowned in a boating accident off Newport in 1892, at the age of thirty-two. A marble version of *The Bather* is in the collection of the Metropolitan Museum of Art. By comparing *The Bather* with MacMonnies's *Bacchante* one may well perceive how late 19th-century American sculptors under French influence were inclined to render the nude female figure. And by contrasting Stewardson's *Bather* with Hiram Powers's *Greek Slave* one may recognize the difference between the impact French art had on American sculpture and the impact of Italian neoclassicism a generation or two earlier.

Sculpture in America at the beginning of the 19th century was a faltering, often unconfident affair, made by artisans and craftsmen, wood-carvers or stonecutters, who had not yet really comprehended the full potential of plastic form. But by the end of the century it displayed a sense of grandeur and dignity in the portraiture of Ward and Saint-Gaudens, an ability to personify national virtues in the art of Daniel Chester French, a propensity for richly modeled form in the work of Bartlett, a rugged self-confidence in the work of Remington, and a thorough mastery of the Beaux-Arts style in the sculptures of MacMonnies. The contrast is pointed up by sculpture's role as modest carving applied to furniture or gravestones or as shop signs or figureheads at the beginning of the century, whereas the great exposition held in Chicago in 1893 was a brilliant display of sculptural decoration that fairly dominated the scene, truly vying with architecture for the attention of the eye. American sculptors were no longer artisans but now stood confidently alongside their academic brethren in Rome, Paris and other European centers of art. For them, the century closed in a jubilantly triumphant crescendo — and they were little aware of the approach of the modern movement that would appear suddenly and riotously before the American public in the Armory Show of 1913.

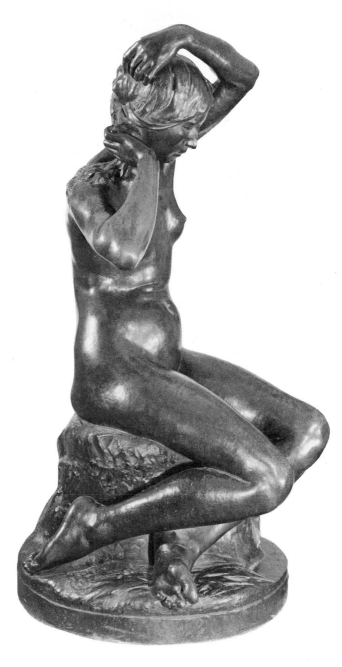

118. Edmund Stewardson. *The Bather*, 1890. Bronze, 46 inches high. Pennsylvania Academy of the Fine Arts, Philadelphia; Gift of Thomas Stewardson, 1895.

Notes

1. Henry James, *William Wetmore Story and His Friends* (Boston: Houghton Mifflin & Co., 1903), vol. 2, p. 76.

2. Albert Ten Eyck Gardner, *American Sculpture: A Catalogue of the Collection of the Metropolitan Museum of Art* (New York: The Metropolitan Museum of Art, 1965), pp. 101–02.

3. Ibid., p. 101.

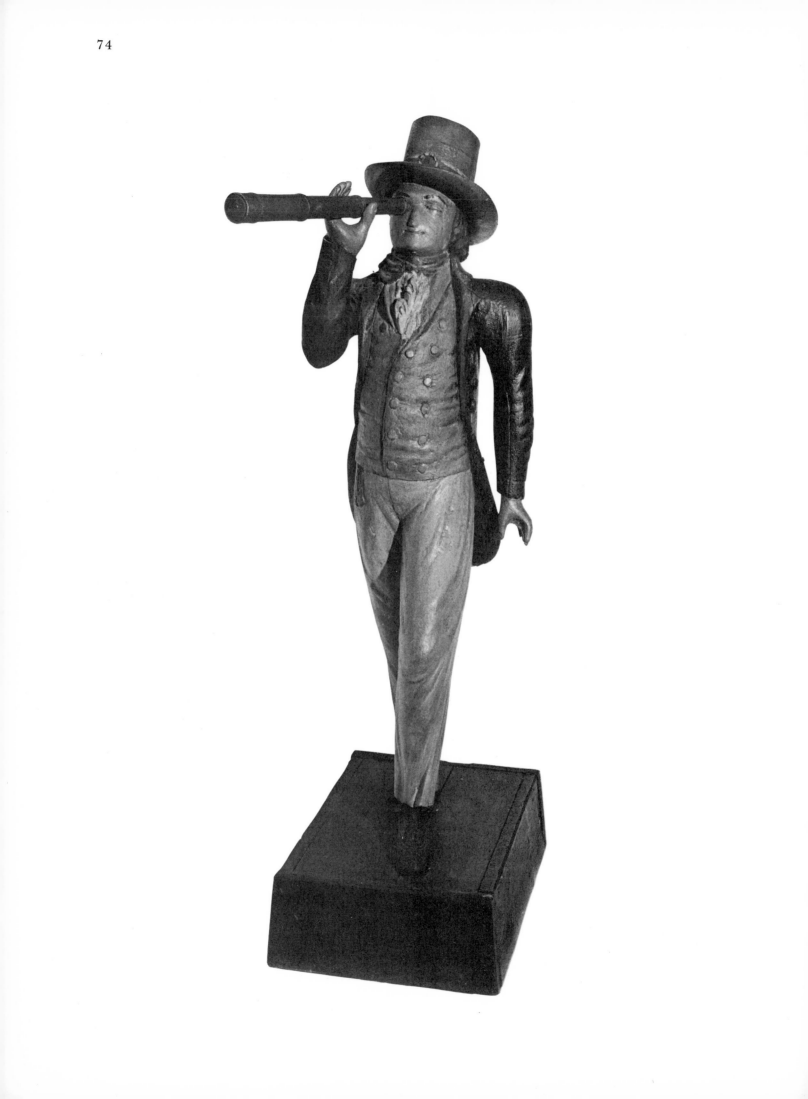

The Innocent Eye

American Folk Sculpture

Tom Armstrong

FOLK ART MAY YET BE RECOGNIZED as the outstanding achievement in American art in the 18th and 19th centuries as a parallel accomplishment to fine arts of the academic tradition. Admired and cherished by many, it is generally ignored or put aside by art historians. The literature on American folk art, which begins in the 1920s, is to a great extent concerned with biographical and historical facts. Consequently, determinations of quality have been associated primarily with the importance of the works of art as documents.

The lack of emphasis upon the aesthetic merits of American folk art and the undue attention to other considerations are due to some extent to the continuous debate over proper nomenclature for this category of American art. This has so preoccupied scholars and collectors that for many the appreciation of the work has become secondary to discussions of terminology. The anecdotal material on folk art has so consistently displaced true aesthetic judgments that the various terms that have been assigned to describe it refer more to the life and character of the artist than to his work.

There has never been a general survey of American painting or sculpture which included more than a token reference to American folk art. Folk sculpture was not the subject of special study, unrelated to a museum exhibition, until Jean Lipman's book *American Folk Art in Wood, Metal and Stone,* published in 1948. Many of the artists are still unknown, the development of artists'

styles is difficult in many cases to ascertain, and the influences, other than prints and illustrated publications of the 19th century, are obscure. Approaching folk sculpture with the accepted methods of systematic research is often futile and, accordingly, many art historians ignore it.

Folk sculptors in the late 18th and 19th centuries created the indigenous art of a country with a developing economy based upon an awareness of individual integrity. The comparison of folk sculpture with other American sculpture of the same period confirms that it is most closely related to the life of the people. European influences dominated the work of academic artists as the artistic tradition of the country emerged in the 19th century. For most sculptors, the overwhelming motivation was to achieve competence in the mode of European prototypes. This is the major reason 19th-century folk sculpture surpasses the accomplishments of fine artists as a basic expression of the American people.

The fine arts tradition in America was based upon and encouraged by the development of academies of fine arts. Prior to the first meeting of the New York Academy of the Fine Arts on December 3, 1802, Robert Livingston, American Minister to the Court of France, had initiated a purchase fund to purchase casts of ancient sculpture in the collection of the Louvre to send to New York City.

The casts are said to resemble the originals in everything but the material, and may be procured for less than One Hundred guineas each, packed for the transportation at Havre. The first to be procured are the Apollo Belvidere, Venus de Medicis, Laocoon, Antinous, and such other six as the Minister may determine.[1]

OPPOSITE: 139. Unknown artist. *Ship Chandler's Sign,* c. 1850, probably New England. Polychromed wood, 48⅞ inches high. Mystic Seaport, Inc., Mystic, Connecticut.

In a report in 1827 of a committee to arrange the minutes and accounts of the American Academy it refers to Livingston's plan and states:

their object was by placing within view of the citizens of New York, copies of the admired works of the ancient Greek and Roman sculptors, to cultivate the public taste; and at the same time to render accessible in our own City to young men who might be disposed to study the Fine Arts, those high Examples which form the basis of Education in all the Academies of modern Europe. . . .[2]

When the Pennsylvania Academy of the Fine Arts was chartered in 1805, the Statement of Purposes of the Board of Directors established that the purpose of this institution was:

the cultivation of the Fine Arts, in the United States of America, by introducing correct and elegant copies from works of the first masters, in sculpture and painting and by thus facilitating the access to such standards, and also by occasionally conferring moderate but honorable premiums, and otherwise assisting the studies and exciting the efforts of the artists, gradually to unfold, enlighten and invigorate the talents of our Countrymen.[3]

Young Nicholas Biddle, Secretary to the American Minister to the Court of France, was asked by a Philadelphia friend to procure "fine casts of the most valuable in ancient statues" for the new institution. Biddle consulted with Houdon to decide which were the finest works from the Louvre, and over fifty casts arrived in Philadelphia from Bordeaux in February 1806.

It is important to realize the association of the emerging interest in the fine arts in America with the classic European tradition in order to understand the vitality of American art of the same period relatively unrelated to the past. The folk sculptor was apart from tradition, outside the small cultured class — a person with vision and talent able to respond to the need of his contemporaries for objects to use and dignify their lives.

The development of abstract art in the United States in the 20th century and the rediscovery of 18th- and 19th-century American folk art occurred at approximately the same time and are closely related. In 1913 the International Exhibition of Modern Art at the 69th Infantry Regiment Armory, Lexington Avenue and 25th Street, New York City, introduced European abstract art to American artists and the general public. In his introductory statement to the first exhibition of abstract painting in America at the Whitney Museum of American Art in February 1935, Stuart Davis wrote:

the American artist became conscious of abstract art by the impact of the Armory Show in 1913. Previous to this important event in the art education in the United States, there were several American artists working in Europe who were incorporating the abstract viewpoint in their canvases. But it was the Armory Show of 1913 with its huge panorama of the scene of art for the foregoing seventy-five years which brought to the American artist as a whole the realization of the existence of abstract art, along with its immediate artistic historical background. . . . There was no American artist who saw this show but was forced to revalue his artistic concepts. The final charge was touched off in the foundations of the Autocracy of the Academy in a blast which destroyed its strangle hold on critical art values for ever.[4]

In the summer of 1913, Hamilton Easter Field, founder and editor of *The Arts* magazine, began the Ogunquit School of Painting and Sculpture in Ogunquit, Maine, where Marsden Hartley, Bernard Karfiol, Yasuo Kuniyoshi, Gaston Lachaise, Robert Laurent and Niles Spencer were among the artists he invited to work in fishing shacks he had acquired for his art colony.

As early as the summer of 1916, Laurent and Karfiol collected American antiques, including folk art, during trips to towns near Ogunquit. Robert Laurent was one of the first collectors of American folk sculpture and in 1924 purchased the small 19th-century figure *Man with Grapes*, considered to have been originally displayed in a bar, in Wells, Maine (Fig. 141).[5] The figure was in his home in 1926, the year Edith and Samuel Halpert rented an adjacent farm from Laurent and visited him with their guest, Holger Cahill, to see his folk art collection in what Walt Kuhn called "the little museum of Ogunquit."

Making Music by Bernard Karfiol depicts the interior of the living room of Laurent's home with folk paintings on the wall exactly as the Halperts and Cahill saw them. Laurent's children John and Paul are in the foreground (Fig. 119).

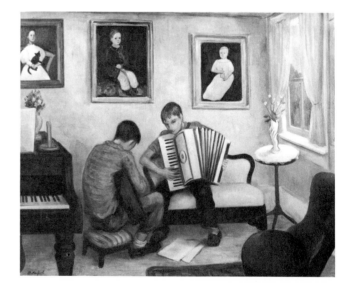

119. Bernard Karfiol. *Making Music*, 1938. Oil on canvas, 32 x 40 inches. Private collection. Robert Laurent's sons, John and Paul, in living room of Laurent home in Ogunquit, Maine.

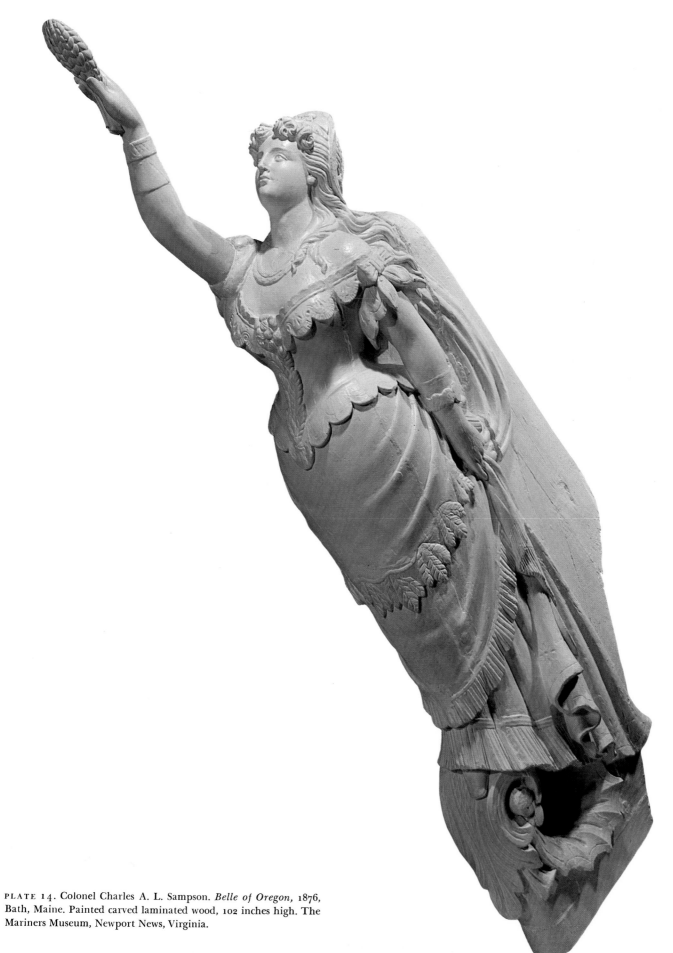

PLATE 14. Colonel Charles A. L. Sampson. *Belle of Oregon*, 1876, Bath, Maine. Painted carved laminated wood, 102 inches high. The Mariners Museum, Newport News, Virginia.

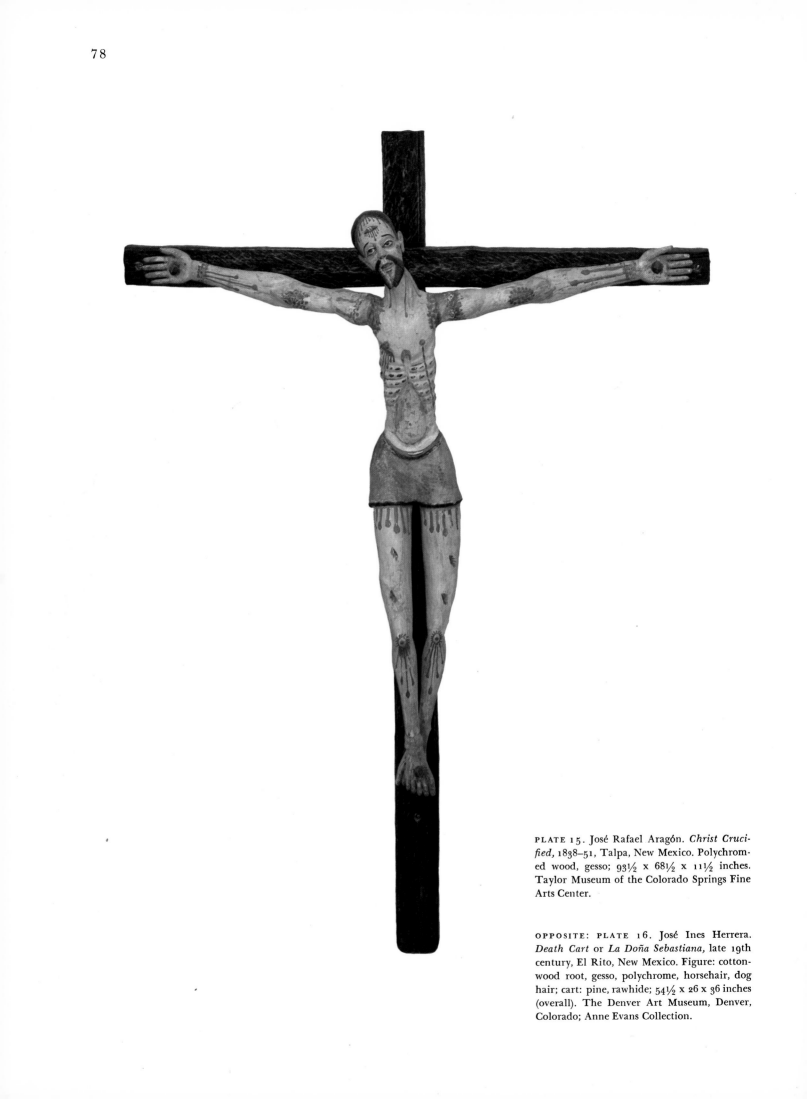

PLATE 15. José Rafael Aragón. *Christ Cruci-
fied*, 1838–51, Talpa, New Mexico. Polychrom-
ed wood, gesso; 93½ x 68½ x 11½ inches.
Taylor Museum of the Colorado Springs Fine
Arts Center.

OPPOSITE: PLATE 16. José Ines Herrera.
Death Cart or *La Doña Sebastiana*, late 19th
century, El Rito, New Mexico. Figure: cotton-
wood root, gesso, polychrome, horsehair, dog
hair; cart: pine, rawhide; 54½ x 26 x 36 inches
(overall). The Denver Art Museum, Denver,
Colorado; Anne Evans Collection.

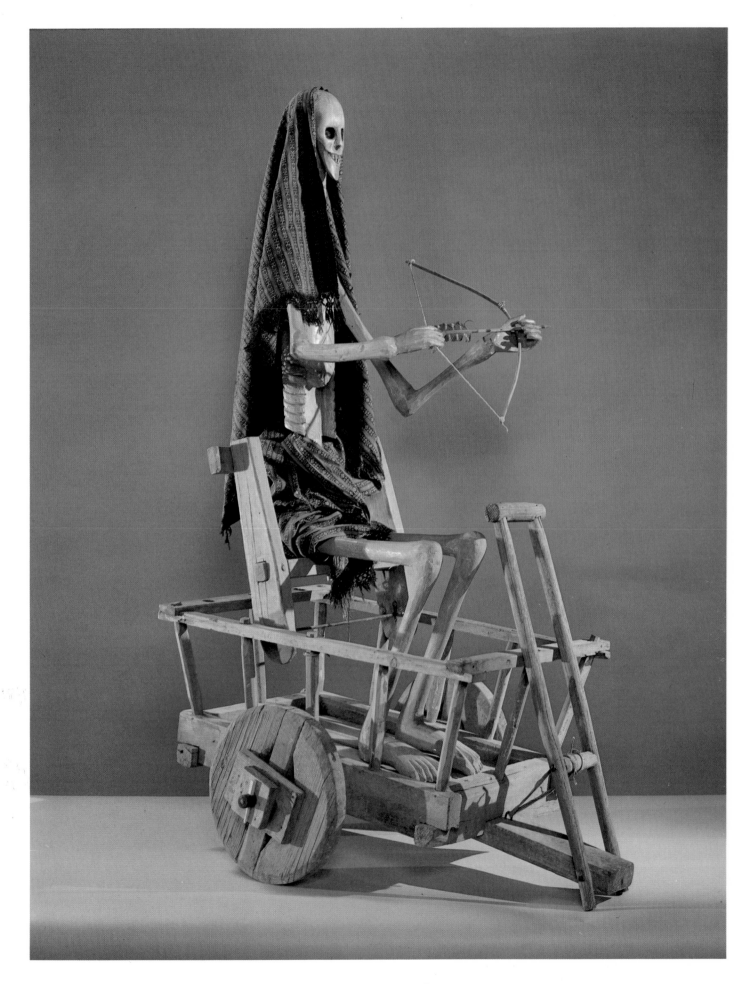

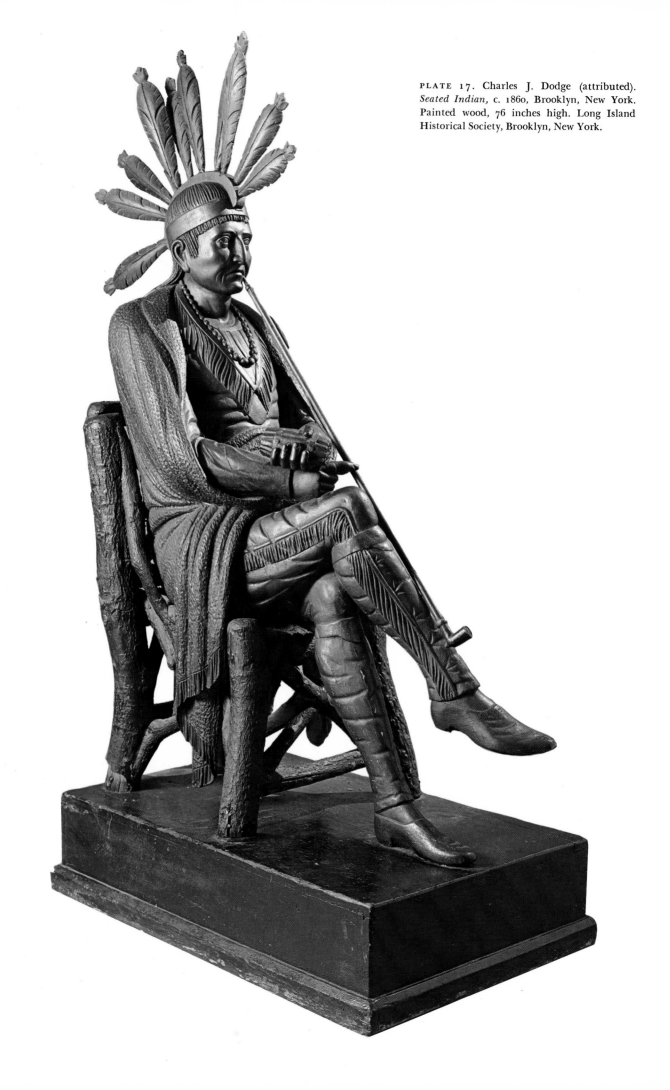

PLATE 17. Charles J. Dodge (attributed).
Seated Indian, c. 1860, Brooklyn, New York.
Painted wood, 76 inches high. Long Island
Historical Society, Brooklyn, New York.

PLATE 18. Augustus Saint-Gaudens. *The Puritan,* 1899. Bronze, 31 inches high. The Metropolitan Museum of Art, New York; Bequest of Jacob Ruppert, 1939.

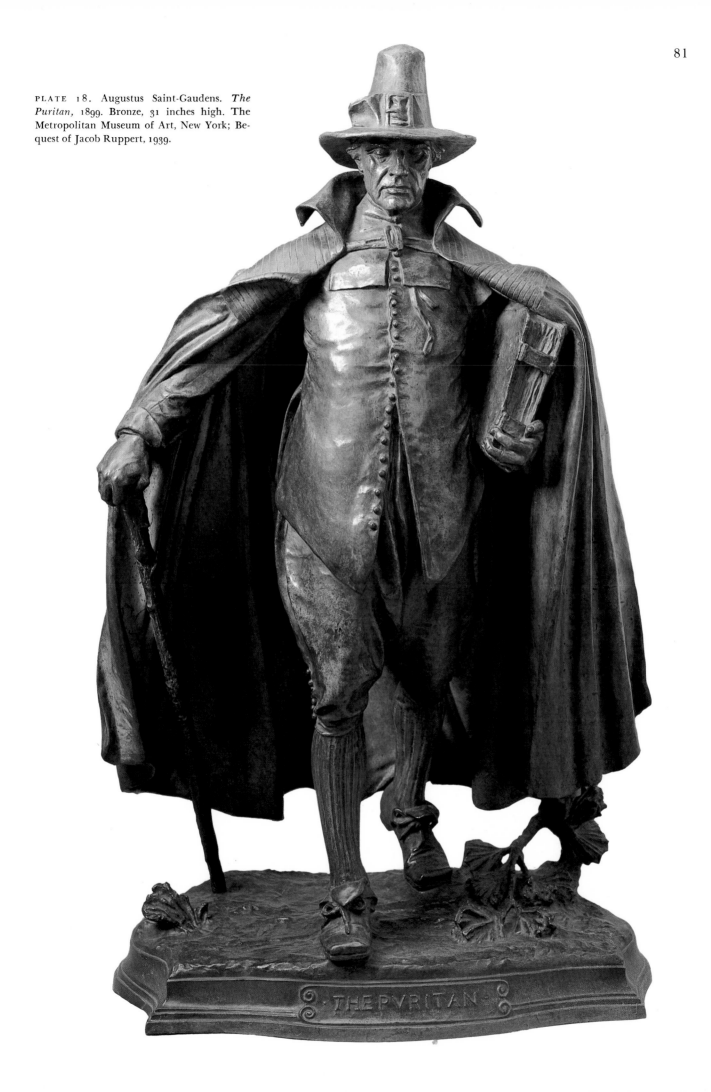

PLATE 19. Skillin Shop (attributed). *Eagle and Snake,* c. 1790, Boston. Gilded wood, metal and glass; 73 inches long. Collection of Dr. William Greenspon.

PLATE 20. Unknown artist. *Sternboard* (traditionally attributed to the ship *American Indian*), c. 1785, Plymouth County, Massachusetts. Polychromed wood, 116½ inches long. Shelburne Museum, Shelburne, Vermont.

PLATE 21. Unknown artist. *Angel Gabriel Weathervane* (with original directional points), c. 1800, New England. Gilt metal, 122 inches high. Collection of Dr. William Greenspon.

OPPOSITE: PLATE 22. Unknown artist. *Harry Howard, Chief Engineer of the New York Volunteer Fire Department,* c. 1860, New York. Polychromed wood, 91 inches high. The New-York Historical Society.

120. Unknown artist. *Animal Toys,* c. 1850, Pennsylvania. Painted wood; giraffe, 16¼ inches high. Collection of Stewart E. Gregory. Formerly in the collection of Juliana Force, Director of the Whitney Studio Club, 1918–28, and of the Whitney Museum, 1930–48.

121. Wood Gaylor. *Picnic, Maine,* 1923. Oil on canvas, 13 x 20½ inches. Collection of Mr. and Mrs. John Laurent. From left to right: Adelaide Lawson Gaylor, John Laurent, Katherine Schmidt, Dorothy Varian, Robert Laurent, Mimi Laurent, Alice Newton, Frank Osborne and Yasuo Kuniyoshi.

Holger Cahill and Edith Halpert were the most influential personalities in the early connoisseurship of American folk art. Cahill was the first scholar to write extensively on the subject, and his early writings have never been surpassed in their concise and accurate explanation of the history and aesthetics of folk art. Edith Halpert opened the Downtown Gallery in the fall of 1926, and in 1929 she became the first dealer in American folk art when she expanded her gallery to include the American Folk Art Gallery. She was advisor and dealer for many great patrons, including Abby Aldrich Rockefeller and Electra Havemeyer Webb, whose folk art collections are now in Williamsburg, Virginia, and Shelburne, Vermont.

The first public exhibition of American folk art was at the Whitney Studio Club, 8 West Eighth Street, New York City, in February 1924, organized by the artist Henry Schnakenberg. Juliana Force, Director of the Club, had already begun to assemble one of the first collections of folk art which included a group of stylized toys from Pennsylvania (Fig. 120). In 1923 Wood Gaylor had painted *Picnic, Maine* depicting his friends at Field's Ogunquit School of Painting and Sculpture which Laurent inherited and ran after Field's death in 1922 (Fig. 121). Four artists included in Gaylor's painting, Kuniyoshi, Dorothy Varian, Frank Osborne and Alice Newton, were also lenders to this first exhibition of American folk art titled *Early American Art.*

The 1924 exhibition at the Whitney Studio Club was followed by an article by Alexander Brook in the February 1925 issue of *Charm,* a magazine then published by Bamberger's department store in Newark, New Jersey. Brook, Assistant Director of the Whitney Studio Club from 1923 to 1927, was the first to suggest the modern artist's attraction to folk art when he wrote, "perhaps he sees in [it] the real foundation for present and future American art." [6]

In October 1930, in connection with the Massachusetts tercentenary celebration, the three undergraduate members of the Harvard Society for Contemporary Art, Inc., Lincoln Kirstein, John Walker and Edward M. M. Warburg, presented *American Folk Painting,* the first exhibition of the subject with a title incorporating the term "folk." Their interest in contemporary art encouraged them in this project as expressed in the catalogue statement by Lincoln Kirstein:

The Harvard Society for Contemporary Art . . . considers that these paintings, created one hundred or two hundred years ago, have the most valid and direct links with contemporary art.[7]

In the exhibition catalogue by the Harvard Society for Contemporary Art, with the distinguishing symbol by Rockwell Kent on the cover, the categories of work included "Models in Water Colour for Tattoos" and, for the first time, the recognition of the sculptural importance of gravestones illustrated with "Photographs of New England Gravestones."

One month later, the Newark Museum presented the exhibition *American Primitives* to be followed in the fall of 1931 by the exhibition *American Folk Sculpture.* Holger Cahill organized these exhibitions, and in the catalogue of the sculpture show he provided the following explanation of the genesis of folk art:

Folk art usually has not much to do with the fashionable art of its period. It is never the product of art movements, but comes out of craft traditions, plus that personal something of the rare craftsman who is an artist by nature if not by training. This art is based not on measurements or calculations but on feeling, and it rarely fits in with the standards of realism. It goes straight to the fundamentals of art — rhythm, design, balance, proportion, which the folk artist feels instinctively.[8]

He also confirmed that American artists of the early 20th century were attracted to American folk sculpture as an antecedent to their own work:

American folk sculpture has been almost without honor in its own country until very recently. Contemporary interest in it began with the modern artists who found in this folk expression a kinship with their own work, and a proof that there is an American tradition in the arts which is as old as the European colonization of this country, and which is vital today.[9]

Jean Lipman has been the most important scholar to continue Cahill's pioneering efforts to elaborate upon the abstract qualities of American folk art. The aesthetics of American folk sculpture will not become properly distinguished until the works are more completely discussed and understood in terms of the development of 20th-century abstraction. The intuitive ability of the folk artist to abstract an observation or emotion inspired by nature into a personal statement is the core of American folk art. If we accept this ability as the supreme achievement of the artist's special sensitivity, then folk art is the major visual art in the United States in the 19th century, particularly in the area of sculpture.

In 1932 Cahill organized and catalogued the exhibition of Abby Aldrich Rockefeller's collection at the Museum of Modern Art, *American Folk Art: The Art of the Common Man in America 1750-1900,* which, more than any previous exhibition, established American folk art as an important aspect of American art. Subsequent scholarship has divided folk sculpture into general categories based upon original purpose: toys, gravestones, Spanish-American religious art, ship's sternboards and figureheads, cigar-store figures and other shop signs, carousel and circus carvings, weathervanes and whirligigs, decoys and household ornaments.

Objects considered works of art which were originally intended to serve a specific function but subsequently detached from that purpose transcend the primary objectives of the maker. The artists who produced the body of work which is now considered American folk sculpture were responding in most instances to a need for a symbolic or functional object. The purpose of the sculpture was set forth by people with little knowledge of the hierarchy of established art who set few criteria beyond the function. The folk sculptor, unaffected by stylistic trends of academic art, responded with a personal vision to produce abstracted forms of an intensity equal to the directness of the original purpose of the objects.

New England gravestone carvers, the first folk sculptors who created works for a definite purpose, were forced to work within restricted iconographic limitations. In their book *Memorials for Children of Change,* Dickran and Ann Tashjian describe the function of the carver as a producer of art in the Puritan culture:

A Puritan was supposed to manifest restraint and moderation in the face of death in the family lest his spiritual love for God be superseded by a profane love for mortals. . . . Thus, with respect to a monument for the deceased, the Puritan hired a professional artisan to express that which was inchoate in himself. In turn, the carver appropriated visual conventions that were socially acceptable, and through the designs, he articulated that which was either inexpressible or, if expressed, uncontrollable. In this way the carver achieved a crucial aesthetic distance for the surviving family and community.[10]

The bold simple composition of the late 18th-century gravestone of Polly Coombes, indicating the dependence upon symmetry in folk art, employs a linear pattern related to the established curve of the stone. The design combines a variety of shape, line and texture to produce a bold, abstracted impression of an angel whose wings sprout from her head (Fig. 122). The second layer of her hair, the curve of the wings, the sharply upturned mouth and two bouncing curls impart a levity to this bright-eyed angel.[11] As incised designs, gravestones can be considered the beginning of a sculptural tradition in New England folk art. However, the limitation to surface decoration restricts expression in three dimensions.

Gravestones, as representative of early American religious art, are not as completely associated with religious rites and rituals of the people as are examples of Spanish-American folk art of the Southwest which comprise the most significant religious art native to this country. The southwestern portion of the United States was colonized at an early date by Spanish settlers migrating from Mexico; the city of Santa Fe, New Mexico, was established as early as 1610. The major path of settlement was up the Rio Grande and missionary activity established churches at each of the major Indian pueblos. Migration from Mexico always included one or more Franciscan missionaries to administer to the needs of the immigrants and to convert the Indians of the area to Catholicism. Because of the difficulty of transportation from Mexico — over one thousand miles by mule train — the immigrants were forced to manufacture almost everything they needed from locally available materials. A distinctive form of folk art developed in response to the need for religious articles to decorate the many churches and homes of the new immigrants. Very few examples of religious art were actually brought from Mexico, and

the vast majority was locally produced. At first religious art was made by members of the clergy copying from prints and books, but later it was produced also by the laity which explains the range of interpretation of sources represented in this art.

A Spanish-American religious art object, whether a painting or a sculpture, is known as a santo (saint or holy) and the maker as a Santero.[12] Santos can be either a painted panel, known as a retablo, or a three-dimensional work, known as a bulto, usually carved in sections from the root of a cottonwood tree, coated with gesso and painted with tempera. In one of the largest examples, Christ Crucified, attributed to José Rafael Aragón, made between 1838 and 1851, the crucified Christ is represented by simplified forms, the extension and elongation of which are emphasized by the painted patterns of blood, notably at the wrists, relating to the direction of the forms rather than a realistic portrayal (Pl. 15). In this bulto, one of a dozen from the Duran Chapel at Talpa, New Mexico, the right side of the figure's tilted head and the outline of the left hip and leg establish a curve of the figure which accentuates the sense of supplication and human weakness in contrast to the unyielding dominance of the rigid, supporting Cross.[13]

New Mexico, a part of Spain, was governed by a Spanish viceroy in Mexico City until 1821 when administration was transferred to the Mexican government. In 1828 the Mexican government recalled all priests of Spanish birth from New Mexico, and it was from this time until about 1850, when New Mexico came under American domination with the arrival of Archbishop Lamy, that the New Mexican church was largely without professional leadership. During these years the Penitente Brotherhood, actually an offshoot of the Third Order of Saint Francis, dominated the religious scene. Although most of

122. Unknown artist. Gravestone of Polly Coombes, died 1795, Bellingham, Massachusetts. Slate. Photograph courtesy of Ann Parker.

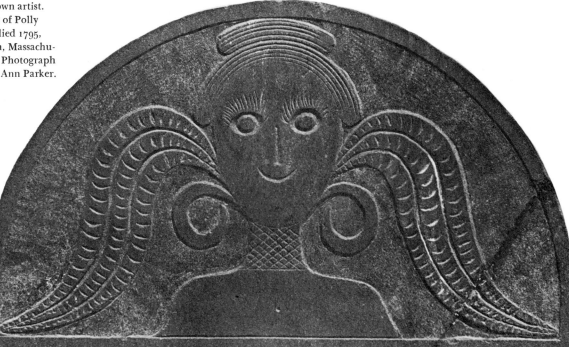

the religious art was manufactured for use in the churches and homes, objects such as the Death cart were for special use in the Moradas (meeting houses) of the Penitente Brotherhood and were carried or drawn in Good Friday processions.

Death Cart was made by José Ines Herrera sometime during the period 1890 to 1910 in the area of El Rito, New Mexico (Pl. 16). It symbolizes the triumph of death after the Crucifixion and before the Resurrection.[14] The figure of death carries a bow and arrow, a symbolic substitute for the traditional scythe in an area of the country still threatened by Indians' arrows. The stylized figure with its wig of gray horse hair and tufts of dog hair, and yellow pallor, is a frighteningly eerie symbol to elicit an emotional response and encourage religious fervor.

The art of the Santero largely died out after the Southwest passed into United States hands from Mexico. Commercially manufactured religious items became more readily available because of increased and easier trade with major United States centers in the East. The years between 1750 and about 1850 mark the period of greatest activity of the Santero, although many earlier examples are known. After 1850 a limited production of santos continued in the more remote New Mexican villages and for use in the Penitente Moradas, but the necessity for homemade versions was alleviated by the availability of commercial examples.

It is in direct wood carving that the American folk artist excelled in both the southwestern and eastern sections of the country in the late 18th and 19th century. Religious symbols predominate in the Southwest but in the East the development of a national identity was creating increased need for decorative motifs and patriotic symbols. Despite Benjamin Franklin's enthusiasm for the native turkey, the American bald eagle was approved by Congress on June 20, 1782, as the national symbol for the Great Seal of the United States. The eagle quickly became a popular symbol of patriotism and a major theme for wood-carvers. The gilded carved-wood *Eagle and Snake,* attributed to the Skillin workshop, Boston, about 1790, is believed to have been part of the decoration of the Boston Custom House (Pl. 19). The snake is symbolic of the union of the Colonies and was originally used on flags with the motto: "Don't Tread on Me." The linear design of the snake echoes the outline of the top of the eagle and contributes to the symmetry and interest of the design.

The development of the New England shipping industry provided the folk carver with increasing patronage for his work. The unknown sculptor who carved the sternboard of the ship *American Indian* about 1785 created a symmetrical composition with a central Indian figure between a lion and deer which is well propor-

tioned to the area of the panel (Pl. 20).[15] The illusion of space in the panel is intensified by the overlapping legs of the Indian and the drapery of the Indian's skirt which falls outside of the decorative border across the bottom of the panel. The contour pattern of the Indian, lion and deer as a linear design is unified by the connecting outlines of the forms including the top line of the Indian's right arm which extends to become the outline of the top of the lion's head. The same flattening of surface pattern through connection of contours on the same spatial plane occurs as the line of the Indian's left leg and foot extends to define the leg of the deer. The curves of the composition are repeated in parallel rhythms throughout the carved panel. The strongest linear definitions are the outlining edges of solid forms except for the lion's tail, emphasized as a superimposed linear form which curls over the lion's hindquarters to the top of his back.

The iconography of the sternboard has never been interpreted. The hand of the Indian, who has apparently shot the deer, is placed upon the turned head of the lion. The Indian has a belt of tobacco leaves and cape of bear skin with the ears of the animal forming a decorative flat pattern behind the Indian's modeled head.

The symbolism could be interpreted as America represented by the central figure of the richly clad Indian, Peace on the left as a friendly, smiling, imperial lion and Plenty to the right of the Indian as the captured animal of the forest.[16] If this interpretation is accurate, then the anonymous folk carver has created a more intriguing representation of the theme than John and Simeon Skillin, Jr., carved six years later in 1791 for the top of a chest-on-chest by Stephen Badlam of Dorchester for the Salem shipping magnate Elias Hasket Derby to present to his daughter as a gift for her second wedding anniversary (Fig. 123).

In the Skillins' group of three figures, Peace is represented on the left holding a palm frond, with an olive-leaf wreath on her head, symbols familiar from ancient statues. The figure of Plenty on the right holds the classical horn of plenty filled with fruit and grain and wears a wreath of corn. The central figure, representing Liberty, holds a laurel wreath, a Roman symbol of victory, and the Phrygian cap on her pike (Fig. 124). The cap, a symbol of newly freed Roman slaves, was later adopted as a symbol of the American Sons of Liberty.[17] The Skillin workshop would probably have had available James Gibbs's *Book of Architecture,* 1728, which illustrates in Plate 114 two reclining classically draped figures on the pediment of a tomb (Fig. 125).[18] The Skillins incorporated a lexicon of classic symbolism into their carving for America's wealthiest patrons of the 18th century. The unknown folk carver of the sternboard used familiar references to interpret what appears to be the same allegory

LEFT: 123. Stephen Badlam. Chest-on-chest, 1791. Mahogany, 101 inches high. Yale University Art Gallery, New Haven, Connecticut; The Mabel Brady Garvan Collection.

ABOVE: 124. John and Simeon Skillin, Jr. *Peace, Virtue and Plenty*, 1791. Detail of Fig. 123.

RIGHT: 125. James Gibbs. Plate 114, *Book of Architecture*, London, 1728. Photograph courtesy of The Henry Francis du Pont Winterthur Museum, Winterthur, Delaware.

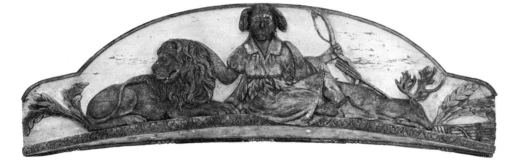

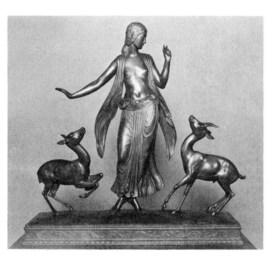

ABOVE: 126. Unknown artist. *Stern-board* (traditionally attributed to the ship *American Indian*), c. 1785, Plymouth County, Massachusetts. Polychromed wood, 116½ inches long. Shelburne Museum, Shelburne, Vermont.

LEFT: 127. Paul Manship. *Dancer and Gazelles*, 1916. Bronze, 69¾ inches high. Corcoran Gallery of Art, Washington, D.C.

for the sailors and people on the docks to view on the stern of a New England sailing vessel.

The folk carver's simplified forms in the *American Indian* sternboard and the association of three figures through the intuitive use of compositional devices, such as subtle repetition of curving shapes and unification of the overall pattern of the carving, allies this work with the 20th-century sculpture *Dancer and Gazelles* by Paul Manship (Figs. 126, 127) more than with the academic carving of his contemporaries, the Skillin brothers. The folk carver employed design elements known to Manship which the Skillins never realized in their efforts to create a fashionable neoclassic sculpture ornament.

Costume in folk sculpture is an element which increases its association with the people for whom it served a purpose. This is particularly true in ship figureheads,

ABOVE LEFT: 128. Colonel Charles A. L. Sampson. *Belle of Bath,* 1877, Bath, Maine. Painted wood, 102 inches high. Watercolor illustration from Index of American Design; photograph courtesy of the National Gallery of Art, Washington, D.C.; Index of American Design.

ABOVE CENTER: 129. Colonel Charles A. L. Sampson. *Forest Belle.* 1877, Bath, Maine. Painted wood, about 120 inches high. Oregon Historical Society, Portland.

ABOVE RIGHT: 130. Detail of *New York City — a Recent Wedding at a Fashionable Church on Fifth Avenue.* Published in *Frank Leslie's Illustrated Newspaper,* 1873. Engraving, 14 x 20¼ inches. Culver Pictures.

among the boldest wood carvings produced by folk carvers during the 19th century. Four of the known figureheads by the Bath, Maine, carver Colonel Charles A. L. Sampson are each costumed as fashionable women of the same period in which the figureheads were carved. The *Belle of Bath, Belle of Oregon* and *Western Belle* were carved for ships of the same names built for the grain trade (Fig. 128, Pl. 14).[19] The *Belle of Oregon,* carved in the centennial year of 1876, is holding a bunch of grain in her extended right hand and has a decorative row of grain clusters around the skirt of her costume which is as fashionable as those worn by members of the wedding party and guests in an engraving of a wedding in New York City in 1873 (Fig. 130). The fourth known figurehead attributed to Sampson is in the collection of the Oregon Historical Society (Fig. 129).[20] Figureheads such as these were idealized representations of the women sailors wanted to remember during long voyages and accordingly were carved as recognizable women of the period.

131. William Rinehart. *Latona and Her Children, Apollo and Diana,* 1874. Marble, 46 inches high. The Metropolitan Museum of Art, New York; Rogers Fund, 1905.

In the third quarter of the 19th century, one of the most fashionable academic sculptors of the period was William Rinehart. His marble figure *Latona and Her Children,* finished two years before the *Belle of Oregon* was carved, illustrates the vast differences in attitude between the popular neoclassic sculpture of the period and American folk sculpture (Fig. 131).

The style in which popular figures and heroes are immortalized in sculpture can be considered indicative of the aspirations of the sculptor, his sensitivity to popular taste, the demands of patronage and the dictates of historic precedent. Two life-size, full-length 19th-century portraits illustrate the differences between the response of the academic sculptor and the unknown folk artist to commissions for memorial portrait sculpture. Horatio Greenough's monumental marble *Washington,* installed in the rotunda of the Capitol in Washington, D.C., in 1841, is a dramatic contrast to the carved wood figure of Harry Howard by an unknown sculptor, which appears in a lithograph of the period depicting it on a pedestal on the roof, surmounting the facade, of Firemen's Hall at 155 Mercer Street, New York City (Fig. 136). One is an ambitious effort to create a classic colossus; the other, an American portrait dignifying a hero of the people in his time.

Harry Howard was a popular figure as a volunteer fireman in Manhattan and Chief Engineer of the New York Volunteer Fire Department from 1857 to 1860 (Fig. 132). To honor him, a full-length, carved wood portrait in his fireman's uniform was placed on top of Firemens Hall which is still standing in lower Manhattan. Holding a fire horn to his mouth in his right hand with

his left upraised with finger pointing in an attitude of leadership and command, this over-life-size wood figure placed three stories above the street dignified and immortalized the fireman as a hero among his contemporaries (Pl. 22). The lithograph honoring the erection of the Hall in 1854, listing the architect and others involved, shows the figure reversed. The figure was drawn on the stone as observed and the image of the popular, recognizable symbol of good citizenship, outlined against the sky, was reversed in the print.

When the young academic sculptor Horatio Greenough was commissioned by a resolution of the Congress of the United States to memorialize George Washington in an appropriate popular image, he chose to depict him in the guise of a god, surrounded by iconographic references to American history and the triumphs of the gods of antiquity. A full-length marble figure, naked to the waist, is seated on a throne with upraised hand and finger pointing as a ruler arresting the attention of his subjects (Fig. 135). When the statue was placed in the rotunda of the Capitol in 1841, it was ridiculed because of its nakedness and classical conception which was regarded as a disguised image of the American statesman the public idolized. The sculptor's ambition to work in the classic tradition had led him beyond the limits of popular taste.

The void between the pointing fingers of the semi-nude Washington and the uniformed Harry Howard can be imagined as the conceptual difference between the parallel traditions of 19th-century American sculpture molded in the shadow of classic form and American folk art produced in the glow of popular enthusiasm.

Much of the fashionable academic portrait sculpture in the middle of the 19th century depicts figures attired in neoclassic translations of drapery and costume of the past. When Hiram Powers was commissioned for the bronze portrait of Daniel Webster to commemorate the Massachusetts Senator's career as an eloquent statesman, he portrayed him in clothes of the period which obviously did not encourage Powers to model his figure with the same assurance and conviction that he had previously displayed in figures draped in flowing folds of classic drapery (Fig. 134). Powers's attention to superficial details of costume diverted him from a concern for the underlying form covered by the baggy attire of the 1858 figure. Carved in the same period, the portrait of Harry Howard is realized in simplified forms which minimize realistic elements to emphasize volumes and focus attention upon the attitude of the figure. It is more sculptural, more an interpretation of the structure of the human figure translated into volumes of solid form as illustrated in the view of the figure's back carved and shaped to indicate the power and strength of the erect man (Fig. 133).

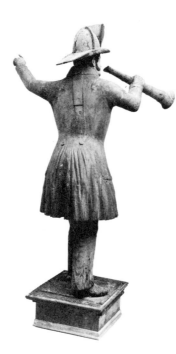

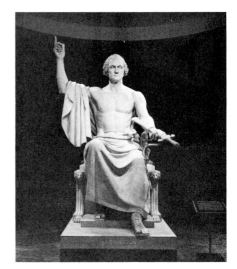

ABOVE LEFT: 132. J. Gurney. *Harry Howard, Chief Engineer of the New York Volunteer Fire Department.* Photograph, inscribed "Seamen, Lichtenstein, Esq. with the Chief's Compliments, October, 1858." The Museum of the City of New York.

ABOVE CENTER: 133. Back view of *Harry Howard, Chief Engineer of the New York Volunteer Fire Department,* c. 1860. (See Pl. 22.)

ABOVE RIGHT: 134. Hiram Powers. *Daniel Webster,* 1858. Bronze, 96 inches high. Boston State House.

ABOVE: 135. Horatio Greenough. *George Washington,* 1832–41. Marble, 136 inches high. National Collection of Fine Arts, Smithsonian Institution, Washington, D.C. (See Figs. 45a-c, pp. 34–35.)

LEFT: 136. Endicott and Company. *Firemen's Hall, 155 Mercer Street, New York City,* c. 1860. Lithograph. The New-York Historical Society.

The manner in which the American Indian is portrayed in 19th-century American sculpture provides further insight into the different artistic concepts and attitudes of European-trained, classically inspired American academic sculptors and of folk sculptors. In the middle of the century, two sculptors interpreted the American Indian for public locations, one for the United States Capitol building in Washington, D.C., the other for a tobacco shop at 78 Montague Street, Brooklyn, New York. The contrast between the materials employed by the carvers — marble and wood — is representative of more subtle dichotomies which make these two interpretations of the same subject pivotal works in the understanding of the parallel traditions of American sculpture.

In 1853, Thomas Crawford, who had been living and working as an American sculptor in Rome for eighteen years, received a large commission to design the frieze for the pediment of the east front of the Senate wing of the United States Capitol. *The Dying Chief Contemplating the Progress of Civilization,* one of the group of figures in the frieze, was carved later as a separate sculpture (Fig. 138). The life-size marble figure is a romanticized interpretation of the despondent Indian's futile struggle as American civilization moved West. The allegorical representation of the Indian's plight is interpreted by Crawford as a neoclassic nude male figure with moccasins and headdress symbolizing his identity.

The *Seated Indian* tobacconist figure, carved in the same period and attributed to the New York carver Charles J. Dodge, is a realistically portrayed characterization of an Indian chief whose elegance and solitude are a dramatic contrast to Crawford's superficial resolution of an emotionalized concept (Pl. 17). Seated on a log chair, holding cigars and smoking a pipe, this life-size figure represents the tradition of using Indians as trade signs for tobacco products which began in England in the 16th century as tobacco became a popular import from the Colonies. The fully modeled figure has been conceived as a dignified representation of a Chief whose cape encloses the volumes of his shoulders and arms and falls symmetrically on both sides of his lap, emphasizing the grace of his extended crossed legs (Fig. 137).

ABOVE: 137. Charles J. Dodge (attributed). *Seated Indian,* c. 1860, Brooklyn, New York. Painted wood, 76 inches high. Long Island Historical Society, Brooklyn, New York. (See Pl. 17.)

RIGHT: 138. Thomas Crawford. *The Dying Chief Contemplating the Progress of Civilization,* 1856. Marble, 55 inches high. The New-York Historical Society.

By the middle of the 19th century Indians were popular images in front of tobacco shops and the production of these trade signs was an active business for many carvers. The *Thin Indian Chief,* made in the third quarter of the 19th century, is a solution to the restrictions of an unknown carver's limited material which precluded fully realized modeling of the figure. Carved in low relief, with a maximum width of five boards, each approximately two inches thick, joined vertically, the sculpture employs devices which strengthen the impression of three-dimensional form. The legs, one board wide, are separated, with one foot forward overlapping the other — providing a relationship of the two in space and giving the figure a sense of forward movement. The corresponding diagonal tilt of the axis of the waist, which occurs with a shift in weight when one foot is placed in front of the other, is indicated in the back where the belt is emphasized in relief and associated with the borders of the sleeves of the figure's costume, one higher than the other. The side and front views, particularly of the head, give very different impressions of volume and indicate the carver's skill in creating the illusion of rounded form. Throughout the figure, linear surface designs and emphasized modeled areas combine to increase the overall impression of fully realized volumes (Pl. 30 and p. 109).

Direct carving is the most predominant technique in American folk sculpture and wood is the medium most often employed. During the first half of the 19th century, wood-carvers found a need for their talent in the shipping industry where they were employed to identify the purpose of vessels, the ambitions of their owners and the dreams of the sailors — in figureheads, sternboards and other carved decorations. As the industry developed and great wooden sailing ships were replaced in the third quarter of the century by steam vessels with metal hulls, many ship carvers were forced to find new outlets for their skills. The developing economy had created a need for trade signs to advertise the wares of shops in urban and rural areas and carvers responded to this need. The variety of these figures attests to the wide use of three-dimensional objects to attract the public which, in contrast to the present, was apparently more influenced by sculptural representation than by the graphic messages of flat signs.

For a ship chandler's shop around 1850, probably in New England, a standing, fully realized figure of a man raising a telescope to his eye served as the informative invitation to a customer for ship supplies (Fig. 139, p. 74). The alert attitude of the figure is intensified by the open, tense gesture of the left hand, indicating the surprise of newly seen vistas. The unknown sculptor has incorporated into the figure a distinct personality which could be remembered and repeatedly attract customers. The carving of drapery and indication of realistic details complements the physical presence of the figure which has a command of its environment.

As baseball became a popular sport in the second half of the 19th century, figures of baseball players were used to attract customers to shops of various purposes. The foreshortened polychromed body of *The Baseball Player* by the New York carver Samuel A. Robb, one of the most prolific carvers of the period, is immediately identified through his sure stance and solid physique as a sports figure determined to succeed (Pl. 25).

In 1924 the sculptor Robert Laurent acquired the small, stylized wood figure of a man holding a greatly oversized bunch of grapes in his upraised left arm from an antiques dealer in Wells, Maine. As discussed by Daniel Robbins in this book, sculptors associated with the development of modern art in the early 20th century were exponents of direct carving. The figure of *Man with Grapes* is related through the abstraction of form to carved works by Laurent and the sculptor Elie Nadelman, an early and important collector of American folk sculpture (Figs. 140, 141, 142).[21] As a work of the 19th century, it is a precursor of modern art and was collected by Laurent as an antecedent to the development of his work.

The purpose of the *Father Time* is unknown (Pl. 24). Originally draped with a black velvet loincloth, it is believed to have been a shop figure and reportedly had a mechanism rigged to the shop door which, when opened, activated the right arm of the figure causing the scythe to strike the bell. The sculptor has combined a wood carving with other materials in a figure which develops a theme of curved outlines related to the fully rounded forms of the body. This work and *Man with Grapes* are statements by unknown artists which exceed the observations of literal vision and express the interpretive ability of the folk carver to abstract form.

The variety of shop signs and the sculptors' ability to relate them to their purpose is illustrated by the life-size, full-length *Tinsmith,* made about 1895 and used as the shop sign in the window of the West End Sheet Metal and Roofing Works Corp., Brooklyn, New York (Pl. 28). The figure is attributed to the proprietor, J. Krans. Debonair in tails and top hat with a cane hung over his wrist, the figure is composed of uniformly rounded shapes expressive of the character of the material from which it was made. The sleek, tubular forms and the straight edges of the contours contribute to give the figure as seen from various viewpoints, the neat, orderly appearance of a perfectly tailored gentleman as durable and rigidly stable as the product he represents.

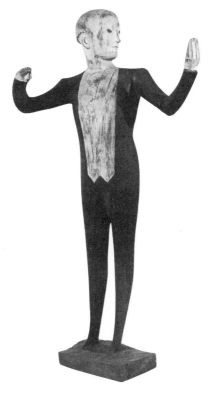

ABOVE LEFT: 140. Robert Laurent. *Flirtation*, 1921. Bronze (cast from mahogany carving of 1921), 20 inches high. Collection of Mr. and Mrs. John Laurent.

ABOVE: 141. Unknown artist. *Man with Grapes*, c. 1875, Maine. Painted wood and wire, 15 inches high. Guennol Collection, New York. Originally acquired by Robert Laurent in 1924 in Wells, Maine.

LEFT: 142. Elie Nadelman. *Chef d'Orchestre (Orchestra Conductor)*, c. 1919. Cherry wood and gesso, 38½ inches high. Hirshhorn Museum and Sculpture Garden, Smithsonian Institution, Washington, D.C.

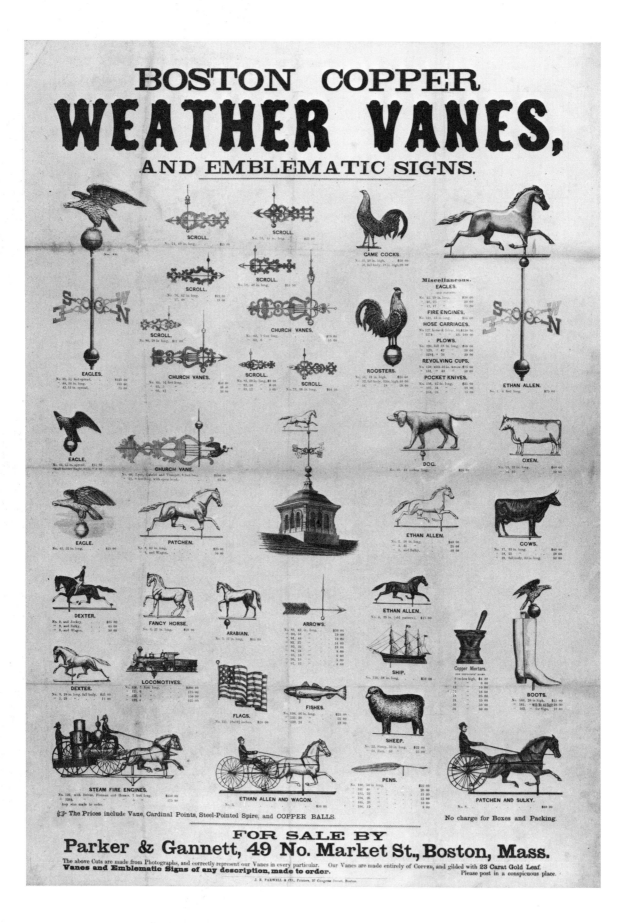

American folk art is primarily associated with rural life, and domestic animals are an important subject in both sculpture and painting. The association of the horse with transportation, agriculture and sports in the 19th century is apparent in folk sculpture — particularly in weathervanes depicting farm animals, famous trotters and racers, and in carousels, a major amusement now almost completely vanished (Fig. 143). A late example, *Carousel Horse,* made by Stein and Goldstein sometime between 1912 and 1916, is one of the noblest examples of the carousel carver's art, conceived and decorated with unrestrained exuberance (Pl. 27). Seated upon the panther-skin saddle, gripping the expansively carved open curls of the mane, young riders could envision romantic adventure as they pranced toward the golden ring.

Scale is a primary consideration in sculpture, particularly in the depiction of realistic subjects. The relationship between the scale of the original subject and the sculpture and the size of the sculpture in relation to the human figure both affect a response to the work. The carousel rooster, four times larger than its subject in nature and approximately the height of a six-year-old child, is a monumental realization of the subject with an intensified attitude of movement for a carousel ride which could transport a young rider to the world of the Brobdingnagian Giants visited by Gulliver (Pl. 26). The form of the rooster, made by Edmond Brown of St. Johnsbury, Vermont, in about 1900, has been simplified and translated into a stylized shape that incorporates the essential recognizable elements of the subject into an abstracted interpretation.

The decorative stylization of simple, everyday things, particularly barnyard animals, is one of the outstanding aspects of folk sculpture. Weathervanes afforded the folk sculptor the opportunity to silhouette shapes and emphasize the design of outlined pattern. The carved pine roosters of the Bridgton, Maine, farmer James Lombard, made in the last quarter of the 19th century, are among the most decorative works in American folk sculpture (Fig. 144). When they are compared, Lombard's development of patterned design is seen to have variety

OPPOSITE: 143. Broadside advertising commercially available, factory-made weathervanes sold by Parker & Gannett about 1889. Companies such as this and Fiske and Co., also in Boston, supplied weathervanes for a growing market inspired by an appreciation of unique handcrafted examples. Printed on paper, 32½ x 23 inches (sight). Abby Aldrich Rockefeller Folk Art Collection, Williamsburg, Virginia.

RIGHT: 144. James Lombard. *Hen and Rooster Weathervanes,* c. 1885–90, Bridgton, Maine. Painted wood, 20 inches long. Top three, New York State Historical Association, Cooperstown; bottom, collection of Mr. and Mrs. Richard Hankinson. The second rooster from the top came from the Lombard farm in Bridgton, Maine.

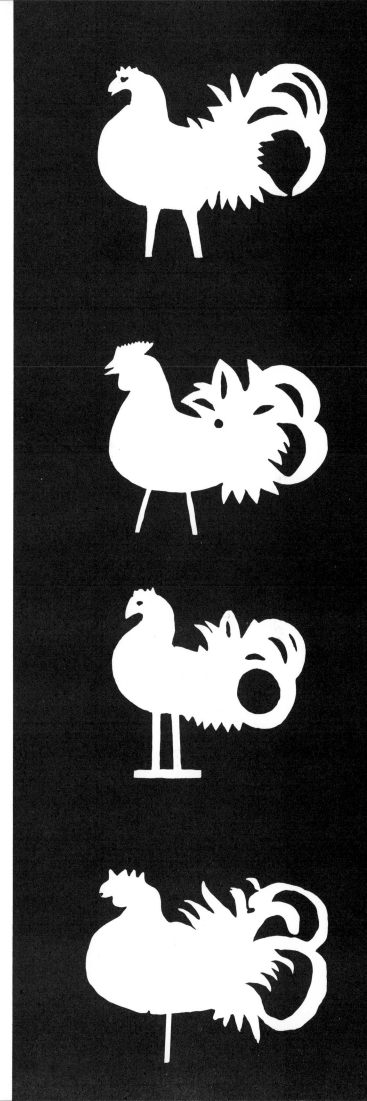

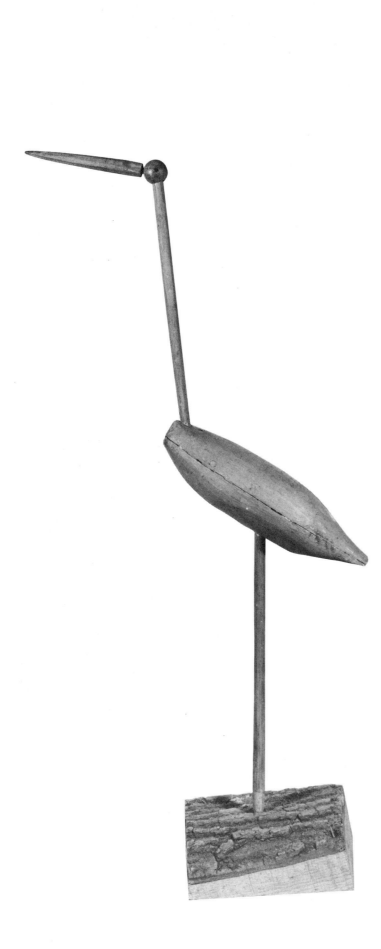

and strength. Originally painted with yellow ochre to simulate gold leaf, they express a response to decorative abstract design which incorporated spatial patterns in contrast to solid forms and make these objects timeless examples of an artist's translation of observation into design. Repetitions of shapes in varying sizes, rounded forms contrasted with pointed outlines, solid shapes repeated in the outline of spaces between solids, clusters of small shapes related to large areas—all are executed in the creative process requiring design decisions which Lombard seems to have made with an intuitive sense of the excitement of pure form. Even the basic composition is well considered—contrasting the simple shape of the breast and head of the bird to the complex pattern of the tail. With our eyes accustomed to the work of contemporary sculptors, we realize the genius of this Maine farmer.

The image of the archangel Gabriel, guardian of the heavenly treasury and messenger of annunciations, was often used as a weathervane pattern for churches. The *Angel Gabriel Weathervane*, complete with original hand-wrought directional points, is reported to have come from a New England church and was made about 1800 (Pl. 21). It is an example of the folk artist's ability to complete to final realization the overall concept of a sculpture. The stylized silhouette of the flying angel was cut and then reinforcing bands were attached to both sides of the figure. The artist greatly strengthened the horizontal axis of the work through the continuous lines of the reinforcements. Even the widths of the bands seem appropriately proportioned as they establish a linear armature supporting the flying angel, whose contour when seen above a church, like the clouds beyond, is composed of curved lines.

Bird decoys were an indigenous craft of American Indians who shaped them of mud and grass to lure wild fowl. By the middle of the 19th century the demand for decoys for commercial game hunting as well as sports had created a business for folk carvers. Many carved wood examples are now considered unique expressions as works of art and exceed their original utilitarian purpose. Before the passage of various conservation acts in the first quarter of the 20th century, decoys of heron, egret, bittern, crane and swan were made for feather hunters who

145. Unknown artist. *Crane Decoy*, c. 1907. Wood, 51 inches high. Inscribed "George Martin's Crane, Barnegat, June 1907." Private collection.

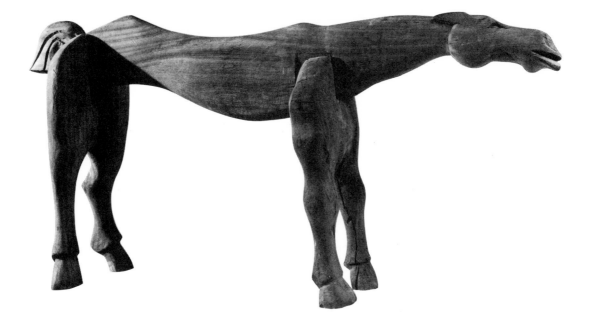

146. Alexander Calder. *The Horse,* 1928. Wood, 34¾ inches long. The Museum of Modern Art, New York; acquired through the Lillie P. Bliss Bequest.

supplied trimmings for ladies' fashions. Later, many of these decoys of birds which are not legal game were used as "confidence" decoys to attract game birds. The *Crane Decoy,* inscribed "George Martin's Crane, Barnegat, June 1907," was probably made for this purpose, because cranes in nature sometimes act as look-outs with feeding geese (Fig. 145).

The *Crane Decoy* is the work of an artist who recognized the basic elements which characterize the subject and interpreted them with direct means into an extremely simple statement. It is the solution many contemporary artists seek to achieve in their attempts to produce the maximum effect through minimum means. The only reference to the original function of the parallel dowels representing the legs and neck of the crane is their vertical axis and relationship to the body. The length of each element of the bird creates an ascending rhythm of forms. The pointed beak, which terminates the succession of shapes, is parallel to the outline of the tail section under the body which is approximately the same length and also related as part of the only other element of the composition which ends as a point. The folk artist through intuitive understanding of scale and use of compositional elements in a silhouette pattern has established not only a lure for other birds but an abstract sculpture.

In 1928, Alexander Calder made *The Horse,* a box-wood figure now in the collection of the Museum of Modern Art (Fig. 146). About the same time, Edgar Alex-

ander McKillop, living in Balfour, North Carolina, made one of his four known works, *Hippoceros,* combining the elements of a rhinoceros and hippopotamus, now in the Abby Aldrich Rockefeller Folk Art Collection (Pl. 29). This coincidence encourages the application of similar judgments about the work which further assist us to establish that folk art should not be separated as a curiosity in the history of American art but should be considered within the same hierarchy of criteria which we apply when making judgments about contemporary art.

Calder's horse, carved and assembled in three parts, expresses the essential character of the animal in an abstracted manner, with emphasis upon the attitude of the legs and the extended neck and head. McKillop's carved wooden figure expresses the artist's similar ability to select and to emphasize those elements which contribute most to his personal statement.

Hippoceros has teeth resembling piano keys, glass taxidermist eyes, and originally had rhinestones in its nostrils. The tongue is a leather boxing glove which is rigged to move in and out as the turntable of the phonograph in the animal's back revolves. A strange creature, it has a presence which attests to the artist's ability to combine materials, sound and motion in a unified statement which becomes a uniquely powerful image.

In the 19th century, American folk sculpture was the expression of a response by untrained artists to a particular need of the people for functional objects. The decline

147. James Hampton. *Throne of the Third Heaven of the Nations Millenium General Assembly*, c. 1950–64, seen here as discovered in Hampton's garage after his death in 1964. National Collection of Fine Arts, Smithsonian Institution, Washington, D.C.

of the agrarian society with the development of an industrialized economy and the urbanization of the country after the Civil War eliminated the general need of society for artists to produce symbols and decoration. In the 20th century there are examples of untrained and unknown artists such as McKillop, but these artists are separated now from a tradition of producing work for a particular part of the population. Twentieth-century folk sculpture is the individual expression of untrained artists who have generally remained apart from the cultural developments of the society. Their work is produced more for self-satisfaction than, as in the past, for the needs of others.

The recognition of eccentric grass-roots artists in the 20th century and an appreciation of their work is primarily the result of an article by Gregg N. Blasdel in the September/October 1968 issue of *Art in America* and the exhibition *Naives and Visionaries* organized by the Walker Art Center, Minneapolis, with the assistance of Mr. Blasdel and others, in 1974. Possibly as a result of these artists' rejection of the simplicity of industrial and architectural form of the 20th century, much of the work is environmental and embellished with a profuse abundance of decorative elements. One of the most inventive and startling 20th-century environments is the *Watts Towers*. Calvin Trillin in an article in *The New Yorker* in May 1965 described this incredible complex of structures and towers built by Sam Rodia in Watts, California, which was first discussed as a work of art by Jules Langsner in *Arts and Architecture* in July 1951 (Figs. 148a–c). Absorbed in this project from 1921 to 1954, Rodia worked alone to construct the main 90-foot tower and associated spires and structures of cement and found materials to create a gigantic personal fantasy.

The *Throne of the Third Heaven of the Nations Millenium General Assembly,* by James Hampton, is another example of a 20th-century work made as a result of the artist's personal motivation and eccentricities (Pl. 23). Inspired by religious conviction and a belief in the Second Coming of Christ and based upon mystical experiences in which God appeared to him, Hampton began constructing the *Throne* about 1950 in a garage near his home in Washington, D.C., where he worked, until his death in 1964, as a night janitor for the General Services Administration (Fig. 147).

Using found materials and old furniture which he covered with gold and silver foil, Hampton created an environment which he hoped would be used for educational

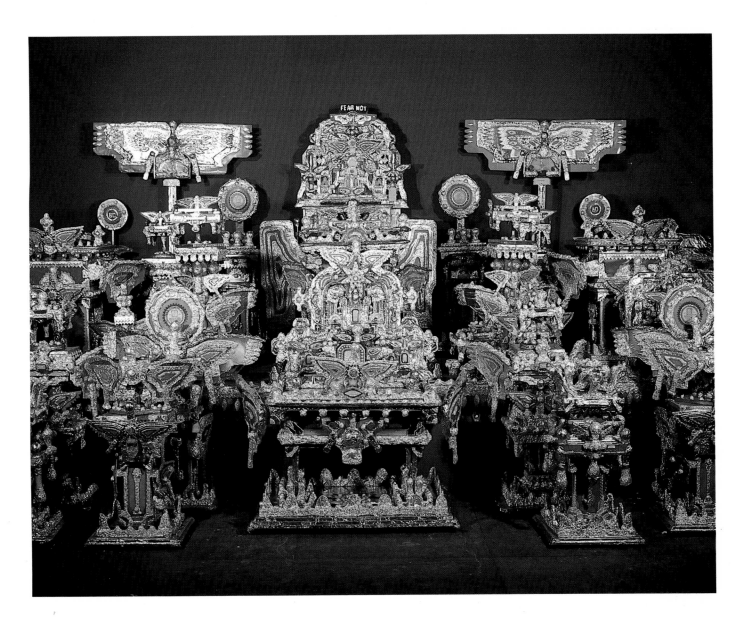

PLATE 23. James Hampton. *Throne of the Third Heaven of the Nations Millenium General Assembly,* c. 1950–64. Wood, glass, metal and other found objects covered with gold and silver foil; 10½ feet x 26 feet, 11 inches x 14½ feet. National Collection of Fine Arts, Smithsonian Institution, Washington, D.C.

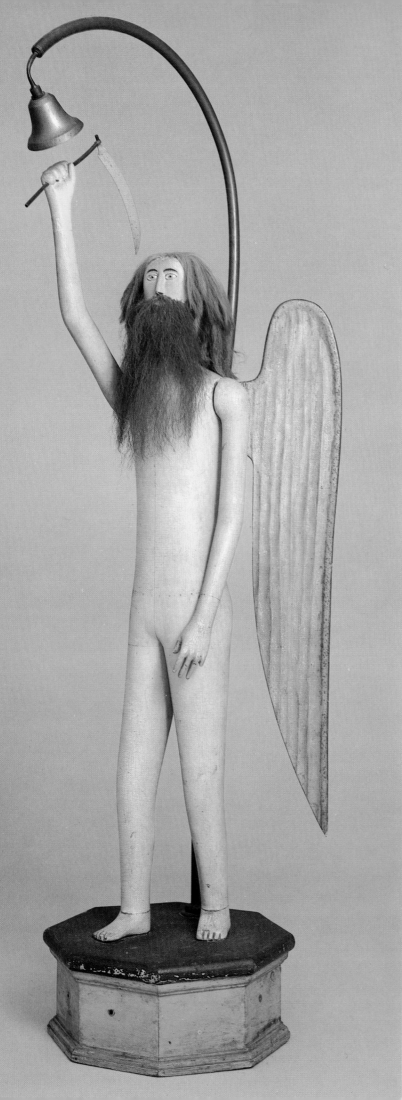

PLATE 24. Unknown artist. *Father Time,* c. 1900, Mohawk Valley, New York. Painted wood, metal, hair; 48 inches high. Museum of American Folk Art, New York.

OPPOSITE: PLATE 25. Samuel A. Robb. *The Baseball Player,* between 1888 and 1903. Inscribed "Robb 114 CENTRE ST. N.Y." Polychromed wood, 85¼ inches high. Heritage Plantation of Sandwich, Massachusetts.

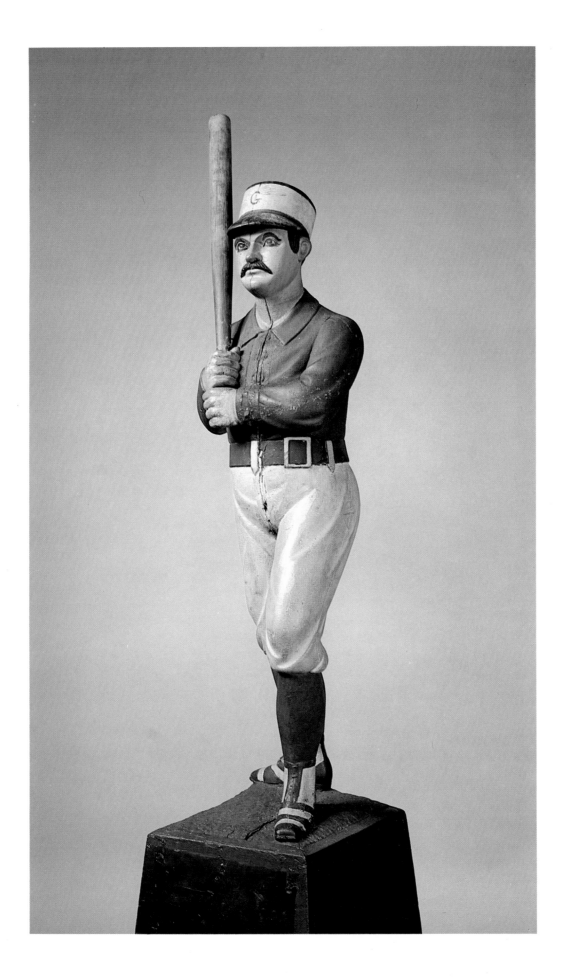

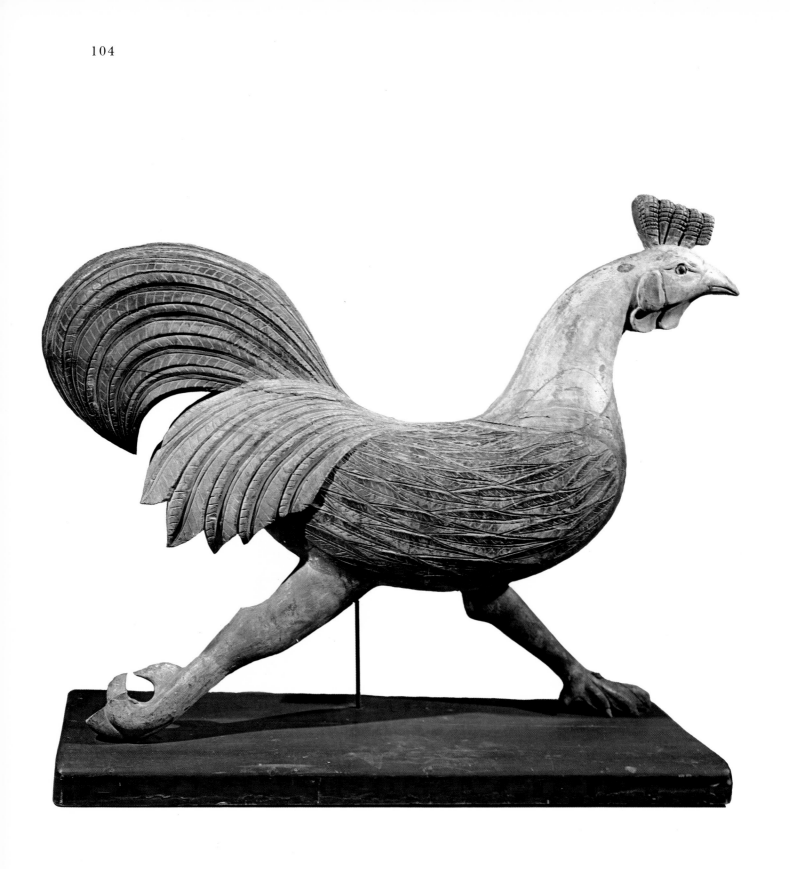

PLATE 26. Edmond Brown. *Carousel Rooster*, c. 1900, St. Johnsbury, Vermont. Polychromed wood, 39 inches high. Collection of Mrs. Joseph Halle Schaffner.

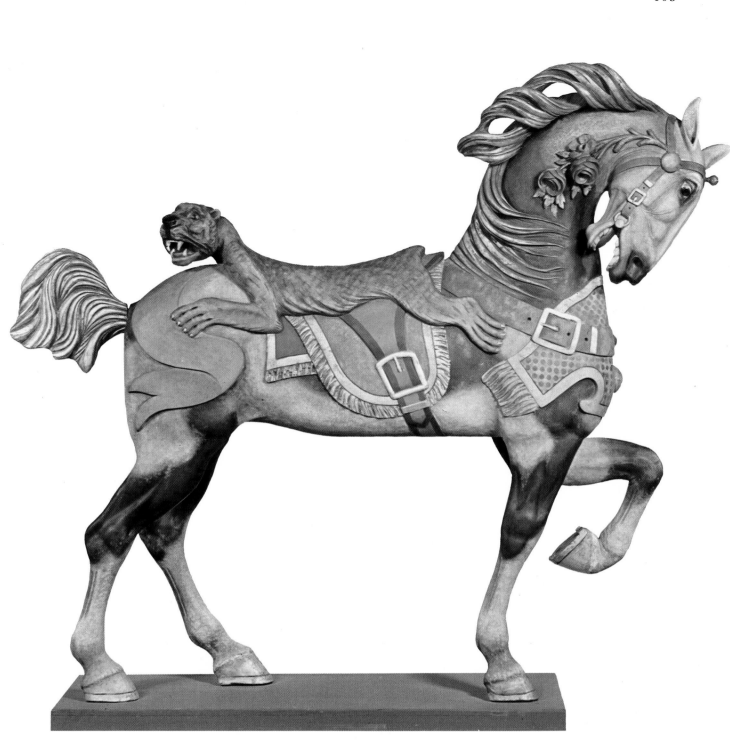

PLATE 27. Stein and Goldstein. *Carousel Horse,* between 1912 and 1916, Brooklyn, New York. Polychromed wood, 71 inches long. The Eleanor and Mabel Van Alstyne American Folk Art Collection; National Museum of History and Technology, Smithsonian Institution, Washington, D.C.

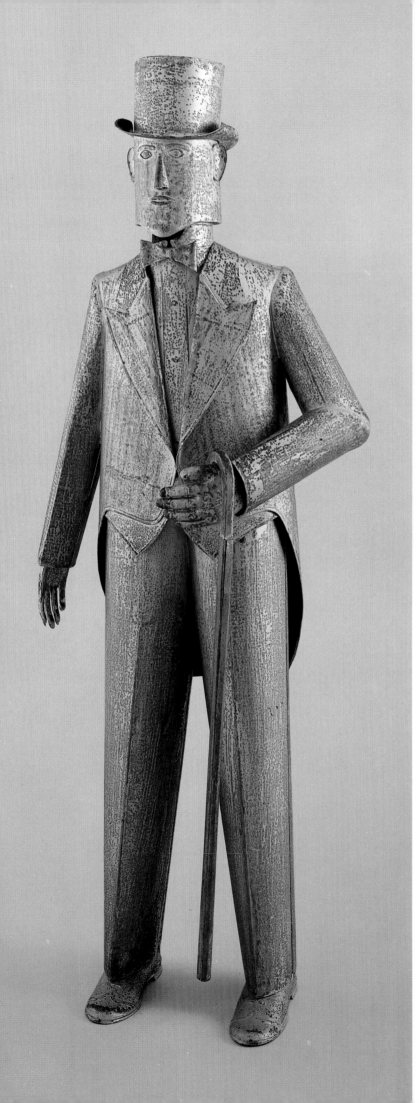

OPPOSITE: PLATE 28. J. Krans (attributed). *Tinsmith*, c. 1895, Brooklyn, New York. Tin, 72 inches high. Collection of Mr. and Mrs. Eugene S. Cooper.

PLATE 29. Edgar Alexander McKillop. *Hippoceros*, c. 1928. Walnut, bone, leather, glass, brass, metal; 58¼ inches long. Abby Aldrich Rockefeller Folk Art Collection, Williamsburg, Virginia.

PLATE 30. Unknown artist. *Thin Indian Chief*, 1850–75, found in Virginia. Polychromed wood, 72¼ inches high. Virginia Museum of Fine Arts, Richmond.

purposes. He used it for solitary services on Sundays, but it did not become widely known until after his death when it was found and acquired by the National Collection of Fine Arts. As a sculptural experience it incorporates reflective materials which give a glittering patina to tables, chairs and pedestals encrusted with elaborate surface decoration of knobs and ornaments made of light bulbs and other found objects covered with gold and silver foil. James Hampton's shining metallic world, arranged symmetrically around the throne prepared for God, was his consuming private experience to which he devoted the last fourteen years of his life.

The tradition which produced the masterworks of American folk art in the 19th century has ended. The works are now appreciated in terms of 20th-century modern art which consciously recognizes many of the same aesthetic criteria intuitively realized by American folk sculptors of the past. As the expression of the people of the country in the 18th and 19th centuries, it surpasses the arts based on foreign traditions which were superimposed upon our developing cultural heritage.

Notes

1. Mary Bartlett Cowdrey, *American Academy of Fine Arts and American Art Union* (New York: The New-York Historical Society, 1953), p. 9.

2. Lois Marie Fink and Joshua C. Taylor, *Academy: The Academic Tradition in American Art* (Washington, D.C.: Smithsonian Institution Press for the National Collection of Fine Arts, 1975), p. 27.

3. Anna Wells Rutledge, *Cumulative Record of Exhibition Catalogues: The Pennsylvania Academy of the Fine Arts, 1807–1870; The Society of Artists, 1800–1814; the Artists' Fund Society, 1835–1845* (Philadelphia: American Philosophical Society, 1955), p. 1.

4. Stuart Davis, Introduction to *Abstract Painting in America* (New York: Whitney Museum of American Art, 1935).

5. Twenty-seven works have been selected for the folk art section of this book, of which at least eight, including *Man with Grapes*, are reproduced in the Index of American Design, now at the National Gallery of Art. Others are: *Belle of Bath, Belle of Oregon, Forest Belle, Ship Chandler's Sign, Baseball Player, Carousel Horse* and *Carousel Rooster*. The Index, compiled between 1935 and 1941 and consisting of over 17,000 watercolor illustrations by artists employed by the federal government for this project, created a new interest in American folk art and drew public attention, for the first time, to religious art of the Southwest. See Clarence P. Hornung, *Treasury of American Design* (New York: Harry N. Abrams, n.d.).

6. Also in 1924, in December, the Dudensing Galleries held an exhibition of folk paintings which included both *Child with Kitten* and *Dover Baby*, owned by Robert Laurent and illustrated as the left and right paintings in the group of three on

Details of *Thin Indian Chief* (see Pl. 30, opposite).

ABOVE AND OPPOSITE: 148a-c. Sam Rodia. *Watts Towers*, 1921–54, Los Angeles. Cement, steel, glass, wood and other found materials; 99½ feet high. Photographs courtesy of Seymour Rosen.

the wall of his living room in *Making Music* by Karfiol (Fig. 119). Guy Eglington in the February 1925 issue of *International Studio* and Deogh Fulton in the March issue illustrated these 19th-century works and dated *Dover Baby* in the 17th century. *Child with Kitten* has recently been attributed to Zebakiah Belknap (1781–1858). See Guy Eglington, "Art and Other Things," *International Studio*, vol. 80 (February 1925), pp. 417–19; also Deogh Fulton, "Cabbages and Kings," *International Studio*, vol. 80 (March 1925), pp. 489–90.

7. Harvard Society for Contemporary Art Inc., *Exhibition of American Folk Painting in Connection with the Massachusetts Tercentenary Celebration* (Cambridge, Mass., 1930).

8. Holger Cahill, Introduction to *American Folk Sculpture: The Work of 18th and 19th Century Craftsmen* (Newark: The Newark Museum, 1931), p. 13.

9. Ibid., p. 18.

10. Dickran and Ann Tashjian, *Memorials for Children of Change* (Middletown, Conn.: Wesleyan University Press, 1974), p. 233.

11. Ibid., pp. 245–46. The epitaph on the gravestone of Polly Coombes reads:

In Memory of
Mifs Polly Coombe^s
of Bellingham; who
expired on y,^e 16.th of
Nov. 1795 in the 25. th
year of her age.

Reader attend: this state
will soon be thine.
Be thou in youthful health
Or in decline;
Prepare to meet thy God

12. The Santeros were largely anonymous until recent studies by the late E. Boyd, published in the book *Popular Arts of Spanish New Mexico* (Santa Fe: Museum of New Mexico Press, 1974). Large groups of santos were examined and grouped on the basis of similarity of style. Descriptive names were applied to the unknown artists, such as the Quill Pen Santero, the Chili Painter, the Master of the Dotted Line, the Santo Niño Santero, etc. Tree-ring dates were taken for many of the retablos to date them and to help substantiate these groupings. Gradually the names of the individual artists became known. Sometimes the clue was a rare signed panel, sometimes an obscure mention in an old church record, and sometimes through oral tradition in a small Southwest town. By now the names of a number of these artists are known, although many remain anonymous.

13. The figure of Christ is jointed at the shoulders so that the arms can be moved. It was originally displayed lying in an open-work coffin and on Good Fridays mounted on a Cross. In 1944 it was permanently attached to the Cross and the coffin is now exhibited separately. The back of the figure contains a large opening representing a wound, in which a heart with a human face is suspended.

14. In New Mexican interpretations of the triumph of death, the Death Angel was frequently conceived as a female figure, as in this example, and known as La Doña Sebastiana or La Muerta. See Robert Stroessner and Cile M. Bach, *Santos of the Southwest: The Denver Art Museum Collection* (Denver, 1970), pp. 52–53; also Boyd, op. cit., pp. 462–64.

15. No documentation has been found substantiating the existence of the ship *American Indian*. The sternboard was first illus-

trated by Pauline A. Pinckney in *American Figureheads and Their Carvers* (New York: W. W. Norton & Company, 1940), Pl. xxvi and p. 100. She attributed it to an American ship, built about 1785 on the North River in Plymouth County, Massachusetts. The piece was at one time in the collection of William Randolph Hearst. The Shelburne Museum acquired it through Edith Halpert from Robert Carlen of Philadelphia.

16. From the Colonial period through the end of the Revolution, the symbol most often used to personify the American Colonies was an Indian princess, frequently depicted with bow and arrow. See E. McClung Fleming, "The American Image as Indian Princess," *Winterthur Portfolio*, II (1965), pp. 65–81; also Ellwood Parry, *The Image of the Indian and the Black Man in American Art, 1590–1900* (New York: George Braziller, 1974), pp. 68–69.

17. Benjamin A. Hewitt, "Simeon Skillin's 'The Spirit of America'," *The Mabel Brady Garvan Galleries: American Arts and the American Experience* (New Haven, Conn.: Yale University, 1973), pp. 24–25.

18. Wayne Craven, *Sculpture in America* (New York: Thomas Y. Crowell Company, 1968), pp. 13, 36.

19. The ship *Belle of Bath* exploded and sank at sea on route to Hong Kong on June 30, 1897. The figurehead has always been reproduced from an Index of American Design watercolor illustration derived from a photograph (see n. 5). The figurehead *Western Belle*, in the collection of the Peabody Museum of Salem, Massachusetts, is illustrated as Fig. 75 in M. V. Brewington, *Shipcarvers of North America* (Barre, Mass.: Barre Publishing Company, 1962).

20. I am grateful to Nathan Lipfert, Assistant Curator, Bath Marine Museum, for drawing my attention to the figurehead in the Oregon Historical Society, and to Ron Brentano, Curator, Oregon Historical Society, for providing additional information about its history. It is thought that this figurehead came from the ship *Forest Belle,* built in Bath, Maine, in 1877. On its first voyage to Hong Kong the ship ran aground in Kwanlang Bay, Formosa, and a few days later was set on fire by a band of Chinese. The figurehead is said to have floated ashore, where it was picked up and shipped back to the United States. However, Mr. Lipfert believes that the figurehead from the *Forest Belle* was not this example but probably an Indian maiden. Since the figurehead's original location is uncertain, I prefer to think of it as the "Wayward Belle."

21. Nadelman, who came to the United States from Europe in 1914, was one of the most enthusiastic early collectors of folk art, both European and American. Between 1924 and 1926 he and his wife built a museum on their estate in Riverdale, which was later opened to the public. Their collection eventually comprised as many as 15,000 objects, including the figure of Harry Howard (Pl. 22). In 1935, because of financial difficulties stemming from the Depression, the Nadelmans decided to sell their collection, hoping it would be kept intact. This proved impossible, and in 1937 it was dispersed, the majority of the works going to the New-York Historical Society and the Abby Aldrich Rockefeller Folk Art Collection in Williamsburg. See Mr. and Mrs. G. Glen Gould, "The Nadelman Ship Figureheads," *International Studio*, vol. 94 (September 1929), pp. 51–53; also "New York: Folk Art Purchased by the New-York Historical Society," *Art News*, vol. 36 (February 5, 1938), p. 17. For a more extensive bibliography see Lincoln Kirstein, *Elie Nadelman* (New York: The Eakins Press, 1973), p. 328.

Statues to Sculpture

From the Nineties to the Thirties

Daniel Robbins

UNDERSTANDING THE COURSE of sculpture in America from the Civil War until after the First World War requires an awareness of the sculptor's conception of his calling, a sentiment paralleling the popular but nonprofessional identification of sculpture as statuary. In 1923, when Adeline Adams, wife of the successful turn-of-the-century sculptor Herbert Adams, wrote, "the sculptor's masterpiece must be able to resist the spiritual wear and tear of the market place of the world's opinion,"[1] she was not yet so much disturbed by new "weird works" or "the new spirit of expressionism"[2] as she was confident that the societal definition of sculpture as an expression of national need and purpose would endure. The identification of sculpture with American ideals and history found formal endorsement in 1864, when legislation introduced by Justin Smith Morrill of Strafford, Vermont, a founder of the Republican party, transformed the old chamber of the U.S. House of Representatives into the National Hall of Statuary (Fig. 149).

It was no coincidence that this legislative act, in a small way responsive to years of lobbying by American sculptors, was passed when Hiram Powers of Vermont was still enjoying international fame, the first American sculptor to achieve such recognition. Furthermore, the opportunity to determine the function of the old chamber of representatives was a consequence of the advancement of the architectural program of the Capitol in

Washington, an example of the practical link between architecture and sculpture that remained a cardinal influence on the development of sculpture through, and even after, the First World War. Sculptors depended on the favor of architects for commissions, which, in addition to providing the sculptor with his livelihood, also shaped his reputation. Most important commissions were public: for civil government, either state or national, for Washington, for a state capitol, for a federal building, for a square or park that required a commemorative statue, or for world's fairs or other public pageants that celebrated moments regarded as solemn and crucial in the unfolding history of the Republic. Such commissions, representing official endorsement, were inevitably statues, or groups of statues, not merely because sculpture separate from figural representation had not yet been invented, but also because the values that American society wished to enshrine could not be visualized in any other way. Only professional sculptors used the term "sculpture" for their work. Architects, legislators, patrons and public alike referred to sculpture as statues.

The history of American sculpture through the early years of the 20th century is inseparable from ideas concerning sculpture's purpose or destination: consequently it is deeply involved in questions of patronage. Unlike painting, which could tolerate individual eccentricities, sculpture remained a public art. Even architecture, because it was regarded more as a functional necessity than an art, allowed for more variation and individual expression, had more room in which to express itself, than sculpture. Architecture was at once both public and private, answering private requirements for living that

OPPOSITE: Jo Davidson working on portrait of Gertrude Stein, Paris, 1920. Photograph by Man Ray, dated 1926. Collection of Arnold H. Crane. (See Fig. 188.)

sometimes included strange spaces or embellishments. Since the builder of a house was often its owner, private architecture (even into the beginning of this century and especially in rural areas) united patron and artist. But in sculpture, which theoretically occupies a territory somewhere between fulfilling the public demands expected of architecture and following the independence of easel pictures, only the folk carver or whittler escaped the intense pressures that defined the high purposes and, consequently, dictated the appearance of the work.

A definition of the function of sculpture was slow to develop because the United States, from the Revolution to the Civil War, had more pressing needs than the deliberate physical manifestation of its new culture. After the Civil War, however, public sculpture was increasingly in demand; and, although the World's Columbian Exposition held in Chicago in 1893 marks a highpoint in the professional sculptor's satisfaction in the knowledge that his services were, and would continue to be, needed, the next forty years saw a plateau of activity maintained and even heightened. Despite the general acclaim accorded to the sculptural program (led by Saint-Gaudens) of the Chicago Exposition, the sculptors of the United States organized into an association, the National Sculpture Society, "to spread the knowledge of good sculpture; foster the taste for, and encourage the production of, ideal sculpture for the household and museums."[3] Although the Sculpture Society had other important aims, and cer-

149. Benjamin Henry Latrobe, architect. National Hall of Statuary, Washington, D.C. From 1819 to 1857 this was the chamber of the House of Representatives. Photograph courtesy of the Architect of the Capitol.

150. Daniel Chester French. *Republic*, 1892, World's Columbian Exposition, Chicago, 1893. Gilded plaster, 64 feet high, destroyed.

tainly expected to "promote the decoration of public and other buildings, squares and parks with sculpture of a high class," the professionals were impelled to organize by their dim realization of the peculiar consequences arising from the public view of sculpture. All of them chafed under the disadvantages of sculpture. Charles de Kay, art editor of the *New York Times* and one of the principal organizers of the Sculpture Society, wrote, in his letter inviting John Quincy Adams Ward (the first President of the Society) to attend the initial organizational meeting, that "annual exhibitions neither provide properly for sculpture nor secure a fair showing thereof. Moreover, the people who buy art objects rarely buy sculpture not being educated to understand it."[4]

The following four decades belong to the National Sculpture Society, whose members, ranging from Saint-Gaudens to de Creeft, were the most important sculptors at work in the country: those who consistently secured the best, most visible and richest commissions. Their first organizational aim, however, was not achieved. They did not succeed in educating people to acquire sculpture for household use. The reason they failed (and indeed the reason they eventually came to be regarded as a moribund society) had to do with the idealistic definition of sculpture that prevailed in 1893, a definition that no founding member of the society would have questioned. Their goal was to put ideal sculpture into houses and museums, that is, to make new patrons buy the kind of art they made. But the sculpture they made could not easily be accommodated by private citizens; and the museums — then just beginning, although on the whole sympathetic — felt a more urgent obligation to concentrate on the art of the past.

Daniel Chester French's colossal statue of 1892, *Re-*

FAR LEFT: 151. Adolph A. Weinman. *The Descending Night* (also called *The Setting Sun*), n.d. Bronze, 55¼ inches high. Designed as a fountain figure for the Panama-Pacific International Exposition, San Francisco 1915. Krannert Art Museum, University of Illinois, Urbana-Champaign.

LEFT: 152. Adolph A. Weinman. *The Rising Day*, n.d. Bronze, 57½ inches high. Designed as a fountain figure for the Panama-Pacific International Exposition, San Francisco, 1915. Krannert Art Museum, University of Illinois, Urbana-Champaign.

public, epitomized all that was then demanded of great sculpture (Fig. 150). Towering as high or higher than the neoclassic palaces of the Columbian Exposition, the Republic *was* Columbia, an embodiment of lofty virtue, noble idealism and familiar symbolism. Columbia stood surrounded by the waters of Olmsted's lagoon as the United States was insulated by oceans; the virtues that she, and her sisters and brothers in front or on top of the palaces of Mechanic Art or Agriculture, embodied were widely regarded as uniquely American. But it would have been asking too much from even private citizen Cornelius Vanderbilt II to have such a statue installed on the grounds of his cottage at Newport. Thirty years later, searching for an expression that would characterize the high quality of the sculpture of Ward, French and Saint-Gaudens, Adeline Adams used the term "moral earnestness."[5] She could not think in terms other than those of the monumental and public. The integrity of the American Republic was identified with the genius of the artist who could express the moral spirit of the country. However improbable it seems to us, as late as 1923 "the very foundation of artistic conscience" was "moral earnestness," an attempt to express in statuary the self-conscious and, one may add, widely appreciated qualities of America. The art criticism of the late 19th and early 20th century, although familiar with notions of influence and on easy terms with formal properties of balance, texture, movement and the like, nevertheless preferred to go directly to what it regarded as the heart of the matter: that is, the degree to which the work of sculpture penetrated the spiritual values that were ideal for the age. No art was so identified with spiritual values (and spiritual values were seldom so identified with government) as sculpture in post–Civil War America. The period from the first Chicago fair through the 1920s was the time when most of the public sculpture conceived in

the spirit of Justin Morrill's Hall of Statuary was executed; it was also the time of the decay of the very values, aesthetic and ethical, that American sculptors trained at the end of the 19th century took as axiomatic. Just as very few Americans questioned the legitimacy of celebrating General Thomas, or Admiral Farragut, or General Burnside, or the sense of participating in a historical adventure the outcome of which would be inevitably glorious because of total confidence in the superiority of democratic government, so sculptors, architects and patrons felt there was endless work to do in translating each rich historical incident, each incandescent personality into stone or bronze. Statesmen, generals and admirals, ordinary soldiers and sailors were succeeded by businessmen, immigrants, labor leaders, and finally by popular heroes, firemen and sports figures. In New York, the work of such sculptors as Frederick MacMonnies, French, Chester Beach, A. Phimister Proctor, Karl Bitter, Adolph A. Weinman, Herbert Adams, Attilio Piccirilli, Henry Merwin Shrady, Hermon A. MacNeil, Victor D. Brenner, George E. Bissell, Frederic W. Ruckstull, Charles H. Niehaus, Philip Martiny, George Grey Barnard, Anna Hyatt Huntington, Paul Bartlett, A. Stirling Calder, James Earle Fraser and a dozen more great names from the roster of the National Sculpture Society dominated buildings and public places through the 1920s. Similar public manifestations took place all over America, and the high tide of sculptural activity at the turn of the century in Washington, Philadelphia and Boston is punctuated in other regions by the exuberant world's fairs and their programs: Buffalo in 1901, St. Louis in 1904 and San Francisco in 1915 (Figs. 151, 152). These fairs, as the first Centennial itself and as all the European, particularly the French, exemplars had demonstrated, also provided sculptors with the opportunity for work and the chance to establish reputations.

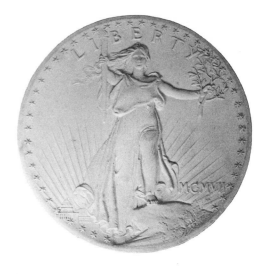

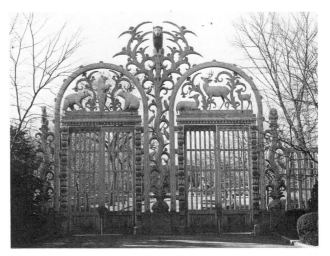

ABOVE LEFT: 153. Dewey Arch, 1899, now destroyed. View of columns and arch looking north on Fifth Avenue at Madison Square, New York. The dedication of the Arch celebrated Admiral George Dewey's victory at Manila Bay in 1898. Photograph courtesy of The New-York Historical Society.

ABOVE RIGHT: 154. Augustus Saint-Gaudens. Cast of $20 gold piece, *Standing Liberty*, 1905–7. Plaster, 12 inches in diameter. U.S. Department of the Interior, National Park Service; Saint-Gaudens National Historic Site, Cornish, New Hampshire.

RIGHT: 155. Paul Manship. *Paul J. Rainey Memorial Gate*, 1933. Bronze, 42 x 36 feet. New York Zoological Society.

BELOW: 156. Karl Bitter. *Pomona*. Bronze, 7¾ feet high. Statue surmounts the *Pulitzer Fountain*, designed by Thomas Hastings, completed in 1916. Grand Army Plaza, New York. Home of Cornelius Vanderbilt II, at Fifth Avenue and 58th Street, seen behind the fountain.

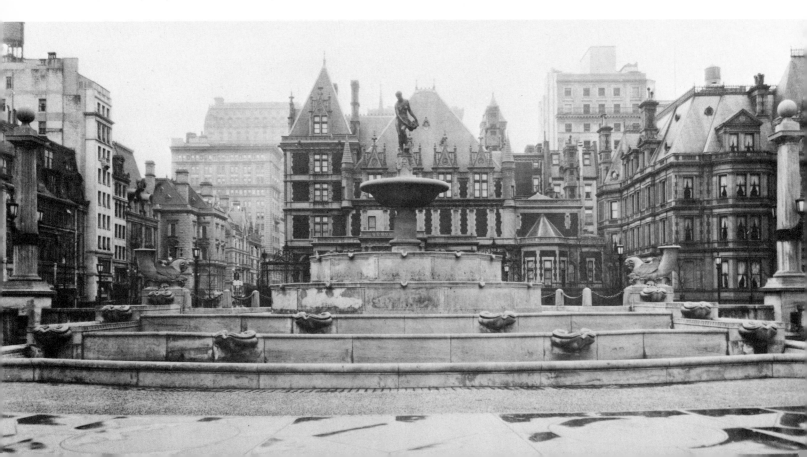

The fairs or fetes (like the Dewey Arch, 1899) enabled untried talent to come to public attention; but in order to secure a position working up the giant projects conceived by patrons and architects, young sculptors found it advantageous to be apprenticed to established figures (Fig. 153). Therefore, for a time in American sculpture, at the end of the 19th century and well into the 20th, an apprenticeship program existed that was more akin to the atelier systems of earlier centuries than still existed in any other art or, indeed, in any other modern nation. The pedigree obtained by the master-pupil relationship continued on well into the 1930s, when to be a grand-pupil of the great Saint-Gaudens was still a significant factor in the award of public commissions. Saint-Gaudens, who died in 1907, had as apprentices MacMonnies, Fraser, Weinman, Martiny and Proctor. Of these, Martiny was the master of Hermon MacNeil, and MacNeil was the master of Jo Davidson; Proctor, the great animal sculptor, employed Lee Lawrie, whose *Atlas* at Rockefeller Center is known to almost every New Yorker and visitor. In another lineage, Paul Manship, a pupil of Isidore Konti, employed Gaston Lachaise and Reuben Nakian for many years. This system of apprentices and assistants, many of whom gradually rose to prominence, only began to fade after the First World War and did not die until after the Second.

Fueled by the social idealism that made sculpture identical with statues, it was not hard for sculptors to find or invent subjects. In every important public building — from library to railroad station (Library of Congress, 1897; Pennsylvania Station, 1910), bridges (the Manhattan Bridge, 1916), parks, zoos (Fig. 155), wherever the people were to congregate — there must be monuments to the accomplishments and ideals of American democracy. In New York and in Philadelphia, Boston, Chicago and St. Louis, and finally on the West Coast, monuments continued to be inspired by Lincoln and the Grand Army. Seemingly endless rows of the great men and women of all time were needed: Old Testament Prophets, lawgivers from antiquity, classical poets, Renaissance artists, allegories of continents, of time, of fame, of truth, of justice, of integrity, of commerce and industry, of medicine, of navigation, of the seasons, of victory, of peace (Fig. 156). Despite the effect, suggesting a centralized government agency given the responsibility of a didactic or uplifting art, these statues were the results of a laissez-faire society whose patrons — private citizens though they were — had as much pride as they had stake in a free government. If the continuous development of the outdoor sculpture at Washington seems to have more order to it than that in other cities, it is mainly because of the clarity of L'Enfant's master plan for that city.[6]

Absurd though it seems, a good case can be made for turn-of-the-century sculpture as a war industry. At this high period of activity, coincident with the neo-imperialism of Teddy Roosevelt, sculptors may have wondered privately, as Mrs. Adams did only in 1923, what would happen if the nation had no more battles to commemorate? Could the United States run out of great men and women? Perhaps not. Yet the spirit of moral earnestness, that naïve and optimistic but singularly American idealism that shaped the definition of sculpture up to the First World War, began to wane. The most obvious symptom of the societal change that allowed a new kind of sculpture to develop is the fact that so many war memorials after the first European conflict took the form of buildings or parks instead of statues.

It is a piety of art history to ascribe to the Armory Show of 1913 a paramount role in changing the course of American painting. Certainly the effects of European modernism were evident in painting much sooner than in sculpture, probably for the same reasons dimly perceived by the National Sculpture Society when it was founded: that sculpture was not so widely patronized, cost more, took longer to make and, finally, allowed for comparatively little individual expression. The Sculpture Society had accomplished much by coordinating public and quasi-public projects. One of its great triumphs occurred in 1907 when the government turned to professional sculptors for the creation of coins, the gold pieces of Saint-Gaudens (Fig. 154), the Buffalo nickel of Fraser (1913), the Mercury dime of Weinman (1916), the Liberty quarter of MacNeil (1916). However, the attempt to educate the art patron to incorporate small ideal sculpture into his home was less successful.

For American sculptors, the Armory Show passed with hardly a ripple of interest. Platoons were already beginning work on the program initially conceived by Karl Bitter, and carried out under the supervision of A. Stirling Calder, for the 1915 San Francisco Panama-Pacific International Exposition (Pl. 32). Working harmoniously with architects like Kelham and Bernard Maybeck of San Francisco, McKim, Mead and White, Thomas Hastings, and Henry Bacon of New York, the most prominent sculptors (as well as many ambitious newcomers including numerous immigrants) were often represented with colossal works. These were made of artificial travertine, the latest improvement on staff — a plaster and hemp fiber mixture developed by the French — for temporary exhibition palaces. It is important to stress that these sculptors regarded themselves as modern and that they were so regarded by a preponderance of the American art world. The only exception was a tiny group of artists — mostly painters — who had had firsthand experience with contemporary European avant-garde art. It is useless to search among the names of the 45 sculptors at the San

Francisco Exposition for the men considered today the modernists of the period: Gaston Lachaise or Elie Nadelman, John Storrs or Robert Laurent.

One of the young sculptors who was much praised and whose reputation was made at San Francisco was Robert I. Aitken, whose *Fountain of the Earth,* a descendant of MacMonnies's Columbian fountain of 1893, was declared by Stirling Calder "deeply interpretative of the trend of modern thought" (Fig. 159). The *Fountain* employed modern techniques of artificial illumination, using jets of steam to give the effect of the earth swimming out of chaos. Furthermore, its heavy relief panels dealt with daringly modern themes: natural selection and the survival of the fittest; elemental emotions, including "sexual love and physical parenthood without enlightenment" (Fig. 158). Ten years before the Scopes "Monkey" trial, to deal with Darwinism in public sculpture was perhaps modern and daring, yet our chief interest in Aitken is the fact that years later it was he, not Gaston Lachaise, who won a major commission for the American Telephone and Telegraph Company building in New York.

The centerpiece for the San Francisco fair was Stirling Calder's *Fountain of Energy,* a work even more revealing of the sculptor trying to cope with modern needs and to adjust his conception to the greater purpose of the American accomplishment that was being celebrated. Stirling Calder was enormously gifted and his huge sculpture was a marvel of daring balance and bold conception (Pl. 31). Like the best of the sculptors whose work he managed to oversee, he was preoccupied with formal concerns, with the knowing use of form and movement to achieve an end, and like almost all American sculptors he believed ardently in the values that he sought to embody. These were important because they were public, and hence particularly suited to expression in sculpture. "Energy, Lord of the Isthmian Way . . . the power of the future, the superman, approaches. Twin inspirations, the two sexes to denote the dual nature of man — urge him onward, contacting human energy with divine.[7] Note the steadiness of the central figure, sense of firmness and security, despite the motion of the whole. This is due to the hold of the feet upon the stirrups, and the weight of the body in the saddle"[8] (Fig. 157).

Calder dealing with energy, Aitken dealing with evolution, Gertrude Whitney dealing with the race of life, all continued to believe a credo that had been enunciated clearly more than fifty years earlier by Erastus Dow Palmer: "The mission of the sculptor's art, is not to imitate forms alone, but through them to reveal the purest and best of our nature. And no work in sculpture, however well wrought out physically, results in excellence,

157. A. Stirling Calder. Study for figures on top of the *Fountain of Energy,* 1915. Panama-Pacific International Exposition, San Francisco. Present location of study unknown. (See Pl. 31.)

BELOW: 158. Robert I. Aitken. Panel from *Fountain of the Earth (Survival of the Fittest),* 1915. Artificial travertine. Panama-Pacific International Exposition, San Francisco.

BOTTOM: 159. Robert I. Aitken. *Fountain of the Earth,* 1915. Artificial travertine. Shown in the central pool of the Court of Abundance, Panama-Pacific International Exposition, San Francisco.

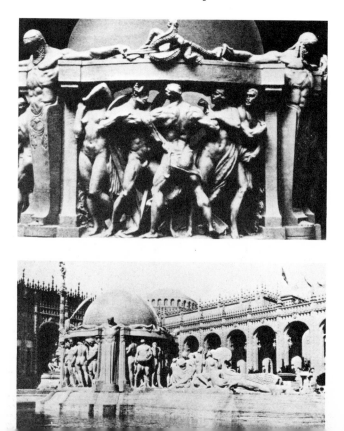

unless it rests upon, and is sustained by the dignity of a moral or intellectual intention." [9]

Palmer's definition for ideal sculpture had remained surprisingly current for more than fifty years; it had endured through the major changes in style, technique and attitude toward material that had occurred about 1875: the ascendancy of bronze over marble, of modeling over carving. At the end of the 19th century, and in the early 20th, even the American sculptors regarded as rebels or radicals continued to conceive of sculpture in much the same way as Palmer had. Their most intense differences concerned the nature of man; that is, they resolved to put into sculpture their individual philosophical speculation. The leader in the movement of purification was George Grey Barnard, and it is of some importance that Barnard's singular idealism, strength of character, and his rejection of what he regarded as the easy path of familiar symbolism (so seductive and self-justifying for those who created public art) led not only to highly personal interpretations of lofty aspirations but also to a view of technique as a symbol of content, a re-engagement of stonecutting as a favored technique. The question of integrity, aesthetic and moral, was posed afresh in Barnard's *Struggle of the Two Natures in Man*, 1894, huge, carefully planned, cut from a single block of marble (Fig. 160). The personal effort of cutting the marble

was heroic, and as hard work by hand already pointed to human salvation in post-Ruskinian thought, it constituted a rallying cry for the young idealists in the American Arts and Crafts movement. Barnard attracted some of the most vibrant and ambitious young students at the Art Students League, where he taught at the turn of the century.

As late as 1927, when Jacob Epstein (who had lived in England since 1905, yet was regarded as the leading apostle of bearable modernism by American art authorities) came to New York to testify at the Brancusi trial, he declared, "George Barnard is the most important American sculptor of the day." [10] Epstein called Barnard's *Two Natures* "stupendous"; he also regarded William Zorach as very fine. Although he was willing to admit that American sculpture was, on the whole, better than English, he nevertheless declared that he could see "no school that can be classified as American" in the sense of architecture or literature. This was strange news to the members of the National Sculpture Society and their apologists who regarded the period from Saint-Gaudens forward as "The Golden Age of American Sculpture." [11]

Around 1900, however, when a flavor of Art Nouveau touched his style, and even in his later works for the State Capitol at Harrisburg (1902–10), Barnard was only faintly symptomatic of the slow breakdown and recon-

BELOW: 160. George Grey Barnard. *Struggle of the Two Natures in Man*, 1894. Marble, 101½ inches high. The Metropolitan Museum of Art, New York; Gift of Alfred Corning Clark, 1896.

RIGHT: 161. George Grey Barnard. *Grief*, n.d. Marble, 47 inches high. The Metropolitan Museum of Art, New York; Gift of Mrs. Stephen C. Clark, 1967.

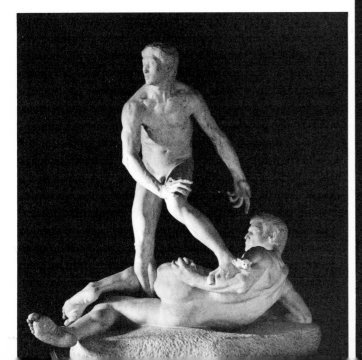

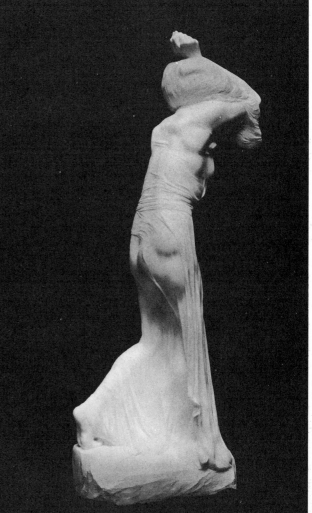

stitution of sculptural values that finally began to occur in America only after the First World War (Fig. 161). The most notable development, the first serious challenge to the dominance of the Beaux-Arts style, was a sweeping, worldwide passion for direct carving of stone, marble and wood, a complex phenomenon that is usually referred to as the aesthetic of materials (Pl. 34). In the United States it began slowly, even before the Armory Show, with the carving of the young French immigrant Robert Laurent. With William Zorach's work of the early 1920s, it took firm root. By the 1930s, the notion of direct carving was the dominant idea of modernism and it continued well into the 1940s despite the development of new techniques. At first it was a theoretical and technical argument between proponents of cutting directly into a material and modeling in clay (Fig. 163). In the days before assemblage, before the welding that Gonzalez had pioneered and Picasso adapted, there were only

162. Attilio Piccirilli. *National Maine Monument,* 1913. 63⅓ feet high (overall). Columbus Circle, New York. The architect was H. VanBuren Magonigle. Photograph courtesy of the Museum of the City of New York.

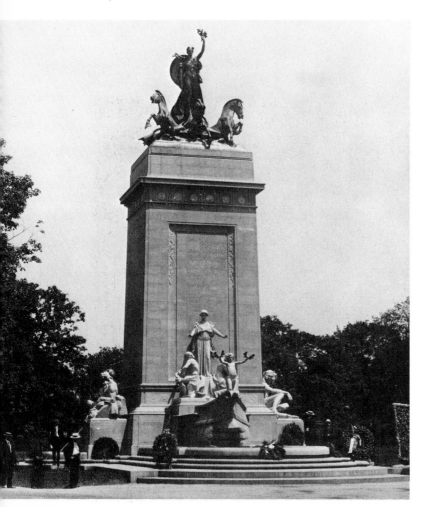

two ways of making sculpture: either modeling from a soft material, usually clay, or carving from a hard one, often rock or wood. The theoretical argument between modeling versus carving reduced to an additive as opposed to a subtractive approach to form. Theoreticians of the twenties and early thirties all over the world saw the whole history of sculpture in these terms; for example, they would include assemblage as additive, related to modeling not carving![12]

The argument between the two methods, which modernists of the 1920s and 1930s believed would be settled in favor of carving, was a restatement of the dispute that had occurred when the expatriate New England sculptors who had made a colony in Rome before 1850 yielded to the Beaux-Arts tradition in Paris. Mid-nineteenth-century sculptors like Powers and Palmer regarded themselves as intellectuals, as thinkers concerned primarily with spiritual values. After conceiving and modeling an idea, they turned the translation of it over to technicians, whose work was then considered a lower level of activity in the hierarchy of art production. Italy was rich in stonemasons and the American consumption of such skilled labor — peasants adept at using the pointing instrument to render mind into matter — was surely the reason that led the Piccirilli family to settle in New York; there Attilio and his five brothers created many monuments (notably the *National Maine Monument* and the *Firemen's Memorial*) and assisted on countless more (Fig. 162). For the men of 1850 the eternity of an idea demanded marble. Just as idea was pure form, so its manifestation — even if only an approximation — gained in value if it would endure and could be linked with antiquity. The rebels of Saint-Gaudens's generation felt that the idea, whatever it was, suffered in translation from personal, even spontaneous, modeling to impersonal laborious carving. Impressed with the vitality and immediacy of the French tradition, sensing in it a suitability for those elements of realism favored by American patrons and public — button holes, boots, baggy pants and heavy seams — they shifted to France and her bronze foundries (see Wayne Craven, "Images of a Nation in Wood, Marble and Bronze," p. 47). Another practical advantage of bronze was that the original model was capable of almost endless reproduction, so that an edition could be made if the work proved to be popular (or if a market could be developed). The bronze sculptors who followed Saint-Gaudens, however, did not dispense with studio assistants; indeed, the assistants in a successful studio were more than ever required to enlarge, to contract, to rework, to finish.

So thoroughgoing was this studio system, and so elaborate in process (the surface treatment of bronze had become almost rococo, especially in the hands of MacMon-

nies), that the advocates of direct carving took up the
idea of truth-to-material with a sense of religious devo-
tion, as if it had never occurred before. After Laurent,
who learned the technique in France, and Zorach (Pl.
33), who exerted the greatest influence and was the most
articulate spokesman for the movement, came a host of
Europeans including Heinz Warneke, Henry Kreis, Carl
Schmitz and José de Creeft(Fig. 165). This aesthetic left
wing of sculpture was the source and example for Chaim
Gross (Fig. 164), the chief proponent of carving to
emerge in the decade of the 1930s, as well as for Ahron
Ben-Shmuel, Richard Davis, John Hovannes; and it had
a profound effect on the powerful abstract sculptor Raoul
Hague. To these artists, carving established a symbiotic
relationship with the material, whether wood or stone,

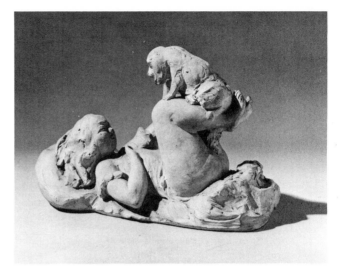

ABOVE: 163. Reuben Nakian. *The Lap Dog*, 1927. Terra-cotta, 10½
inches long. Whitney Museum of American Art, New York.

LEFT: 164. Chaim Gross. *Strong Woman (Acrobat)*, 1935. Lignum
vitae, 48¼ inches high. Hirshhorn Museum and Sculpture Garden,
Smithsonian Institution, Washington, D.C.

BELOW: 165. José de Creeft. *The Cloud*, 1939. Greenstone, 13½
inches high. Whitney Museum of American Art, New York.

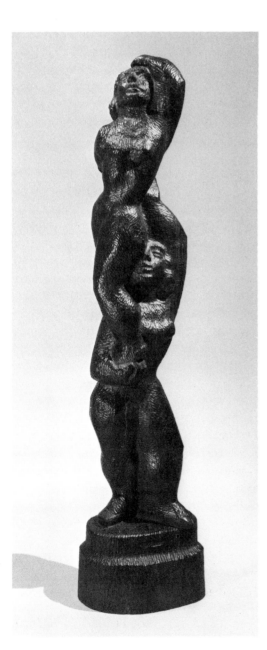

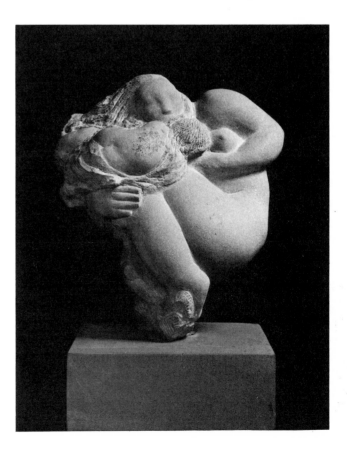

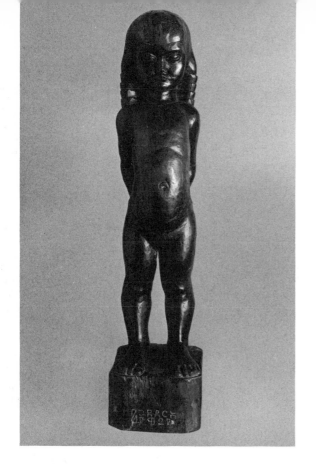

166. William Zorach. *Figure of a Child,* 1921. Mahogany, 23 inches high. Whitney Museum of American Art, New York; Gift of Dr. and Mrs. Edward J. Kempf.

167. William Zorach. *Torso,* 1932. Labrador granite, 33 inches high. Collection of the Sara Roby Foundation, New York.

and they even admitted that the total design was dependent on the mass of the material. To accept the dictates of limestone or wood was to yield to a discipline presumed to be inherent in material itself (Pl. 37). It followed that no carver could have assistants significantly involved in the work; that the sculpture would slowly take shape from a dialogue between artist and material; that imitative naturalism would inevitably decline as material itself — almost organically — rejected the contorted, manipulated activity that the previous generation had frozen in bronze.

The sculptor's image of himself also changed. The idea that he was primarily a thinker, even a philosopher, vanished; he became a worker who found realization through the process of his art. The tools of carving became identified with the sculptor, and inspiration was sought and found, not only in the anonymous work of the medieval carver but in all work called primitive. A wonderful, or perhaps wondrous, rapprochement was created between the romantic image of Michelangelo freeing the slave from the block (by responding to the limitations of the material), the stone carvers of the 12th century and the African and Pre-Columbian sculpture just then (1920s) beginning to achieve recognition beyond the narrow circle, first, of ethnologists and, second, of modern painters (Fig. 166). Along with this workmanlike attitude toward the craft of sculpture, there also developed the belief that great art could be immediately recognized by the untutored, that is, by the mass of the people. The identification of the modern artist, modern because of his attitude toward material, with the anonymous carver of Romanesque times or of Africa, was also a code for his frequent association with the left wing in politics. This accelerated the decline of the old Beaux-Arts symbolism, but it did not assist in the creation of a new one.

In the 1930s, when the aesthetic of materials was the cutting edge of self-conscious modernism in the United States, it was hotly debated whether Laurent, Zorach or de Creeft had first developed the technique (Fig. 167). This debate should not obscure the fact that direct carving was a worldwide reaction that had begun in Europe, in large measure in reaction to Rodin. Bartholomé's attempt to simplify French art, his carving in local limestone when some of Rodin's bronzes were being carved by assistants into marble, had initiated a rite of purification,[13] soon followed by all those European sculptors who were struggling to escape the overwhelming effect of Rodin's personality.

On the eve of the First World War, a new and popular (indeed a people's) style appeared to be in the ascendancy everywhere. Furthermore, very apparent to the Europeans (who were prepared to agree that their sculpture had not changed very much since Donatello) was the fact

that national schools had ceased to have much signif-
icance. While sculpture had become truly international
in Europe, America was still enjoying, however briefly,
the notion that it had succeeded in forging a national
style. It was not about to give up such a precious accom-
plishment without a fight. This unconscious decision
retarded the history of our sculpture up to the Second
World War, even though the premise that a national
style of sculpture existed was of doubtful validity.

By 1929, even though carved sculpture could hardly be
called dominant in the United States, reference to the
aesthetic of materials colored all serious criticism and
history. Medium is "the watchword today," wrote Agnes
Rindge,[14] but to the "glyptic" quality of stone was coun-
terposed the almost equally valid "ductile" quality of
metal. According to such evenhanded, nonpartisan at-
tempts to assess sculpture, the greatest sin was to mix the
manners — to conceive a work in clay intending that it be
pointed up into a large, carved piece. It was "cheating,"
for example, to produce transient effects of light or frozen
motion in so solid a medium as marble. Searching in his-
tory for constants, Rindge came down on the side of
carving. The "cardinal virtues of sculpture," according
to this bright, forward-looking pupil of Chandler Post,
were "monumentality and repose."

Even a fundamentally conservative but competent and
successful sculptor like Malvina Hoffman paid her trib-
ute to process: she posed for photographs wielding a
hammer and traded her much publicized status as a
pupil of Rodin for the role of disciple of Mestrovic (Fig.
168). Curiously symptomatic, too, of the eagerness to
compromise with the craft-carved tradition associated
with primitive cultures (African, archaic, Sumerian,
Egyptian, Pre-Columbian) was Hoffman's commission,
about 1930, from the Field Museum of Natural History
in Chicago to render in bronze the races of man. Official
art and anthropology were responding in their own way
to the strange absorption of other cultures that had en-
tered public consciousness after the First World War
and, by the end of the twenties, had helped to capsize
the Western tradition of public art, especially of sculp-
ture (Fig. 169). The popular response, the response of
Malvina Hoffman, was to answer the fascination exerted
by primitivism with a quasi-scientific interest in the
exotic.

The answer expressed in the work of Paul Manship,
however, was far more subtle (Pl. 36). It was earlier, and
it had important European parallels, notably the accom-
plishments of Carl Milles. As the second alternative to
the Beaux-Arts style, it won the laurels in passing for
modern, contemporary art, while the Zorachs, Laurents
and de Creefts had to wait in the wings for the moment
of recognition to come, which it never quite did. By the

168. Malvina Hoffman, ninety feet above street level, finishing the
head of *England,* Bush House, London, 1925. Reprinted by permis-
sion of Charles Scribner's Sons from Malvina Hoffman, *Heads and
Tales,* 1936.

169. John Storrs. *Study for Walt Whitman Monument,* 1919. Bronze,
11½ inches high. Robert Schoelkopf Gallery, New York.

beginning of the century, if the proponents of European carving had already proclaimed their affinities for other places and times, it was most notably Bourdelle who turned to 5th- and 6th-century B.C. Greek sculpture and who rendered linear elements in bronze with increasing stylization. Yet Bourdelle's manner — and Maillol's as well — was robust in comparison with that of Manship, who in 1912 returned from a coveted three-year stay at the American Academy at Rome. Eventually, Manship became the fully mature master of what may be called the "Style Conscious"[15] manner, a manner that grew to enjoy great favor in our country (Fig. 170). Initially regarded with disapproval by solidly tradition-loving critics like Royal Cortissoz,[16] Manship's first champion was Albert Gallatin, whose 1917 vignette on the sculptor is an unexpected prelude to his subsequent identification with the extremes of European modernism.[17] Manship's elegance, clarity of outline, streamlining of form (with continual references to archaic Greek sculpture) rapidly became the official art of the twenties and thirties. His smooth, yet energetic, linear force identified with the popular requirements of modernity. His deliberately archaizing features also politely satisfied respectable, if vaguely perceived, affinities for primitivism, and, although he occasionally — in a penchant for frontality —

drew upon Far Eastern sources (Epstein called it "tea-party Buddhism"), Manship's work generally remained within the familiar Western Greco-Roman tradition (Fig. 171). Furthermore, it was very good, superbly crafted, and arrived on the scene just in time to offer an alternative to the heavy monuments of public art, which no longer seemed fashionable to the children of the very rich who had paid for memorials in the past.

As Gallatin noted, Manship's first one-man exhibition "created a veritable sensation among the large public interested in artistic achievement." Correctly observing the importance of gesture in *Dancer and Gazelles,* Gallatin recognized that the lessons Manship drew from Indian sculpture linked him to the past, but he insisted that the sculptor possessed "fire and vigor," and struck "a purely modern note." Gallatin never publicly recanted his endorsement of Paul Manship but, seven years later, he wrote at length in praise of the unrecognized genius of one of Manship's studio assistants, Gaston Lachaise. Gallatin's shift of allegiance from Manship to Lachaise summarizes an extremely important phenomenon for the development of American sculpture during the first three or four decades of the century. It is symptomatic of a change in taste among patrons. Probably because Manship possessed those superficial stylistic traits

170. Paul Manship. *Centaur and Dryad,* 1913. Bronze, 28 inches high. The Metropolitan Museum of Art, New York; Amelia B. Lazarus Fund, 1914.

171. Paul Manship. *Flight of Europa,* 1925. Gilt bronze, 20½ x 31 x 7¾ inches. National Collection of Fine Arts, Smithsonian Institution, Washington, D.C.; Gift of the artist.

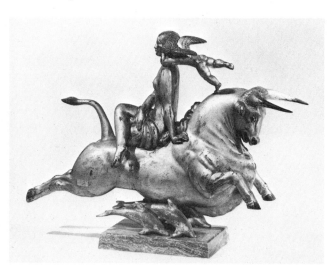

PLATE 31. A. Stirling Calder. *Fountain of Energy*. Artificial travertine. Panama-Pacific International Exposition, San Francisco, 1915.

PLATE 32. Bernard R. Maybeck, architect, Colonnade, Palace of Fine Arts. Panama-Pacific International Exposition, San Francisco, 1915.

126

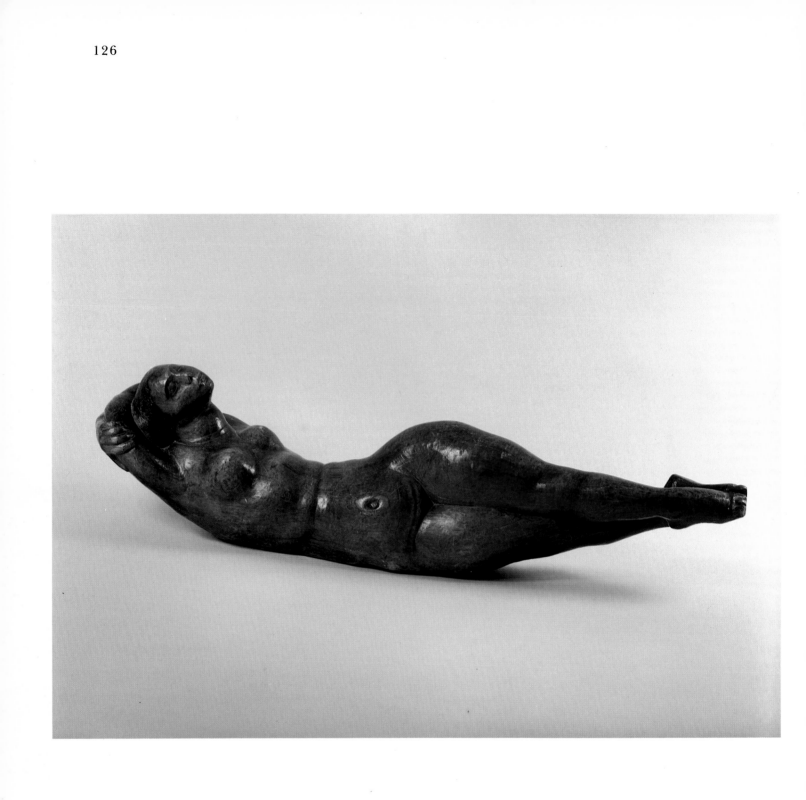

PLATE 33. William Zorach. *Floating Figure,* 1922. Wood, 9 x 33 x 7 inches. Albright-Knox Art Gallery, Buffalo, New York; Room of Contemporary Art Fund.

OPPOSITE: PLATE 34. Robert Laurent. *The Flame,* c. 1917. Wood, 18 inches high. Whitney Museum of American Art, New York; Gift of Bartlett Arkell.

PLATE 35. Elie Nadelman. *Standing Fawn*, c. 1914. Bronze, 19 x 16
x 9½ inches. Museum of Art, Rhode Island School of Design, Prov-
idence; Bequest of Miss Ellen D. Sharpe.

PLATE 36. Paul Manship. *Dancer and Gazelles*, 1916. Bronze, 69¾
inches high. Corcoran Gallery of Art, Washington, D.C.

OPPOSITE: PLATE 37. John B. Flannagan. *Chimpanzee*, 1928. Granite, 10¾ inches high. Whitney Museum of Art of American Art, New York.

PLATE 38. John B. Flannagan. *Figure of Dignity — Irish Mountain Goat*, c. 1932–33. Granite, horns of cast aluminum, concrete plinth; 55¾ inches high. The Metropolitan Museum of Art, New York; Gift of the Alexander Shilling Fund, 1941.

PLATE 39. Herbert Haseltine. *Percheron Stallion (Rhum)*, 1930. Bardiglio marble, 29 x 26½ x 11 inches. Field Museum of Natural History, Chicago.

of modernism that initially had interested Gallatin, the men and women of Gallatin's social class (whose parents, in whatever American city, had served on the art commissions that raised money for the statues erected with steady frequency since the 1880s), having tired of the monumental and become cynical by the "war to end all wars," turned to Manship for garden ornaments rather than monumental public art. It was not merely that the monumental style failed among the second and third generation Beaux-Arts sculptors of America, nor so much a lack of talent, as an overwhelming shift in public sentiment that found public statuary no longer of inspiring interest. The most dramatic indication of the failure of private and public authorities to embody national sentiment in a large commemorative monument was the failure of the Victory Arch to achieve permanency (Fig. 176). Presumably, the Arch had everything in favor to insure its success; the newly reigning Beaux-Arts architect Thomas Hastings had designed it, carefully distributing many commissions not only to the most recognized but also to some of the most promising, young talent (Lachaise made seven panels on the Victory Arch). The desire of government, business, and the fervor of the citizenry briefly seemed to coincide in this celebration of the return of the American Expeditionary Force. But the Victory Arch, built in 1919 in staff for the return-

ing heroes to march through, had to be taken down since there was no public demand to build it in enduring stone.

Some sculptors, Gertrude Vanderbilt Whitney among them, underwent a pronounced and lasting change in manner (Figs. 174, 175, 177). In preparing for the relief panels assigned, Mrs. Whitney resolved to face realistically the horrors of the war, and her style veered sharply away from ideal figures toward a realistic genre first introduced into 20th-century American sculpture by Mahonri Young and practiced for a time against difficult odds by Young, by Abastenia St. Leger Eberle and — in the twenties — by the young left-leaning Baizerman. This shift to genre realism was actually the first challenge to the hegemony of Beaux-Arts sculpture in the early 20th century; but it was hopelessly unsuccessful at the outset and failed to generate wide attention until the mid-1930s, when distant followers of Young and Eberle, men like Harry Wickey and Max Kalish, found a brief place in the sun of social realism (Fig. 178).

From the very beginning of his career as an art student in Paris, Mahonri Young seems to have been attracted by the examples of Meunier and Minne rather than Rodin. This was perhaps a corollary of his early admiration for Millet (Figs. 172, 173). As early as 1904, he made a small statue of a laborer, *Bovet Arthur,* and he continued to

LEFT: 172. Mahonri M. Young. *Man with a Pick,* 1915. Bronze, 28½ inches high. The Metropolitan Museum of Art, New York; Gift of Mrs. Edward H. Harriman, 1918.

ABOVE: 173. Mahonri M. Young. *Man with Wheelbarrow,* 1915. Bronze, 12 inches high. Whitney Museum of American Art, New York.

134

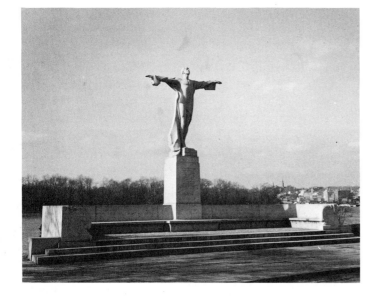

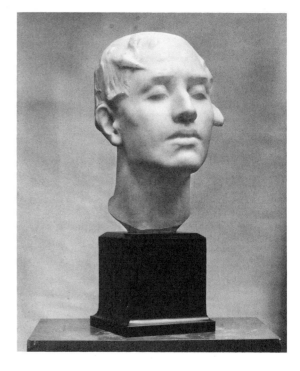

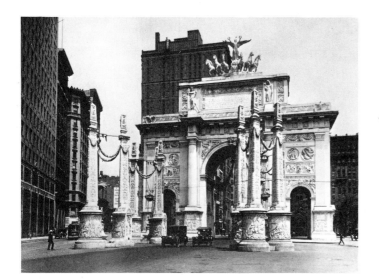

ABOVE LEFT: 174. Gertrude Vanderbilt Whitney. *Titanic Memorial*, 1931. Granite, 15 feet high. Potomac Park, Washington, D.C.

ABOVE RIGHT: 175. Gertrude Vanderbilt Whitney. *Head for Titanic Memorial*, 1924. Marble, 12¾ inches high. Whitney Museum of American Art, New York.

LEFT: 176. Victory Arch, 1919, designed by Thomas Hastings, Madison Square, New York. Staff, destroyed. Photograph courtesy of the Museum of the City of New York.

BELOW: 177. Gertrude Vanderbilt Whitney. Bas-relief for the Victory Arch (Expeditionary Force Monument), 1918–19. Bronze, 24 x 64 x 9 inches. Collection of Flora Whitney Miller.

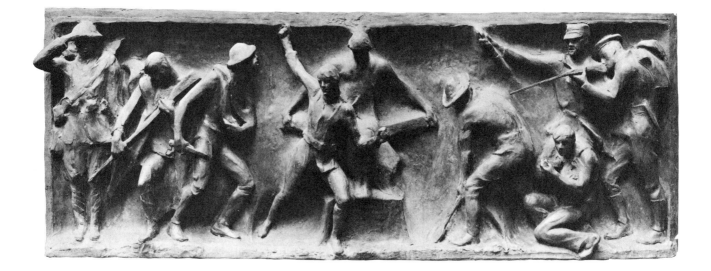

celebrate the worker with vigor and understanding at least through the teens, seldom lapsing into sentimentality or excessive romanticism. Significantly, *Bovet Arthur* won a medal at the National Academy of Design in 1911; official academic art, perhaps sensing a transitional moment, was anxious to demonstrate that it recognized true ability even when it was manifest in a subject that was unconventional or ugly. Similarly, in 1910 Abastenia St. Leger Eberle's work *Windy Doorstep* also won a medal from the National Academy of Design (Fig. 180). The work of Eberle and Young found buyers among museums (for example, the Metropolitan, Worcester, Detroit, Chicago) but among almost no private patrons! That is, small-scale genre sculpture in bronze, with significant overtones of social observation, occasionally even of protest, found no market place, no patronage, very simply because it was regarded as ugly, uninspiring and clearly not fit for either public edification (enlarged) or private enjoyment in house or garden. In this connection, a fine example of social and artistic context is demonstrated by the fact that Eberle's small statue in the Armory Show, a girl being sold into (white) slavery (Fig. 183), aroused a storm of violent controversy, while Hiram Powers's *Greek Slave* and Erastus Dow Palmer's *White Captive* (Pl. 9; Fig. 62) represented ideals applauded and much praised in the mid-19th century (Eberle had been a talented pupil of Barnard at the League). Not surprisingly, Eberle's only committed defenders were found in the socialist, not the art, press. Had she not become seriously ill during the First World War, Eberle's development might have been illuminating. Clearly, however, she was doomed to fail — as was Young — in promoting a genre whose time was never to come. Nevertheless, by contrast in subject to the Dalou-inspired middle-class genre pieces of Bessie Potter Vonnoh (Fig. 184) or the anecdotal cowpoke adventures of Remington, the work of Young and Eberle is from every point of view exceptional. Young, who was himself an athlete, was able to make a market by shifting from labor to sports, and he ultimately became famous for his spirited treatments of athletes, especially boxers (Fig. 179).

Recalling the post–Civil War success of John Rogers's groups (Fig. 96), a vogue among ordinary folk for plaster sculpture, one can only marvel at how well high art propaganda had done its work during the last decades of the 19th century. The mass market that had been open to Rogers fifty years earlier no longer existed for Young and Eberle. The National Sculpture Society's hope of creating a demand for "ideal" sculpture in private collections, that is, households, could never come to pass, since the society was born with a self-contradictory purpose. Its strength came from the practice of a group of sculptors who had successfully identified the art of sculp-

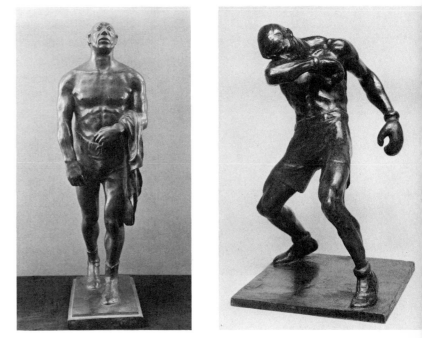

ABOVE LEFT: 178. Harry Wickey. *The Old Wrestler*, 1938. Bronze, 19¾ inches high. Whitney Museum of American Art, New York; Gift of Mrs. Gertrude V. Whitney.

ABOVE RIGHT: 179. Mahonri M. Young. *Groggy*, 1926. Bronze, 14¼ inches high. Whitney Museum of American Art, New York.

ture with public statuary, the highest form of which was the ideal. In promulgating this lofty definition, the main tendency of post–Civil War sculpture, it treated with contempt those small plaster statuary groups of John Rogers which, of course, were designed precisely to reach the mass of the people in their own homes! (The waning popularity of the Rogers groups in the 1890s was due in large measure to the successful imposition of the Society's ideas of high sculpture.) Thus, the powerful and triumphant new aesthetic found itself reduced to only one major market place and sought, unsuccessfully, to develop another. So triumphant, however, was the aesthetic and so powerful its identification of idealism and heroism with public statuary that the public never became convinced that sculpture cast in such a mode could enter the home.

It should also be noted that the ideals Young wished to celebrate with his laborers, or Eberle with her vivid glimpses of life on the Lower East Side of New York, were decidedly the substitution of one kind of glorification for another (Figs. 181, 182). Much as a sculptor of ideal pretentions would view with mild contempt the enchanting genre pieces of Vonnoh, dismissing them as bibelots, so also would Young and Eberle and Baizerman. The middle-class, well-dressed mother, with children, pets, and a comfortable chair, was considered just as trivial by

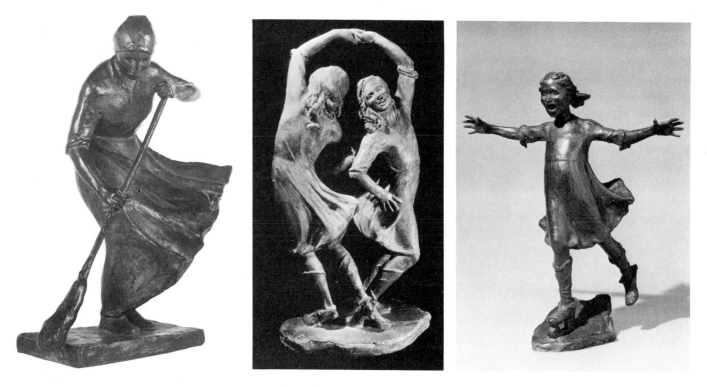

ABOVE LEFT: 180. Abastenia St. Leger Eberle. *Windy Doorstep,* 1910. Bronze, 13½ inches high. Worcester Art Museum, Worcester, Massachusetts.

ABOVE CENTER: 181. Abastenia St. Leger Eberle. *Avenue A (The Dance of the Ghetto Children),* c. 1914. Plaster, 15¼ inches high. Kendall Young Library, Webster City, Iowa.

ABOVE RIGHT: 182. Abastenia St. Leger Eberle. *Roller Skating,* before 1909. Bronze, 13 inches high. Whitney Museum of American Art, New York.

BELOW: 183. Abastenia St. Leger Eberle. *White Slave,* plaster statuette. Exhibited in the 1913 Armory Show, present location unknown; shown on cover of *The Survey* Magazine for May 3, 1913.

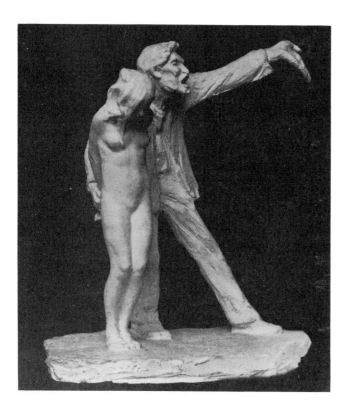

those who idealized the dignity of labor or the energy of the exotic new classes as she was by those who idealized the moral earnestness inherent in French's *Alma Mater* (Fig. 185). It was not until after the Second World War, with the triumph of another — and quite different — conception of high art that sculpture became as collectible as painting.

Well into the 20th century, a sculptor could become successful only by means of a commission for an important piece, the commission usually being determined by a group of public spirited citizens working in close harmony with government and relying on the advice of an architect. If, after years of being an assistant, a young sculptor, as a result of the success of his part of an ensemble either at a world's fair or civic celebration, was entrusted with more individual commissions, his ultimate hope for a livelihood rested on the possibility that one or more of his images might capture such acclaim that Tiffany or Gorham or Doll and Richards would make and market small-scale reproductions. For example, in 1897 Saint-Gaudens received a $100,000 commission for his *Seated Lincoln* in Chicago; much of the money was spent on atelier expenses; but he secured his living because of

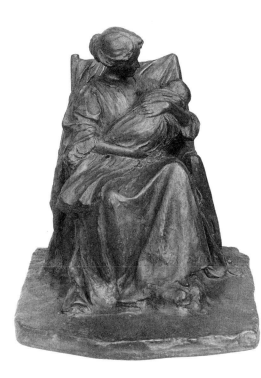

ABOVE: 184. Bessie Potter Vonnoh. *The Young Mother,* 1896. Bronze, 14½ inches high. The Metropolitan Museum of Art, New York; Rogers Fund, 1906.

RIGHT: 185. Daniel Chester French. *Alma Mater,* unveiled 1903. Bronze, 8 feet high. Columbia University, New York.

the demand for small replicas that produced royalty income. Because of their reputations as packagers of public virtue, Saint-Gaudens or French, who lived and worked until 1931, also were in great demand as makers of portrait statues. Founders of railroads or industrial mills, university presidents and church fathers, often had their portraits made if they were important enough. Following a rich historical tradition, funerary memorials were commissioned not by the ordinary citizen but by those who had accumulated fortunes. Such private commissions were infrequent even early in the 20th century, not merely because of the considerable cost but because the public identified sculpture only with the commemoration of the very important. As the rich, not surprisingly, considered themselves important and, moreover, were the only patrons who could afford to commission individual portraits in bronze or stone, they naturally turned first to those sculptors whose reputations had already been established through the channels of public art.

Especially after the First World War a new class of people came to be regarded — and to regard themselves — as important enough to have their portraits made: newly famous theatrical, musical and artistic celebrities.

Malvina Hoffman and Jo Davidson recorded them, inaugurating a new path to patronage as society turned from the traditional virtues (money and patriotism) toward more glamorous, possibly creative figures such as Pavlova, Paderewski and Gertrude Stein (Figs. 186, 187, 188). From time to time artists had "done" each other, their families or exchanged work out of mutual regard (Saint-Gaudens and John Singer Sargent, for example, or Saint-Gaudens and Robert Louis Stevenson), but only now had the artist become sufficiently celebrated by the public that doing a portrait bust of one became a credit and hence a passport to a perhaps less interesting face but a more certain income.

As the numbers of people who could afford sculpture on this reduced scale increased early in the 20th century, private practice followed public. Private gardens on country estates began to be embellished like public parks, and the genres of garden sculpture and fountains presented yet another opportunity for the already successful sculptor. Obviously, a statue of civic virtue would have seemed incongruous beside a swimming pool or tennis court; hence the successors to the masters of civic virtue were called upon for fauns, bacchantes, dancing

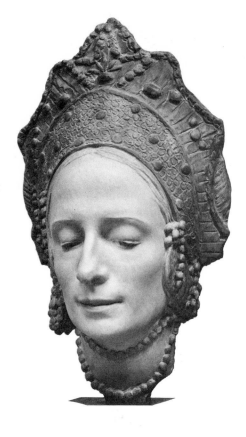

FAR LEFT: 186. Malvina Hoffman. *Mask of Anna Pavlova,* 1924. Tinted wax, 15½ inches high. The Metropolitan Museum of Art, New York; Gift of Mrs. L. Dean Holden, 1935.

LEFT: 187. Gaston Lachaise. *Georgia O'Keeffe,* 1927. Alabaster, 23 inches high. The Metropolitan Museum of Art, New York; The Alfred Stieglitz Collection, Gift of Georgia O'Keeffe, 1949.

BELOW: 188. Jo Davidson. *Gertrude Stein,* 1920, cast 1954. Bronze, 31¼ inches high. Whitney Museum of American Art, New York.

girls, fishing boys and, most interestingly, animals. In such a climate, or such a market place, is it any wonder that Eberle's bronze images of East Side ragpickers found so few takers? That, despite admiration for their technical competence and possibly even sympathetic interest in their sociological curiosity, Young's laborers found their way into only a small number of museums whereas his sporting statues might be called popular. Baizerman's work over ten years (the small-scale sculptures of the modern urban worker made during 1920–30) was finally — and desperately — combined into a singularly ambitious project as a monument to Lenin (Figs. 189, 190, 191, 192). It was offered to the Soviet government, which apparently never responded to the offer, although by making it Baizerman signaled how appropriate was the symbolism: simply the converse of capitalist virtues.

It was inevitable that Manship's streamlined style would triumph in the United States after the war, when the bloom had come off civic virtue, and the destination of sculpture was less likely to be a public plaza (Fig. 194) than a private garden. Since it had come down from the pedestal, sculpture was now more in demand for the embellishment of private outdoor spaces. While sculptors' values changed only very slowly, and sculptors

themselves continued to observe a hierarchy of values in their attitude toward work, they nevertheless followed the exigencies of life and either produced what was called for or ceased to produce at all. Thus lip service continued to be paid to moral earnestness and ideal sculpture well into the new century.

Like Hermon A. MacNeil, whose *Sun Vow* was America's most popular sculpture by 1900, Cyrus E. Dallin had made a success as a sculptor of Indians (Figs. 195, 196). In 1912, Dallin declared that "ideal work is just beginning."[18] American sculptors had been obliged to spend their lives executing orders for memorials of defunct statesmen and soldiers, and, as the clouds gathered for the First World War and the dispersal of the climate that had for so long identified idealism precisely with such figures, Dallin continued to believe that the time "is perhaps near at hand when the growing culture and education of the public will accept — nay — demand from the sculptor works embodying his loftiest ideals." As we know, Dallin's loftiest ideals were communicated through the depiction of Indians, a somewhat tardy, possibly guilt-ridden revival of the 18th-century "noble savage" idea, romanticized and timely in its coincidence with the new vogue for primitivism then sweeping through the world of art. (James Earle Fraser's *End of the Trail* was the universal favorite at the San Francisco Panama-Pacific Exposition, 1915.) And Lorado Taft, surely one of the most influential and highly regarded of sculptors, teachers and writers on sculpture, dreamed around 1926 of creating a great museum of comparative sculpture in Chicago (out of the Fine Arts Pavilion of the 1893 fair) because "the highest emotions and aspirations of humanity have been crystalized into the worlds great sculpture,"[19] as he himself strove to do in his *Fountain of Time* (1922) and *Fountain of Creation,* never finished for the Midway at Chicago (Fig. 193).

Within the less serious and less rigorously defined category of garden sculpture, the early 20th-century American sculptor could innovate, since he was not required to fulfill commemorative expectations. From the turn of the century, artists found in animal sculpture (as had Barye earlier) a vehicle to communicate individual emotion ranging from the grand to the trivial. Herbert Haseltine furnishes perhaps the best example of how the animal sculptor could for a time become a serious exponent of modern ideas about form. Haseltine began as a high society, polo-playing youth whose small statue of King Edward's charger rocketed him to fame. His *Meadowbrook Team* of 1909, depicting what was for Harry P. Whitney and his friends a triumph as important, perhaps, as a national battle, is a brilliant solution to the problems of action, scale and space (Fig. 200). During the war, like some of the sculptors who worked on the

189. Saul Baizerman. *Road Builder's Horse,* 1921–22. Bronze, 4 inches high. From "The City and the People" series. Whitney Museum of American Art, New York.

ABOVE LEFT: 190. Saul Baizerman. *Road Builder,* 1939. Hammered copper, 28½ inches high. Zabriskie Gallery, New York.

ABOVE RIGHT: 191. Saul Baizerman. *Hod Carrier,* c. 1929. Bronze, 6¾ inches high. From "The City and the People" series. Zabriskie Gallery, New York.

192. Saul Baizerman. *Barrel Roller,* c. 1920. Bronze, 4 x 3 x 2 inches. From "The City and the People" series. Collection of Mr. and Mrs. Nathan Gates.

Victory Arch, his style became more fluid. In *Field Artillery* and *Les Revenants* he coped with the grimness of battle, and one presumes that his attempt to express an unpleasant and inglorious reality made a permanent impression on his work, for even in his later portrait statues of horses his work was radically and permanently changed (Fig. 199). His bronze horse portraits executed before the war are particular portraits of the loved, valiant, courageous or pampered animals of the rich; the stone animals made after the war are generalized animals striving to communicate the vital capacity of animal life, an endless, enduring quality that this fashionable sculptor could express best in stone. He had encountered Egyptian sculpture and his bulls, hogs, sheep and, above all, horses no longer dwelled on the glamor of the subject but rather on the pure and dignified forms of the animal, smoothly carved from hard and often exquisitely colored stone (Pl. 39). His was an independent conversion to the carved aesthetic symptomatic of the meeting of varying manners in a genre that became newly popular and serious. His horses compare favorably with the mysterious withdrawal of Zorach's dogs or cats (Fig. 197), or with the innocence and grace of Nadelman's (or Manship's or Jennewein's) fawns (Pl. 35), or with the humor of Flannagan and Alexander Calder (Fig. 198), or the strength and virility of Proctor and Huntington or with the elegance of Bruce Moore (Figs. 201, 203, 204).

Many a sculptor who desired to express either individual feelings or realistic formal observation (as with the *Turning Turtle* of Albert Laessle) found that he could do it, and sell it, in the guise of animal sculpture (Fig. 202). In the veritable zoo that was widely produced during the 1920s (the Americans had European parallels in

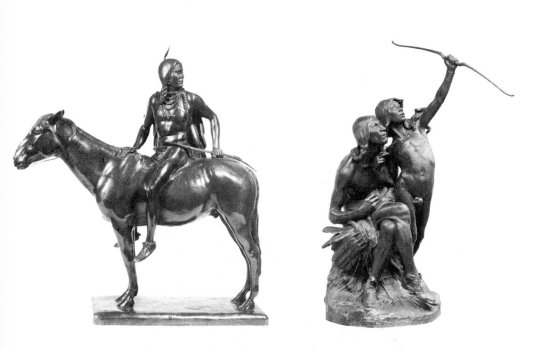

TOP: 193. Lorado Taft. *Fountain of Creation*, 1909. Plaster, 27 x 30 x 15 inches. Model for central group of an unrealized project for the Midway in Chicago. Krannert Art Museum, University of Illinois, Urbana-Champaign.

ABOVE CENTER: 194. Paul Manship. *Prometheus*, 1932–33, cast in 1955 from sketch for Prometheus Fountain, Rockefeller Center, New York. Gilt bronze, 6½ x 6 x 2¼ inches. Minnesota Museum of Art, St. Paul.

FAR LEFT: 195. Cyrus E. Dallin. *The Scout*, 1910. Bronze, 39 x 38 x 12 inches. Collection of Mr. and Mrs. Erving Wolf.

LEFT: 196. Hermon Atkins MacNeil. *The Sun Vow*, n.d., original 1898. Bronze, 73 inches high. The Metropolitan Museum of Art, New York; Rogers Fund, 1919.

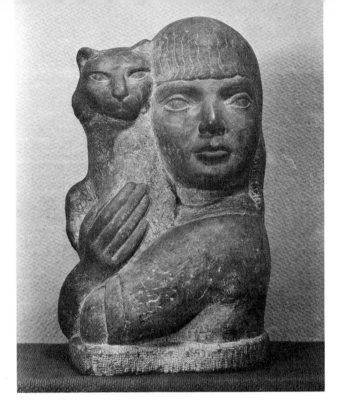

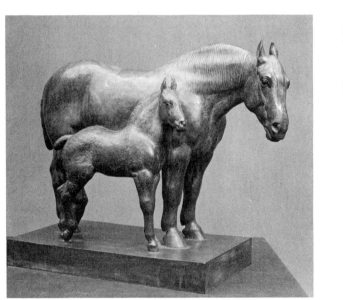

ABOVE LEFT: 197. William Zorach. *Child with Cat*, 1926. Tennessee marble, 18 inches high. The Museum of Modern Art, New York; Gift of Mr. and Mrs. Sam A. Lewisohn, 1939.

ABOVE RIGHT: 198. John B. Flannagan. *Elephant*, 1929–30. Bluestone, 13½ inches high. Whitney Museum of American Art, New York.

LEFT: 199. Herbert Haseltine. *Percheron Mare and Foal*, 1925. Bronze and onyx, 29 inches long. The Metropolitan Museum of Art, New York; Gift of Mrs. Florence Blumenthal, 1926.

BELOW: 200. Herbert Haseltine. *Meadowbrook Team*, 1909. Bronze, 41 x 68 x 39½ inches. Whitney Museum of American Art, New York.

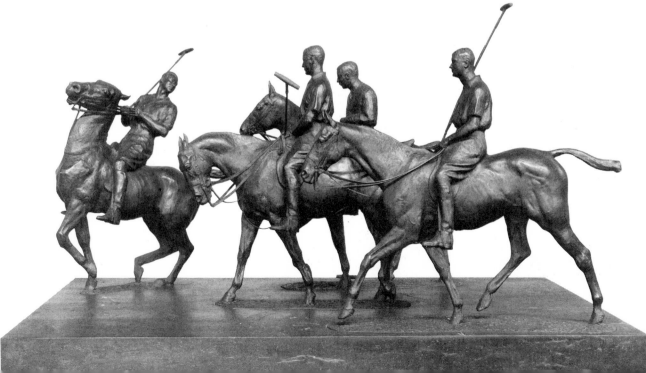

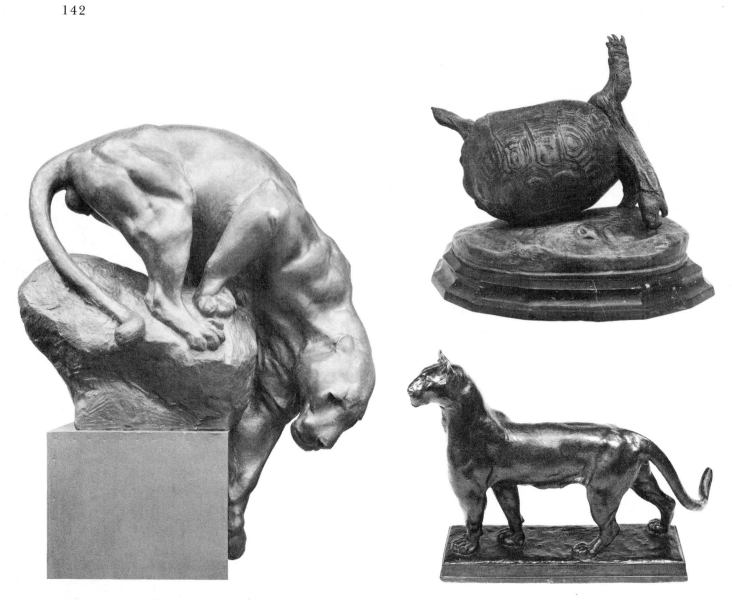

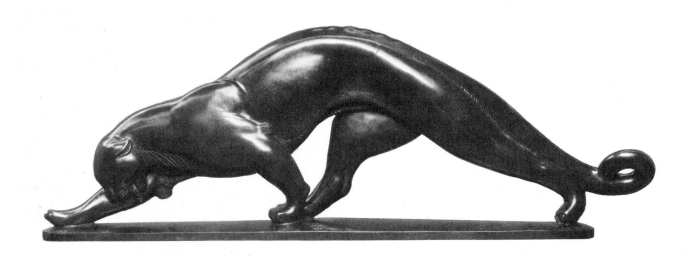

ABOVE: 201. Anna Hyatt Huntington. *Reaching Jaguar*, 1906, cast 1926. Bronze, 45 inches high. The Metropolitan Museum of Art, New York; Gift of Archer M. Huntington, 1925.

TOP RIGHT: 202. Albert Laessle. *Turning Turtle,* 1905. Bronze, 8 x 10½ x 6½ inches. The Metropolitan Museum of Art, New York; Rogers Fund, 1917.

ABOVE: 203. A. Phimister Proctor. *Puma*, 1909. Bronze, 11½ x 12½ x 3¾ inches. The Brooklyn Museum, New York; Gift of George D. Pratt.

BELOW: 204. Bruce Moore. *Panther,* 1929. Bronze, 42½ inches long. Whitney Museum of American Art, New York.

the work of Mataré, Gaul and Pompon) an important, even crucial, phase in the development of modernism can be detected, a phase comparable perhaps to the "softening up" stage in hypothetical revolutionary social processes. Animal sculpture both was acceptable to the public and admitted a wide range of emotional and formal expression (Fig. 205). It also admitted a diversity of stylistic practice (Fig. 206). That is, the self-consciously carved piece by Zorach or the vastly entertaining and chunky wood hacking of Calder's *Double Cat* (Figs. 207 a and b) could cohabit the same pavilion with the graceful, smooth gazelles of Manship or the playful hounds of Anna Hyatt Huntington (Fig. 208). As W. R. Valentiner noted in his introduction to the *Letters of John B. Flannagan*, "the poorest creature in the world has taken the place of man"[20] (Fig. 209). This substitution was only possible because of a changed attitude toward sculpture: it was desirable and it was desirable for individual ownership. This was a necessary precondition for the modern sculptor to achieve for his work an independence of destination without which he would never be allowed to indulge his personal views of life, his emotions, or his concept of pure form, whether invested with private meaning, or arranged for its own sake.

The three principal challenges to the dominance of the Beaux-Arts ideal and its centrality in American sculpture by means of sculpture's enshrinement as a public art were fused together by the 1920s. They were particularly evident in animal sculpture because this category was the most consumable form of sculpture (Pl. 38). The genre tendency, the style-conscious (quasi-public in Manship; quasi-religious in Faggi, whose *St. Francis* would be equally comfortable in garden or in church; an easy blend of abstract and anecdotal in Robus [Figs. 210, 212]), and the carved aesthetic ("My aim is to produce sculpture as direct and swift in feeling as drawing— sculpture with such ease, freedom and simplicity that it hardly seems carved but rather to have endured so always"[21]) were joined in the twenties by another, still more serious challenge. This was exclusively European in origin, almost wholly derived from Cubism, and practiced by either foreigners or expatriates. Ultimately, the seeds planted in the United States by the immigrants Nadelman and Archipenko, cultivated in European isolation by expatriate John Storrs and sporadically by the painter Max Weber (Fig. 211), nourished by the introduction of works by Brancusi and Duchamp-Villon into a handful of private collections (such as that formed by John Quinn), carried the day in the United States as they did throughout Europe (Pl. 40). The lesson so long resisted by American sculpture and evident in varying degrees in the work of the Europeans was that form and space alone carry content, idea and emotion without re-

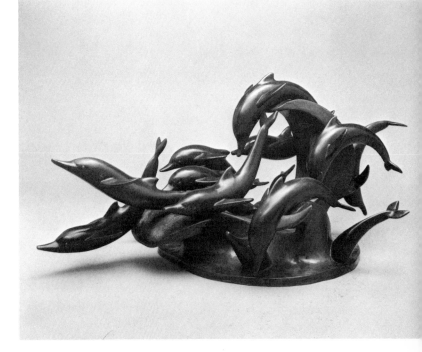

205. Gaston Lachaise. *Dolphin Fountain,* 1924. Bronze, 17 x 39 x 25¼ inches. Whitney Museum of American Art, New York.

206. Robert Laurent. *Duck,* c. 1921. Whitewood, 19½ inches high. The Newark Museum, Newark, New Jersey.

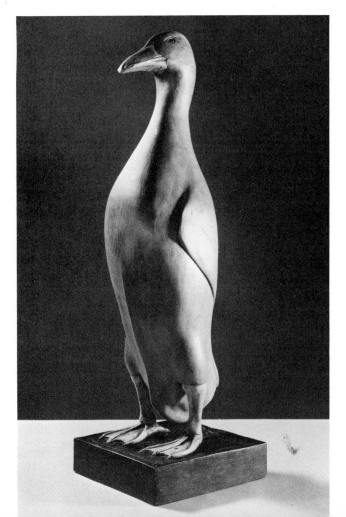

144

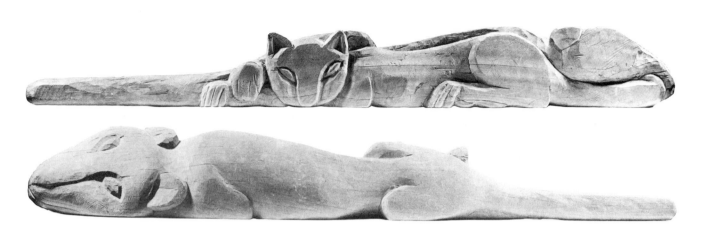

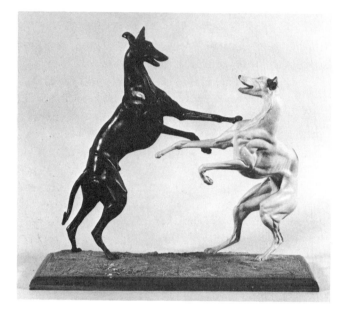

ABOVE: 207a, b. Alexander Calder. *Double Cat,* 1930. Wood, 51 inches long. Whitney Museum of American Art, New York; Gift of the Howard and Jean Lipman Foundation, Inc.

LEFT: 208. Anna Hyatt Huntington. *Greyhounds Playing,* 1936, re-modeled c. 1945 from larger version. Latex ceramic compound, 18 x 21 x 9 inches. The Hispanic Society of America, New York.

BELOW: 209. John B. Flannagan. *Cobra and Mongoose,* 1938. Granite, 26 inches high. Graham Gallery and Zabriskie Gallery, New York.

BELOW: 210. Hugo Robus. *Girl Washing Her Hair,* 1940, after original plaster of 1933. Marble, 30½ inches long. The Museum of Modern Art, New York; Abby Aldrich Rockefeller Fund, 1939.

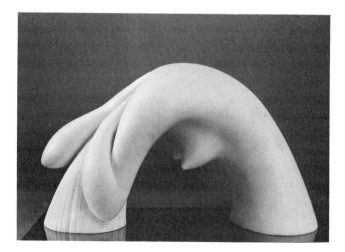

gard to representation. This complex idea, already highly developed in Europe before 1914, and central both to Cubism and abstract art, was too far from the tradition of the statue to meet with anything but blank indifference or hostility. During the 1920s, it was recognized at best as the expression of laboratory experiment and tolerated on this level; at the same time, it was suspected (correctly) of embodying only personal attitudes. Around 1930, it was still inappropriate for sculpture to "be nothing but the self-sufficient expression of an extremely personal sensibility."[22] In short, modern sculpture was still being denied the independence and isolation of the modern easel picture. Advanced painting had enjoyed a condition of freedom from destination that had developed continuously throughout the 19th century. It was this freedom that the National Sculpture Society mistakenly identified as a household market that they wanted painting to share with sculpture. But, as Gleizes and Metzinger wrote in 1912, "A painting carries within itself its raison d'etre. . . . Essentially independent, necessarily complete, it need not immediately satisfy the mind; on the contrary, it should lead it little by little toward the imaginative depths where burns the light of organization. It does not harmonize with this or that ensemble, it harmonizes with the totality of things, with the universe; it is an organism."[23] For sculpture to win a similar freedom was difficult. Even in Europe, in Paris, in the very crucible of modernism before the First World War, it was difficult for sculpture to develop or for the independent work of Brancusi, of Duchamp-Villon, of Boccioni, of Gaudier-Brzeska, of Nadelman, Archipenko and Lipchitz to find a sympathetic audience.

ABOVE: 211. Max Weber. *Spiral Rhythm*, 1915. Gilded plaster, 24 inches high. Forum Gallery Inc., New York.

LEFT: 212. Alfeo Faggi. *St. Francis*, 1915, cast 1921. Bronze, 53 inches high. Albright-Knox Art Gallery, Buffalo, New York; Room of Contemporary Art Fund.

213. Elie Nadelman. *Ideal Head,* c. 1915. Marble, 13 inches high. Museum of Art, Rhode Island School of Design, Providence; Gift of Mrs. Gustav Radeke.

Nadelman had been among the first to experiment with abstract form. Arriving in America in 1914, driven from France by the war, he could not understand why, as late as 1923, no one realized that he had "completely revolutionized the art of our time."[24] He felt that as early as 1907 his drawings had introduced into art the very idea of plastic significance. Comparing himself favorably to those European artists on the frontiers of modernism, in his own mind he regarded himself as the parent of Cubism. Yet his success in sculpture, which began in Europe in 1911 with the purchase of his entire London show by Helena Rubinstein (who proposed to use his work as trademarks or symbols for the "scientific beautification of modern woman"[25]), continued in America with a palatable simplification of those once difficult researches into pure volume (Fig. 213). His enchanting painted wooden caricatures are a kind of gentle, witty genre sculpture in which modernism itself seems to be mocking both its reluctant patrons and subjects — the host, the hostess, the singer, the dancer (Fig. 214). Nadelman's wealth and his refusal to participate in the battle for modern sculpture had the effect of removing him as a rallying point for any group of American sculptors or emerging patrons. One has the impression that he was waiting to be called upon, yet he seldom was summoned. Finally, by 1932, his architectural sculpture for the Fuller Building (Fig. 215), although vigorous and brilliant, reveals that he took as much from America as he gave, for he chose as apposite

RIGHT: 214. Elie Nadelman. *Dancer,* c. 1918–21. Wood, 30 inches high. Private collection.

BELOW: 215. Elie Nadelman. *Construction Workers,* 1930–32. Limestone, 12 feet high. Detail from the facade of the Fuller Building, 57th Street at Madison Avenue, New York. Photograph courtesy of the estate of Elie Nadelman.

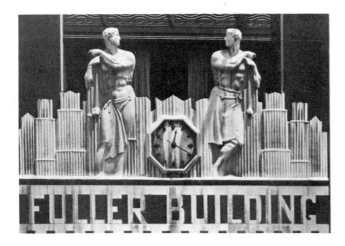

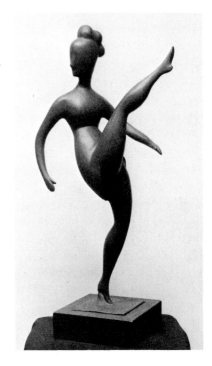

to a New York skyscraper the theme of the worker, rendering him modern through a geometric stylization not wholly dissimilar to the manner of Manship.

Archipenko, another restless European, came to the United States in the early twenties hoping to find an audience in a country that seemed to crave sculpture. By 1923 he had opened his own school but, by the mid-twenties, he had so accommodated his earlier cubist style to the prevailing demands of American buyers that much of his work is barely distinguishable from that of the members of the National Sculpture Society with whom he exhibited quite comfortably in San Francisco in 1929 (Fig. 216). Although Archipenko, too, failed to secure major public commissions (which he wanted badly) he won grudging admiration for his elegant craftsmanship (Fig. 217). When John Storrs (who lived and worked almost exclusively in Paris) showed at New York's Brummer Gallery in 1927, the effect was much as if he were a foreign artist. Not that he was as controversial — or as good — as Brancusi; it was simply that his cubist-derived style was regarded as foreign to the United States (Figs. 219, 220). The presence of Nadelman and Archipenko in the United States, however, and Storrs in France, nevertheless contributed to the American consciousness of the internationalization of sculpture. Archipenko's accommodation by the Sculpture Society and the modest success of his school in New York contributed to the slow process of familiarization, which was itself accompanied by a mild contempt (Pl. 41). "The sculptor content with an armless or legless Torso"[26] reveals his impotency; at best he made a bibelot. Like a well-turned phrase, such works could not be viewed as a whole or serious statement. As late as the thirties, public sculpture required the crystallization of an ideal, preferably a public one (like David Smith's Medals for Dishonor), in order to be regarded as ambitious (Fig. 218).

The most extraordinary exception to this was Gaston Lachaise (Pl. 43). In every way Lachaise was a peculiar figure in American sculpture. Unlike the European immigrant modernists (Archipenko, Nadelman, even Laurent) with whom he is now associated because of his pioneer status, he was never a part of advanced art circles in Paris, which he left in 1905 (Figs. 221, 222). On the contrary, he was trained directly in the Beaux-Arts tradition, with an overlay of exposure to Art Nouveau decoration; he slipped easily into the prevailing assistant-master role that existed even in Boston, where he worked under Henry Kitson before coming to New York to help Paul Manship, carving many of the figures on the *J. Pierpont Morgan Memorial* (Fig. 228). What distinguished Lachaise, however, was the unique quality of his vision: "He saw the entire universe in the form of [a] woman," as Marsden Hartley wrote,[27] and at every opportunity he

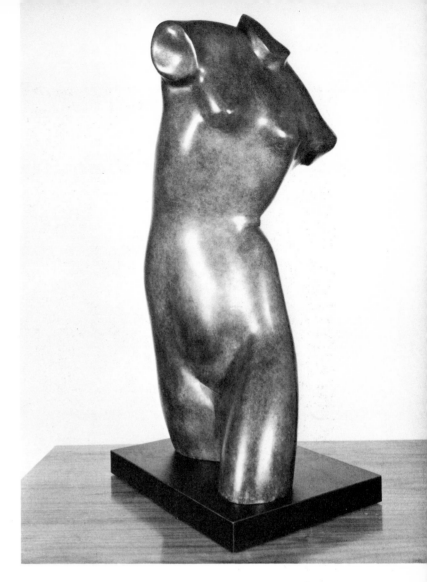

216. Alexander Archipenko. *Turning Torso*, 1921. Bronze, 28 inches high. Perls Galleries, New York.

217. Alexander Archipenko. *Torso in Space*, 1936. Metalized terra-cotta, 60 inches long. Whitney Museum of American Art, New York; Gift of Mr. and Mrs. Peter Rubel.

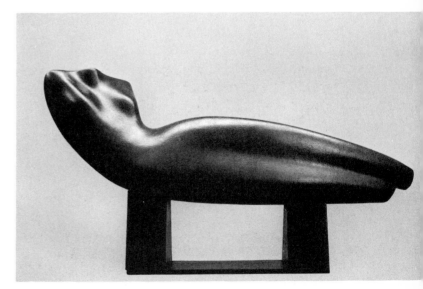

LEFT: 218. David Smith. *Medal for Dishonor: Bombing Civilian Populations.* 1939. Bronze, 9¼₆ inches in diameter. Estate of David Smith, courtesy of Knoedler Contemporary Art, New York.

BELOW LEFT: 219. John Storrs. *Male Nude (l' Homme nu),* 1922. Carved composition stone, 30¾ inches high. Des Moines Art Center, Des Moines, Iowa; James D. Edmundson Fund.

BELOW RIGHT: 220. John Storrs. *Abstract Figure,* 1934. Bronze, 33½ inches high. Robert Schoelkopf Gallery, New York.

OPPOSITE: PLATE 40. John Storrs. *Composition Around Two Voids,* 1932. Stainless steel, 20 x 10 x 6 inches. Whitney Museum of American Art, New York; Gift of Monique Storrs Booz.

OPPOSITE: PLATE 41. Alexander Archipenko. *Walking Woman,* 1937. Terra-cotta, 25½ x 7 x 11 inches. Perls Galleries, New York.

PLATE 42. Sidney Gordin. *Construction, Number 10,* 1955. Painted steel, 36 x 41½ x 27 inches. Whitney Museum of American Art, New York.

221. Gaston Lachaise. *La Force Eternelle (Eternal Force)*, 1917. Bronze, 12¾ inches high. Hirshhorn Museum and Sculpture Garden, Smithsonian Institution, Washington, D.C.

OPPOSITE: PLATE 43. Gaston Lachaise. *Standing Woman* (also called *Elevation*), 1912–27, cast 1937. Bronze, 70 inches high. Whitney Museum of American Art, New York.

222. Gaston Lachaise. *Dancing Woman*, c. 1915. Bronze, 11 inches high. Collection of Mrs. C. Oliver Wellington.

molded his ideal, beloved woman. He substituted for an ideal virtue his own ideal woman; he glorified sex (Fig. 223)! Perhaps, had he been in love with civic virtue, he would have rescued the Beaux-Arts tradition, but instead he was so busy either eking out a living as an assistant or pouring his own abundant creative energy into his personal obsession that he never became adept at what patrons thought suitable for the public. This was a source of pain and chagrin not only to Lachaise but also to the growing circle of his young admirers, who resented the fact that his work could not be found in public places. Gallatin, in 1924, put his finger on the problem, pointing out that Lachaise had never been given an important medal or prize, was not represented in a public museum, because "his work must be considered as sculpture"[28] (Fig. 224).

Noting that Lachaise had not yet produced any work of heroic size, Gallatin expressed high hope that he might soon prove himself with a twenty-two-foot stone figure for the American Telephone and Telegraph building, where Manship had gotten him some work and a chance to compete for the principal figure. This major figure was never executed, however, for the commission went to Aitken, whose Zeus, appropriately armed with a thunderbolt, was only a shade more banal than Lachaise's proposed allegory, a demure, classically draped figure holding the globe in one hand and the city in the other (Fig. 227). Gallatin was an amazing litmus for the period: his complaint on behalf of Lachaise — that he had not yet been given the chance to produce work of heroic size — may seem out of keeping with the scale of Lachaise's accomplishment, yet it is an accurate index of

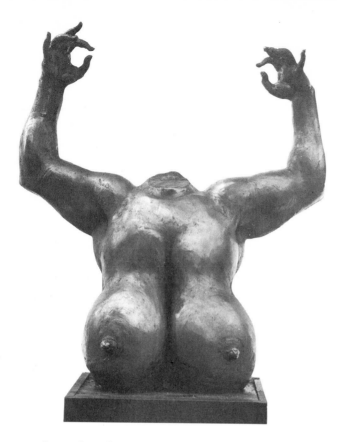

223. Gaston Lachaise. *Torso with Arms Raised*, 1935, cast 1973. Bronze, 37 inches high. Lachaise Foundation, courtesy of Robert Schoelkopf Gallery, New York.

224. Gaston Lachaise. *Walking Woman*, 1922. Polished bronze, 19¼ inches high. Hirshhorn Museum and Sculpture Garden, Smithsonian Institution, Washington, D.C.

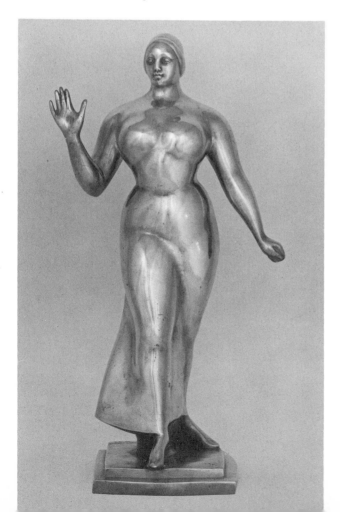

how Lachaise and his admirers felt. For fifteen years Lachaise struggled to develop a monumental sculpture, *The Mountain (La Montagne Heroique),* a work of epic metaphor, finally realizing it only on the Lenox estate of modern painter George L. K. Morris in 1934.[29] Lachaise shared many of the ambitions of his generation and desired to prove himself on a grand scale, but the opportunities scarcely ever arrived, and when they did — as at the Chicago World's Fair of 1933, called *A Century of Progress* — his work was a failure: stiff, mannered, pretentious (Fig. 225).

There is no particular irony in the fact that modern sculpture began to triumph only in spite of itself, that those whom we tend to regard as the pioneers of American modernism (Lachaise, Storrs, Archipenko, Nadelman) wanted to engage the socially, intellectually, and spiritually important or significant subject demanded of public sculpture but were rarely given the opportunity. When, as at the *Century of Progress,* official patronage determined to exploit what it finally had begun to realize was the look of the future, awarding Storrs (Fig. 226) and Lachaise major commissions, the statues and reliefs produced were not very different from the work of that most articulate of the anti-modernists Lorado Taft. Taft's *Judicial Branch* and Storrs's *Legislative Branch* are like two peas in a pod (Figs. 229, 230). And Zorach's monument *Builders of the Future* at the 1939 New York World's Fair is more a child of the tradition than of an individual artist (Fig. 231). At issue was the modern sculptor's failure to realize that his own style and its sculptural concerns were forged *outside* the limits of social purpose. When society's concept of destination bent to accommodate the new sculptors, the sculptor himself, with gratitude, met official recognition more than halfway, and the result was, if not ludicrous, at least incongruous. Ultimately Storrs was able to execute some splendid architectural decoration, but his best sculpture remains apart from the socially useful context. Lachaise was a great sculptor but, except for his portraits, his work achieved its remarkable quality precisely because he was kept an outsider, because his sculpture expressed his own monumental idea of Sex, an idea which American society was not quite ready to regard as a lofty aspiration to be placed atop an art museum or library beside Theology, Law and Labor.

The sculptors of the first thirty years of our century won from a grudging society the right for their art to be as independent as easel painting. Storrs, Lachaise, Archipenko, Nadelman, however, paid a price for this permission: their sculptural heirs were, for a time at least, relegated to the sidelines.[30] Sculpture was taken *away* from public building, from parks and squares. The American

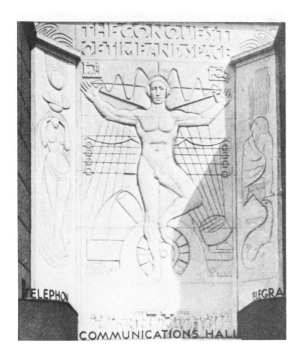

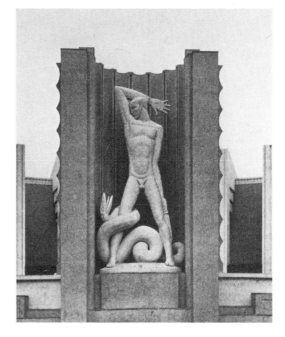

ABOVE LEFT: 225. Gaston Lachaise. *The Conquest of Time and Space,* 1933. Relief, approximately 20 feet high, over entrance to Communications Hall at the Chicago World's Fair, *A Century of Progress.*

ABOVE RIGHT: 226. John Storrs. *Knowledge Combating Ignorance,* 1933. Sculpture in niche leading to the Hall of Science at the Chicago World's Fair, *A Century of Progress.*

BELOW LEFT: 227. Gaston Lachaise. Model for figure for American Telephone and Telegraph building, 1921–23. Plaster, destroyed.

BELOW RIGHT: 228. Paul Manship. *J. Pierpont Morgan Memorial,* 1915–20. Limestone tablet, 134 x 64 inches. Installed in the Great Hall of the Metropolitan Museum of Art, New York, in 1920. Manship's design was cut in the stone by Gaston Lachaise, then his studio assistant.

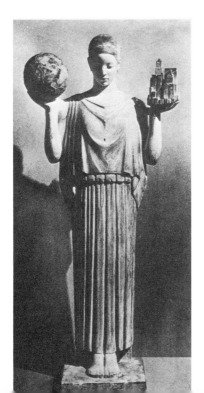

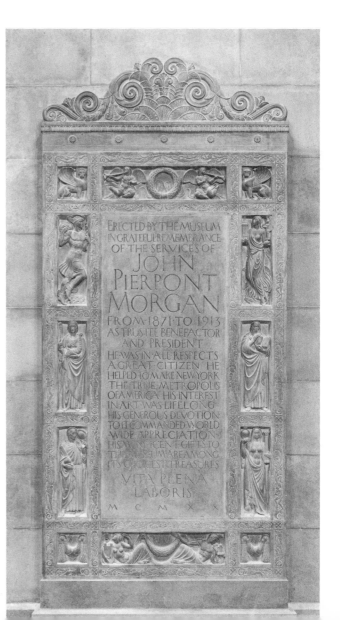

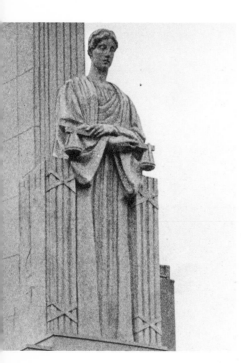
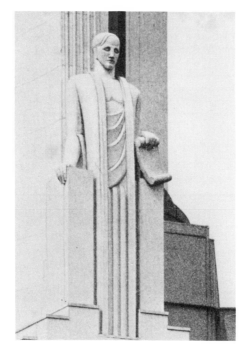
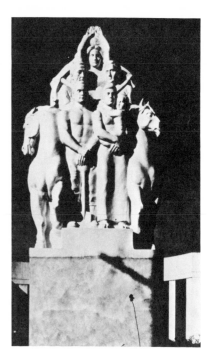

ABOVE LEFT: 229. Lorado Taft. *The Judicial Branch*, 1933. Statue, approximately 20 feet high, outside the U.S. Government Building at the Chicago World's Fair, *A Century of Progress.*

ABOVE CENTER: 230. John Storrs. *The Legislative Branch*, 1933. Statue, approximately 20 feet high, outside the U.S. Government Building at the Chicago World's Fair, *A Century of Progress.*

ABOVE RIGHT: 231. William Zorach. *Builders of the Future*, 1939. Plaster, approximately 16 feet high. Created for the New York World's Fair, 1939–40.

sculptor won the right to compete in the arena of free expression with painters at the cost of confinement to private collections and museums — at least until very recently. It was really only after the Second World War that the modern sculptor was finally freed of being a statue maker, free to make independent, isolated objects fully expressive of private feeling. There have been advantages, but also disadvantages, attending this situation.

In the middle of the three decades under consideration, at the time of the First World War, the European artist Marcel Duchamp recognized (or perhaps invented) an irony in the evolution of modern art. By investing a found object with a private iconography and emotion and exposing it to culture, he knew that public feelings would attach to it through time, as snow to a snowball rolling downhill. Much as a certain type of snow is required to roll a ball of substantial mass, so, too, is a cer-

tain kind of society required to stick its aesthetic values upon a found object, like the snow shovel, *In Advance of the Broken Arm* (Fig. 232). Perhaps sensing the ultimate laissez-faire solution to the meaning of art objects in America, Duchamp leaped over the phase of individual expression and provided the opportunity for culture to write in its own values any way and any time it wanted to. For a long time the challenge lay on the ground, of no special interest. Years later, in the fifties and the sixties, the idea was picked up and became actively pursued. If the principal accomplishment of the main line of early 20th-century modern sculpture was to win for the medium the right to be independent, Duchamp and his followers, Morton Schamberg and Man Ray, went a step further and claimed for their art the right to be not only without destination but without a fixed purpose, or expression, or set of formal concerns (Figs. 233, 234).

ABOVE LEFT: 232. Marcel Duchamp. *In Advance of the Broken Arm*, 1945 replica of 1915 original. Wood and metal, 47¾ inches high. Yale University Art Gallery, New Haven, Connecticut; Gift of Katherine S. Dreier to the Collection Société Anonyme.

ABOVE RIGHT: 233. Morton L. Schamberg. Photograph of *God;* work c. 1916, photograph 1917. Assemblage of miter box and plumbing trap, 10½ inches high. Work, The Philadelphia Museum of Art; photograph, The Metropolitan Museum of Art, New York; Elisha Whittelsey Fund, 1973.

RIGHT: 234. Man Ray. *Cadeau*, 1921-63. Mixed media, 5 inches high. Collection of Mr. and Mrs. Michael Blankfort.

In order that such limitless freedom might actually come to pass, as it has, startling changes had to occur in American society and art patronage. Sculpture was separated from public function, and its great strides in formal invention were made on a relatively modest scale. The statues that once seemed to define the high purpose of the medium were first replaced by fountains and sundials, and then by elegant small works. This came about because of the rise of a new class of art patron, and most of all, with the rise of a new kind of institution, the museum of modern art. "If sculpture is not designed to be a monument, a fountain, a park ornament," wrote Agnes Rindge, as her former classmates helped to found the Museum of Modern Art in 1929, "the only place for it is the museum." The German art historian Wilhelm Worringer wrote in "Art Questions of the Day" in August 1927 that if the social role of art was played out, as seemed to be the case with sculpture, then the only common ground between public and artist would become the art museum; all created art is intended for it, but for a sculptor to show his full capacity, the museum is positively essential.[31] Thus was born, about a decade before the final arrival of American modern sculpture, that peculiar relationship between artist, private collector and the museum — with the consequences we feel today.

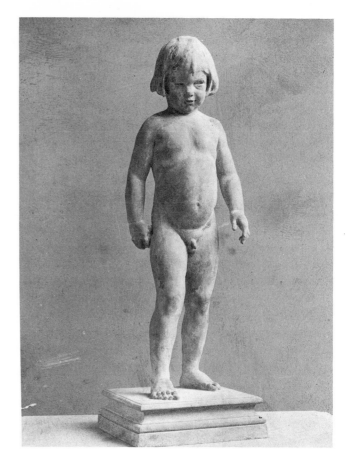

235. A. Stirling Calder. *The Man Cub,* c. 1901. Bronze, 44 inches high. The Metropolitan Museum of Art, New York; Rogers Fund, 1922.

Notes

1. Adeline Adams, *The Spirit of American Sculpture* (New York: The Gilliss Press, 1923), p. 56.

2. Ibid., p. 74.

3. From the constitution of the National Sculpture Society, May 30, 1893.

4. Quoted in Theodora Morgan, "Seventy Five Years of American Sculpture," *National Sculpture Review,* vol. 17 (Summer 1968), p. 7.

5. Adams, op. cit., p. 55.

6. See Lewis I. Sharp, *New York City Public Sculpture, by Nineteenth-Century Artists* (New York: The Metropolitan Museum of Art, 1974), for an account of the diversity of public sculpture in New York.

7. Margaret Calder Hayes, in a letter to Daniel Robbins (September 15, 1975; filed at Whitney Museum), shared an item of family iconography with regard to the *Fountain of Energy.* She pointed out that "Fame and Glory, springing from each shoulder," were "reputed to have been Sandy and me!" Sandy (Alexander) Calder had served as the model for his father in *Man Cub* (Fig. 235), a bronze of c. 1901.

8. Quoted from Introduction by A. Stirling Calder in Stella G. S. Perry, *Sculpture and Mural Decoration of the Exposition: A Pictorial Survey of the Art of the Panama-Pacific International Exposition* (San Francisco: Elder & Co., 1915).

9. Erastus Dow Palmer, "Philosophy of the Ideal," *The Crayon,* 1856, quoted in Wayne Craven, *Sculpture in America* (New York: Thomas Y. Crowell Company, 1968), p. 161.

10. Arnold L. Haskell, *The Sculptor Speaks: Jacob Epstein to Arnold L. Haskell* (Garden City, N.Y.: Doubleday, Doran and Company, 1932), p. 151. It is entirely consonant with Barnard's method and ambition that he should be remembered chiefly today as a man so in love with his sources that over the years he spent in France — in good part as an impoverished student — he formed a collection of Romanesque sculpture and architectural fragments so outstanding that it was subsequently acquired by the Metropolitan Museum of Art, with funds given by John D. Rockefeller, Jr., to become the nucleus of the Cloisters.

11. For example, *The Golden Age of American Sculpture* by Loring Holmes Dodd (Boston: Chapman & Grimes, 1936).

12. See, for example, Kineton Parkes, *The Art of Carved Sculpture* (London: Chapman and Hall, 1931).

13. Jacques Schnier, *Sculpture in Modern America* (Berkeley and Los Angeles: University of California Press, 1948), ascribes the specific idea of direct carving (that is, a direct attack with no preliminary drawing) to the French sculptor Joseph Bernard, whose work was seen at the Armory Show. Other European proponents of direct carving whose work attracted attention around 1913 were Brancusi, Hernandez, Zadkine, Mestrovic and Eric Gill.

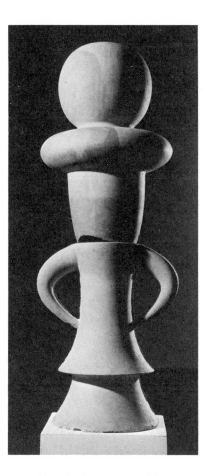

236. Isamu Noguchi. *The Queen*, 1931. Terra-cotta, 45½ inches high. Whitney Museum of American Art, New York; Gift of the artist.

237. Isamu Noguchi. *News*, 1938–39. Stainless steel plaque, 20 x 17 feet. Associated Press Building at Rockefeller Center, New York. Photograph courtesy of Rockefeller Center, Inc.

14. Agnes Rindge, *Sculpture* (New York: Payson and Clarke, 1929), p. 170.

15. I am indebted to Joshua C. Taylor for the use of this term.

16. Royal Cortissoz (*New York Herald*, April 11, 1920) called Manship mechanical, disparaged his work by referring to it contemptuously (but correctly) as "garden decoration." See Frederick D. Leach, *Paul Howard Manship, An Intimate View* (St. Paul: Minnesota Museum of Art, 1972).

17. A. E. Gallatin, *Paul Manship: A Critical Essay on His Sculpture and an Iconography* (New York: John Lane, 1917). The article was written in Bar Harbor, Maine, where a reduced version of Manship's 1916 New York show was replaying.

18. M. Stannard May, "The Work of Cyrus E. Dallin," *New England Magazine*, vol. 48 (November 1912), pp. 408–15, for this and following quotes.

19. Ada B. Taft, *Lorado Taft: Sculptor and Citizen* (Greensboro, N.C.: Mary T. Smith, 1946), p. 80.

20. Margherita Flannagan, ed., *Letters of John B. Flannagan* (New York: Curt Valentin, 1942), p. 13 in Introduction by W. R. Valentiner.

21. John Flannagan in a 1929 letter to Carl Zigrosser; ibid., p. 20.

22. Stanley Casson, Introduction, *XXth Century Sculptors* (London: Oxford University Press, 1930), pp. 4–5.

23. Albert Gleizes and Jean Metzinger, *Du Cubisme* (Paris, 1912); English translation by Robert L. Herbert in *Modern Artists on Art* (Englewood Cliffs, N.J.: Prentice-Hall, 1964), p. 5.

24. Nadelman, in *Elie Nadelman*, William Murrell, ed. (Woodstock, N.Y.: William M. Fisher, 1923), n.p.

25. According to Lincoln Kirstein, in *The Sculpture of Elie Nadelman* (New York: The Museum of Modern Art, 1948), p. 26.

26. Rindge, op. cit., p. 170.

27. Quoted in Gerald Nordland, *Gaston Lachaise: The Man and His Work* (New York: George Braziller, 1974), p. 2.

28. A. E. Gallatin, *Gaston Lachaise* (New York: E. P. Dutton and Co., 1924), p. 7.

29. Nordland, op. cit., pp. 114–16.

30. Noguchi's early development illustrates the burden of working on two sides. *The Queen*, showing his rapid assimilation of European accomplishment, particularly Brancusi and Giacometti (Fig. 236); and the 1938–39 cast relief he made for the Associated Press Building at Rockefeller Center, part of a period style, but remote from Noguchi (Fig. 237).

31. Wilhelm Worringer, "Art Questions of the Day," *Monthly Criterion*, August 1927, quoted in Rindge, op. cit., pp. 149–51.

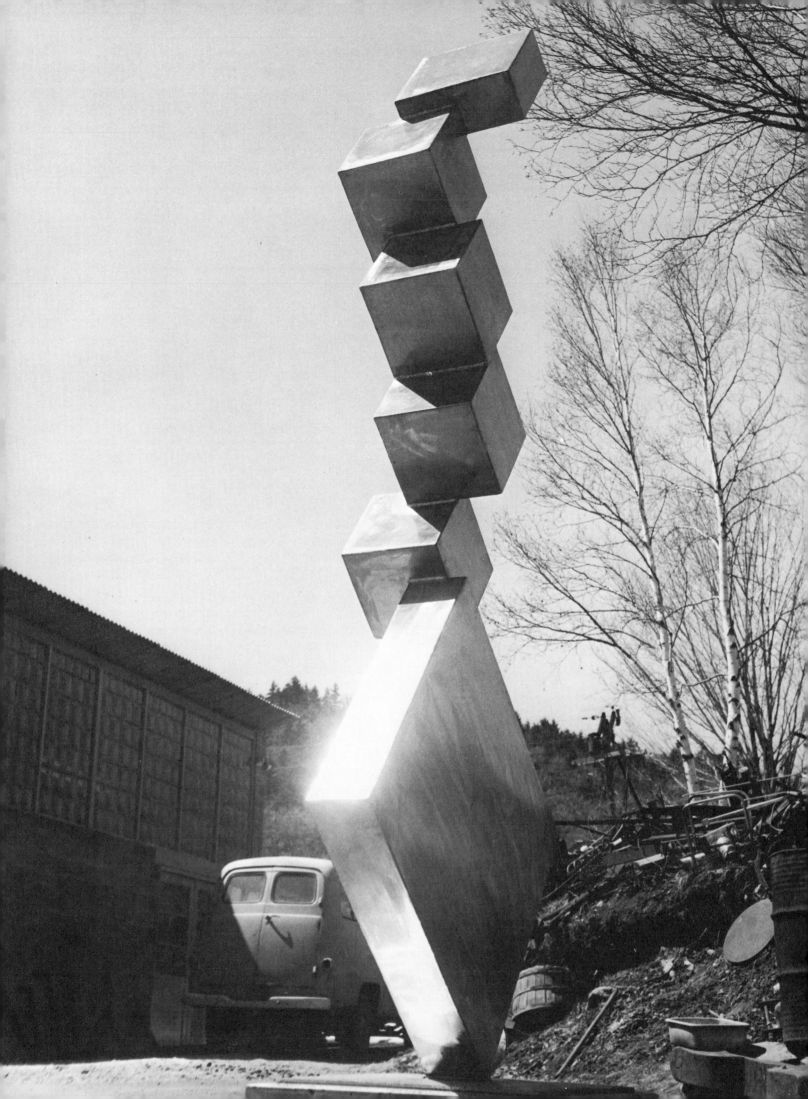

Magician's Game

Decades of Transformation, 1930-1950

Rosalind E. Krauss

SCULPTURE'S MEANING does not reduce to a bottom line called "technique." A history of sculpture written simply as an account of method — carving, modeling, welding and so on — would be unfaithful to the wide range of ideas any one material or procedure can potentially express, as it would distort the fact that the same kind of meaning can be housed in a variety of forms. All the same, innovations in technique clearly *are* symptoms of some kind of shift in consciousness. In that sense, technical invention does function as an early-warning system to alert us to the probability that a new kind of content is forcing, or permitting, or suggesting, new processes by which to express it.

In the two decades between 1929 and 1949 sculpture sustained what was probably the greatest expansion in sheer technique to occur in many centuries. There was, first of all, the incorporation of welding into sculptural practice, with the result that it was possible to form a new kind of metal object. To the vocabulary of metal sculpture, hitherto restricted to the dense solidity of the bronze cast, it was possible to add a type of work assembled from paper-thin sheet or sinuously curved rod. Standing freely in space, the sculpture made by this process could support itself not in the manner of the classical column, but rather along the lines of the gridlike steel truss (Pl. 47). Although sculpture made in this fashion could displace

space in three dimensions (on the model of the open cage), it could also take the form of an extremely linear, two-dimensional frame and still remain physically self-supporting. And this it did. So that along with the innovation of welding came a correlative departure: freestanding sculpture that was shockingly flat.

Yet another technical expansion of the options for sculpture appeared in the guise of motion. The individual parts of a sculpture were no longer understood as necessarily fixed in relation to one another, but could be made to change position within a work constructed as a moving object. Motorizing the sculpture was only one of many possibilities taken up in the 1930s. Other strategies for getting the work to move involved structuring it in such a way that external forces, like the wind or the touch of a viewer, could initiate motion. For that alternative it was necessary to investigate the technology of weights and counterbalances, of catenary arches to distribute loads along a series of hinged sections, or the action of various kinds of bearings and pendulums (Fig. 238). The ways of producing motion proliferated like the colors on a painter's palette, ranging from the complex patterns generated by the oscillating motor to the sheer simplicity (technically speaking) of particles of sand shifting within a glass container. But whatever the mechanism employed, movement brought with it a new attitude toward the issue of sculptural unity: a work might be made of widely diverse and even discordant elements; their formal unity would be achieved through the arc of a particular motion completing itself through time.

Like the use of welding and movement, the third of these major technical expansions to develop in the 1930s

OPPOSITE: David Smith, *Cubi I*, 1963. Stainless steel, 124 x 34½ x 33½ inches. Photographed at Bolton Landing, New York, by David Smith. The Detroit Institute of Arts, Detroit, Michigan. (See Pl. 49.)

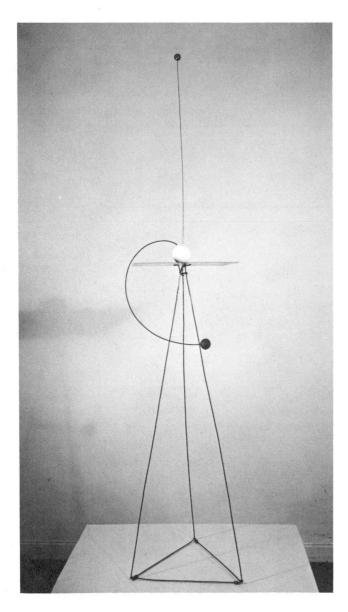

Given the separateness of their technical concerns, it is not surprising that these three bodies of work assume an extremely different appearance one from the other. Cornell's exists at the scale of the miniaturist, its boxed collections of curios operating within the contracted space of intimacy (Pl. 45). Calder's, wiry and expansive, extending its arms out into space like so many pseudopodia, implies the capture of large amounts of territory by means of fragile, wafting networks of line (Fig. 239). While David Smith's work, brooding and immobile, inserts itself into space with extreme planarity, instating its presence in the landscape by means of a man-sized, abstract emblem or sign (Fig. 240).

But past their unlikeness to one another — in appearance, in technical application, in the expression of personal sensibility — there is a set of concerns that the works of these three men share, a set of ideas that connects them to one another and to the work of many of their American contemporaries. Most succinctly put, these concerns derive from a recognition of the Unconscious. What began to happen to sculpture in the 1930s and 1940s was the expression of a fundamentally changed experience. The novels of James Joyce were understood by other artists as only the first indicator that for art to be serious, or ambitious, or authentic, it must attempt to capture the modes and moods of consciousness itself; it must try to explore an experience whose depths were now understood to involve the undercurrents of fantasy, dream and desire. In 1943 one of the editors of *View* magazine was stating what he took to be the obvious when he wrote that in the preceeding decade "the two main themes of inspiration were the *unconscious* and the *masses*. The

and 1940s addressed the issues of sculptural materials and sculptural unity. But *its* medium for doing so was the found object. To create a sculpture by assembling parts that had been fabricated originally for a quite different context did not necessarily involve a new technology. But it did mean a change in sculptural practice, for it raised the possibility that making sculpture might involve more a conceptual than a physical transformation of the material from which it is composed.

In the United States during the two decades in question three extraordinary careers developed, each one exploring a different aspect of this group of technical departures. Those are the careers of David Smith, whose formal thinking developed in relation to procedures of welding; Alexander Calder, whose attitudes toward sculpture were clarified in relation to motion; and Joseph Cornell, whose work was conceived entirely through forming unexpected conjunctions between found objects.

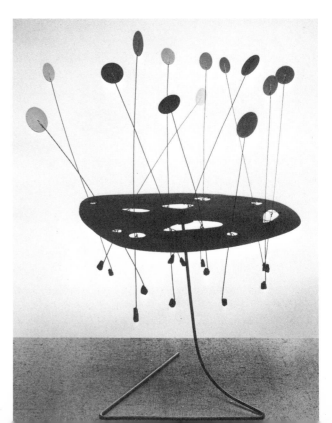

genuine artist, the pure poet, the authentic composer according to his political inclinations, believed either that his mission consisted in expressing the deeper feelings of the masses, or in giving form to his own dreams."

Of the two thematic concerns named by the *View* essay — the Unconscious and the masses — it was the first that profoundly affected American sculpture, confronting its practitioners with the need to find or develop new forms and new techniques through which to explore that content. In detailing the variety of responses American sculptors made to this thematic material, it might be well to begin with Joseph Cornell whose work demonstrates that material most obviously. For Cornell's is the body of work that, through its direct connection to Surrealism, explicitly declared its intention to explore a space that was intensely psychological.

The sculpture of Joseph Cornell comes in one form only. It appears as a box. The two variants Cornell allowed himself within this basic format were the box that was oriented horizontally — to a table — or vertically — to a wall. The boxes intended for the wall display their contents to the viewer through the transparent glass planes that form their front surface. The boxes that sit on the table generally have lids which may be removed in order to inspect the objects they contain. In no case are these boxes larger than a foot and a half in any dimension, and in many instances they are much smaller, so it is clear they are meant to be lifted — the ideal mode of examining them is by holding them in one's hands (Fig. 241, p. 170). In this sense they present themselves to us with a certain kind of plausibility as an extension of our own space. Like knives, forks and plates, they are things we might grasp and use. Even the wall-hung boxes persist in establishing this locale of the mundane. The "soap bubble sets" are like the packaged toys one might receive as a child; the "natural histories" take the form of decoratively encased biological displays; the "pharmacies" recapitulate the medicine cabinet; the "slot machines" suggest the scoreboards of those adult games that inhabit the penny arcade or the local bar.

What Cornell meant by this strategic ordinariness might be best explored through his 1942 *Homage to the Romantic Ballet,* a simple wooden box with a lid that could contain anything from sewing materials to cigars but in this instance is specified as a case for jewelry (Fig. 245). Lifting its top, one finds three types of elements arranged inside. On the bottom there is a bed of blue sand; suspended above this on a glass shelf are twelve clear plastic cubes that resemble ice, and on the velvet lining of the raised lid is an inscription which reads:

On a moonlight night in the winter of 1855 the carriage of Maria Taglioni was halted by a Russian highwayman, and that ethereal creature commanded to dance for this audience of one

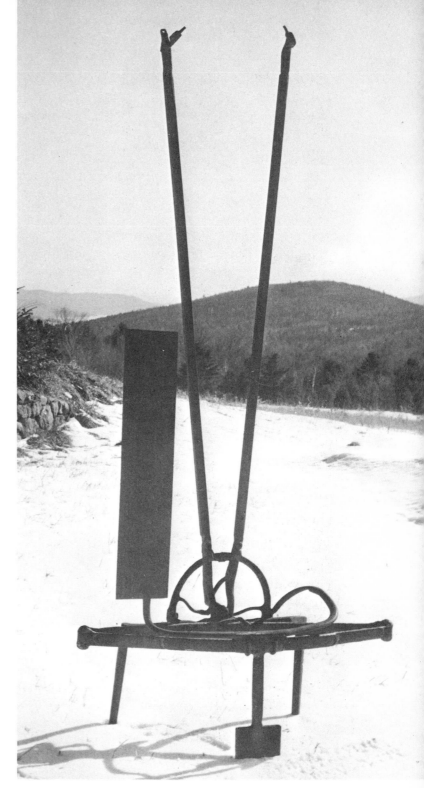

240. David Smith. *Five Spring,* 1956. Steel, stainless steel and nickel, 77⅝ x 36 x 14¾ inches. Estate of David Smith, courtesy of Knoedler Contemporary Art, New York.

OPPOSITE, ABOVE: 238. Alexander Calder. *Little Ball with Counterweight,* c. 1930. Sheet metal, wood and wire; 63¾ x 12½ x 12½ inches. Collection of Mr. and Mrs. Leonard J. Horwich.

OPPOSITE, BELOW: 239. Alexander Calder. *Aspen,* 1948. Metal, 38¼ x 25 x 22 inches. Galerie Beyeler, Basel, Switzerland.

upon a panther's skin spread over the snow beneath the stars. From this little actuality arose the legend that, to keep alive the memory of this adventure so precious to her, Taglioni formed the habit of placing a piece of ice in her jewel casket or dressing table drawer where melting among the sparkling stones, there was evoked a hint of the starlit heavens over the ice-covered landscape.

What we are given in this assembly of things is more than a simple narrative about a 19th-century ballerina. Instead it is a model of the workings of psychological association. Cornell presents his work to us as though it were a matter of knives and forks and plates, because it is this very kind of commonplace object that is the starting point for chains of associated memory. The plate that was used for a particular occasion may be very ordinary and much of the time we may use it without connecting anything remarkable to it. But just the same, as it sits within the real space of our everyday life, something may happen to trigger the private associations it carries and then it will seem to float to a different place or level in our consciousness, like a strange piece of driftwood with memories clinging barnaclelike to its surface. Of course, *Homage to the Romantic Ballet* demonstrates this phenomenon by recalling the highly conscious act of Mlle Taglioni who had ice cubes placed among her belongings in order to elicit the shock and transport of a particular memory. But Cornell was using this to create a model for a more general, a more pervasive situation.

What Cornell wanted was to establish the terrain of the ordinary as his sculptural space, one particular portion of which was suddenly transformed by a set of psychically charged accretions. It was as though this common object, to which chains of private associations adhered, was a kind of hole or chink in the continuous surface of reality into which the viewer's own unconscious had flowed. So that real space was not an unbroken unity, but a world that was fractured into many different locales —every piece of furniture, every common object having the potential to become a stage on which could be enacted the private theater of memory, fantasy or remembered dream.

The syntax of this fractured reality had been proposed to Cornell by an extraordinary phenomenon from the European canon of Surrealist art. In the early 1930s Cornell became aware of the function of collage in Max Ernst's pictorial novels, the most celebrated of which is *La femme 100 têtes* (Fig. 242). On the pages of that book Ernst projects a sequence of apparently normal spaces, the structures of which are established by the 19th-century engravings of landscapes or domestic interiors that Ernst uses as his basic material. With extreme stealth, Ernst then insinuates into these scenes material foreign to them, sometimes objects from engineering

manuals or details from fashion catalogues — objects of a texture and scale separate from the background space of the collage, objects to which the pictured occupants of that space are completely oblivious. The result is that for the viewer the context of a normal room is transformed into a psychically fractured space. Without flattening or dispelling his sense of depth, Ernst uses these collages to play havoc with the viewer's notions of the metaphysical continuity of his own world.

The Surrealist use of collage derived, then, from a strategy of disruption. It asserted that the ground of reality was constantly interrupted by these outposts that could be occupied by the viewer's unconscious. And Cornell, in constructing the habitats of that occupation, was using collage as well to exhibit something about the structure of the occupying force.

The way that Cornell arranged his chosen objects within the boxes had to do with his ambition to make out of those banal materials a model of the Unconscious and its processes. He therefore wished to form a concatenation of elements each of which would join the space of the box from different points of origin within real life. So that, for example, the *Medici Slot Machine* juxtaposes a real compass and a real ball with a map of the Palatine Hill and a reproduction of a painting by the Renaissance artist Moroni (Pl. 46). Although, on the one hand, the map and reproduction are real objects like the compass and ball, they are, on the other, objects of a special kind. They are also *representations* of a distant reality—distant both in space and time. This quality of difference

242. Max Ernst. ". . . et la troisième fois manquée," fourth of 147 collages reproduced in *La femme 100 têtes* (Paris: Editions du Carrefour, 1929). 9 x 7½ inches. Collection of the Reis family.

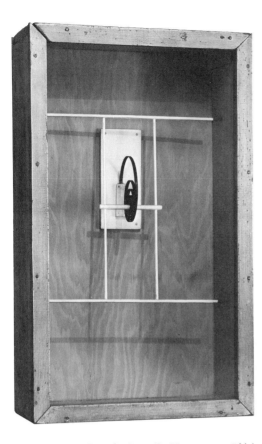

ABOVE LEFT: 243. Joseph Cornell. *Homage to Blériot,* 1956. Box containing painted wood trapeze supported by rusted steel spring; 18½ x 11¼ x 4¾ inches. Collection of Mr. and Mrs. Edwin A. Bergman.

ABOVE RIGHT: 244. Joseph Cornell. *Dovecote,* 1952. Painted wood, 16¾ x 11¾ x 3⅜ inches. Collection of Mrs. R. B. Schulhof.

BELOW LEFT: 245. Joseph Cornell. *Homage to the Romantic Ballet,* 1942. Wooden box with plexiglas cubes, velvet and collage, 4 x 10 x 6¾ inches. Collection of Mr. and Mrs. Richard L. Feigen.

BELOW RIGHT: 246. Joseph Cornell. *Penny Arcade for Lauren Bacall,* early 1940s. Wood, glass, paper; 20½ x 16 x 3½ inches. Private collection.

247. Alberto Giacometti. *No More Play,* 1933. Marble, wood, bronze; 23 x 17⅝ inches. Collection of Mr. and Mrs. Julien Levy.

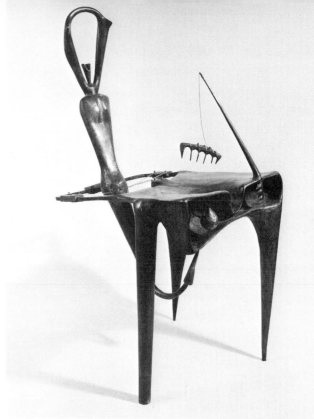

248. David Hare. *Magician's Game,* 1944. Bronze, 40¼ x 18½ x 25¼ inches. The Museum of Modern Art, New York; Given anonymously, 1969.

the represented boy and the schematic ground plan have from the compass and ball operates to distinguish the ball and compass from one another as well. For those two objects, while not being representations, are still dissimilar to one another in that the compass measures a territorial reality which it can only fractionally occupy.

Yet whatever the divergence in scale, function and level of actual presence of the things it contains, the nature of the Cornell box is that it is a magical equalizer of all these differences. That is, within the space of the Cornell box, all these object/images acquire the same degree of presence or density — they are all "there" on an equal footing.

Cornell's use of the collage technique was aimed at establishing this kind of equivalent presence between different types of objects in an effort to project a model of the Unconscious. For he wanted to structure it as that medium in which an array of affective objects and experiences are stored — each one having the potential to emerge into consciousness with equal force and none of them being any more "real" to experience than the other. The Cornell box is thus simultaneously a model of the space of the Unconscious *and* a common object which occupies our own exterior space in a way that disrupts its continuity. It is the projection of a psychological interior outward onto the material of the external world (Figs. 243, 244).

If this transformed segment of the ordinary is the space Cornell wished his sculpture to construct, his work is fashioned in such a way as to make clear that the medium through which this transformation takes place is time. The train of associations, although they assemble in that unitary setting that we call consciousness, do make their appearance to us sequentially — one after the other. It is this dimension of experience — its temporality — that Cornell established through the movement that is orchestrated into almost all of the boxes. In *Homage to the Romantic Ballet* the grains of sand are free to shift along the bed of the work, and the transparent cubes extend an invitation to the viewer to readjust their positions. In other boxes, such as the *Penny Arcade for Lauren Bacall* (Fig. 246) or the *Medici Slot Machine,* this temporal dimension is expressed through the action of a ball that can be made to roll along narrow passageways and through the various compartments of the works by the action of the viewer, tilting and angling the ground plane of the box. In each of these cases it is clear that the temporal movement comes as a result of the viewer's own manipulation of the object.

Cornell's boxes, in this respect, are an extension of a particular strategy for sculpture developed in the early 1930s by the Surrealist sculptor Alberto Giacometti. *No More Play,* a work of 1933, is, like many other Giacomettis from the same time, modeled on the idea of the board

game (Fig. 247). It implies an internal movement to be carried out by the viewer who repositions the separate elements of the work on a base fashioned like a playing board, doing this over the extended time of "moves" made in the course of a game. The character of this time is that it is, like the viewer's heartbeat or the words that he pronounces in conversation, synchronized with the real time of his experience. It is the extended time through which he lives. It was Giacometti's intention, as it became Cornell's, that the sculpture's temporal existence be specifically coordinated with the time of ordinary experience. To continue the earlier analogy, it was to be like the time of picking up a knife and fork to eat, or putting down a glass.

The board game strategy for sculpture, with its insistence on real time and its exploitation of ordinary, real space, was a way of projecting the Unconscious outward, of demonstrating how it is experienced. It was a means of showing that it is not only buried deep within the material of our psyches, but roams phantomlike through exterior space, strangely materializing itself when we least expect it.

It was not only Cornell who understood the importance of the board game model for sculpture: David Hare grasped it as well. Hare, who edited the American Surrealist magazine *VVV* and exhibited with the Surrealists in the early 1940s, employed the image of the board game in his 1944 bronze sculpture *Magician's Game* (Fig. 248). There the human figure is rendered ambiguously as either seated in front of a gaming table or, centaurlike, partially transformed into one. For the lower half of the body has been fashioned as a table with various pieces of the game to be played suspended in potential motion above and below its surface. In this way the ground of the player's psyche is depicted as simultaneously incorporated within the limits of the body *and* located outside those limits.

This impulse to materialize the psyche, to project it outward, to instate it as the furniture of one's existence, resulted in a variety of formally strategic moves on the part of those artists working in this country who were affected by the Surrealists. Frederick Kiesler had this in mind when he designed the space for Art of This Century, a New York gallery set up by Peggy Guggenheim in the early 1940s which permanently displayed Surrealist art as well as exhibiting the work of younger Americans (Fig. 249).

Celebrated for its eccentricity, Kiesler's design called for paintings to be mounted on swivel hinges attached to baseball bats projecting from the gallery's curving walls, and sculpture to be installed on bases that resembled — depending on their orientation — chairs or tables. But Kiesler's objectives had nothing to do with the outland-

249. Frederick Kiesler. Design for Art of This Century, 1942, a Surrealist gallery of curved-wall construction. Kiesler seated at left. Photograph by Berenice Abbott.

250. Frederick Kiesler. *Galaxy*, 1951. Wood construction, 144 inches high. Collection of Nelson A. Rockefeller.

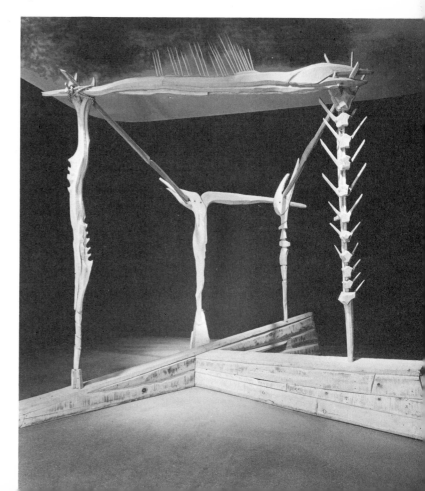

168

ish or the perverse. Rather, he was attempting to give to paintings and sculpture that quality of being real objects fully embodied within the viewer's own space. The furniturelike bases suggested the relationship of the sculpture they carried to the ordinary objects of his experience; the swivel mounts allowed the paintings to be held between the viewer's hands and moved around, so that the pictures were also sensed as a kind of object.

With Art of This Century, Kiesler was constructing a space that had *some* of the stability and continuity that we understand as the real space we inhabit. What he added to this was a sense of repeated disruptions or breaks in its continuous surface, for each painting was not only an object but also a perspective. It had its own internal space that seemed to set up a minor crosscurrent within the flow of reality, as though it were a break in the dike through which a portion of the space of the room was draining away.

One could say, of course, that any room full of pictures would seem to pierce the walls on which they hang with multiple vistas: with spaces that provide illusioned avenues leading away from the space in which one is standing. But the conventional easel painting, in being a window onto another space—that of a landscape or a peopled interior—proposes that we hold our own reality in abeyance and that we imaginatively transport ourselves into *its* world. It does not ask to be understood as a lesion in the continuous fabric of our *own* reality. Kiesler's design made the paintings and sculptures into objects in order to suggest that they are the furnishings of the viewer's real space—furnishings which, like the Cor-

nell boxes, open up strange chinks in the wall of reality through which are glimpsed the psychological underpinnings of our material world. In so doing Kiesler was establishing Art of This Century as a life-sized model of the fractured space of *La femme 100 têtes*. He was, once again, suggesting that the real space of the viewer's life and the objects which people it are already psychically charged or psychically inhabited, and further, that the psyche itself is formed by its conjunction with the real elements of the external world.

At the same time Art of This Century was a proposal for artists to work at a scale that is environmental, manipulating the real space through which the viewer moves. His own efforts toward an environmental sculpture led Kiesler to *Galaxy,* a work of 1951, that employs a series of ramps in an effort to reorient the viewer's sense of the nature of the very ground on which he moves (Fig. 250).

For sculpture to form an environment had become the ambition of several other American artists during the late 1940s. This was certainly the intention of Louise Bourgeois in her first two sculpture shows at the Peridot Gallery in 1949 and 1950. There the empty gallery was understood to function as a room that was rhythmically punctuated by polelike sculptures which would create "an environment of abstract *personnages.*" Interested not only in the individual pieces but in the space as a whole, Bourgeois imagined it as a kind of ritualized atmosphere through which she could "summon all of the people I missed. I was not interested in details; I was interested in their physical presence. It was some kind of an encounter." And the nature of this encounter was that kind of projection of the Unconscious onto the space of the real that formed the model of surreality.

This impulse toward working with the terms of real space led Bourgeois as well to construct a work like *The Blind Leading the Blind* (1949) in which the sculpture has the quality of a furniturelike occupant of the room in which it stands (Pl. 50). As such, it appears as a rational or commonplace object which has, however, the capacity to house or enclose its own world of associations (Fig. 251).

For Louise Nevelson, too, an environmental scale became a requisite term in her thinking about sculpture.

LEFT: 251. Louise Bourgeois. A detail of *The Blind Leading the Blind,* 1949. (See Pl. 50.)

OPPOSITE: PLATE 44. Alexander Calder. *Calderberry Bush,* 1932. Painted sheet metal, wood, wire and rod; 84 inches high. Collection of Mr. and Mrs. James Johnson Sweeney.

ABOVE: PLATE 45. Joseph Cornell. *A Pantry Ballet (for Jacques Offenbach)*, 1942. Mixed media, 10½ x 18 x 6 inches. Collection of Mr. and Mrs. Richard L. Feigen.

OPPOSITE: PLATE 46. Joseph Cornell. *Medici Slot Machine*, 1942. Mixed media, 15½ x 12 x 4⅜ inches. Collection of the Reis Family, New York.

LEFT: FIG. 241. Joseph Cornell. *L'Egypte de Mlle Cléo de Mérode; cours élémentaire d'histoire naturelle*, 1940. Apothecary's wooden box with bottles, cork and miscellaneous materials; 10⅝ x 7¼ x 4¾ inches. Collection of Mr. and Mrs. Richard L. Feigen.

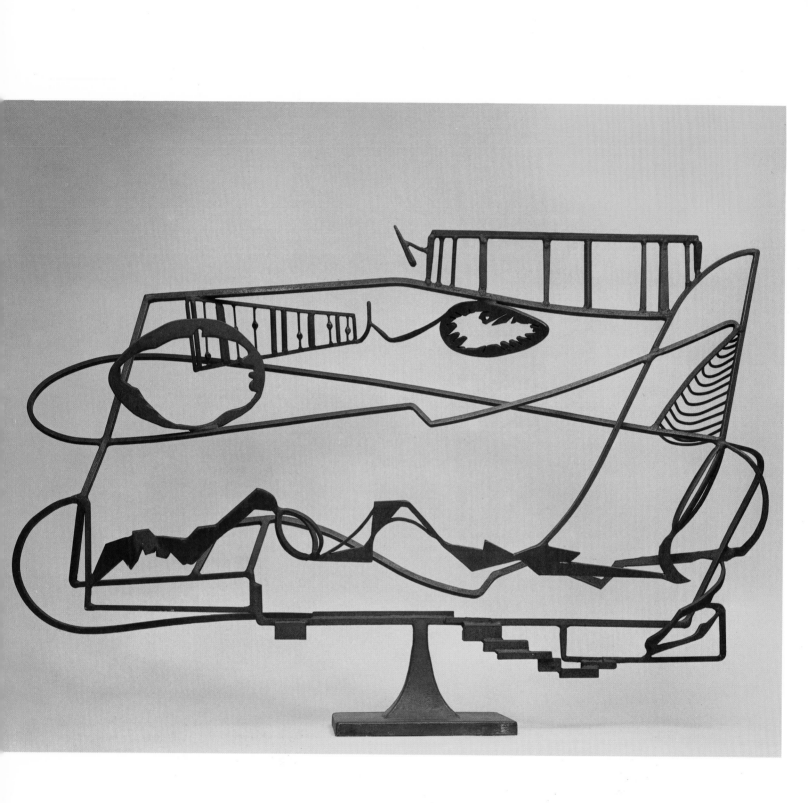

PLATE 47. David Smith. *Hudson River Landscape*, 1951. Welded steel, 49½ x 75 x 16¾ inches. Whitney Museum of American Art, New York. (See p. 254.)

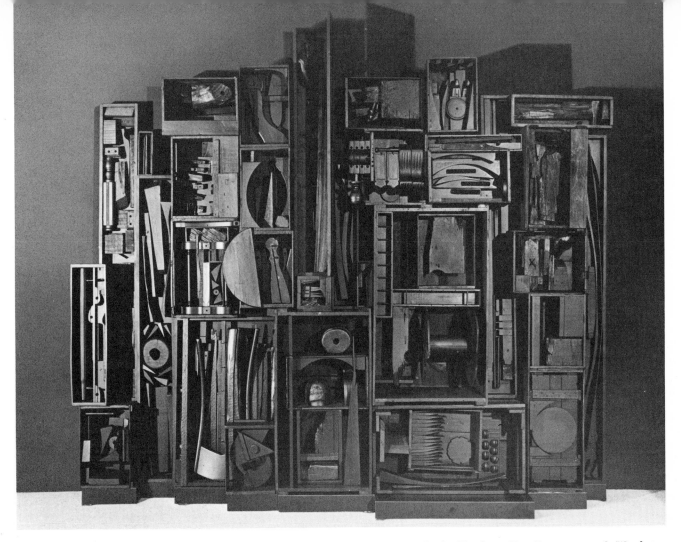

ABOVE: 252. Louise Nevelson. *Sky Cathedral — Moon Garden +
One,* 1957–60. Painted wood, 109 x 130 x 19 inches. Private col-
lection.

BELOW: 253. Louise Nevelson. *First Personage,* 1956. Wood; two
pieces, 94 x 37 1/16 x 11 1/4 inches (overall). The Brooklyn Museum,
New York; Gift of Mr. and Mrs. Nathan Berliawsky.

Some of her earliest exhibitions were, like Bourgeois's,
conceived as full-scale environments, with the sculptures
forming not only totemlike figures within the room, but
its "furniture" and its partitionlike walls (Fig. 253).

Throughout the 1950s and early 1960s Nevelson ex-
plored the medium of the "wall" as a means of enforcing
the experience of the sculpture as a component of real
space. As had been true of Cornell's work, it was essen-
tial to her conception of the nature of real space that
these walls appear as encrustations of associations. And
to that end she, too, employed collages of found objects.

Modular in their construction, the walls are built of
boxes, each of which holds a series of mundane wooden
objects such as newel posts, toilet seats or rolling pins.
Like Cornell's boxes, Nevelson's modules suggest a dual
identity: they are both the model of an interior space in
which associations are housed, *and* the exterior space of
real objects from which psychological experience is
formed. But unlike Cornell, Nevelson does not depend
on actual movement within the separate boxes to sug-
gest the temporal dimension of experience. Rather, the

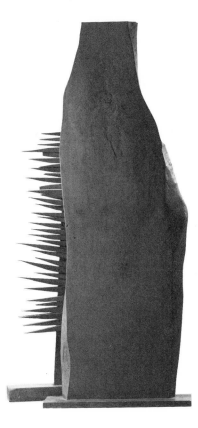

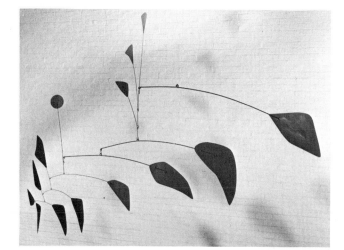

254. Alexander Calder. *Big Red*, 1959. Painted sheet metal and steel wire, 74 x 114 inches. Whitney Museum of American Art, New York; Gift of the Friends of the Whitney Museum of American Art.

255. Alexander Calder. *Thirteen Spines*, 1940. Sheet steel, aluminum, iron cable, steel shaft, paint; 86⅓ inches high. Wallraf-Richartz-Museum, Cologne.

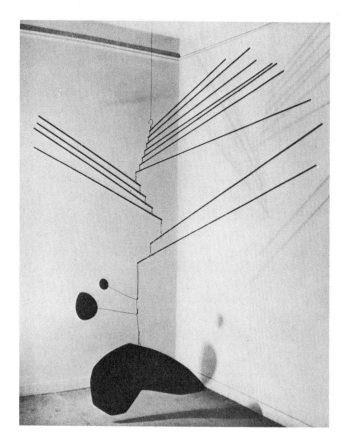

modular structure itself creates an analogue of the sequential piling up of moments, one after another (Fig. 252). The rhythmic repetition of the units, and within them the regularized beat of visually similar components, establishes a formal language by which to create the sensation of real time.

To turn from the somber density of a wall by Nevelson to the fragile linearity of a Calder mobile may seem like shifting between two entirely different worlds (Fig. 254). Indeed, Alexander Calder's art has never involved itself in the issue of the found object, nor in the sense of cloistered depth suggested by the structure of the box. In fact, the first exhibition of Calder's fully ambitious sculpture took place under the aegis of Abstraction-Création, a Paris group of nonrepresentational artists whose vocabulary was made up of hard-edge geometric forms with no associations to the objects of everyday use. Calder's work for that 1931 exhibition was entirely a matter of abstract geometries wrought by the linear intersections of bent metal wire.

But it is important to acknowledge that Calder's attachment to abstraction was always qualified by a deep commitment to his own sense of the temporal component of experience. So that when Calder went to visit Mondrian in 1930, and was deeply impressed by what he saw, he nonetheless felt impelled to introduce the idea of real motion to the painter. "I thought at the time how fine it would be," Calder noted, "if everything there moved; though Mondrian himself did not approve of this idea at all."

Calder's interest in motion had manifested itself in the late 1920s in Paris through the vehicle of his Circus which he performed to a wide circle of artists, musicians and writers. Set in Calder's studio in Montparnasse, the Circus was formed of wood and wire toy figures. There were bareback riders, trapeze artists, sword swallowers, weight lifters and trained dogs, each one going through the procedures of its "act" in a contracted, miniaturized space. Both Calder and his audience relished the suspense generated in that tiny theater of childlike fantasy — the dilated time it took for the act to complete itself, the unpredictable outcome of either success or failure (Fig. 256).

In the course of these performances Calder made many friends among the Parisian art world, one of whom was the Surrealist painter Joan Miró, who shared both Calder's love of the circus and his concern for the intensely focused world of fantasy (Fig. 257). Yet Calder understood his own fantasy space to be, unlike the static field of painting, dependent on the course that objects took as they moved through time.

Calder's response in Mondrian's studio was, therefore, not simply an idle wish or a casual observation. Instead, Calder was imagining what it would be for the work of

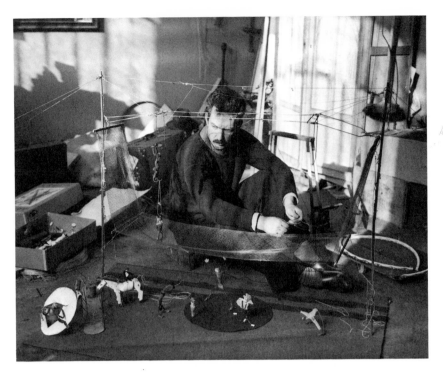

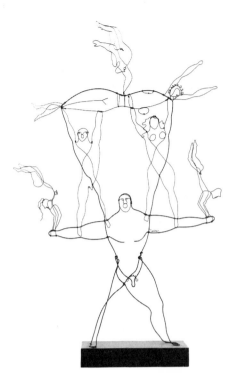

256. Photograph of Alexander Calder operating his Circus, 1929, by André Kertesz.

257. Alexander Calder. *The Brass Family*, 1929. Brass wire, 64 x 41 x 8½ inches. Whitney Museum of American Art, New York; Gift of the artist.

art to reverberate with the patterns it seemed to form and re-form within his own consciousness as he studied it. He was envisioning what it would be like if the course of his own formal "reading" of the work — a mental act which took place in time — were to be projected outward into the actual space in which he moved and the work resided. Through this wish that consciousness be projected outward, and in its corollary acknowledgment that the course of consciousness is inherently temporal, Calder's sensibility can be seen as tied to that of Giacometti's or Cornell's — despite the distance that separates the formal vocabularies they chose to use.

Out of the hypothetical situation that Calder fantasized in Mondrian's studio the mobile was born. It is therefore not surprising that the mobiles initially took the form of motorized paintings, their brightly colored geometric elements organized along the two-dimensional plane of an implied picture surface, the motor-driven armatures creating a constant shift of pattern between the separate lines and planes. But by 1932 Calder had turned to the idea of wind-driven motion; and with the wind as his energizing factor, Calder became involved, once again, in two of the central aspects of the earlier Circus performances. One of these concerned the erratic quality of the wind which caused the mobiles to engage in unpredictable courses of motion. The other had to do with the sensation of suspense built into an object whose internal

coherence was entirely a matter of loads and counterweights: the sustained equilibration of a balancing act.

Calderberry Bush, the first large wind-driven work, sets the pattern for the extraordinary fusion of oppositions on which the subsequent mobiles are based (Pl. 44). Most simply put, these are the oppositions between the rationality of its design and structure and the whimsy and irrationalism of its movement. From the open, pyramidal cage of its base, the work extends a slender, six-foot mast which in turn supports a linked chain of rods and planes. The extraordinary openness of the sculpture — its quality of being a revealed skeleton from which all flesh has been stripped away — allows the viewer fully to inspect and comprehend the work's structure. One can see that the heavy ball at the base of the mast is a counterweight to the more numerous but lighter elements at the object's summit. But against the logic of this revealed system of physical balance the counterevidence of a strongly felt visual imbalance is at work. So that one feels a tension between what is revealed to thought and what is given to sensation. The work's unpredictable and sporadic movements, when they begin, heighten rather than dispel this tension.

Calderberry Bush seems to be a calculated and highly determined object which is at the same time open to the whimsy and self-determination which we associate with free will. Thus, no matter how open the object is to in-

spection, one still feels it to have an interior current of energies which are paradoxically not available to one's vision. The sense that the work somehow has a private interior from which the voluntarism of its action arises is further enhanced by the anthropomorphism that clings to the sculpture no matter how abstract its constituent forms. The mast suggests the spine of a human figure and the branching elements at the top allude to head and arms. Thus, to the logic and lucidity of an abstract construction, Calder adds the quality of spontaneous impulse and changing feeling that we associate with the experience of our lived humanity. In this continual play between what is rational and what is not, one feels the work to manifest or exteriorize the moods and patterns of the Unconscious.

Calder's art is impressive in the range of feelings it can evoke and explore. Where *Calderberry Bush* projects a sense of fastidious delicacy, the later *Thirteen Spines* (1940) is far more brooding and ritualistic (Fig. 255). In its vertical stacking of spikey and slightly threatening

elements, it suggests a connection with the image of the totem that came to obsess so many of Calder's American fellow sculptors in the decade of the 1940s.

As we have already seen, the totem image had been a model for Louise Bourgeois's pole sculptures with their vertically assembled aggregations of elements; as well, it was the basis for some of the earliest objects Louise Nevelson constructed. Similarly, the totem played an important formal role in the development of Isamu Noguchi's sculpture during the 1940s. The 1943 *Monument to Heroes* suspends shapes of wood and bone in the openings that form the regular intervals along the sides of a rising column (Fig. 260). The quality of this sculpture is that of the kind of fetish object in which the Surrealists took an enormous interest.

The standing marble figures Noguchi made during the mid and late 1940s, works like *Kouros* or *Cronos*, projected a similar aura of ritual presence, despite the classical cast of their Greek names (Fig. 258). Assembled from separate marble planes that were slotted into one another

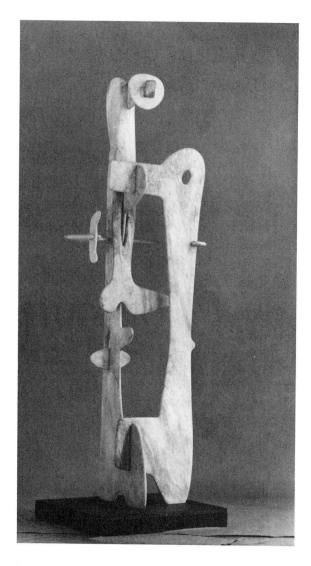

LEFT: 258. Isamu Noguchi. *Kouros*, 1944–45. Pink Georgia marble, 117 inches high. The Metropolitan Museum of Art, New York; Purchase, Fletcher Fund, 1953.

ABOVE: 259. Isamu Noguchi. *Night Land*, 1947. York fossil marble, 14 x 45 x 35 inches. Collection of Madelon Maremont Falxa.

at right angles, these works envision the human body as an aggregate of emblematic forms.

Noguchi's use of the totem's composite makeup is only one evidence of his interest in exploring the space and time of ritual. His work on stage settings and sculpture to be used as stage props is a further expression of this commitment. As he wrote, "Theatre is a ceremonial; the performance is a rite. Sculpture in daily life should or could be like this. In the meantime, the theatre gives me its poetic, exalted equivalent." And he added, "My interest is the stage where it is possible to realize in a hypothetical way those projections of the imagination into environmental space which are denied us in actuality." In the space of the performance and through its temporal unraveling, Noguchi could embed his sculpture in an experience of lived time (Fig. 261). That he should want this for his work links him to the concerns with the temporal conditions of consciousness and the desire to project this outward into actual space that we have seen expressed by so many of his American contemporaries.

Many of Noguchi's most interesting formal departures have similar thematic ties. *Night Land,* a black stone sculpture of 1947, participates in the Cornellian strategy of investing something that appears to be an object of use with the resonance of projected fantasy (Fig. 259). Resembling a low-lying table, *Night Land* allies itself with the actual space of the viewer. It is an early expression of Noguchi's interest in asserting the floor as the base of several sculptural elements distributed along its surface.

In Noguchi's thinking the totem image was one element in a larger space of ritual which the viewer himself could enter. The possibilities for this entry were already prefigured in that Surrealist view of the totem as the material residue of unconscious desires energized by magical beliefs. But for some of Noguchi's contemporaries the totem functioned as a much more threatening image which needed to be secured as something set apart from the viewer's space (Fig. 263). Both Seymour Lipton and Herbert Ferber began working in relation to a standing totemic figure in the late 1940s and early 1950s, both of

260. Isamu Noguchi. *Monument to Heroes,* 1943. Paper, wood, bones, string; 30 inches high. Collection of the artist.

261. Isamu Noguchi. *Shrine of Aphrodite,* 1962. Wood, canvas, and metal; from set for *Phaedra,* choreographed by Martha Graham. Collection of the Martha Graham Center for Contemporary Dance, Inc., New York. Photograph by Martha Swope.

them envisioning this presence as dramatically withdrawn from the continuous space of the real.

Lipton creates this sense of encapsulation by constructing his figures from curved metal sheaths which project the figure as a dense, enclosed and armored being; while Ferber uses a schematic cage to contain the brazed metal elements that form his animistic image (Figs. 262, 264). For both sculptors the part-by-part syntax of the totem is a way of depicting the figure in terms of the powerful psychic forces at war within the container of the human body. By using the visual metaphors of armor or cage, these sculptors could depict both the outer bulk of the human body *and* allow a view into its expressionistically wrought interior. In the late 1940s, welding became their instrument for building this openwork, three-dimensional construction.

Welding was also the technique by which David Smith elaborated his image of the totem in a series that began in the late 1940s and continued through the course of his mature career. But unlike the images that Ferber or Lipton fashioned, Smith's totems appear to knife across the viewer's line of sight, their initial strangeness arising from their heedless lack of volume, from the almost aggressive flatness of their bladelike assemblies. Against the background of that compulsive interest in volume that forms the modern sculptural tradition, Smith's Tank-totems have the presence of a kind of cutout.

ABOVE LEFT: 262. Seymour Lipton. *Pioneer,* 1957. Nickel-silver on Monel metal, 94 inches high. The Metropolitan Museum of Art, New York; Gift of Mrs. Albert A. List, 1958.

ABOVE RIGHT: 263. Barnett Newman. *Here I (to Marcia),* 1950, cast 1962. Bronze, 96 x 26 x 27 inches. Collection of Annalee Newman.

RIGHT: 264. Herbert Ferber. *Homage to Piranesi II,* 1962–63. Copper and brass, 90 x 46½ x 46½ inches. The Metropolitan Museum of Art, New York; Gift of William Rubin, 1965.

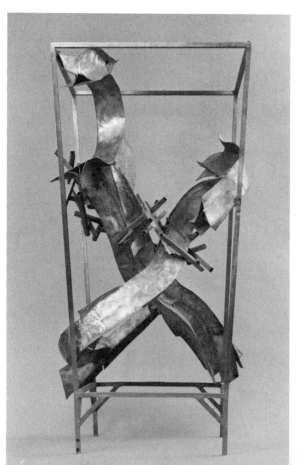

Projecting two disclike elements from a tall, vertical stem, *Tanktotem V* earns its title in the way it suggests the presence of the human figure (Fig. 265). The discs, fashioned from tank tops or boiler heads, locate the lower parts of the torso; while the channellike vertical section draws the body upward into a representation of the totemic head. Yet, in the very way that the human image is brought into existence, one feels confronted not so much by a representation of figural presence, as by an emblem of it. And this emblematic quality lies less in the economy of form with which the figure is stated, or even in the way the steel channels that form the stem establish themselves as linear, or drawn, than in that extreme two dimensionality which gives to the work the insistent aspect of something like a signpost set up freely within one's space.

Although *Tanktotem V* is part of a long series of sculptures to which Smith gave the designation "totem," it is a member of an even larger body of works that investigate the human figure without specific mention of a ritual object. Some of these Smith named Agricola, some he called Voltri or Cubi. But whatever the title, Smith consistently envisioned the body as occupying a strange borderland between the human figure and the abstract sign.

If he did so it was because his thinking about sculpture was deeply affected by what he saw as the essence of totemism itself. The form of his work and the notion of the totem became two interlocking and reciprocal metaphors which pointed to the same thing: the goal of effecting a profound physical separation between the viewer and the work of art.

In sketchbooks from the 1940s, into which Smith entered notations for sculpture and cryptic expressions of the ideas which interested him, one finds drawings of objects labled "totem" and references to psychoanalytic texts. Given Smith's interest in Freud's writing, it is probable that Smith's view of totemism was drawn primarily from *Totem and Taboo,* a work which insistently tied those primitive practices into the contemporary structure of relationships described by the psychoanalytic model. For Smith, then, the totem was not an archaic object. Rather, it was a powerfully abbreviated expression of a complex of feelings and desires which he felt to be operative in himself and within modern society as a whole.

In *Totem and Taboo,* totemism is depicted as a system used by primitive cultures to prohibit incest. It works as a set of strictures and codes to insure that members of a given tribe or clan will not marry or cohabit with each other but will be forced to seek partners outside their own tribal families. Identifying the tribe itself with a particular totem object — usually an animal — each tribe member takes on the name of that object. By doing so, the lawlike taboos that apply to the totem animal apply to its

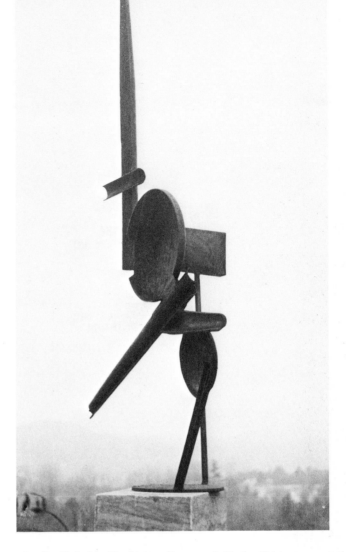

265. David Smith. *Tanktotem V*, 1955–56. Steel, 96¾ x 52 x 15 inches. Collection of Howard and Jean Lipman.

266. Jacques Lipchitz. *Figure,* 1926–30, cast 1937. Bronze, 85½ inches high. The Museum of Modern Art, New York; Van Gogh Purchase Fund.

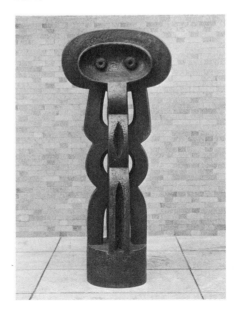

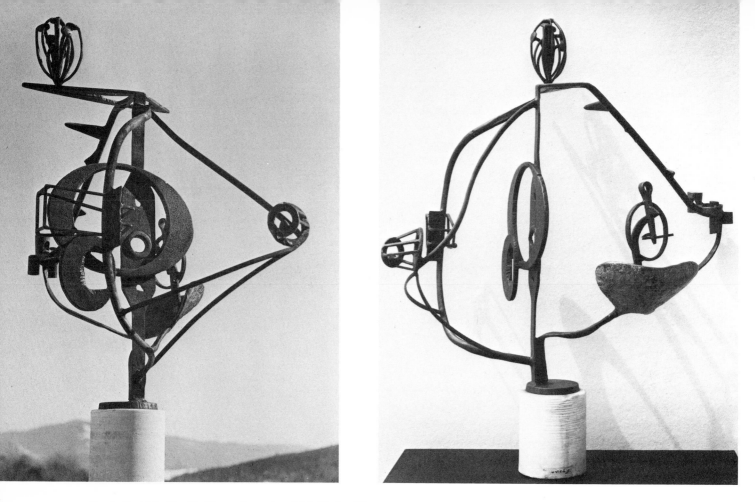

267a, b. David Smith. *Blackburn: Song of an Irish Blacksmith,* 1949–
50. Steel and bronze, 46¼ x 41 x 24 inches; stone base, 8 inches high
x 7¼ inches in diameter. Wilhelm-Lehmbruck-Museum der Stadt,
Duisburg, Germany.

human surrogates as well. These laws function to make the totem inviolate, establishing it as a sacred object, and setting it apart from all other things which might be physically appropriated. Usually it can not be killed or eaten, or even touched; for some tribes the taboo extends to prohibit looking at the totem. Since the tribesmen and women carry the name of the totem, the laws of taboo apply to themselves, making incestuous union a violation of the tribal law. Totemism was seen by Freud as a wide-spread and culturally significant admission of particular unconscious desires, acknowledged by the very system used to prohibit their fulfillment.

In Smith's eyes, this structuring of the relationship between two members of a set such that the appropriation of the one by the other is outlawed became important during the 1940s for both personal and political reasons. World War II was taking place, and Smith identified its carnage in the sexual and cannibalistic terms that made totemism suddenly relevant. What began to take place within Smith's art was the formulation of a sculptural strategy which would translate the taboos or embargoes of totemism into a language of form. The goal of this formal endeavor was to create an extreme distance be-

tween the sculptural object and its viewer — a distance that would allow neither a conceptual appropriation of the work nor an experience of sensuously possessing it through touch.

By 1950, in a work called *Blackburn: Song of an Irish Blacksmith,* Smith had consolidated this formal language. For *Blackburn* projects the human figure from within a sculptural syntax that establishes an extreme kind of visual disjunction. This disjunction depends on the fact that the two major views of the work — full-front and profile — are very difficult to read as aspects of the same object (Figs. 267 a, b).

The kind of interrelationship of aspects that *Blackburn* avoids is to be found, for instance, in a standing figure of 1926–30 by Jacques Lipchitz called *Figure* (Fig. 266). There the principle of construction is to intersect two nearly identical silhouettes at right angles, so that a full redundancy operates between all views of the work. If we are not surprised at the way front and side views mimic one another, it is because each of the figure's profiles have the appearance of links of a chain and therefore read as the external manifestation of an internal string of spherical spaces. Characterizing the inner body as a

string of invisible beads, Lipchitz's *Figure* projects all external facets of that interior as identical. Visually, the work is an interlock system in which the profile views can be read off the front view and the front can be fully determined by simply inspecting the work from the side. Because of this the structure of *Figure* is exceedingly easy to understand; it offers us a simply grasped conception of the organization of the body's volume.

In comparison to this, *Blackburn* projects its front image of the human torso as an open frame in which all sculptural detail appears to be pushed to the peripheries of the work, leaving its interior an open void through which the eye easily passes to the space beyond. The effect of this view is one of scant aloofness. It is a kind of hieratic image of the human figure, shown frontally, nearly symmetrical, noncorporeal, the body reduced to a silhouette of bent steel rod, the void of its interior contrasted with the machine elements which collect along its exterior rim. Unlike the Lipchitz *Figure,* the front view of *Blackburn* is completely deadpan. It does not, that is, prepare its viewer for an experience of its other perspectives, its other sides.

If the side view of *Blackburn* cannot be calculated from the front, this is because it accepts a whole complex of expression which the face of the work both negates and disdains. From the side, the interior of the torso is noisy with figurative incident, filled with a clutter of metal shape, like a shelf in a machine shop heaped with old tools and new parts. Dense with a jagged overlay of forms, the torso from the side has an effect of agitated confusion, unlike the open serenity of the frontal view. And the relationship of head to body changes as well. Instead of the former view's declaration of symmetry, there is now an eccentric displacement of the head off axis, which underscores the rich tension the work generates from the side. From this profile of *Blackburn,* one feels, then, that one is not so much seeing another view of the work, as that one is seeing almost . . . another work.

It is by insisting upon this discontinuity between its separate views that Smith captures and incorporates in *Blackburn* the fundamental law of totemism, rather than merely resuscitating the surface primitivism of its original forms. Totemism was about the establishment of distance between the object and its viewer, about the embargo on the possible appropriation of it, about the maintenance of it as something set apart. By refusing to endow his work with a sense of formal inevitability by which the sculpture could be delivered over to the spectator's intellectual grasp, Smith creates a formal analogue of this separateness.

In exploring this language of formal disjunction Smith removed his work from the parental umbrella of Constructivist aesthetics under which many of his fellow

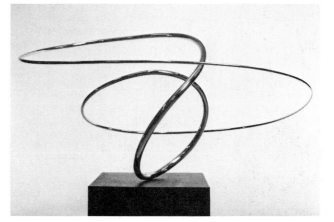

268. José de Rivera. *Construction #107,* 1969. Stainless steel forged rod, 21½ x 41 x 41 inches. Hirshhorn Museum and Sculpture Garden, Smithsonian Institution, Washington, D.C.

sculptors worked. For his American contemporaries were guided by the procedures of a Constructivist logic which was concerned with displaying the unity of the sculptural object. Perhaps the purest form of that logic is to be found in the work of José de Rivera who used simple, twisted loops of gleaming chrome to imply the generation of a larger volume from the slow, spiral movements of a fibrous core (Fig. 268). The work of George Rickey and Len Lye further develops this concept of using the movements of lines through space as a way of netting a sense of volume (Figs. 269, 270). In addition, this sense that volume should be grasped as the logical emanation of a central structural principle made the medium of relief sculpture extremely compatible to Constructivist sensibilities. For relief implies that one need but a single view of the object to grasp its entire three-dimensional development. The essence of that development can be made available from one viewpoint only. Gertrude Greene's and Theodore Roszak's early reliefs are examples of this conviction (Figs. 274, 272).

As well, the work of Richard Lippold, Sidney Gordin and Ibram Lassaw proceeds from this Constructivist desire to project each aspect or facade of a three-dimensional object as a symmetrical and redundant expression of a central idea (Pl. 42). Lassaw's *Star Cradle,* made in 1949, about the same year as *Blackburn,* is separated from Smith's arbitrariness and premeditated incoherence by its own strict concern for unity. In *Star Cradle* the principle of intersecting planes establishes the center of the work as a source from which its fins radiate with total repetitiveness and symmetry. Looking at *Star Cradle* from its "front," we are aware that if it were to rotate on either its horizontal or vertical axis, the work would

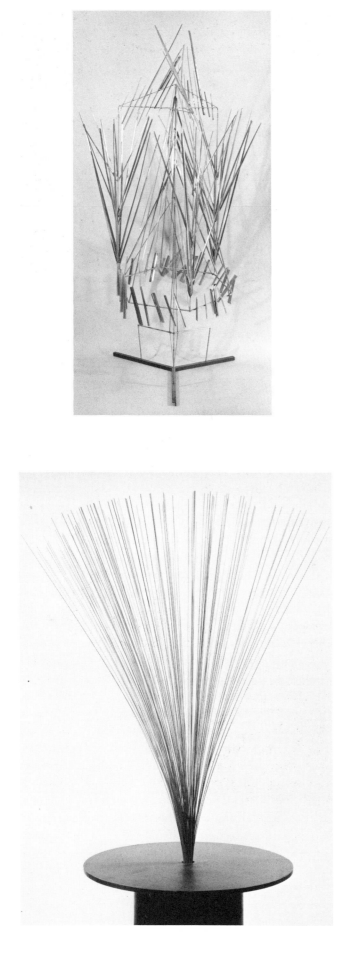

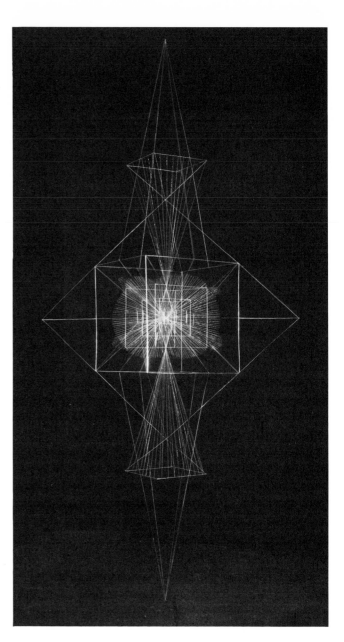

ABOVE LEFT: 269. George Rickey. *Omaggio a Bernini,* 1958. Stainless steel, 68½ x 36 x 36 inches. Whitney Museum of American Art, New York; Gift of Mr. and Mrs. Patrick B. McGinnis.

LEFT: 270. Len Lye. *Steel Fountain,* 1959. Stainless steel rods and motor, 85 inches high. Whitney Museum of American Art, New York; Gift under the Ford Foundation Purchase Program.

ABOVE RIGHT: 271. Richard Lippold. *Variation Number 7: Full Moon,* 1949–50. Brass rods, nickel-chromium and stainless steel wire; 120 inches high. The Museum of Modern Art, New York; Mrs. Simon Guggenheim Fund, 1950.

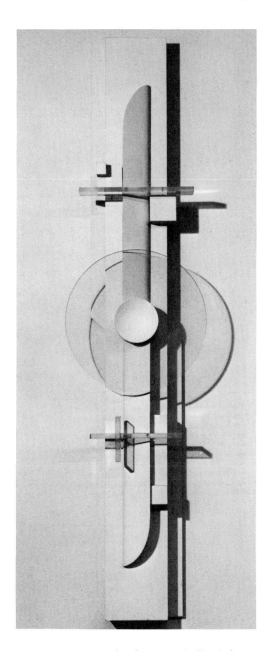

ABOVE LEFT: 272. Theodore Roszak. *Vertical Construction*, 1942. Plastic and painted wood, 76 x 30 x 5 inches. Whitney Museum of American Art, New York; Gift of the artist.

ABOVE RIGHT: 273. Ibram Lassaw. *Star Cradle*, 1949. Stainless steel and lucite, 11¼ x 16 x 11¼ inches. Collection of the artist.

RIGHT: 274. Gertrude Greene. *Space Construction*, 1942. Painted composition board and wood, 39½ x 27½ x 3 inches. Whitney Museum of American Art, New York; Gift of Balcomb Greene.

ABOVE AND ABOVE RIGHT: 275a, b. David Smith. *Voltri XVII*, 1962. Steel, 95 x 31⅜ x 29¾ inches. Collection of Lois and Georges de Menil.

BELOW: 276. David Smith. *Zig IV*, 1961. Painted steel, 95⅜ x 84¼ x 76 inches. Collection of the New York Shakespeare Festival; Gift of Howard and Jean Lipman to the Vivian Beaumont Theater.

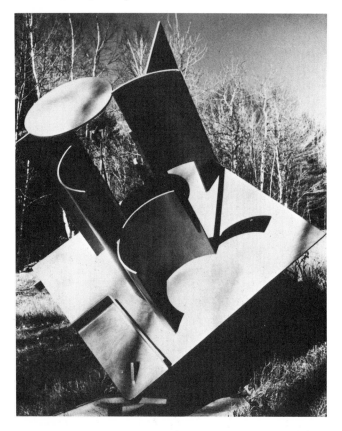

continue to display the same information about this structure (Fig. 273). The simplicity of *Star Cradle's* logic is multiplied and developed but not changed in the elegant and impressive *Variation Number 7: Full Moon* that Lippold made in 1949-50 (Fig. 271). The fact that *Full Moon* is to be viewed only from the front, without any diminished sense of completeness, testifies to the sculptor's preoccupation with the logic of its organization.

In contrast, Smith's lack of logical coherence is expressed not only formally, through his rejection of the principles of geometric organization, but thematically as well. For, by using the metaphor of totemism, Smith distances himself from the kind of technological content that characterized an orthodox Constructivism (Fig. 278).

Looking from the time of *Blackburn* ahead to the last years of Smith's career, the same formal and the same thematic concerns continue to shape his work. *Voltri XVII* of 1962, for example, has that same avoidance of a predictable relationship between front and profile view (Figs. 275 a, b). From the front it assumes that same quality of hieratic verticality and flatness, while from the side it relaxes into an image of somewhat disheveled sensuousness.

In Smith's later work he found many other formal equivalents for the strategy he had used in *Blackburn* to state the work of sculpture as something that would elude the viewer's conceptual appropriation. In some objects, like *Cubi I*, he employs a sense of precariousness or imbalance to dispel the idea that the work devolves from a stable, fixed spine or core (Pl. 49). As well, he burnishes the stainless steel face of the forms so that there will seem to be a separation between the surface of the work and its underlying volume.

But whatever the formal means employed, Smith's sculpture consistently proceeded from his own response to the fact of the Unconscious. He was in this sense every bit as much a child of the 1930s and 1940s as were Cornell or Calder. Where his vision differed from theirs was in his own sense of the brutality and violence potential in the unconscious life of man. This destructiveness was a force that Smith explored in the privacy of his sketchbooks and notebooks and in the small-scale sculpture he made during the 1940s. It was as well a violence that Smith projected onto the seeming neutrality of his mature choice of medium: "Possibly steel is so beautiful," Smith wrote, "because of all the movement associated with it, its strength and functions. . . . Yet it is also brutal; the rapist, the murderer and death-dealing giants are also its offspring." Smith's response to the Unconscious was to turn the forces of consciousness against it — to create a formal language of prohibition that would acknowledge the fact of unconscious desire, while at the same time aborting it. The ethical and formal commands of distance between viewer and object became completely interrelated in Smith's work; their effectiveness as sculpture depended on their simultaneous maturation (Figs. 276, 277).

By the mid-1960s David Smith strove to increase the abstractness of his sculptural language as well as the scale through which to project it. In this one feels that his last sculptures anticipate that change in mood that characterizes American art of the past decade. But if Smith's last work anticipates this change, it does not wholly join it. Throughout his career there is a powerful consistency of theme and a fidelity to the ground rules of structure that he had established in the late 1940s. The extraordinary originality of his contribution must still be seen through the perspectives of his own generation.

277. David Smith. *Voltri XIX*, 1962. Steel, 55¼ x 45 x 50 inches. Collection of Mr. and Mrs. Stephen D. Paine.

278. David Smith. *Voltron XVIII*, 1963. Steel, 110⅞ x 67⅛ x 15⅛ inches. On loan from the Empire State Plaza Art Collection through the auspices of Governor Hugh L. Carey. *Voltron XVIII* will be placed in its permanent location in the Empire State Plaza, Albany, New York, as of October 15, 1976.

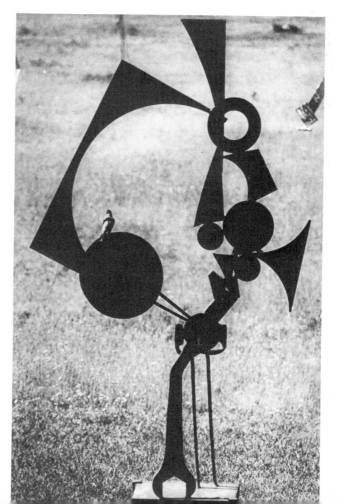

Two Decades of American Sculpture

A Survey

Barbara Haskell

THE CREATIVE ATMOSPHERE and international recognition achieved by Abstract Expressionist painting was not shared by American sculpture until the sixties. Although sculpture began to attract a greater number of young artists as early as the fifties, it was generally dominated by the Cubist tradition of open welded forms. By the early sixties, this situation had changed and American sculpture became as prominent and vital as painting. For the first time, recognizable movements developed which were solely sculptural. This emergence of sculpture as a primary force in the evolution and redefinition of art has been one of the crucial changes in American art during the last two decades.

During the fifties sculptors centered their attention on the attempt to translate the spirit and imagery of Abstract Expressionism into three-dimensions. One of the first major assimilations of the energy and spontaneity of New York School painting was John Chamberlain's recognition of the sculptural possibilities of crushed automobile body parts (Pl. 51). Although his technique of welding separate pieces of scrap metal together remained within the tradition of Cubist assemblage developed by Picasso and Gonzalez in the late twenties, Chamberlain transformed the basically planar format of the Cubists into an overwhelmingly volumetric statement. By limiting the manipulation of materials to fitting and welding, Chamberlain allowed the materials themselves to play a major role in determining form and expression. The

tension of crushed metal in these compressed monolithic forms corresponded to the power and gestural quality of the "action painters," particularly Willem de Kooning.

Mark di Suvero also succeeded in adapting the heroic vision and the bold, dynamic forms of New York School painters. His early work combined the thrusting imagery and powerful gesture typical of Franz Kline's paintings with a sense of monumental scale characteristic of the California landscape in which he grew up. His use of unrefined materials and found objects increased the expression of raw energy and power suggested by the scale and imagery (Fig. 280). The majority of di Suvero's works incorporate a mobile element held in place by a sophisticated system of suspensions and balances. These pieces are not meant to be precious objects, removed from life; rather, they are meant to be played on and interacted with physically.

The Constructivist qualities of geometry and careful engineering, always present in di Suvero's works, became increasingly evident as he limited his materials to industrially fabricated steel plates and I beams (Pl. 48). As his work evolved from the massive forms of the early period to the structural clarity and linear elegance of his recent pieces di Suvero continued to utilize the Constructivist compositional elements of strong diagonals, tetrahedral forms and precise suspension systems.

Concurrent with but independent of Chamberlain and di Suvero, a group of sculptors in California adapted the spirit of Abstract Expressionist painting to the ceramics medium. These artists, notably Peter Voulkos, John Mason and Kenneth Price, pioneered a direct attack on the traditional concerns of ceramicists and forced the

OPPOSITE: 297. Walter De Maria. *Mile Long Drawing*, 1968, Mohave Desert. Chalk, lines 3 inches wide, 12 feet apart. Collection of the artist.

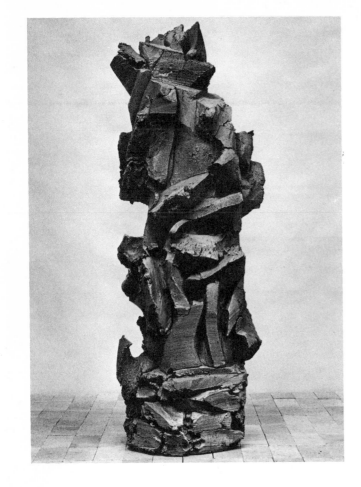

medium into the direction of sculpture by dealing with shape and surface without regard to utility or function.

Two traditions reinforced the basic orientation of these artists. One was a tradition in Japanese pottery which accepted asymmetry and apparent imperfection or incompleteness. The other, and perhaps more influential, was Abstract Expressionist painting, whose active, intensely energized surfaces could be translated directly into clay. Similarly, the gestural spontaneity and process involvement of Abstract Expressionism were suited to clay, which can be worked quickly when wet.

Although working closely together and sharing an anti-traditonalism regarding the ceramics medium, the approaches these artists took toward their work were fundamentally different. Mason and Voulkos did share a sense of exploration and involvement with physical size unprecedented in contemporary ceramics. Voulkos's working method, however, was to make a variety of thrown units which he assembled with epoxies, while Mason was more interested in the plasticity of wet clay and made his pieces as one unit (Fig. 279). Both these artists eventually felt alienated from the physical manipulation and size limitations that seemed inevitable with clay. Voulkos turned to bronze casting in the middle sixties and Mason began using standard, industrially produced firebricks in the late sixties. Although involved

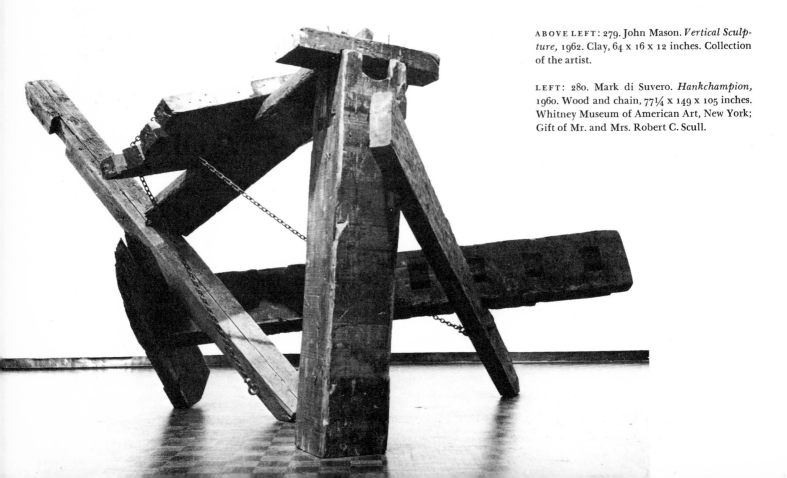

ABOVE LEFT: 279. John Mason. *Vertical Sculpture,* 1962. Clay, 64 x 16 x 12 inches. Collection of the artist.

LEFT: 280. Mark di Suvero. *Hankchampion,* 1960. Wood and chain, 77¼ x 149 x 105 inches. Whitney Museum of American Art, New York; Gift of Mr. and Mrs. Robert C. Scull.

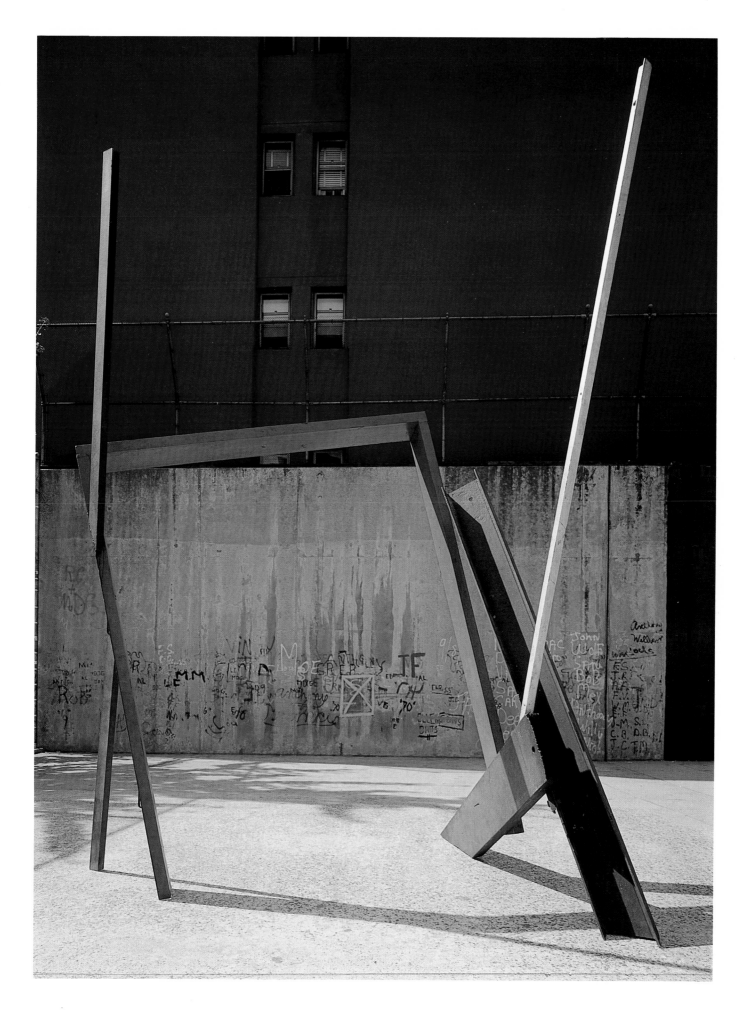

PLATE 48. Mark di Suvero. *Blue Arch for Matisse,* 1962. Steel and
painted steel, 132 inches high. Moderna Museet, Stockholm.

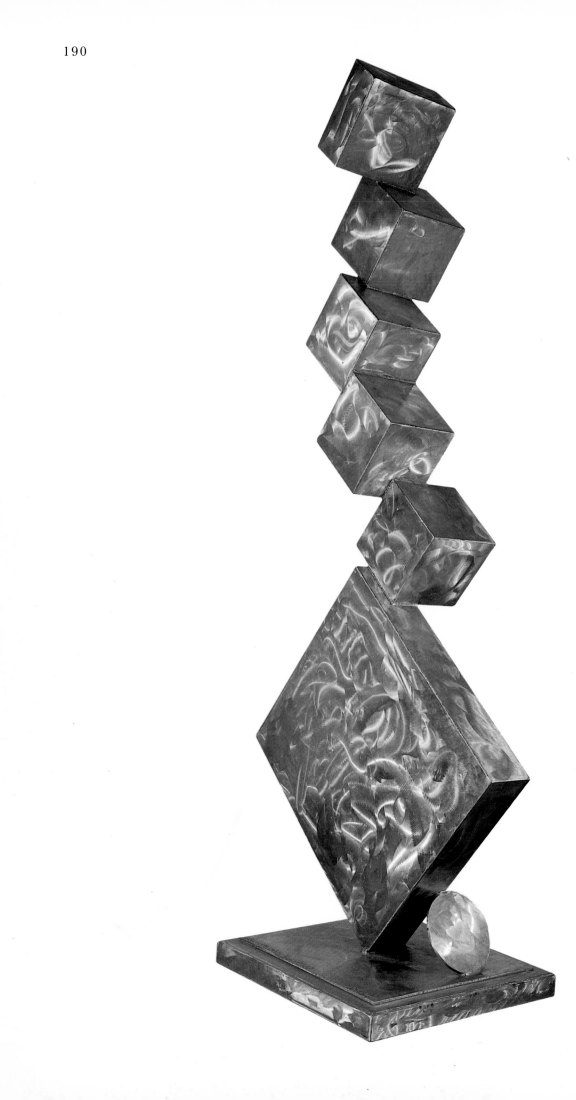

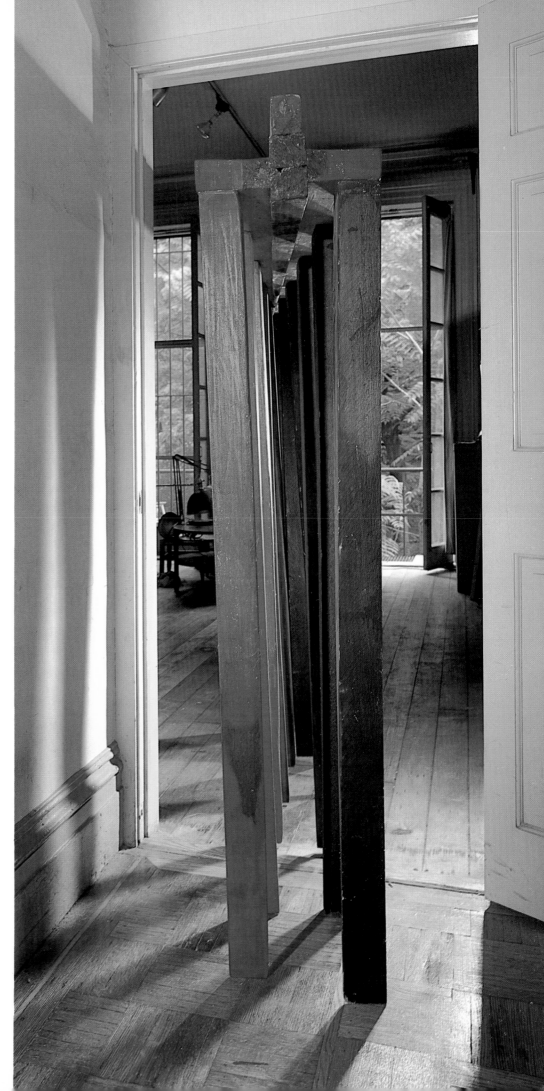

OPPOSITE: PLATE 49. David Smith. *Cubi I*, 1963. Stainless steel, 124 x 34½ x 33½ inches. The Detroit Institute of Arts, Detroit, Michigan. (See p. 160.)

PLATE 50. Louise Bourgeois. *The Blind Leading the Blind,* 1949. Painted wood, 84 x 84 x 7 inches. Lent by the artist, courtesy of Fourcade, Droll Inc., New York. (See Fig. 251, p. 168.)

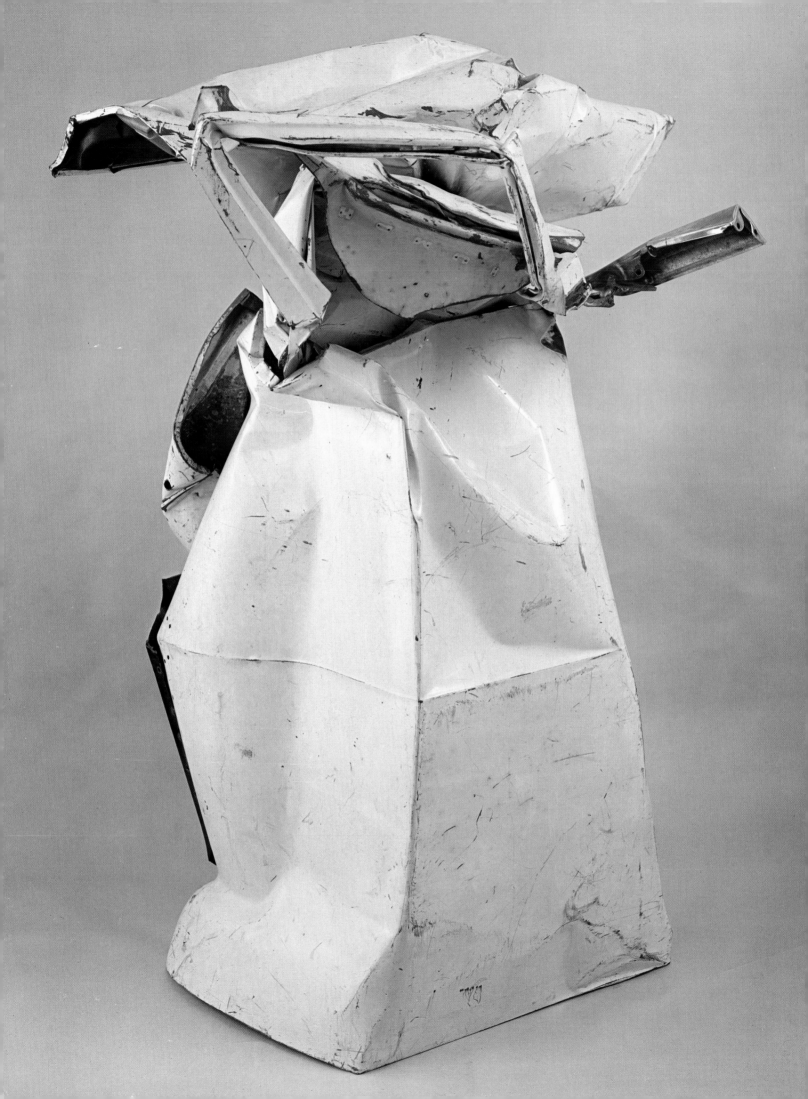

with Mason and Voulkos as a student, Price soon rejected the Abstract Expressionist aesthetic and turned to polychrome forms expressing an enigmatic biomorphism atypical of the ceramic tradition (Fig. 281).

A separate but concurrent assimilation of Abstract Expressionism occurred in the sculpture of Jasper Johns and Robert Rauschenberg. Both these artists utilized the painterly brushwork characteristic of the fifties but applied it to commonplace images found in their immediate environment. The introduction of ordinary objects into a work of art was not unique to this period. Beginning with the Cubists' collages at the turn of the century, fragments of the environment had been incorporated into artworks in order to invoke the "reality" of actual objects and thereby to fracture the separateness of the work of art. In the fifties, this question about the nature of the art object and its relation to life and representation was reformulated by Rauschenberg and Johns.

A dialectic exists in Rauschenberg's work between the presence of tangible objects and the spatial illusionism generated by intermediary passages of painterly brushwork (Pl. 53). Like Chamberlain, di Suvero and the junk sculptors of the late fifties, Rauschenberg's use of refuse from the environment is a rejection of the idea that one type of material is more or less appropriate to a work of art than another. In a sense it is a legacy of American Pragmatism which allows anything to be used providing it is available and serves the purpose. What differentiates Rauschenberg's work from the junk tradition is his utilization of objects for their value as referential images as well as for their formal properties. Rauschenberg's attitude toward his "palette" of objects is affectionate. He maintains a Zen-like acceptance of everything as having equal potential value (Figs. 282, 283).

Johns's confrontation with illusionism differs from Rauschenberg's. Instead of incorporating existing objects into his work, Johns's bronze sculptures suggest the original object and question the nature of illusionism by examining the relationship between the depicted and the

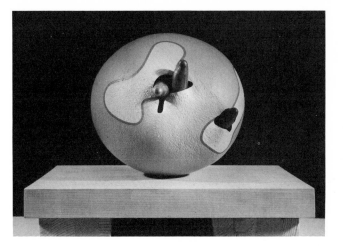
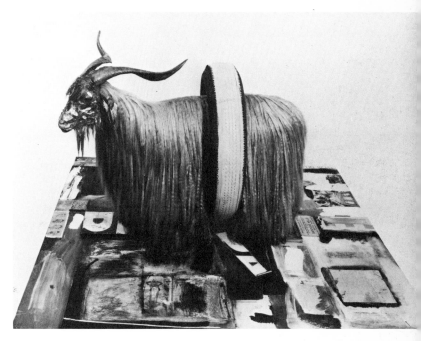
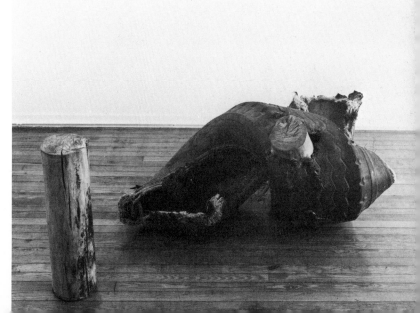

ABOVE RIGHT: 281. Kenneth Price. *S. L. Green*, 1963. Painted clay, 9½ x 10½ x 10½ inches. Whitney Museum of American Art, New York; Gift of the Howard and Jean Lipman Foundation, Inc.

RIGHT CENTER: 282. Robert Rauschenberg. *Monogram*, 1959 Combine with ram, 48 x 72 x 72 inches. Moderna Museet, Stockholm.

RIGHT: 283. Robert Rauschenberg. Untitled, 1973. Tire tread and logs, 28 x 63 x 40 inches. Collection of the artist.

OPPOSITE: PLATE 51. John Chamberlain. *Velvet White*, 1962. Welded automobile metals, 81½ x 61 x 54½ inches. Whitney Museum of American Art, New York; Gift of the Albert A. List Family.

"real" object (Pl. 59). In contrast to the activity and movement of Rauschenberg's work, Johns's elegant sculptures convey a sense of stillness and passivity.[1]

Given their use of images resembling familiar objects, Rauschenberg and Johns are considered precursors of the movement that became known as Pop art. For similar reasons, Claes Oldenburg and George Segal were also initially identified with this movement. However, since Pop art deals almost exclusively with images drawn from two-dimensional, reproduced sources such as photographs, newsprint and comic books, it has never been a particularly informative category for either of these artists.

Although everyday objects are the inspiration for Oldenburg's expression, he is also a formal artist and his work can be seen from this perspective. All his objects are reducible to a few simple forms, basically cones, cylinders and cubes. It is the variation and combination of these forms that produce the subject. For example, the *Hamburger* is simply four stacked cylinders; the *Ice Bag* is a disk on top of a cone; the *Fagends* are cylinders. These essential geometric forms go through intricate metamorphoses or "impersonations" as they shift their identity from one image to another. Once Oldenburg's objects are recognized as combinations of simple geometric forms which are repeated and modified, formal correlations to a whole range of diverse objects can be seen: the *Ice Bag* relates to Mount Fuji, to a bag ashtray, to a punching bag, to an ice-cream cone or to baseball bats. They are part of the same formal "family" or iconographic genealogy in which each object echoes or "rhymes" with the forms of other objects (Fig. 284).

Oldenburg bases his art on the parody inherent in opposites. By substituting or displacing the intrinsic char-

acteristics of objects, Oldenburg creates an art of irony and humor. A rigid object like the saw might be presented in soft, yielding materials, and a soft object, like a baked potato, might be executed in rigid materials. Contradiction and its resulting humor also lie in transformations of scale, as in the enlargement of a trivial object to colossal proportions (Fig. 285).

Humor exists because, in spite of the alteration of characteristics that Oldenburg imposes on his objects, the basic nature of the original object is still understood. The object itself sets up mental expectations which the work of art contradicts. The humorous, almost absurd, effect of the soft plug derives from the fact that people know the nature of a hard plug. Not only are the shape and size of the original known, but its function, too, is known. Thus when Oldenburg denies that function—making a soft saw that cannot saw, food that cannot be eaten, a nose that is a freeway tunnel—the result is humorous.

The human body is continually evoked in Oldenburg's work through fragments of it, such as in the *Nose* and *Knees,* or through allusion and metaphor. All of Oldenburg's objects are surrogates for the body or parts of the body and one can easily discern in his cast of objects the corporeal human counterpart of each piece: a human face in the *Geometric Mouse;* a body in the *Three-Way Plug;* breasts in the *Light Switches* and *Fireplug.* Equally as important as the parallels between the represented object and specific body parts is the generalized suggestion of the human body conveyed by the soft, yielding quality of his soft sculpture. The presence of man is additionally evoked through objects of human association: utilitarian items, wearing apparel and food.

Like Oldenburg, Segal's approach to objects is consonant not only with representation but with abstraction as well. To focus only on the plaster figures and ignore the color, textural and spatial relationships between figures or between a figure and another object is to miss the expressiveness of his pieces. Segal's compositions are characterized by a formal severity and sparseness that has been compared to the work of Jacques Louis David and Edward Hopper.[2] Like these painters, Segal makes use of rectilinear and parallel composition in which verticals are opposed to horizontals and formal elements echo throughout the whole (Pl. 63).

Segal is interested in the human condition and uses his plaster casts and objects from the environment to explore how people relate to the shapes and things around them. Feelings of solitude and alienation are often evoked by the frozen quality of his figures.

Segal's achievement also lies in the area of expressive individual figures. He is interested in capturing revelatory psychological gestures or characteristic stances of the body. Since his casting method takes a considerable

LEFT: 284. Claes Oldenburg. *Dormeyer Mixer,* 1965. Ink and collage of clippings on notebook page, 10⅞ x 8 inches. Collection of the artist.

RIGHT: 285. Claes Oldenburg. *Project for a Beachhouse in the form of the Letter Q,* 1972. Pencil, crayon and chalk on paper; 29 x 23 inches. Collection of Mrs. Melville J. Kolliner.

period of time, the sitter's artificial poses are necessarily broken down. Segal himself is quite conscious of the expressive potential of gesture: "A person," he says, "may reveal nothing of himself and then suddenly make a movement that contains a whole autobiography."[3]

Another mode of expression utilizing recognizable images is represented in the works of Lucas Samaras, H. C. Westermann and William T. Wiley. Of these artists Samaras is the most closely affiliated with the Surrealists' desire to explore the poetic transformations that result from the displacement and juxtaposition of unrelated objects. Although a strong sense of formal, geometric structures underlies his work, he is primarily interested in the irrational and the psychologically charged.

The world that Samaras has created is one of narcissistic self-absorption in which every object alludes in some way to his own body through mirrors, photographs, X rays and reproductions or drawings of body parts. The Mirror Rooms extend this narcissistic involvement to the viewer (Fig. 286).

Ambivalence and opposition underlie all Samaras's work. The brightly colored, shining objects that often cover or fill his sculptures are a festive glitter of pins, knives and razor blades that express the duality of pleasure and pain, violence and beauty (Fig. 288). Similarly, the eroticism pervading his work is both inviting and

286. Lucas Samaras. *Corridor*, 1967. Glass mirror and crystal spheres over wood structure, 96 x 102 x 93 inches. Los Angeles County Museum of Art; Gift of the Kleiner Foundation.

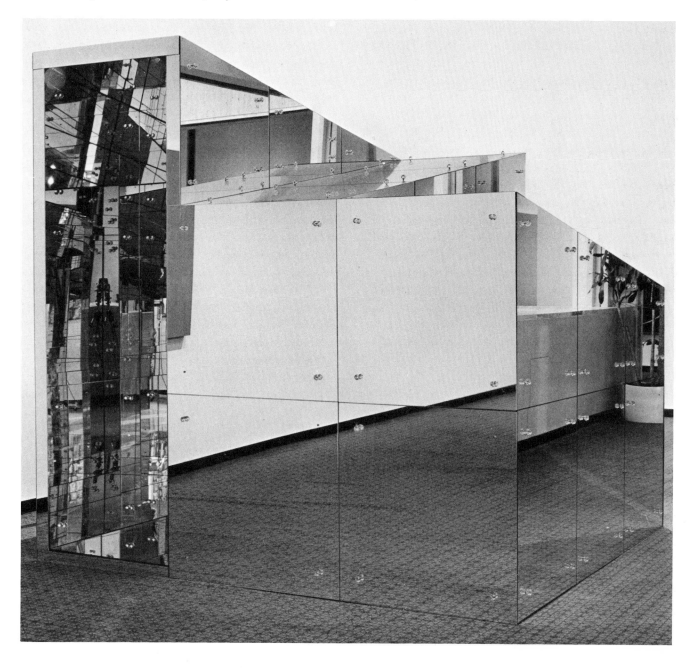

menacing. Even the geometry of his containers is subverted by their randomly arranged surfaces and gay colors. In the Mirror Rooms, the ubiquitous structural device of the "container" is undermined by the mirrors' reflecting surfaces.

Enigma and paradox exist, too, in the work of Westermann and Wiley. In contrast to the fetishistic, obsessive character of Samaras's work, their art is a synthesis of Surrealism and a Dadaist predilection for visual and verbal puns. Although Westermann often incorporates words into his pieces and relies on a literary visual rhetoric, Wiley makes greater use of the verbal tradition. Whimsical accounts of commonplace events in ordinary life are inscribed on many of his watercolors. These narratives resemble Oriental anecdotes in their apparent obscurity and the treatment of small events and details as revelations. Wiley fuses an embracing, affirmative attitude toward nature and reality with a humor generated by sophisticated language games. Often his wit takes the form of riddles, puns and double meanings as exemplified in his titles *Know Place in Particular* and *No Mad is an Island*.

The images in Wiley's three-dimensional constructions relate directly to his paintings and watercolors (Pl. 54). They unite his Dadaist and Surrealist orientations with an interest in the expressive qualities of fragile, informally organized, organic materials that relate to the loose structures of the process artists (Fig. 287).

Wiley's influence as a teacher and as a presence has been germinal to the San Francisco region. His predisposition for "art about art" and his interest in punning and word games have influenced many artists, including Bruce Nauman. Nauman's early rubber, fiberglass and neon works (Fig. 325) and Wiley's sculptures have both been related to the witty, visceral sensibility that became known in northern California as "funk."

LEFT: 287. William Wiley. *Ship's Log*, 1969. Mixed-media construction, 82 x 78 x 54 inches. San Francisco Museum of Art.

ABOVE: 288. Lucas Samaras. *Untitled Box Number 3*, 1963. Pins, rope, stuffed bird and wood; 24½ x 11½ x 10¼ inches. Whitney Museum of American Art, New York; Gift of the Howard and Jean Lipman Foundation, Inc.

ABOVE: 289. Donald Judd. Untitled, 1965. Aluminum and anodized aluminum, 8¼ x 253 x 8¼ inches. Whitney Museum of American Art, New York; Gift of the Howard and Jean Lipman Foundation, Inc.

RIGHT: 290. Donald Judd. Untitled, 1973. Carbon steel; each box, 9 x 40 x 31 inches. Private collection.

A crucial shift in focus separates the work of these sculptors from the work of those that followed in the sixties. The primary formal concern of artists has traditionally been compositional — i.e., the harmonious balancing of major and minor parts in hierarchical relationships. In the fifties painters such as Barnett Newman and Mark Rothko introduced an entirely new set of attitudes which reversed these traditional suppositions regarding compositional arrangement. In their "non-relational" paintings, pictorial images were related exclusively to the structure of the framing edge rather than to other analogous shapes on the field. Following their example, many artists stopped addressing themselves to the ordering of internal relationships. Although composition could not be avoided completely, it became less important than the communication of the expressive qualities inherent in the materials themselves. Just as painters downgraded design in order to elevate color to prominence, sculptors sought to de-emphasize composition so that the physical properties of materials would be perceived with greater clarity. The Minimalists sought to achieve this by utilizing symmetrical, unitary wholes and systems based on modular repetition or series progression (Figs. 289, 290). While they succeeded in eliminating hierarchical relationships, they nevertheless continued to impose a structure on their materials. Not until the late sixties did the process artists achieve the abrogation of compositional control by allowing the procedure used in making the work and the inherent properties of the materials to determine the form.

This emphasis on the physical properties of materials

correlates with the formalist thinking of the sixties in which works of art were discussed in terms of their material properties rather than in terms of their expressive or emotional connotations. This formalist orientation was influenced by Clement Greenberg's view that each of the artistic disciplines should strive for the most explicit statement of those aspects belonging exclusively to that medium and should exclude those properties not in keeping with the medium's essential nature. In the visual arts, this amounted to stressing the physical qualities of an art work and eliminating the subjective or metaphysical.

Emphasis on the objectively physical reflected the literalism which dominated the art of the sixties. Literalism — the rejection of illusion and the demand for actual rather than depicted forms and space — had characterized the work of Rauschenberg and Johns in the fifties. In Rauschenberg's "combine" paintings, images were treated in a literal manner by being actually incorporated into the work as opposed to being depicted by the artist. "I don't want a picture to look like something it isn't," he said. "I want it to look like something it is. And I think a picture is more like the real world when it's made out of the real world."[4] Johns, on the other hand, expunged illusionistic spatial recession by eliminating the sense of a shape against a background. By choosing an inherently two-dimensional image such as a flag and making it coextensive with the shape and dimensions of the pictorial field, Johns insured that his painting was identical with what it represented, that is, it was a flag as well as a picture of a flag.

Despite these precedents, by the middle sixties a number of painters came to feel that painting could never be successfully anti-illusionistic. Feeling that painting would always evoke an illusionistic space, they renounced it for the creation of objects in which space and image were actual rather than depicted. To the extent that the art object is identical with what it represents, the Minimal and Pop movements are related.[5] In a sense, the literalism of the period was a demand for a thoroughgoing realism.

Several traditions reinforced this distaste for illusion and metaphor. The desire for factual, clearly articulated structures was a rejection of the perceived ambiguity and emotional excesses of second-generation Abstract Expressionism. It was also an extension of the fundamental American orientation toward the factual and the specific implicit in Pragmatism. As Barbara Rose has pointed out, the identification of truth with the concrete, the factual and the uncontrived places these arists within a tradition that has been so continuous as to almost constitute *the* American tradition.[6]

Minimalism was the first sculptural movement to incorporate literalist principles into an abstract format. Utilizing a vocabulary of simplified, geometric forms, the Minimalist artists excluded all excess and redundancy, creating some of the most austere work in the history of art. They expunged the momentary and transitory in favor of order, stability and permanence. In place of the energized thrusts and counterthrusts of the Cubist sculptural tradition, the Minimalists introduced an art of stasis. Due to their distillation of form to elementary volumes, artists such as Carl Andre, Larry Bell, Ronald Bladen, Walter De Maria, Dan Flavin, Robert Grosvenor, Donald Judd, Ellsworth Kelly, Sol LeWitt, Robert Morris, Tony Smith, Robert Smithson and Anne Truitt were initially identified with Minimalism.

The reductive forms in their work relate to theories of perception in Gestalt psychology. According to Gestalt theory, shapes are perceived by organizing them into "wholes" or patterns. Concepts like squareness, roundness and so on, previously thought to be generalized or

291. Ronald Bladen. Untitled, 1968. Wood, 12 x 16 x 3 feet. Fischbach Gallery, New York. *Three Elements*, also by Bladen, seen at left.

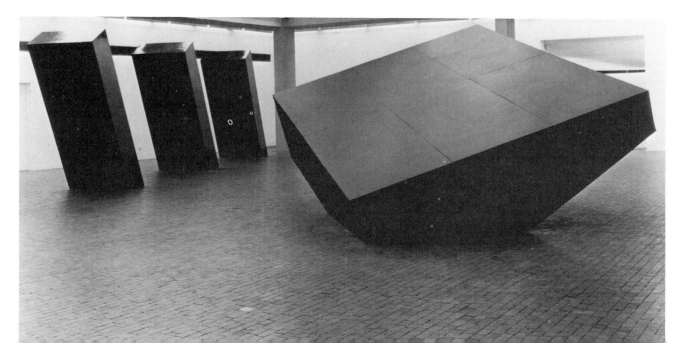

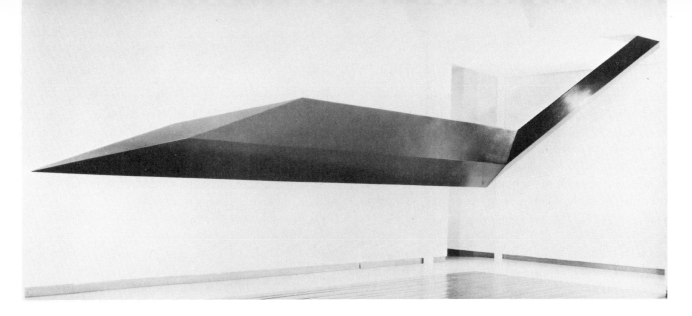

292. Robert Grosvenor. *Tenerife,* 1966. Fiberglass, plywood, steel and synthetic polymer lacquer; 23 feet long. Whitney Museum of American Art, New York; Gift of the Howard and Jean Lipman Foundation, Inc.

abstract, are considered the primary data of perception. Since vision proceeds from the general to the particular, overall structural features like squareness are a direct and more elementary experience than the perception of specific details.

The totality of the gestalts or single-image forms that the Minimalists employed can be apprehended immediately. In contrast to earlier sculptors who structured perception into sequential units by requiring the viewer to move around the work, the Minimalists, in effect, isolated the present by employing forms that could be grasped instantly and whose totality could be understood from every vantage point. In their desire to further eliminate anything that would detract from the unitary quality of the work, they utilized homogeneous color areas, careful fabrication and texturally undifferentiated surfaces. The result is an art of extraordinary immediacy and physical presence.

The Minimalists implicitly idealized the contemporary industrial landscape. Their ascetically simplified forms are analogous to the imagery of the American Precisionist painters of the twenties and to the clarity and simplicity with which they depicted their industrial subject matter. While Pop artists responded to the mass-media images of American culture, the Minimalists responded to the forms of the urban environment. The Minimalists used industrial materials and processes much as the Pop artists used commonplace media images and advertising techniques.

The theoretical positions of the Minimalists were publicly articulated primarily through the writings of Donald Judd and Robert Morris. In contrast to Morris's involvement with the issues of perception and ambiguity, Judd is primarily interested in maximizing the viewer's attention to the literal or physical properties of mate-

rials: their color, reflectiveness, transparency, density and texture.

Judd began his career as a painter but turned to the making of three-dimensional objects because of the unavoidable illusionism in painting. Central to his art is the desire for perceptually explicit shapes that contain no ambiguity. To this end he employs clearly defined forms, smooth surfaces and colors that give the greatest visual clarity to angles and contours. He further clarifies structures by the exposure of interior space and by oppositions of texture and color between the exterior and interior surfaces.

Initially the severity of Judd's forms was mitigated by their polished, lustrous surfaces and brilliant color. His use of vibrant motorcycle paint and light-reflecting industrial materials — brass, copper, stainless steel, anodized aluminum and plexiglas — give the pieces a sensuous elegance (Pl. 56). Complex surface patterns are created by the play of reflections on these materials. Recently, Judd's concern with visually activated surfaces has extended to galvanized metal and to the wood-grain patterns of plywood which contrast sharply with their inert volumes.

More dynamic and aggressive than the Minimal style, yet sharing its simplification of form and clarity of image, are the works of Ronald Bladen, Robert Grosvenor and Tony Smith. Favoring a gesturally dynamic vocabulary of diagonal forms, Bladen's and Grosvenor's works form an assertive rather than a passive relationship with their surroundings. The scale of their work dominates both the environment and the viewer and shares a defiance of gravitational restrictions. Bladen's forms are either cantilevered into space or seem to float above the floor as though their movement had been frozen (Fig. 291). Although related to their settings by virtue of their archi-

tectural form, Bladen's pieces exist as solitary presences. They are structurally independent of their settings and are supported by an elaborate inner structure of weights and balances rather than by being attached to the floor. Bladen has spoken of his involvement with large scale as "an attempt to reach that area of excitement belonging to natural phenomena such as a gigantic wave poised before it makes its fall or man-made phenomena such as the high bridge spanning two distant points." [7]

Grosvenor's work, on the other hand, depends on the architecture for structural support. His suspended linear thrusts use the floor and ceiling as defining planes and are not conceived as self-contained or isolated. He sees them as articulating the space between the floor and ceiling and having no existence apart from this interrelationship (Fig. 292).

Concurrent with the literalist orientation of the sixties was a fundamental attack on the conventional notion of sculpture as an isolated object with fixed boundaries.

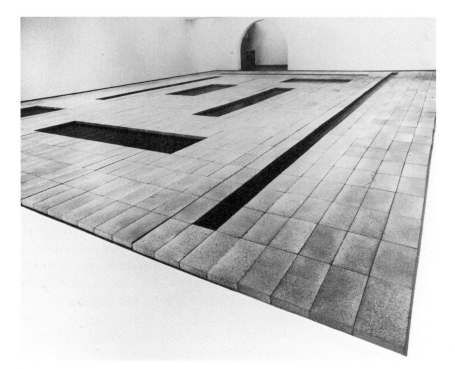

LEFT: 293. Carl Andre. *Cuts,* 1967. Concrete, 2 inches x 30 x 42 feet. Installation at Dwan Gallery, Los Angeles, March 8–April 1, 1967.

BELOW: 294. Dan Flavin. *An Artificial Barrier of Green Fluorescent Light (To Trudie and Enno Develing),* 1968–69. Fluorescent light; 14 units, each 48 inches; 30 feet overall. Leo Castelli Gallery, New York.

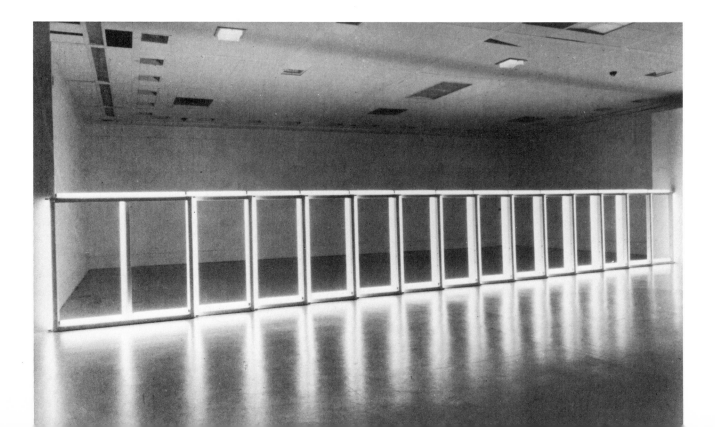

This movement away from the isolated, discrete object took four basic directions: the interrelationship of objects and site, earthworks, process art and concept art.

Recent attitudes toward psychological and physical relationships between objects have been radically influenced by space travel, Oriental philosophy, quantum and astrophysics and electronic technology. Objects are no longer seen as fixed and separate; environments are no longer static enclosures. It has become increasingly obvious that we are living in an age of complex interrelationships. It was to these altered patterns of life that sculptors began addressing themselves in the sixties.

The first manifestations of these concepts of relatedness occurred in Minimal sculpture. The generally large scale of Minimal art and the use of geometric forms that related to the architecture of the exhibition space tended to integrate the sculpture with the environment. Minimalist objects were placed directly on the floor rather than on pedestals. This decreased the tendency to view their work as isolated entities, separate from the environment or the viewer's space. Artists such as Flavin, Grosvenor, Judd and Morris further integrated their work with its surroundings by using the walls and ceiling of the exhibition space as structural components of their work.

As the distinction between object and environment broke down, the idea of an immutable relationship between chosen objects and existing environments emerged. One of the first artists to articulate the move away from the self-contained, discrete object was Carl Andre. Since Andre's pieces consist of modular, interchangeable units held in place principally by their own weight, their shape and dimension can be designed to fit specific spaces. Since the materials are neither unique nor precious in themselves, they assume their "art" identity only when organized and presented as such by the artist. The overall form of the pieces is determined by each particular exhibition space, which in turn becomes an integral part of the piece. In his 1967 Dwan Gallery exhibition, the concept of an "object" separate from the environment is totally eliminated (Fig. 293). In this work, floor-hugging blocks divide the gallery floor geometrically, giving it a figure-field relationship much as images would on a canvas background. The areas not covered with bricks are as essential to the piece as the brick patterns themselves. Although Andre's pieces retain a degree of autonomy as objects in that, once realized, they can be reassembled at another site, his concept of "sculpture as place" has remained an underlying assumption of much of advanced sculpture since the mid-sixties.

Artists such as Andre, Judd, Morris, John Mason and Richard Serra have increasingly relied on the dictates of indoor and outdoor sites to determine form and scale. This interdependence between object and location is often determined by the geography or physical conditions of the place. Serra and Judd have both made pieces that exploit the slope of a particular site and Andre's modules are often determined by the type of materials available at the chosen location. Mason's work, like Andre's, utilizes modular arrangements of horizontally repeated firebricks but differs from Andre's in relying on sequential geometric progressions (Pl. 55). Once the original module and progression of his pieces have been established, they can be extended to adapt to any site.

Dan Flavin's work anticipated this integration of sculpture and setting. Although in his early pieces the fluorescent fixtures appear as discrete images, they imbue the space with color auras which extend beyond the material boundaries of the fixtures. As his work developed, his interest shifted from the fluorescent tube as an image to the examination of its potential for spatial articulation. Initially these pieces altered the viewer's perceptions of particular areas. His corner installations, for example, perceptually dematerialize the right-angled intersection of the two walls into which they are placed and cannot be dealt with apart from this architectural context (Pl. 57). Utilizing groupings of individual pieces, Flavin transformed the character of entire rooms. As early as his 1964 Green Gallery exhibition, he treated the entire gallery space as an environment for the light by utilizing the floors, ceilings and walls as reflective surfaces. Eventually, his control of space moved from groupings of isolated pieces to the systemic organization of light as space in his corridors and barriers (Fig. 294).

While this aspect of Flavin's work places him in the vanguard of artists who are dissolving the boundaries between sculpture and environment, his work also has affinities with the literalism of the Minimalists with whom he was initially associated. Flavin leaves his fixtures unchanged and makes no attempt to disguise or de-emphasize their physicality. Due to the form of his industrially produced fixtures, the expression is linear and the space is characterized by an austere geometry.

Of the artists whose interests have focused upon the environmental aspects of their work, Flavin, Larry Bell, Robert Irwin and Bruce Nauman use space itself as a continuum to be structured and characterized. Their primary concern is not for discrete objects but for perceptually encompassing experiences. Generally, these works come into being at a specific location and cease to exist when they are removed from that location.

This use of space differs markedly from the sculptural environments explored in the late fifties and early sixties by artists such as Allan Kaprow, Claes Oldenburg, Rob-

ert Whitman and Jim Dine. These early environments grew out of the artists' involvement with assemblages and Happenings and were characterized by emotionally charged associative images. Contemporary environmental spaces, on the other hand, derive from the austerity and abstractness of Minimal art and are concerned with the physiology and phenomenology of perception.

Larry Bell creates works whose boundaries are not easily perceptible. His most well-known contribution to environmental spaces consists of large upright glass panes placed at right angles to each other. Varying the density of the vacuum-coated reflective surface gives the glass different degrees of reflection, transparency and opacity. As the viewer walks around and through the piece, both the environment and the viewer's own image appear, multiply and disappear, creating a perceptual ambiguity in which it is difficult to separate illusion from reality. Due to the viewer's confusion in distinguishing the actual three-dimensional glass panes from the constantly shifting illusory reflections, these works cannot be seen as separate, fixed objects. The surrounding space seen through and reflected by the glass panels merges optically with the piece and becomes an intrinsic part of it. The traditional dualism of subject and object is diminished by the integration of the multiple reflections of the viewer's image in the work. These pieces are constantly changed by factors outside them, like people passing back and forth, and fluctuations of light and shadow (Fig. 295).

Similarly, Robert Irwin believes that the bracketing of objects is not possible, that all the elements in the room are part of the experience of the room and even slight changes in the architecture of a space can alter one's experience of it. In the early seventies Irwin began relying on the simplest number of means — stretching a string or constructing a wall across a room — to effect perceptual change. Much of his work operates on a low threshold of visual discrimination which forces viewers to make a considerable effort to discern and thus become conscious of the nature and process of perception.[8]

With the earthworks of artists like Walter De Maria, Michael Heizer and Robert Smithson since the late sixties, and more recently Robert Morris, sculpture transcended the self-contained, discrete object in another direction. "Earthworks" is a general category that includes three types of work, each having a slightly different relationship to the site: (1) indoor pieces in which elements of the landscape are brought into the gallery (De Maria's *Dirt Room* in which all the rooms of the gallery were filled with fluffy, level dirt, and Smithson's Non-Site bins of material extractions from rock quarries; Figs. 296, 339), (2) works that consist of cutting, digging or marking directly on or in the natural landscape (Heizer's *Isolated Mass/Circumflex* and De Maria's *Mile Long Draw-*

295. Larry Bell. *The Iceberg and Its Shadow,* 1975. Inconel and silicon dioxide on ⅜-inch plate glass; 45 sections of varying sizes. Collection of the artist.

ing; Figs. 322, 297 on p. 186), (3) works that add foreign elements to the landscape (De Maria's *Lightning Field* and Smithson's *Spiral Jetty;* Figs. 298 on p. 211, and 352).

Earthworks are an extension of the literalist reliance on the inherent properties of materials to function as both medium and content. As content, earth invokes the epic grandeur of the American landscape which has always been equated with the "heroic." To the extent that the earth-artists, the Abstract Expressionists and the 19th-century Hudson River School painters evoke the "sublime" force of nature, they are related. The interest of the earth-artists in land also reflects the same disappointment in the quality of urban environments that generated 19th-century landscape painting and more recently has sparked the environmentalist movement.

A major impetus behind outdoor earthworks was the artists' desire to transcend the size limitations imposed by urban and interior spaces. Only in uninhabited land could the artists find vast distances unencumbered by architecture. These works are generally so large that viewing them in their entirety from one location is impossible and time becomes an intrinsic factor in the experience of the space. Since walking through and around them is essential, they establish an intimate relationship with the viewer. Earthworks integrate so completely with their environment that the character of the site becomes part of the piece. For example, the quiet serenity of open spaces and the ability to focus without the distractions of cities are as much a part of the experience of De Maria's *Mile Long Drawing* as the marks themselves. Because it is impossible to determine where the piece stops and the surrounding landscape begins, these outdoor earthworks ultimately extend the notion of the absolute interdependence of artwork and site. To understand the difference between an earthwork and a sculpture by David Smith located in an outdoor setting is to understand the fundamental inversion that has taken place in recent sculpture.

By virtue of their relationship with site, these pieces, as well as other site-dictated sculptures, place a new set of demands on the object-oriented gallery and museum. Obviously these works cannot be transported from one location to another. As a result, many pieces are experienced primarily through verbal descriptions or photographic documentation. A significant number of them remain at the project stage for lack of funds or because they are unrealizable. It is at this point that land art and concept art overlap.

Whereas art traditionally has been concerned with stability and permanency, these works are concerned with change and metamorphosis. The structural transformations and possible disappearance that can occur due to the variable processes of nature on organic materials are completely accepted. The pieces are thus open-ended in both spatial and temporal terms. This use of mutable materials parallels the ascendency of organic form that occurred in the late sixties with the development of anti-form and process concepts.

Although working with ephemeral materials, and extended, indeterminate boundary lines, the earth-artists retained their commitment to the reductive forms and modular arrangements of Minimalism. This Minimalist legacy is evident in Smithson's utilization of modules in his Non-Sites, the simple geometry of Heizer's *Isolated Mass/Circumflex* and the regularized placement of the poles in De Maria's *Lightning Field.* Structurally, these pieces are thus a combination of the indeterminate, mutable format of the "non-object" and the simple, geometric forms of the Minimalists.

Problems of transitory space and mutable materials which interested the earth-artists also found expression in the movement that was known as process or anti-form art. These two terms point to the underlying assumptions behind this work — the focus on process and gesture, and the mutability and indeterminacy of structure.

In place of the preconceived forms and strictly delineated shapes of the Minimalists, artists like Eva Hesse, Keith Sonnier, Robert Morris, Richard Serra, Barry Le Va and Bruce Nauman began predicating their work on mutability and random distribution. Reacting against the order and structural clarity of Minimalism, these

296. Walter De Maria. *Dirt Room,* 1968. Pure dirt, 1680 cubic feet. Installation at Galerie Heiner Friedrich, Munich, September–October 1968.

299. Carl Andre. *Joint*, 1968. Baled hay; 183 units, each 14 x 18 x 36 inches; 274 feet long overall; destroyed.

300. Richard Serra. *Belts*, 1966–67. Vulcanized rubber and neon, 84 x 228 x 20 inches. Collection of Giuseppe Panza di Biumo.

artists began using non-rigid materials in loose, indeterminate arrangements. In contrast to the discrete, unitary perceptions possible with Minimal art, their pieces must be seen as a continuum of heterogeneous details. Often characterized by apparent disorder and chaos, these pieces subvert the traditional sculptural values of form and substantiality. Rather than resting in a fixed state of resolution, these pieces have an ephemeral, impermanent quality which suggests the transient state of "becoming." The artists are not involved with preconceived, enduring forms. As Hesse said, "I am interested in finding out through working on the piece some of the potential and not the preconceived. . . ."[9]

While a number of works by artists such as Andre, Sonnier, Serra and Morris utilize non-rigid materials to illustrate temporality (Figs. 299, 300), others focus on the provisional nature of placement, order and distribution. These works are composed of separate parts whose relative positions are alterable. In distribution works by Le Va or Andre, materials are scattered on the floor and left wherever they land (Fig. 304). Other distributions would, of course, result in other arrangements. Similarly, there are no definite, predetermined relationships between the components in Hesse's *Seven Poles* which may be arranged according to the dictates of the particular space (Fig. 305).

Robert Pincus-Witten has pointed out that post-Minimal art can be seen as a merging of Oldenburg's soft sculpture and the gestural tradition of Abstract Expressionism.[10] Until Oldenburg's introduction of flexible materials, sculpture had always been hard and permanent. Because Oldenburg's materials are soft, his objects can change configuration over time, or be manipulated and rearranged at will. Movement, change and metamorphosis are the constants of his work (Pl. 52). His exploration of different states of an object through color, size and substance changes — as in the "hard," "soft" and "ghost" versions of the Toilet — is a manifestation of this interest in permutation and mutability (Figs. 301, 302, 303).

OPPOSITE PAGE, LEFT COLUMN:

TOP: 301. Claes Oldenburg. *Toilet — Hard Model*, 1966. Cardboard, wood and other materials; 44 x 28 x 33 inches. Hessischen Landesmuseum, Darmstadt, Germany; Karl Ströher Collection.

CENTER: 302. Claes Oldenburg. *Soft Toilet*, 1966. Painted vinyl filled with kapok, wood; 50½ x 32⅝ x 30⅞ inches. Collection of Mr. and Mrs. Victor W. Ganz.

BOTTOM: 303. Claes Oldenburg. *Soft Toilet — "Ghost" Version (Model "Ghost" Toilet)*, 1966. Painted canvas filled with kapok, wood; 51 x 33 x 28 inches. Collection of the Albert A. List Family.

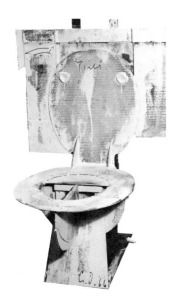

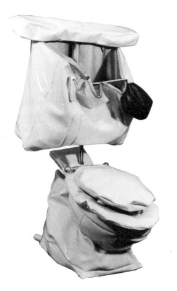

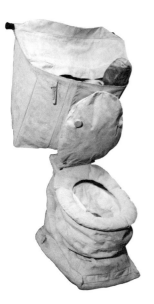

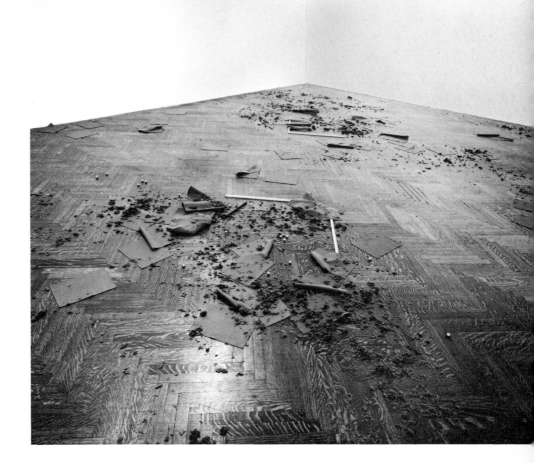

304. Barry Le Va. *Polarities*, 1967. Equal quantities of different materials DROPPED and PLACED IN, ON, and OUT in relation to specific boundaries. Installation at Bykert Gallery, New York, May 1975.

305. Eva Hesse. *Untitled (Seven Poles)*, 1970. Fiberglass over polyethlene over aluminum wire; 7 units, each 74–111 inches high x 10–16 inches in circumference. Collection of Mr. and Mrs. Victor W. Ganz.

306. Richard Serra. *House of Cards,* 1969. Lead, 48 x 55 x 55 inches. Collection of George and Wendy Waterman.

307. Richard Serra. *Splashing,* 1968. Lead, variable size. Leo Castelli Gallery, New York.

Although breaking away from the strict formalism of the Minimalists, artists such as Hesse, Nauman and Serra combined their interest in compositional variability and fragile materials with a structured presentation. Hesse unites the modular repetitions and seriality of Minimalism with biomorphic imagery. By modifying Minimalist organization with organic shapes and delicate materials, she transmutes the detached "cool" of the Minimalists into an intensely personal and emotional vision.

The form these pieces take is dictated by the materials and the processes used in making the work rather than by a preconceived formal order which the artist wishes to express. In Serra's splashed lead pieces the form derives jointly from the simple shape of the corner or wall into which hot lead is thrown and the action of throwing (Fig. 307). This technique of setting up the parameters of a situation then allowing chance to determine the final outcome characterizes much of process art. Since the internal relationship of parts is de-emphasized, the procedure used in making the work and the strength of the unrefined materials become the principal expressive and emotion-bearing elements. This allows the artist to simultaneously maintain a raw power in the total work and a detachment from the design.

Whereas the majority of process works are residues or records of a completed process, Serra's *House of Cards* is a manifestation of a continuing process (Fig. 306). Since the steel plates are not permanently joined, the physical forces — gravity, friction and inertia — operate continuously to maintain the piece in a state of arrested motion. In this way, time is incorporated into Serra's

work. A quality of danger attends these particular pieces because of the weight of the materials and their potential for collapse. This threat maintains for the viewer a constant awareness not only of the physical qualities of the materials, but those of the environment and the viewer as well.

The work of the process artists reflects an attitude quite different from that held by the Minimalists. While the position of the process artists derives basically from a rejection of Minimalism, the work itself reflects the indeterminate and transitory qualities of life. Whereas artists have traditionally sought to impose an order on the contradictions and irrationality of life, the process artists accepted complexity and change as the defining features in both the processes of nature and art.

Post-Minimal sculpture such as earthworks and process art is characterized by horizontal expansion. Prior to Minimal art, sculpture was predominantly vertical, an orientation that related it to the human body. With Minimalism and the desire to avoid anthropomorphic allusions, verticality was abandoned. In spite of this shift from the vertical format, most Minimal works are autonomous, measurable objects which are perceived as individual units or "figures." With post-Minimal art, self-contained forms are discarded in place of horizontal, loose accumulations. Robert Morris has characterized the distinction between Minimal sculpture and this method of horizontal structuring as the difference between a figurative and a landscape mode.

Another movement toward transcending the boundaries of the sculptural "object" is the displacement of focus from the object to the idea. Extending Marcel Duchamp's dictum that art is an experience not an object, artists began making art whose primary objective is to engage viewers' minds as much as their eyes.

One of the first to emphasize the concept over its embodiment in a physical object was Sol LeWitt. When LeWitt's work first appeared in the middle sixties, it was immediately categorized as Minimalist. It did share formal characteristics with that movement in that it was composed of non-hierarchical, open grids that served as structural modules which could be combined together to form larger configurations. These works operate as three-dimensional line drawings, completely enveloping the space they delineate (Fig. 308, p. 212). However, their form and physical presence are not what primarily interests LeWitt. For him, the most important consideration is the system underlying each work; the pieces themselves exist as manifestations of these systems. LeWitt employs open, unitary cubes to de-emphasize physically so that the viewer will concentrate on the arrangement of forms, not the forms themselves. All the planning and decisions about a piece — its basic module and organizational pattern — are formulated in advance of its execution. Executing the idea becomes simply a matter of utilizing all the possible permutations based on a predetermined progression or repetition of the basic module (Fig. 310). This method of determining form by logical arrangements of the basic module or its numerical derivations is shared by a number of contemporary artists, among them Andre, Flavin and Judd who utilize it as a means of predetermining the relationship of internal parts and thus reducing their own compositional control.

LeWitt's premise that the concept is as important as the visual realization of a system has been extended by other artists to works that exist principally as ideas in photographic or written form. By de-emphasizing their material aspects, these works restore the equality of content and form. Like other post-Minimal styles, the creation of an art independent of objects or traditional boundaries challenges the conventional role of sculpture.

309. Christopher Wilmarth. *My Divider*, 1972–73. Glass and steel, 60 x 78 x 94 inches. Collection of the artist.

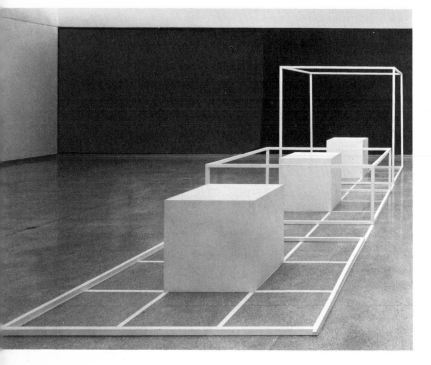

No sculptural expression was ever so closely allied with painting as the sculpture of the sixties. Never had so many sculptors begun their careers as painters, nor had so many painters concurrently produced sculpture. In both cases, the imagery and issues in their paintings were extended three dimensionally. As Judd noted, "The new work obviously resembles sculpture more than it does painting, but it is nearer to painting."[11]

The Minimalists shared the non-hierarchical, single-image format characteristic of American art in the sixties with Pop artists like Andy Warhol and Roy Lichtenstein, and color abstractionists like Frank Stella and Kenneth Noland. Even the Minimalists' rejection of an in-the-round reading in favor of sculpture whose totality could be comprehended from any vantage point corresponds to the instantaneous perception possible with two dimensions.

The two directions in which Minimal and process art developed reflected the split that occurred in Abstract Expressionism between the gestural abstraction, or "action painting," of Willem de Kooning and Jackson Pollock and the chromatic abstraction of Barnett Newman, Mark Rothko and Ad Reinhardt. Minimal art relates to

310. Sol LeWitt. *B-258*, 1966. Baked enamel on aluminum, 81 inches x 24 feet, 2¼ inches x 81 inches. The Museum of Modern Art, New York; Elizabeth Bliss Parkinson Fund.

311. Ellsworth Kelly. *Black White*, 1968. Painted steel plate, 100 x 146 x 38½ inches. The Detroit Institute of Arts, Detroit, Michigan; Gift of the artist and the Founders Society.

OPPOSITE: PLATE 52. Claes Oldenburg. *Three Way Plug, Scale A (Soft), Prototype in Blue*, 1971. Wood, naugahyde, rope, metal, plexiglas; 144 x 77 x 59 inches (variable). Des Moines Art Center, Des Moines, Iowa; Coffin Fine Arts Trust Fund.

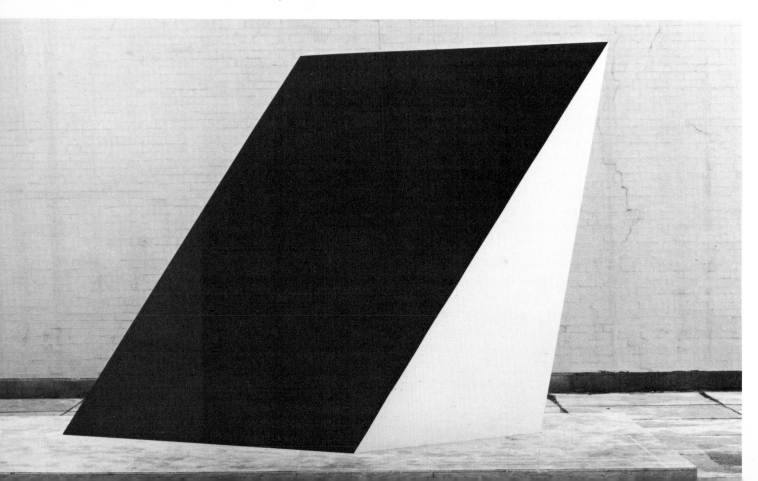

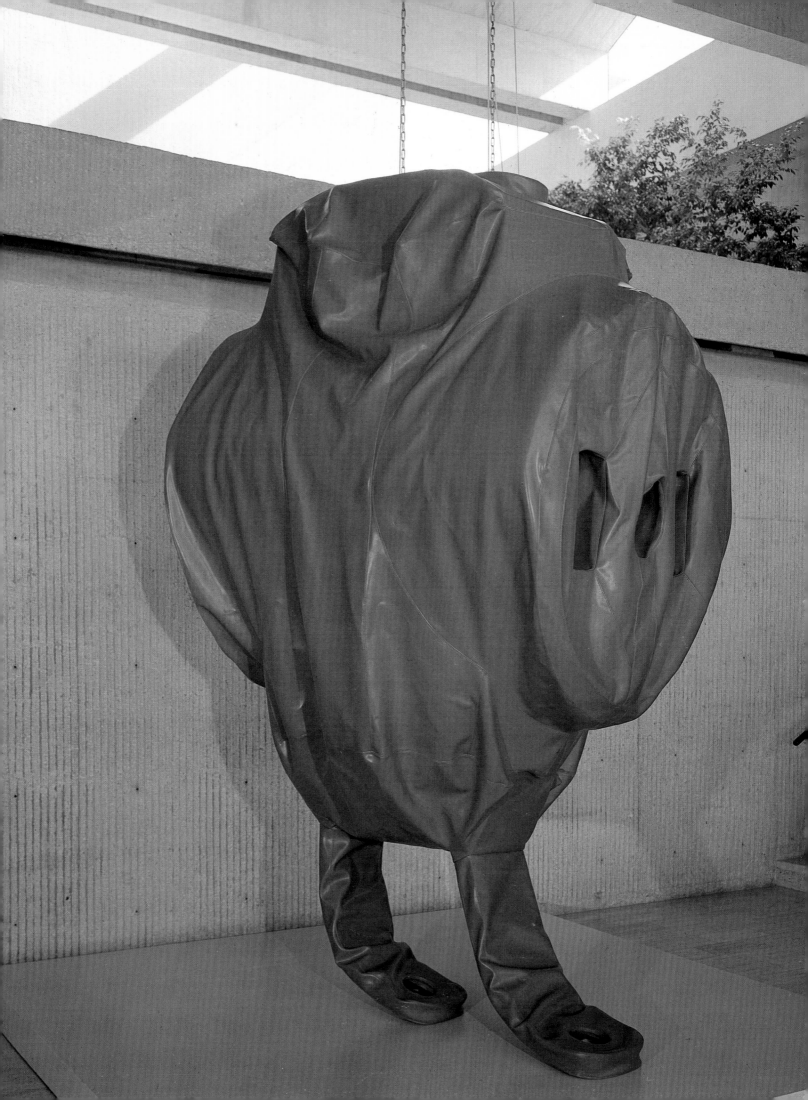

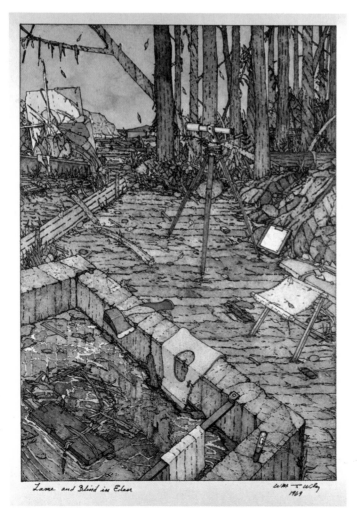

ABOVE: PLATE 53. Robert Rauschenberg. Untitled, 1958. Pencil and watercolor on paper, 24¼ x 36⅛ inches. Whitney Museum of American Art, New York; Gift of Mr. and Mrs. B. H. Friedman.

LEFT: PLATE 54. William Wiley. *Lame and Blind in Eden,* 1969. Watercolor on paper, 30 x 22 inches. Collection of Mr. and Mrs. Harry W. Anderson.

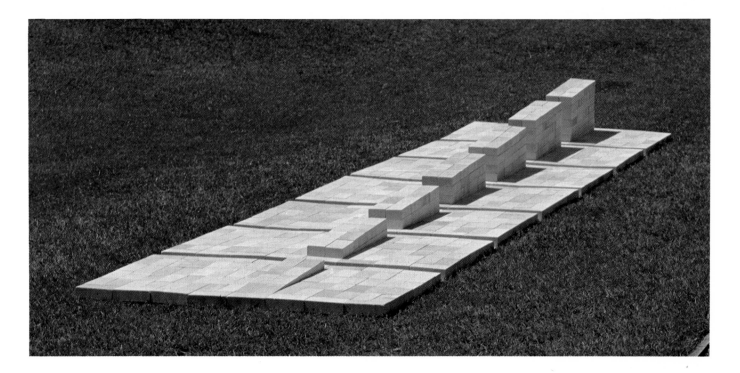

ABOVE: PLATE 55. John Mason. *Firebrick Sculpture — Grand Rapids*, 1973. Firebrick, 25½ x 310½ x 72 inches. Hansen Fuller Galleries, San Francisco.

BELOW: FIG. 298. Walter De Maria. *Lightning Field*, 1973–76. 640 stainless steel poles being placed 200 feet apart, one per acre, on a square mile of flat land in the southwestern United States; each pole 18 feet high by 2 inches in diameter. DIA Art Foundation, N.Y.

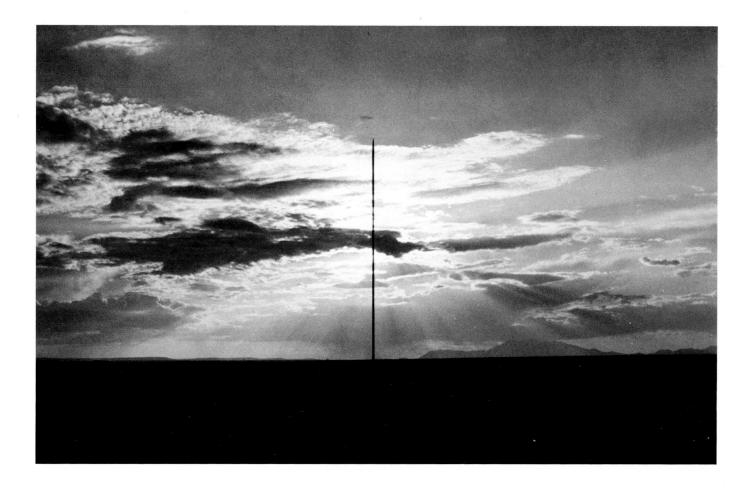

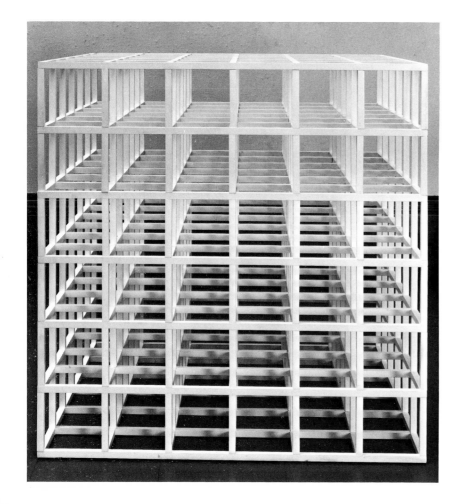

LEFT: FIG. 308. Sol LeWitt. *Open Modular Cube,* 1966. Painted aluminum, 60 x 60 x 60 inches. Art Gallery of Ontario, Toronto.

BELOW: PLATE 56. Donald Judd. Untitled, 1966. Painted cold-rolled steel; ten units, 48 x 120 x 120 inches (overall). Whitney Museum of American Art, New York; Gift of the Howard and Jean Lipman Foundation, Inc.

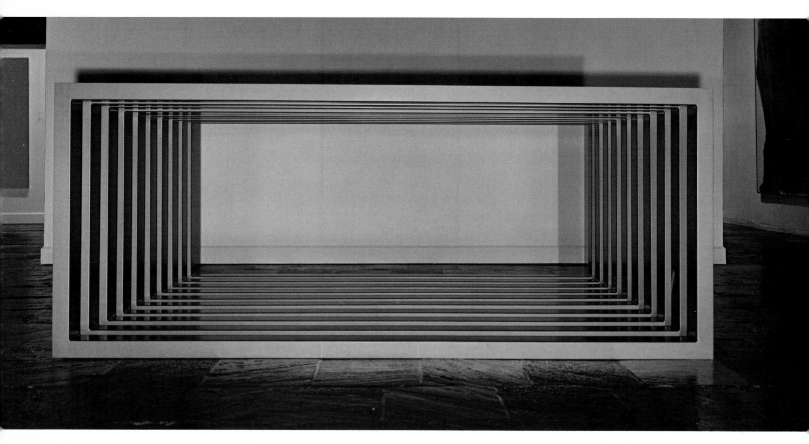

the non-hierarchical, single-image format of the chromatic abstractionists, while process art can be seen in terms of the gestural, "allover" quality in Pollock's drip paintings. The reliance by the process artists on physical gesture and its residue to create form, the cultivation of random and chance effects, and the assertion of the physical qualities of materials relate their work to that of the earlier action painters.

Some of the sculpture of the sixties expressed pictorial concerns directly. Ellsworth Kelly's single-image, planar sculptures are often freestanding equivalents of shapes that have been derived from his canvas fields. His primary concern, both in his paintings and his sculpture, is the articulation of shape through the coextension of color and area. Although his angled steel sculptures occupy three-dimensional space, they appear two dimensional due to their shape and color properties (Fig. 311). Christopher Wilmarth's work is characterized by an intense painterliness in surface and color (Fig. 309). His recent pieces, composed of steel and glass plates etched with acid, create a translucency and a greenish, sfumato-like tonality, while the wires in his pieces function both as structural and as linear, "drawn" elements which further enhance the pictorial quality. Keith Sonnier's treatment of the gallery wall as a field for his subtle color-light images is also pictorial (Fig. 312). The neon tubes, rubber strips and wires in his and Serra's early pieces appear as three-dimensional extensions of the linear elements on a canvas surface.[12] By virtue of their horizontal extension, floor pieces by artists such as Andre, Le Va or Serra and most indoor and outdoor earthworks treat the gallery floor or surface of the earth as a visual field upon which images may be drawn. This close relationship between two-dimensional readings and three-dimensional objects indicates a greater hybridization of painting and sculpture.

As artists extended the traditional boundaries of their disciplines, not only has the relationship between painting and sculpture become more complex, but the most recent directions in art elude categorization altogether. Existing definitions of sculpture no longer clearly apply; categorical criteria such as three dimensionality, permanency, craft and discrete space are no longer operative. Much of the new work such as performance, body art, video and language art deals with spatial concerns but seldom utilizes traditional sculptural formats. These works propose a theoretical rather than a physical continuum which irrevocably challenges the historical definition of sculpture as object.

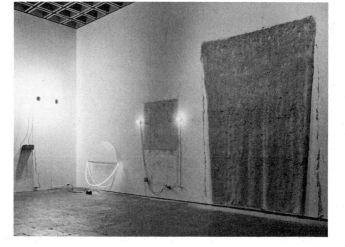

312. Installation of works by Keith Sonnier in *Anti-Illusion: Procedures/Materials*, Whitney Museum of American Art, New York, May 19–July 6, 1969.

Notes

1. Leo Steinberg, *Other Criteria* (New York: Oxford University Press, 1972), p. 47.

2. William C. Seitz, *George Segal* (New York: Harry N. Abrams, n.d.), p. 91.

3. Statement by the artist in "Ghost Maker," *Time*, May 11, 1970, p. 72.

4. Calvin Tomkins, *The Bride and the Bachelors: The Heretical Courtship in Modern Art* (New York: The Viking Press, 1965), pp. 193–94.

5. Donald Judd, in fact, termed Pop art "imagist specific objects."

6. Barbara Rose, "Problems of Criticism, VI: The Politics of Art Part III," *Artforum*, vol. 7 (May 1969), pp. 46–51.

7. Jean Reeves, "60-Foot Painted Steel Sculpture Will Grace Plaza of Marine Center," *Buffalo* [New York] *News*, June 17, 1971.

8. Michael Compton, text in *Larry Bell, Robert Irwin, Doug Wheeler* (London: The Tate Gallery, 1970).

9. Cindy Nemser, "An Interview with Eva Hesse," *Artforum*, vol. 8 (May 1970), p. 60.

10. Robert Pincus-Witten, "Eva Hesse: Post-Minimalism into Sublime," *Artforum*, vol. 10 (November 1971), pp. 32–44.

11. Donald Judd, "Specific Objects," *Arts Yearbook 8: Contemporary Sculpture* (New York: The Art Digest, 1965), p. 77.

12. Robert Pincus-Witten, "Rosenquist and Samaras: The Obsessive Image and Post-Minimalism," *Artforum*, vol. 11 (September 1972), pp. 63–69.

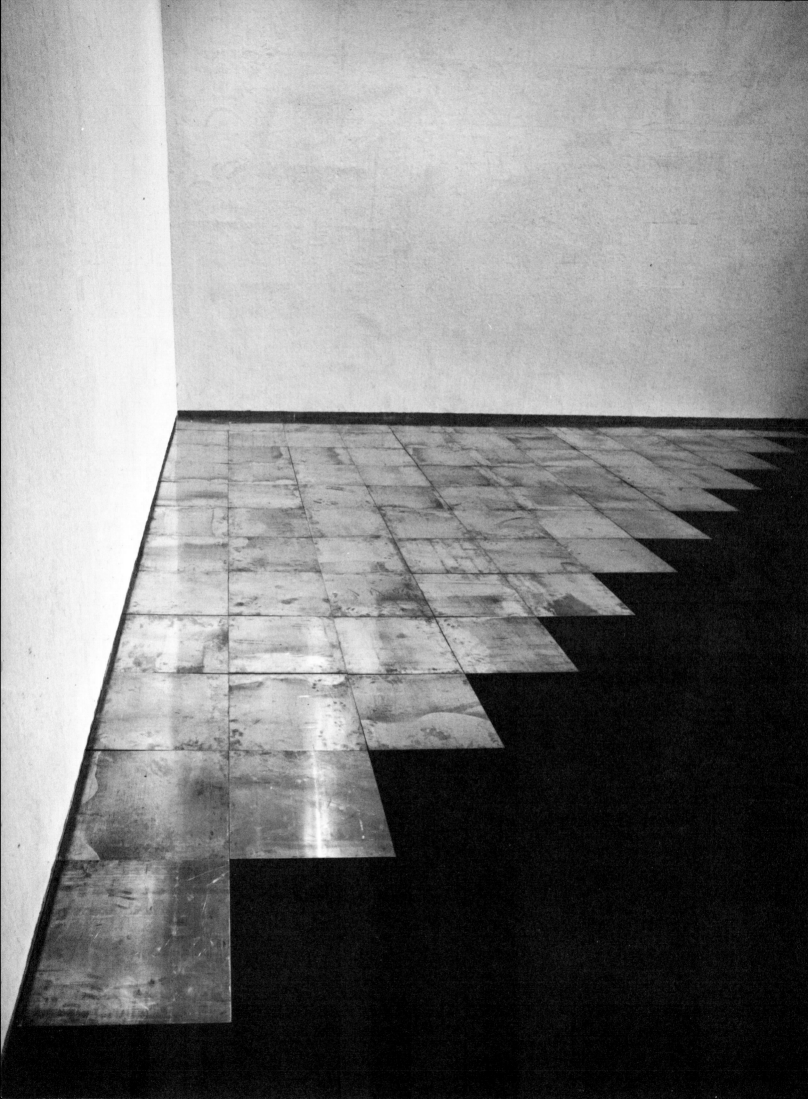

Shared Space

Contemporary Sculpture and its Environment

Marcia Tucker

IN THE 1950S AND EARLY 1960s, Abstract Expressionist artists established a visual vocabulary which narrated a heroic, postwar chauvinism; as a style, Abstract Expressionism began to shake off its immediate ties to a European, parent tradition and to evolve a native, American sensibility — tough, independent, forcefully physical, aggressive, emotionally intricate and variegated. The attitudes and activities prompted by this style were deeply rooted in a humanitarian, romantic and rebellious concept of art and culture, and were expressed in works of art that celebrated the individual, the eccentric, the handmade, the spontaneous. Abstract Expressionist paintings were metaphors for emotional states, humanitarian concerns, introspective inquiry and extroverted dialogue. Abstract Expressionism was also an art of contradiction because direct, forceful execution became the vehicle for the expression of transcendental, metaphysical meaning. These mythological and even religious values in the paintings of Rothko, Newman, Still, Kline and de Kooning have not altered their viability for the succeeding generation of painters, who see the work as valid, if not prototypical.

However, sculpture of the 1950s, while incorporating the same metaphysical content, has not become part of the vocabulary of most recent three-dimensional work. To the contrary, most sculptors have reacted against it.

With the exception of David Smith, Noguchi, and a few others, the sculptural forms of Abstract Expressionism have not yet had an influence beyond their own decade. Robert Smithson, in a 1967 article, railed against metaphoric content via criticism:

The myth of the Renaissance still conditions and infects much criticism with a mushy humanistic content. Re-birth myths should not be applied as "meanings" to art. Criticism exists as a *language* and nothing more. *Usage precedes meaning.*[1]

Smithson was also obliquely referring to those artists who saw themselves as the inheritors of a venerable tradition, whereas he, Carl Andre, Michael Heizer, Robert Morris and others were reacting in contradiction to it. Andre heralded, for himself and others, the end of art made in the studio; on the West Coast, Robert Irwin was to abandon the studio altogether and, like Andre, make pieces where and when he could and would. Andre has succinctly described the evolution of contemporary art:

There was a time when people were interested in the bronze sheath of the Statue of Liberty, modeled in the studio. And then there came a time when artists were not really concerned with the bronze sheath but were interested in Eiffel's iron interior structure, supporting the statue. Now artists are interested in Bedloe's Island.[2]

In short, with a few exceptions, present-day sculpture has generally rejected anthropomorphic, transcendental, nostalgic and metaphysical content.

Formerly the making of sculpture itself was a primary vehicle for expressing humanity's ability to affect change by altering an inert or resistant mass. Traditional methods include carving, modeling, constructing, casting, and

OPPOSITE: 313. Carl Andre. *Twelfth Copper Corner,* 1975. Copper, ¼ x 236¼ x 236¼. Sperone Westwater Fischer Inc., New York.

drawing in space; the method of direct carving, for instance, has been described in terms of the image of a figure trapped within the block, waiting for the sculptor to free it.

In the 1960s, painting became less a vehicle for emotional and metaphysical states; partly reflecting the persuasiveness of the critic Clement Greenberg, it was characterized by a profound commitment to itself. Such work, eliminating all conventions shared with other art forms (as well as the world at large), stressed, according to Greenberg, the shape of the support and the flatness of the picture plane, and denied illusion other than that made by a painted mark on a surface. Ironically, without abandoning a highly sophisticated metaphorical content, painting thus began to share with sculpture a literal quality, or "objectness." While painting occupied critical attention, *l'art pour l'art*, a 19th-century concept, became increasingly the rule in the mid-1960s. Sculpture

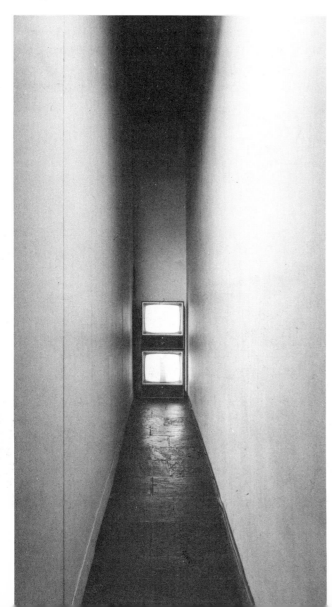

314. Bruce Nauman. *Live Taped Video Corridor*, 1968–70. Panels and video equipment, 17½ x 40 x 3 feet (variable). Collection of Giuseppe Panza di Biumo.

of the period, left to its own devices, became engaged in a diametrically opposed process, breaking down rather than refining an existing vocabulary. Greenberg himself noted:

Given that the initial look of non-art was no longer available to painting, since even an unpainted canvas now stated itself as a picture, the borderline between art and non-art had to be sought in the three-dimensional, where sculpture was, and where everything material that was not art was also.[3]

In negating the old vocabulary, sculptors began to explore and exploit new materials, rejecting the idea that sculpture should be permanent or even visibly three dimensional. The use of materials like hay, dust, air, glass, earth, debris, water and steam meant that the value of the work was no longer commensurate with the value of the materials employed. Ephemeral or improbable sculptural situations—called "pieces" rather than "sculpture"—were created; Nauman placed a microphone deep inside a tree trunk and amplified the sounds it captured, while Oldenburg's 1967 proposal for an outdoor city exhibition suggested calling Manhattan a work of art. Barry Le Va's *Velocity Piece* (1969) was an "impact run." He ran at full speed from one wall to another (50 feet away) and back, trying not to check his speed at the point of impact; the piece lasted an hour and forty-three minutes, had no observers and a sound tape of the proceedings was made.

Tony Smith made sculpture so large that it seemed as though the scale itself was its content. In the mid-1960s many artists like Smithson, Heizer, Morris, Andre and De Maria began to work outdoors on a large scale, making the landscape rather than the studio their arena. The work of other artists bordered on invisibility, an anomaly since sculpture had always been described as an art of solid form or mass. Sylvia Stone and Christopher Wilmarth used transparent, planar material, while Robert Irwin's scrim pieces, beginning about 1970, organized light in such a way as to poise it on the threshold of invisibility. Carl Andre, in this respect, commented that he liked "works of art which are invisible if you're not looking for them. I like this thing about being able to be in the middle of the work."[4] Other radical explorations included an examination of the artist as both subject and object (Nauman, Le Va, Sonnier, Morris) in video, film and objects, and ultimately included extensions into theater, wherein the spectator became the subject and object of the work (as in Nauman's *Live Taped Video Corridor*, where the viewer is seen on the monitor approaching it upside down and backwards; Fig. 314). Many artists turned to work in which the process of making dictated the final form of the piece; random distribution or scatter pieces were done by Andre, Graves, Nau-

man, Morris, Le Va, Serra, Smithson, Heizer, Hesse and others.

Areas related loosely to sculptural concerns, such as language, film, dance, theater and music, also became part of a sculptural vocabulary. For instance, Kienholz's tableaux are distinctly theatrical in feeling, and share their format (and, in part, their effect) with works produced on a proscenium stage. Nauman has done performances and written "poem" pieces; Morris was involved in dance in the early 1960s; Graves, Smithson and Serra have made films. Not surprisingly, the 1970s have seen sculpture expand even further outside the field of fine arts altogether for methodologies, structures, iconographies, materials and other connections to the physical and phenomenal world.

For instance, the Los Angeles County Museum, for the *Art and Technology* project begun in 1967, invited dozens of artists to collaborate with business and industry on pieces involving advanced technology. One of them, Robert Irwin, working with the artist Jim Turrell and a scientist, Ed Wortz, initiated a series of experiments dealing with habitation in space, Ganz fields, anechoic chambers, alpha-wave and bio-feedback systems. The project culminated in a 1971 symposium in which people from many non-art disciplines met in an alterable environment which Irwin built for the occasion.

One aspect of the expansion of sculpture generally considered apart from others is political involvement of various kinds. The materials sculptors use, the necessity for large storage and exhibition spaces, the equipment required for fabrication, and the dependence upon commissions when one works in large scale are only some of the factors which tie sculptors, more than painters, to the economy and therefore to political reality. Some artists, like Carl Andre, tackle the issue of politics by separating themselves from a consumer economy and using inexpensive and readily available materials.

What do you do to make sculpture without a strong economic factor? . . . I found that it's necessary for me to . . . make sculpture as if I had no resources at all except what I could scavenge or beg or borrow or steal.[5]

Others, like Kienholz and Westermann, have made biting, ironic tableaux which, while subsuming propaganda under the issues of visual narration, nonetheless establish their point through humor or horror. Westermann's drawing *Death Ship Run Over by a '66 Lincoln Continental* (1966; Fig. 323) parodies a capitalist world as it floats on a sea of dollar bills, while his *A Country Gone Nuts* is an attack on American violence, in comicbook style . Edward Kienholz's tableau *Portable War Memorial* (1968) incorporates a recording of Kate Smith singing "God Bless America," a statue of the Marines on Mount Suribachi, a hot dog/chili stand, a coke machine that works, and a blackboard memorial on which inscriptions can be altered to refer to events in the country where the piece is being shown (Fig. 315).

Sculpture of the past fifteen years, in fact, has expanded

315. Edward Kienholz. *Portable War Memorial*, 1968. Tableau: figures and flag, blackboard, restaurant furniture, photographs, wood, metal, fiberglass; 9½ x 8 x 32 feet. Wallraf-Richartz-Museum, Cologne; Ludwig Collection.

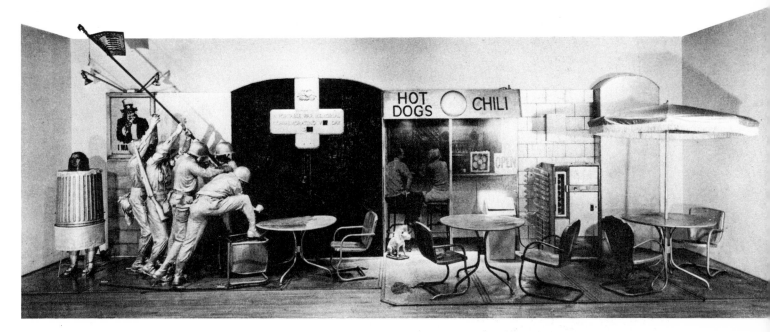

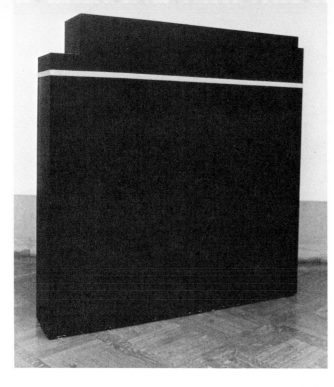

its own definition to such an extent that some of its most radical manifestations have explored areas thought to be the exclusive reserve of painting, that is, representation, the use of applied color, and illusionism. About 1962 Anne Truitt began to make what she calls "three-dimensional paintings." She was one of the first sculptors to simplify the form ("they're just painted wooden boxes," she says) in order to focus attention on the sensory and emotive qualities of the pieces through the use of applied color. Pieces like *Carson* (1963) are among the earliest contemporary sculpture to be characterized as "presences"; they make the question of whether it is painting or sculpture irrelevant (Fig. 316).

Similarly, Richard Tuttle made works which, from the early 1960s, were impossible to categorize. His 1965 painted wood configurations and his wrinkled, dyed cloth shapes (c. 1968) could be hung on the wall or placed on the floor, so that the same object could be seen spatially or pictorially, depending on the context (Figs. 317, 318). This focus signaled another radical change from the sculpture of the 1950s; whereas sculpture, as a contained

ABOVE LEFT: 316. Anne Truitt. *Carson*, 1963. Painted wood, 71 x 72 x 13 inches. Collection of Helen B. Stern.

LEFT: 317. Richard Tuttle. *Grey Extended Seven,* 1967. Dyed canvas, 48½ x 59½ inches (irregular). Whitney Museum of American Art, New York; Gift of the Simon Foundation and the National Endowment for the Arts.

BELOW: 318. Richard Tuttle. *The Fountain,* 1965. Painted wood, 1 x 40 x 40 inches. Collection of Richard Brown Baker.

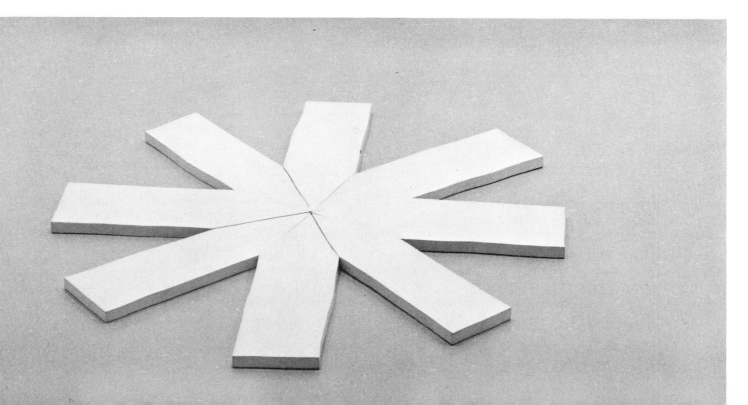

object, could be counted on to remain the same no matter where it was situated, work such as Tuttle's, Andre's, and especially Robert Irwin's focused as much energy on the situation or context as on the object itself. In Irwin's case, the 1968 disc pieces were only the beginning of a continuing effort to make the work and its context coextensive.

Many sculptors explored both painting and sculpture, either turning from one to the other as a point of departure, or maintaining both modes throughout long periods of time. Jasper Johns, for instance, questioned the traditional restriction of painting to a two-dimensional plane when he painted almost identical reversed images on both sides of *The Small Figure 3* (1960),[6] done about the same time as sculptures of the Ballantine Ale cans and the Savarin can with brushes (Fig. 319, Pl. 59). Keith Sonnier's latex, flocking and neon pieces of about 1968 have been compared to a painter's palette, and his video pieces which followed them seen as "luminous ambience — with the same instantaneity that a color field painting possesses."[7] Richard Artschwager, referring to his *Table with Tablecloth* (1964) denied its sculptural qualities (Fig. 320).

It's more like a painting, pushed into three-dimensions. It's a picture of wood. The tablecloth is a picture of a tablecloth. It's a multi-picture.[8]

For some, like Nancy Graves, painting became another aspect of sculptural form, a way of exploring topological concerns by using topology itself, so that a flat surface could, as in her moon map paintings, stand for a three-dimensional but experientially inaccessible geographic surface.

Tony Smith reversed the characteristics generally assigned to each discipline by making concrete paintings and illusionistic sculpture. That is, he used frontal, unequivocal geometric forms in the painting but made the sculpture comprehensible only part by part, through its large size and elusive geometry (Fig. 321).

For Heizer, on the other hand, painting and sculpture shared the same concerns, the painting containing a figure-ground relationship analogous to that of his configurations on the landscape itself. Heizer's looped *Isolated Mass/Circumflex* (1968; Fig. 322) and the *Nevada Depressions* of the same year are linear forms on an indeterminate field when seen from the air or in photographs. Similarly, Barry Le Va's 1967–68 works, such as *Distribution Piece,* utilize the floor as a "ground" on which the gray felt particles, randomly and densely scattered, create a homogeneous and highly pictorial pattern (see Fig. 304).

The problem of the inherent illusionism of applied color in sculpture has been handled in a variety of ways.

TOP: 319. Jasper Johns. *Painted Bronze II (Ale Cans),* 1964. Painted bronze, 5½ x 8 x 4½ inches. Collection of the artist.

ABOVE: 320. Richard Artschwager. *Table with Tablecloth,* 1964. Formica on wood, 25½ x 44 x 44 inches. Leo Castelli Gallery, New York.

Anne Truitt successfully solved it by using color to create sensation rather than to define form. Robert Morris eliminated associative color altogether from his 1964–66 pieces, arriving at a neutral painted gray surface that would allow the form to be read immediately and unequivocally. George Sugarman's use of color is diametrically opposed to Morris's. Splayed out horizontally along the floor, pieces like *Inscape* (1964) and *Two in One* (1966) use intense unequivocal color to create a broken, free, nonrelational space in which the parts of the piece are separated rather than united in a gestalt (Pl. 60, Fig. 324).

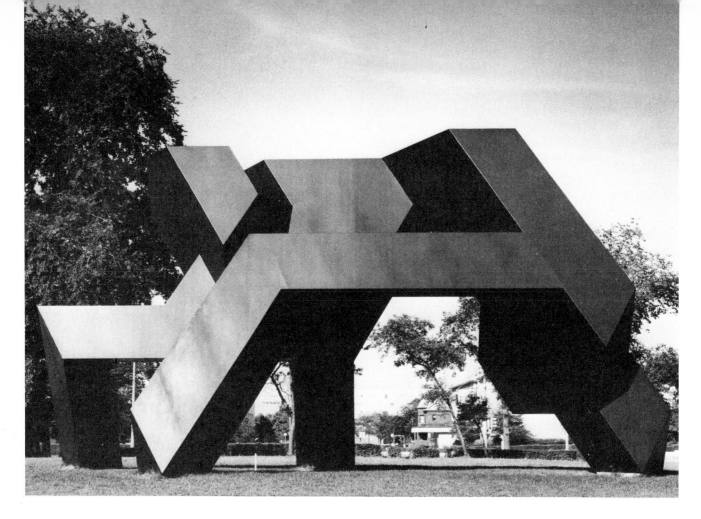

ABOVE: 321. Tony Smith. *Gracehoper,* erected 1972. Sheet steel, 23 x 46 x 22 feet. The Detroit Institute of Arts, Detroit, Michigan.

BELOW: 322. Michael Heizer. *Isolated Mass/Circumflex,* 1968, Massacre, Dry Lake, Nevada. Negative mass, 120 x 12 feet. Photograph by Gianfranco Gorgoni, courtesy of Fourcade, Droll Inc., New York.

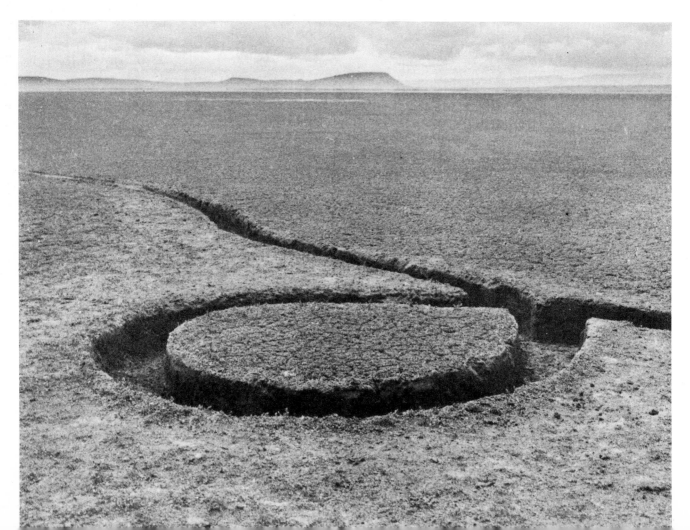

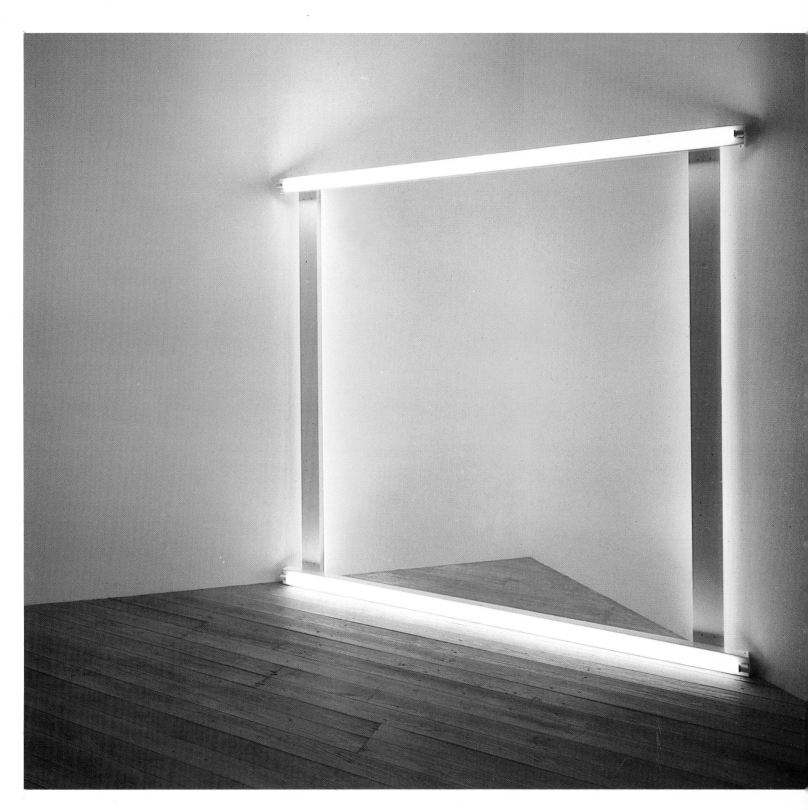

PLATE 57. Dan Flavin. *untitled (to the "innovator" of Wheeling Peachblow)*, 1968. Daylight, pink and yellow fluorescent light; 96 x 96 inches. Leo Castelli Gallery, New York.

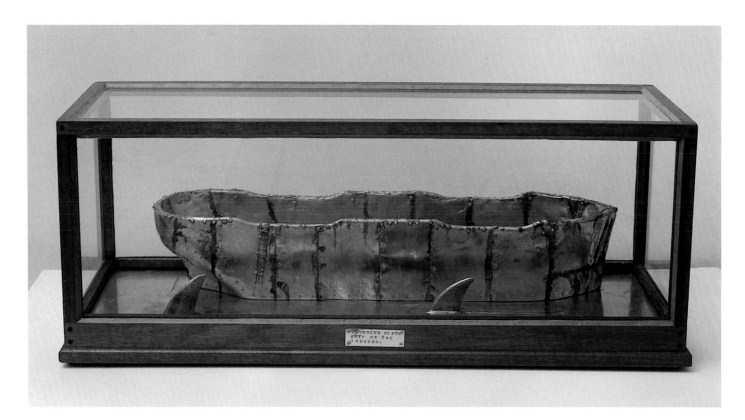

ABOVE: PLATE 58. H. C. Westermann. *American Death Ship on the Equator*, 1972. Copper, amaranth wood, glass; 12 x 36 x 13¾ inches. Collection of Mr. and Mrs. Henry M. Buchbinder.

BELOW: FIG. 323. H. C. Westermann. *Study for Death Ship Run Over by a '66 Lincoln Continental*, 1966. Ink and watercolor on paper, 9¾ x 13½ inches. Private collection.

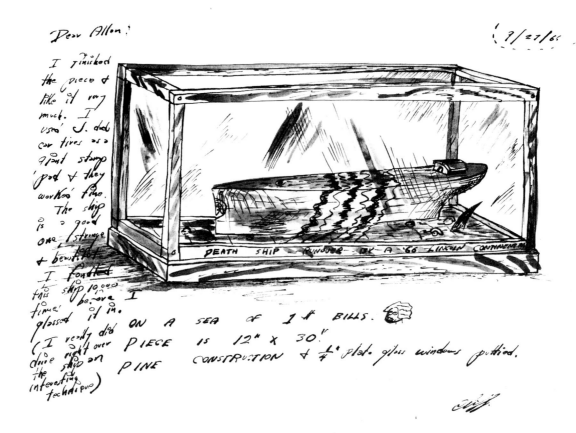

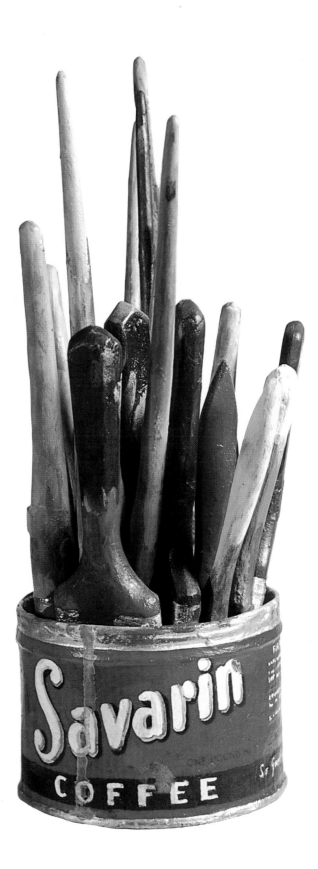

PLATE 59. Jasper Johns. *Painted Bronze (Savarin can with brushes)*,
1960. Painted bronze, 13½ inches high x 8 inches in diameter.
Collection of the artist.

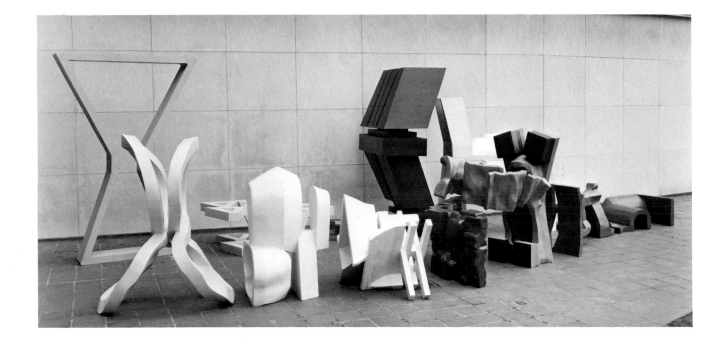

FIG. 324. George Sugarman. *Two in One,* 1966. Painted wood; 7 feet, 6 inches x 23 feet, 6 inches. Collection of the artist.

PLATE 60. George Sugarman. *Inscape,* 1964. Polychromed laminated wood, 24 x 144 x 108 inches. Collection of the artist.

PLATE 61. Edward Kienholz. *The Wait*, 1964–65. Tableau: epoxy, glass, wood and found objects; 80 x 148 x 78 inches. Whitney Museum of American Art, New York; Gift of the Howard and Jean Lipman Foundation, Inc.

FOLLOWING PAGES:

LEFT: PLATE 62. Richard Artschwager. *Mirror-Mirror/Table-Table*, 1964. Formica on wood; 2 mirrors, each 37 x 25 x 5 inches; 2 tables, each 24 x 25 x 30 inches. Collection of Mr. and Mrs. Al Ordover.

RIGHT: PLATE 63. George Segal. *Cinema*, 1963. Plaster figure, illuminated plexiglas, metal sign; 118 x 96 x 39 inches. Albright-Knox Art Gallery, Buffalo, New York; Gift of Seymour H. Knox.

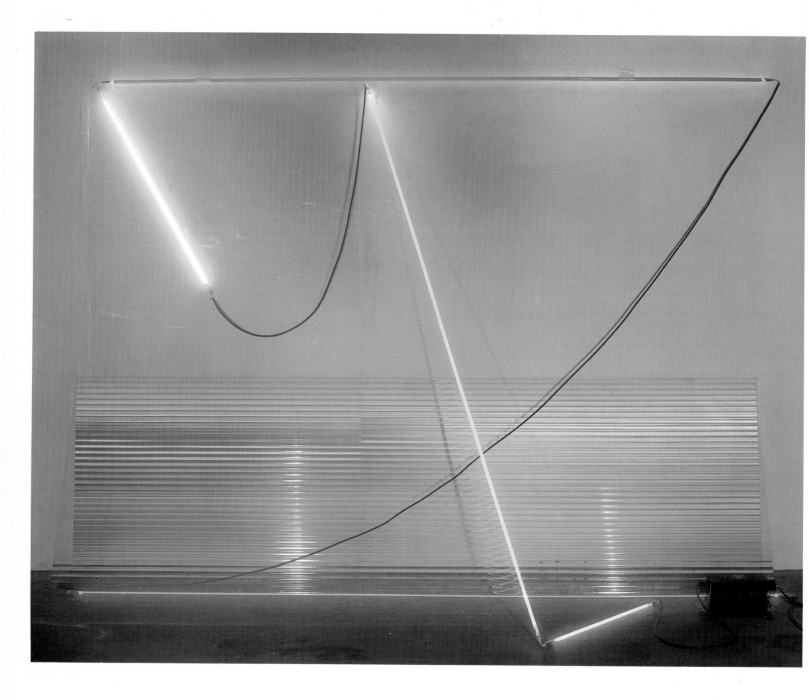

PLATE 64. Keith Sonnier. *Ba-O-Ba, Number 3, 1969.* Glass and neon with transistor; 91¼ x 122¾ x 24 inches. Whitney Museum of American Art, New York; Gift of the Howard and Jean Lipman Foundation, Inc.

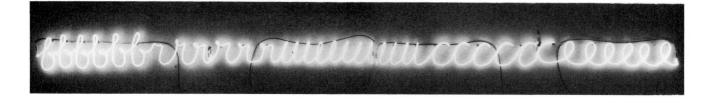

Peter Voulkos's color, in pieces like *Little Big Horn* (1959), comes directly out of painting, since he was a painter and ceramicist until the late 1950s (Fig. 326). His color, he says, is used toward emotive ends and is actually painting on a three-dimensional surface.[9]

Color can also be created through the use of light, retaining literal, sculptural properties: Dan Flavin's neon color is structural, defining corners, edges, planes; Sonnier's neon pieces, like *Ba-O-Ba, Number 3* (1969), are pictorial and romantic, informing the glass or wall surface behind it in the way that a painted line might activate the surface of a canvas (Pl. 64); Nauman takes the linear quality of neon a step further, allowing it to spell out, in writing, cryptic remarks like "The true artist helps the world by revealing mystic truths" *(Window or Wall Sign, 1967)* or *"My Name as Though it were Written on the Surface of the Moon"* (1968; Fig. 325).

Sculpture can reverse illusionism. Nancy Graves's naturalistic camels (1967–70) use realistic, recognizable images to explore abstract, sculptural concerns, such as mass, surface and spatial displacement.[10] Jasper Johns's ale and Savarin cans translate the idea of painting a picture of a picture (as in the target or map paintings) into making a sculpture of an already three-dimensional painted object.

Sculptural rather than pictorial illusionism, on the other hand, is essential to Sylvia Stone's enormous pieces in which tinted, transparent planes of plexiglas render each aspect of the total form illusory or illusionistic. In a classic sense Stone's use of mirrors in pieces like

Green Fall (1970) and *Grand Illusion* (1974) is a way of denying the base while maintaining it (Fig. 327). In this way, the use of mirrors is the perfect means of adapting illusion to sculpture without negating sculpture's literalness.

ABOVE: 325. Bruce Nauman. *My Name As Though It Were Written on the Surface of the Moon,* 1968. White neon tubing, 11 x 204 inches. Collection of Mr. and Mrs. Michael Sonnabend.

BELOW: 326. Peter Voulkos. *Little Big Horn,* 1959. Polychromed and underglazed stoneware, 60 x 33 x 36 inches. The Oakland Museum, Oakland, California; Gift of the Art Guild of The Oakland Museum Association.

BOTTOM: 327. Sylvia Stone. *Grand Illusion,* 1974. Glass and plexiglas, 40 inches x 21 x 10 feet. Collection of the artist.

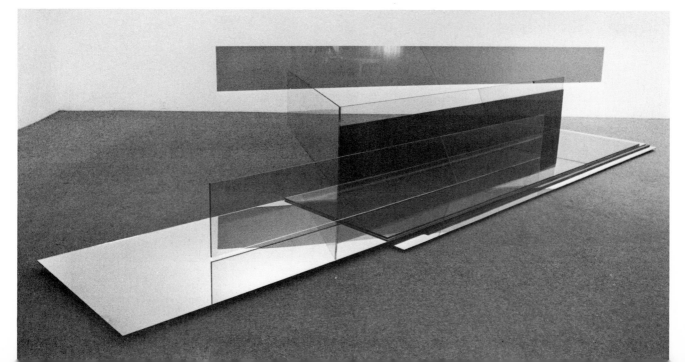

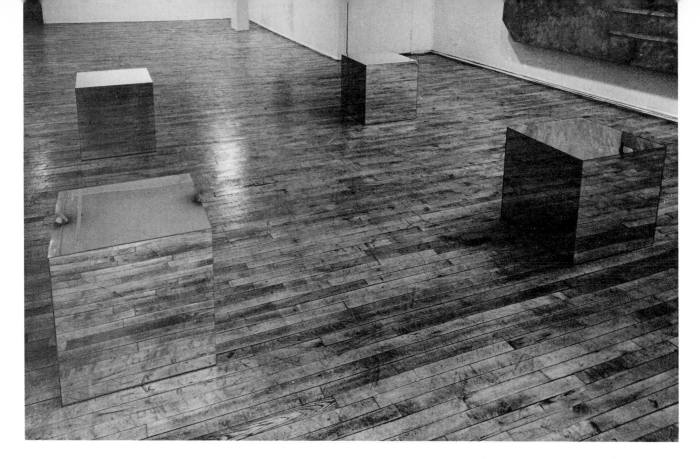

ABOVE: 328. Robert Morris. Untitled, 1965. Plexiglas mirrors on wood, 21 x 21 x 21 inches. Leo Castelli Gallery, New York.

BELOW: 329. Lucas Samaras. *Mirror Room*, 1966. Glass and wood, 96 x 120 x 96 inches. The Albright-Knox Art Gallery, Buffalo, New York; Gift of Seymour H. Knox.

330. Robert Smithson. *First Mirror Displacement,* 1969, Yucatan, Mexico. Each mirror 12 inches square. Photograph courtesy of John Weber Gallery, New York.

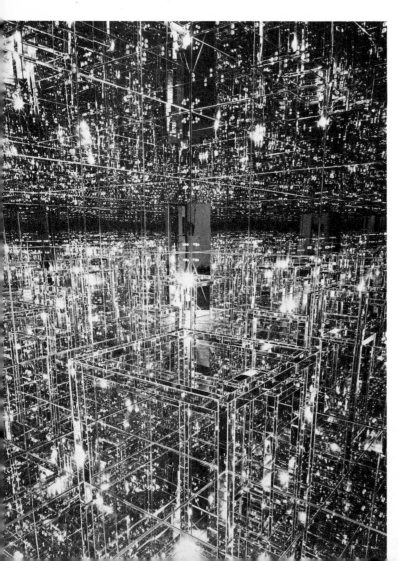

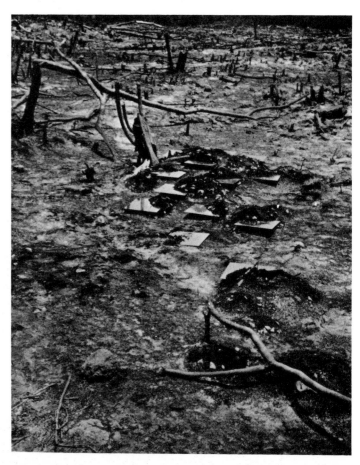

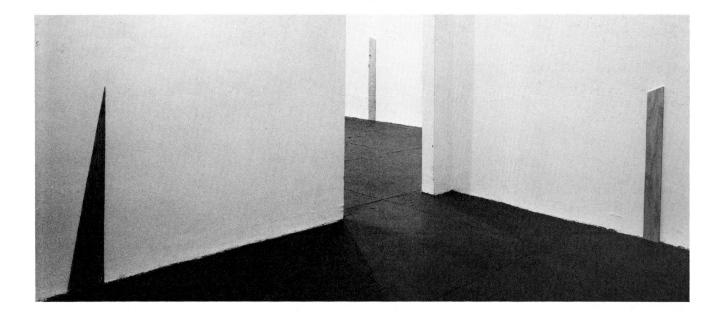

Robert Morris's mirrored cubes (1965), in which plexiglas mirrors cover the five visible sides of four twenty-eight-inch plywood cubes, dematerialize the most solid and stable sculptural form, the cube, substituting nothing for something in one of the great visual puns of so-called Minimalist art (Fig. 328). Nauman, doing the opposite—visually materializing rather than dematerializing—used a mirror at the end of a two-inch-wide, fifty-foot-long corridor to create the illusion that the corridor turns and continues beyond the point where we can still see into it. Lucas Samaras's *Mirror Room* (1966) creates a contained environment in which endless reflected images, images within images, top, bottom and sides, one behind the other to infinity, are the visual analogue for timelessness (Fig. 329).

Whereas the mirrors of Nauman, Morris and Samaras reflect a vertical image, Stone's bases and Smithson's mirror displacements use illusion on a horizontal plane (Fig. 330). This alteration exemplifies a major change that took place in sculpture between the 1950s and the mid-1960s. Vertical dimensions in sculpture have, in general, been replaced by horizontal ones, except in situations like those cited where the human image, itself a prototype of verticality, is literally reflected.

A change from the vertical to the horizontal can be seen as one manifestation of the present move away from the transcendental content of much Abstract Expressionist sculpture, especially in that

> The vertical . . . has always been considered the *sacred* dimension of space. It represents a 'path' towards a reality which may be 'higher' or 'lower' than daily life, a reality which conquers gravity, that is, earthly existence, or succumbs to it. . . . If verticality has something surreal about it, the horizontal directions represent [humanity's] concrete world of action.[11]

Moreover, verticality "represented" the standing human figure; a move to pure abstraction in the early 1960s rendered such anthropomorphic references obsolete for many younger artists.

ABOVE: 331. Richard Tuttle, *3rd, 5th and 1st Slats*, 1974. Plywood and white paint, approximately 36 inches high. Collection of Jock Truman.

BELOW: 332. Carl Andre. *Decks*, 1974. Installation at John Weber Gallery, April 6–May 1, 1974.

The difference between one's experience of verticality and horizontality can be demonstrated by comparing recent installations by Tuttle and Andre. Richard Tuttle's markerlike plywood slat pieces (1974), beginning at floor level and terminating about three feet up the wall, arrest motion. They are flat, mute and vertical; the feeling of the room which contains them is that of temporal, spatial suspension and isolation (Fig. 331). Andre's 1974 installations at the John Weber Gallery (New York) and Ace Gallery (Vancouver, Canada) begin at the wall and extend horizontally partway along the floor; they are active, purposeful, evolutionary (Fig. 332).

In a similar vein, Tony Smith stated that because all thinking is done in these two dimensions, "any angle off that is very hard to remember. For that reason I make models – drawings would be impossible."[12] Likewise it has been remarked that Carl Andre's most obvious contribution to contemporary sculpture has been his work's identification with horizontality,[13] a format which Andre has retained since his 1965 exhibition at the Tibor de Nagy Gallery in New York, in which he stacked slabs of white styrofoam on top of each other in a horizontal pattern (Fig. 333).

The general change from vertical to horizontal in sculpture is more than a straightforward reaction to the formal configurations of the 1950s. Questioning the meaning of these dimensions and how they affect our movements, perceptions and activities leads us into the theoretical area of operational space. By examining how different kinds of space and dimensions affect our lives, some of the problems of dealing with contemporary sculpture may be illuminated; while sculpture was formerly considered to be an art of mass, it is now, above all, an art of space.

333. Carl Andre. Detail of three works, *Crib, Coin* and *Compound*, 1965, installed at Tibor de Nagy Gallery, New York, January 1965. Works composed of white styrofoam beams, 9 x 21 x 108 inches; overall dimensions vary. Photograph courtesy Sperone Westwater Fisher Inc.

The most obvious differences between radical sculpture and other spatial arts, since they have increasingly come to resemble each other in recent years, are those of function and intent. Robert Smithson, in a caption for his "Site-Selection" of Pine Flat Dam, Sacramento, California, wrote, "This dam is seen as a functionless wall. When it functions as a dam it will cease being a work of art and become a 'utility'."[14] Smithson's *Spiral Jetty* does not go anywhere except into itself, Andre's floor pieces do not protect the floor, Artschwager's furniture cannot be used. In instances where the sculptor does not make a recognizable or visible object, as has been the case with Robert Irwin at certain times, it is only intention that separates the artist's activity from other kinds of activities. "The only thing unique to being an artist," says Irwin, "is taking up the position of being an artist."[15] In this regard, Donald Judd has often been quoted as saying, "It's art if I say it is."

Despite differences of function and intent that separate sculpture from other objects in the world, space is their shared dimension. Existential space, "the product of an interaction between the organism and the environment in which it is impossible to disassociate the organization of the universe perceived from that of the activity itself,"[16] involves operations or activities. It can be divided into three constituent elements, that of *place* (or center), *path* (or direction) and *domain* (or area).[17] Domain differs from place only in that it is defined in architectural theory as "a relatively unstructured 'ground' on which places and paths appear as more pronounced 'figures',"[18] whereas place is more localized.[19]

Place is defined in terms of proximity or enclosure, path (or direction) in terms of continuity. Place is characterized by a specific size and its center represents what is known to us; centers are places of action, where particular activities are engaged in.[20] Essential to place, and to center, is the idea of mobility, of "arrival and departure and of inside and outside."[21] Unlike path, this category has no goal. In sculptural terms, one might, for instance, describe Robert Morris's *Labyrinth* (1974) as a place containing a path directed toward a center or goal, which can be known only through the evolution of time and space, that is, the viewer's passage through it (Fig. 334). Compared with Carl Andre's *Lever* (1966; Fig. 335), which is a goal-less, directed path made of firebricks, Morris's piece necessitates a completely different activity in order to experience the work, and results in a different experience; it involves the attainment of a goal and the sense of place, subsumed, at final destination, by one's inability to perceive the path by which one attained that goal.

For Andre, place and path are both intrinsic to his work. He has remarked that his pieces are "always very

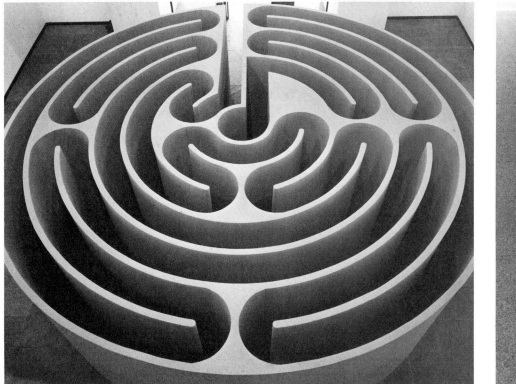

334. Robert Morris. *Labyrinth,* 1974. Painted masonite, plywood and two-by-fours; 96 inches high, 30 feet in diameter. Institute of Contemporary Art, Philadelphia.

335. Carl Andre. *Lever,* 1966. Firebricks, 29 feet long x 4½ x 8⅛ inches (overall). The National Gallery of Canada, Ottawa.

much concerned with place,"[22] and that "there's always a relationship between the object as a place in itself and the place where the object is."[23] He also remarked, in another interview, that

my idea of a piece of sculpture is a road . . . we don't have a single point of view for a road at all, except a moving one, moving along it.[24]

An analysis of place and path in the work of Andre and others is complicated by the fact that the two elements are most often found in combination with each other and operate on many levels, some of which have been isolated and defined in recent architectural theory. The first is that of objects determined by the function of the *hand,* such as grasping, seizing, forming, etc. The second pertains to *furniture* or objects determined by the size of the body and its immediate activities. The third and fourth levels deal with dwellings, that is, the *house* (a private place, the dimensions of which are obtained from more extended body movements) and the *urban* or more public dwelling level, determined by social interaction. The fifth and sixth levels are those of *landscape,*

expressing human interaction with the natural environment and *geography,* which is a level of general knowledge, obtained as a result of travel from one landscape to another.

The first two categories embrace forms which tend to be permanent in the history of civilization. "Being directly connected with certain functions, 'things' usually have a maximum of precise form."[25] Jasper Johns's ale and coffee cans, Peter Voulkos's clay vessels and Ken Price's cups are things used and known by the hand; though beer and coffee cans are relatively recent additions to civilization, their form — that of a container — is ancient and enduring. Similarly, on the literal level of "furniture," Richard Artschwager's Pop *Mirror-Mirror/ Table-Table* (1964) and Robert Morris's *Hearing* (1972; a recording, an electrified copper chair, a lead couch and a zinc table of slightly different proportions) have in common, despite widely differing styles and intentions, a focus on the relationship of body activities to ideas (Fig. 336). For Artschwager (Pl. 62), taking furniture out of its functional context makes the experience of space.

ABOVE: 336. Robert Morris. *Hearing*, 1972. Installed at Leo Castelli Gallery, April 18–May 6, 1972. Three pieces on a platform 12 feet square with 2-foot sections cut out of the corners. Chair: copper, 48 x 24 inches; bed: lead, 24 x 72 inches; table: galvanized aluminum, 78 inches long x 36 inches wide; base covered with sand. Leo Castelli Gallery, New York.

FAR LEFT: 337a. Lucas Samaras. *Chair Transformation Number 25A*, 1969–70. Plastic and wire, 42 x 20 x 22 inches. Whitney Museum of American Art, New York; Gift of Howard and Jean Lipman Foundation, Inc.

LEFT: 337b. Lucas Samaras. *Chair Transformation Number 12*, 1969–70. Synthetic polymer on wood, 41½ x 36 x 13 inches. Whitney Museum of American Art, New York; Gift of the Howard and Jean Lipman Foundation, Inc.

BELOW: 338. Claes Oldenburg. *Bedroom Ensemble*, 1963. Wood, vinyl, metal, fake fur and other materials; 17 x 21 feet. The National Gallery of Canada, Ottawa.

an abstraction which grows naturally out of looking at, looking into, looking through, walking, opening, closing, sitting, thinking about sitting, passing by, etc. For some time I have been making works which specifically invite one or more of these activities. Each of the marble-ized works instructs or proposes by its configuration one or more of these activities.[26]

In Morris's piece, electrifying the furniture signals discomfort as well as actual danger, requiring that one engage in an activity (remain standing) contrary to that ordinarily demanded by furniture. Other examples of "furniture" transformed by intent and removal of function are Lucas Samaras's *Chair Transformations* (1969–70) Claes Oldenburg's *Bedroom Ensemble* (1963), or Kienholz's adaptation of furniture to narrative ends in *The Wait* (1964–65; Figs. 337a and b, 338, Pl. 61).

The house (a place containing an interior structure) and the urban level (of which enclosure and cluster are basic elements) relate to sculpture on a large scale, to which the viewer's mobility and perceptual understanding in time are basic. The path is generally an element which directs one to a settlement, differentiated from its surroundings by its density. Michael Heizer's uninhabitable *City* in the desert valley north of Las Vegas, begun in 1971 and partially completed (*Complex One* was finished in 1974), is a powerful example of the urban architectural concept expanded, refined and removed from function (Pl. 66). In its entirety, the complex will occupy three square miles in an area without roads or other habitation. Heizer's piece extends clearly into the adjacent landscape level, "that of the 'ground' on which the configurations of existential space have developed."[27]

In the graphic outdoor pieces of De Maria, Smithson and Heizer, the "ground" of landscape space has been taken literally by relating it to the figure-ground aspects of painting, expanded to landscape dimensions. By analogy, the "scatter" pieces of many artists throughout the late 1960s, while done within the interior dimensions of a room, are transformations by means of which the outdoors is brought inside – De Maria's earth-filled room in Munich (1968; Fig. 296), Robert Morris's 1968 and 1969 interior earthworks in New York, and Robert Smithson's Non-Site bins, which he called "three-dimensional maps," containing rocks from the original site (Fig. 339). Smithson utilized the idea of place in a highly abstract way, one which belongs to the final, geographical level; space-time solutions to problems of the most complex sort, such as those which involve travel from one geographical area to another, are sought by dealing with topological properties, whose interpretation is found in a system of mapping. Maps are themselves topological in nature, and "stand for" the three-dimensional horizontal surface of the earth – or even, in Nancy Graves's case, of the moon. Le Va's drawings for

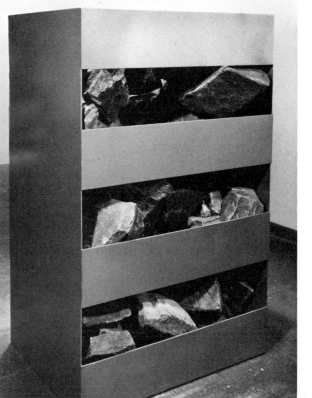

339. Robert Smithson. *Non-Site (Palisades-Edgewater, NJ)*, 1968. Enamel, painted aluminum and stone; 56 x 26 x 36 inches. Whitney Museum of American Art, New York; Gift of the Howard and Jean Lipman Foundation, Inc.

his Walking Stick pieces (1972–73) are diagrammatic renderings of an activity in real space and real time, just as the sticks themselves, lying on the floor, are the residue of the bodily activity employed in their placement (Fig. 340). Maps refer to three-dimensional and sometimes physically inaccessible locations. A further extension of the geographic level involves the transfer of information, or knowledge, from one place to another, and is "thought rather than lived."[28] This level of space is a comparatively new one and conceptual art belongs in this category.[29]

In sculpture, as in the other spatial arts, the interaction of places and surroundings creates the problem of inside and outside, a fundamental topological relationship of existential space.[30] In contemporary sculpture, especially, the dialectic of inside/outside operates on every level. In the most general sense, it is at the heart of all art, since art is the externalization of interior dimensions – emotional, physical, intellectual and perceptual.

ABOVE: 340. Barry Le Va. *Center Points and Lengths (through Tangents)*, 1974–75. Installation at Contemporary Arts Center, Cincinnati, Ohio, 1975. Wood pieces arranged in a system of tangent circles.

LEFT: 341. Michael Heizer. *Adze Dispersal*, 1968–71. Stainless steel, ½ x 20 x 7 feet (variable). Fourcade, Droll Inc., New York.

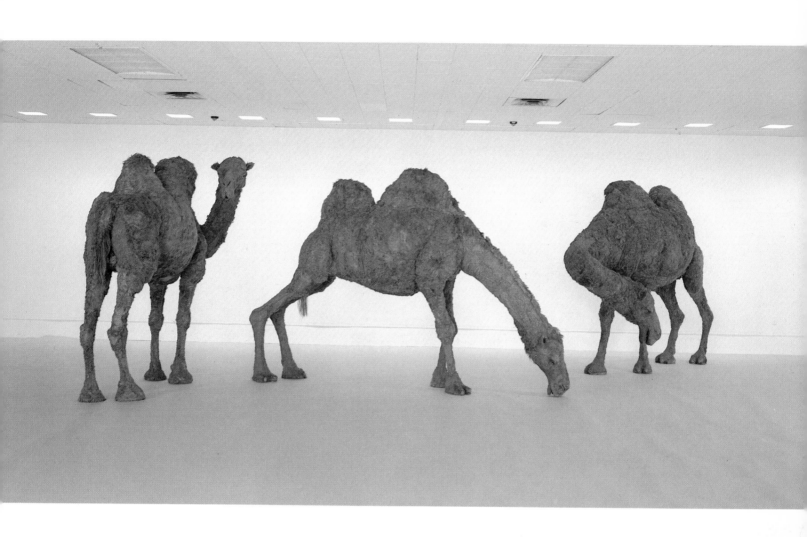

PLATE 65. Nancy Graves. *Camel VII, Camel VI, Camel VIII,* 1968–
69. Wood, steel, burlap, polyurethane, animal skin, wax, oil paint;
96 x 108 x 48 inches, 90 x 144 x 48 inches and 90 x 120 x 48 inches.
The National Gallery of Canada, Ottawa.

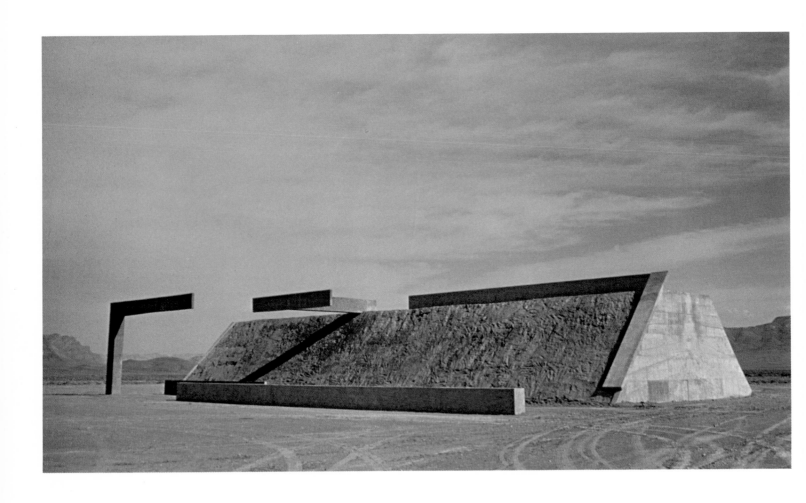

PLATE 66. Michael Heizer. *The City, Complex One,* 1972–74, central eastern Nevada. Cement, steel, earth; 23½ x 140 x 110 feet. Fourcade, Droll Inc., New York. Photograph by Gianfranco Gorgoni.

PLATE 67. Robert Smithson. *Amarillo Ramp,* 1973, near Amarillo, Texas. Red sandstone shale; diameter at top, 150 feet. Estate of Robert Smithson, courtesy of John Weber Gallery, New York. Photograph by Gianfranco Gorgoni.

240

PLATE 68. Sylvia Stone. *Another Place,* 1972. Plexiglas, 80 x 204 x 338 inches. Collection of Al Held.

342. Carl Andre. *37 Pieces of Work,* 1969. Aluminum, copper, steel, magnesium, lead and zinc; 3/8 x 432 x 432 inches overall. Collection of the artist.

More specifically, Andre's *37 Pieces of Work* (1969) is to be walked on (Fig. 342; also Fig. 313). When standing in the middle of it, one is both inside its parameters and outside its surface. Nancy Graves's work, from the earliest Camel piece on, has also centered on this issue. She began with the exterior form of the animal, then opened it, explored its skeletal structure, the shamanistic aspects of the culture in which the animal is used, and in a further extension of the concept, made two films of camels in their "real" context (Pl. 65). Robert Morris's *I-Box* (1962) opens to reveal a picture of the artist, naked (Figs. 343a, b). Containment, concealment, mystery and revelation in such early Morris pieces as *Box with the Sound of Its Own Making* (1961) are expressed in the transparent metal mesh sculptures of 1967 by containers whose closed form nonetheless reveals both inside and outside simultaneously. In more recent projects, he continues to play with this question, either by placing us inside the sculpture, as in *Labyrinth* (1974), or placing it inside us, as in *Voice* (1974), by means of recorded sound.

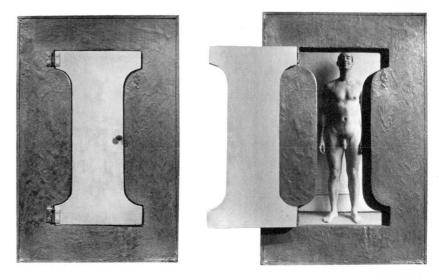

RIGHT: 343a. Robert Morris. *I-Box* (closed), 1962. Mixed media, approximately 12 x 18 inches. Leo Castelli Gallery, New York.

343b. *I-Box* (open).

Bruce Nauman has also explored inside/outside issues throughout his work, from the 1965 fiberglass pieces, split and turned out, to the room environments of the 1970s. In *Two Rooms: Empty, Sealed and Private* (1970) the viewer can see only the empty room on a video monitor, and the viewer's image is projected into the sealed room where it cannot be seen at all. What is public is made private, and vice versa.

The value of these spatial categories is not a hierarchic one; work does not "advance" as it moves from the level of "things" to that of "general knowledge." Rather, its value is operational, serving to clarify how or why we experience specific works the way we do. Some of the most radical work of the past few years, for example, deals directly with small-scale objects. Among Richard Tuttle's earliest pieces are small white cardboard boxes (1963), almost weightless and small enough to be held in the hand. The handmade quality of Tuttle's wire/shadow/graphite works (1974) contributes substantially to their fragile mystery, in which the activities of the artist's hand directly translate those of the eye and mind (Fig. 344).

Nauman's *From Hand to Mouth* (1967) is a visual pun on a verbal cliché, a seemingly handcrafted object which is actually a wax casting, and an ironic commentary on the relationship between language and the body (Fig. 345). Andre makes a more formal statement; his pieces are composed of tiny parts laid end to end, each component of which is easily hand-held. These linear works are

ABOVE: 344. Richard Tuttle. *7th Wire Piece*, 1972. Wire, nails and pencil; approximately 24 x 12 inches. Betty Parsons Gallery, New York.

LEFT: 345. Bruce Nauman. *From Hand to Mouth*, 1967. Wax over cloth, 30 x 10 x 4 inches. Collection of Joseph Helman.

BELOW: 346. Robert Irwin. Installation at Mizuno Gallery, Los Angeles, January–February 1974.

experienced as paths, on which one moves forward and backward. The path, in addition to signifying continuity, also presents an experiential tension between the known (where one starts) and the unknown (where one is going).[31] (Andre spent several years in the early 1960s working as a brakeman and conductor for the Pennsylvania Railroad, which influenced his work to some extent.)

Changes in scale create drastic changes in the experience of familiar objects. Claes Oldenburg's work is powerful not only by virtue of its humor, but because things that we ordinarily relate to in terms of our body size (lipsticks, baseball mitts, toilets, bedroom furniture) are blown up to architectural proportions. H. C. Westermann's narrative sculpture, on the other hand, often reduces the scale. In his Death Ship series, for instance, miniaturization allows the viewer to see the whole story, as it were, at once (Pl. 58).

Other sculptures create their own environment, occupying an area between the tangibility of "things" and the openness of landscape. Irwin's recent pieces, which are alterations of rooms (he calls them "volumes"), require a minimum amount of careful building to produce a maximum effect. Irwin's rooms are so subtle, and perceptually so low-keyed, that the piece and the environment are indistinguishable, pursuing the issues embodied in the earlier discs, which appeared to be flush with the wall although they actually extended out from it by about one foot (Fig. 346). Nauman's rooms are exactly the opposite of Irwin's, placing an emotional overload on the viewer in a subtle way; for instance, a 1972 wallboard room had a sound and speaker system inside the walls so that once inside the room, one heard a tape loop of Nauman's voice, whispering urgently, "Get out of the room, get out of my mind!" The unsettling, physically disruptive sensations produced by the piece were due partly to the fact that the room's intrinsic value as a habitable space was subverted by the message it contained.

The equation of a dwelling place with the inside of the mind is a classic one, manifest in almost all sculpture that is experienced on the level of "dwelling." Sylvia Stone, for instance, described the genesis of her large plexiglas sculptures of 1972–74 as a desire to create a tranquil, poetic environment as an alternative to the real world. Sculptural domains such as hers, as well as actual domains, are defined by their edges. In the sweeping arcs and planes of *Another Place* (1974; Pl. 68), as in reality,

edges are the linear elements not considered as paths: they are usually, but not always, the boundaries between two kinds of areas.[32]

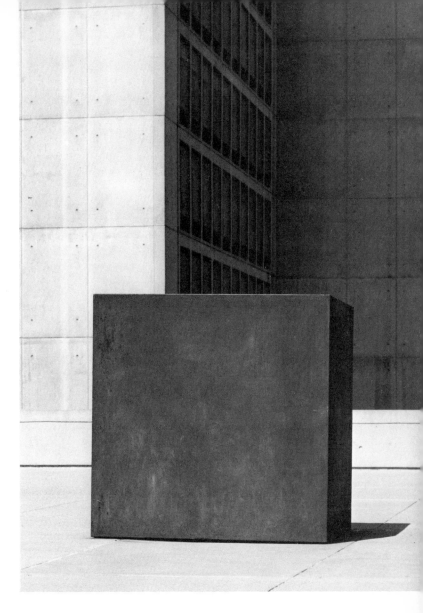

347. Tony Smith. *Die*, 1962. Steel, 72 x 72 x 72 inches. Fourcade, Droll Inc., New York.

One critic aptly described Stone's pieces as "barriers to encase the fullness of seemingly empty space . . . to pin down illusion, map out its dimensions in terms of a gallery space, a particular place."[33]

Anne Truitt's pieces, which were meant to be outdoor works, have the appearance of having come into existence all at once. Truitt's *Carson*, like Tony Smith's *Die* or Morris's untitled gray plywood box, seems to have formed itself, a characteristic of dwellings or settlements as they appear on the horizon, or from above (Fig. 347). They have an inert, expectant quality, seeming to provoke the viewer to wait endlessly for something to happen.

George Sugarman's *Inscape* (1964; Pl. 60), by its horizontal formal relationships, evokes interior situations because of scale, yet suggests both the immensity of landscape and the private emotions it elicits. Tony Smith's model for *Generation*, to be built at a height of over thirty feet, explores interior and exterior relation-

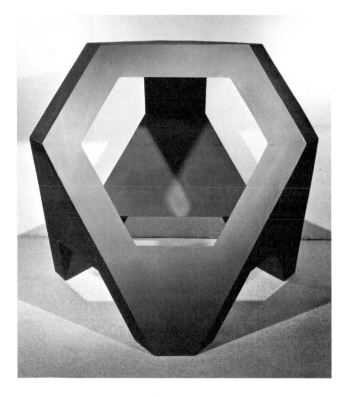

ships that are close to architecture except that the open configuration precludes the function of shelter (Fig. 348). Most of Smith's pieces, however, are more horizontal than vertical, so that one's movement is directed along as well as through them.

Relationships to the urban environment may be implicit or explicit (Fig. 350). Richard Serra's mock-up for a city piece, *Ollantayambo* (1974), consisted of eight plates in a trapezoidal form (Fig. 349). The piece

is . . . composed of an outer structure and an inner experience. . . . Externally, the work is a city skeleton, a tomb trapping time in stasis, a deserted fortress echoing forgotten power, a hollow form whose occult shape symbolizes a latent but unused and never to be used potency. . . . Externally, the work belongs to and recognizes the city both in its material and its method.[34]

On the landscape level we can find the area of most obvious change in recent sculpture, that is, the shift away from studio art to one that is predominantly horizontal and topological, conforming to the surface of the earth. It has been noted earlier that change does not imply advance; certain earth works appear to be reiterations of classic issues in new dimensions, whereas some of the most startling and resistant work is done—like Tuttle's, for example—on a very small scale, and inside the studio. However, the expanding definition of sculpture in recent years has had its strongest impact outdoors.

Because "things" are directly perceived and their forms

348. Tony Smith. *Generation,* 1965. Cardboard, 17½ inches high. Model for a proposed painted plywood sculpture to be 32 feet high. Fourcade, Droll Inc., New York.

349. Richard Serra. *Ollantayambo,* 1974. Artist's plan for work to be made from Cor-ten steel, 120 x 83 feet overall.

change very little over time, they are more specific and directly apprehendable. On the level of dwellings, or landscape, there is an increasing difficulty in perceptual apprehension because of the nature of vision and what one can take in at once. On the most comprehensive level, that of geography and general knowledge, which involves travel, forms are so difficult to perceive that they must be mediated to the level of "things" via maps or photographs. Because geometric forms differentiate themselves from a field more readily than non-geometric ones, the larger a piece of sculpture, the more geometrical it tends to be. Heizer's *City* and Smithson's *Amarillo Ramp*, for instance, are completely geometrical, thus compensating for the perceptual complexity of situating the piece in the immensity of the landscape (Pl. 67).

In terms of place, Nauman's projects for underground pieces (1973) and Morris's 1971 *Observatory*, a conical structure 230 feet in diameter, are extreme examples of using the landscape as a middle plane from which a locus can be expanded, or into which it can be dug (Fig. 351).

Smithson, talking about working outdoors, noted that "the desert is less 'nature' than a concept, a place that swallows up boundaries."[35] The artist, who died in a plane crash while viewing the site of *Amarillo Ramp* in 1973, used a circular or spiral pathlike configuration in many of his drawings and executed pieces. *Spiral Jetty* (1970) uses a goal-less path (you arrive at a point where you must start back again) to illustrate entropy — the concept that the energy in the universe strives toward an increasing degree of dissipation and disorder. Smithson focused his attention not on the beauty of the natural landscape which he utilized to make his work, but on the results of entropy on it. Thus, *Spiral Jetty*, built of large stones that one stumbles on when traversing it, turns inward on itself and becomes smaller the farther and longer you walk on it (Fig. 352). *Amarillo Ramp* alters one's view of the surrounding landscape as one walks along it, but its path also circles around to come to rest on itself. Its solitary and striking aspect in the landscape may be explained partly by the fact that

a circular space has no direction and 'rests in itself.' *Centralization* therefore stresses the isolated figure-character of a space.[36]

Smithson's outdoor pieces are examples of sculpture in which the work's spatial character as a path relates to its temporal character in a specific way. "Grasping time," says Piaget,

is tantamount to freeing oneself from the present, to transcending space by a mobile effort, i.e., by reversible operations. To follow time along the simple and irreversible course of events is simply to live it without taking cognizance of it. To know it, on the other hand, is to retrace it in either direction.[37]

Smithson's work, like the best contemporary sculpture, regardless of its methods, materials, scale and operational mode, reinforces the fact that we experience sculpture directly in terms of its operations, or what it does. The distinctions that must be made between works of art and other objects or situations, therefore, can be made on the basis of how they are experienced. Because the artist is relieved of the necessity of producing functional things, dwellings, sites or theories,

the work of art can concretize a possible complex of phenomena, that is, a new combination of known elements. In this way it manifests possible, not yet experienced life-situations, and it requests perceptions of new kinds, experiences which become meaningful according to their relationship with the already existing world of objects.[38]

It is to explicate the difference between what is brought into existence and what is already there that the objects and situations of our present spatial existence can be used — as a framework against which to examine those works of art which have contributed, in the past two decades, to a new and often puzzling vocabulary of sculptural form.

350. Richard Serra. *Sight Point*, 1971–75. Cor-ten steel, 14 x 40 feet overall. Installed at the Stedelijk Museum, Amsterdam.

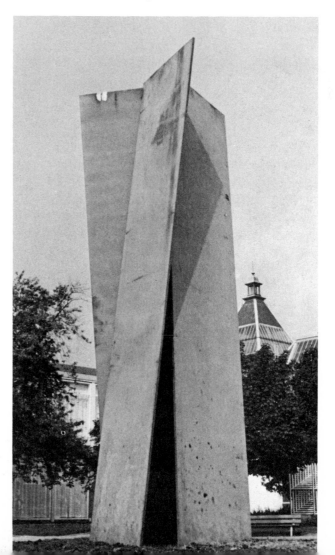

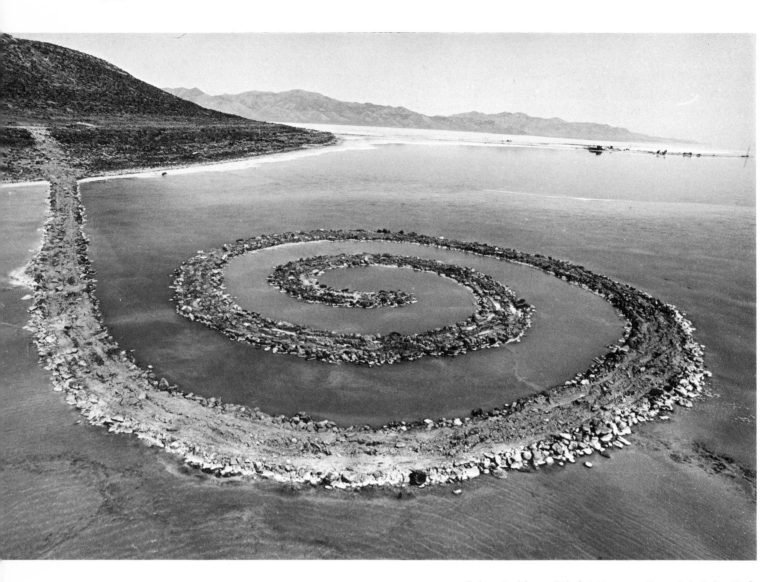

Notes

1. Robert Smithson, "Towards the Development of an Air Terminal Site," *Artforum*, vol. 5 (Summer 1967), p. 40.

2. Quoted from excerpts from symposium on WBAI-FM, March 8, 1970, in *Six Years: The dematerialization of the art object from 1966 to 1972*, Lucy Lippard, ed. (New York and Washington: Praeger Publishers, 1973), p. 156.

3. Clement Greenberg, "Recentness of Sculpture," *American Sculpture of the Sixties* (Los Angeles: Los Angeles County Museum of Art, 1967), p. 24.

4. Phyllis Tuchman, "An Interview with Carl Andre," *Artforum*, vol. 8 (June 1970), p. 57.

5. Ibid., p. 60.

6. *Richard Brown Baker Collects!* (New Haven, Conn.: Yale University Art Gallery, 1975), p. 50.

7. Robert Pincus-Witten, "Keith Sonnier: Video and Film as Color Field," *Artforum*, vol. 10 (May 1972), p. 37.

8. Interview with Richard Artschwager, "The Object: Still Life," *Craft Horizons*, vol. 25 (September/October 1965), p. 54.

9. In conversation with the author, April 1975.

351. Robert Smithson. *Spiral Jetty*, 1970, Great Salt Lake, Utah. Black rock, salt crystals, earth, red water (algae); coil 1500 feet long by approximately 15 feet wide. Photograph by Gianfranco Gorgoni, courtesy of John Weber Gallery, New York.

10. Realist sculptors like Duane Hanson or John de Andrea are not so much concerned with abstract concepts as with replication, or a sculptural version of trompe l'oeil painting.

11. Christian Norberg-Schulz, *Existence, Space and Architecture* (New York and Washington: Praeger Publishers, 1971), p. 21.

12. Sam Wagstaff, Jr., "Talking with Tony Smith," *Artforum*, vol. 5 (December 1966), p. 18.

13. Jeremy Gilbert-Rolfe, in "Reviews," *Artforum*, vol. 12 (June 1974), p. 68, a review of Carl Andre's work at John Weber Gallery.

14. Smithson, op. cit., p. 36.

15. In conversation with the author, June 1975.

16. Norberg-Schulz, op. cit., p. 11.

17. This discussion of existential space has been drawn from Norberg-Schulz's theories. His writing takes into account other phenomenologists who have dealt extensively with spatial issues, among them Gaston Bachelard, Maurice Merleau-Ponty and Jean Piaget.

352. Robert Morris. *Observatory,* 1971. Earth, timber, granite, steel, water; 230 feet across. Installed at Umviden, the Netherlands.

18. Norberg-Schulz, op. cit., p. 23.

19. For the purposes of this discussion *place* and *domain* have been combined, since the area of theater and performance, involving those physical activities for which domain functions as a potential place, are outside the scope of this essay.

20. Norberg-Schulz, op. cit., p. 19.

21. Ibid., p. 49.

22. "Interview with Carl Andre," 1968, *Avalanche,* Fall 1970, p. 20.

23. Ibid., p. 22.

24. Tuchman, op. cit., p. 57.

25. Norberg-Schulz, op. cit., p. 32.

26. Wouter Kotte, "Interview with Richard Artschwager," *Artschwager Utrecht Projekt* (Utrecht, The Netherlands: Hedendaagse Kunst, 1972), n.p.

27. Norberg-Schulz, op. cit., p. 28.

28. Ibid.

29. This is especially true of the work of John Baldessari, Jan Dibbets, Vito Acconci and others who use photo documentation to transfer information, as opposed to artists involved in language or semiotics; this area of conceptual art is also outside the immediate scope of this essay.

30. Norberg-Schulz, op. cit., p. 25.

31. Ibid., p. 21.

32. Ibid., p. 24, quoting Kevin Lynch.

33. Corrine Robins, "Sylvia Stone: The Edges of Illusion," *Art Spectrum,* January 1975, p. 33.

34. Donald B. Kuspit, "Richard Serra's City Piece," *Arts,* vol. 49 (January 1975), p. 48.

35. Robert Smithson, "A Sedimentation of the Mind: Earth Projects," *Artforum,* vol. 7 (September 1968), p. 49.

36. Christian Norberg-Schulz, *Intentions in Architecture* (Cambridge, Mass.: M.I.T. Press, 1965), p. 136.

37. Jean Piaget, *The Child's Conception of Time,* 1927, A. J. Pomerans, trans. (New York: Ballantine Books, 1971), p. 283.

38. Norberg-Schulz, *Intentions in Architecture,* p. 74.

LAST DAY AT
TYLER'S BUILDING.

POWERS'
Greek Slave

The Exhibition of this World Renowned Statue,

Over which Poets have grown sublime, and Orators eloquent, will
CLOSE THIS EVENING, AUG. 1st. ☞ By special request.

NONE BUT LADIES AND FAMILIES WILL BE ADMITTED DURING THE AFTERNOON OF EACH DAY.

THE SUBJECT IS A

GRECIAN MAIDEN,

Made captive by the Turks, and exposed for sale in the Bazaar of Constanti-
nople. This statue is the property of Mr. Powers, and is the same one for-
merly exhibited in New York, and which has been on exhibition for several
years. The one at the World's Fair, which is pronounced

THE GEM OF THE WHOLE COLLECTION,

was made by Mr. Powers, from the same Model, for Capt. Grant, of the Royal
Navy, and has never been in America. Capt. Grant kindly placed it in the
American department of the Great Exhibition.

We hope, while all the world is admiring the Greek Slave in the Crystal
Palace, the citizens of this place will improve this opportunity to see it at their
own doors.

One writer says, the Greek Slave receives the most unqualified
admiration. Not one of all the

Fifty Thousand Daily Visitors!!

Leave the Exhibition without acknowledging the genius of our own Ameri-
can artist, Powers.

ADMISSION 25 CTS. PAMPHLETS 6¼ CTS.
Open from 9 A. M. till 9 P. M.

Franklin Office, 132 Chapel Street.

*Broadside Announcing the
Appearance of Hiram Powers's
Greek Slave, n.d. Printed on
paper, 9⅝ x 5½ inches.
Collection of Mr. and Mrs.
John McCoubrey.*

Selected Bibliography

These listings are not meant to be exhaustive; readers seeking additional sources may consult those references below that are marked with an asterisk (*) and the references given under the biographies of individual sculptors (see pp. 255–323).

References are arranged alphabetically by author, if known, or by title, with exhibition catalogues listed either under the corporate body that prepared the catalogue or the city in which the corporate body is located.

General References

Adams, Adeline. *The Spirit of American Sculpture.* New York: The National Sculpture Society, 1929.

Albuquerque, The Junior League of; and The University of New Mexico Art Museum. *Twentieth-Century Sculpture* (introduction by V[an] D[eren] C[oke]). Albuquerque: The University of New Mexico Art Museum, [1966].

The American Art Journal, vol. 4, November 1972. Entire issue is devoted to articles on 19th-century American sculpture.

*Andersen, Wayne. *American Sculpture in Process: 1930–1970.* Boston: New York Graphic Society, 1975.

*Archives of American Art. *A Bicentennial Bibliography of American Art,* in preparation. Sections on American sculpture and sculptors are planned.

*Arnason, H. H. *History of Modern Art: Painting, Sculpture, Architecture.* New York: Harry N. Abrams, n.d.

Artforum, vol. 5, Summer 1967. Special issue on American sculpture.

Arts Yearbook 8: Contemporary Sculpture (introduction by William Seitz). New York: The Art Digest, 1965.

Ashton, Dore. *Modern American Sculpture.* New York: Harry N. Abrams, n.d.

——. "New York Commentary," *Studio International,* vol. 174, December 1967, pp. 277–79.

*The Baltimore Museum of Art. *The Partial Figure in Modern Sculpture: From Rodin to 1969* (text by Albert E. Elsen). Baltimore, 1969.

*Baur, John I. H. *Revolution and Tradition in Modern American Art.* Cambridge, Mass.: Harvard University Press, 1951.

The Britannica Encyclopedia of American Art. Chicago: Ecyclopaedia Britannica Educational Corporation, n.d.; distributed by Simon and Schuster, New York.

*Broder, Patricia Janis. *Bronzes of the American West.* New York: Harry N. Abrams, n.d.

*Brummé, C. Ludwig. *Contemporary American Sculpture* (introduction by William Zorach). New York: Crown Publishers, 1948.

The Buffalo Fine Arts Academy, Albright-Knox Art Gallery. *Plus by Minus: Today's Half-Century* (foreword by Gordon M. Smith; text by Douglas MacAgy). [Buffalo, N.Y.], 1968.

*Burnham, Jack. *Beyond Modern Sculpture: The Effects of Science and Technology on the Sculpture of this Century.* New York: George Braziller, n.d.

——. *Great Western Salt Works: Essays on the Meaning of Post-Formalist Art.* New York: George Braziller, 1974.

Caffin, Charles H. *American Masters of Sculpture.* New York: Doubleday, Page & Company, 1903; Freeport, N.Y.: Books for Libraries Press, 1969 (reprint).

*California, University of; The Art Museum and The Committee for Arts and Lectures. *Directions in Kinetic Sculpture* (preface by Peter Selz; introduction by George Rickey; statements by the artists). Berkeley, Calif., 1966.

Chicago, The Art Institute of. *A Generation of Innovation* (foreword by C. C. Cunningham; introduction by A. James Speyer). [Chicago, 1967].

——. *Idea and Image in Recent Art* (introduction by Anne Rorimer; statements by the artists). Chicago, 1974.

Cincinnati, The Contemporary Arts Center. *Monumental Art* (statements by William A. Leonard and others). [Cincinnati, 1970?].

*Clapp, Jane. *Sculpture Index*, vol. 2. Metuchen, N.J.: The Scarecrow Press, 1970.

Clark, William J., Jr. *Great American Sculptures*. Philadelphia: Gebbie & Barrie Company, 1878; New York: Garland Publishing, due 1976 (reprint).

Clement, Clara Erskine and Laurence Hutton. *Artists of the Nineteenth Century*, 2 vols. Boston: Houghton, Osgood and Company, 1879; St. Louis: North Point, 1969 (reprint of 1884 edition).

Cooper, Jeremy. *Nineteenth-Century Romantic Bronzes*. Boston: New York Graphic Society, 1975.

Cortissoz, Royal. *American Artists*. New York and London: Charles Scribner's Sons, 1923.

*Crane, Sylvia E. *White Silence: Greenough, Powers, and Crawford, American Sculptors in Nineteenth-Century Italy*. Coral Gables, Fla.: University of Miami Press, 1972.

*Craven, Wayne. *Sculpture in America*. New York: Thomas Y. Crowell Company, 1968.

_____. "1776 — How America Really Looked: Sculpture," *The American Art Journal*, vol. 7, May 1975, pp. 34–42.

*Cummings, Paul. *A Dictionary of Contemporary American Artists* (2nd ed.). New York: St. Martin's Press, 1971.

Davies, Hugh M. and Sally E. Yard. "Some Observations on Public Sculpture," *Arts Magazine*, vol. 50, January 1976, pp. 67–69.

Delaware, University of; Department of Art History and Division of Museum Studies, in cooperation with the Delaware Art Museum. *Avant-Garde Painting and Sculpture in America, 1910–25* (William Innes Homer, general ed.). Wilmington, 1975.

Dictionary of American Biography (Allen Johnson and Dumas Malone, ed.). New York: Charles Scribner's Sons, 1927–74.

Dodd, Loring Holmes. *The Golden Age of American Sculpture*. Boston: Chapman & Grimes, 1936.

*Dunlap, William. *A History of the Rise and Progress of the Arts of Design in the United States* (new ed; Frank W. Bayley and Charles E. Goodspeed, ed.), 3 vols. Boston: C. E. Goodspeed & Co., 1918; New York: Dover Publications, 1969 (reprint).

*Ekdahl, Janis. *American Sculpture: A Guide to Information Sources*. Detroit: Gale Research Company, in preparation.

Fairmount Park Art Association. *Sculpture of a City: Philadelphia's Treasures in Bronze and Stone*. New York: Walker Publishing Co., 1974.

"Fifty-Six Painters and Sculptors," *Art in America*, vol. 52, August 1964, pp. 22–79.

Forbes, Harriette Merrifield. *Gravestones of Early New England: And the Men Who Made Them, 1653–1800*. Boston: Houghton Mifflin Company, 1927; New York: Da Capo Press, 1967 (reprint).

French, H. W. *Art and Artists in Connecticut*. Boston: Lee and Shepard, Publishers; New York: Charles T. Dillingham, 1879. New York: Kennedy Graphics and Da Capo Press, 1970 (reprint).

Gardner, Albert Ten Eyck. *American Sculpture: A Catalogue of the Collection of The Metropolitan Museum of Art*. New York: The Metropolitan Museum of Art, 1965; distributed by New York Graphic Society, Greenwich, Conn.

*_____. *Yankee Stonecutters: The First American School of Sculpture, 1800–1850*. New York: Columbia University Press for The Metropolitan Museum of Art, 1945.

*Gerdts, William H. *American Neo-Classic Sculpture: The Marble Resurrection*. New York: The Viking Press, 1973.

*Giedion-Welcker, Carola. *Contemporary Sculpture: An Evolution in Volume and Space* (Mary Hottinger-Mackie and Sonja Marjasch, trans.). New York: George Wittenborn, 1955.

Goldstein, Carl. "The Direct Cast and Sculpture," *Arts Magazine*, vol. 50, January 1976, pp. 86–89.

Goldwater, Robert. *What Is Modern Sculpture?* New York: The Museum of Modern Art, 1969; distributed by New York Graphic Society, Greenwich, Conn.

*Goode, James M. *The Outdoor Sculpture of Washington, D.C.: A Comprehensive Historical Guide*. Washington: Smithsonian Institution Press, 1974.

*Groce, George C. and David H. Wallace. *The New-York Historical Society's Dictionary of Artists in America, 1564–1860*. New Haven, Conn., and London: Yale University Press, 1957.

"The Guggenheim International (with a statement by Edward F. Fry)," *Art in America*, vol. 55, September/October 1967, pp. 25–43.

Hunter, Sam. *Modern American Painting and Sculpture*. New York: Dell Publishing Co., 1959.

*_____ and John Jacobus. *American Art of the Twentieth Century: Painting, Sculpture, Architecture*. New York: Harry N. Abrams, n.d.

The Jewish Theological Seminary of America, The Jewish Museum. *Primary Structures: Younger American and British Sculptors* (introduction by Kynaston McShine). New York, 1966.

_____. *Recent American Sculpture* (foreword by Hans van Weeren-Griek; essays by Max Kozloff and others). New York, 1964.

*Kelly, James J. *The Sculptural Idea* (2nd ed.). Minneapolis: Burgess Publishing Company, 1974.

Kozloff, Max. "The Further Adventures of American Sculpture," *Arts Magazine*, vol. 39, February 1965, pp. 24–31.

*Kulturmann, Udo. *The New Sculpture: Environments and Assemblages* (Stanley Baron, trans.). New York and Washington: Frederick A. Praeger, Publishers, 1968.

*Los Angeles County Museum of Art, Contemporary Art Council. *American Sculpture of the Sixties* (Maurice Tuchman, ed.; essays by Lawrence Alloway and others). Los Angeles, 1967; hardcover edition distributed by New York Graphic Society, Greenwich, Conn.

*McSpadden, J. Walker. *Famous Sculptors of America*. New York: Dodd, Mead & Company, 1924; Freeport, N.Y.: Books for Libraries Press, 1968 (reprint).

Merriewold West, Inc. *Projects in Nature: Eleven Environmental Works Executed at Merriewold West* (introduction by Edward F. Fry). [Far Hills, N.J.], 1975.

Monumenta Newport Inc. *Monumenta: A Biennial Exhibition of Outdoor Sculpture* (introduction by Sam Hunter, ed.). Newport, R.I., 1974.

Müller, Grégoire and Gianfranco Gorgoni. *The New Avant-Garde: Issues for the Art of the Seventies*. New York and London: Praeger Publishers, 1972.

National Sculpture Review (Adolph Block, ed.). New York, 1951–.

The National Sculpture Society. *Exhibition of American Sculpture Catalogue*. [New York], 1923.

_____ in cooperation with the Trustees of the California Palace of the Legion of Honor. *Contemporary American Sculpture*. [New York], 1929.

The Nebraska Art Association. *American Sculpture* (preface by Norman A. Geske). [Lincoln, Neb.?], 1970.

New York, The Metropolitan Museum of Art. *New York City Public Sculpture, by Nineteenth-Century American Artists* (catalogue by Lewis I. Sharp; walking tours by David W. Kiehl). [New York], 1974.

*____. *New York Painting and Sculpture: 1940–1970* (text by Henry Geldzahler; reprinted essays by Harold Rosenberg and others). New York: E. P. Dutton & Co., 1969.

*____. *Nineteenth-Century America: Paintings and Sculpture* (introduction by John K. Howat and John Wilmerding; texts by John K. Howat, Natalie Spassky and others). [New York, 1970]; distributed by New York Graphic Society, n.p.

* New York, The Museum of Modern Art. *Abstract Painting and Sculpture in America* (text by Andrew Carnduff Ritchie). New York, 1951.

____. *American Painting and Sculpture 1862–1932* (essay by Holger Cahill). New York, 1932.

____. *Spaces* (text by Jennifer Licht). New York, 1969.

The Newark Museum. *A Survey of American Sculpture: Late Eighteenth Century to 1962* (text by William H. Gerdts). Newark, N.J., 1962.

Notable American Women 1607–1950: A Biographical Dictionary (James T. Edwards, ed.), 3 vols. Cambridge, Mass.: Harvard University Press, The Belknap Press, 1971.

The Oakland Museum. *Public Sculpture/Urban Environment* (introduction by George W. Neubert). Oakland, Calif., 1974.

* Proske, Beatrice Gilman. *Brookgreen Gardens Sculpture* (new ed., rev. and enlarged). Brookgreen Gardens, S.C.: Brookgreen Gardens, 1968.

*Ritchie, Andrew Carnduff. *Sculpture of the Twentieth Century.* New York: The Museum of Modern Art, [1952]; distributed by Simon and Schuster, New York.

* Rose, Barbara. *American Art Since 1900* (rev. ed.). New York and Washington: Praeger Publishers, 1975.

____. "Looking at American Sculpture," *Artforum*, vol. 3, February 1965, pp. 29–36.

____. "Shall We Have a Renaissance?" *Art in America*, vol. 55, March/April 1967, pp. 30–39.

Saint Louis, City Art Museum of. *7 for 67: Works by Contemporary American Sculptors* (text by Emily S. Rauh). St. Louis, 1967.

* San Francisco Museum of Art. *Unitary Forms: Minimal Sculpture by Carl Andre, Don Judd, John McCracken, Tony Smith* (introduction by Suzanne Foley). San Francisco, 1970.

Schnier, Jacques. *Sculpture in Modern America.* Berkeley and Los Angeles: University of California Press, 1948.

Seeman, Joan. "The Flowering of American Sculpture," *Art News*, vol. 74, December 1975, pp. 46–48.

* Selz, Jean. *Modern Sculpture: Origins and Evolution* (Annette Michelson, trans.). New York: George Braziller, 1963.

*Seuphor, Michel. *The Sculpture of This Century* (Haakon Chevalier, trans.). New York: George Braziller, 1960.

*Smithsonian Institution, National Collection of Fine Arts. *Academy: The Academic Tradition in American Art* (text by Joshua C. Taylor and Lois Marie Fink). Washington: Smithsonian Institution Press, 1975.

____. *Sculpture: American Directions, 1945–1975* (essay by Walter Hopps). Washington: Smithsonian Institution Press, due 1976.

*The Solomon R. Guggenheim Museum. *Guggenheim International Exhibition 1967: Sculpture from Twenty Nations* (introduction by Edward F. Fry). New York, 1967.

* ____. *Guggenheim International Exhibition 1971* (essays by Diane Waldman and Edward F. Fry). New York: The Solomon R. Guggenheim Foundation, 1971.

*Taft, Lorado. *The History of American Sculpture* (new ed., rev.). New York: The Macmillan Company, 1924; New York: Arno Press, 1969 (reprint).

Taxay, Don. *The U. S. Mint and Coinage: An Illustrated History from 1776 to the Present* (foreword by Gilroy Roberts). New York: Arco Publishing Company, 1966.

"Ten Sculptors: A Photo Portfolio," *Archives of American Art Journal*, vol. 13, no. 4, 1973, pp. 9–13.

*Thorp, Margaret Farrand. *The Literary Sculptors.* Durham, N.C.: Duke University Press, 1965.

Tuckerman, Henry T. *Book of the Artists: American Artist Life.* New York: G. P. Putnam & Son, 1867; New York: James F. Carr, 1967 (reprint).

*Vassar College Art Gallery. *The White, Marmorean Flock: Nineteenth-Century American Women Neoclassical Sculptors* (introduction by William H. Gerdts, Jr.; catalogue by Nicolai Cikovsky, Jr., and others). [Poughkeepsie, N.Y.], 1972.

Vermeule, Cornelius. *Numismatic Art in America: Aesthetics of the United States Coinage.* Cambridge, Mass.: Harvard University Press, The Belknap Press, 1971.

Walker Art Center. *Eight Sculptors: The Ambiguous Image* (introduction by Martin Friedman; essays by Martin Friedman and Jan van der Marck). Minneapolis, 1966.

*____. *Fourteen Sculptors: The Industrial Edge* (essays by Barbara Rose, Christopher Finch and Martin Friedman). Minneapolis, 1969. (Friedman's essay reprinted in *Art International*, vol. 14, February 1970, pp. 31–40.)

*____. *Twentieth-Century Sculpture, Walker Art Center: Selections from the Collection* (introduction by Martin Friedman). Minneapolis, n.d.

____. *Works for New Spaces* (introduction by Martin Friedman). Minneapolis, 1971.

*The Washington Gallery of Modern Art. *A New Aesthetic* (text by Barbara Rose; statements by the artists). [Washington], 1967.

*Whitney Museum of American Art. *Anti-Illusion: Procedures/Materials* (essays by James Monte and Marcia Tucker). New York, 1969.

American Indian Sculpture

*Barbeau, Marius. *Totem Poles,* 2 vols. National Museum of Canada Bulletin no. 119, Anthropological Series no. 30. Ottawa, 1930.

____. *Haida Carvers in Argillite.* National Museum of Canada Bulletin no. 139, Anthropological Series no. 38. Ottawa, 1957.

*Birket-Smith, Kaj. *Eskimos.* New York: Crown Publishers, 1971.

*Buck, Peter H. *Arts and Crafts of Hawaii.* Bernice P. Bishop Museum Special Publication no. 45. Honolulu, 1957.

*Chicago, The Art Institute of. *The Sculpture of Polynesia* (catalogue by Allen Wardwell). [Chicago], 1967.

*Colton, Harold S. *Hopi Kachina Dolls: With a Key to Their Identification.* Albuquerque: The University of New Mexico, 1949.

*Cox, J. Halley with William H. Davenport. *Hawaiian Sculpture.* Honolulu: The University Press of Hawaii, 1974.

De Menil, Adelaide and William Reid. *Out of the Silence.* New York: Outerbridge & Dienstfrey, 1971.

Emory, Kenneth P. "Hawaii: God Sticks," *Ethnologia Cranmorensis,* no. 3, 1938, pp. 9–10.

*Feder, Norman. *American Indian Art.* New York: Harry N. Abrams, n.d.

*Flint Institute of Arts. *The Art of the Great Lakes Indians* (introduction by Charles E. Cleland; text by Milford G. Chandler and others). [Flint, Mich.], 1973.

Greater Victoria, Art Gallery of. *Images Stone B.C.: Thirty Centuries of Northwest Coast Indian Sculpture* (text by Wilson Duff). Saanichton, B.C.: Hancock House, 1975.

*Harding, Anne D. and Patricia Bolling, comps. "Bibliography of North American Indian Art." Washington: United States Department of the Interior, Indian Arts and Crafts Board, 1938. Mimeographed.

*Hawthorne, Audrey. *Art of the Kwakiutl Indians: And Other Northwest Coast Tribes.* Seattle and London: University of Washington Press; Vancouver: The University Press of British Columbia, 1967.

Hoffman, Walter James. "The Graphic Art of the Eskimos: Based upon the Collections in the National Museum," *Report of the United States National Museum,* 1895, pp. 739–968.

_____. "The Midewiwin or 'Grand Medicine Society' of the Ojibwa," *Seventh Annual Report of the Bureau of [American] Ethnology to the Secretary of the Smithsonian Institution,* 1885–86, pp. 143–300.

*Holm, Bill. *Crooked Beak of Heaven: Masks and Other Ceremonial Art of the Northwest Coast.* Seattle and London: University of Washington Press, 1972.

*Inverarity, Robert Bruce. *Art of the Northwest Coast Indians,* 2nd ed. Berkeley and Los Angeles: University of California Press, 1967.

*Lowie, Robert H. *Indians of the Plains.* New York and London: McGraw-Hill Book Company, 1954.

Luquiens, Huc-Mazelet. *Hawaiian Art.* Bernice P. Bishop Museum Special Publication no. 18. Honolulu, 1931.

Malin, Edward and Norman Feder. "Indian Art of the Northwest Coast," *Denver Art Museum Quarterly,* Winter 1962, entire issue.

*Murdock, George Peter. *Ethnographic Bibliography of North America,* (3rd ed.). New Haven, Conn.: Human Relations Area Files, 1960.

*Ray, Dorothy Jean. *Eskimo Masks: Art and Ceremony.* Seattle and London: University of Washington Press, 1967.

Ritzenthaler, Robert. *Iroquois False-Face Masks.* Milwaukee Public Museum Publications in Primitive Art no. 3. Milwaukee, 1969.

*_____ and Lee A. Parsons, eds. *Masks of the Northwest Coast: The Samuel A. Barrett Collection* (text by Marion Johnson Mochon). Milwaukee Public Museum Publications in Primitive Art no. 2. Milwaukee, 1966.

*Siebert, Erna and Werner Forman. *North American Indian Art: Masks, Amulets, Wood Carvings and Ceremonial Dress from the Northwest Coast* (Philippa Hentges, trans.). London: Paul Hamlyn, 1967.

*Smithsonian Institution, National Collection of Fine Arts, Renwick Gallery. *Boxes and Bowls: Decorated Containers by Nineteenth-Century Haida, Tlingit, Bella Bella, and Tsimshian Indian Artists* (foreword by Joshua C. Taylor; text by William C. Sturtevant and others). Washington: Smithsonian Institution Press, 1974.

United States Office of Indian Affairs, Education Division. Indian Handcrafts Pamphlets nos. 1–9. N.p., 1940–45; distributed by Haskell Institute, Lawrence, Kan.

*United States, The National Gallery of Art. *The Far North: Two Thousand Years of American Eskimo and Indian Art* (text by Henry B. Collins and others). Washington, 1973.

The Vancouver Art Gallery. *Arts of the Raven: Masterworks by the Northwest Coast Indian* (text by Wilson Duff; articles by Bill Holm and Bill Reid). [Vancouver, B.C.], 1967.

*Walker Art Center and others. *American Indian Art: Form and Tradition* (text by Andrew Hunter Whiteford and others). New York: E. P. Dutton & Co., 1972.

*West, George A. "Tobacco, Pipes and Smoking Customs of the American Indians," *Bulletin of the Public Museum of the City of Milwaukee,* vol. 17, June 11, 1934, 2 parts.

*Whitney Museum of American Art. *Two Hundred Years of North American Indian Art* (text by Norman Feder). New York and London: Praeger Publishers, 1971.

*Wingert, Paul S. *American Indian Sculpture: A Study of the Northwest Coast.* New York: J. J. Augustin, 1949.

American Folk Sculpture

*Abby Aldrich Rockefeller Folk Art Collection and The High Museum of Art. *Folk Art in America: A Living Tradition* (preface and text by Beatrix T. Rumford). Atlanta: The High Museum of Art, 1974.

*Bishop, Robert. *American Folk Sculpture.* New York: E. P. Dutton & Co., 1974.

Blasdel, Gregg N. "The Grass-Roots Artist," *Art in America,* vol. 56, September/October 1968, pp. 24–41.

*Boyd, E. *Popular Arts of Spanish New Mexico.* Santa Fe: Museum of New Mexico Press, 1974.

Bradshaw, Elinor Robinson. "American Folk Art in the Collection of the Newark Museum," *The Museum,* vol. 19, Summer/Fall 1967, entire issue.

*Brewington, M. V. *Shipcarvers of North America.* Barre, Mass.: Barre Publishing Company, 1962; New York: Dover Publications, 1972 (corrected republication).

*Christensen, Erwin O. *Early American Wood Carving.* Cleveland: World Publishing Company, 1952; New York: Dover Publications, 1972 (reprint).

Earnest, Adele. *The Art of the Decoy: American Bird Carvings.* New York: Bramhall House, 1965.

*Fried, Frederick. *Artists in Wood: American Carvers of Cigar-Store Indians, Show Figures, and Circus Wagons.* New York: Clarkson N. Potter, 1970; distributed by Crown Publishers.

*_____. *A Pictorial History of the Carousel.* New York: A. S. Barnes & Co., 1964.

Harvard Society for Contemporary Art, Inc. *Exhibition of American Folk Painting in Connection with the Massachusetts Tercentenary Celebration.* Cambridge, Mass., 1930.

*Hemphill, Herbert W., Jr., and Julia Weissman. *Twentieth-Century American Folk Art and Artists.* New York: E. P. Dutton & Co., 1974.

Hornung, Clarence P. *Treasury of American Design* (with reprinted introduction by Holger Cahill). New York: Harry N. Abrams, n.d.

*Lipman, Jean. *American Folk Art in Wood, Metal and Stone.* N.p.: Pantheon, 1948; New York: Dover Publications, 1972 (reprint).

*New York, The Museum of Modern Art. *American Folk Art: The Art of the Common Man in America, 1750–1900* (text by Holger Cahill). New York, 1932.

The Newark Museum. *American Folk Sculpture: The Work of Eighteenth- and Nineteenth-Century Craftsmen* (text by Holger Cahill). Newark, N.J., 1931.

*Pinckney, Pauline A. *American Figureheads and Their Carvers.* New York: W. W. Norton & Company, 1940; Port Washington, N.Y.: Kennikat Press, 1969 (reprint).

"Rediscovery: A Remarkable Trade Sign," *Art in America,* vol. 58, September/October 1970, pp. 90–91.

Steele, Thomas J. *Santos and Saints — Essays and Handbook.* Albuquerque: Calvin Horn Publisher, 1974.

*Stroessner, Robert and Cile M. Bach. *Santos of the Southwest: The Denver Art Museum Collection.* [Denver: Denver Art Museum, 1970].

*Tashjian, Dickran and Ann Tashjian. *Memorials for Children of Change.* Middletown, Conn.: Wesleyan University Press, 1974.

*Walker Art Center. *Naives and Visionaries.* New York: E. P. Dutton & Co., 1974.

*Whitney Museum of American Art. *The Flowering of American Folk Art 1776–1876* (by Jean Lipman and Alice Winchester). New York: The Viking Press, 1974.

Sculpturing Techniques

*Chichura, Diane B. and Thelma K. Stevens. *Super Sculpture: Using Science, Technology and Natural Phenomena in Sculpture.* New York and Melbourne: Van Nostrand Reinhold Company, 1974.

Clarke, Geoffrey and Stroud Cornock. *A Sculptor's Manual.* New York: Reinhold Book Corporation, 1968.

Hauser, Christian. *Art Foundry.* New York and Melbourne: Van Nostrand Reinhold Company, 1972.

*Irving, Donald J. *Sculpture: Materials and Process.* New York and Melbourne: Van Nostrand Reinhold Company, 1970.

*Kelly, James J. *The Sculptural Idea* (2nd ed.). Minneapolis, Burgess Publishing Company, 1974.

Marrits, Louis E. *Modeled Portrait Sculpture.* South Brunswick, N.J., and New York: A. S. Barnes and Company, 1970.

Mills, John W. *The Technique of Casting for Sculpture.* New York: Reinhold Publishing Corporation, 1967.

_____. *The Technique of Sculpture.* New York: Reinhold Publishing Corporation, 1965.

*Newman, Thelma R. *Plastics as Sculpture.* Radnor, Pa.: Chilton Book Company, 1974.

Percy, H. M., with Edward Folkard. *New Materials in Sculpture* (2nd ed., rev.). London: Alec Tiranti, 1965.

*Rich, Jack C. *The Materials and Methods of Sculpture.* New York: Oxford University Press, 1947.

*Verhelst, Wilbert. *Sculpture: Tools, Materials, and Techniques.* Englewood Cliffs, N.J.: Prentice-Hall, 1973.

Zaidenberg, Arthur. *The New and Classic Sculpture Methods.* New York: World Publishing, 1972.

Trade card of Samuel A. and Charles Robb at 114 Centre Street, New York. Collection of Frederick Fried.

Artists' Biographies

and Bibliographies

Abbreviations of Frequently Cited References from the Selected Bibliography

Britannica. *The Britannica Encyclopedia of American Art.* Chicago: Encyclopaedia Britannica Educational Corporation, n.d.; distributed by Simon and Schuster, New York.

Caffin. Caffin, Charles H. *American Masters of Sculpture.* New York: Doubleday, Page & Company, 1903; Freeport, N.Y.: Books for Libraries Press, 1969 (reprint).

Craven. Craven, Wayne. *Sculpture in America.* New York: Thomas Y. Crowell Company, 1968.

DAB. *Dictionary of American Biography* (Allen Johnson and Dumas Malone, ed.). New York: Charles Scribner's Sons, 1927–74.

Gardner. Gardner, Albert Ten Eyck. *American Sculpture: A Catalogue of the Collection of the Metropolitan Museum of Art.* New York: The Metropolitan Museum of Art, 1965; distributed by New York Graphic Society, Greenwich, Conn.

Gerdts. Gerdts, William H. *American Neo-Classic Sculpture: The Marble Resurrection.* New York: The Viking Press, 1973.

Los Angeles. Los Angeles County Museum of Art, Contemporary Art Council. *American Sculpture of the Sixties* (Maurice Tuchman, ed.; essays by Lawrence Alloway and others). Los Angeles, 1967; hardcover edition distributed by New York Graphic Society, Greenwich, Conn.

McSpadden. McSpadden, J. Walker. *Famous Sculptors of America.* New York: Dodd, Mead & Company, 1924; Freeport, N.Y.: Books for Libraries Press, 1968 (reprint).

Müller. Müller, Grégoire and Gianfranco Gorgoni. *The New Avant-Garde: Issues for the Art of the Seventies.* New York and London: Praeger Publishers, 1972.

Notable. *Notable American Women 1607–1950: A Biographical Dictionary* (James T. Edwards, ed.), 3 vols. Cambridge, Mass.: Harvard University Press, The Belknap Press, 1971.

Proske. Proske, Beatrice Gilman. *Brookgreen Gardens Sculpture* (new ed., rev. and enlarged). Brookgreen Gardens, S.C.: Brookgreen Gardens, 1968.

Taft. Taft, Lorado. *The History of American Sculpture* (new ed., rev.). New York: The Macmillan Company, 1924; New York: Arno Press, 1969 (reprint).

Whitney. Whitney Museum of American Art. *Anti-Illusion: Procedures/Materials* (essays by James Monte and Marcia Tucker). New York, 1969.

OPPOSITE: David Smith working on *Hudson River Landscape*, Bolton Landing, New York, 1951. (See Pl. 47.)

Carl Andre

Alexander Archipenko

Carl Andre

Born January 16, 1935, Quincy, Massachusetts

From 1951 to 1953 Carl Andre attended Phillips Academy, Andover, Massachusetts, where he studied art with Patrick Morgan and met Frank Stella, Hollis Frampton and Michael Chapman. In 1954 he worked briefly for the Boston Gear Works and traveled in England and France, and in 1955–56 he served as an intelligence analyst in the army. Upon moving to New York City in 1957, Andre renewed his friendships with Chapman, Stella and Frampton. Andre's first large wood sculptures, made in Stella's studio, bear affinities to the verticality of Brancusi and Stella's stripe paintings. In 1960 Andre completed his Pyramid series, stacked units that he called "sculpture as structure." From 1960 to 1964 he worked as a freight brakeman and conductor for the Pennsylvania Railroad in Newark, New Jersey. The experience had some effect on his artistic development as his sculpture became "more like roads than like buildings." Most of his work up through this period has been lost or destroyed, but much has since been reconstructed. In 1964 E. C. Goossen invited Andre to remake *Pyramid* for a show at the Hudson River Museum, Yonkers, New York, and Bennington College in Vermont — Andre's first public exhibition. The following year he was invited by Henry Geldzahler to exhibit in the *Shape and Structure* show at Tibor de Nagy Gallery, New York. About this time Andre broke away from vertical form and began to move toward "sculpture as place." Using materials such as metal (copper, aluminum, steel, lead), styrofoam and bricks, Andre made both the material and its properties function as interchangeable components of the whole, in which the environment is yet another component of place, thereby adhering to his formula of "form = structure = space." In 1968 he received an award from the National Council on the Arts. His major one-man exhibitions include those at the Guggenheim Museum, 1970; the Museum of Modern Art, New York, 1973; and the Kunsthalle in Bern, 1975.

*Bern, Kunsthalle. *Carl Andre: Sculpture, 1958–1974.* Bern, 1975.

Müller.

San Francisco Museum of Art. *Unitary Forms: Minimal Sculpture by Carl Andre, Don Judd, John McCracken and Tony Smith* (introduction by Suzanne Foley). San Francisco, 1970.

*Solomon R. Guggenheim Museum. *Carl Andre* (text by Diane Waldman). New York: The Solomon R. Guggenheim Foundation, 1970.

*Whitney.

Alexander Archipenko

Born May 30, 1887, Kiev, Russia
Died February 25, 1964, New York City

Alexander Archipenko studied painting and sculpture at the Kiev Art School from 1902 to 1905. In 1908 he moved to Paris, where he studied at the Ecole des Beaux-Arts for only two weeks and then in the Paris museums. In 1910 Archipenko began exhibiting with other Cubists at the Salon des Artistes Indépendants and the following year at the Salon d'Automne. Led by the brothers Duchamp, Villon and Duchamp-Villon, Archipenko and others in 1912 formed the Section d'Or, a dissident Cubist group with which Archipenko exhibited his sculpture for several years. Also in 1912 Archipenko opened his own art school in Paris, and his first one-man show outside Russia was held in Hagen, Germany. An exhibitor in the 1913 New York Armory Show, Archipenko lived in Nice from 1914 to 1918. He exhibited his work in many European cities and in 1921 moved to Berlin, where he opened another art school. In 1923 he immigrated to the United States, founded yet another art school, in New York City, and later became an American citizen. Archipenko's American works include "Archipentura," a machine he invented in 1924 to show paintings in motion, and post-1947 plastic carvings illuminated from within. From 1923 until his death he taught in many North American schools and colleges, including the New Bauhaus School of Industrial Arts; the Universities of Kansas City, Washington, Oregon, Delaware and British Columbia; and intermittently at his own schools in New York, Chicago, Los Angeles and Woodstock, New York. Archipenko's frequent exhibitions include more than 118 one-man shows in his lifetime and a posthumous retrospective organized in 1967 by the U.C.L.A. Art Gallery for eleven American museums and then circulated by the National Collection of Fine Arts to major museums in Europe.

*Archipenko, Alexander and others. *Archipenko: Fifty Creative Years 1908–1958.* New York: Tekhne Publications, 1960.

"Archipenko Dies; Cubist Sculptor," *The New York Times,* February 26, 1964, p. 32.

*California, University of; at Los Angeles; Art Galleries. *Alexander Archipenko: A Memorial Exhibition 1967–1969* (foreword by Katharine Kuh; text by Frances Archipenko, Frederick S. Wight and Donald H. Karshan). N.p.: University of California, 1967 (softcover ed.); n.p.: The Ward Ritchie Press, 1967 (hardcover ed.).

Hildebrandt, Hans. *Alexander Archipenko.* Berlin: Ukrainske Slowo, 1923.

Kovler Gallery. *Archipenko: Content and Continuity* (text by Donald H. Karshan; preface by Marjorie B. Kovler). Chicago, 1968.

Lanes, Jerrold. Pp. 77–78 in "New York," *Artforum,* vol. 9, September 1970.

*Smithsonian Institution, The National Collection of Fine Arts. *Archipenko: International Visionary* (Donald H. Karshan, ed.; republished essays by Guillaume Apollinaire and Guy Habasque; statement by Frances Archipenko; and writings by the artist). Washington: Smithsonian Institution Press, 1969.

Wight, Frederick S. "Retrospective for Archipenko," *Art in America,* vol. 55, May 1967, pp. 64–69.

Richard Artschwager

Born December 26, 1924, Washington, D.C.

Raised in New Mexico, Richard Artschwager graduated from Cornell University in 1948 with a bachelor's degree in biology and chemistry. In 1950 he

moved to New York, where he studied for a year with Amédée Ozenfant and began designing and building furniture commercially. In 1962 Artschwager began making furniture-related constructions: large, simple, geometric sculptures constructed of man-made materials, which were often veneered in formica — a material central to Artschwager's art — as in *Table with Tablecloth* (1964). In the later 1960s he produced bulky wall pieces and freestanding works with marbleized formica surfaces. Concurrent with his sculpture, Artschwager produced both abstract and figurative paintings. During 1963–64 he began to paint grid-transferred photographic images of buildings and ornate interiors. His unique grisaille technique applied to strongly textured cellotex board, as in *Interior* (1963), produced blurred pointillistic effects. Later sculptures, such as *Triptych 4* (1966), combined marbleized formica constructions with grisaille paintings. Artschwager's recent conceptual works focus on the distribution or placement of his "blp," a copyrighted eight-inch-oval shape, which was used in *100 Locations* in the 1968 Whitney Museum Annual. The artist cites Cézanne, Seurat, Johns, Rauschenberg, Bontecou and Oldenburg as his major influences, and he points to Cubism's use of ready-made textures in the collage as one source of his work. Artschwager has been represented in such shows as *Primary Structures* at the Jewish Museum, 1966; *Sonsbeek '71*, the Netherlands; and *Documenta V*, 1972.

Baker, Elizabeth C. "Artschwager's Mental Furniture," *Art News*, vol. 66, January 1968, pp. 48–49, 58–61.

C[ollins], J[ames]. P. 75 in "Reviews," *Artforum*, vol. 12, February 1974.

The Howard and Jean Lipman Foundation and the Whitney Museum of American Art. *Contemporary American Sculpture: Selection 1* (foreword by John I. H. Baur). [New York, 1966].

Karp, Ivan. "Rent is the Only Reality or the Hotel Instead of the Hymn," *Arts Magazine*, vol. 46, December/January 1972, pp. 47–48.

———. Pp. 28–30, 54 in "Object: Still Life," *Craft Horizons*, vol. 25, September/October 1965.

The Jewish Theological Seminary of America, The Jewish Museum. *Primary Structures: Younger American and British Sculptors* (introduction by Kynaston McShine). New York, 1966.

Hezekiah Augur

Born February 21, 1791, New Haven, Connecticut
Died January 10, 1858, Connecticut (?)

Prevented by his father, a carpenter-joiner, from following him in a manual trade, Hezekiah Augur, at the age of nine, was apprenticed to a grocer and four or five years later to an apothecary. A year later he became a clerk in a mercantile house and finally a partner in a dry goods business, which left him bankrupt by December 1816. In an attempt to recover his losses, Augur opened a fruit shop, where, in his spare time, he indulged in his love for carving and began to carve chair legs and other ornament for a local cabinetmaker. The income from his invention of a machine for making worsted lace and epaulets enabled him to settle his debts and his father's death also freed him to open his own wood-carving shop. The year 1823 marked a turning point in Augur's career: Samuel F. B. Morse encouraged him to carve a bust modeled on a cast of the head of the Apollo Belvedere. Carved directly in marble, Augur's copy was exhibited in 1825 at the Academy of Arts in New York City, where critics hailed the work a success and called Augur the "Yankee Phidias." By 1827 Augur had completed a commemorative marble bust of the mathematician Alexander Metcalf Fisher. The bust was presented to Yale College by members of Fisher's 1813 class and in 1833 Yale named Augur an honorary alumnus. Earlier Augur had carved what became his most celebrated work, *Jepthah and His Daughter*, a pair of marble statuettes, which was given to Yale's Trumbull Gallery in 1835. In 1834 Augur was commissioned to execute one of his few public sculptures, a bust of Chief Justice Oliver Ellsworth for the Supreme Court room in the United States Capitol. Four years later he was commissioned to design bronze medals for the bicentennial of New Haven's settlement. Little is known about Augur's career during the last twenty years of his life.

*Craven.

*Dunlap, William. *A History of the Rise and Progress of the Arts of Design in the United States* (new ed., Frank W. Bayley and Charles E. Goodspeed, ed.), vol. 3. Boston: C. E. Goodspeed & Co., 1918.

French, H. W. *Art and Artists in Connecticut*. New York: Charles T. Dillingham; Boston: Lee and Shepard, 1879. New York: Kennedy Graphics and Da Capo Press, 1970 (reprint).

H[amilton], G[eorge] H[eard]. "New Haven Sculptors," *Bulletin of the Associates in Fine Arts at Yale University*, vol. 8, June 1938, pp. 70–72.

Larkin, Oliver. "Early American Sculpture: A Craft Becomes an Art," *The Magazine Antiques*, vol. 56, September 1949, pp. 176–78.

*N[ash], E[dwin] G. *DAB*, vol. 1, pp. 48–49.

Richard Artschwager

Saul Baizerman

Born December 25, 1889, Vitebsk, Russia
Died August 30, 1957, New York City

Interested in art as a boy, Saul Baizerman had one year (1904) of formal art training in Russia at an imperial art school in Odessa. Immigrating to America in 1910, he soon moved to New York City, where he attended the National Academy of Design for one year. Sponsored by the architect Lloyd Warren, Baizerman enrolled as the first student in sculpture in the Beaux-Arts Institute of Design, studying there until 1920. Throughout his career Baizerman's only subject was the human figure, but during 1920–25 he abandoned its traditional academic treatment and began to discover the formal potential of hammering the metal in creating his small cast bronzes. This unique method, later extended to hammering copper sheets from both sides until they reached the shape he wanted, remained Baizerman's sculptural technique for the rest of his life. During the early

Saul Baizerman

Thomas Ball

George Grey Barnard

1920s he started *The City and the People,* a series of hammered sculptures based on observations of contemporary life, in which no work was more than 1½ feet high. Later he concentrated on the heroic nude figure, as in *Exuberance* and *March of the Innocents,* his "sculptural symphonies" of 1932–39. Baizerman traveled widely in Europe during the 1920s and his first one-man show was held at the Dorien Leigh Galleries, London, in 1924. It was not until 1933 that he had his first exhibition in the United States, held at the Eighth Street Gallery, New York. This show consisted of Baizerman's small bronzes from the early 1920s since all of his early hammered pieces had been completely destroyed in a studio fire in January 1931; his hammered works were exhibited for the first time in his one-man show at the Artists' Gallery, New York, in 1938. From 1934 to 1940 Baizerman taught sculpture, drawing and anatomy at his Baizerman Art School. The year 1949 brought acclaim and mourning: he received an award at the Pennsylvania Academy's Annual Exhibition of Painting and Sculpture and the Whitney Museum made the first museum purchase of one of his hammered bronzes; but he suffered the death of his wife of twenty-nine years, the artist Eugenie Silverman Baizerman. Baizerman received a Guggenheim Fellowship in 1952 and the following year the Walker Art Center organized a major traveling retrospective of his work. Five years later Baizerman died of cancer, while preparations were under way for his one-man exhibition at the Institute of Contemporary Art, Boston.

*Boston, Institute for Contemporary Art. *Saul Baizerman* (foreword by Thomas M. Messer). Boston, 1958.

E[dgar], N[atalie]. P. 10 in "Previews and Reviews," *Art News,* vol. 70, January 1972.

Goodnough, Robert. "Baizerman Makes A Sculpture," *Art News,* vol. 51, March 1952, pp. 40–43, 66–67.

The Heckscher Museum. *Saul Baizerman* (with reprint of Julius S. Held's 1953 text). Huntington, N.Y., 1961.

Kramer, Hilton. "Art," *The Nation,* vol. 196, February 9, 1963, pp. 127–28.

L[evin], K[im]. P. 11 in "Previews and Reviews," *Art News,* vol. 66, November 1967.

Walker Art Center. *Saul Baizerman* (text by Julius S. Held). Minneapolis, 1953.

Thomas Ball

Born June 3, 1819, Charlestown, Massachusetts
Died December 11, 1911, Montclair, New Jersey

Son of a house and sign painter, Thomas Ball left school at the age of twelve to support his family. He worked as an errand boy at a Boston museum, where he learned to cut silhouettes and began to study drawing and painting. In 1837 Ball opened a studio in Boston and earned his living by painting miniatures. Graduating to portraits and "ideal" compositions, he gained recognition in the late 1840s when his painting of a scene from *King Lear* was bought by the American Art Union. Although he had no formal training in sculpture, Ball in 1850–51 began

making cabinet busts, the most famous being his bust of Jenny Lind. In 1854, together with his wife, Ball sailed for Italy and established a sculpture studio in Florence, where he worked for the first time with life models. In his autobiography he noted that he "was somewhat disappointed at first at not finding the models all Venus di Medicis [*sic*], as that had been my ideal of the female form." In 1855 Ball moved to Rome and profited from his close association with the American sculptor Hiram Powers, an influential proponent of idealized and classicized forms. In 1857 Ball returned to Boston and began working on two panels for Horatio Greenough's statue of Benjamin Franklin. The following year he was commissioned to execute what became his most famous work — an equestrian statue of George Washington for the Boston Public Garden (unveiled in 1869). Ball returned to Florence in 1864 and by the 1870s the majority of his commissions were portrait statues, the two most notable being *Charles Sumner* (1878, Boston Public Garden) and *Daniel Webster* (1876, Central Park, New York City). In 1875 his bronze composition *Emancipation Group* was erected in Washington, D.C. Among his students was the noted American sculptor Daniel Chester French. In 1897 Ball returned to America, where he lived until his death at the age of ninety-two with his daughter and her husband, the sculptor William Couper.

Ball, Thomas. *My Threescore Years and Ten: An Autobiography* (2nd ed.). Boston: Roberts Brothers, 1892.

*Craven.

N[ash], E[dwin] G. *DAB,* vol. 1, pp. 552–54.

Partridge, William. "Thomas Ball," *New England Magazine,* n.s., vol. 12, May 1895, pp. 291–304.

George Grey Barnard

Born May 24, 1863, Bellefonte, Pennsylvania
Died April 25, 1938, New York City

As a youth George Grey Barnard taught himself taxidermy and was briefly apprenticed to a jewelry engraver. Later at Chicago's Art Institute he drew from casts of works by Michelangelo, whose sculpture was to remain his lifelong ideal. Traveling to Paris in 1883, Barnard pursued his sculptural training at the Ecole des Beaux-Arts and in Pierre Jules Cavelier's studio. In 1886 Barnard met Alfred Corning Clark, son of a founder of the Singer Manufacturing Company, who became his friend and patron. Clark commissioned Barnard's first professional works — the marble versions of *Boy* and *Brotherly Love,* a memorial to Clark's close friend, the Norwegian opera singer Lorentz Severin Skougaard — and later the sculptural group *Struggle of the Two Natures in Man,* which won acclaim at the rebel Salon du Champ de Mars of 1894. Against Clark's and Rodin's advice, Barnard returned to America in 1894. Settling in Washington Heights, New York, he gradually isolated himself from the art world. During 1900–1903 he taught at the Art Students League; in 1902 he received a commission — up to that date the largest to an American sculptor — for the sculptures

for the Pennsylvania State Capitol Building in Harrisburg. To fulfill this commission Barnard returned to France in 1903 and remained in Europe for most of the next ten years. While there he formed his collection of medieval art, which was sent back to Washington Heights and installed in his "cloister museum." With funds donated by John D. Rockefeller, Jr., the Metropolitan Museum of Art bought this collection in 1925 and the following year reopened Barnard's museum as The Cloisters. Barnard spent his declining years developing a visionary work, a part of which was called *Rainbow Arch,* to be dedicated to the mothers of the war dead but never completed. Awarded gold medals at the Paris Exposition in 1900 and the Pan-American Exposition in Buffalo in 1901, Barnard was a member of the National Institute of Arts and Letters and the National Sculpture Society. He died a week before the reopening of The Cloisters on its present site in upper Manhattan's Fort Tryon Park.

*Craven.

Dickson, Harold E. "Barnard and Norway," *The Art Bulletin,* vol. 44, March 1962, pp. 55–59.

———. "Barnard's Sculpture for the Pennsylvania Capitol," *The Art Quarterly,* vol. 22, Summer 1959, pp. 126–47.

———. "The Origin of 'The Cloisters'," *The Art Quarterly,* vol. 28, no. 4, 1965, pp. 252–75.

———. "George Grey Barnard's Controversial Lincoln," *The Art Journal,* vol. 27, Fall 1967, pp. 8–15, 19, 23.

The Pennsylvania State University Library and The Pennsylvania Historical and Museum Commission. *George Grey Barnard: Centenary Exhibition 1863–1963* (introduction by Harold E. Dickson). [University Park, Pa., and Harrisburg], 1964.

Roof, Katharine. "George Gray [sic] Barnard: the Spirit of the New World in Sculpture," *The Craftsman,* vol. 15, December 1908, pp. 270–80.

Taft.

Paul Wayland Bartlett

Born January 24, 1865, New Haven, Connecticut
Died September 20, 1925, Paris

Son of the sculptor and critic Truman Howe Bartlett, Paul Wayland Bartlett in 1874 was sent to school in France, the country where he was to spend most of his life. In 1879 Bartlett exhibited his first work at the Paris Salon and in 1880 entered the Ecole des Beaux-Arts, studying under Pierre Jules Cavelier. Bartlett also studied with the animal sculptor Emmanuel Frémiet at the Jardin des Plantes, and he became such a skilled animalier that he was often asked by other sculptors to model animals for their pieces. America was introduced to Bartlett's work when his *Bohemian Bear Tamer* (1887) was exhibited at the Columbian Exposition in Chicago in 1893. Soon thereafter he began to receive major commissions: those for statues of Columbus and Michelangelo for the Library of Congress (1894); an equestrian Lafayette to be presented to France (1899–1908); a pediment for the House wing of the United States Capitol representing the flourishing of America and carved at a special studio set up

in Washington (1909); and six monumental figures of knowledge for the New York Public Library (1915). He also modeled the figures for the pediment (1908–9) designed by John Quincy Adams Ward for the New York Stock Exchange. More interested in historical figures than contemporary portraiture, Bartlett modeled images that were symbolic and ethnological. In 1901 he won a gold medal at the Pan-American Exposition in Buffalo and the grand prize at the St. Louis Exposition in 1904. Bartlett received many French and American honors: He was elected an academician of the National Academy of Design in 1917 and the president of the National Sculpture Society in 1918. While in France he won an honorable mention at the Salon of 1887, a medal of honor in 1889 and a gold medal in 1901; he was made a chevalier of the Legion of Honor in 1895, an officer in 1908 and a commander in 1924.

American Academy of Arts and Letters. *Catalogue of Memorial Exhibition of the Works of Paul Wayland Bartlett.* Publication no. 76. [New York], 1931.

Bartlett, Ellen Strong. "Paul Bartlett: An American Sculptor," *New England Magazine,* vol. 33, December 1905, pp. 369–82.

Carroll, Mitchell. "Paul Bartlett's Decorative Sculptures for the New York Public Library," *Art and Archaeology,* vol. 3, January 1916, pp. 34–39.

———. "Paul Bartlett's Pediment Group for the House Wing of the Nation's Capitol," *Art and Archaeology,* vol. 1, January 1915, pp. 163–73.

Fairman, Charles E. *Art and Artists of the Capitol of the United States of America.* Washington: U.S. Government Printing Office, 1927.

Klaber, John J. "Paul Wayland Bartlett's Latest Sculpture," *The Architectural Record,* vol. 39, March 1916, pp. 265–78.

Sturgis, Russell. "The Pediment of the New York Stock Exchange," *Scribner's Magazine,* vol. 36, September 1904, pp. 381–84.

Walton, William. "Mr. Bartlett's Pediment for the House of Representatives, Washington, D.C.," *Scribner's Magazine,* vol. 48, July 1910, pp. 125–28.

———. "Recent Work by Paul W. Bartlett," *Scribner's Magazine,* vol. 54, October 1913, pp. 527–30.

Wheeler, Charles V. "Bartlett (1865–1925)," *The American Magazine of Art,* vol. 16, November 1925, pp. 573–85.

Larry Bell

Born December 6, 1939, Chicago

Graduating from high school in Encino, California, in 1957, Larry Bell studied at the Chouinard Art Institute in Los Angeles from 1957 to 1959. As a painter, Bell ventured into three-dimensional problems with shaped canvases before taking up sculpture exclusively in 1964. His first sculptures were framed cubes of mirrored and transparent glass that exploited optical illusion through refraction and reflection. He experimented with different metal coatings to effect opaque colors and varied densities in the mirrored surfaces. For several years Bell worked toward a more atmospheric imagery by paring down his boxes to essentials, dispensing with the mirrored surfaces in favor of transparent mineral

Paul Wayland Bartlett

Larry Bell

Ronald Bladen

Gutzon Borglum

coatings, which introduced an evanescent color into his work. In 1966 Bell acquired his own vacuum-coating equipment, which allowed him to exercise subtle control over the coating process and also to work with larger surfaces. At this time Bell decided to present his boxes at eye level on clear plastic bases to allow the light to travel up and through them. His irridescent cubes had become well known in Los Angeles and New York by 1967, when one-man shows of his work were held in Paris and Amsterdam. In an effort to eliminate the sense of confined space in his work, Bell began to produce environmental works. With the assistance of union labor, irridescent films of vaporized metal were deposited on wall-sized, freestanding plates of glass, which were set up as intersecting partitions in an exhibition space at the Pasadena Art Museum in 1972. Bell maintains his large factorylike studio in Venice, California, and has exhibited regularly at the Pace Gallery, New York, since 1965.

Coplans, John. "Larry Bell," *Artforum*, vol. 3, June 1965, pp. 27–29.

Daniele, Fidel. "Bell's Progress," *Artforum*, vol. 5, June 1967, pp. 68–71.

New York, The Museum of Modern Art. *Spaces* (text by Jennifer Licht). New York, 1969.

*Pasadena Art Museum. *Larry Bell* (exhibition organized by Barbara Haskell). [Pasadena, 1972].

Perreault, John. "Union-Made: Report on a Phenomenon," *Arts*, vol. 41, March 1967, p. 28.

Plagens, Peter. "Larry Bell Reassessed," *Artforum*, vol. 11, October 1972, pp. 71–73.

*The Tate Gallery. *Larry Bell, Robert Irwin, Doug Wheeler* (foreword by Norman Reid; text by Michael Compton). London, 1970.

Ronald Bladen

Born July 13, 1918, Vancouver, Canada

Ronald Bladen studied at the Vancouver School of Art and at the California School of Fine Arts in San Francisco, the city where he lived for fifteen years after attending school. During World War II he worked as a ship welder while devoting his free time to painting and gaining a knowledge of steel construction, which he would later apply in his massive sculptures. In 1957 Bladen arrived in New York City, where he painted in association with the members of the Brata Gallery, including George Sugarman, Nicholas Krushenick and Al Held. By 1962 Bladen's bas-relief paintings already showed an affinity to sculptural form; by 1965 his transition to sculpture was complete when he exhibited three pieces, including *The Rockers,* in the group show *Concrete Expressionism* at New York University's Loeb Student Center. Although his only moving piece to date, *The Rockers* proved seminal to his later sculptural ideas because it represented Bladen's first "attempt to capture space." In the 1960s his cantilevered, an-axial sculptures placed him among the leading representatives of Minimal art. Bladen emerged as a major sculptor with his three-element, untitled sculpture consisting of tilting rhomboids, which was shown at the *Primary Structures* exhibition at the Jewish Museum in 1966. Other works include *The X*

(1967), exhibited in the *Scale as Content* show at the Corcoran Gallery of Art, Washington, D.C.; *Black Triangle* (1966), installed in its steel version in 1969 in New York City; *Barricade,* built for the 1968 Whitney Museum Annual; and *The Cathedral Evening,* created for a show at the Walker Art Center, Minneapolis, in 1969. Among Bladen's most recent works is an uncompleted sculpture for Hammarskjöld Plaza in New York City.

Ashton, Dore. "Concrete Expressionist Art at New York University," *Studio International,* vol. 170, August 1965, p. 88.

———. "Jeunes talents de la sculpture Américaine," *Aujourd'hui,* vol. 10, January 1967, p. 159.

Holstein, Jonathan. Pp. 273–74 in "New York's Vitality Tonic for Canadian Artists," *Canadian Art,* vol. 21, September 1964.

Kingsley, April. "Ronald Bladen: Romantic Formalist," *Art International,* vol. 1, September 20, 1974, pp. 42–44.

*Los Angeles.

Robins, Corinne. "The Artist Speaks: Ronald Bladen," *Art In America,* vol. 57, September 1969, pp. 76–81.

Sandler, Irving. "Ronald Bladen: 'Sensations of a Different Order,'" *Artforum* vol. 5, October 1966, pp. 32–35.

Vancouver Art Gallery. *Ronald Bladen/Robert Murray* (quotations from the artists). [Vancouver], 1970.

Walker Art Center. *Fourteen Sculptors: The Industrial Edge* (essays by Barbara Rose, Christopher Finch and Martin Friedman). Minneapolis, 1969.

Wheeler, Dennis F. "Ronald Bladen and Robert Murray in Vancouver," *Artforum,* vol. 8, June 1970, pp. 50–54.

Gutzon Borglum

Born March 25, 1867, near Bear Lake, Idaho
Died March 6, 1941, Chicago

Raised in Nebraska, John Gutzon de la Mothe Borglum, the son of Danish pioneers, attended Saint Mary's College, near Topeka, Kansas. He was apprenticed to a lithographer and fresco painter in Los Angeles and studied at the Mark Hopkins Art Institute in San Francisco. About 1890 he went to Paris to study sculpture and entered the Académie Julian (where his younger brother Solon was to study a few years later) and the Ecole des Beaux-Arts. At the Académie he worked under Antonin Mercié, but he was most influenced by Rodin's work. In 1891 he won membership in the Société Nationale des Beaux-Arts for his small bronze *Death of the Chief.* Returning to America in 1893, Borglum exhibited his *Indian Scouts* at the Columbian Exposition in Chicago. He then went to London, where he had his first exhibition and received commissions for portraits and mural decorations. He settled in New York City in 1902; two years later at the St. Louis Exposition he exhibited seven sculptures, including *Mares of Diomedes* (1904), which won the gold medal. In 1905 Borglum executed the statues of the twelve apostles for the Cathedral of St. John the Divine in New York City, and in 1908 he completed

the six-ton marble head of Abraham Lincoln for the Library of Congress. Shortly thereafter Borglum was commissioned to carve Robert E. Lee's portrait into the side of Stone Mountain, near Atlanta. Work was interrupted in 1923 when Borglum became embroiled in a controversy with the commissioners of the project, and he was dismissed in 1925. In 1927 Borglum began working on his best-known project, the portrait heads of four American presidents carved into Mount Rushmore, South Dakota; the portrait of Washington was unveiled in 1930, Jefferson in 1936, Lincoln in 1937 and Theodore Roosevelt in 1939. After Borglum's death, his son Lincoln completed the project. Known for his passionate commitment to America and his spirited and compassionate portraits of its heroes, Borglum completed as many as 170 statues and monuments during his lifetime.

*Broder.

Casey, Robert J. and Mary Borglum. *Give the Man Room: The Story of Gutzon Borglum.* Indianapolis and New York: The Bobbs-Merrill Company, 1952.

Chase, George Henry and Chandler Rafton Post. *A History of Sculpture.* New York and London: Harper & Brothers Publishers, 1925.

*Craven.

Dawdy, Doris Ostrander. *Artists of the American West: A Biographical Dictionary.* Chicago: The Swallow Press, 1974.

National Cyclopedia of American Biography, vol. 30, pp. 69–71. New York: James T. White & Company, 1943.

Wilkins, Thurman. *DAB,* supp. 3, pp. 87–90.

Solon H. Borglum

Born December 22, 1868, Ogden, Utah
Died January 30, 1922, Stamford, Connecticut

Solon Hannibal Borglum grew up in Nebraska, where he was instilled with a deep compassion and understanding for animals and the Plains Indians. As a young man he was put in charge of his father's cattle ranch, but influenced by his brother Gutzon, who encouraged his drawing and gave him instruction after they had traveled to California, Borglum entered the Cincinnati Art Academy in 1895. Having studied there for two years under the direction of the equestrian sculptor Louis Rebisso, Borglum went to Paris in 1897. There he attended the Académie Julian, received criticism from Emmanuel Frémiet, Denys Peuch and Augustus Saint-Gaudens and exhibited *Lassoing Wild Horses* and *Winter* at the Salon of 1898; the next year his model of *Stampede of Wild Horses* won an honorable mention. Returning to America with his new wife in 1899, Borglum revisited the frontier and created the marble *Burial on the Plains* before returning to France, where he exhibited and won a silver medal for *On the Border of White Man's Land* (modeled 1899; cast in bronze 1906) at the Paris Exposition. In 1901 Borglum established a studio in New York and won a silver medal at the Pan-American Exposition in Buffalo. For the St. Louis Exposition in 1904, he created four large groups of cowboys and Indians, including *The*

Blizzard, an impressionistic piece that conveyed the force of the environment, and *The Sioux Indian Buffalo Dance;* he won a gold medal for his statuette *In the Wind.* In 1906 Borglum bought a farm in Silvermine, Connecticut, where he subsequently established his studio and created colossal portraits of Civil War generals and several equestrian monuments. Returning to America in 1919 after serving in France in World War I, Borglum established the American School of Sculpture in Manhattan in order to encourage an indigenous art. In the last years of his life he created several ideal statues, but throughout his career he maintained his devotion to the primitive western life, capturing the vitality and tension of movement in his spirited studies of horses, riders and Indians. Borglum was elected a member of the National Sculpture Society in 1901 and an associate member of the National Academy of Design in 1911. His comparative anatomy textbook *Sound Construction* was published a year after his death from appendicitis.

Caffin.
Craven.
*Davies, A. Mervyn. *Solon H. Borglum: A Man Who Stands Alone.* Chester, Conn.: Pequot Press, 1974.
Gardner.
*Taft.

Solon H. Borglum

Louise Bourgeois

Born December 25, 1911, Paris

Louise Bourgeois began her artistic career as a child in the family craft of restoring ancient tapestries. After much preparation in mathematics, she studied art from 1936 to 1938 in Paris at the Ecole du Louvre, the Ecole des Beaux-Arts, the Académie de la Grande Chaumière and in Fernand Léger's studio. In 1938 Bourgeois settled in New York City, continuing her studies at the Art Students League. She was first known as an abstract painter and exhibited paintings in the Whitney Museum's Painting Annuals from 1945 to 1948. Her first one-woman show, of drawings, engravings and wood sculpture, was held in 1945 at the Bertha Schaefer Gallery, New York. Bourgeois's first all-sculpture show, at New York's Peridot Gallery in 1949, generally showed single, painted, wooden, vertical forms, which, although separate, were arranged in groups. However, one work — *The Blind Leading the Blind* — with six vertical forms supporting a horizontal "roof," forecast Bourgeois's later multipart and environmental sculpture. In the 1950s she continued making painted wood carvings but their vertical elements are closely clustered and project from a single base. In the 1960s she began to carve her clustered forms in stone or modeled them in plaster and papier-mâché, sometimes to be cast in bronze; these works were exhibited in 1964 at the Stable Gallery in a show that also included her earliest plaster and latex lair images. Her next one-woman show of sculpture, in December 1974 at the 112 Greene Street Gallery, exhibited these later lair environments as they had developed from 1970 to 1974. Her frequent group exhibitions include the Whitney Museum's *Nature in*

Louise Bourgeois

Victor D. Brenner

Henry Kirke Brown

Abstraction, 1958; Fischbach Gallery's *Eccentric Abstraction*, 1966; and the International Sculpture Biennale, Carrara, Italy, 1969. Bourgeois has taught sculpture at Pratt Institute, Brooklyn College and Goddard College.

Andersen, Wayne. *American Sculpture in Process: 1930–1970.* Boston: New York Graphic Society, 1975.

———. "American Sculpture: The Situation in the Fifties," *Artforum*, vol. 5, Summer 1967, pp. 60–67.

*Lippard, Lucy. "Louise Bourgeois: From the Inside Out," *Artforum*, vol. 13, March 1975, pp. 26–33.

Marandel, J. Patrice. "Louise Bourgeois," *Art International*, vol. 15, December 1971, pp. 46–47, 73.

Oeri, Georgine. "The Object of Art," *Quadrum*, no. 16, 1964, pp. 14–15.

Pearlstein, Philip. "The Private Myth: Louise Bourgeois," *Art News*, vol. 60, September 1961, pp. 44–45.

Robbins, Daniel. "Sculpture by Louise Bourgeois," *Art International*, vol. 8, October 20, 1964, pp. 29–31.

Rubin, William. "Some Reflections Prompted by the Recent Work of Louise Bourgeois," *Art International*, vol. 13, April 20, 1969, pp. 17–20.

Sondheim, Alan. P. 23 in "Arts Reviews," *Arts Magazine*, vol. 49, March 1975.

Victor D. Brenner

Born June 12, 1871, Siauliai, Lithuania
Died April 5, 1924, New York City

Victor David Brenner was apprenticed to his father, a mechanic and seal cutter, at the age of thirteen. Three years later he moved to Riga, where he worked for a jewelry engraver. Moving to New York City in 1890, Brenner was employed by a die-cutter and engraver until 1893, when he began to work on a free-lance basis for various jewelers and silversmiths. In 1896 he enrolled at the National Academy of Design, where he studied under John Quincy Adams Ward. By 1898 Brenner had saved enough money to travel to Paris, where he studied under Oscar Roty and attended the Académie Julian. Brenner became Roty's assistant and soon began to receive commissions for medals and tablet portraits, receiving an honorable mention at the Salon of 1900 and a bronze medal at the Paris Exposition that year. He returned to New York City in 1901 and began teaching the newly established class in coin and medal design at the National Academy of Design. Brenner was awarded silver medals for his work at the St. Louis Exposition in 1904 and the Panama-Pacific Exposition in San Francisco in 1915; in 1922 he received the Saltus Silver Medal of the American Numismatic Society, of which he was a member. Although Brenner was best known for his portrait plaques, medals and coins, including the Lincoln penny (designed in 1909), he also created portrait busts, among them *Charles Eliot Norton* (1903, Fogg Art Museum) and *Samuel P. Avery*, his early patron (1912, Brooklyn Museum), and a large-scale monument, the Schenley Memorial Fountain in Pittsburgh (1919). Brenner was a member of the National Sculpture Society and the Architectural League of New York.

Caffin.

The National Sculpture Society. *Exhibition of American Sculpture Catalogue.* [New York], 1923.

"See a Penny, Pick It Up," *National Sculpture Review*, vol. 20, Summer 1971, p. 5.

Taft.

Henry Kirke Brown

Born February 24, 1814, Leyden, Massachusetts
Died July 10, 1886, Newburgh, New York

As a child Henry Kirke Brown cut silhouettes, and in 1832 he became apprenticed to the Boston portrait painter Chester Harding. To raise money for a trip to Italy, Brown went to Illinois in 1836 to work as a railroad surveyor. A year later he moved to Cincinnati, where he painted portraits and produced his first sculptured bust. After returning to Boston in 1839 and becoming discouraged by the fierce competition for commissions there, he accepted an invitation to go to Albany, New York, where he was kept busy modeling portrait busts during 1840. In 1841 he returned to Boston, where he remained for a year, until friends supplied him with funds for the Italian trip; in 1842 he sailed to Florence. There he carved his Albany busts in marble and created *Indian Boy* (1843), a subject he continued to explore in his effort to forge a style that was quintessentially American. By 1843 Brown had moved to Rome, where he made biblical and mythological pieces. In 1846 he returned to America and set up a studio in New York City, forming close friendships with Asher B. Durand, Daniel Huntington, Henry Peters Gray and William Cullen Bryant. By 1848 he had moved his studio to Brooklyn, establishing one of the first American foundries for casting bronze sculpture. Brown's Italian pieces were shown at the National Academy of Design in 1847 in the first one-man sculpture show ever held in New York City, and in 1851 he was elected an academician of the Academy. That year he received his most important commission, the equestrian *George Washington* for Union Square, New York City. With the assistance of his apprentice, John Quincy Adams Ward, Brown completed the work in 1853. In 1861 he returned to Newburgh, New York, where he had established his studio in 1857 and remained until his death.

Clark, William J., Jr. *Great American Sculptures.* Philadelphia: Gebbie Barrie, Publishers, 1878.

Cleaveland, N. "Henry Kirke Brown," *Sartain's*, vol. 8, February 1951, pp. 135–38.

Craven, Wayne. "Henry Kirke Brown: His Search for an American Art in the 1840s," *The American Art Journal*, vol. 4, November 1972, pp. 44–58.

———. "Henry Kirke Brown in Italy, 1842–1846," *The American Art Journal*, vol. 1, Spring 1969, pp. 65–77.

*Craven.

Gardner.

Lee, Hannah. *Familiar Sketches of Sculpture and Sculptors*, vol. 2. Boston: Crosby, Nichols, and Co., 1854.

Lee, James. *The Equestrian Statue of Washington.* New York: John F. Trow, 1864.

New York, The Metropolitan Museum of Art. *New York City Public Sculpture, by Nineteenth-Century American Artists* (catalogue by Lewis I. Sharp; walking tours by David W. Kiehl). [New York], 1974.

Taft.

Sculptural Scene," *Apollo,* vol. 15, March 1932, pp. 109–13.

Paulin, L. R. E. "Alexander Stirling Calder: A Young Philadelphia Sculptor," *House and Garden,* vol. 3, June 1903, pp. 317–25.

Poore, Henry Rankin. "Stirling Calder, Sculptor," *The International Studio,* vol. 67, April 1919, pp. xxxvii–li.

A. Stirling Calder

Born January 11, 1870, Philadelphia
Died January 6, 1945, New York City

Son of the sculptor Alexander Milne Calder and father of Alexander Calder, Alexander Stirling Calder turned his attention to art after being rejected by West Point. Entering the Pennsylvania Academy of the Fine Arts in 1885, he studied under Thomas Eakins and Thomas Anshutz. In 1890 Calder went to Paris, studying under Henri Chapu at the Académie Julian and under Alexandre Falguière at the Ecole des Beaux-Arts. He returned to Philadelphia in 1892 and began to model portrait busts and nudes. In 1903 Calder became an instructor at the Philadelphia Museum School of Industrial Art, but his career as a sculptor did not begin in earnest until he won a silver medal at the St. Louis Exposition in 1904. After moving to New York City in 1910, Calder taught at the National Academy of Design and later at the Art Students League. By 1913, the year he was elected an academician of the National Academy, he had already begun a large amount of work, including *Fountain of Energy,* for San Francisco's Panama-Pacific Exposition in 1915; eventually he became head of its sculptural program. His work for the Exposition was followed by commissions for the Depew Fountain (1915, Indianapolis); a statue of Washington for New York City's Washington Square Arch (1918); the Swann Memorial Fountain (1924, Philadelphia); the Leif Ericsson Memorial (1932) donated to Reykjavík, Iceland (which won the gold medal of the Architectural League of New York); and *Tragedy and Comedy,* a monument to Shakespeare for Logan Circle, Philadelphia (awarded the McClees Prize at the Pennsylvania Academy in 1932). Although thoroughly wedded to the Beaux-Arts tradition, Calder was one of the few sculptors of his day to combine aspects of the new modernism in his later work.

Alexander Calder

Born July 22, 1898, Lawnton
(now Philadelphia), Pennsylvania

After receiving a degree in mechanical engineering from Stevens Institute of Technology in 1919, working at many odd jobs and enjoying a night-school drawing class, Alexander Calder (son and grandson of noted sculptors) decided to become an artist and studied under John Sloan, Boardman Robinson and others at the Art Students League during 1923–26. Calder's two weeks of sketching the circus for the *National Police Gazette* in 1925 profoundly affected his career: the drawings were published as *Animal Sketching* in 1926 and that year he left for Paris, where he began to create a miniature animated circus, whose performances introduced Calder to Paris's international art world. In 1926 he also made his first wire portraits (the earliest is a caricature of Josephine Baker), a natural evolution from his Circus figures, and these works comprised his first one-man show at the Weyhe Gallery, New York, in 1928. His visit to Mondrian in 1930 inspired Calder briefly to paint abstractions and henceforth to make abstract and colored sculptures. For the past forty-five years Calder's sculpture has developed within the two modes he invented in the early 1930s — "stabiles" (the name Arp gave to the stationary abstract sculptures Calder exhibited in 1931) and "mobiles" (the name Duchamp gave to the motor- or hand-powered motile sculptures Calder exhibited in 1932). Calder soon gave up mechanically produced motion for that produced naturally by air and wind. Excepting the war years of 1938–46 lived in Connecticut, Calder has commuted since 1926 between the United States and France and has exhibited extensively in both countries. His sculptures, growing increasingly monumental since the late 1940s, have also been shown regularly in countless exhibitions and permanent public installations in other European countries and in Asia and South America; in October 1976 he will be the subject of a large retrospective at the Whitney Museum.

Bowes, Julian. "The Sculpture of Stirling Calder," *The American Magazine of Art,* vol. 16, May 1925, pp. 229–37.

Calder, Alexander Stirling. *Thoughts of A. Stirling Calder on Life and Art* (Nanette Calder, comp. and ed.). New York: privately printed, 1947.

*Craven.

Davidson, Jean. "Four Calders," *Art in America,* vol. 50, Winter 1962, pp. 69–73.

Grafly, Dorothy. "The Ericsson Memorial for Iceland," *The American Magazine of Art,* vol. 23, November 1931, pp. 391–94.

Hoeber, Arthur. "Calder — A 'Various' Sculptor: A Man of Craftsmanship and Brains," *The World's Work,* vol. 20, September 1910, pp. 13,377–88.

Parkes, Kineton. "Stirling Calder and the American

*Arnason, H. H. and photographs by Pedro E. Guerrero. *Calder.* Princeton, N.J.: Van Nostrand, 1969.

Belleu, Peter. *Calder.* Barcelona: Ediciones Polígrafa, 1969.

Calder, Alexander. *Calder: An Autobiography with Pictures.* New York: Pantheon Books, 1966; French edition (Jean Davidson, trans.) published by Maeght Editeur, n.p., 1972.

Chicago, Museum of Contemporary Art. *Alexander Calder: A Retrospective Exhibition* (text by Albert Elsen). Chicago, 1974.

Fondation Maeght. *Calder* (text by James Johnson Sweeney and others). Saint-Paul [France], 1969.

A. Stirling Calder

Alexander Calder

John Chamberlain

Joseph Cornell

*Lipman, Jean, ed., with Nancy Foote. *Calder's Circus.* New York: E. P. Dutton & Co., in association with the Whitney Museum of American Art, 1972.

*Mulas, Ugo, photographs and design; H. Harvard Arnason, text; and Alexander Calder, comments. *Calder.* New York: The Viking Press, 1971.

New York, The Museum of Modern Art. *A Salute to Alexander Calder* (essay by Bernice Rose). New York, 1969.

*Solomon R. Guggenheim Museum and Paris, Musée National d'Art Moderne. *Alexander Calder* (introduction by Thomas Messer). New York, 1964.

*Sweeney, James Johnson. *Alexander Calder* (rev. ed. of the Museum of Modern Art's 1943 exhibition catalogue). New York: The Museum of Modern Art, 1951.

John Chamberlain

Born April 16, 1927, Rochester, Indiana

John Chamberlain's professional art training began at the School of the Art Institute of Chicago during 1950–52. Thereafter he briefly attended the University of Illinois and studied at Black Mountain College in North Carolina during the 1955–56 academic year before returning to Chicago, where his first one-man exhibition was held at the Wells Street Gallery in 1957. In 1953 Chamberlain had renounced representational art as well as traditional methods of carving and modeling. Welded metal became his favorite medium and by 1957 he had developed a method of open, airy construction similar to David Smith's. Soon after moving to New York City in 1957, Chamberlain turned to constructing scrap-metal assemblages from welded and crushed automobile parts. The first of these assemblages — composed of parts of a 1929 Ford that Chamberlain had found on the painter Larry River's property — *Shortstop* was shown in Chamberlain's earliest New York exhibition (1958), a group show at the Hansa Gallery. Starting in 1959 Chamberlain worked solely with the bodies of wrecked automobiles, dealing with the effects of compression, color and light, in addition to the problems of mass and formal relationships. Since 1963 he has explored similar problems in other mediums: From 1963 to 1965 he created paintings using auto lacquer on masonite and formica; in 1966–67 he created sculpture with squashed foam rubber, in 1967–68 with crushed galvanized metal, in 1969 with crushed paper bags coated with resin and watercolor, in 1970 with mineral-coated melted plexiglas and, beginning in 1971, with crumpled industrial aluminum foil. Since 1967 Chamberlain has also created a number of videotape films. Recipient of a Guggenheim Fellowship in 1966, he has been invited to show his work in many national and international exhibitions. He has had one-man shows at the Cleveland Museum of Art in 1967 and the Guggenheim Museum in 1971 and regularly at the Leo Castelli Gallery, New York, since 1959.

Baker, Elizabeth C. "The Chamberlain Crunch," *Art News,* vol. 70, February 1972, pp. 26–31, 60.

Foote, Nancy. P. 105 in "Reviews and Exhibitions," *Art in America,* vol. 62, March 1974.

Henning, Edward B. "An Important Sculpture by John Chamberlain," *The Bulletin of the Cleveland Museum of Art,* vol. 60, October 1973, pp. 242–46.

Leider, Philip. "A New Medium for John Chamberlain," *Artforum,* vol. 5, February 1967, pp. 48–49.

*Los Angeles.

Rose, Barbara. "How to Look at John Chamberlain's Sculpture," *Art International,* vol. 7, January 1964, pp. 36–38.

_____. "On Chamberlain's Interview," *Artforum,* vol. 10, February 1972, pp. 44–45.

*The Solomon R. Guggenheim Museum. *John Chamberlain: A Retrospective Exhibition* (text by Diane Waldman; excerpts from conversation between Elizabeth C. Baker and others). New York, 1971.

Thomsen, Barbara. P. 90 in "Reviews and Previews," *Art News,* vol. 73, February 1974.

Tuchman, Phyllis. "Interview with John Chamberlain," *Artforum,* vol. 10, February 1972, pp. 38–43.

Joseph Cornell

Born December 24, 1903, Nyack, New York
Died December 29, 1972, Flushing, New York

Joseph Cornell received no formal art training and while in school concentrated primarily on the sciences. Upon graduating from Phillips Academy in Andover, Massachusetts, in 1921, he worked for a while in his father's textile business. In 1929 he settled with his family (his father had already died) in a house on Utopia Parkway in Flushing, Queens, where he was to live until his death. In the early 1930s Cornell entered the New York City art scene through his involvement with the many Surrealist painters and writers who congregated at the Julien Levy Gallery, which had opened in New York in 1931. Greatly influenced by the montage technique Max Ernst used in his album *La femme 100 têtes,* Cornell created his first collages, which, together with another work, were included in a Surrealist group show at Levy's gallery in January 1932 — Cornell's first exhibition. By 1936 Cornell's work had received enough recognition to be included in a major New York museum show, *Fantastic Art, Dada and Surrealism,* at the Museum of Modern Art. By this date Cornell had developed his distinctive forms of collage and shadow box (small, usually glass-fronted), whose ingredients he assembled from his hoardings of a great variety of objects. Balls, stuffed birds, clocks, newspaper and magazine illustrations, astrological maps, antique trinkets and an assortment of nostalgic paraphernalia, in part collected on his regular visits to secondhand book shops, were some of the objects his art combined. Beginning in the 1930s Cornell also made several surrealistic films, which sometimes incorporated discarded portions of Hollywood movies. In the late 1940s Cornell was still frequenting the New York art scene, but by the late '50s he had acquired the reputation of a recluse, who saw only a few selected people in his home. Cornell always had great admiration for children; in the winter of 1972 the Cooper Union School of Art and Architecture organized an exhibition of his work dedicated to the children of lower Manhattan. Some of his

other notable exhibitions were his one-man shows at the Pasadena and Guggenheim museums in 1967 and the two shows organized by Henry Geldzahler at the Metropolitan Museum — the group exhibition *New York Painting and Sculpture: 1940–1970* in 1969 and an exhibition of Cornell's collages in 1970.

*ACA Galleries. *Joseph Cornell* (text by John Bernard Myers). New York, 1975. (Myers's essay also published in *Art News*, vol. 74, May 1975, pp. 33–36).

Ashbery, John. "Cornell: The Cube Root of Dreams," *Art News*, vol. 66, Summer 1967, pp. 56–64.

Ashton, Dore. *A Joseph Cornell Album.* New York: Viking Press, 1974.

Brown, Gordon. "A Visit with Joseph Cornell," *Arts*, vol. 41, May 1967, p. 51.

Coplans, John. "Notes on the Nature of Joseph Cornell," *Artforum*, vol. 1, February 1963, pp. 27–29.

Griffen, Howard. "Auriga, Andromeda, Cameoleopardalis," *Art News*, vol. 56, December 1957, pp. 24–27, 63–65.

Johnson, Ellen H. "Arcadia Enclosed: The Boxes of Joseph Cornell," *Arts*, vol. 39, September/October 1965, pp. 35–37.

*New York, The Metropolitan Museum of Art. *New York Painting and Sculpture: 1940–1970* (text by Henry Geldzahler; reprinted essays by Harold Rosenberg and others). New York: E. P. Dutton & Co. 1969.

*New York, The Museum of Modern Art. *Dada, Surrealism and their Heritage* (text by William S. Rubin). New York, [1968]; distributed by New York Graphic Society, Greenwich, Conn.

*The Solomon R. Guggenheim Museum. *Joseph Cornell* (introduction by Thomas M. Messer; essay by Diane Waldman). New York: The Solomon R. Guggenheim Foundation, 1967.

Thomas Crawford

Born March 22, 1813(?), New York City
Died October 10, 1857, London

As a boy Thomas Crawford studied drawing, architectural history and the lives of ancient Greek and Roman artists; he also collected old prints and possibly some casts of sculpture. About 1827 he was apprenticed to a wood-carver and at about nineteen went to work for [John] Frazee and Launitz's stonecutting firm. There he helped carve marble busts and cut designs into gravestones and mantelpieces while spending his evenings drawing at the National Academy of Design, which was to elect him an honorary member in 1838. In 1835 he became the first American sculptor to permanently settle in Rome, where he spent his first year studying in the studio of the neoclassical sculptor Bertel Thorvaldsen. That year Crawford also studied anatomy in a hospital mortuary and drawing and modeling in life classes at the French Academy. To support himself, Crawford began carving portrait busts in 1836 and in 1839 executed in plaster his first major work, *Orpheus and Cerberus.* Through the promotional efforts of George Washington Greene and Charles Sumner, Crawford was able to replicate this ideal work in marble in 1843 and to show it with his other sculptures in

Boston in an 1844 exhibition which firmly established Crawford's reputation in America. The latter year Crawford returned to the United States to marry Louisa Ward, a New York heiress, with whom he moved back to Rome in 1845 to work on many small commissions. While visiting America during 1849–50, he won a commission for his first bronze sculptures — an equestrian monument of George Washington and six other Virginia patriots for Capitol Square, Richmond. In 1853 Crawford was also commissioned to create the pedimental sculpture *Progress of Civilization* for the United States Senate. Other commissions for the Capitol followed: colossal statues *History* and *Justice* for the Senate, bronze doors for the House and Senate, and a 19½-foot-high bronze figure called *Armed Liberty* or *Freedom* for the Capitol dome. Crawford's death at the age of forty-seven, from eye and brain cancer, left several of these projects to be completed posthumously. Although his career had lasted only twenty years, Crawford had completed more than sixty works and left about an equal number in clay or plaster.

Brumbaugh, Thomas B. "The Evolution of Crawford's 'Washington'," *The Virginia Magazine of History and Biography*, vol. 70, January 1962, pp. 3–29.

*Crane, Sylvia E. *White Silence: Greenough, Powers, and Crawford, American Sculptors in Nineteenth-Century Italy.* Coral Gables, Fla.: University of Miami Press, 1972.

*Gale, Robert L. *Thomas Crawford: American Sculptor.* Pittsburgh: University of Pittsburgh Press, 1964.

*Gardner, Albert Ten Eyck. *Yankee Stonecutters: The First American School of Sculpture 1800–1850.* New York: Columbia University Press for The Metropolitan Museum of Art, 1945.

Greene, George Washington. "Crawford, the Sculptor," *Knickerbocker*, vol. 17, February 1841, p. 174.

Hillard, George Stillman. "Thomas Crawford: A Eulogy," *Atlantic Monthly*, vol. 24, July 1869, pp. 40–54.

Osgood, Samuel. *Thomas Crawford and Art in America.* New York: John F. Trow and Son, 1875.

Tuckerman, Henry T. "Crawford and Sculpture," *Atlantic Monthly*, vol. 2, June 1858, pp. 64–78.

Cyrus E. Dallin

Born November 22, 1861, Springville, Utah
Died November 14, 1944, Arlington Heights, Massachusetts

As a child in Utah, Cyrus Edwin Dallin made friends with Ute Indians nearby. From this association began his lifelong commitment to portraying through sculpture the dignity of the American Indian. In 1880 Dallin was sent to Boston, where he studied under Truman Howe Bartlett. Two years later he opened his own studio and in 1884 sculpted his first Indian subject, *Indian Chief*. In 1888 Dallin went to Paris to study at the Académie Julian under Henri Chapu, and after Buffalo Bill's Wild West Show toured Paris in 1889, Dallin sculpted his first equestrian Indian work, *Signal of Peace*. He returned to America in 1890, where his work soon won rec-

Thomas Crawford

Cyrus E. Dallin

Jo Davidson

ognition, and in 1893 he was elected to the National Sculpture Society. After several years in Salt Lake City and a year of teaching at Drexel Institute in Philadelphia, Dallin returned to Paris in 1897 to study under Jean Dampt. During his three years in Paris, Dallin executed another important work, *Medicine Man* (1898), which won a gold medal at the Paris Exposition in 1900. Back in America, Dallin executed the last two of his four great Indian equestrian sculptures — *The Protest,* shown at the St. Louis Exposition in 1904, and *The Appeal to the Great Spirit,* which won a gold medal at the 1909 Paris Salon. From 1900 to 1940 Dallin taught at the Massachusetts State Normal Art School. His most famous work from this period is *Massasoit,* erected in 1921 on Coles Hill in Plymouth, Massachusetts.

*Broder.

*Craven.

Downes, William Howe. "Cyrus E. Dallin, Sculptor," *Brush and Pencil,* vol. 5, October 1899, pp. 1–18.

____. "Cyrus E. Dallin, Sculptor," *New England Magazine,* vol. 21, October 1899, pp. 196–209.

____. "Mr. Dallin's Indian Sculptures," *Scribner's Magazine,* vol. 57, June 1915, pp. 779–82.

Hedges, Katherine Thayer. "Dallin the Sculptor: His Indian Stories in Marble," *The American Magazine of Art,* vol. 15, October 1924, pp. 521–27.

Long, E. Waldo. "Dallin, Sculptor of Indians," *The World's Work,* vol. 54, September 1927, pp. 563–68.

May, M. Stannard. "The Work of Cyrus E. Dallin," *New England Magazine,* vol. 48, November 1912, pp. 408–15.

Seaton-Schmidt, A. "An American Sculptor: Cyrus E. Dallin," *The International Studio,* vol. 58, April 1916, pp. 109–14.

Jo Davidson

Born March 30, 1883, New York City
Died January 3, 1952, near Tours, France

Born and brought up on Manhattan's Lower East Side, Jo Davidson attended the Art Students League when he was sixteen. Urged by his poor family to become a doctor, he stayed with a sister in New Haven, Connecticut, while studying for a course-equivalency examination, a prerequisite for his admission to medical school. He soon acquired his first patron, a New Haven lawyer, who showed Davidson's drawings to the head of the Yale Art School. The latter invited Davidson to attend Yale's art classes without charge and there Davidson soon discovered his love for working in clay. About 1901 Davidson convinced Hermon MacNeil to hire him as a studio assistant, a job Davidson held until 1904. About a year later he executed his first commission — a bronze statuette of David, which was shown in the Society of American Artists' forthcoming annual exhibition. In 1907 Davidson went to Paris, where he ended his formal training with three weeks' study at the Ecole des Beaux-Arts. Several months later he met Gertrude Vanderbilt Whitney, who became his friend and patron, buying his first sculpture that was sold in Paris. During his first trip back to America in 1910, Davidson had his first American one-man show at the New York Cooperative Society. His first large

exhibition in New York was held at the Glaenzer Galleries in 1911; later that year he had a one-man show at the Reinhardt Galleries in Chicago and another at the Reinhardt Galleries in New York in 1913. The latter year he was heavily represented by seven sculptures and ten drawings at the Armory Show, and he exhibited at the subsequent International Exhibition of Modern Art in Chicago. By the end of World War I he had gained an international reputation as a portrait sculptor, a "plastic historian," who had sculptured the busts of President Woodrow Wilson (1916) and the Allied war leaders, including Marshal Foch and General Pershing (1918–19). Davidson was extremely prolific and popular during the next three decades; he won the Maynard Prize of the National Academy of Design in 1934 and later was made a chevalier of the French Legion of Honor. In 1947 the American Academy of Arts and Letters held a retrospective of almost two hundred of Davidson's works, which was also held at the Museum of Science and Industry, New York, in 1948, for the benefit of the United Nations Children's Appeal.

Craven.

Davidson, Jo. *Between Sittings: An Informal Autobiography.* New York: The Dial Press, 1951.

"Editorial: Jo Davidson," *The Art Digest,* vol. 26, January 15, 1952, p. 5.

"Jo Davidson, Sculptor, Dies Abroad at 68," *New York Herald Tribune,* January 3, 1953, p. 16.

Lansford, Alonzo. "Reviewing Jo Davidson, Biographer in Bronze," *The Art Digest,* vol. 22, December 15, 1947, p. 20.

*Proske.

United States, National Gallery of Art. *Presidents of the South American Republics: Bronzes by Jo Davidson.* Washington, 1942.

José de Creeft

Born November 27, 1884, Guadalajara, Spain

In 1888 José de Creeft and his family moved to Barcelona, where nine years later he was apprenticed to a maker of religious images and then at a bronze foundry. Moving with his family to Madrid in 1900, he there studied drawing and was apprenticed to the Spanish government's official sculptor, Don Agustín Querol. In 1905 de Creeft moved to Paris, where he studied at the Académie Julian and exhibited for the first time in 1909 at the Salon des Artistes Français. To learn how to reproduce his clay and plaster models in stone without the intervention of a workman, de Creeft worked as a stonecutter in the shop La Maison Greber during 1911–14. After having destroyed all his clay and plaster models, de Creeft began carving his own sculpture directly in wood by 1915; in 1916 he completed and exhibited his first direct carving in stone. De Creeft has subsequently explored other sculptural techniques: he assembled *Le Picador* (1925) from abandoned pipes and scrap metal and used hammered sheets of lead in many works, including *Dante* (1963). However, direct carving of the human, and particularly the female, form has remained de Creeft's preeminent sculptural

José de Creeft

choice. In 1927 he received his first important Spanish commission — two hundred stone carvings — which he completed for a Majorcan estate by 1929. After a brief stay in England that year, de Creeft traveled to the United States. While visiting the West Coast, he had his first American one-man show at the Seattle Art Institute. De Creeft settled in New York City in September 1929 and had his first New York show three months later. During the 1930s and '40s de Creeft taught at numerous institutions, including the New School for Social Research, Black Mountain College and the Art Students League. In 1940 he became an American citizen. He received his first major commission in 1951 from Philadelphia's Fairmount Park Association and completed *Alice in Wonderland* in bronze for New York's Central Park in 1959. The following year the American Federation of Arts organized a retrospective of de Creeft's sculpture, which traveled to fourteen United States museums. Although over ninety, de Creeft teaches at the Art Students League and exhibits regularly at Kennedy Galleries, New York.

Campos, Jules. *José de Creeft*. New York: Erich S. Hermann, 1945.

*____. *The Sculpture of José de Creeft* (with a statement by the artist). New York: Kennedy Graphics and Da Capo Press, 1972.

Cunningham, John, ed. *José de Creeft*. Athens, Ga.: University of Georgia Press and the National Sculpture Society, 1950.

*Devree, Charlotte. *José de Creeft*. New York: The American Federation of Arts, 1960.

Thornton, Gene. "José de Creeft on Art: 'It Doesn't Necessarily Spoil Things if People Enjoy It'," *Art News*, vol. 72, January 1973, pp. 68–70.

Welty, Eudora. "José de Creeft," *Magazine of Art*, vol. 37, February 1944, pp. 42–47.

Walter De Maria

Born October 1, 1935, Albany, California

From 1953 to 1959 Walter De Maria studied at the University of California, Berkeley, where he received a B.A. in history and an M.A. in art. His earliest artistic interest had been music: he became a professional drummer at the age of fifteen and played with the rock group Velvet Underground in 1964. He moved to New York City in 1960. During 1960–62, De Maria made Minimalist sculpture of unpainted plywood, such as *Boxes for Meaningless Work*, which was included in his two-man show (1963) with Robert Whitman at Nine Great Jones Street, a cooperative space they ran together. Subsequently, De Maria made "invisible drawings," in which light pencilings of words appear, as in *Water, Water, Water* (1964). De Maria's first one-man show, held in 1965 at the Paula Cooper Gallery, New York, was followed by those at Cordier & Ekstrom, New York, in 1966 and the Nicholas Wilder Gallery, Los Angeles, in 1968. After the last show De Maria made several trips to the desert, where he created such lineal works as *Mile Long Drawing* (1968) with chalk and *Las Vegas Piece* (1969) with a bulldozer. Starting with its representation in *Documenta IV* in 1968, much of De Maria's work has been shown in Europe (particularly in Germany), where he has had one-man shows at the Kunstmuseum, Basel, Switzerland, in 1972, and the Hessiches Landesmuseum, Darmstadt, Germany, in 1974. De Maria created *Earth Room* for his 1968 show at Galerie Heiner Friedrich, Munich, filling the gallery with 1600 cubic feet of dirt, and showed five beds of spikes at the Dwan Gallery, New York, in 1969. Since the early 1970s De Maria has been working on his large *Lightning Field*, a square mile in the Southwest in which 640 eighteen-foot-tall pointed steel rods are being inserted. De Maria's works, related to earth, conceptual and Minimal art, are paradoxical because, on the one hand, they invite the viewer to experience them directly, as in *Suicide*, a tall, narrowing, wooden structure that one can enter but less easily penetrate, or *Bed of Spikes*, a source of real rather than symbolic danger; but, on the other hand, they impose such barriers as geographical distance, unclimbable steps, time control and faintness of drawing to thwart or delay their accessibility.

Adrian, Dennis. "Walter De Maria: Word and Thing," *Artforum*, vol. 5, January 1967, pp. 28–29.

Bourdon, David. "Walter De Maria: The Singular Experience," *Art International*, vol. 12, December 20, 1968, pp. 39–43, 72.

De Maria, Walter. "Conceptual Art," *Arts Magazine*, vol. 46, May 1972, pp. 39–43.

Frank, Peter. Pp. 126–27 in "Review of Exhibitions," *Art in America*, vol. 62, November/December 1974.

"High Priest of Danger," *Time Magazine*, vol. 93, May 2, 1969, p. 54.

Müller.

*The Solomon R. Guggenheim Museum. *Guggenheim International 1971* (essays by Diane Waldman and Edward F. Fry). New York: The Solomon R. Guggenheim Foundation, 1971.

Walter De Maria

José de Rivera

Born September 18, 1904, West Baton Rouge, Louisiana

When he was six years old, José A. Ruiz moved with his parents from his mother's family's sugar plantation to New Orleans, where he attended public school; later José adopted his maternal grandmother's maiden name, de Rivera, as his surname. Working with his father, an engineer in a sugar mill, José learned smithery and machine repair. Thus prepared, de Rivera easily found employment in foundries and machine shops after graduating from high school in 1922. Two years later he moved to Chicago, where from 1928 to 1931 he studied drawing at the Studio School in night classes taught by the mural painter John W. Norton. In 1930 de Rivera created his first sculptures, small geometric human and animal shapes in metal, whose highly polished finish was paradigmatic for most of his future work. That same year his third sculpture, *Bust*, Brancusian in its composition and simplification of form, was shown in the Art Institute of Chicago's American Painting and Sculpture Annual. Upon his return from travel and independent study in Europe and North Africa in 1932, de Rivera de-

José de Rivera

Mark di Suvero

cided to become a professional sculptor. In 1938 he executed his first construction, *Red and Black (Double Element)*, in painted aluminum, and his symbolic *Flight*, under WPA auspices, for Newark Airport. His first one-man show in New York was held at the Mortimer Levitt Gallery in 1946, and since 1952 he has shown regularly at the Grace Borgenicht Gallery, New York. Two retrospectives of his sculpture, both shown at the Whitney Museum, were organized by the American Federation of Arts in 1961 and the La Jolla Museum of Contemporary Art in 1972. Hilton Kramer has described the gleaming curvilinear abstractions that made up the larger part of the contents of de Rivera's retrospectives as "a form of drawing in space [in which] a great deal of labor has been invested in creating a delicate illusion of light, space, and movement."

*The American Federation of Arts. *José de Rivera* (text by John Gordon). New York, 1961.

Ashton, Dore. "The Sculpture of José de Rivera," *Arts*, vol. 30, April 1956, pp. 38–41.

Case, William D. "In the Museums: José de Rivera at the Whitney," *Arts Magazine*, vol. 46, May 1972, p. 87.

D[ownes], R[ackstraw]. P. 87 in "Reviews and Previews," *Art News*, vol. 68, November 1969.

Kramer, Hilton. "José de Rivera," *The Age of the Avant-Garde: An Art Chronicle of 1956–1972*, pp. 386–89. New York: Farrar, Straus and Giroux, [1973].

La Jolla Museum of Contemporary Art. *José de Rivera: Retrospective Exhibition 1930–1971* (introduction by Thomas S. Tibbs). La Jolla, Calif., [1972].

New York, The Museum of Modern Art. *Twelve Americans* (Dorothy C. Miller, ed.). New York, 1956.

Mark di Suvero

Born September 18, 1933, Shanghai, China

In 1941 Mark di Suvero and his family (his parents were Italian) emigrated from China to California. There he attended college from 1953 to 1957: first at San Francisco City College; then at the University of California at Santa Barbara, where he studied sculpture with Robert Thomas and philosophy; and two final years at the University of California at Berkeley, where he studied sculpture with Stefan Novak and received a B.A. in philosophy. In 1957 he moved to New York City and there had his first one-man show at the Green Gallery in October 1960. Less than eight months earlier, while in an elevator working at an odd moving job, di Suvero had suffered an almost fatal, body-crushing accident, from which he did not truly recover until 1964. Nevertheless, in 1962 he had helped found the influential Park Place Gallery, the first SoHo cooperative gallery, with which he was associated until its breakup in 1967. In 1963 he visited California and there at Point Reyes during 1964–65 he made his first large outdoor sculptures. Di Suvero's previous sculpture (1958–62), in wood, had combined Constructivist composition with expressionist handling of form; since 1964 he has incorporated movement into his

works. On another trip to California in 1966, di Suvero built a huge Peace Tower in Los Angeles as his contribution to an artists' protest against the war in Vietnam. Di Suvero's political discontent led to his self-imposed exile to Europe in 1971. Looking for ways to continue his sculpture, he spent time in the spring and summer of 1972 first in Eindhoven, the Netherlands, where he made and exhibited large outdoor works in a two-man show with Ettore Colla, and then in Duisburg, Germany, for his one-man show at the Wilhelm-Lehmbruck Museum. During 1973–74 he lived intermittently in Chalon-sur-Saône, Burgundy, France, where again he created and exhibited new sculpture. In 1975 he had two major shows, the first at the Jardin des Tuileries in Paris, the second at the Whitney Museum and various outdoor sites in New York City. His recent works in these two exhibitions are made of steel beams, wire and other metal components. Di Suvero is the recipient of such honors as the Logan Medal (which had been designed by David Smith) and grants from the Longview and Walter K. Gutman foundations.

Baker, Elizabeth C. "Mark di Suvero's Burgundian Season," *Art in America*, vol. 62, May/June 1974, pp. 59–63.

Chicago, The Art Institute. *Sculpture in the Park* (essay by Max Kozloff). Chicago, 1974.

*Eindhoven, Stedelijk van Abbemuseum. *Ettore Colla, Mark di Suvero* (introduction by J. Leering; essays by M. Fagiolo and Hein Reedijk). Eindhoven, 1972.

Geist, Sidney. "A New Sculptor: Mark di Suvero," *Arts*, vol. 35, December 1960, pp. 40–43.

Kozloff, Max. "Mark di Suvero: Leviathan," *Artforum*, vol. 5, Summer 1967, pp. 41–46.

Ratcliff, Carter. "Mark di Suvero," *Artforum*, vol. 11, November 1972, pp. 34–42.

Rose, Barbara. "Mark di Suvero," *Vogue*, vol. 161, February 1973, pp. 160–62, 202–3.

*Whitney Museum of American Art. *Mark di Suvero* (text by James K. Monte). New York, 1975.

Charles J. Dodge

Born 1806, New York City
Died 1886, Brooklyn, New York

At the age of twenty-two Charles J. Dodge began working as a shipcarver. It was probably sometime between 1828 and 1833 — the year he became a partner in his father Jeremiah Dodge's shipcarving business — that Charles carved his father's bust. Carved in pine and painted white to resemble marble, the portrait was donated by Charles's granddaughter to the New-York Historical Society in 1952. In 1835 the Dodges carved a new head for the decapitated figurehead of President Andrew Jackson for the frigate *Constitution*, but by 1842 their partnership had dissolved and Charles had moved to his own shop on South Street and Market Slip. Continuing as a carver, he entered into community politics and was elected an alderman in 1845. Perhaps feeling two jobs burdensome, Dodge formed a partnership in 1846 with Jacob S. Anderson, which only lasted a year. In 1855 Dodge became a Hall of Records assessor and upon his father's death in 1860 took over Jeremiah

Dodge's carving shop. He became a deputy tax commissioner in 1864 and tax commissioner three years later. Two carved wood sculptures attributed to Dodge are a larger-than-life-size statue of Jim Crow, now in the Shelburne Museum, Vermont, and a seated Indian figure, used as a sign for a Brooklyn tobacco shop and now owned by the Long Island Historical Society. In 1870 Dodge gave up his carving shop and moved first to South Second Street and then in 1874 to the home he built near the waterfront in Brooklyn, where he lived for the remaining twelve years of his life.

Brewington, M. V. *Shipcarvers of North America.* Barre, Mass.: Barre Publishing Company, 1962; New York: Dover Publications, 1972 (corrected republication).

*Fried, Frederick. *Artists in Wood: American Carvers of Cigar-Store Indians, Show Figures, and Circus Wagons.* New York: Clarkson N. Potter, 1970; distributed by Crown Publishers.

The New-York Historical Society. Pp. 16–22 in "Report of the Board of Trustees," *Annual Report for the Year 1952.* New York, 1953.

Pinckney, Pauline A. *American Figureheads and Their Carvers.* New York: W. W. Norton and Company, 1940; Port Washington, N.Y.: Kennikat Press, 1969 (reprint).

Winchester, Alice. "Editorial," *The Magazine Antiques,* vol. 99, May 1971, p. 695.

Zabriskie, George A. "Ships' Figureheads in and About New York," *The New-York Historical Society Quarterly,* vol. 30, January 1946, pp. 5–16.

Marcel Duchamp

Born July 28, 1887, Blainville, France
Died October 2, 1968, Neuilly, France

Marcel Duchamp was introduced to art by his older brothers Jacques Villon, the painter, and Raymond Duchamp-Villon, who became known for his Cubist sculpture. Duchamp graduated from the Lycée Corneille in Rouen in 1904 and the following year attended the Académie Julian. In 1908 he relocated to Neuilly, often spending time at his brothers' studios in nearby Puteaux, where he met the artists Franz Kupka, Fernand Léger and Francis Picabia, and the poet Apollinaire. By 1912 Duchamp had abandoned all the best-known avant-garde movements — from Impressionism to Fauvism to Cubism and beyond. That year he began to experiment with unconventional materials in his search for an artistic expression that was not so purely visual. Duchamp turned increasingly toward sculpture and in 1913 he collected the first Ready-made, elevating the commonplace object to the status of art. By 1914 Duchamp's brothers and Apollinaire had joined the army. Medically exempt from service, Duchamp accepted Walter Pach's invitation to visit America and in 1915 he moved to New York, staying temporarily with Louise and Walter Arensberg, his first patrons. Here he continued to collect Ready-mades, attempting to exhibit his famous *Fountain,* a urinal presented upside-down, at the Society of Independent Artists in 1917. He was also absorbed during these years with gathering, refining and assembling the images that now appear in his *Large Glass* (1915–

23). His friend Man Ray assisted with several of his Ready-mades and collaborated with him in 1921 on the publication of *New York Dada.* The two also joined forces with Katherine S. Dreier in founding the Société Anonyme. Although Duchamp concentrated primarily on chess after 1923, he did develop several motorized optical devices, or Precision Optics, which explored the images created by revolving spirals. After 1940 he expanded upon the idea of the Ready-mades, producing in 1951 *Objet-Dard,* a plaster cast taken from the mold of one of his own sculptures. Although sympathetic to the Dadaists and, through André Breton, the Surrealists, Duchamp was never a member of either group, preferring instead to create his own avant-garde.

Duchamp, Marcel. "Apropos of Readymades," *Art and Artists,* vol. 1, July 1966, p. 47.

———. *Notes and Projects for the Large Glass* (selection and introduction by Arturo Schwarz). New York: Harry N. Abrams, 1969.

———. *Salt Seller: The Writings of Marcel Duchamp (Marchand du Sel),* Michel Sanouillet and Elmer Peterson, ed. New York: Oxford University Press, 1973.

Lebel, Robert. *Marcel Duchamp* (chapters by André Breton, Marcel Duchamp and H. P. Roche; George Heard Hamilton, trans.). New York: Grove Press, 1959.

*New York, The Museum of Modern Art, and Philadelphia Museum of Art. *Marcel Duchamp* (Anne d'Harnoncourt and Kynaston McShine, ed.). [New York], 1973; hardcover ed. distributed by New York Graphic Society, Greenwich, Conn.

Pasadena Art Museum. *Marcel Duchamp: A Retrospective Exhibition* (text by Walter Hopps). Pasadena, 1963.

*Schwarz, Arturo. *The Complete Works of Marcel Duchamp.* New York: Harry N. Abrams, n.d.

*Tate Gallery. *The Almost Complete Works of Marcel Duchamp* (text by Richard Hamilton; notes and bibliography by Arturo Schwarz), 2nd ed. London: Arts Council of Great Britain, 1966.

Thomas Eakins

Born July 25, 1844, Philadelphia
Died June 25, 1916, Philadelphia

After graduating from Philadelphia's Central High School, where his schooling had included four years of drawing, Thomas Cowperthwait Eakins attended the Pennsylvania Academy of the Fine Arts from 1861 or 1862 to 1866 and studied anatomy at Jefferson Medical College. In 1866 he enrolled in the Ecole des Beaux-Arts in Paris, where he studied painting under Jean Léon Gérôme and sculpture under Augustin Dumont and attended Léon Bonnat's private painting classes. Before returning to the United States in 1870, Eakins spent six months in Spain, where he discovered and admired the art of Velázquez and Ribera. A realist painter of the human figure in indoor and outdoor settings, as an instructor of life classes and anatomy at the Pennsylvania Academy, Eakins stressed painting directly from live nude models and introduced the study of sculpture into his classes. He became director of the Academy School in 1882, but his radical teaching meth-

Copyright © Arnold Newman

Marcel Duchamp

Thomas Eakins

Abastenia St. Leger
Eberle

Alfeo Faggi

ods forced his resignation in 1886. Eakins's early sculptural activities were largely limited to the modeling of small sculptures as an aid to his painting. However, in the early 1880s he also wrote a paper on relief sculpture and created five reliefs of genre or pastoral subjects. The two genre reliefs, *Spinning* and *Knitting,* were based on his earlier watercolors; the largest pastoral relief and one of his paintings of the same year, 1883, were titled *Arcadia.* Eight years later Eakins was commissioned to sculpt the horses for the sculptor William O'Donovan's high-relief equestrian figures of Lincoln and Grant (1893–94) for Prospect Park, Brooklyn. In 1893, also commissioned with O'Donovan, Eakins produced another major sculpture — two bronze reliefs (a third was completed by Charles H. Niehaus) of *The Battle of Trenton* and *The American Army Crossing the Delaware* for the Trenton Battle Monument in New Jersey. Although he exhibited at the Pennsylvania Academy, the National Academy of Design and the Society of American Artists from the 1870s on, his first and only one-man exhibition during his lifetime was held in 1896 at the Earle Galleries, Philadelphia. Generally unrecognized until his later years, it was only after his death that Eakins began to receive considerable critical attention.

*Goodrich, Lloyd. *Thomas Eakins: His Life and Work.* New York: Whitney Museum of American Art, 1933.
*The Corcoran Gallery of Art. *The Sculpture of Thomas Eakins* (text by Moussa M. Domit). Washington, 1969.
Hendricks, Gordon. "Eakins' William Rush Carving His Allegorical Statue of the Schuylkill," *The Art Quarterly,* vol. 31, Winter 1968, pp. 382–404.
*____. *The Life and Work of Thomas Eakins.* New York: Grossman Publishers, 1974.
*McHenry, Margaret. *Thomas Eakins Who Painted.* Oreland, Pa.: privately printed, 1946.
Moffett, Cleveland. "Grant and Lincoln in Bronze." *McClure's Magazine,* vol. 5, October 1895, pp. 419–32.
*New Jersey State Museum. *The Trenton Battle Monument: Eakins Bronzes* (Zoltan Buki and Suzanne Corlette, ed.). Trenton, 1973.
*Porter, Fairfield. *Thomas Eakins.* New York: George Braziller, 1959.
Whitney Museum of American Art. *Thomas Eakins: Retrospective Exhibition* (text by Lloyd Goodrich). New York, 1970; New York and London: Praeger Publishers, 1970 (hardcover).

Abastenia St. Leger Eberle

Born April 6, 1878, Webster City, Iowa
Died February 26, 1942, New York City

Raised in Canton, Ohio, where she studied clay modeling with Frank Vogan, and in Puerto Rico, where her father, an army doctor, was stationed, Mary Abastenia St. Leger Eberle moved to New York City in 1899. There she studied for three years at the Art Students League, where her teachers included George Grey Barnard and Kenyon Cox. In 1904 Eberle shared a New York studio and collaborated on sculpture groups with Anna Vaughn Hyatt, Eberle contributing the human figures, Hyatt the animals. That year one of their works, *Men and Bull,* won a bronze medal at the St. Louis Exposition. After having visited Italy in 1907–08 and Paris in 1913, Eberle opened a studio in 1914 on Manhattan's Lower East Side. She equipped the studio with a playroom, where she could observe and model the children from this crowded tenement section. Interested in social service and believing in the artist's social responsibilities, she shared with the painters of the Eight a preference for portraying urban street life in her art. Eberle was elected a member of the National Sculpture Society in 1906; in 1910 her sculpture the *Windy Doorstep* was awarded the Helen Foster Barnett Prize by the National Academy of Design, and five years later her work won a bronze medal at the Panama-Pacific Exposition in San Francisco. After becoming seriously ill in 1919, she remained relatively inactive as a sculptor during the rest of her life. Nevertheless, she was elected an associate member of the National Academy in 1920; was honored with a one-woman exhibition at the Macbeth Gallery, New York, in 1921; and won the Lindsey Morris Sterling Memorial Prize from the Allied Artists of America in 1932.

"Abastenia Eberle, Long a Sculptor," *The New York Times,* February 28, 1942, p. 17.
P. 105 in *Biographical Sketches of American Artists.* Lansing, Mich.: Michigan State Library, 1924.
*Craven, Wayne. *Notable,* vol. 1, pp. 548–49.
Gardner.
The National Sculpture Society. Pp. 52–53 in *Exhibition of American Sculpture Catalogue.* New York, 1923.
____ in cooperation with the California Palace of the Legion of Honor. Pp. 84–85 in *Contemporary American Sculpture.* [New York], 1929.
*Proske.

Alfeo Faggi

Born September 11, 1885, Sesto Fiorentino, Italy
Died October 16, 1966, Woodstock, New York

As a boy Alfeo Faggi took his first drawing lessons from his father, an architect and frescoer. At the age of thirteen Faggi began a four-year course at the Academia delle Belle Arti in Florence, followed by his study of anatomy in a hospital. Feeling oppressed by Italy's thralldom to neoclassical bombast and the lack of appreciation for his sculpture at home, Faggi chose to immigrate to the United States in 1913. Here he developed a personal yet primitive style, whose simplified and elongated forms often reminded critics of those of the Pisanos and of Faggi's other late medieval Italian art ancestry. In America he became best known for his statues and reliefs with religious content and for portrait busts, usually cast in bronze. Soon after his arrival, Faggi married Beatrice Butler, a musician he had known in Italy. Settling in Chicago, he had his first one-man show there in 1914 at the Henry Reinhardt Galleries. With war breaking out in Europe, Faggi was called back to Italy to join the army in 1916. He returned to Chicago in 1919 and soon became an American citizen. His one-man show at the Arts Club of Chicago in 1919 attracted the interest of Stephen Bourgeois, who gave Faggi his

first one-man show in New York at the Bourgeois Galleries in 1921. In the early 1920s Faggi and his family moved to the art colony Woodstock, New York, where Faggi spent his first three years completing a major commission, which he had received in Chicago from Mrs. Frank R. Lillie — a monumental *Pietà* (he was to create a smaller version ten years later) and fourteen reliefs, *The Stations of the Cross,* for the Church of St. Thomas the Apostle in Chicago. Important one-man exhibitions were held in 1927 at the Art Institute of Chicago and in 1930 at the Ferargil Gallery, New York. Faggi's retrospective at Buffalo's Albright Art Gallery in 1941 reviewed the preceding thirty years of his career, beginning with his Italian works and concluding with the large bas-reliefs of nudes modeled in 1936 and plaster figures of 1940. Recipient of the Logan Prize from the Art Institute of Chicago in 1942, Faggi was a frequent exhibitor at the Weyhe Gallery New York, in the 1950s. He was also a founding member and later director of the Woodstock Artists Association.

Bourgeois Galleries. *Exhibition of Sculptures by Alfeo Faggi* (preface by Richard Offner). New York, 1921.

Breuning, Margaret. "Margaret Breuning Writes: Alfeo Faggi," *Arts,* vol. 31, February 1957, p. 50.

Brian, Doris. "Faggi of Florence," *The Art Digest,* vol. 24, January 1, 1950, p. 12.

*The Buffalo Fine Arts Academy, Albright Art Gallery. *Sculpture and Drawings by Alfeo Faggi.* Buffalo, N.Y., 1941.

Cheney, Martha Candler. *Modern Art in America.* New York and London: McGraw-Hill Book Company (Whittlesey House), 1939.

Eglington, Guy. *Reaching for Art.* Boston: Morley & Mitchell, 1931.

"Faggi Fled from Ghosts of the Dead Great," *The Art Digest,* vol. 6, September 1, 1932, p. 17.

Moore, Marianne. "Is the Real the Actual?" *The Dial,* vol. 73, December 1922, pp. 620–22.

Morsell, Mary. "As They Are: 'Man of the Hills'," *The Art News,* vol. 33, November 3, 1934, p. 11.

with soldered repousséed sheets of lead; by 1950 his personal style emerged, based on his use of welded metal to create open, hollow forms, as in his extensive series of "calligraphs." In 1950 the B'nai Israel Synagogue in Millburn, New Jersey, commissioned Ferber to do a facade sculpture, *And the Bush Was Not Consumed,* an Abstract Expressionist metal construction, which marked his evolvement toward spatial sculpture. In 1954 he began his "roofed" sculptures (*Sun Wheel,* 1956) and "caged" sculptures (*Homage to Piranesi,* 1957). When his "room," *Sculpture as Environment, Interior,* was installed at the Whitney Museum in 1961, Ferber's work had already evolved into environmental sculpture. In 1962–63 a traveling retrospective opened at the Walker Art Center, Minneapolis. Ferber has had many one-man shows in New York at the Betty Parsons, Kootz and André Emmerich galleries. He has also been a visiting professor of sculpture at the University of Pennsylvania, Rutgers University and Bennington College.

Dennison, George. "Sculpture as Environment: The New Work of Herbert Ferber," *Arts,* vol. 37, May/June 1963, pp. 86–91.

Faison, S. Lane, Jr. "The Sculpture of Herbert Ferber," *College Art Journal,* vol. 16, Summer 1958, pp. 363–71.

Ferber, Herbert. "On Sculpture," *Art in America,* vol. 42, December 1954, pp. 262–65, 307–8.

"Ferber, Herbert," *Current Biography Yearbook,* pp. 137–38. New York: The H. W. Wilson Company, 1960.

Goodnough, Robert. "Ferber Makes a Sculpture," *Art News,* vol. 51, November 1952, pp. 40–43, 66.

Goossen, E. C. and others. *Three American Sculptors: Ferber, Hare, Lassaw.* New York: Grove Press, 1959.

Tuchman, Phyllis. "An Interview with Herbert Ferber," *Artforum,* vol. 9, April 1971, pp. 52–57.

*Walker Art Center. *The Sculpture of Herbert Ferber* (text by Wayne V. Andersen). Minneapolis, 1962.

Herbert Ferber

Herbert Ferber

Born April 30, 1906, New York City

Herbert Ferber received both his B.S. (1927) and his D.D.S. (1930) from Columbia University. He also studied sculpture at night at the Beaux-Arts Institute of Design in New York City from 1927 to 1930, and he has subsequently maintained careers both as a sculptor and a dentist. Influenced by William Zorach, Ernst Barlach and Aristide Maillol, Ferber began his sculptural career in the 1930s as a carver of wood and stone, executing figurative pieces that displayed affinities with pre-Columbian sculpture and African art. His first one-man exhibition was held at the Midtown Galleries, New York, in 1937. After a trip in 1938 to Europe, where Ferber was particularly impressed with Romanesque sculpture, he returned to New York and became a member of the "Studio 35" group. In the early 1940s, under the influence of Henry Moore's work, Ferber developed a more open sculptural form and then moved toward surrealistic abstraction. In 1945 he began working

John B. Flannagan

Born April 7, 1895, Fargo, North Dakota
Died January 6, 1942, New York City

When John Bernard Flannagan was five years old, his father died, and Flannagan spent five years in an orphanage because his mother was unable to support him. In 1914 he began to study painting at the art school of the Minneapolis Institute of Arts, and in 1917 he left his studies to serve in the merchant marine. After his discharge in 1922, Flannagan was hired by the painter Arthur B. Davies to work on his farm in Congers, New York. There, with Davies's encouragement, Flannagan resumed painting and also began carving wood. Flannagan's first exhibition came in 1923 when he participated in a group show in New York City with Davies, Walt Kuhn, Charles Sheeler, William Glackens, and Maurice and Charles Prendergast. By 1927 Flannagan had abandoned painting and wood sculpture and settled upon stone carving as his primary medium. Basically self-taught, he preferred to carve natural field stones, which he searched for himself. During 1930–31

John B. Flannagan

Dan Flavin

James Earle Fraser

Flannagan and his wife spent a year in Clifden, Ireland, a trip largely financed by the Weyhe Gallery, New York. A second stay in Ireland during 1932–33 was made possible by a Guggenheim Fellowship. The second return from Ireland was followed by bouts with alcoholism and a nervous breakdown, which resulted in a seven-month rest in a sanitarium and the end of Flannagan's marriage. The second half of the 1930s brought several one-man shows and the completion of a commission for Philadelphia's Fairmount Park Association. In 1939 Flannagan was the victim of a hit-and-run automobile accident. Severely injured, he underwent four brain operations that left him physically and emotionally debilitated. Despite the encouragement of his second wife, Margherita, and a partial resumption of his artistic activities, Flannagan committed suicide in his New York City studio, two months before his forthcoming one-man exhibition at the Buchholz Gallery, New York.

Arnason, H. H. "John Flannagan," *Art in America,* vol. 48, Spring 1969, pp. 64–69.

Flannagan, John B. "The Image in the Rock," *The Magazine of Art,* vol. 35, March 1942, pp. 90–95.

———. *Letters of John B. Flannagan* (Margherita Flannagan; ed.; introduction by W. R. Valentiner). New York: Curt Valentin, 1942.

New York, The Museum of Modern Art. *The Sculpture of John B. Flannagan* (Dorothy C. Miller, ed.; introduction by Carl Zigrosser; and reprint of John B. Flannagan's "The Image in the Rock"). New York, 1942. (Entire catalogue reprinted in *Five American Sculptors: Calder, Flannagan, Lachaise, Nadelman, Lipchitz.* New York: The Museum of Modern Art and Arno Press, 1969).

Pach, Walter. "John B. Flannagan, American Sculptor," *The Kenyon Review,* vol. 5, 1943, pp. 384–93.

The Weyhe Gallery and Minnesota Museum of Art. *John B. Flannagan: Sculpture and Drawings from 1924–38* (introduction by Robert J. Forsyth; reprint of John B. Flannagan's "The Image in the Rock"). St. Paul: Minnesota Museum of Art, 1973.

Dan Flavin

Born April 1, 1933, Jamaica, New York

Educated until 1952 at Roman Catholic parochial schools in New York City, Dan Flavin had begun drawing by the age of five. Upon leaving the army, he attended four sessions at Hans Hofmann's school in New York City in 1956, received private criticism from the painter Albert Urban and took art history courses at the New School for Social Research. He then studied the tools and materials of painting and drawing for two semesters under Ralph Mayer at Columbia University. Through 1961 Flavin created Abstract Expressionist drawings, which were often inscribed with text, and collaged relief constructions, which frequently incorporated found objects, such as flattened tin cans. Flavin's first one-man show was held at the Judson Gallery, New York, in 1961. That year he began to employ electric light in his constructions, which he then called "icons." During the next three years he produced a series of these icons — painted or linoleum-covered, boxlike, masonite wall reliefs on which incandescent or fluorescent lights were mounted, usually as a framing edge. In 1963

he created his first light work without a supporting construction — *The Diagonal of May 25, 1963,* an eight-foot-long fluorescent light tube affixed diagonally to the wall. This work was first shown in the group exhibition *Black, White and Grey* at the Wadsworth Atheneum, Hartford, Connecticut, in 1964. His two one-man shows later in 1964, at the Kaymar and Green galleries, New York, gave him his initial opportunities to experiment with the optical illusions resulting from varying the placement of the fluorescent tubes on the wall. He subsequently discarded all but the fluorescent tube and its fixture as his sculptural medium and has developed the combination and positioning of fluorescent tubes of varied shapes and colors into more elaborate constructions and environments. Among Flavin's numerous one-man exhibitions are a 1967–68 show at Chicago's Museum of Contemporary Art, a retrospective organized by the National Gallery of Canada in 1969, and 1973 shows at the St. Louis and Cologne [Germany] art museums. His group exhibitions include *American Sculpture of the Sixties,* Los Angeles County Museum, 1967; *Documenta IV,* Kassel, Germany, 1968; and the *Sixth Guggenheim International Exhibition,* Solomon R. Guggenheim Museum, 1971. Flavin was guest lecturer in design at the University of North Carolina at Greensboro in 1967 and Albert Dorne Guest Professor at the University of Bridgeport, Connecticut, in 1973.

Alloway, Lawrence. "Art," *The Nation,* vol. 210, February 9, 1970, p. 155.

Burnham, Jack. "A Dan Flavin Retrospective in Ottawa," *Artforum,* vol. 8, December 1969, pp. 48–55.

*Canada, The National Gallery of. *Dan Flavin, Fluorescent Light, Etc. from Dan Flavin* (essays by the artist and others; catalogue by Brydon Smith). Ottawa, 1969.

*Los Angeles.

Müller.

Perreault, John. "We Applaude *[sic]* the Artist's Good Taste and Exquisite Control," *The Village Voice,* vol. 16, November 4, 1971, p. 25.

Plagens, Peter. "Rays of Hope, Particles of Doubt," *Artforum,* vol. 11, June 1973, pp. 32–35.

*The St. Louis Art Museum. *Drawings and Diagrams 1963–72 by Dan Flavin* (foreword by Emily S. Raugh), vol. 1; *Corners, Barriers and Corridors in Fluorescent Light from Dan Flavin* (introduction by Emily S. Raugh), vol. 2. St. Louis, 1973.

*Wallraf-Richartz-Museum and Cologne, Kunsthalle. *Dan Flavin: Three Installations in Fluorescent Light* (introduction by Manfred Schneckenburger; reprinted statements by Dan Flavin; catalogue by Evelyn Weiss and others). Cologne, 1973.

James Earle Fraser

Born November 4, 1876, Winona, Minnesota
Died October 11, 1953, Westport, Connecticut

James Earle Fraser spent several years of his boyhood in the frontier territory of Dakota, an experience that generated his lifelong affection for western American life and his wish to memorialize its heroes and victims — Theodore Roosevelt, pioneers, Indians, buffalo and horses — in his art. After a brief residence in Minneapolis, the Frasers moved to Chi-

cago, where James became an assistant to the German-born sculptor Richard W. Bock and attended night classes at the Art Institute. Inspired by the sculpture he saw at the Columbian Exposition, Fraser made in 1894 the first model for *End of the Trail*, his sympathetic depiction of a vanquished Indian rider, which Fraser's *New York Times* obituary judged to be the best-known sculpture in America in 1953. Continuing his studies at the Ecole des Beaux-Arts under Alexandre Falguière and at the Académies Julian and Colarossi in Paris, Fraser there came to Augustus Saint-Gaudens's attention when *End of the Trail* was exhibited in 1898. (An enlarged stucco version of the statue, now in the Cowboy Hall of Fame in Oklahoma City, was awarded the gold medal at San Francisco's Panama-Pacific Exposition in 1915; a life-size bronze casting of the statue was completed in 1929 and installed in Waupun, Wisconsin.) Fraser became one of Saint-Gaudens's assistants, accompanying him to America in 1900 and helping him in his New Hampshire studio for two years. In 1902 Fraser moved to New York City, where he set up his own studio in Macdougal Alley. He taught at the Art Students League from 1906 to 1911, the year he designed the buffalo and Indian-head nickel, whose subjects Fraser had chosen to give the coin a singularly American identity; the nickel was first issued in 1913. That year Fraser married the sculptor Laura Gardin. A prolific creator of large-scale public monuments throughout the United States, Fraser was also acclaimed for his designs of many medals and medallions, including the Navy Cross, and he received the Saltus Medal from the American Numismatic Society in 1919. His other honors included the 1951 gold medal for sculpture of the American Academy of Arts and Letters and the medal of honor of the National Sculpture Society, of which Fraser had been president and honorary president.

*Craven.

Goode, James M. *The Outdoor Sculpture of Washington, D.C.: A Comprehensive Historical Guide.* Washington: Smithsonian Institution Press, 1974.

"James Fraser Dies; Noted Sculptor, 76," *The New York Times*, October 12, 1953, p. 27.

Kennedy Galleries. *James Earle Fraser: American Sculptor.* New York, 1969.

Krakel, Dean F. *End of the Trail: The Odyssey of a Statue.* Norman, Okla.: University of Oklahoma Press, 1973.

Louchheim, Aline B. "Most Famous Unknown Sculptor," *The New York Times Magazine*, vol. 100, May 13, 1951, pp. 24–25, 65–67.

Morris, Joseph F., ed. *James Earle Fraser.* Athens, Ga.: University of Georgia Press, 1955.

*Proske.

John Frazee

Born July 18, 1790, Rahway, New Jersey
Died February 24, 1852, Compton Mills, Rhode Island

An impoverished farm boy, John Frazee was apprenticed in his teens to the bricklayer-mason William Lawrence. At the age of eighteen Frazee decided to become a stonecutter, after chiseling Lawrence's name into stone to mark his completion of a bridge over the Rahway River. Frazee learned how to hew stone, moved to New Brunswick in 1814 and opened a stonecutting business with a partner. His son's death in 1815 prompted Frazee to carve his earliest representation of the human figure, that of *Grief*, on his child's tombstone. In New York City in 1818 he and his brother opened another marble-cutting shop, where he carved mantelpieces, church memorials and tombstones and concentrated on perfecting his lettering. After copying a bust of Franklin and modeling the figure of one of his children, Frazee, in 1824, carved his first marble bust, a memorial portrait of John Wells, which is believed to be the first marble bust carved in this country by a native American. Frazee was also the only sculptor among the fifteen artists who founded the National Academy of Design in January 1826. Five years later he was awarded a commission from Congress to do a bust of John Jay for the Capitol, thereby becoming the first American-born sculptor to be awarded a government commission. His other portrait commissions included a bust of Chief Justice John Marshall (with many replicas), and seven busts, including that of Daniel Webster, for the Boston Athenaeum. During his partnership (1831–39) with the sculptor Robert E. Launitz in another stone-carving business, Frazee broadened his accomplishments and served as architect and superintendent of the New York Custom House from 1834 to 1841.

A[dams], A[deline]. *DAB*, vol. 7, pp. 1–3.

Caldwell, Henry Bryan. "John Frazee, American Sculptor." Unpublished master's thesis, New York University, 1951.

*C[raven], W[ayne]. *Britannica*, pp. 187–88.

Craven.

Dunlap, William. *A History of the Rise and Progress of the Arts of Design in the United States* (new ed.; Frank W. Bayley and Charles E. Goodspeed, ed.), 3 vols. Boston: C. E. Goodspeed & Co., 1918.

Frazee, John. "The Autobiography of Frazee, the Sculptor," *North American Magazine*, vol. 5, April 1835, pp. 395–403; *North American Quarterly Magazine*, vol. 6, July 1835, pp. 1–22. Excerpts in *American Collector*, vol. 15, September 1946, pp. 15–16; October 1946, pp. 10–11; November 1946, pp. 12–13.

Taft.

Torres, Louis. "John Frazee and the New York Custom House," *Journal of the Society of Architectural Historians*, vol. 23, October 1964, pp. 143–50.

Daniel Chester French

Born April 20, 1850, Exeter, New Hampshire
Died October 7, 1931, Stockbridge, Massachusetts

Raised in Cambridge and Concord, Massachusetts, Daniel Chester French had his first art classes with Abigail May Alcott in Concord. In the early 1870s French went to Boston to study anatomy with William Rimmer and drawing with William Morris Hunt while modeling small genre pieces. In the spring of 1870 French spent one month in New York City studying with John Quincy Adams Ward, under whose influence he began to seek higher forms of sculpture. In 1873 the town of Concord awarded

John Frazee

Daniel Chester French

Sidney Gordin

Charles Grafly

him his first commission, the bronze *Minute Man*. Upon completion of the plaster model in 1874, French went to Italy and studied with Thomas Ball in Florence. Returning to America in 1876 and settling in Washington, French modeled many portrait busts, including *Ralph Waldo Emerson* (1879) and the seated *John Harvard* (1884, Harvard University). He also completed his first allegorical groups for government buildings in St. Louis, Philadelphia and Boston. In 1886 French left for Paris, where he studied under Antonin Mercié and worked on *Lewis Cass* (1886, Statuary Hall, United States Capitol). A year later French returned to America and opened a studio in New York, where he applied his Parisian academic training to the *Thomas Gallaudet Memorial* (1888, Washington) and *The Angel of Death and the Sculptor* for the Martin Milmore Memorial (1891, Forest Hills Cemetery, Boston). In 1892 French went to Chicago, where he created the colossal *Republic* and, with Edward Clark Potter, *The Triumph of Columbus* for the Columbian Exposition. In 1893 he established his summer studio, *Chesterwood*, in Stockbridge, Massachusetts. There and in New York, he modeled such works as the *Hunt Memorial* for Central Park (1898); *Four Continents* (1907, New York Custom House); *Mourning Victory* for the Melvin Memorial in Concord (1909); a standing *Lincoln* (1912, Lincoln, Nebraska); *Alma Mater* (1915, Columbia University); and, finally, the seated *Lincoln* for the Lincoln Memorial in Washington (1922). French was elected an academician of the National Academy of Design in 1901 and was made a chevalier of the French Legion of Honor in 1910.

Adams, Adeline. *Daniel Chester French, Sculptor.* Boston: Houghton Mifflin Company, 1932.

Coffin, William A. "The Sculptor French," *Century,* vol. 59, April 1900, pp. 871–79.

Cresson, Margaret French. *Journey into Fame: The Life of Daniel Chester French.* Cambridge, Mass.: Harvard University Press, 1947.

French, Mrs. Daniel Chester. *Memories of a Sculptor's Wife.* Boston: Houghton Mifflin Company, 1928.

Moore, N. Hudson. "Daniel Chester French," *The Chautauquan,* vol. 38, October 1903, pp. 141–48.

Richman, Michael. "The Early Public Sculpture of Daniel Chester French," *The American Art Journal,* vol. 4, November 1972, pp. 97–115.

Rockwell, Edwin A. "Daniel Chester French," *The International Studio,* vol. 41, September 1910, pp. lv–lxii.

Seaton-Schmidt, Anna. "Daniel Chester French, Sculptor," *The American Magazine of Art,* vol. 13, January 1922, pp. 3–10.

Taft, Lorado, "Daniel Chester French, Sculptor," *Brush and Pencil,* vol. 5, January 1900, pp. 145–63.

Walton, William, "The Field of Art: Some of Daniel C. French's Later Work," *Scribner's Magazine,* vol. 52, November 1912, pp. 637–40.

Sidney Gordin

Born October 24, 1918, Cheliabinsk, Russia

Having spent his early childhood in Shanghai, China, Sidney Gordin arrived in New York City with his family in 1922. His interest in architecture led him to study at the Brooklyn Technical High School, where he took courses in drafting and mechanical drawing. In 1937 Gordin decided to become an artist and entered Cooper Union, where he studied under Morris Kantor, Carol Harrison and Leo Katz until 1941. It was not until 1949 that he began to experiment with brass and steel wire sculpture, creating linear and planar pieces that revealed his earlier interest in architecture and his relationship to Constructivism. His work from this period, typified by his series of painted steel "rectangulars," displays the influence of Mondrian and Neo-plasticism, but by the mid-1950s he was adding looping curves to his constructions. Gordin's work was first exhibited in a group sculpture show at the Metropolitan Museum of Art in 1951 and later that year in one-man shows at Bennington College and the Peter Cooper Gallery. The first of his one-man shows at the Grace Borgenicht Gallery was held in 1953, and since 1959 he has had several shows at the Dilexi Gallery, San Francisco; Gordin was represented in Whitney Museum Annuals from 1952 to 1957, circulating exhibitions of the Museum of Modern Art in 1952–53, and in Pennsylvania Academy Annuals in 1954–55. In the spring of 1973 Gordin was a contributor to the show *Post-Mondrian Abstraction in America* at Chicago's Museum of Contemporary Art. He was commissioned to create pieces for Temple Israel in Tulsa in 1959 and the Envoy Towers in New York City in 1960. Gordin has taught at Pratt Institute and the University of California at Berkeley.

Baur, John I. H. "Sidney Gordin," *Art in America,* vol. 42, Winter 1954, pp. 20–21, 70.

Burnham, Jack. Pp. 36–39 in "Mondrian's American Circle," *Arts Magazine,* vol. 48, September/October 1973.

P. 76 in "Fifty-six Painters and Sculptors," *Art in America,* vol. 52, August 1964.

F[itzsimmons], J[ames]. P. 17 in "Fifty-seventh Street," *Art Digest,* vol. 27, June 1953.

S[chuyler], J[ames]. P. 19 in "Reviews and Previews," *Art News,* vol. 60, November 1961.

Ventura, Anita. P. 78 in "San Francisco: Seeking and Finding," *Arts Magazine,* vol. 39, March 1965.

Charles Grafly

Born December 3, 1862, Philadelphia
Died May 5, 1929, Philadelphia

At the age of seventeen Charles Allan Grafly was apprenticed as a carver at John Struthers's stone yard and worked on architectural ornamentation for the Philadelphia City Hall. He soon began formal instruction at the Spring Garden Institute, and from about 1884 he studied at the Pennsylvania Academy of the Fine Arts under Thomas Eakins and Thomas Anshutz. In 1888 Grafly went to Paris, where he studied drawing under Adolphe William Bouguereau and Albert François Fleury at the Ecole des Beaux-Arts and modeling under Henri Chapu at the Académie Julian. The Salon of 1890 accepted two of Grafly's works, the heads *St. John* and *Daedalus;* his *Mauvais Présage* won an honorable mention at the Salon of 1891 and was later shown at the Columbian

Exposition of 1893 in Chicago. In 1892 Grafly returned to Philadelphia and became an instructor of modeling at Drexel Institute and the Pennsylvania Academy of the Fine Arts, where he taught until his death. A master of allegory, Grafly won the gold medal at the Paris Exposition in 1900 for a group of small bronzes, including the symbolic *Vulture of War* (1895–96) and *The Symbol of Life* (1897). From 1890 to 1905 Grafly created many sculptures, usually for fairs and expositions, such as his *Fountain of Man* for the Pan-American Exposition in Buffalo in 1901 and his personifications of Great Britain and France for the New York Custom House (1904). Grafly was also renowned for his portrait busts — many of which were of his fellow artists — which dominated his work after 1905 and won him the Widener Medal (1913), the gold medal of the National Academy of Design (1918) and the Potter Palmer Gold Medal of the Art Institute of Chicago (1921). Grafly is best known for his marble monument of Major General George Gordon Meade, unveiled in 1927 in Washington, D.C., which combines portraiture with allegorical figures in the round. In 1905 Grafly was elected an academician of the National Academy of Design.

*Craven.

Pennsylvania Academy of the Fine Arts. *Memorial Exhibition of Works by Charles Grafly*. Philadelphia, 1930.

*Proske.

Simpson, Pamela. "The Sculpture of Charles Grafly." Unpublished doctoral dissertation, University of Delaware, 1974.

Trask, John E. D. "Charles Grafly, Sculptor," *Arts and Progress*, vol. 1, February 1910, pp. 83–89.

Wilcox, Uthai Vincent. "A Tribute to Peace — the Meade Memorial," *The American Magazine of Art*, vol. 188, April 1927, pp. 194–98.

Nancy Graves

Born December 23, 1940, Pittsfield, Massachusetts

After having graduated from Vassar College (B.A., 1961) and Yale University's School of Art and Architecture (B.F.A., 1962; M.F.A., 1964), Nancy Stevenson Graves won a Fulbright-Hayes Fellowship for painting, which sent her to Paris in 1964–65. She then spent part of 1965 in North Africa and the Near East and in 1965–66 lived and worked in Florence. There she executed her first sculptures of life-size Bactrian camels. Later in 1966 she moved to New York City and further experimented with ways to produce these sculptures: she built wood and steel armatures; covered them with the skins of animal embryos; stuffed the skins with polyurethane to form humps; and tinted the skins with oil paints. In 1968 she had her first New York one-woman show at the Graham Gallery, followed by her second at the Whitney Museum in 1969; both exhibitions featured her camels. In the early 1970s Graves continued her sculptural exploration of animal anatomy in floor and hanging pieces reproducing the bones and skins of paleontological specimens. She also developed a sculptural imagery suggestive of American Indian shamanistic

objects in such works as *Bones, Skins, Feathers* (1970), which was included in her one-woman show (1972) at Philadelphia's Institute of Contemporary Art. She united her interest in totemic and biomorphic shapes in her vinelike construction of thirty-eight vertical steel rods, *Variability and Repetition of Variable Forms* (1971), which was shown in her solo exhibition at the Museum of Modern Art, New York, in December 1971. In 1971 Graves received such honors as a Vassar College fellowship and a Paris Biennale grant; the following year she was awarded a grant from the National Endowment for the Arts. Graves's most recent one-woman exhibitions — at the La Jolla [California] Museum of Contemporary Art (1973), the André Emmerich Gallery, New York (1974), and the Janie C. Lee Gallery, Houston (1975) — have been devoted primarily to her paintings and drawings. Most of these works have employed a cartographic imagery often derived from photographs taken by interplanetary satellites. Graves has also become known as a filmmaker and her films have been shown in film festivals in London, New York and Boston and at museums in the 1970s.

Arn, Robert. "The Moving Eye: Nancy Graves, Sculpture and Painting," *Artscanada*, vol. 31, Spring 1974, pp. 42–48.

Channin, Richard. "Facture and Information: Nancy Graves' Antarctica Paintings," *Arts Magazine*, vol. 50, October 1975, pp. 80–82.

Glueck, Grace. "Art Notes: You Can Almost See Bedouins," *The New York Times*, March 31, 1968, Section 2, p. 32.

*La Jolla Museum of Contemporary Art. *Nancy Graves* (preface by Sebastian Adler; statement by Nancy Graves; and introduction by Jay Belloli). La Jolla, Calif., 1973.

*Pennsylvania, University of; Institute of Contemporary Art. *Nancy Graves: Sculpture and Drawing 1970–1972* (essays by Yvonne Rainer and Martin W. Cassidy). Philadelphia, 1972.

Richardson, Brenda. "Nancy Graves: A Way of Seeing," *Arts Magazine*, vol. 46, April 1972, pp. 57–61.

Schjeldahl, Peter. "From Stuffed Camels to Clam Shells," *The New York Times*, December 26, 1971, Section 2, p. 25.

Wasserman, Emily. "A Conversation with Nancy Graves," *Artforum*, vol. 9, October 1970, pp. 42–47.

Gertrude Greene

Born May 24, 1911, Brooklyn, New York
Died November 25, 1956, New York City

Gertrude Glass first studied sculpture at the Leonardo da Vinci Art School in New York City during 1924–26. She married the painter Balcomb Greene in 1926 and moved with him to Vienna for a year. After returning to New York in 1927, they moved to Paris in 1930 and worked there until 1931. They returned once again to New York, where she kept her studio until her death. Beginning in 1942 the Greenes lived in Pittsburgh during the academic year and from 1947 on divided their time between their homes in Pittsburgh and Montauk Point, Long Island. In 1935 Gertrude Greene had begun making relief constructions, which she exhibited as a mem-

Nancy Graves

Gertrude Greene

Horatio Greenough

Chaim Gross

ber of the Painters and Sculptors Guild and the Federation of Modern Painters and Sculptors. That year she and the sculptor Ibram Lassaw bought steel forges and began to experiment in making sheet-metal sculptures. Greene, however, was better known as an abstract painter than as a sculptor: she was included in the Whitney Museum's 1950 Painting Annual; was represented as a painter in the 1951 exhibition *Abstract Painting and Sculpture in America* at New York's Museum of Modern Art; showed paintings in her first one-woman exhibition at the Grace Borgenicht Gallery, New York, in December 1951, and her second at the Bertha Schaefer Gallery, New York, in October–November 1955; and was described as a painter in her *New York Times* obituary. From 1937 to 1944 she had also exhibited with the American Abstract Artists, a group she helped found. A year after her show at the Bertha Schaefer Gallery, Greene died following a long illness. A posthumous exhibition of her painted wood relief constructions, drawings and collages was held at the Bertha Schaefer Gallery from December 1957 to January 1958.

The American Federation of Arts. *Balcomb Greene* (essay by John I. H. Baur). New York, 1961.

A[shbery], J[ohn]. Pp. 20–22 in "Reviews and Previews," *Art News*, vol. 56, January 1958.

Bertha Schaefer Gallery. *Gertrude Greene Constructions*. New York, 1957.

"Gertrude Greene Dies; Painter, 52," *The New York Times*, November 27, 1956, p. 38.

Goossen, E. C. and others. *Three American Sculptors: Ferber, Hare, Lassaw*. New York: Grove Press, 1959.

H[olliday], B[etty]. P. 50 in "Reviews and Previews," *Art News*, vol. 50, December 1951.

Horatio Greenough

Born September 6, 1805, Boston
Died September 18, 1852, Somerville, Massachusetts

Showing an interest in sculpture as a boy, Horatio Greenough learned the practical skills of carving from the architect and carver Solomon Willard and the stonecutter Alpheus Cary. Greenough also drew from the casts of antique statues at the Boston Athenaeum. As a student at Harvard College, he met Washington Allston, his first mentor and lifelong friend. In 1825 Greenough sailed for Europe and settled in Rome, where he met the Danish neoclassical sculptor Bertel Thorvaldsen and studied at the French Academy housed in the Villa Medici. In 1827 he returned to Boston to recover from a bout with Roman fever. During a brief visit to Washington, D.C., Greenough met the artist Samuel F. B. Morse and the wealthy Baltimore collector Robert Gilmor, Jr., who became his first patron. Before returning to Italy in 1828, Greenough was commissioned to execute several portrait busts of prominent citizens, including President John Quincy Adams. Greenough established his studio permanently in Florence, where he studied under Lorenzo Bartolini and met James Fenimore Cooper, who became his patron and friend. In 1832 the federal government commissioned Greenough to execute a heroic marble statue of George Washington (completed 1840) for the Capitol's rotunda. The government again commissioned him, in 1837, to execute a group, *The Rescue* (completed 1851), to decorate the east front of the Capitol. That year Hiram Powers came to Florence and Greenough loaned him studio space, materials and workmen. In 1840, the year his pamphlet *Aesthetics of Washington* was published, Greenough became the first American member of the Royal Academy in Florence. In the 1840s Greenough continued his lifelong pursuit of classical knowledge while executing a small number of portrait busts. In 1851 he decided to leave Italy and return to Boston, and in 1852 he settled in Newport, Rhode Island. His book *Travels, Observations and Experience of a Yankee Stonecutter* was published in the last year of his life.

Brown, Theodore M. "Greenough, Paine, Emerson and the Organic Aesthetic," *Journal of Aesthetics and Art Criticism*, vol. 14, May 1956, pp. 304–17.

Crane, Sylvia E. "Aesthetics of Horatio Greenough in Perspective," *Journal of Aesthetics and Art Criticism*, vol. 24, Spring 1966, pp. 415–27.

____. White Silence: Greenough, Powers, and Crawford, American Sculptors in Nineteenth-Century Italy. Coral Gables, Fla.: University of Miami Press, 1972.

Craven, Wayne. "Horatio Greenough's Statue of Washington and Phidias' Olympian Zeus," *The Art Quarterly*, vol. 26, no. 4, 1963, pp. 429–40.

Greenough, Frances Boott, ed. *Letters of Horatio Greenough to His Brother, Henry Greenough*. Boston: Ticknor and Company, 1887; New York: Kennedy Graphics and Da Capo Press, 1970 (reprint).

*Greenough, Horatio. *Form and Function* (Harold A. Small, ed.). Berkeley and Los Angeles: University of California Press, 1947.

____. *The Travels, Observations and Experience of a Yankee Stonecutter*. New York: G. P. Putnam and Company, 1852; Gainsville, Fla.: Scholars' Facsimiles & Reprints, 1958 (reprint).

Tuckerman, Henry T. *A Memorial of Horatio Greenough*. New York: G. P. Putnam & Co., 1853; New York and London: Benjamin Blom, 1968 (reprint).

*Wright, Nathalia. *Horatio Greenough: The First American Sculptor*. Philadelphia: University of Pennsylvania Press, 1963.

____, ed. *Letters of Horatio Greenough, American Sculptor*. Madison, Wis.: The University of Wisconsin Press, 1972.

Chaim Gross

Born March 17, 1904, Wolowa, Austrian Galicia

Chaim Gross traces his love for wood to his early childhood in the forested region of the Carpathian Mountains, where his father for a time worked for a lumber company. Routed by World War I, the Grosses fled their homeland and Chaim made his way to Budapest, where he discovered his pleasure in drawing. By 1920 he had had two brief opportunities for studying art, but faced with political turmoil in postwar central Europe, Gross immigrated to New York City when he was seventeen. Working as a delivery boy, he enrolled at the Educational Alliance Art School, where he met the Soyer broth-

ers and others, and at the Beaux-Arts Institute of Design, where Elie Nadelman was one of his teachers. In 1927 he decided to devote himself to sculpture and briefly attended the Art Students League to learn the technique of direct carving from Robert Laurent. Five years later Gross's first one-man show was held at the gallery at 144 West 13th Street in Greenwich Village. One of many artists to benefit from the New Deal's art projects, Gross strengthened his reputation in the late 1930s as a result of his commissions for sculpture for federal buildings in Washington, D.C., and for the New York World's Fair. In 1927, as a sculptor, teacher (at the Educational Alliance and elsewhere) and, later, writer, Gross had joined the revival of direct carving in America. For about twenty-five years he carved almost exclusively in wood — preferring its hard, more exotic varieties — and also in stone. In the late 1950s he began to cast most of his work in bronze from plaster models shaped initially by carving. His subjects have varied little: the human form — women, children, dancers and circus performers — generally in groups and in motion; but his compositions have honored his change of medium — vertical and concentrated in wood, acentric and open in bronze. Gross's career has been noted by many exhibitions and awards, including election to the National Institute of Arts and Letters in 1964 and a one-man exhibition at the National Collection of Fine Arts in 1974.

*Getlein, Frank. *Chaim Gross.* New York: Harry N. Abrams, 1974.

Gross, Chaim, *The Technique of Wood Sculpture.* New York: Vista House, Publishers, 1957; New York: Arco Publishing Co., 1966 (reprint).

_____ with Peter Robinson. *Sculpture in Progress.* New York: Van Nostrand Reinhold, 1972.

The Jewish Theological Seminary of America, The Jewish Museum. *Chaim Gross: Exhibition* (introduction by S[tephen] K[ayser]). New York, 1953.

*Lombardo, Josef Vincent. *Chaim Gross, Sculptor.* New York: Dalton House, 1949.

Smithsonian Institution, National Collection of Fine Arts. *Chaim Gross: Sculpture and Drawings* (foreword by Joshua C. Taylor; essay by Janet A. Flint). Washington: Smithsonian Institution Press, 1974.

Whitney Museum of American Art. *Four American Expressionists: Doris Caesar, Chaim Gross, Karl Knaths, Abraham Rattner* (essay on Chaim Gross by Lloyd Goodrich). New York, 1959; New York: Frederick A. Praeger, 1959 (hardcover).

Robert Grosvenor

Born March 31, 1937, New York City

After having graduated from high school in Rhode Island, Robert Grosvenor went to Europe for further training: he attended the Ecole des Beaux-Arts in Dijon, France, in 1956; studied architecture and naval design at the Ecole Nationale des Arts Decoratifs in Paris from 1957 to 1959; and attended the University of Perugia, Italy, in the summer of 1958. After additional European travel, Grosvenor returned to the United States and settled in Philadelphia, where he began his artistic career as a painter in 1960. He moved to New York City in 1961, occupying the

same downtown loft building as Mark di Suvero and John Chamberlain. A self-taught sculptor, Grosvenor began making wax and cardboard reliefs and crushed sheet-metal sculptures. In 1962 he and nine other artists founded the cooperative Park Place Gallery, where Grosvenor exhibited until 1965. His works from the mid-1960s were generally huge painted plywood and/or metal cantilevers, hard-edged linear volumes intended to be conceptualized as bridges connecting interior spaces. Grosvenor emerged as a nationally known sculptor when his work *Transoxiana* (1965) was included in the 1966 exhibition *Primary Structures* at the Jewish Museum. His reputation was further strengthened when *Tenerife* and *Still No Title,* products of his six-month stay in California in 1966, were shown at the Dwan Gallery in Los Angeles and in *American Sculpture of the Sixties* at the Los Angeles County Museum in 1967. That year he also executed a monumental indoor/outdoor work for New York University's Loeb Student Center. During the late 1960s he undertook two large sculptural constructions for outdoor sites — one on a cliff in Newport, Rhode Island; the other, *Floating Red Double T* (1965–68), in Long Island Sound, off Byram, Connecticut (the work unintentionally sank, however). For the exhibition *Sonsbeek 71: Beyond Lawn and Order* in Arnhem, the Netherlands, Grosvenor created *Keel Piece,* a massive sheet of steel sunk into the ground with only its edge revealed; eventually, the edge also sank into the ground, but this disappearance was intentional. Since 1972 Grosvenor has exhibited wood sculptures — single, often weathered, timbers, which have been broken or trimmed and rest horizontally on the floor — at the Paula Cooper Gallery, New York.

Bourdon, David. "Cantilevered Rainbow," *Art News,* vol. 66, Summer 1967, pp. 28–31, 77–79.

Kurtz, Bruce. "Reports: Sonsbeek," *Arts Magazine,* vol. 46, September/October 1971, pp. 50–52.

_____. "Robert Grosvenor's Sculpture: 1965–1975," *Arts Magazine,* vol. 50, October 1975, pp. 70–72.

Masheck, Joseph. "Robert Grosvenor's Fractured Beams," *Artforum,* vol. 12, May 1974, pp. 36–39.

Robins, Corinne. "Floating Sculpture," *Art in America,* vol. 56, March/April 1968, pp. 72–75.

Ruda, Ed. "Park Place: 1963–1967," *Arts Magazine,* vol. 42, November 1967, pp. 30–33.

*Walker Art Center. *Fourteen Sculptors: The Industrial Edge* (essays by Barbara Rose, Christopher Finch and Martin Friedman). Minneapolis, 1969. (Friedman's essay also in *Art International,* vol. 14, February 1970, pp. 31–40.)

James Hampton

Born April 8, 1909, Elloree, South Carolina
Died November 4, 1964, Washington, D.C.

James Hampton, the son of a Baptist minister, claimed to have completed the tenth grade, but no records of his education have ever been found. In 1939 he moved to Washington, D.C., where he worked as a cook in several local cafés. In 1942 Hampton joined the army and served for three years in Texas, Seattle, Hawaii, Guam and Saipan. After his discharge in 1945 he became a night janitor for

Robert Grosvenor

James Hampton

Copyright © Arnold Newman

David Hare

the General Services Administration in Washington, a job he held until his death.. Throughout his life Hampton experienced mystical visions, and his religious convictions, based on a strong belief in the Second Coming of Christ, inspired his only known work, *Throne of the Third Heaven of the Nations Millenium General Assembly*. Hampton began to construct the throne about 1950 in an unheated rented garage. Although the central sections of the throne were completed and positioned at the time of his death, the work in its present state is probably unfinished.

*Bishop, Robert. *American Folk Sculpture*. New York: E. P. Dutton & Co., 1974.

Geremia, Ramon. "Tinsel, Mystery Are Sole Legacy of Lonely Man's Strange Vision," *The Washington Post*, December 15, 1964.

*Hemphill, Herbert W., Jr., and Julia Weissman. *Twentieth-Century American Folk Art and Artists*. New York: E. P. Dutton & Co., 1974.

Walker Art Center. *Naives and Visionaries*. New York: E. P. Dutton & Co., 1974.

David Hare

Born March 10, 1917, New York City

David Hare attended schools in New York, Arizona and Colorado until 1936 and made his first sculptures, small in size, while still in high school. A chemistry student interested in a medical career, Hare never formally studied art. After leaving school he became a commercial photographer and spent two years photographing surgical operations. His first one-man show — of his photographs — was held at the Hudson D. Webster Gallery, New York, in 1939. The following year he produced a portfolio of color photographs of southwestern American Indians for the American Museum of Natural History. Through working with the photographic technique of "heatage," developed by the Surrealist photographer Raoul Ubac, Hare became acquainted with the European Surrealists who had settled in New York City to escape the war. Showing his photographs, Hare was one of the few Americans to exhibit in the only group show of the Surrealist refugees in New York, *The First Papers of Surrealism* (1942). Assisted by André Breton, Max Ernst and, later, Marcel Duchamp, Hare founded and edited the Surrealist periodical *VVV*, which was published from June 1942 to February 1944. In 1942 Hare began to sculpt, in a style distinctly Surrealist not only in its preference for nonabstract, ambiguous and metamorphic imagery, but also in its reliance on psychic automatism as a spur to visualization. Although he had initially modeled his sculptures in various materials, about 1951 Hare began sculpting in metal, welding it directly or, later, melting it into molds for casting. From the mid-1940s through the early 1960s, he had many one-man sculpture shows in New York; his first three were held at Peggy Guggenheim's gallery Art of This Century during 1944–47. In 1948, with other Abstract Expressionists who had exhibited at that gallery, Hare opened the school Subjects of the Artists, which existed for only a year. Hare lived in France during the 1950s, but by

the mid-1960s he was back in America teaching at the Philadelphia College of Art, which presented a retrospective of his work in 1965. About this time Hare turned to painting and exhibited these new works at the Staempfli Gallery, New York, in 1969.

Andersen, Wayne. *American Sculpture in Process: 1930–1970*. Boston: New York Graphic Society, 1975.

A[shton], D[ore]. *Britannica*, p. 159.

Goldwater, Robert. "David Hare," *Art in America*, vol. 44, Winter 1956–57, pp. 18–20, 61. (Reprinted, with biographical notes, in Goossen, E. C. and others. *Three American Sculptors: Ferber, Hare, Lassaw*. New York: Grove Press, 1959.)

Goodnough, Robert. "David Hare Makes a Sculpture," *Art News*, vol. 55, March 1956, pp. 46–59.

Hare, David. Reply in Rose, Barbara and Irving Sandler. "The Sensibility of the Sixties," *Art in America*, vol. 55, January 1967, p. 52.

———. "The Spaces of the Mind," *Magazine of Art*, vol. 43, February 1950, pp. 48–53.

Maillard, Robert. *New Dictionary of Modern Sculpture*. New York: Tudor Publishing Company, 1970.

New York, The Museum of Modern Art. *Dada, Surrealism and Their Heritage* (text by William S. Rubin). New York, [1968]; distributed by New York Graphic Society, Greenwich, Conn.

Herbert Haseltine

Born April 10, 1877, Rome
Died January 8, 1962, Paris

Son of the landscape painter William Stanley Haseltine and nephew of the sculptor James Henry Haseltine, Herbert Haseltine graduated from Harvard College in 1899. He subsequently studied painting and drawing at the Royal Academy in Munich, under Professor Alessandro Morani in Rome and at the Académie Julian in Paris. In 1905 he became a pupil of the French painter Aimé Morot, who encouraged him to devote his attention to sculpture. Haseltine's sculpture group *Riding Off* was exhibited and won an honorable mention at the Paris Salon of 1906. This realistic bronze piece suggests Haseltine's interest in animal portraiture, a subject for which he became noted throughout his career. In June 1914, Haseltine and the sculptor E. O. Rossales were represented in a two-man exhibition at the Goupil Gallery in London. Haseltine's post-World War I animal sculpture was greatly influenced by the stylization of ancient Egyptian and Indian art. Executed in various mediums, including marble, bronze and limestone, his animal portraits were occasionally embellished with semiprecious stones and gold plate. Although he lived primarily in Paris and exhibited frequently in France and England, Haseltine's work was well known in the United States, and he received numerous commissions from American patrons. His major sculptural works included a gilded bronze equestrian statue of George Washington for the National Cathedral in Washington, D.C., and the portrayal of the famous race horse Man O' War for Lexington, Kentucky. In 1934 Haseltine was awarded the Speyer Memorial Prize of the National Academy

Herbert Haseltine

of Design for his *Aberdeen Angus Bull*. He was a member of the National Sculpture Society and the National Institute of Arts and Letters. In 1946 he was elected an academician of the National Academy of Design.

Craven.

Field Museum of Natural History. *Sculptures by Herbert Haseltine of Champion Domestic Animals of Great Britain*. Zoology Leaflet 13. Chicago, 1934.

"Herbert Haseltine Dead at 84; Sculptured Statues of Animals," *The New York Times*, January 9, 1962, p. 47.

Knoedler Galleries. *Herbert Haseltine: Exhibition of Sculpture*. London, 1930.

Parkes, Kineton. "Herbert Haseltine: Animal Sculptor," *Apollo*, vol. 12, August 1930, pp. 108–13.

Saint-Bernard, Gui. "Herbert Haseltine's Animal Portraiture," *The Studio*, vol. 100, October 1930, pp. 264–69.

Shipp, Horace. "Herbert Haseltine, Animalier," *Apollo*, vol. 57, June 1953, pp. 221–23.

The National Sculpture Society. *Herbert Haseltine* (foreword by the artist). New York: W. W. Norton & Company, 1948.

Michael Heizer

Born 1944, Berkeley, California

As a teenager Michael Heizer often accompanied his anthropologist father on archaeological digs. Although this experience may have influenced his later development, Heizer's initial artistic interest was painting. In 1963–64 he attended the San Francisco Art Institute and painted in a figural style, but by late 1964 he was creating large, severely reductive, shaped canvases. Upon his arrival in New York City in 1966, although still painting in this style, Heizer also turned to sculpture, or more accurately, to earthworks. He focused on the manipulation of raw material on a scale so monumental that it extended beyond the spatial dimensions of the traditional gallery or museum exhibition. *Double Negative* (1969, reworked 1970) at Virgin River Mesa, Nevada, *Circular Surface Planar Displacement* (1970) near Las Vegas, and *Drag Mass Displacement* (1969–71), in front of the Detroit Institute of Arts, articulate Heizer's statement that "man will never create anything really large in relation to the world — only in relation to himself and his size." In 1969 Heizer created "depressions" in Bern and Munich, but his main preoccupation continues to be with desert space and the interplay of natural forces, which disperse, erase or erode his giant works, and can be summed up in his statement: "As the physical deteriorates, the abstract proliferates, exchanging points of view." In 1971 Heizer began working on his largest earth project, *City*, which will cover, when completed, three square miles north of Las Vegas.

Bell, Jane. "Positive and Negative New Paintings by Michael Heizer," *Arts Magazine*, vol. 49, November 1974, pp. 55–57.

Davis, Douglas. "The Earth Mover," *Newsweek*, vol. 84, November 18, 1974, p. 113.

The Detroit Institute of Arts. *Michael Heizer/Actual Size*. Detroit, 1971.

The Solomon R. Guggenheim Museum. *Guggenheim International Exhibition 1971* (essays by Diane Waldman and Edward F. Fry). New York: The Solomon R. Guggenheim Foundation, 1971.

Heizer, Michael. "The Art of Michael Heizer," *Artforum*, vol. 8, December 1969, pp. 32–39.

Herrera, Hayden. "Michael Heizer Paints a Picture," *Art in America*, vol. 62, November/December 1974, pp. 92–94.

Müller, Grégoire. "Michael Heizer," *Arts Magazine*, vol. 44, December 1969, pp. 42–45.

————.

Waldman, Diane. "Holes Without History," *Art News*, vol. 70, May 1971, pp. 44–48, 66–68.

Eva Hesse

Born January 11, 1936, Hamburg, Germany
Died May 29, 1970, New York City

Fleeing Hitler's regime, Eva Hesse and her family settled in New York City in 1939. Soon her parents divorced and her mother committed suicide. At the age of sixteen Hesse attended Pratt Institute for a semester and then transferred to Cooper Union, where she studied for three years. She completed her education at Yale University, receiving the Yale Norfolk Fellowship in 1957 and a B.F.A. in 1959. Two years later she married the artist Tom Doyle and in 1964 moved to Germany, where she researched her annihilated family's history and began making sculpture. In 1965 she exhibited collaged reliefs, her last vibrantly colored works, in Düsseldorf before returning to New York in the fall. In 1966 Hesse again suffered personal loss: she and her husband separated and her father died. She became absorbed in her work, which during the next four years asserted its anti-Constructivist concerns in ways that rejected Minimalism's hard-edged geometry and emotional reserve, yet shared in its serialization of motif and austere monochromaticism. Two other artists working in opposition to formalist traditions, Sol LeWitt and Robert Smithson, became her close friends. In September 1966 Hesse's sculptures were included in *Eccentric Abstraction*, the exhibition Lucy Lippard organized at the Fischbach Gallery, New York; Hesse's pieces were made of rubber tubing, synthetic resins, cord, cloth, wire, papier-mâché and wood and connoted sexual and other organic images. Celebrating the absurd through its joining of unlikely materials and contradictory impulses, Hesse's work subsequently appeared in many other group exhibitions: a show organized in 1966 by Mel Bochner at the School of Visual Arts (where Hesse taught in 1968–69); the Leo Castelli warehouse exhibition organized by Robert Morris in 1968; the Whitney Museum's *Anti-Illusion* show in 1969; and *A Plastic Presence*, organized by the Milwaukee Art Center. In 1969 Hesse underwent the first of three futile operations to remove a brain tumor. Two years after her death the Guggenheim Museum paid tribute to her with a memorial exhibition of her work.

Alloway, Lawrence. "Art," *The Nation*, vol. 216, January 22, 1973, pp. 124–26.

Michael Heizer

Eva Hesse

Malvina Hoffman

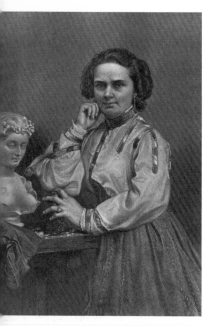

Harriet Hosmer

Levin, Kim. "Eva Hesse: Notes on New Beginnings," *Art News,* vol. 72, February 1973, pp. 71–73.

Lippard, Lucy R. "Eccentric Abstraction," *Art International,* vol. 10, November 20, 1966, pp. 28, 34–40. (Revised version is reprinted in Lippard, Lucy R. *Changing.* New York: E. P. Dutton & Co., 1971.)

_____. "Eva Hesse: The Circle," *Art in America,* vol. 59, May/June 1971, pp. 68–73.

*Nemser, Cindy. Pp. 200–29 in *Art Talk: Conversations with Twelve Women Artists.* New York: Charles Scribner's Sons, 1975.

Owens-Corning Fiberglas Corporation. *Tony DeLap, Frank Gallo, Eva Hesse: "Trio"* (text by Lawrence Alloway). [New York, 1970].

Shapiro, David. "The Random Forms in Soft Materials and String by the Late Young Innovator Eva Hesse," *Craft Horizons,* vol. 33, February 1973, pp. 40–45, 71–72.

*The Solomon R. Guggenheim Museum. *Eva Hesse: A Memorial Exhibition* (essays by Robert Pincus-Witten and Linda Shearer; statement by the artist). New York: The Solomon R. Guggenheim Foundation, 1972.

*Whitney.

Malvina Hoffman

Born June 15, 1885, New York City
Died July 10, 1966, New York City

Daughter of a piano soloist with the New York Philharmonic, Malvina Cornell Hoffman grew up in a culturally prominent family, which nurtured her artistic ambitions. While attending the Brearley School in New York City during her teens, she studied at the Women's School of Appied Design and the Art Students League; she also studied painting under John W. Alexander and sculpture at the Veltin School under Herbert Adams and George Grey Barnard. Accompanied by her widowed mother, she made her first trip to Europe in 1910. In Paris she convinced Rodin to take her on as a pupil and studied in his studio and at the Académie Colarossi until 1914. However, she interrupted her Paris training three times with trips back to America, spending the winters of 1911–13 in New York City, where she studied anatomy at Columbia University's College of Physicians and Surgeons. By 1914 her circle of artistic friends in Paris was wide and she had been introduced to the world of Gertrude Stein, Nijinsky, Matisse and Brancusi. Active as a sculptor throughout her life, Hoffman produced fountains, statuettes and heroic and architectural sculpture but became best known for her many portrait sculptures, particularly those of celebrities. She was enthusiastic about interpreting the art of contemporary Russian dance in sculptural form and gained popularity and awards for her relief and freestanding sculptures of her close friend Anna Pavlova, portrayed either alone or dancing with various male partners. In 1929 Hoffman received her largest commission — the execution of more than one hundred figures representing the racial types of mankind for permanent exhibition in Chicago's Field Museum of Natural History in 1933 — and she embarked with her musician husband, Samuel Grimson, on a two-year journey around the world to study and model various peoples in their native environments. Winner of the National Sculpture Society's gold medal of honor in 1964, Hoffman also wrote several books, including two autobiographies and a textbook on sculpture.

*C[raven], W[ayne]. *Britannica,* p. 282.

*Craven.

Grand Central Art Galleries. *Exhibition of Recent Sculptures and Drawings by Malvina Hoffman.* New York, 1929.

Hoffman, Malvina. *Heads and Tales.* New York: Charles Scribner's Sons, 1936.

_____. *Sculpture Inside and Out.* New York: W. W. Norton, 1939.

_____. *Yesterday Is Tomorrow: A Personal History.* New York: Crown Publishers, 1965.

*Proske.

Harriet Hosmer

Born October 9, 1830, Watertown, Massachusetts
Died February 21, 1908, Watertown, Massachusetts

As a girl Harriet Goodhue Hosmer was encouraged to pursue an active outdoor life by her physician father, whose wife and three other children had died from tuberculosis. Her father also encouraged her artistic talents, and both factors gave Hosmer the confidence and independence to seek a career considered unorthodox for women of her day. At the age of sixteen she attended boarding school in Lenox, Massachusetts, where she met the actress Fanny Kemble, who became her lifelong friend. A few years later Hosmer studied with the Boston sculptor Peter [?] Stephenson. In 1850, after an unsuccessful attempt to enter medical school in Boston, Hosmer visited a school friend in St. Louis, where she persuaded a local physician to give her anatomy lessons. After traveling in the Midwest, she and another actress-friend, Charlotte Cushman, went to Italy in 1852. Hosmer established her residence in Rome and studied with the noted British neoclassical sculptor John Gibson. She once wrote that she could "learn more and do more . . . in [Rome], in one year than . . . in America in ten." Her coterie of friends — a large group of foreign intellectuals, British aristocracy and European royalty — included Robert and Elizabeth Barrett Browning, the latter writing that Hosmer "emancipates the eccentric life of a perfectly 'emancipated female.'" Considered the most famous woman sculptor of her day, Hosmer was the leader of what Henry James dubbed "a white, marmorean flock." Her work appealed to the 19th-century taste for sentimental and literary subjects, and her "mythological creations," particularly her popular statue *Puck* (1856), established her financial independence. In 1860, during a brief visit to America, Hosmer was commissioned by the city of St. Louis to model a statue of Senator Thomas Benton. Her neoclassical statue of the Hellenistic queen Zenobia (c. 1859) was probably her most successful work, and the companion marble statues *The Sleeping Faun* (1865) and *The Waking Faun* (1866) were also favorably received. In 1900

Hosmer returned to America, where she spent the last years of her life.

A[dams], A[deline]. *DAB,* vol. 9, pp. 242–43.

Bradford, Ruth A. "Life and Works of Harriet Hosmer," *New England Magazine,* vol. 45, November 1911, pp. 265–69.

*Craven.

Hosmer, Harriet. *Letters and Memories* (Cornelia Carr, ed.). New York: Moffatt, Yard, & Co., 1912.

McSpadden.

*Thorpe, Margaret Farrand. *Notable,* vol. 2, pp. 221–23.

———. "The White, Marmorean Flock," *New England Quarterly,* vol. 32, June 1959, pp. 147–69.

Van Rensselaer, Susan. "Harriet Hosmer," *Antiques,* vol. 84, October 1963, pp. 424–28.

*Vassar College Art Gallery. *The White, Marmorean Flock: Nineteenth-Century American Women Neoclassical Sculptors* (introduction by William H. Gerdts, Jr.; catalogue by Nicolai Cikovsky, Jr., and others). [Poughkeepsie, N.Y.], 1972.

Anna Hyatt Huntington

Born March 10, 1876, Cambridge, Massachusetts
Died October 4, 1973, New York City

Anna Vaughn Hyatt spent her childhood summers on a Maryland farm, which nurtured her fascination with animals, particularly horses. Influenced in part by her older sister, Harriet, a sculptor, Hyatt turned to modeling animals at the age of nineteen. She studied with Henry Hudson Kitson in Boston; when she was twenty-four, her first one-woman show, consisting of forty animal sculptures, was held at the Boston Arts Club. In 1902 she began her studies at the Art Students League under Hermon MacNeil and Gutzon Borglum. A product of her two-year collaboration with sculptor Abastenia St. Leger Eberle, the bronze *Men and Bull* was exhibited at the St. Louis Exposition in 1904. In 1907 Hyatt traveled to France, where she had a studio in Auvers-sur-Oise, and a year later she went to Italy. In Paris she received an honorable mention at the Salon of 1910 for a model of Joan of Arc; a larger, revised version, cast in bronze, was erected on Riverside Drive in New York City in 1915 and won the Purple Rosette from the French government. Hyatt's other works include *Diana of the Chase,* winner of the Saltus Medal of the National Academy of Design in 1922; *El Cid Compeador,* erected in Seville in 1927; *Bulls Fighting,* winner of the Shaw Prize of the National Academy of Design in 1928; and *Greyhounds Playing,* winner of the Widener Gold Medal of the Pennsylvania Academy of the Fine Arts in 1937. In 1923 Hyatt married Archer M. Huntington, a poet and philanthropist, and in 1931 they founded Brookgreen Gardens, near Charleston, South Carolina. Originally intended as a nature retreat and a sculpture garden for her works, it was enlarged to include works of other sculptors. Renowned for her expert anatomical work, Huntington once explained that "animals have many moods, and to represent them, is my joy." In 1922 she was elected an academician of the National Academy of Design and a chevalier of the French Legion of Honor. A retro-

spective of her work was held at the American Academy of Arts and Letters in 1936, and in 1940 she was awarded a special medal from the National Sculpture Society.

American Academy of Arts and Letters. *Catalogue of an Exhibition of Sculpture by Anna Hyatt Huntington.* New York, 1936.

Bouvé, Pauline Carrington. "The Two Foremost Women Sculptors in America: Anna Vaughn Hyatt and Malvina Hoffman," *Art and Archaeology,* vol. 26, September 1928, pp. 74–82.

Evans, Cerinda W. *Anna Hyatt Huntington.* Newport News, Va.: The Mariners Museum, 1965.

Ladd, Anna Coleman. "Anna V. Hyatt — Animal Sculptor," *Art and Progress,* vol. 4, 1912, pp. 773–76.

National Sculpture Society. *Anna Hyatt Huntington.* (foreword by Eleanor Mellon). New York: W. W. Norton and Co., 1947.

*Proske.

Royère, Jean. *Le musicisme sculptural: Madame Archer Milton Huntington.* Paris: Messein, 1933.

Smith, Bertha H. "Two Women Who Collaborate in Sculpture," *The Craftsman,* vol. 8, June/September 1905, pp. 623–33.

Robert Irwin

Born September 12, 1928, Long Beach, California

Robert Irwin studied in Los Angeles at the Otis (1948–50), Jepson (1951) and Chouinard (1951–53) art institutes. As a teacher at Chouinard in 1957–58 and the University of California at Los Angeles in 1962 and at Irvine in 1968–69, and as a theorist, Irwin has greatly influenced younger West Coast artists. Beginning his career as an Abstract Expressionist painter in the 1950s, Irwin has evolved toward an increasingly incorporeal art: His Minimalist two-color line paintings of 1959–63 gave way during 1963–65 to dot paintings executed on rectangular bowed canvases hung several inches out from the wall. These works were succeeded by spray-painted discs — of aluminum in 1966–67, of frosted and transparent plexiglas in 1968 — which Irwin carefully illuminated by spotlights so that disc, cast shadows and wall were integrated into the viewer's experience. His subsequent clear acrylic prismatic columns and "light volumes," in which sheets of nylon scrim were juxtaposed with natural and artificial light sources (as in *Rotunda* in the Corcoran's 1971 Biennial) further explored the dematerializing effects of light. By 1971 Irwin had arrived at an aesthetic philosophy that precluded object-making, and during 1971–72 he traveled and lectured extensively. Beginning with his participation in the Los Angeles County Museum's *Art and Technology* program, Irwin has joined Dr. Edward Wortz of the Garrett Aerospace Open Research Facility in ongoing research into perceptual phenomena and built the environment to house NASA's first National Symposium on Habitability (1972). Since 1973 Irwin has again given form to his complex theories on art and perception in his architectonic arrangements of interior light and space at the Mizuno (Los Angeles) and Pace (New York) galleries, the San Francisco Museum of Art (1973) and in a series of "continuing

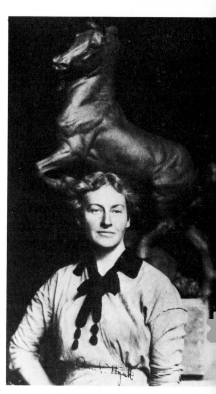

Anna Hyatt
Huntington

Robert Irwin

Chauncey B. Ives

responses" at the Fort Worth Art Museum (1975–76).

Baker, Elizabeth C. "Los Angeles, 1971," *Art News*, vol. 70, September 1971, pp. 27–39.

Butterfield, Jan. "An Uncompromising Other Way," *Arts Magazine*, vol. 48, June 1974, pp. 52–55.

——. "Interview with Robert Irwin: Re-shaping the Shape of Things," *Arts Magazine*, vol. 47, September/October 1972, pp. 30–32.

——. "Interview with Robert Irwin: The State of the Real," *Arts Magazine*, vol. 46, Summer 1972, pp. 47–49.

*Chicago, Museum of Contemporary Art. *Robert Irwin* (foreword by Stephen Prokopoff; essay by Ira Licht). Chicago, 1975.

Drath, Viola. P. 41 in "The 32nd Corcoran Biennial: Art as Visual Event," *Art International*, vol. 15, May 1971.

*Fort Worth Art Center Museum. *Robert Irwin — Doug Wheeler, 1969* (essay by Jane Livingston). [Fort Worth(?), Tex., 1969].

*The Jewish Theological Seminary of America, The Jewish Museum. *Gene Davis, Robert Irwin, Richard Smith*, section 2 (essay on Irwin by John Coplans). New York, 1968.

Los Angeles County Museum of Art, Contemporary Art Council. *Robert Irwin/Kenneth Price* (essay on Irwin by Philip Leider). Los Angeles, Calif., 1966.

*The Tate Gallery. *Larry Bell, Robert Irwin, Doug Wheeler* (text by Michael Compton). London, 1970.

Chauncey B. Ives

Born December 14, 1810, Hamden, Connecticut
Died August 2, 1894, Rome

At the age of sixteen Chauncey Bradley Ives, a farmer's son, became an apprentice to the wood-carver Rodolphus E. Northrop in New Haven and is believed to have studied there also with Hezekiah Augur. About 1837 Ives moved to Boston and began direct carving in marble; his first work in Boston, a copy of Sir Francis Chantrey's bust of Sir Walter Scott, was bought by New York's Apollo Association, which gave the work as one of its lottery prizes in 1841. During the next seven years Ives modeled and carved portrait busts in Boston, New Haven and New York City, where he settled about 1841. That year five of his portraits were included in the National Academy of Design exhibition. To improve his health and further his training, Ives moved in 1844 to Italy, where he lived for the rest of his life except for frequent short trips back to America. He settled first in Florence, then moved to Rome in 1851. Although Ives continued to sculpt portrait busts (usually of Americans abroad and after 1846 always in marble), he preferred to concentrate on ideal works, which became a major source of his fame. In 1847 he carved *Boy and Dove,* the first of his statues of children, his most popular series of ideal sculptures. In the late 1860s he executed several commissions for public statuary: a standing figure of Bishop Thomas Church Brownell — his earliest bronze work — for Washington (now Trinity) College in Connecticut; and for the state of Connecticut the marble statues of Roger Sherman (1868) and Jonathan Trumbull (1869) for Statuary Hall, Washington, D.C. The statue of Trumbull was later reproduced for the Connecticut State Capitol at Hartford. In the Centennial Exhibition of 1876 in Philadelphia, Ives was represented by his classical group *Ino and Bacchus* (1873) and two portrait busts. Although Ives's career began to decline after 1875, in the late 1880s he worked on several monuments to be cast in bronze. His last major work, *The Willing Captive* (also known as *White Captive and Indian*), was based on one of his works of 1862, which was later put into marble. Cast in bronze in 1886, *The Willing Captive* was installed in Newark, New Jersey's Lincoln Park a year after Ives's death.

A[dams], A[deline]. *DAB*, vol. 9, p. 518.

*Craven.

Gardner.

Gerdts, William H. "Chauncey Bradley Ives, American Sculptor," *Antiques*, vol. 94, November 1968, pp. 714–18.

——. "Marble and Nudity," *Art in America*, vol. 59, May 1971, pp. 60–67.

Jasper Johns

Born May 15, 1930, Augusta, Georgia

Jasper Johns grew up in Allendale and Sumter, South Carolina. He received his formal art training at the University of South Carolina, which he attended for about 1½ years during 1947–48. Soon after moving to New York City in 1949, he was drafted into the army for two years. In 1952 he returned to New York, where he began to paint, supporting himself at odd jobs until 1958 and became friends with Robert Rauschenberg, the dancer-choreographer Merce Cunningham and the composer John Cage. In 1954 Johns started to paint pictures of letters, targets, circles and American flags, frequently attaching objects to the paintings, as in *Book* and *Drawer* (both 1957). Beginning with his encaustic *Flag* (1954), during 1954–60 Johns created many sculpted objects (often painted casts of mass-produced items such as flashlights, beer cans and lightbulbs) while continuing to produce the paintings with attachments; his works of the early 1960s, such as the Sculpmetal, plaster and glass *The Critic Sees* (1961), reveal the influence of Marcel Duchamp, whose name appears in Johns's notebooks of this period. Johns's first exhibition, *Artists of the New York School: Second Generation,* at the Jewish Museum in 1957, brought him to the attention of Leo Castelli, whose New York gallery gave Johns his first (1958) and many subsequent one-man shows. Since his one-man shows in 1959 at the Galleria d'Arte del Naviglio in Milan and the Galerie Rive Droite in Paris, Johns has been represented in numerous European exhibitions, including a one-man show at the Whitechapel Gallery, London, in 1964. That year the Jewish Museum presented a major retrospective of his work. Although Johns does not consider himself a Pop artist, his works also have been included in many exhibitions of Pop art in the United States and Europe. Johns was among the first American artists to collaborate with Tatyana Grossman at her lithography workshop on Long Island. In 1968 he began making lithographs at Gemini Graphics Editions, Los Angeles, and in 1970 one-man exhibitions

Jasper Johns

of his prints were held at the Museum of Modern Art, New York, and the Philadelphia Museum. On October 18, 1973, Johns's painting *Double White Map* (1965) was sold at auction in New York for $240,000, the highest price ever paid for a 20th-century American work of art.

*Belgrade, Museum of Modern Art of. *Antonio Tàpies — Jasper Johns* (essays on Johns by Miodrag B. Protíc and Irina Subotíc, the latter's translated by S. Petrovíc). Belgrade, 1969.

*The Jewish Theological Seminary of America, The Jewish Museum. *Jasper Johns* (essays by Alan R. Solomon and John Cage). New York, 1964.

*Kozloff, Max. *Jasper Johns*. New York: Harry N. Abrams, [1969].

*————. *Jasper Johns*. New York: Harry N. Abrams, [1972].

Steinberg, Leo. *Jasper Johns*. New York: George Wittenborn, 1963.

Tillim, Sidney. "Ten Years of Jasper Johns," *Arts Magazine*, vol. 38, April 1964, pp. 22–26.

Whitney Museum of American Art. *American Pop Art* (exhibition directed and text by Lawrence Alloway). New York: Collier Books, 1974.

Young, Joseph E. "Jasper Johns — An Appraisal," *Art International*, vol. 13, September 1969, pp. 50–55.

Donald Judd

Born June 3, 1928, Excelsior Springs, Missouri

Donald Clarence Judd spent his boyhood in the Midwest, Philadelphia and suburban New Jersey. Interested in art as a boy, at the age of eleven Judd took private art lessons for a year. Graduating from high school in 1946, he served in the army in Korea until late 1947. When he returned home to New Jersey, he studied at the Art Students League through the summer of 1948 and decided to become an artist. After a year at the College of William and Mary, he studied in New York City until 1953: day classes at the Art Students League and night classes at Columbia University, which awarded him a B.S. in philosophy. From 1953 until the early 1960s Judd continued to paint and exhibited some of these paintings in group shows at the Montclair Art Museum and in New York at the City Center Art Gallery and the Panoras Gallery. His first one-man show took place at Panoras in 1957, the year he reentered Columbia for graduate study in art history. In 1959 he began writing art reviews, first for *Art News* and for the next five years for *Arts Magazine* and other art periodicals. The years 1960–62 were crucial for Judd's transition from painter to sculptor: He moved from painterly low reliefs to his first fully three-dimensional wall relief (1961) to his first freestanding floor piece (1962). His group and one-man exhibitions at the Green Gallery in 1963 introduced this new work to critical attention, and in early 1964 he had his first piece fabricated in metal. Much of his subsequent work has consisted of boxes or other solid-geometric units, fabricated in metal or metal and plexiglas and often painted, which are placed on the floor or cantilevered from the wall, sometimes singly, sometimes in stacks, sometimes in progressions along a horizontal bar. Represented by the Leo Castelli Gallery since

1965, Judd has had his work in countless group exhibitions and has been recognized by large one-man exhibitions at the Whitney Museum in 1968, the Pasadena Museum in 1971 and the National Gallery of Canada in 1975.

Agee, William C. "Unit, Series, Site: A Judd Lexicon," *Art in America*, vol. 63, May/June 1975, cover and pp. 40–49.

*Canada, National Gallery of. *Donald Judd* (exhibition and catalogue organized by Brydon Smith; essay by Roberta Smith; and catalogue raisonné of Judd's work). Ottawa, 1975.

Eindhoven, Stedelijk van Abbemuseum. *Don Judd* (introduction by J. Leering and selected writings by Don Judd). Eindhoven, 1970.

Judd, Donald. *Complete Writings*. New York: New York University Press (in association with the Press of Nova Scotia College of Art and Design), due fall 1975.

*Pasadena Art Museum. *Don Judd* (text and interview of Judd by John Coplans). Pasadena, 1971.

*Whitney Museum of American Art. *Don Judd* (text by William C. Agee; notes by Dan Flavin; and selected writings by the artist). New York, 1968.

Ellsworth Kelly

Born May 31, 1923, Newburgh, New York

Ellsworth Kelly studied art at Pratt Institute during 1941–42 and in 1943 was drafted into the army, where he served in the Engineers Camouflage Batallion during World War II, an experience that was to influence his innovative use of visual paradox in his painting and sculpture. He visited Paris for the first time in 1944. After the war, in 1945, he returned to the United States and during 1946–48 studied at the Boston Museum of Fine Arts school. In 1948 Kelly returned to Paris, where he studied at the Ecole des Beaux-Arts until 1950 and taught at the American School. His first one-man show, at the Galerie Arnaud, Paris, in 1951, exhibited his early modular, multipaneled, hard-edge paintings. From this work evolved his later freestanding, painted metal sculpture, which articulated both negative and positive space in precise cut-out planes and contours. Kelly spent the following year painting in Sanary in the south of France, and in 1954 he settled in New York City, where he continued his series of flat primary-color paintings. In 1956 he had his first American one-man show, at the Betty Parsons Gallery, New York, and received his first sculpture commission, for the lobby of the Transportation Building, Philadelphia. In his sculpture Kelly has experimented with the interplay of visual distortions in open space, and his work has been described by John Coplans as a "conception of a perfected order." Kelly's work has been included in many major shows: the *Guggenheim International Exhibition 1967: Sculpture from Twenty Nations*, the Solomon R. Guggenheim Museum, New York, 1968; *New York Painting and Sculpture: 1940–1970*, the Metropolitan Museum of Art, 1970; and a retrospective at the Museum of Modern Art, New York, 1973.

*Coplans, John. *Ellsworth Kelly*. New York: Harry N. Abrams, n.d.

Donald Judd

Ellsworth Kelly

Edward Kienholz

Frederick Kiesler

Copyright © Arnold Newman

"Kelly, Ellsworth," *Current Biography Yearbook 1970* (Charles Moritz, ed.), pp. 214–17. New York: The H. W. Wilson Company, 1971.

*New York, The Museum of Modern Art. *Ellsworth Kelly* (text by E. C. Goossen). New York, 1973.

Rose, Barbara. "Ellsworth Kelly as Sculptor," *Artforum*, vol. 5, Summer 1967, pp. 51–55.

Edward Kienholz

Born October 23, 1927, Fairfield, Washington

Edward Kienholz was born to a farming family, which expected him to become a rancher, and he was trained in carpentry, mechanics and plumbing. After attending high school in Fairfield and several northwestern colleges, he supported himself at a variety of odd jobs and moved to Los Angeles in 1953. A self-taught artist, Kienholz had begun to paint while still in high school, and in 1954 he began to make wooden relief paintings — sometimes one a day. The following year his first show was held at the Café Galleria, a Los Angeles coffee shop. In 1956 Kienholz opened one of Los Angeles's earliest avant-garde galleries, The Now Gallery; when that gallery closed a year later he and Walter Hopps opened the Ferus Gallery. In the late 1950s Kienholz's work became more three-dimensional and figurative: his first relief paintings — panels on which he glued or nailed scraps of wood and which he then painted, usually with a broom — had been abstract. In 1958 he attached a wholly three-dimensional found object, a deer's head, to his panel *The Little Eagle Rock Incident* — this title was Kienholz's first to refer to a contemporary event; in 1959 he made his first free-standing construction *(John Doe)*. By 1961 he had expanded his constructions into tableaux, completely three-dimensional environments into which life-size figures and mostly found objects are assembled. *Roxy's,* his first tableau, was exhibited at the Ferus Gallery in 1961. That year his work gained a larger audience when it was included in the Museum of Modern Art's exhibition *The Art of Assemblage.* His work received greater national attention when local officials tried, unsuccessfully, to remove works they found morally offensive from his one-man show at the Los Angeles County Museum in 1966. In the 1960s Kienholz's assemblages were widely shown in galleries and museums in California and on the East Coast, and during 1970–71 a major show of his tableaux was circulated to museums in six European countries.

Hopkins, Henry. "Edward Kienholz," *Art in America*, vol. 53, October/November 1965, p. 73.

"Horror Show," *Newsweek*, vol. 78, August 9, 1971, p. 65.

Kozloff, Max. "Art," *The Nation*, vol. 206, January 1, 1968, pp. 29–30.

*London, Institute of Contemporary Arts. *Edward Kienholz*. London, 1971. (Varying editions of the catalogue were available in the European cities to which the exhibition traveled.)

*Los Angeles County Museum of Art. *Edward Kienholz* (text by Maurice Tuchman). Los Angeles, 1966. (Text reprinted in *Artforum*, vol. 4, April 1966, pp. 41–44.)

Tillim, Sidney. "The Underground Pre-Raphaelitism of Edward Kienholz," *Artforum*, vol. 4, April 1966, pp. 38–40.

Washington Gallery of Modern Art. *Edward Kienholz: Work from the 1960s* (foreword by Walter Hopps). Washington, 1968.

Wight, Frederick. "Edward Kienholz," *Art in America*, vol. 53, October/November 1965, pp. 70–73.

Frederick Kiesler

Born September 22, 1896, Vienna
Died December 27, 1965, New York City

Frederick John Kiesler studied architecture at the Institute of Technology and the Academy of Fine Arts in Vienna. In the early 1920s he worked as an architect, and by 1923 he had designed the first version of the Endless House, originally intended as a space theater; that year he joined the De Stijl group of abstractionists. In 1924 Kiesler was architect and artistic designer of Vienna's International Exhibition of New Theater Technique, and the following year he designed the Austrian theater exhibit at the Paris World's Fair. At the Theatre Guild's and *Little Review's* invitation, Kiesler came to New York City in 1926 and ten years later became an American citizen. During the late 1930s and '40s he was associated with the Surrealists, for whom he designed the International Surrealist Exhibition (1947) in Paris, the exhibition for which Kiesler created his first sculpture, *Totem of Religions.* Interested in integrating the plastic arts into an environmental context, Kiesler conceived the theory of "correalism," in which "each part [leads] a life of coexistence . . . with the others." He applied this to his "endless sculpture," which is indigenous to and indeed *becomes* the environment. Kiesler's wood construction *Galaxy* (first version 1947–48, second 1951), was exhibited in the *Fifteen Americans* show at the Museum of Modern Art in 1952, and his other environmental sculptures were shown in his one-man exhibition at the Guggenheim Museum in 1964. Kiesler's later architectural works include the design of the "Universal Theater," commissioned in 1961, and the Shrine of the Book, a sanctuary in Jerusalem, in 1965. The Jerusalem project, completed in association with Armand Bartos, with whom Kiesler had established an architectural firm in 1957, earned the firm an American Institute of Architects' award of merit in 1966. Kiesler also served as scenic director of the Juilliard School of Music from 1933 to 1957 and director of the Columbia University School of Architecture's Laboratory for Design Correlation from 1936 to 1942.

Galerie Nächst St. Stephan, Vienna. *Frederick Kiesler* (texts by Frederich St. Florian, Frederich Czagan and the artist). Innsbruck: Allerheiligen Press (Peter Weiermair), 1975.

Howard Wise Gallery. *Frederick Kiesler* (essay by the artist). New York, 1969.

Kiesler, Frederick. *Inside the Endless House.* New York: Simon and Schuster, 1966.

——. "Second Manifesto of Correalism," *Art International*, vol. 9, March 1965, pp. 16–23.

——. "The Future: Notes on Architecture as Sculpture," *Art in America*, vol. 54, May/June 1966, pp. 57–68.

Levin, Kim. "Kiesler and Mondrian, Art into Life," *Art News,* vol. 63, May 1964, pp. 38–41, 49–50.

*The Solomon R. Guggenheim Museum. *Frederick Kiesler: Environmental Sculpture* (essay by the artist). New York: The Solomon R. Guggenheim Foundation, 1964.

Gaston Lachaise

Born March 19, 1882, Paris
Died October 18, 1935, New York City

The son of an accomplished woodworker and cabinetmaker, Gaston Lachaise at the age of thirteen entered the Ecole Bernard Palissy, where he studied drawing, modeling, carving and art history. Accepted into the Ecole des Beaux-Arts in 1898, Lachaise studied there for several years under Jules Thomas and exhibited at four annual Salons. Between 1900 and 1903 he fell in love with Isabel Dutaud Nagle, a married woman from Boston, who was to provide the lifelong inspiration for Lachaise's most renowned works — the monumental, voluptuous female nudes. Leaving the Beaux-Arts to serve in the army, he then went to work as a craftsman for the jeweler and glassmaker René Lalique and earned enough money to follow Mrs. Nagle to America. Lachaise arrived in Boston in January 1906 and soon became an assistant to the sculptor Henry Hudson Kitson. In 1912 Lachaise joined Kitson in New York City but soon left his employ to work for the sculptor Paul Manship. The next few years were a period of personal and artistic growth for Lachaise: one of his sculptures was shown in the Armory Show of 1913; in 1916 he became an American citizen; and in 1917 he was finally able to marry Mrs. Nagle. In 1918 at the Bourgeois Galleries, New York, Lachaise had his first one-man show, which included *Standing Woman (Elevation).* From the 1920s until his death in 1935 Lachaise's income derived primarily from sales of his decorative animal sculptures and commissions for architectural decoration and portrait sculpture. Among his many portraits were those of art figures he knew — Georgia O'Keeffe, Alfred Stieglitz, Edgar Varèse, John Marin and E. E. Cummings. Recognition came steadily in the 1920s: Lachaise's work was frequently reproduced in *The Dial;* a monograph on him, by Albert Gallatin, was published in 1924; and one-man shows were held in New York at Steiglitz's Intimate Gallery in 1927 and at the Brummer Gallery in 1928. In early 1935 Lachaise was honored by a retrospective — the first of the work of a living American sculptor — at the Museum of Modern Art, New York, eight months before his death at fifty-three from leukemia.

Cornell University, Herbert F. Johnson Museum of Art; and others. *Gaston Lachaise, 1882–1935* (introduction by Gerald Nordland). Ithaca, N.Y., 1974.

Gallatin, A. E. *Gaston Lachaise.* New York: E. P. Dutton and Co., 1924.

Knoedler (M.) & Company. *Gaston Lachaise, 1882–1935* (introduction by Lincoln Kirstein). New York, 1947.

Lachaise, Gaston. "A Comment on My Sculpture," *Creative Art,* vol. 3, August 1928, pp. xxii–xxvi.

*Los Angeles County Museum of Art. *Gaston Lachaise, 1882–1935: Sculpture and Drawings* (introduction by Gerald Nordland; chronology, bibliography and catalogue information by Donald Goodall). Los Angeles, 1963.

New York, The Museum of Modern Art. *Gaston Lachaise: Retrospective Exhibition* (introduction by Lincoln Kirstein). New York, 1935. (Entire catalogue reprinted in *Five American Sculptors: Calder, Flannagan, Lachaise, Nadelman, Lipchitz.* New York: The Museum of Modern Art and Arno Press, 1969.)

*Nordland, Gerald. *Gaston Lachaise: The Man and His Work.* New York: George Braziller, 1974.

The Sculpture of Gaston Lachaise (with an essay by Hilton Kramer and appreciations by Hart Crane and others). New York: The Eakins Press, 1967.

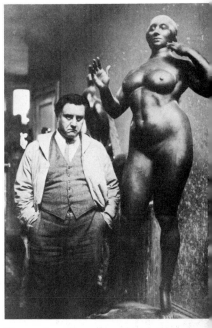

Gaston Lachaise

Albert Laessle

Born March 28, 1877, Philadelphia
Died September 4, 1954, Miami, Florida

Albert Laessle graduated from the Spring Garden Institute in 1896, from Drexel Institute in 1897, and in 1901 from the Pennsylvania Academy of the Fine Arts, where he studied under Charles Grafly and Thomas Anshutz. In 1902 the Pennsylvania Academy awarded him the Stewardson Prize, and in 1904 he won the Cresson Traveling Scholarship, which enabled him to spend the next three years in Paris, where he studied under Michel Béguine. After returning to Philadelphia in 1907, Laessle executed portrait busts in Grafly's studio for several years. His real passion, however, was modeling the small creatures of the riverbank and common barnyard animals, and he so excelled as an animalier that Lorado Taft wrote: "No one can make a toad more appealing nor portray the home life of a lobster with a tenderer sentiment." Laessle's animal group *Turtle and Lizards* (c. 1902), modeled while studying with Grafly, was exhibited at the St. Louis Exposition in 1904, and a year later he created *Turning Turtle,* exhibited at the Paris Salon of 1907. Laessle maintained a studio near the Philadelphia Zoological Gardens, and from this close observation came many charming bronzes, including his goat statue *Billy* (1915, Rittenhouse Square, Philadelphia), which won a gold medal at the Panama-Pacific Exposition in San Francisco; *Penguins* (1917, Philadelphia Zoological Gardens), winner of the Widener Memorial Gold Medal at the Pennsylvania Academy of the Fine Arts; and the striding eagle *Victory* (1918). Laessle was an instructor at the Pennsylvania Academy from 1921 to 1939, and during these years he continued to execute lifelike bronzes of his favorite creatures. In 1928 he completed *Dancing Goat* and his *Duck and Turtle* won the McClees Prize at the Pennsylvania Academy that year. His equestrian statue of General Gallusha Pennypacker with tigers (after a conception of Charles Grafly) was installed at Logan Square, Philadelphia, in 1934. Laessle was elected an academician of the National Academy of Design in 1932.

"Albert Laessle," *Pennsylvania Academy of the Fine Arts, School Circulation,* 1936–37, p. 11.

"Albert Laessle, Sculptor, is Dead," *The New York Times,* September 8, 1954, p. 32.

*Craven.

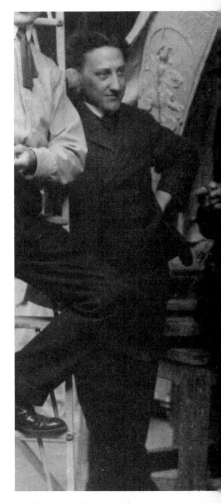

Albert Laessle

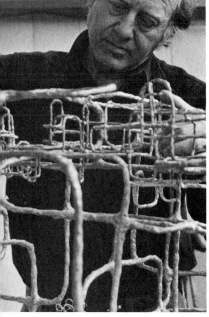

Ibram Lassaw

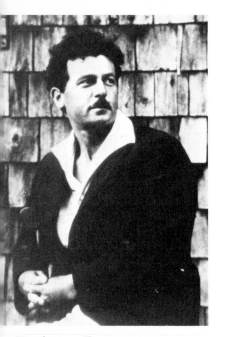

Robert Laurent

"Laessle, Albert," *National Cyclopaedia of American Biography*, vol. 40, pp. 306–7. New York: James T. White & Co., 1955.

"Laessle Resigns," *The Art Digest*, vol. 14, November 15, 1939, p. 27.

Miller, D. Roy. "A Sculptor of Animal Life," *The International Studio*, vol. 80, October 1924, pp. 23–27.

The National Sculpture Society. *Exhibition of American Sculpture Catalogue*. New York, 1923.

———— in cooperation with the Trustees of the California Palace of the Legion of Honor. *Contemporary American Sculpture*. [New York], 1929.

*Proske.

Ibram Lassaw

Born May 4, 1913, Alexandria, Egypt

In 1921 Ibram Lassaw arrived with his family in the United States, where they settled in New York City, and seven years later he became an American citizen. At the age of fourteen Lassaw began his formal study of sculpture at the Clay Club (later the Sculpture Center) under Dorothea Denslow, and he remained there until 1932, studying concurrently during 1930–31 at the Beaux-Arts Institute of Design. Lassaw was working with open-metal sculpture as early as 1933, and he was one of the first Americans to create abstract pieces. That year he took a job with the Federal Arts Project of the WPA, working until 1942, while also making shadow boxes and sculptures of brazed iron rods. In 1942 Lassaw was drafted into the army, where he learned direct welding, an experience that would lead to his mature style. By 1950 he had bought his own welding equipment and was creating linear wire mazes, building them with molten metals, which he colored with acids and alkalies. In these "polymorphous spaces," such as *Milky Way* (1950) and *Galaxy of Andromeda* (1951), he sought "to achieve a kind of space dance." Lassaw had his first of many one-man shows at the Kootz Gallery, New York, and in 1957 a retrospective of his work was held at M.I.T. In the 1960s Lassaw began hammering and bending brazed bronze or brass sheets into monumental pieces such as *Equinox* (1963) and *Cytherea* (1964.) Inspired by Zen philosophy, Lassaw has sought to unify man, nature and the cosmos in his organic structures, stating that "the relationships of all created things . . . are a complete, ever-evolving organism which the artist apprehends and 'creates.'" He has also executed many architectural sculpture commissions, notably the facade *Pillar of Fire* for Temple Beth-El, Springfield, Massachusetts; *Columns of Clouds* for Temple Beth-El, Providence, Rhode Island; and *Clouds of Magellan* for Philip Johnson's Glass House. Lassaw taught sculpture at American University in 1950 and was artist-in-residence at Duke University in 1962–63, and the University of California, Berkeley, in 1964–66. In 1973 a retrospective of his work was held at the Heckscher Museum, Huntington, Long Island.

Campbell, Lawrence. "Lassaw Makes a Sculpture," *Art News*, vol. 53, March 1954, pp. 24–27, 66–67.

Craven.

*Duke University. *Ibram Lassaw* (statements by the artist). [Durham, N.C., 1963].

Goossen, E. C. and others. *Three American Sculptors: Ferber, Hare, Lassaw*. New York: Grove Press, 1959.

Heckscher Museum. *Ibram Lassaw*. Huntington, N.Y., 1973.

Gertrude Kasle Gallery. *The Sculpture of Ibram Lassaw* (text by Sam Hunter). Detroit, 1968.

Sawin, Martica. "Ibram Lassaw," *Arts*, vol. 30, December 1955, pp. 2–6.

Robert Laurent

Born June 29, 1890, Concarneau, Brittany, France
Died April 20, 1970, Cape Neddick, Maine

Robert Laurent benefited early in life from the patronage and connoisseurship of Hamilton Easter Field, the influential American painter, editor and teacher, who became a surrogate father to Laurent. Especially inspired by the carvings of Maillol, Gauguin and African artists, Laurent's interests turned from painting to sculpture and in 1907 he traveled with Field to Rome, where Laurent learned wood carving and studied at the British Academy and under Maurice Sterne. Returning to the United States with Field in 1910, Laurent quickly joined the incipient forces of modern art in New York City. His first noteworthy exhibition, a two-man show with Field in 1915 at the Daniel Gallery, successfully introduced Laurent's wood reliefs to New York's art public. By 1917 he was also carving wooden sculpture in the round, thus inaugurating in American sculpture the conscious aesthetic of direct carving of three-dimensional forms. Upon Field's death in 1922 Laurent inherited Field's entire estate and decided to continue the summer art school Field had begun on his farm in Ogunquit, Maine. Laurent's first one-man exhibition, at the Bourgeois Gallery, New York, in 1922, reflected the expansion of his direct-carving technique into the mediums of alabaster and other stones. By the late 1920s he was also working in bronze, and stimulated by Gaston Lachaise's example, fixed on the nude female form as his primary subject. For fifteen years Laurent taught intermittently at the Art Students League in New York. During this time his monumental female nudes earned him sculptural commissions for Manhattan's Radio City Music Hall (1932); Fairmount Park, Philadelphia (1936); and the Federal Trade Building in Washington, D.C. (1938). He was awarded the Logan Prize of the Art Institute of Chicago for his *Kneeling Figure* in 1938. From 1939 to 1942 Laurent taught at Vassar and Goucher colleges and the Corcoran Gallery and Brooklyn Museum art schools before accepting the resident sculptor position at Indiana University in 1942. He remained at Indiana for nearly twenty years, continuing to teach at his summer art school in Ogunquit through 1961. Named professor emeritus at Indiana in June 1960, he was elected to the National Institute of Arts and Letters shortly before his death.

*Craven.

Delaware, University of; Department of Art History and Division of Museum Studies, in cooperation with the Delaware Art Museum. *Avant-Garde Painting and Sculpture in America, 1910–25* (Wil-

liam Innes Homer, general ed.; text on Laurent by Douglas Hyland). Wilmington, 1975.

Eglington, Guy. "Modern Sculpture and Laurent," *The International Studio*, vol. 80, March 1925, pp. 439–44.

Frost, Rosamund. "Laurent: Frames to Figures, Brittany to Brooklyn," *Art News*, vol. 40, April 1–14, 1941, pp. 10–11, 37.

Indiana University, Department of Fine Arts. *Laurent: Fifty Years of Sculpture* (text by Henry R. Hope). [Bloomington, Ind., 1961].

Kraushaar Galleries. *Robert Laurent, Memorial Exhibition* (text by Roberta K. Tarbell). New York, 1972.

Kent, Norman. "Robert Laurent, a Master Carver," *American Artist*, vol. 29, May 1965, pp. 42–47, 73–76.

*New Hampshire, University of. *The Robert Laurent Memorial Exhibition, 1972–1973* (texts by Henry R. Hope and Peter V. Moak). Durham, N.H., 1972.

Read, Helen Appleton. "Robert Laurent," *The Arts*, vol. 9, May 1926, pp. 251–59.

Strawn, Arthur. "Robert Laurent," *Outlook and Independent*, vol. 157, April 1, 1931, p. 479.

Barry Le Va

Born 1941, Long Beach, California

Barry Le Va attended the Otis Art Institute in Los Angeles from 1964 to 1967. His early works consisted of arrangements of folded pieces of canvas upon which painted jigsaw puzzle parts were scattered. In 1967 Le Va experimented with altering arrangements of such materials as gray felt, ball bearings, chrome and wood, showing the unlimited possibilities of artworks that could be created from a given set of materials. In 1968 he became an instructor at the Minneapolis College of Art and Design; in 1969 his first one-man show was held at the Minneapolis School of Art and his work was included in the Whitney Museum's *Anti-Illusion* show. By this time his works, often referred to as "distributions," had been further dematerialized: flour was sifted onto the museum's floor and gray cement powder was distributed over snow. His *Velocity Pieces,* first performed at the University Museum in Columbus, Ohio, in 1969, and at the La Jolla Museum of Art, California, in 1970, were "process" works in which Le Va ran back and forth between opposite walls, crashing into them until exhausted, while recording the sound of his movements on tape to be played back for the audience. In 1970 Le Va began to have numerous international exhibitions, and one-man shows were held at the Galerie Ricke, Cologne, the Nigel Greenwood Gallery, London, and the Galleria Toselli, Milan. Three years later he had his first one-man show in America at the Bykert Gallery, New York, where he distributed rods and slices of wooden dowels on the floor according to an elusive but precise plan, such as *12 to 3: End Touch — Ends Cut (Zig-Zag/End over End).* In his recent work Le Va has continued to explore how the viewer can conceptually organize and activate a piece given a limited amount of physical and visual information. Le Va taught at Princeton University during 1973–74.

Baker, Kenneth. "Barry Le Va at Bykert," *Art in America*, vol. 61, September/October 1973, pp. 117–18.

Boice, Bruce. "Barry Le Va," *Artforum*, vol. 11, June 1973, pp. 82–83.

Gilbert-Rolfe, Jeremy. "Barry Le Va," *Artforum*, vol. 13, September 1974, pp. 79–80.

Le Va, Barry. "Notes on a Piece by Barry Le Va: Extended Vertex Meetings: Blocked; Blown Outward," *Studio International*, vol. 182, November 1971, pp. 178–79.

Livingston, Jane. "Barry Le Va: Distributional Sculpture," *Artforum*, vol. 7, November 1968, pp. 50–54.

Nemser, Cindy. "Subject-Object: Body Art," *Arts Magazine*, vol. 46, September/October 1971, pp. 41–42.

Pincus-Witten, Robert. "Barry Le Va: The Invisibility of Content," *Arts Magazine*, vol. 50, October 1975, pp. 60–67.

Rosing, Larry. "Barry Le Va and the Non-descript Distribution," *Art News*, vol. 68, September 1969, pp. 52–53.

*Whitney.

Young, Joseph E. "Los Angeles," *Art International*, vol. 15, January 1971, pp. 51–52.

Barry Le Va

Sol LeWitt

Born 1928, Hartford, Connecticut

Sol LeWitt received his B.F.A. from Syracuse University in 1949, and in 1965 he had his first one-man show in New York at the Daniels Gallery, where he exhibited angled rectangular wall and floor pieces lacquered in monochromes. From 1964 to 1967 LeWitt taught at the Museum of Modern Art School and the following year at Cooper Union. By this time he had begun to refer to his work as conceptual art, insisting that the artist is a servant of a predetermined ordering system and that "the artist cannot imagine his art and cannot perceive it until it is complete." In all of his work LeWitt has exercised a rigid control over the concept, systematically and logically following it to its conclusion. Early in his career he concluded that a blind person could make art — that the concept was more important than the visual result — and he proved this conviction in many of his graphite wall drawings, where assistants "blindly" followed his simple written or spoken instructions. His later work, particularly his white skeletal modular structures such as *Untitled Cube (6)* (1968), remains true to his conceptual logic. In 1968 LeWitt's *46 Three-Part Variations on 3 Different Kinds of Cubes* (the title of which is explicit of a number of his works) was installed at the Dwan Gallery, New York, and that year he exhibited other serial compositions in Los Angeles, Munich, Düsseldorf and Zurich. During 1969–70 LeWitt taught at the School of Visual Arts, New York, and then at New York University. While preparing his second major European exhibition, at the Gemeentemuseum, The Hague, in 1970, his friend Eva Hesse died, and he asked that the exhibition be dedicated to her. In 1974 LeWitt's *Variations of Incomplete Open Cubes* was exhibited at the John Weber Gallery, New York.

Sol LeWitt

Richard Lippold

Seymour Lipton

Alloway, Lawrence. "Sol LeWitt: Modules, Walls, Books," *Artforum*, vol. 13, April 1975, pp. 38–44.

Antin, David. "It Reaches a Desert in Which Nothing Can Be Perceived but Feeling," *Art News*, vol. 70, March 1971, pp. 38–39.

Bochner, Mel. "Serial Art, Systems: Solipsism," *Arts Magazine*, vol. 41, Summer 1967, pp. 39–43.

G[oossen], E[ugene] C. *Britannica*, p. 344.

*The Hague, Gemeentemuseum. *Sol LeWitt* (statements by Carl Andre and others; writings by the artist). [The Hague, 1970].

Kuspit, Donald B. "Sol Le Witt: The Look of Thought," *Art in America*, vol. 63, September/October 1975, pp. 42–49.

LeWitt, Sol. "Paragraphs on Conceptual Art," *Artforum*, vol. 5, June 1967, p. 79.

Lippard, Lucy R. "Sol LeWitt: Non-Visual Structures," *Artforum*, vol. 5, April 1967, pp. 42–46.

Müller.

Perreault, John. "Circles, Lines and a Legend," *The Village Voice*, vol. 18, February 8, 1973, p. 27.

Richard Lippold

Born May 3, 1915, Milwaukee

From 1933 to 1937 Richard Lippold studied at the University of Chicago and the School of the Art Institute of Chicago, graduating from the latter with a B.F.A. in industrial design. Upon graduation he worked as an industrial designer, first for the Cherry-Burrell Corporation in Chicago for two years and then in his own firm in Milwaukee during 1939–41. In 1940 he married Louise Gruel, a dancer, and taught at the Layton School of Art in Milwaukee. The following year he went to Ann Arbor to teach design at the University of Michigan until 1944, when he moved to New York City. He continued his teaching career at Goddard College, Vermont, during 1945–47; Trenton Junior College, New Jersey, during 1947–52; and Hunter College, New York City, during 1953–65. In 1942 Lippold had made his first sculptures — constructions of wire and scrap metal found in an Ann Arbor junkyard. Four years later he executed *New Moonlight*, which was exhibited in 1947 in his first of many one-man shows at the Willard Gallery, New York. Considered by Lippold to be his first self-sustaining sculpture, it heralded the abstract, usually symmetrical, wire and metal hanging constructions for which he was to become known. His *Variation Number 7: Full Moon* (1949–50), bought by and exhibited in the Museum of Modern Art, New York, in 1950, was exhibited in France in 1955 and brought him international attention. He has since executed numerous commissions, particularly for large-scale architectural sculptures, for the following locations: Harkness Commons, Harvard University, 1950 (requested by Walter Gropius); Metropolitan Museum of Art, 1956; Inland Steel Building, Chicago, 1957; wine museum, Château Mouton-Rothschild, Pauillac, France, 1960; Philharmonic (now Avery Fisher) Hall, Lincoln Center New York, 1962 (at the time of its installation, the sculpture for this site was the largest of the 20th century); Pan Am Building, New York, 1963; and Cathedral of St. Mary the Virgin, San Francisco, 1970. Recipient of such awards as the Brandeis University Creative Arts Award in 1958, the silver medal of the Architectural League of New York in 1960 and the fine arts medal from the American Institute of Architects in 1970, Lippold was elected vice-president of the National Institute of Arts and Letters in 1963.

Campbell, Lawrence. "Lippold Makes a Construction," *Art News*, vol. 55, October 1956, pp. 31–33.

Kaufmann, Edgar, Jr. "Fresh Aspects of American Art: The Inland Steel Building and Its Art," *Art in America*, vol. 45, Winter 1957/58, cover and pp. 22–27.

Lippold, Richard. "Projects for Pan Am and Philharmonic," *Art in America*, vol. 50, Summer 1962, pp. 50–55.

_____. "Sculpture?" *Magazine of Art*, vol. 44, December 1951, pp. 315–19.

New York, The Museum of Modern Art. *Fifteen Americans* (Dorothy C. Miller, ed.). New York, 1952.

Tomkins, Calvin, "Profiles: A Thing Among Things," *The New Yorker*, vol. 39, March 30, 1963, pp. 47 ff.

Seymour Lipton

Born November 6, 1903, New York City

Although Seymour Lipton had an early interest in art, it was not until he had received his D.D.S. from Columbia University in 1927 that he began to sculpt. Entirely self-taught, Lipton seriously turned to sculpture in 1932, although for many years he maintained a dual career as a dentist and sculptor. His early work — wood sculptures worked in an expressionistic figurative style, which reflected the social issues generated by the Depression and World War II — was exhibited in his first one-man show, at the A.C.A. Galleries, New York, in 1938. By 1945, when he started working with sheet lead and began his famous Moloch series, Lipton's work had become abstract and more monumental. In 1948 he had his first of many one-man shows at the Betty Parsons Gallery, New York, and by 1951 he had developed his personal style: Now working with bronze and nickel-silver on sheet steel and Monel (a white bronze alloy), Lipton innovated a unique brazing, or melting, process to texture his surfaces and thereby became a pioneer of direct-metal sculpture. In search of "a controlled organic dynamism," Lipton employed biological imagery in such works as *Spring Ceremonial* (1951), *Sea Bloom* (1952) and *Carnivorous Flower* (1953); later this imagery evolved into a concern with "internal and external anatomy," intimately related to the mythic forces in man and nature and expressed in such works as *Avenger* (1957), *Prophet* (1959) and *Crusader* (1960). A teacher at the New School for Social Research, 1940–58, Lipton was represented in the Museum of Modern Art's *Twelve Americans* exhibition in 1956; at the São Paulo Bienal in 1957; at the Venice Biennale (in a one-man show) in 1958; and since 1946 in every Whitney Museum Sculpture Annual. In 1969 he won the Widener Gold Medal of the Pennsylvania Academy of the Fine Arts for *Gateway*, and his one-man exhibitions include those at Milwaukee's Art Center and University of Wisconsin, 1969; M.I.T., 1971; and the Everson Museum, Syracuse, 1973. His many commissions include three sculptures for Temple Israel,

Tulsa (1953); *Archangel* (1964, Philharmonic [now Avery Fisher] Hall, Lincoln Center, New York); and *Laureate* (1967, Milwaukee Performing Arts Center).

Elsen, Albert. "Lipton's Sculpture as Portrait of the Artist," *College Art Journal*, vol. 24, Winter 1964/65, pp. 113–18.

*_____. *Seymour Lipton*. New York: Harry N. Abrams, n.d.

Lipton, Seymour. "Experience and Sculptural Form," *College Art Journal*, vol. 9, Autumn 1949, pp. 52–54.

_____. "Some Notes on My Work," *Magazine of Art*, vol. 40, November 1947, pp. 264–65.

Marlborough-Gerson Gallery. *Seymour Lipton* (text by Sam Hunter). New York, 1965.

Ritchie, Andrew Carnduff. "Seymour Lipton," *Art in America*, vol. 44, Winter 1956, pp. 14–17.

*Milwaukee Art Center and University of Wisconsin-Milwaukee. *Seymour Lipton* (introduction by Tracy Atkinson). [Milwaukee, 1969].

James Lombard

Born June 26, 1865, Baldwin, Maine
Died February 27, 1920, Bridgton, Maine

James Lombard attended school in Baldwin, Maine, where he probably carved his earliest works. Later he moved to Bridgton, Maine, where he spent most of his life farming and making furniture and weathervanes. Lombard's best-known weathervanes, including one found on his own farm in Bridgton, were carved during the late 1880s. He specialized in cutting the silhouettes of hens and roosters in pine and then attaching their legs separately.

*Bishop, Robert. *American Folk Sculpture*. New York: E. P. Dutton & Co., 1974.

*Lipman, Jean. *American Folk Art in Wood, Metal and Stone*. N.p.: Pantheon, 1948; New York: Dover Publications, 1972 (reprint).

"Three Weathervanes," *The Magazine Antiques*, vol. 57, May 1950, cover and p. 349.

Len Lye

Born July 5, 1901, Christchurch, New Zealand

Len Lye was educated at the Wellington Technical College and the Canterbury College of Fine Arts in Christchurch. As a boy he was continually fascinated with motion, and as early as the age of seventeen he experimented with crude, manually operated kinetic constructions. Later Lye became intrigued with Australian aboriginal rituals and dances and in 1920 began to work seriously with kinetics in Samoa, where he had gone to further pursue primitive art forms. A few years later he traveled to Sydney, Australia, where his interest in the dynamics of kinetics led him into film animation. Lye innovated the technique of inscribing images directly onto film, and after moving to London in 1926 he began to receive film commissions, producing *Tusalava* for the London Film Society in 1928 and *Color Box* for the British Post Office in 1935. In 1946 Lye relocated again, this time to the United States, where he became a citizen. Continuing his film work, Lye also

developed his Tangible Motion Sculptures — tangible in that they emphasize motion rather than the object — exhibiting them in 1961 in the auditorium of New York's Museum of Modern Art, and in the *Art in Motion* show held at the Stedelijk Museum in Amsterdam and the Moderna Museet in Stockholm. His tangible structures, such as *Revolving Harmonic* (1960), *Roundhead* (1961), *Fountain* (1963) and *Zebra* (1964) are lyrical abstractions that reflect Lye's early interest in the structure and movement of primitive dances. In 1965 five of his electronically activated and programmed constructions, including *The Flip and Two Twisters, The Loop* and *Sky Snake*, were "performed" in his one-man show at the Howard Wise Gallery, New York. That same year Lye had one-man shows at the Albright-Knox Art Gallery, Buffalo, and the Contemporary Arts Center, Cincinnati. Setting strips of metal or stainless-steel rods and tubes in motion, sometimes silent and sometimes in synchronization with sound, Lye "choreographs" variations in tempo and achieves a unique illumination through vibration and reflection, emphasizing "the grace and power of motion, not . . . imagery."

A[shton], D[ore]. *Britannica*, p. 355.

Burnham, Jack. *Beyond Modern Sculpture: The Effects of Science and Technology on the Sculpture of this Century*. New York: George Braziller, n.d.

*California, University of; The Art Museum and The Committee for Arts and Lectures. *Directions in Kinetic Sculpture* (preface by Peter Selz; introduction by George Rickey; statements by the artists). Berkeley, Calif., 1966.

"Forms in Air," *Time*, vol. 74, August 24, 1959, p. 56.

Howard Wise Gallery. *Len Lye's Bounding Steel Sculptures* (statement by the artist). New York, 1965.

Lye, Len. "Tangible Motion Sculpture," *The Art Journal*, vol. 20, Summer 1961, pp. 226–27.

_____ and Lou Adler. "Description of *Roundhead I*," *The Art Journal*, vol. 20, Summer 1961, p. 228.

Mancia, Adrienne and Willard Van Dyke. "The Artist as Film-maker: Len Lye," *Art in America*, vol. 54, July 1966, pp. 98–106.

*Rickey, George. *Constructivism*. New York: George Braziller, 1967.

Samuel McIntire

Born Salem, Massachusetts; baptized
January 16, 1757
Died February 6, 1811, Boston

Samuel McIntire was the son of the Salem housewright Joseph McIntire, Sr., who trained his sons Joseph, Samuel and Angier in the family building trade. Samuel soon broadened his occupation to include decorative wood carving and architectural design. He worked extensively for the wealthy Salem merchant Elias Hasket Derby, whose early accounts refer to the craftsman as a carpenter and joiner. By the 1790s, however, McIntire was carving interior architectural details for the Derby family and others and furniture for the cabinetmaking firm of Elijah and Jacob Sanderson. He also did joinery and carved ornamental details and figureheads for a number of

Len Lye

Samuel McIntire

Derby ships, such as the *Mount Vernon* in 1798. Today McIntire is known primarily for his architecture, initially heavy in proportion, as in his Peirce-Nichols House and the remodeled Benjamin Pickman House, but subsequently lighter and Adamesque, as in his Pingree House. These three houses, like most of McIntire's buildings, were in Salem; he also submitted a design, which was rejected, for the United States Capitol. In addition, McIntire tried his hand at sculpture by carving in wood numerous eagles and reliefs and, in his later years, occasional portrait busts, namely of John Winthrop and Voltaire. In 1802 McIntire designed and executed for the Salem Common four ornamental gateways, each of which he adorned with a relief medallion of George Washington. Further evidence of McIntire's interest in sculpture can be seen in his inventory, which included numerous carving tools, a book on antique sculpture and medallion portraits of Washington and Franklin. However, despite the many examples of carving and sculpture which have been attributed to McIntire, relatively few works can be firmly documented to his shop. His son Samuel Field McIntire continued the family trade following McIntire's death.

*Clunie, Margaret B. "Salem Federal Furniture." Master's thesis in progress, University of Delaware.

Comstock, Helen. "McIntire in 'Antiques,'" *Antiques*, vol. 71, April 1957, pp. 338–41.

Cousins, Frank and Phil M. Riley. *The Woodcarver of Salem, Samuel McIntire*. Boston: Little, Brown and Company, 1916.

*The Essex Institute. *Samuel McIntire, a Bicentennial Symposium, 1757–1957* (Abbott Lowell Cummings and others, contributors; Benjamin Labaree, ed.). Salem, Mass., 1957.

Keyes, Homer Eaton. "Milton, Beverly and Salem," *The Magazine Antiques*, vol. 23, April 1933, pp. 142–43.

Kimball, Fiske. "The Estimate of McIntire," *The Magazine Antiques*, vol. 21, January 1932, pp. 23–25.

———. *Mr. Samuel McIntire, Carver, the Architect of Salem*. Portland, Me.: The Southworth-Anthoensen Press, for the Essex Institute, Salem, Mass., 1940.

Swan, Mabel M. "McIntire: Check and Countercheck," *The Magazine Antiques*, vol. 21, February 1932, pp. 86–87.

———. "A Revised Estimate of McIntire," *The Magazine Antiques*, vol. 20, December 1931, pp. 338–43.

———. *Samuel McIntire, Carver, and the Sandersons, Early Salem Cabinet Makers*. Salem, Mass.: The Essex Institute, 1934.

Edgar Alexander McKillop

Frederick MacMonnies

Edgar Alexander McKillop

Born June 8, 1878, Balfour, North Carolina
Died August 4, 1950, Balfour, North Carolina

Edgar Alexander McKillop, grandson of an Irish immigrant, spent most of his life in the area around Balfour, North Carolina. He married Lular Moor on December 16, 1906, and they had two daughters, both of whom are still living. There is some question whether McKillop was a farmer or a blacksmith by profession. In his spare time he carved numerous objects in wood, including clocks (which he fitted with parts from Sears, Roebuck), musical instruments, victrolas, knives and furniture. He is said to have invented and patented a machine for cleaning bobbins, which he sold to the Balfour Textile Mills. In spite of McKillop's prolific output, only four of his works are known today.

*Abby Aldrich Rockefeller Folk Art Collection and The High Museum of Art. *Folk Art in America: A Living Tradition* (preface and text by Beatrix T. Rumford). Atlanta: The High Museum of Art, 1974.

*Bishop, Robert. *American Folk Sculpture*. New York: E. P. Dutton & Co., 1974.

*Hemphill, Herbert W., Jr., and Julia Weissman. *Twentieth-Century American Folk Art and Artists*. New York: E. P. Dutton & Co., 1974.

Frederick MacMonnies

Born September 28, 1863, Brooklyn, New York
Died March 22, 1937, New York City

Frederick William MacMonnies became an assistant in the studio of Augustus Saint-Gaudens in 1880, while attending night classes at the Art Students League and the National Academy of Design. In 1884 MacMonnies went to Paris, where he studied under Alexandre Falguière and Antonin Mercié at the Ecole des Beaux-Arts. At Saint-Gaudens's request, however, MacMonnies returned to America in 1887 to assist his former master, reentering Falguière's studio a year later as his assistant. In 1886 and 1887 MacMonnies won the Prix d'Atelier, the highest honor awarded to foreign students at the Beaux-Arts, and in 1889 his *Diana* won an honorable mention at the Paris Salon. MacMonnies had now opened a Paris studio and was soon receiving commissions from America, including those for the statues of Nathan Hale (1890, City Hall Park, New York) and MacMonnies's patron James S. T. Stranahan (1891, Prospect Park, Brooklyn), both exhibited at the Salon of 1891. The year 1893 was an important one for MacMonnies: He created both his spirited *Bacchante and Infant Faun*, to be presented to the Boston Public Library, and the *Barge of State* (or *Triumph of Columbia*), the central fountain at the Columbian Exposition in Chicago. The public recognition MacMonnies enjoyed from these works brought a flood of commissions: the statue of Shakespeare (1895) and the bronze doors *The Art of Printing* (c. 1898) for the Library of Congress; the Quadriga and Army and Navy groups (1898–1901) for the Soldiers' and Sailors' Memorial Arch and *The Horse Tamers* (1899), the gatepost groups, for Prospect Park, Brooklyn; the Denver Pioneer Monument (1910); and the fountain figures *Truth* and *Inspiration* for the New York Public Library (1913). World War I forced MacMonnies to return to the United States, where he turned to portrait painting. He continued to produce sculpture, however, and in 1919 his controversial male nude *Civic Virtue* was unveiled at City Hall Park, New York, causing one feminist group to protest that "his man was trampling woman underfoot." MacMonnies's most important work of this period was the Battle of the Marne Monument, erected near Meaux, France, in 1926. Rejecting neoclassicism through his decorative and

energetic sculptures, MacMonnies preserved the Beaux-Arts tradition throughout his career. In 1896 he was made a chevalier of the French Legion of Honor (and a commander in 1933), and in 1906 he was elected an academician of the National Academy of Design.

Caffin.

Cortissoz, Royal. "An American Sculptor: Frederick MacMonnies," *The Studio*, vol. 6, October 1895, pp. 17–26.

*Craven.

Greer, H. H. "Frederick MacMonnies, Sculptor," *Brush and Pencil*, vol. 10, April 1902, pp. 1–15.

Low, Will Hicok. "Frederick MacMonnies," *Scribner's Magazine*, vol. 18, November 1895, pp. 617–28.

"The MacMonnies Pioneer Monument for Denver: An Embodiment of the Western Spirit," *The Century Magazine*, vol. 80, October 1910, pp. 876–80.

*McSpadden.

Meltzer, Charles Henry. "Frederick MacMonnies, Sculptor," *Cosmopolitan Magazine*, vol. 53, July 1912, pp. 207–11.

New York, The Metropolitan Museum of Art. *New York City Public Sculpture, by Nineteenth-Century American Artists* (catalogue by Lewis I. Sharp; walking tours by David W. Kiehl). [New York], 1974.

Strother, French. "Frederick MacMonnies, Sculptor," *The World's Work*, vol. 11, December 1905, pp. 6,965–81.

Hermon Atkins MacNeil

Born February 27, 1866, Everett, Massachusetts
Died October 2, 1947, College Point, Queens, New York

Hermon Atkins MacNeil attended Massachusetts Normal Art School in Boston and taught modeling and drawing at Cornell University for three years. In 1888 he went to Paris, where he studied under Henri Chapu at the Académie Julian and under Alexandre Falguière at the Ecole des Beaux-Arts. Upon his return to America in 1891, MacNeil found work in Chicago at the approaching Columbian Exposition; there he assisted the sculptor Philip Martiny and made two sculptures for the Electrical Building. Later his imagination was stirred by the American Indians who performed in "Buffalo Bill" Cody's Wild West Show at the exposition. One of these Indians posed for MacNeil's first Indian sculpture and for *A Primitive Chant,* the model of which MacNeil later completed in Rome. Remaining in Chicago until 1896, MacNeil taught at the Art Institute following his trip to the Southwest for further observation of the Indians, who were his primary sculptural subject until about 1910. Thereafter he turned to large-scale portrait statuary and memorials, such as his bronze *Ezra Cornell* (c. 1915–17) for Cornell University and his World War I monuments in Albany and Flushing, New York, and Whitinsville, Massachusetts. In 1896 he won the first Rinehart Scholarship for study in Rome, where he spent three years at the American Academy before going to Paris for a year. After exhibiting sculpture and win-

ning a silver medal at the Paris Exposition of 1900, MacNeil returned to the United States and established his studio at College Point, New York City, where he lived for the rest of his life, teaching intermittently at Pratt Institute, the Art Students League and the National Academy of Design. He won gold medals at the Pan-American Exposition in Buffalo in 1901 and the Panama-Pacific Exposition in San Francisco in 1915. In 1917 the Architectural League of New York awarded him a gold medal of honor for his large frieze for the Missouri State Capitol. Elected an academician of the National Academy of Design in 1906 and to the National Institute of Arts and Letters, MacNeil served as president of the National Sculpture Society during 1910–12 and 1922–24.

Block, Adolph. "Hermon A. MacNeil — Fifth President, National Sculpture Society," *National Sculpture Review*, vol. 12–13, Winter/Spring 1963/64, pp. 17, 28.

*Broder.

C[raven], W[ayne]. *DAB*, supp. 4, pp. 533–34.

Gardner.

Holden, Jean Stansbury. "The Sculptors MacNeil," *The World's Work*, vol. 14, pp. 9,403–19.

*McSpadden.

*Proske.

Taft.

Paul Manship

Born December 24, 1885, St. Paul, Minnesota
Died January 31, 1966, New York City

Having received his earliest training at the St. Paul Institute of Art, Paul Howard Manship left school in 1903 to work for an engraving company and then independently as an illustrator and designer. Moving to New York City in 1905, he studied briefly at the Art Students League before becoming Solon H. Borglum's assistant. Manship studied under Charles Grafly at the Pennsylvania Academy of the Fine Arts in 1906, but in 1907 he returned to New York to become an assistant to Isidore Konti. Manship's earliest honor came in 1909 when he won the Prix de Rome, which enabled him to spend three years at the American Academy in Rome. There and in Greece Manship became inspired by Renaissance sculpture and, especially, archaic Greek art, adapting both styles but never imitating them. He returned to New York in 1912, the master of archaic classicism, and received many important commissions for garden sculpture, including pieces for the estates of Mrs. Rockefeller McCormick, Charles Schwab and Herbert Pratt, and the reliefs for New York's Western Union Building. At the Architectural League of New York in 1913, Manship received immediate attention with works such as *Centaur and Dryad* (winner of the Barnett Prize of the National Academy of Design that year), and in 1916 his extremely successful first one-man show was held at the Berlin Photographic Gallery, which exhibited among the 150 pieces *Dancer and Gazelles* (winner of the Barnett Prize a year later). In 1916 Manship was elected an academician of the National Academy, and four years later, with the help of his assistant Gaston Lachaise, he completed the J. P. Morgan relief memorial for the Metropolitan Mu-

Hermon Atkins MacNeil

Paul Manship

John Mason

Clark Mills

seum of Art. In 1922, the year Manship moved his studio to Paris, he received the annual professorship of sculpture at the American Academy in Rome. Here he completed his *Diana,* and soon after, its companion piece, *Actaeon,* was completed in Paris. After his return to New York in 1927 Manship's major commissions included those for the Paul J. Rainey Memorial Gateway for the Bronx Zoo (1934), the *Prometheus Fountain* at Rockefeller Center (1934) and the Woodrow Wilson memorial, *Celestial Sphere,* for the League of Nations (1939, Geneva, Switzerland). Among his many honors and memberships, Manship served as chairman of the Smithsonian Art Commission from 1944 until his death.

Cortissoz, Royal. *American Artists.* New York and London: Charles Scribner's Sons, 1923.

Craven.

Gallatin, A. E. "An American Sculptor, Paul Manship," *The Studio,* vol. 82, July 1921, pp. 137–44.

_____. *Paul Manship: A Critical Essay on His Sculpture and an Iconography.* New York: John Lane, 1917.

_____. "The Sculpture of Paul Manship," *Bulletin of the Metropolitan Museum of Art,* vol. 11, October 1916, pp. 218–22.

*Hamline University and Minnesota Museum of Art. *Paul Howard Manship, An Intimate View: Sculpture and Drawings from the Permanent Collection of the Minnesota Museum of Art* (prologue by Malcolm E. Lein; text by Frederick D. Leach). St. Paul, Minn., 1972.

Manship, Paul. *Paul Manship.* New York: W. W. Norton and Company (under the auspices of the National Sculpture Society), 1947.

*Murtha, Edwin. *Paul Manship.* New York: The MacMillan Company, 1957.

Smithsonian Institution. *A Retrospective Exhibition of Sculpture by Paul Manship* (text by Thomas M. Beggs). Washington, 1958.

_____, National Collection of Fine Arts; and Saint Paul Art Center. *Paul Manship, 1885–1966* (tributes by David E. Finley and others). Washington, 1966.

John Mason

Born March 30, 1927, Madrid, Nebraska

Raised in the desert environment of Nevada, John Mason has lived since 1949 in Los Angeles, where he attended the Otis Art Institute from 1949 to 1952 and the Chouinard Art Institute from 1953 to 1954. In the 1950s, with a group of skilled potters who were exploring the sculptural possibilities of ceramics, including Peter Voulkos (with whom he shared a studio in 1957–58) and Kenneth Price, Mason began to adapt Abstract Expressionist style to ceramics. Although the only member of the group to move away from traditional wheel-thrown pottery, Mason experimented with the properties of clay, exploring shape and surface qualities and the variations of desert textures in his work. In the mid-1950s he worked with pot-form pieces and plaques, and in 1957 he made his first monumental wall relief. Soon Mason was executing both large-scale wall reliefs and freestanding, totemlike sculptures, many of which he left unglazed. In the mid-1960s he began his series of glazed, single-color, geometric freestanding sculp-

tures and wall reliefs, often using cross and X shapes. However, the lengthy firing process and the fragility of these finished pieces led him to experiment with the desert-colored firebricks used in kilns, which allowed greater flexibility in scale and infinite possibilities of arrangement. One of Mason's earlier wall reliefs, *The Blue Wall* (1959), became a permanent installation at the now-defunct Ferus Gallery in Los Angeles, where Mason had several one-man shows; and another relief from 1961 is installed in the Tishman Building in Los Angeles. Formerly head of the sculpture department at Pomona College, Claremont, California, Mason has taught at the Otis Art Institute, Claremont Graduate School, and the University of California at Irvine and at Berkeley, and since 1974 at Hunter College. In 1960 and 1974 Mason had one-man shows at the Pasadena Museum and in 1966 at the Los Angeles County Museum of Art.

California, University of; Irvine, Art Gallery. *Abstract Expressionist Ceramics* (text by John Coplans). [Irvine, 1966]. (Text reprinted in *Artforum,* vol. 5, November 1966, pp. 34–41.)

Coplans, John. "Out of Clay: West Coast Ceramic Sculpture Emerges as a Strong Regional Trend," *Art in America,* vol. 51, December 1963, pp. 40–41.

Giambruni, Helen. "Abstract Expressionist Ceramics," *Craft Horizons,* vol. 26, November/December 1966, pp. 16, 61.

_____. "John Mason at the Los Angeles County Museum of Art," *Craft Horizons,* vol. 27, January/February 1967, pp. 38–40.

Los Angeles County Museum of Art, Contemporary Art Council. *John Mason* (essay by John Coplans). [Los Angeles], 1966.

Nordland, Gerald. "John Mason," *Craft Horizons,* vol. 20, May/June 1960, pp. 28–33.

*Pasadena Museum of Modern Art. *John Mason: Ceramic Sculpture* (statement by R. G. Barnes; text by Barbara Haskell). [Pasadena, 1974].

Clark Mills

Born September 1, 1815, near Syracuse, New York
Died January 12, 1883, Washington, D.C.

Clark Mills spent his youth working at odd jobs and had little formal education. By 1837 he had settled in Charleston, South Carolina, to work as an ornamental plasterer and began modeling busts. Soon he devised a less painful method for making life masks in plaster and his business greatly increased. In 1845 he carved his first work in stone, a bust of Charleston's native son, Secretary of State John C. Calhoun; the bust was purchased by the city of Charleston, which awarded Mills a gold medal for the likeness. While planning a trip to Europe, Mills was commissioned by a sponsor of Hiram Powers, John Preston, to visit Columbia, South Carolina, to execute busts of Preston and his wife and of the Wade Hampton family. Preston also sent Mills to Washington, D.C., to study the sculpture there. Traveling north, Mills stopped off in Richmond, Virginia, to see Houdon's statue of George Washington. In Washington Mills met Postmaster General Cave Johnson, head of the Jackson Monument Committee, who suggested that Mills submit a design for an equestrian statue of Andrew Jackson. Although Mills had never seen an equestrian statue, his model was accepted,

and on January 8, 1853, his bronze statue *Major General Andrew Jackson* was unveiled in Lafayette Park, opposite the White House. Cast by Mills himself in his foundry outside Washington, this statue was the first equestrian and first major bronze sculpture to be cast in America. The success of his *Jackson* soon led Congress to give him a commission for a bronze equestrian statue of Lieutenant General George Washington, which was dedicated on February 22, 1860, in Washington, D.C. That year Mills was also commissioned to cast the late Thomas Crawford's monumental *Armed Liberty*, or *Freedom*, which had been designed to stand atop the dome of the United States Capitol; the figure was installed in December 1863. After the Civil War Mills produced little work, leaving almost entirely unfinished his plan for a colossal memorial to Lincoln.

*Craven.

Goode, James M. *The Outdoor Sculpture of Washington, D.C.: A Comprehensive Historical Guide*. Washington: Smithsonian Institution Press, 1974.

Hopkins, Rosemary. "Clark Mills: The First Native American Sculptor," unpublished M.A. thesis, University of Maryland, 1966.

Rutledge, Anna W. "Cogdell and Mills, Charleston Sculptors," *The Magazine Antiques*, vol. 41, March 1942, pp. 192–93, 205–8.

Taft.

Tuckerman, Henry T. *Book of the Artists: American Artist Life*. New York: G. P. Putnam & Son, 1867; New York: James F. Carr, 1967 (reprint).

Bruce Moore

Born August 5, 1905, Bern, Kansas

Soon after moving to Wichita at the age of twelve, E. Bruce Moore began modeling in clay. While still in high school he attended the Kansas Art Institute one summer and from the age of seventeen to twenty-one studied at the Pennsylvania Academy of the Fine Arts under Charles Grafly and Albert Laessle. Awarded Cresson Traveling Scholarships in 1925–26 and Guggenheim Fellowships in 1929–31, Moore toured western Europe and spent two years in Paris. From 1933 to 1937 he was a studio assistant to James Earle Fraser in Connecticut and New York City and then received an M. R. Cromwell Fellowship, which appointed him visiting sculptor at the American Academy in Rome during 1937–39. Previously a teacher at Wichita University and the New York School of Applied Design for Women, Moore taught intermittently in the 1940s and '50s at Maryland Institute's Rinehart School of Sculpture. In 1950 he moved from New York to Washington, D.C. Professionally, he has become best known for his animal, figure and portrait subjects in traditional mediums, as well as for the many pieces of engraved crystal he has created for Steuben Glass, including *The Queen's Cup*, presented to Queen Elizabeth II by President Dwight D. Eisenhower. Moore's public commissions include the Hooker and King Memorial Doors for Grace Cathedral in San Francisco, two tigers for Princeton University, the portrait statue of General Billy Mitchell at the Air Museum of the Smithsonian Institution and a monumental thirty-one-foot-tall female figure *Columbia* for the National Memorial of the Pacific in Honolulu. For his design of such medals as the Samuel F. B. Morse Medal for the National Academy of Design and the Society of Medalists' Thirty-Fifth Issue, he received the Saltus Medal (1952) of the American Numismatic Society, of which he is a member. Moore also won a Widener Gold Medal (1929) from the Pennsylvania Academy for his *Black Panther* and the Speyer (1935) and Barnett (1936) prizes of the National Academy of Design for his *Pelican Fountain* and *St. Francis*, respectively. A fellow of the National Sculpture Society, Moore received its Henry Hering Memorial Medal in 1968.

De Coux, Janet. "Bruce Moore . . . His Life," *National Sculpture Review*, vol. 21, Summer 1972, pp. 22–23.

"Sculptures and Drawings: Bruce Moore," *American Artist*, vol. 6, June 1942, pp. 21–23.

Wilcox, Dorothy, and Howard Wilcox. "Bruce Moore . . . His Work," *National Sculpture Review*, vol. 21, Summer 1972, pp. 20–21, 27.

*Wilcox, Howard, with research assistance by Dorothy Wilcox. *Bruce Moore: Notes Toward a Review of His Life and Art*. Washington: Estate Book Sales, 1975.

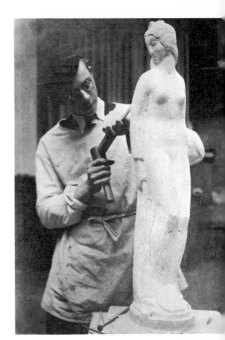

Bruce Moore

Robert Morris

Born February 9, 1931, Kansas City, Missouri

Having studied engineering at the University of Kansas City and art at the Kansas City Art Institute from 1948 to 1950, Robert Morris moved in 1950 to San Francisco, where he attended the California School of Fine Arts. During 1950–51 he served in the army's Corps of Engineers before transferring to Reed College, in Portland, Oregon, where he studied until 1955. Returning to San Francisco that year, Morris was active in improvisatory theater and film and also painted regularly. His paintings were exhibited in his first one-man show, which was held at the Dilexi Gallery in 1957. Moving to New York in 1961, Morris turned to sculpture, beginning with neo-Dada pieces such as *Box with the Sound of Its Own Making* and Minimalist pieces such as *Column*. In 1963 he had his first one-man show in New York at the Green Gallery. While studying art history at Hunter College, Morris wrote his thesis on Brancusi, and in 1966 he received his M.F.A. Since coming to New York Morris has worked in a variety of mediums, including theater/dance improvisations with Yvonne Rainer and others, and has published articles on sculpture in *Artforum* magazine. All of Morris's work articulates his involvement with the relativity of scale and with perception (essentially based on the tenets of phenomenology), in which the viewer perceives both the presence and the essence of the piece. Morris has continued to expand upon this philosophy: from early lead pieces and I-beam and L-beam gestalts (unitary objects), which deal with "the known constant and the experienced variable"; gray felt anti-form pieces of 1968, in which the form is determined solely by gravity; earthwork pieces (first exhibited at the Dwan Gallery in 1968); to mixed-media scatter pieces, which consist of "a continuity of details." In 1969 Morris had one-man exhi-

Robert Morris

Elie Nadelman

bitions at the Corcoran Gallery of Art and the Detroit Institute of Arts. Morris's later works have become semimonumental, particularly those in his one-man show at the Whitney Museum in 1970 and his outdoor pieces that often assimilate natural phenomena (especially weather conditions).

Burnham, Jack. "Robert Morris Retrospective," *Artforum*, vol. 8, March, 1970, pp. 67–75.

*The Corcoran Gallery of Art. *Robert Morris* (essay by Annette Michelson). Washington, 1969.

*Eindhoven, Stedelijk van Abbemuseum. *Robert Morris* (essay by J. Leering). Eindhoven, 1968.

Goossen, E. C. "The Artist Speaks: Robert Morris," *Art in America*, vol. 58, May/June 1970, pp. 104–11.

———. *Britannica*, p. 379.

Morris, Robert. "Some Splashes in the Ebb Tide," *Artforum*, vol. 11, February 1973, pp. 42–49.

Müller.

*Pennsylvania, University of; Institute of Contemporary Art. *Robert Morris/Projects* (foreword by Suzanne Delehanty). Philadelphia, 1974.

The Tate Gallery. *Robert Morris* (by Michael Compton and David Sylvester; with statements by the artist). London, 1971.

Whitney Museum of American Art. *Robert Morris* (text by Marcia Tucker). New York, 1970; New York and London: Praeger Publishers, 1970 (hardcover).

Elie Nadelman

Born February 20, 1882, Warsaw, Russian Poland
Died September 28, 1946, Riverdale, New York

Elie Nadelman studied at the Warsaw Art Academy briefly in about 1899 and for one year after leaving the Russian army in 1901. By late 1904 he was in Paris drawing from the model at the Académie Colarossi and in 1905 decided to devote himself to sculpture. Nadelman became friendly with many of the Parisian avant-garde, including the Steins, Gide, Apollinaire, Picasso and Brancusi; in 1909 his first one-man show was held in Paris at the Galerie Druet. Two years later he had exhibitions in London and Barcelona and in 1913 was represented in the Armory Show, New York. His earliest patrons were the Natanson brothers, founders of *La Revue Blanche,* and Helena Rubinstein. After the outbreak of World War I, with Mme Rubinstein's help, Nadelman sailed to New York City, where he had his first exhibition in 1915 at Alfred Stieglitz's Photo-Secession Gallery. By 1920 he was well established in the New York art world, numbering among his friends Paul Manship, Mahonri Young and Gertrude Vanderbilt Whitney. Late in 1919 Nadelman married Mrs. Joseph Flannery, a wealthy widow, and they moved to an estate in Riverdale, in the northern Bronx. During the next ten years they amassed a large collection of American folk art while Nadelman continued to create and exhibit his sculpture. The Depression brought the Nadelmans great financial losses; after 1929 Nadelman secluded himself in Riverdale, largely refusing to show or sell his work. However, in the early 1930s he experimented with ceramics and created sculptural decorations for New York City's Fuller Building and the Bank of the Manhattan Company. Despite frail health, during World War II Nadelman taught modeling and ceramics as a volunteer at the Bronx Veterans' Hospital. Integrating elements from styles as distant in time as cave painting and Cubism, as variant in their treatment of mass and line as Art Nouveau, folk art and classical Greek statuary, Nadelman's sculpture represents human and animal forms throughout his oeuvre. Positing his art as a statement of formal relationships, Nadelman abridged anatomy, smoothed and simplified volumes, and attempted to limit all lines to curves whose harmonious interplay would tend to schematize natural shapes. A major exhibition reviewing the development of Nadelman's sculpture and drawings was shown at the Whitney and Hirshhorn museums in the fall/winter of 1975/76.

*Kirstein, Lincoln. *Elie Nadelman* (includes a partial catalogue raisonné; statements by the artist; and bibliography by Ellen Grand). New York: The Eakins Press, 1973.

*New York, The Museum of Modern Art. *The Sculpture of Elie Nadelman* (text by Lincoln Kirstein; bibliography by Bernard Karpel). New York, 1948. (Entire catalogue reprinted in *Five American Sculptors: Calder, Flannagan, Lachaise, Nadelman, Lipchitz.* New York: The Museum of Modern Art and Arno Press, 1969.)

Spear, Athena T. "Elie Nadelman's Early Heads (1905–1911)," *Allen Memorial Art Museum Bulletin*, vol. 28, Spring 1971, pp. 201–22.

———. "The Multiple Styles of Elie Nadelman: Drawings and Figure Sculptures ca. 1905–12," *Allen Memorial Art Museum Bulletin*, vol. 31, no. 1, 1973–74.

Whitney Museum of American Art. *The Sculpture and Drawings of Elie Nadelman* (text by John I. H. Baur; chronology by Hayden Herrera). New York, 1975.

Reuben Nakian

Born August 10, 1897, College Point,
Queens, New York

Reuben Nakian began to study art at the age of thirteen in New Jersey, where he and his family had moved two years earlier. Having worked in advertising and at *Century Magazine* for three years and studied at the Independent Art School and the Beaux-Arts Institute of Design in New York City, Nakian became an apprentice to Paul Manship in 1916 and shared a studio with Manship's assistant Gaston Lachaise during 1920–23. From 1922 to 1928 Nakian received a monthly stipend through Juliana Force, director of the Whitney Studio Club, where Nakian's first one-man show was held in 1926. Then known for his smoothly stylized animal sculptures, Nakian executed in the early 1930s two well-received series of portrait busts of artists and President Franklin Roosevelt and his cabinet and an eight-foot-tall statue of Babe Ruth. Influenced by his friend Arshile Gorky, Nakian began to reevaluate his art in 1935, producing little sculpture until the late 1940s. Then he began two series in terra-cotta — incised relief plaques and more three-dimensional works — based on erotic themes from classical mythology and visually allied to Willem de Kooning's expressionist paintings of women. His new sculpture was shown in 1949 in the

Reuben Nakian

first of Nakian's many one-man exhibitions at the Egan Gallery, New York. Seeking a scale more monumental than possible with terra-cotta, Nakian in the 1950s and '60s created several large series of more fully abstract and baroque sculptures — usually in coarsely textured plaster for casting in bronze, as in the *Birth of Venus* (1963–66), less often in steel welded into open constructions of sheets and rods, as in *The Rape of Lucrece* (1955–58). Winning the competition for the commission in 1960, Nakian executed an aluminum sculpture that was installed on the façade of New York University's Loeb Student Center in 1961; that year more than forty of his works were shown in the sixth São Paulo Bienal. Represented as well in the 1968 Venice Biennale, Nakian's work was shown in retrospectives at the Gallery of Modern Art, Washington, D.C., in 1963, and the Museum of Modern Art, New York, in 1966.

Arnason, H. H. "Nakian," *Art International,* vol. 7, April 1963, pp. 36–43.

Goldwater, Robert. "Reuben Nakian," *Quadrum,* no. 11, 1961, pp. 95–102.

Hess, Thomas. "In Praise of Reason," *Art News,* vol. 65, Summer 1966, pp. 22–25, 60.

——. "Introducing the Steel Sculpture of Nakian: The Rape of Lucrece," *Art News,* vol. 57, November 1958, pp. 36–39, 65–66.

——. "Today's Artists: Nakian," *Portfolio and Art News Annual,* no. 4, 1961, pp. 84–89, 168–72.

*New York, The Museum of Modern Art. *Nakian* (essay by Frank O'Hara). [New York, 1966]; distributed by Doubleday and Company, Garden City, N.Y.

"Reuben Nakian," *Location,* no. 1, Spring 1963, pp. 8–15.

Bruce Nauman

Born December 6, 1941, Fort Wayne, Indiana

Bruce Nauman received a B.S. in 1964 from the University of Wisconsin, Madison, where he first studied mathematics, and then art under Italo Scanga. In 1965 he began graduate study in art at the University of California, Davis, where his teachers were Robert Arneson, Manuel Neri and, most important, William T. Wiley, who became Nauman's friend and encouraged the use of word play in his work. That year Nauman stopped painting and began to create objects and performance pieces, two of the varied repertory of forms he would develop during the next decade. In his two earliest performances Nauman acted out a sequence of body movements, an idea resonated by his rubber and fiberglass sculptures of 1965–66, which were exhibited in 1966 in his first one-man show, at the Nicholas Wilder Gallery, Los Angeles, and in Lucy Lippard's *Eccentric Abstraction* show at the Fischbach Gallery, New York. Nauman had received his M.F.A. that spring and moved to San Francisco to teach at the Art Institute. His 1965–66 sculptures had implied the potential postures of the body; now he began to use actual parts of his body as molds for sculpture, whose titles, as in *From Hand to Mouth,* are at times quite literal. In one of his 1965 performances Nauman had used a fluorescent lamp to create formal patterns with his body; beginning in 1966 he made sculptures in which

neon served as templates for portions of his body and in 1967 as a form of script, as in *Window or Wall Sign.* The following year Nauman had his first of many one-man shows at the Leo Castelli Gallery in New York. Five years later his retrospective exhibition was organized by the Los Angeles County and Whitney museums. In her catalogue essay for that exhibition Jane Livingston divides Nauman's sculpture into four classes: works derived from the idea of the backs or the alternation between the interiors and exteriors of objects; works dealing with concealment or unapproachability; works using molds to define interstices; and works in which the spectator can participate. Livingston's compendium form of explanation may be viewed as an analogue to Nauman's own ongoing attempt to codify through his art the multiple ways in which all aspects of experience can be perceived and manipulated.

Eindhoven, Van Abbemuseum. *Kompas 4: Westkust, U.S.A.* (foreword by Jean Leering and others; introduction by Jean Leering). Eindhoven, 1970. Text in Dutch and English.

*Los Angeles County Museum of Art and Whitney Museum of American Art. *Bruce Nauman: Work from 1965 to 1972* (essays by Jane Livingston and Marcia Tucker). Los Angeles: Los Angeles County Museum of Art, 1973.

Müller.

*Whitney.

Bruce Nauman

Louise Nevelson

Born September 23, 1900 (?), Kiev, Russia

By 1905 Louise Berliawsky and her family had immigrated to America and settled in Rockland, Maine, where, she tells us, by the age of nine she knew she would become an artist, indeed a sculptor. Marrying Charles Nevelson in 1920, she moved to New York City, where she studied the performing and visual arts, attending the Art Students League from 1929 to 1930. She continued her art studies with Hans Hofmann in Munich in 1931 and, after her return to New York, studied with him at the Art Students League in 1932, the year she also worked as assistant to the muralist Diego Rivera. She first exhibited in New York gallery group shows in 1933 and her earliest one-woman show was held at the Nierendorf Gallery, New York, in 1941. Her works at this time were small Cubist figural sculptures, shaped in various materials — stone, terra-cotta, plaster and wood — or occasionally cast in metal. By the mid-1950s she had established a new set of sculptural forms — boxes, reliefs, columns and, eventually, walls — which she constructed from a plenary store of wooden findings. In the late 1950s her solo exhibitions could be described as thematic environments, large monochromed ensembles of her abstract modular forms. At this same time, starting with the Whitney Museum's acquisition of *Black Majesty* in 1956, Nevelson's sculptures began their entry into several New York City museum collections. Since the mid-1960s Nevelson's sculpture has at times been fabricated in materials other than wood — aluminum, plexiglas, enamel, formica and, initiated by her commission from Princeton University in 1969 for a monumental work, Cor-ten steel. Elected

Copyright © Arnold Newman

Louise Nevelson

Barnett Newman

Isamu Noguchi

president of New York's Artists Equity in 1957 and of the national group in 1963, Nevelson has received many awards, including seven honorary doctorates and two Tamarind Lithography Workshop fellowships since 1963, to mark her achievement as a sculptor and printmaker. During the last fifteen years Nevelson's sculpture has been shown in innumerable group and individual exhibitions throughout the world and has been the subject of major retrospectives organized by the Whitney Museum, 1967; Museum of Fine Art, Houston, 1969–70; and Walker Art Center, 1973–75.

Baro, Gene. *Nevelson: The Prints*. New York: Pace Editions, 1974.

*Brooklyn Institute of Arts and Sciences, The Brooklyn Museum. *Louise Nevelson: Prints and Drawings, 1953–1966* (text by Una E. Johnson; research by Jo Miller). New York, 1967; distributed by Shorewood Publishers, New York.

Glimcher, Arnold B. *Louise Nevelson*. New York and Washington: Praeger Publishers, 1972.

*Nemser, Cindy. "Louise Nevelson," *Art Talk: Conversations with Twelve Women Artists*, pp. 52–79. New York: Charles Scribner's Sons, 1975.

*Walker Art Center. *Nevelson: Wood Sculptures* (text by Martin Friedman). New York: E. P. Dutton & Co., 1973.

*Whitney Museum of American Art. *Louise Nevelson* (text by John Gordon). New York, 1967.

Barnett Newman

Born January 29, 1905, New York City
Died July 4, 1970, New York City

Barnett Newman, son of Polish immigrants, studied at the Art Students League while attending high school. Studying under John Sloan and Duncan Smith and beginning his friendship with Adolph Gottlieb, Newman continued at the League until his graduation from City College in 1927. Newman worked in his father's clothing business for several years and taught art as a substitute in New York City public high schools from 1931 to 1939. In the early 1940s Newman wrote essays on art, painted his first cosmic landscapes, including *Genetic Moment* (1947), and made calligraphic drawings, applying his interest in ancient and Jewish mysticism. In 1948 Newman, Mark Rothko, William Baziotes, David Hare and Robert Motherwell founded the New York art school Subjects of the Artist; that year Newman created his first "zip" painting, *Onement I,* in which a single stripe cuts vertically through a monochrome field. In 1950 Newman created his first vertical strip sculpture, the two-strip *Here I* (plaster; cast in bronze in 1962), which resembles the stripes in his paintings. Newman's first and second one-man shows were held in 1950 and 1951 at the Betty Parsons Gallery, New York, but discouraged by the unfavorable criticism, he had no one-man shows until 1958 when a retrospective was held at Bennington College and another at French and Company, New York, in 1959. Thereafter, Newman exhibited frequently, and his work influenced many color-field and Minimalist painters. For the Jewish Museum's *Recent American Synagogue Architecture* show in 1963, Newman submitted a model with zigzagging windows, and six

years later the zigzag form reappeared in his 1969 baseless, walk-through sculpture *Zim Zum I*. In 1965 Newman continued his vertical strip sculptures, placing three steel strips, each on a trapezoidal base, upon a platform in *Here II,* followed a year later by the single-strip *Here III*. In Newman's largest sculpture, the Cor-ten steel *Broken Obelisk* (1967, Houston, Texas), his intention was to "break the horizon," in the same way he wanted his stripes to "break the format" in his paintings. In 1969 Newman translated the pyramid form of *Broken Obelisk* into the triangular paintings *Jericho* and *Chartres,* exhibited at the M. Knoedler Gallery, New York. A major retrospective of his work was held at the Museum of Modern Art, New York, in 1971 and in Amsterdam, London and Paris in 1972.

Alloway, Lawrence. "Color, Culture, the Stations: Notes on the Barnett Newman Memorial Exhibition," *Artforum,* vol. 10, December 1971, pp. 31–39.

————. "One Sculpture," *Arts Magazine,* vol. 45, May 1971, pp. 22–24.

G[oosen], E[ugene] C. *Britannica,* pp. 394–96.

*Hess, Thomas B. *Barnett Newman.* New York: Walker and Company, 1969.

Judd, Don. "Barnett Newman," *Studio International,* vol. 179, February 1970, pp. 66–69.

Louw, Roelof. "Newman and the Issue of Subject Matter," *Studio International,* vol. 187, January 1974, pp. 26–32.

*New York, The Museum of Modern Art. *Barnett Newman* (text by Thomas B. Hess). New York, 1971.

Rose, Barbara. "The Passing and Resurgence of Barnett Newman," *New York Magazine,* vol. 4, November 8, 1971, pp. 80–82, 84.

Siegel, Jeanne. "Around Barnett Newman," *Art News,* vol. 70, October 1971, pp. 42–47.

*The Solomon R. Guggenheim Museum. *Barnett Newman: The Stations of the Cross, Lema Sabachtani* (essay by Lawrence Alloway). New York: The Solomon R. Guggenheim Foundation, 1966.

Isamu Noguchi

Born November 17, 1904, Los Angeles

At the age of two, Isamu Noguchi, with his Japanese poet father and American writer-teacher mother, moved to Japan, where Isamu spent his childhood, attending both Japanese and Western schools. He was sent back to America in 1918 to become a student at the Interlaken School in Indiana, but the school was closed and instead he went to a public high school. In 1922 Noguchi was apprenticed briefly to Gutzon Borglum. When Borglum told him he would never become a sculptor, Noguchi moved to New York City and enrolled as a pre-medical student at Columbia University in January 1923. In 1924 he began to study sculpture under Onorio Ruotolo in night classes at the Leonardo da Vinci Art School, where Noguchi had his first one-man show three months later. Receiving Guggenheim Fellowships in 1927–28, he went to Paris. There he met Alexander Calder and became a studio assistant to Constantin Brancusi, whose sculpture Noguchi had deeply admired in New York. Upon Noguchi's return to New York in 1929, he had a one-man show at the Eugene

Schoen Gallery and began to sculpt portrait heads to support himself. The following year he traveled to China, where he studied brush drawing with Chi Pai Shi and then to Japan, where he experimented in making ceramic sculpture. He returned to New York in 1932 and made the first of his many ballet sets for Martha Graham in 1935. Noted for his space-creating sculptures and concerned with assimilating art into everyday life, Noguchi has designed furniture, playgrounds and gardens and completed numerous public sculpture commissions since the 1930s. His acclaimed environmental designs include the gardens for Paris UNESCO (1956–58) and New York's Chase Manhattan Bank Plaza (1961–64), as well as two bridges (1951–52) for Hiroshima's Peace Park. Noguchi has integrated his experience of European modernism and traditional Japanese idioms and materials to create a personal style of abstraction, primarily in the medium of stone carving. At times, his works have referred to Surrealism and the biomorphic imagery of Arp, Miro and Picasso, as in *Avatar* (1947); at other times, his sources have been Japanese — proto-historic *haniwa* figures, as in *Erai Yatcha Hoi (Kintaro)* (1931), and *kasama* ware, as in *Even the Centipede* (1952). Noguchi has had retrospectives in both America and Japan — at the Whitney Museum in 1968 and at the Minami Gallery, Tokyo, in 1973. During the spring of 1975 his steel sculptures of the last two decades were shown at the Pace Gallery, New York.

Craven.

Edgar, Natalie. "Noguchi: Master of Ceremony," *Art News*, vol. 67, April 1968, pp. 50–52, 71–72.

"Feature: Isamu Noguchi," *Art in America*, vol. 56, March/April 1968 (includes "The Artist Speaks" by John Gruen, pp. 28–31; "Past, Present, Future" by Ruth Wolfe, pp. 32–45).

Hess, Thomas B. "Isamu Noguchi '46," *Art News*, vol. 45, September 1946, pp. 34–38, 47, 50–51.

*Indiana University Art Museum, *Noguchi & Rickey & Smith* (foreword by Thomas T. Solley; text by Daniel Mato). Bloomington, Ind., 1970.

Love, Joseph. Pp. 73–74 in "Exhibitions Abroad: Tokyo," *Art News*, vol. 72, September 1973.

Noguchi, Isamu. *A Sculptor's World* (foreword by R. Buckminster Fuller). New York and Evanston: Harper & Row, 1968.

The Pace Gallery. *Noguchi: Steel Sculptures* (preface by Bryan Robertson). New York: Pace Editions, 1975.

Schonberg, Harold C. "Isamu Noguchi, A Kind of Throwback," *The New York Times Magazine*, April 14, 1968, pp. 26–27, 20–30, 32 and 34.

*Whitney Museum of American Art. *Isamu Noguchi* (text by John Gordon). New York, 1968; New York and London: Frederick A. Praeger, 1968 (hardcover).

Claes Oldenburg

Born January 28, 1929, Stockholm, Sweden

Son of a Swedish diplomat, Claes Thure Oldenburg spent his childhood in New York State, Oslo and, after 1936, Chicago, becoming an American citizen sixteen years later. He began his formal art training at Yale University, from which he graduated in 1951, and then studied at the Art Institute of Chicago during 1952–54. In 1953 some of his satirical drawings were included in his first group show at the Club St. Elmo, Chicago; that summer, as a scholarship student, he painted at the Oxbow School of Painting in Michigan. Oldenburg moved to New York in 1956 and, while continuing to draw and paint, worked as a part-time clerk until 1961 in the art libraries of Cooper Union, where he had the opportunity to study art books and drawings. During 1957–59 he became friendly with the printmaker Dick Tyler and interested in Allan Kaprow's ideas for environments and Happenings. In 1959 Oldenburg's first public one-man show was held at the Judson Gallery, New York, where he showed wood and newspaper sculptures and painted papier-mâché objects. In 1960 he created for his Ray Gun Show his first Pop art environments and Happenings, mediums he developed in both *The Store* (1961–62) — a mock store full of plaster goods — and *Bedroom Ensemble* (1963). The experience of making his own props for his Happenings led Oldenburg to create his first sewn, soft canvas sculptures in 1962. Beginning in 1965 he drew plans for colossal public monuments of such popular objects as a pair of scissors, a typewriter eraser and an ironing board. His plan for *1969 Monument for Yale University: Lipstick* was the first to be executed and the monument was placed outdoors on the Yale campus in 1969. Aided by Lippincott, Inc., a fabrication firm, Oldenburg has continued to produce many of these monuments in metal — *Geometric Mouse*, *Colossal Ashtray* and, for Philadelphia in 1976, a forty-foot *Clothespin*. Oldenburg's major one-man exhibitions include his retrospective organized by the Museum of Modern Art (1969), a traveling show originating at the Pasadena Museum (1971) and a three-hundred-work show at the Walker Art Center in 1975. His work has also been shown in many group exhibitions of Pop and contemporary art, including the 1964 Venice Biennale; *American Sculpture of the Sixties*, Los Angeles County Museum, 1967; the 1967 São Paulo Bienal; and *Expo '67* in Montreal.

Baro, Gene. *Claes Oldenburg: Drawings and Prints*. New York and London: Chelsea House Publishers, 1969.

*Johnson, Ellen. *Claes Oldenburg*. Baltimore: Penguin Books, 1971.

M. Knoedler and Company. *Claes Oldenburg Recent Prints*. New York, 1973.

*New York, The Museum of Modern Art. *Claes Oldenburg* (text by Barbara Rose). New York, 1970; distributed by New York Graphic Society, Greenwich, Conn.

Oldenburg, Claes. *Claes Oldenburg Proposals for Monuments and Buildings 1965–1969*. Chicago: Big Table Publishing Company, 1969.

_____. *Raw Notes*. Halifax: The Press of Nova Scotia College of Art and Design, 1973.

_____ and Emmett Williams. *Store Days*. New York and Frankfurt: Something Else Press, 1967.

*Pasadena Art Museum. *Claes Oldenburg: Object into Monument* (essay by Barbara Haskell). Pasadena, Calif., 1971.

*Walker Art Center. *Oldenburg: Six Themes* (essay and interviews with the artist by Martin Friedman). Minneapolis, 1975.

Copyright © Arnold Newman

Claes Oldenburg

Erastus Dow Palmer

Hiram Powers

Bela L. Pratt

Erastus Dow Palmer

Born April 2, 1817, Pompey, New York
Died March 9, 1904, Albany, New York

After a limited formal education, Erastus Dow Palmer learned the trade of carpentry and moved to Utica, New York, about 1840. In 1846 he moved to Albany, New York, where he worked for much of the rest of his life. By the mid-1840s he had begun his artistic career with the cutting of small relief portraits in shell; however, such cameo-cutting strained his eyes and he abandoned it for the making of larger bas-relief and freestanding sculpture. In 1851 he exhibited his *Bust of a Child* at the National Academy of Design, New York. Four years later Palmer's work was favorably reviewed by W. J. Stillman, an editor of the influential art magazine *Crayon,* which published Palmer's essay "Philosophy of the Ideal" in 1856. That year twelve of Palmer's works, including a seminude statue, *Indian Girl* (also called *The Dawn of Christianity;* it was his first attempt at a full-length figure), were exhibited at the Church of the Divine Unity on Broadway in New York City, bringing him to the attention of a wider and more influential audience. Cheered by the favorable response to *Indian Girl,* Palmer had started work by November 1857 on what is now his best-known statue — *The White Captive,* a completely nude figure that was his indigenous answer to Hiram Powers's *Greek Slave.* In 1873, when his reputation was already established, Palmer decided to go to Paris and open a studio in order to execute his commission of a statue of Chancellor Robert Livingston for Statuary Hall in Washington, D.C. A replica of this bronze of 1874 won Palmer first-class honors at the Philadelphia Centennial in 1876. His work in Paris completed, Palmer returned to Albany, where he continued to work into his eighties.

*Craven.
Gardner.
*Gerdts.
Palmer, Erastus Dow. "Philosophy of the Ideal," *Crayon,* vol. 3, January 1856, pp. 18–20; reprinted in *American Art Review,* vol. 2, May/June 1975, pp. 70–77.
Tuckerman, Henry T. *Book of the Artists: American Artist Life.* New York: G. P. Putnam & Son, 1867; New York: James F. Carr, 1967 (reprint).
Webster, J. Carson. "Documentation: A Checklist of the Works of Erastus Dow Palmer," *The Art Bulletin,* vol. 49, June 1967, pp. 143–51.
*_____. "Erastus D. Palmer: Problems and Possibilities," *The American Art Journal,* vol. 4, November 1972, pp. 34–43.

Hiram Powers

Born July 29, 1805, Woodstock, Vermont
Died June 27, 1873, Florence

About 1818 Hiram Powers and his family migrated to Cincinnati, Ohio, to escape famine. Soon after their arrival his father became ill and died. Powers worked at a variety of jobs until he became supervisor of the mechanical section of Dorfeuille's Western Museum in Cincinnati. He learned to model in clay from the Prussian sculptor Frederick Eckstein, who had also settled in Cincinnati. During 1834–37 Powers traveled to Washington, Boston and New York City, obtaining portrait-bust commissions. It was in 1835, during these years of travel, that Powers modeled the portrait busts of President Andrew Jackson, John C. Calhoun and Daniel Webster. With commissions for several more busts, Powers and his family were able to sail for Italy in the fall of 1837. With Horatio Greenough's assistance, they settled in Florence, where they were to remain for the rest of their lives. In 1839 Powers carved his first ideal bust, the popular *Proserpine.* Having completed his first ideal statue, *Eve Tempted* (1842), in 1843 he began the first version of his famed *Greek Slave,* which was exhibited extensively in Europe and America from 1847 to 1857, notably at the Crystal Palace International Exposition in London (1851) and at the world's fair in New York (1853–54); subsequently six full-size and three half-size versions were produced, along with many busts. *The Greek Slave,* more than any of Powers's works, brought him international acclaim. He filled many public and private commissions and continued throughout his productive life to sculpt ideal statues and portrait busts.

Bellows, Henry W. "Seven Sittings with Powers the Sculptor," *Appleton's Journal,* vol. 1, 1869, pp. 402–3.
Boynton, Henry. "Hiram Powers," *New England Magazine,* July 1899, pp. 519–33.
*Crane, Sylvia. *White Silence: Greenough, Powers, and Crawford, American Sculptors in Nineteenth-Century Italy.* Coral Gables, Fla.: University of Miami Press, 1972.
*Craven.
Gardner.
_____. "Hiram Powers and William Rimmer: Two Nineteenth-Century American Sculptors," *Magazine of Art,* vol. 36, February 1943, pp. 42–47.
*Gerdts, William H. *American Neo-Classic Sculpture: The Marble Resurrection.* New York. The Viking Press, 1973.
_____ and Samuel A. Robertson. "The Greek Slave," *The Museum* (published by the Newark Museum), vol. 17, Winter/Spring 1965, pp. 1–32.
Wunder, Richard P. "The Irascible Hiram Powers," *The American Art Journal,* vol. 4, November 1972, pp. 10–15.
_____. *Hiram Powers: Vermont Sculptor.* Taftsville, Vt.: Countryman Press, 1974.

Bela L. Pratt

Born December 11, 1867, Norwich, Connecticut
Died May 18, 1917, Boston

At the age of sixteen Bela Lyon Pratt began his formal training at Yale's School of Fine Arts in New Haven, where he studied under John Ferguson Weir and John Henry Niemeyer. In 1887 he moved to New York City and attended the Art Students League, studying under William Merritt Chase, Kenyon Cox and Augustus Saint-Gaudens, to whom Pratt was an assistant for a brief period. In 1890 Pratt left for Paris to study at the Ecole des Beaux-Arts under Henri Chapu and Alexandre Falguière until 1892 when he returned to the United States. The following year he became nationally known through *The Genius of*

Navigation, his two colossal groups at the Columbian Exposition in Chicago. Pratt then moved to Boston, where he taught at the Museum of Fine Arts school. He spent most of his life in Boston, carving portrait busts, reliefs and architectural decorations (including those for the Pan-American Exposition in Buffalo in 1901), but he also received several commissions for public sculpture in Washington, D.C., which he completed during 1895–96, including the large statue *Philosophy,* the six-figure spandrel *Literature, Science, Art,* and the ceiling medallions *Four Seasons,* all for the Library of Congress. Several of his best-known works are in Boston, among them the figures *Art* and *Science* (1911) at the Boston Public Library and the statue of Edward Everett Hale (1912) in the Boston Public Garden. Pratt was elected an associate member of the National Academy of Design in 1910.

Craven.

Goode, James M. *The Outdoor Sculpture of Washington, D.C.: A Comprehensive Historical Guide.* Washington: Smithsonian Institution Press, 1974.
*Taft.

Kenneth Price

Born February 16, 1935, Los Angeles

Kenneth Price attended the Chouinard Art Institute in 1953–54 and the University of California, Los Angeles, in 1955, and received a B.F.A. from the University of Southern California in 1956. Attending the Otis Art Institute in 1957–58, Price met the sculptor-ceramist Peter Voulkos, who became a major influence. In 1959 Price received an M.F.A. from the New York State College of Ceramics at Alfred University. His earliest works were eccentrically modeled cups with vibrant, often garish color combinations, which he achieved through the use of paint or lacquer as well as glaze. His dome- or mound-shaped pots and jars of the 1950s evolved into a series of egglike shapes with hard outer cases and variously shaped orifices that reveal fingerlike protrusions, as in *B. T. Blue* (1963). These pieces incorporate intense color combinations and biomorphic and sexually-associative forms. As a parallel activity to the "eggs," Price continued to make cups and began to adorn them with a repertoire of tiny animals, as in *California Snail Cup* (1968). Recently Price's interests have included drawings and lithographs, which utilize the imagery of the cups as well as flat, intense Pop-like colors. Since his first one-man exhibition, held in 1960 at the Ferus Gallery in Los Angeles, Price has exhibited regularly in museum group shows and has had one-man exhibitions at the Kasmin and Felicity Samuel galleries, London; the Nicholas Wilder, Gemini G.E.L., and Mizuno galleries, Los Angeles; and the David Whitney and Willard galleries and the Whitney Museum, New York.

California, University of; Irvine, Art Gallery. *Abstract Expressionist Ceramics* (text by John Coplans). [Irvine, 1966]. (Text reprinted in *Artforum,* vol. 5, November 1966, pp. 34–41.)
Gemini G.E.L. *Figurine Cups by Ken Price* (text by Barbara Rose). [Los Angeles, 1970].
Layton, Peter. Pp. 75–76 in "London Commentary," *Studio International,* vol. 179, February 1970.

*Los Angeles County Museum of Art, Contemporary Art Council. *Robert Irwin/Kenneth Price* (essay on Price by Lucy R. Lippard). Los Angeles, 1966.
Ratcliff, Carter. P. 50 in "New York Letter," *Art International,* vol. 15, March 20, 1971.
Seattle Art Museum. *Ten from Los Angeles* (text by John Coplans). Seattle, 1966.

A. Phimister Proctor

Born September 27, 1860, Bozanquit, Ontario, Canada
Died September 5, 1950, Palo Alto, California

Alexander Phimister Proctor's nomadic childhood was spent in Canada, Michigan, Iowa and, from 1871 on, Denver, Colorado, where he directly experienced frontier life and the American wilderness. Best remembered for his sculpture of animals, cowboys and Indians, he was encouraged by his father to study drawing and wood engraving as a teenager in Denver. In late 1885 Proctor left for New York City, where he studied at the National Academy of Design and later at the Art Students League. For the Columbian Exposition of 1893 in Chicago he modeled thirty-seven animal figures and the equestrian statues of a cowboy and an Indian, winning a designer's medal for his many contributions to the fair. After study in Paris at the Académie Julian under the sculptor Denys Puech, Proctor returned to America in 1894 to model the horses for Augustus Saint-Gaudens's equestrian statues of Generals Logan and Sherman. Between 1896 and 1900 Proctor made two more trips to Paris, the first on a Rinehart Scholarship (Proctor and Hermon MacNeil were its inaugural recipients), the second on a commission for the *Quadriga* for the International Exposition of 1900, where the sculpture won a gold medal. In 1907 Proctor completed the lions for the McKinley Monument in Buffalo, New York, and his tigers (1909) for Princeton University earned him the gold medal of the Architectural League of New York. Since the mid-1880s Proctor divided his time in America between New York and Connecticut and several western states. During his later western travels he executed many large works, including the *Bronco Buster* (1918) and *On the War Trail* (1920) for Denver's Civic Center Plaza; *The Circuit Rider* (1922) for Salem, Oregon; and for Kansas City, Missouri, *Pioneer Mother* (1927), which was cast in bronze during Proctor's two-year period as sculptor-in-residence at the American Academy in Rome. His last large-scale sculpture, *Mustangs,* was unveiled on the University of Texas campus two years before his death. In addition to his many monumental works, Proctor was an accomplished sculptor of bas-reliefs and statuettes, such as his bronze *Stalking Panther,* which was presented to Theodore Roosevelt during his last year as president.

*Broder.
Cortissoz, Royal. "Some Wild Beasts Sculptured by A. Phimister Proctor," *Scribner's Magazine,* vol. 48, November 1910, pp. 637–40.
*Craven.
Dial, Scott. "Alexander Phimister Proctor, 1860–1950," *Southwest Art,* vol. 4, May 1975, pp. 60–68.
Dunwiddie, Charlotte. "Alexander Proctor . . . Sculp-

Kenneth Price

A. Phimister Proctor

Robert Rauschenberg

tor in Buckskin," *National Sculptural Review*, vol. 21, Spring 1972, pp. 18–19.

Paladin, Vivian. "A. Phimister Proctor: Master Sculptor of Horses," *Montana, The Magazine of Western History*, vol. 14, Winter 1964, pp. 10–24.

Peixotto, Ernest. "A Sculptor of the West," *Scribner's Magazine*, vol. 68, September 1920, pp. 266–77.

Proctor, Alexander Phimister. *Sculptor in Buckskin: An Autobiography* (Hester Elizabeth Proctor, ed.). Norman, Okla.: University of Oklahoma Press, 1971.

*Proske.

Robert Rauschenberg

Born October 22, 1925, Port Arthur, Texas

After graduating from high school in 1942, Milton Ernest (later known as Robert) Rauschenberg enrolled briefly as a pharmacy student at the University of Texas at Austin. After serving in the navy for 2½ years during World War II, he began his formal art training in 1946 at the Kansas City Art Institute on the G.I. Bill. The following year he left for Paris, where he studied at the Académie Julian. He returned to America to study under Josef Albers at Black Mountain College in North Carolina during 1948–49. Rauschenberg then moved to New York City, married Susan Weil (a New York artist he had met in Paris) and enrolled at the Art Students League, where he studied under Morris Kantor and Vaclav Vytlacil from 1949 to 1950. Rauschenberg's first one-man show was held at the Betty Parsons Gallery, New York, in 1951. Returning to Black Mountain for the summer of 1952, he there became good friends with the avant-garde composer John Cage, whom he had met in New York, and the dancer-choreographer Merce Cunningham; beginning in the 1950s Rauschenberg designed sets, costumes and sometimes lighting for Cunningham's dance company for more than ten years. In the early 1950s Rauschenberg created a group of all white and all black paintings; a number of the latter were collage-paintings in which the paint was applied over newsprint attached to the canvas. These works were shown in his second one-man show, at the Stable Gallery, New York, in 1953. About this time he began to create paintings and constructions that incorporated a widening range of everyday objects into their composition. In 1955 he produced *Bed*, consisting of his paint-splashed pillow, sheet and quilt pulled like canvas over wood stretchers. This was shown in 1958 in Rauschenberg's first of many one-man shows at the Leo Castelli Gallery, New York. During 1955–59 Rauschenberg also created *Monogram*, a stuffed goat (its face painted) encircled by a tire and standing on a painted and collaged platform. Rauschenberg called his assemblages of painting and objects "combines." Since the 1960s he has experimented with silkscreen transfers and lithography, founding the United Press in 1966. His work was awarded first prize at the 1964 Venice Biennale and the Corcoran Gallery's 1965 American Painting Biennial and was shown in retrospectives at the Jewish Museum in 1963 and the Whitechapel Art Gallery, London, in 1964. In recent years Rauschenberg has promoted several collective causes for artists, including Experiments in Art and Technology, royalty legislation and a support system called Change, Incorporated.

Cage, John. "On Robert Rauschenberg, Artist, and His Work," *Metro*, no. 2, May 1961, pp. 37–50.

*Forge, Andrew. *Rauschenberg* (with "Autobiography" by the artist). New York: Harry N. Abrams, [1969].

*_____. *Rauschenberg*. New York: Harry N. Abrams, [1972].

Fort Worth Art Center Museum. *Robert Rauschenberg: Selections* (preface by Henry T. Hopkins). Fort Worth, Tex., 1969.

Hughes, Robert. "Enfant Terrible at Fifty," *Time*, vol. 105, January 27, 1975, p. 60.

*The Jewish Theological Seminary of America, The Jewish Museum. *Robert Rauschenberg* (text by Alan R. Solomon). New York, 1963.

Seckler, Dorothy Gees. "The Artist Speaks: Robert Rauschenberg," *Art in America*, vol. 54, May/June 1966, pp. 73–81, 84.

Tomkins, Calvin. "Profiles: Moving Out," *The New Yorker*, vol. 40, February 29, 1964, pp. 39 ff. (Reprinted in *The Bride and the Bachelors: The Heretical Courtship in Modern Art*, pp. 189–237. New York: The Viking Press, 1965.)

*Walker Art Center. *Robert Rauschenberg: Paintings, 1953–1964* (introduction by Dean Swanson). Minneapolis, 1965.

Man Ray

Copyright © Arnold Newman

Man Ray

Born August 27, 1890, Philadelphia

Man Ray (born Emmanuel Radinski) grew up in New York and graduated from high school in Brooklyn. He started to work as a commercial artist and draftsman while studying at the National Academy of Design, the Art Students League and, after 1912, at the Ferrer Art Center, New York. A visitor to Stieglitz's "291" Gallery and the 1913 Armory Show, Man Ray was especially impressed by Cubism, whose stylistic elements soon began to appear in his paintings. In 1915 he had his first one-man show, of paintings, at the Daniel Gallery, New York; met Marcel Duchamp; and bought his first camera. His natural inclination to invention and iconoclasm further stimulated by his close friendship with Duchamp, Man Ray had explored new techniques in painting, photography and mixed media before 1920. During this period he made his first sculpture, such bronze abstractions as *By Itself I* and *II* (originals, 1918; replicas, 1966). About the same time he made his first objects, Dadaist transmutations of found and incongruously combined elements. An early example is *New York 17* (1917), a nineteen-inch-high wood skyscraper held in a C-clamp; other objects—notably *Cadeau*, an iron with tacks pointing outward from its bottom surface—combine the useful with the injurious. Some of Man Ray's objects, destroyed by visitors to their exhibitions, were re-created later. In 1920 Man Ray began to support himself through photography. That same year he collaborated with Duchamp and Katherine S. Dreier in founding the Société Anonyme, an organization devoted to the collection and exhibition of modern art in the United States. In 1921, after he and Duchamp had published the first

and only issue of *New York Dada*, Man Ray left for Paris, where he immediately joined the Parisian Dada group. He made his first film in 1923 and, participating in the first Surrealist exhibition, at the Galerie Pierre, Paris (1925), fully allied himself with the Surrealist successors to Dada. Throughout the late 1920s and '30s Man Ray exhibited paintings, rayographs and more traditional photographs, collages and sculptural objects in Europe and America. Leaving Nazi-occupied France in 1940, he moved to Hollywood, but in 1951 he returned to France, where he still lives. Man Ray's innumerable one-man shows during the past six decades have included retrospectives at the Los Angeles County Museum in 1966 and the New York Cultural Center in 1975.

*Alexandrian, Sarane. *Man Ray* (Eleanor Levieux, trans.). Chicago: J. P. O'Hara, 1973.

*Los Angeles County Museum of Art. *Man Ray* (introduction by Jules Langsner; essay by Carl Belz; statements by Man Ray and others). Los Angeles, 1966.

Martin, Henry. "Man Ray: Spirals and Indications," *Art International*, vol. 15, May 1971, pp. 60–65.

*Museum Boymans-van Beuningen. *Man Ray* (introduction by R. Hammacher-van den Brande; essay by Alain Jouffroy; bibliography by Arturo Schwarz). Rotterdam, 1971.

Penrose, Roland. *Man Ray*. Boston: New York Graphic Society, 1975.

Ray, Man. *Oggetti d'affezione* [Objects of My Affection] (with an essay and biographical note by Paolo Fossati). Turin: Giulio Einaudi, 1970.

——. *Self-Portrait*. Boston: Little, Brown and Company in association with The Atlantic Monthly Press, 1963.

The New York Cultural Center in association with Fairleigh Dickinson University. *Man Ray: Inventor/Painter/Poet* (essay by Janus [Mario Amaya, trans.] and reprinted article by William Copley). [New York], 1974.

Ribemont-Dessaignes, Georges. *Man Ray*. Paris: Librairie Gallimard, 1924.

Waldberg, Patrick. "Les Objets de Man Ray," *XXe Siècle*, vol. 30, December 1968, pp. 65–80.

Frederic Remington

Born October 1, 1861, Canton, New York
Died December 26, 1909, Ridgefield, Connecticut

In 1878 Frederic Sackrider Remington entered Yale's School of Fine Arts but disliked the school's academic training, which included drawing from antique casts. After his father's death in 1880 Remington left Yale to become a government clerk. In August 1881 he made his first trip to the West, returning after two months with many sketches of frontier life. Receiving his patrimony at twenty-one, he bought a sheep ranch in Kansas, which he sold about a year later, and after two years in Missouri moved to Brooklyn, New York. During 1886 Remington studied at the Art Students League, where J. Alden Weir was his painting teacher. Having finished the semester, Remington returned to the West, which he was to visit at least once each year through the 1890s, following the United States Cavalry in its war against the Indians and recording his impressions of the

western scene. By 1889 Remington had become one of America's best-known magazine illustrators. In 1893 and 1895 the American Art Association Galleries exhibited and auctioned his work; his paintings, however, did not sell well, although *The Bronco Buster*, his first sculpture, exhibited in the 1895 sale, drew favorable reviews. Remington had been introduced to modeling techniques in 1895 by the sculptor Frederic Ruckstull and by October of that year had completed and copyrighted *The Bronco Buster*. With few exceptions Remington's sculpture during the next fourteen years represented cowboys, Indians and the cavalry; his only monumental sculpture, *The Cowboy*, for Fairmount Park, Philadelphia, was unveiled in 1908. When the Henry-Bonnard Foundry burned down in 1898, Remington turned over the casting of his sculpture to the Roman Bronze Works, then the only American foundry using the lost-wax casting method, which permitted the sculptor more freedom and variety of treatment. In 1909 Remington was elected an associate member of the National Academy of Design and moved to Ridgefield, Connecticut, unfortunately only months before he died of appendicitis at the age of forty-eight.

Amon Carter Museum of Western Art. *Frederic Remington* (essay by Peter H. Hassrick). Fort Worth, Tex., n.d.

*Broder.

Card, H. L. *The Collector's Remington*, no. 2: *The Story of His Bronzes, with a Complete Descriptive List*. Woonsocket, R.I.: privately printed, 1946.

——. "Frederic Remington's Bronzes," *The American Scene*, vol. 9, Fall 1964, pp. 48–53.

*Craven.

Edgerton, Giles. "Frederick Remington, Painter and Sculptor: A Pioneer in Distinctive American Art," *The Craftsman*, vol. 15, March 1909, pp. 658–70.

*Hassrick, Peter H. *Frederic Remington: Paintings, Drawings, and Sculpture in the Amon Carter Museum and the Sid W. Richardson Foundation Collections*. New York: Harry N. Abrams, 1973.

*McCracken, Harold. *Frederic Remington: Artist of the Old West*. Philadelphia and New York: J. B. Lippincott Co., 1947.

Wear, Bruce. *The Bronze World of Frederic Remington*. Tulsa: Gaylord, 1966.

George Rickey

Born June 6, 1907, South Bend, Indiana

George Rickey, who spent his childhood and youth in Scotland, had an early aptitude for mechanical devices and their principles — an ability perhaps inherited from his father, a mechanical engineer, or his grandfather, a clockmaker. Rickey attended the Ruskin School of Drawing, Oxford, while also studying modern history at Balliol College, Oxford, where he received his B.A. in 1929 (M.A., 1941). After college he traveled extensively in Europe, staying in Paris for a year to study painting at the Académie André Lhote and at the Académie Moderne under Fernand Léger and Amédée Ozenfant. Rickey taught at the Groton School in Massachusetts for three years, and in 1933 he spent another year in Paris before settling permanently in the United States. In 1937 he

Frederic Remington

Copyright © Arnold Newman

George Rickey

William Rimmer

received the first Carnegie Grant given to an artist, and for the next two years he was artist-in-residence at Olivet College in Michigan. In 1941 he organized the art department at Muhlenberg College in Allentown, Pennsylvania, where he served as chairman until 1948. Although Rickey began his artistic career as a mural and fresco painter, he made his first mobile sculpture in 1945 while serving in the Air Force, and by 1949 he was making Constructivist mobiles, such as *Square and Catenary*, which was exhibited at the Metropolitan Museum in 1951. By the mid-1950s his "useless machines" had become more complex; in 1960, when he moved to a farm in East Chatham, New York, his work became larger in scale, often using simple, elegant blades or "lines" operating on the pendulum principle, as in *Sedge II* (1961), *Two Lines* (1964) and *Peristyle II* (1966), or perfectly engineered rotors and space churners. Rickey has continued to hone his sculpture into a terse imagery of motion through air currents alone, where the movement rather than the form is the aesthetic content. Although his constructions "[have] more in common with clocks than with sculpture," Rickey has expanded on the Constructivist tradition of Naum Gabo and Alexander Calder and remains the major spokesman of kinetic art. In 1966 a retrospective of his work was held at the Corcoran Gallery of Art, Washington, D.C. Also an art historian, Rickey published a comprehensive history of Constructivism in 1967.

*Corcoran Gallery of Art. *George Rickey: Sixteen Years of Kinetic Sculpture* (text by Peter Selz). Washington, 1966.

*Boston, Institute of Contemporary Art. *George Rickey/Kinetic Sculpture* (foreword by Sue M. Thurman; statement by the artist). Boston, 1964.

"George Rickey, Maker of Kinetic Sculpture," *The Baltimore Museum of Art News*, vol. 24, Summer 1961, pp. 10–15.

Indiana University Art Museum. *Noguchi & Rickey & Smith* (foreword by Thomas T. Solley; text by Daniel Mato). Bloomington, 1970.

R[atcliff], C[arter]. *Britannica*, p. 475.

Rickey, George. *Constructivism*. New York: George Braziller, 1967.

———. "The Métier," *Arts Yearbook 8: Contemporary Sculpture* (introduction by William Seitz). New York: The Art Digest, 1965.

William Rimmer

Born February 20, 1816, Liverpool, England
Died August 20, 1879, South Milford, Massachusetts

William Rimmer's father believed himself to be the French dauphin, son of Louis XVI and Marie Antoinette, and transferred this belief and his resulting frustrations to his children, who grew up in Boston. The children also received a royal education from their father, who encouraged William, his eldest, to become an artist. At the age of fifteen, William carved *Despair*, a gypsum statuette modeled after his father, which may be the earliest American sculpture of a male nude and foretells Rimmer's artistic power and originality, undiminished by his lack of formal

art training. Beginning as a youth Rimmer supported himself as a sign and scene painter, soapmaker, lithographer, cobbler (his father's occupation) and, after about 1845, as a self-taught physician. In 1855 he moved to East Milton, Massachusetts. There granite was plentiful, and he began to cut sculpture in it. About 1858 he met the art patron Stephen H. Perkins, for whom Rimmer carved a head of the stoned martyr *St. Stephen*, a granite metaphor for the suffering sculptor. In 1861 Perkins commissioned Rimmer's *Falling Gladiator*, a nude figure for which Rimmer's body served as its only model. Although its execution was hampered by Rimmer's technical ignorance of sculpting in clay, its anatomical veracity provoked charges that it was cast from life when exhibited at the 1862 Paris Salon. First delivered in late 1861, Rimmer's lectures in New England and New York on the representation of the human figure and anatomy brought him greater praise during his lifetime than did his sculptures or visionary paintings. Rimmer's relatively happy residence in New York (1866–70) ended when he lost the directorship of the women's school at Cooper Union. He endured further disappointment when his last sculpture commission, *Faith* (1875), was drastically altered before its installation on the Pilgrim Monument in Plymouth, Massachusetts. Nine months after his death following a breakdown, the Boston Museum honored Rimmer with a memorial exhibition.

Bartlett, Truman H. *The Art Life of William Rimmer: Sculptor, Painter, and Physician*. Boston: James R. Osgood and Company, 1882.

Gardner, Albert T. "Hiram Powers and William Rimmer — Two Nineteenth-Century American Sculptors," *Magazine of Art*, vol. 36, February 1943, pp. 42–47.

*New York, The Metropolitan Museum of Art. *Nineteenth-Century America: Paintings and Sculpture* (introduction by John K. Howat and John Wilmerding; texts by John K. Howat, Natalie Spassky and others). [New York, 1970]; distributed by New York Graphic Society, n.p.

Rimmer, William. *Art Anatomy*. Boston: Little, Brown, and Company, 1877; New York: Dover Publications, 1962 (reprint).

Sarnoff, Charles A. "The Meaning of William Rimmer's *Flight and Pursuit*," *The American Art Journal*, vol. 5, May 1973, pp. 18–19.

*Thorp, Margaret Farrand. *The Literary Sculptors*. Durham, N.C.: Duke University Press, 1965.

*Whitney Museum of American Art and Museum of Fine Arts, Boston. *William Rimmer 1816–1879* (text by Lincoln Kirstein). N.p., [1946].

William Rinehart

Born September 13, 1825, near Union Bridge, Maryland
Died October 28, 1874, Rome

Disinterested in school and farm work, William Henry Rinehart was caught one day by his father modeling a bust of his mother and was put to work cutting, polishing and lettering stone in a marble quarry on his father's farm. In 1846 Rinehart went to Baltimore and was apprenticed at the city's largest stonecutting firm, where he progressed to foreman after two years. During this time he repaired

William Rinehart

the mantelpiece of the wealthy art collector William T. Walters, who later became Rinehart's chief patron. Concurrently, Rinehart studied at night at the Maryland Institute of the Mechanic Arts, which in 1851 gave him a medal for his small stone relief, a copy of a nonclassical painting, Teniers's *The Smokers*. Rinehart's earliest documented exhibition was held at the Maryland Historical Society in 1853; that year his "statuary" also received a silver medal from the Maryland Institute. Seeking further study, Rinehart spent two years in Florence, returning to Baltimore in 1857, in William Rusk's words, "not a stonecutter, but a sculptor." Rinehart brought back with him two pairs of marble reliefs, including *Morning* (also called *Day*) and *Night* (or *Evening*), which show affinities to Thorvaldsen's neoclassical reliefs as well as to the rococo (Gerdts, see bibliography). After a year in Baltimore Rinehart moved to Rome, where, excepting trips to America, he lived for the rest of his life, a favorite host to wealthy American travelers. He followed popular taste by modeling ideal sculptures in the neoclassical manner, but in his memorials and portraits, notably his seated bronze of Chief Justice Roger B. Taney (1872), he often achieved a naturalism not admitted to his other work. Largely remembered for his classicized *Clytie* (marble, 1872), *Latona and Her Children* (1871–74) and the sentimental *Sleeping Children* (1859), Rinehart had, by 1866, also completed his models for two pairs of bronze doors for the United States Capitol, a commission left unfinished by Thomas Crawford. After Rinehart's death much of his estate was left to appreciate until the 1890s when the resulting fund was used to establish the Rinehart School of Sculpture at the Maryland Institute and the Rinehart Scholarship to enable young sculptors to study in Paris or Rome.

C[raven], W[ayne]. *Britannica*, p. 475.

*Craven.

*Gerdts.

*Ross, Marvin Chauncey and Anna Wells Rutledge. *A Catalogue of the Work of William Henry Rinehart, Maryland Sculptor, 1825–1874.* Baltimore: The Peabody Institute and The Walters Art Gallery, 1948.

R[usk], W[illiam] S[ener]. *DAB*, vol. 15, pp. 615–17.

———. *William Henry Rinehart, Sculptor.* Baltimore: Norman T. A. Munder, Publisher, 1939.

Samuel Anderson Robb

Born December 16, 1851, New York City
Died May 5, 1928, New York City

Samuel Anderson Robb, the son of Scottish parents who had immigrated to New York in 1849, was apprenticed to Thomas V. Brooks, a ship carver, sometime after the Civil War. After five years with Brooks he went to work for William Demuth, also a carver. In 1869 Robb enrolled as a part-time student at the National Academy of Design, from which he received a certificate in 1873. He also studied at the "Free Night School of Science and Art" at Cooper Union. Shortly after his marriage to Emma Jane Pelham on June 14, 1876, Robb opened his own carving shop on Canal Street in Manhattan. His wife died in 1878,

six months after the birth of their only child, Clarence, who later became one of his father's assistants. In 1881 Robb married Agnes Loudon. From 1888 until 1903 Robb's shop was located at 114 Centre Street. During this period he became the most prolific wood-carver in the area, producing carousel and cigar-store figures as well as carvings for circus wagons. However, new restrictions against crowding the sidewalks with shop figures and the advent of the electric sign caused a decline in the carving business during the early 1900s. Therefore, when Robb and his family moved to 156th Street in Manhattan in 1910, he was forced to work without assistants for the first time. In 1917 Robb went to Philadelphia, where he was employed by the Ford Motor Company until 1919. He then returned to New York, where he remained until his death.

*Bishop, Robert. *American Folk Sculpture.* New York: E. P. Dutton & Co., 1974.

*Christensen, Erwin O. *Early American Wood Carving.* Cleveland: World Publishing Company, 1952; New York: Dover Publications, 1972 (reprint).

*Fried, Frederick. *Artists in Wood: American Carvers of Cigar-Store Indians, Show Figures, and Circus Wagons.* New York: Clarkson N. Potter, 1970; distributed by Crown Publishers.

*Lipman, Jean. *American Folk Art in Wood, Metal and Stone.* N.p.: Pantheon, 1948; New York: Dover Publications, 1972 (reprint).

Weitenkampf, F. W. "Lo, the Wooden Indian: The Art of Making Cigar-Shop Signs," *The New York Times*, August 3, 1890, p. 13.

Hugo Robus

Born May 10, 1885, Cleveland
Died January 15, 1964, New York City

Son of a Cleveland iron molder, Hugo Robus received his earliest training as a jewelry craftsman. He attended the Cleveland School of Art from 1904 to 1908 before moving to New York City, where he continued his studies at the National Academy of Design. From 1912 to 1914 Robus studied painting in Paris at the Académie de la Grande Chaumière, and one winter he entered the sculpture class of Antoine Bourdelle to study form. Returning to New York in 1915, he continued to paint; his expressive treatment of the human form in his *Bathers, or Composition of Nudes* (1917) can be seen as a forerunner of his later sculptural handling. Turning to sculpture in 1920, Robus worked in isolation for the next decade, translating his study of form into such smoothly modified and rhythmic pieces as *The General* (1922), *Walking Figure* (1923) and the bustlike *Despair* (1927). In 1933 his lyrical, antic *Dawn* was exhibited in the Whitney Museum Sculpture Annual, but it was not until the 1950s that Robus was able to support his family through the sale of his sculpture. During this time he received various awards, including the Widener Gold Medal of the Pennsylvania Academy of the Fine Arts, 1950, and the Alfred B. G. Steel Memorial Prize, Pennsylvania Academy, 1953. Robus taught at Columbia University summer sessions intermittently in the 1940s and '50s, and at the Brooklyn Museum Art School and Hunter College. In all his

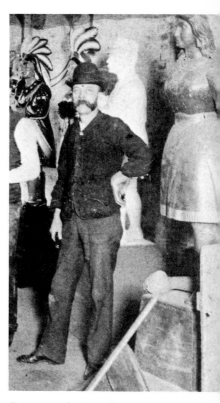

Samuel Anderson Robb

Hugo Robus

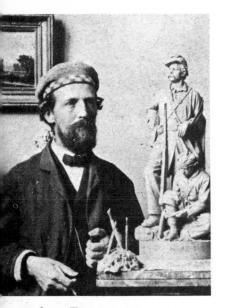

John Rogers

Randolph Rogers

sculptures — from the solemn *Passing Years* (1952), the subtly humorous *Three Caryatids Without a Portico* (1954), the peaceful *Meditating Girl* (1958), to the winsome *Three Graces* (1963) — Robus gave life to what William Zorach described as "the nostalgic mysteries of our inner emotions and dreams" expressed by Robus's work. Robus had one-man exhibitions at the Grand Central Galleries, New York, 1946 and 1949; the Corcoran Gallery of Art, 1958; a retrospective at the Whitney Museum, 1960 (circulated by the American Federation of Arts); and the Forum Gallery, New York, 1963 and 1966.

*The American Federation of Arts. *Hugo Robus* (text by Lincoln Rothschild). New York, 1960.

Craven.

Cross, Louise. "The Sculpture of Hugo Robus," *Parnassus*, vol. 6, April 1934, pp. 13–15.

Forum Gallery. *Hugo Robus* (preface by Lloyd Goodrich). [New York, 1966].

"Hugo Robus," *The New York Times*, January 15, 1964, p. 31 (obituary).

"José de Creeft and Hugo Robus in Retrospect," *Arts*, vol. 34, June 1960, pp. 50–51.

Robus, Hugo. "The Sculptor as Self-Critic," *Magazine of Art*, vol. 36, March 1943, pp. 94–98.

John Rogers

Born October 30, 1829, Salem, Massachusetts
Died July 26, 1904, New Canaan, Connecticut

Although descendant from two wealthy and distinguished Massachusetts families, John Rogers, Jr., was sent to Boston's English High School for a nonclassical education after his father's financial losses precluded his going to college. Leaving school in 1846, Rogers worked for the next nine years chiefly as a machinist and draftsman in the Northeast and as a master railroad mechanic in Hannibal, Missouri. Beginning in 1849 Rogers modeled many small clay figures and genre groups for his own amusement, but it was not until he lost his railroad job in the Panic of 1857 that he decided to become a professional sculptor. Subsidized by relatives, Rogers went to Paris in 1858 intending to study there for two to three years, but after a disappointing two months as a pupil of Antoine Laurent Dantan, he left to study in Rome. There he studied for an equally short time under the English sculptor Benjamin Edward Spence, but again finding his own simple naturalism and belief in the primacy of narrative in conflict with prevailing neoclassical taste, Rogers returned to America in April 1859 and found work as a draftsman in Chicago. Encouraged, however, by the reception his clay group *Checker Players* received at a bazaar, Rogers decided to try his luck as a sculptor in New York City. The Civil War providing him with several marketable subjects, Rogers's quarter-century of success began in 1863 with his production of *Union Refugees*, the sculpture that won him election to the National Academy of Design as an academician. After learning how to reproduce his statuette groups in plaster, Rogers patented his designs and became the first American to mass-produce sculpture for a popular market. By 1893 he had sold between seventy and eighty thousand reproductions for an average price of $14.25. All of these groups depicted human figures enacting episodes from everyday life or from literature. Toward the end of his career, Rogers attempted several monumental works, and his penultimate sculpture, a life-size statue of Abraham Lincoln, earned him a bronze medal at the Columbian Exposition in Chicago in 1893, the year a crippling illness forced his retirement.

Barck, Dorothy C. "Rogers Groups in the Museum of the New-York Historical Society," *The New-York Historical Society Quarterly Bulletin*, vol. 16, October 1932, pp. 67–86.

Bourdon, David. "An Intimate Regard for Everyday Life Made a Homely Art," *Smithsonian*, vol. 6, May 1975, pp. 51–57.

Dyer, Walter A. "The Sculptures of John Rogers," *Antiques*, vol. 9, January 1926, pp. 23–27.

_____. "John Rogers, Sculptor of American Subjects," *Historical Collections of the Essex Institute*, vol. 53, October 1917, pp. 289–96.

Orton, Vrest. *The Famous Rogers Group, A Complete Checklist and Collectors' Manual*. N.p., 1960.

Priest, Elizabeth. "The Rogers Groups," *American Artist*, vol. 20, May 1956, pp. 32–33, 58–62.

*R[usk], W[illiam] S[ener]. *DAB*, vol. 8, pp. 102–3.

Smith, Chetwood and Mrs. Chetwood Smith. *Rogers Groups: Thought and Wrought by John Rogers*. Boston: Charles E. Goodspeed & Co., 1934.

Wall, A. J. "The John Rogers Group," *The New-York Historical Society Quarterly Bulletin*, vol. 21, January 1937, pp. 45–56.

Wallace, David H. *John Rogers: The People's Sculptor*. Middletown, Conn.: Wesleyan University Press, 1967.

Randolph Rogers

Born July 6, 1825, Waterloo, New York
Died July 29, 1892, Rome

By the age of nine Randolph Rogers had moved to the frontier town of Ann Arbor, Michigan, and within three years his formal schooling had ended. A baker's apprentice and dry goods clerk, Rogers also designed several woodcut advertisements for newspapers during 1843–47. Hoping to find work with an engraver, Rogers went to New York City about 1847. Although he was only able to get a job in another dry goods store, his employers discovered his talent for modeling busts and subsidized his trip in 1848 to Italy for training; thus Rogers studied in Florence under the romantic neoclassical sculptor Lorenzo Bartolini until 1850. By 1851 Rogers had established his own studio in Rome, where he settled for the rest of his life. During the 1850s Rogers created his best-known works, generally of sentimental genre or literary subjects: He modeled (he never learned how to carve in marble) his first large ideal sculpture, *Ruth Gleaning*, in 1853, and during 1855–56 created his most replicated work, *Nydia, the Blind Girl of Pompeii*, based on Bulwer-Lytton's 1834 novel. Replicas of these two sculptures, and of Rogers's *Atala and Chactas* (c. 1854), derived from Chateaubriand's literary romance, were exhibited in Philadelphia's Centennial Exposition in 1876. Receiving his first public commission in 1854, Rogers created a statue of John Adams for Mount Auburn Cemetery, Cambridge, Massachusetts. However, Rogers's reputation for

public sculpture derives more from his work for the United States Capitol — his bronze *Columbus Doors* (1855–60), whose schema of nine relief panels and sculptural adornment were inspired by Ghiberti's doors for the Florence Baptistery. In addition to portrait and ideal sculptures, Rogers executed several Civil War monuments in the 1860s and '70s, basing their designs on Thomas Crawford's Washington Monument, Richmond, Virginia, which Rogers had completed after Crawford's death. The first American to be elected to Rome's Accademia di San Luca (1873), Rogers had his career cut short by a paralytic stroke ten years before his death.

*Craven.

D'Ooge, Martin L. *Catalogue of the Gallery of Art and Archaeology of the University of Michigan* (3rd ed.). Ann Arbor, Mich., 1906.

Rogers, Millard F., Jr. "Nydia, Popular Victorian Image," *Antiques*, vol. 97, March 1970, pp. 374–77.

*____. *Randolph Rogers: American Sculptor in Rome*. N.p.: The University of Massachusetts Press, 1971.

R[usk], W[illiam] S[ener]. *DAB*, vol. 16, pp. 107–8.

Theodore Roszak

Born May 1, 1907, Poznan, Poland

At the age of two Theodore J. Roszak immigrated with his family to the United States, settling in Chicago, and began to draw five years later. In 1922 Roszak enrolled in evening classes at the Art Institute of Chicago, switching to day classes in painting and lithography immediately after graduation from high school in 1925. Drawn to New York City in 1926, Roszak studied at the National Academy of Design, took lessons with George Luks and attended philosphy classes at Columbia University, but in 1927 he returned to his studies at the Art Institute of Chicago. Awarded an American Traveling Fellowship in 1928, he visited eastern museums and experimented in lithography in Woodstock, New York, experiments which led to his first one-man exhibition, of lithographs, at the Allerton Gallery, Chicago, in 1928. A major turning point in Roszak's career came in 1929 when he received a two-year Anna Louise Raymond Fellowship for European Study, enabling him to establish a studio first in Prague and later in Paris, where he discovered European modernism. He received a two-year Tiffany Foundation grant upon his return to New York in 1931, and for the next two years he studied design and toolmaking and experimented with sculptures and reliefs in plaster and clay. Making his earliest three-dimensional constructions in 1936, he moved even closer to Constructivist ideas while teaching at the Design Laboratory, New York, during 1938–40. (He also taught at Sarah Lawrence College during 1941–56 and Columbia University during 1970–72.) Starting in 1945 Roszak's geometric sculpture took on freer shapes and more varied surfaces, as in the *Spectre of Kitty Hawk* (1946–47), and semiabstract allusions to wings, bones and rocks appeared in his work. His drive toward more monumental expression is reflected in such public commissions as the spire and bell tower for Eero Saarinen's Chapel at M.I.T. (1956), a thirty-seven-foot-wide eagle for the facade of the United States

Embassy in London (1960) and an outdoor sculpture for the new Public Health Laboratory, New York (1968). In December 1974 Roszak had a one-man show at the Pierre Matisse Gallery, New York, where he has been exhibiting since 1951.

Krasne, Belle. "A Theodore Roszak Profile," *Art Digest*, vol. 27, October 15, 1952, pp. 9, 18.

New York, The Museum of Modern Art. *New Images of Man* (text by Peter Selz; quotations from C. G. Jung and the artist). New York, 1959.

Pierre Matisse Gallery. *Theodore Roszak Sculpture* (statements by the artist, and Lionel Abel). New York, [1962].

Roszak, Theodore. "In Pursuit of an Image," *Quadrum*, vol. 2, November 1956, pp. 49–60.

____. "Some Problems of Modern Sculpture," *Magazine of Art*, vol. 42, February 1949, pp. 53–56.

Sawin, Martica. "Theodore Roszak: Craftsman and Visionary," *Arts*, vol. 31, November 1956, pp. 18–19.

*Walker Art Center. *Theodore Roszak* (text by H. Harvard Arnason). Minneapolis, 1956.

____. *Twentieth-Century Sculpture, Walker Art Center: Selections from the Collection* (introduction by Martin Friedman). Minneapolis, n.d.

Theodore Roszak

William Rush

Born July 4, 1756, Philadelphia
Died January 17, 1833, Philadelphia

As a boy William Rush learned the art of wood carving from his father, a ship's carpenter, and in 1771 he became an apprentice to the English figurehead carver Edward Cutbush. By the time Rush had served in the American Revolution, he was already a well-known figurehead carver, and sometime before the end of the war he had opened his own shop account. In his Front Street shop Rush employed several apprentices to assist him in the initial stages of "roughing out" the wood, and soon he gained an international reputation for figureheads such as his earliest known work, *Indian Trader* (c. 1789), for the ship *William Penn*, and the seated *River God* (c. 1793) for the East India ship *Ganges*. Often referred to as the first native American sculptor, Rush was the first wood-carver to allude to movement in his figureheads, and all of his work possessed a refreshing vitality hitherto unknown in American sculpture. About 1789 Rush began to model in clay, and there is evidence that he studied modeling, probably between 1789 and 1793, with Joseph Wright, the son of the wax modeler Patience Wright. In 1794 Rush joined Charles Willson Peale (his lifelong friend) and Giuseppe Ceracchi to found The Columbianum, a drawing school in Philadelphia, which was disbanded in 1798 after a controversy over the morality of drawing from life models (a cause Rush and Peale championed). In 1805 Rush was among the founders of the Pennsylvania Academy of the Fine Arts, and in 1810 he and Peale became the only artists to serve as directors, a position Rush held until his death. Rush's first venture into true sculpture produced the wood figures *Comedy* and *Tragedy* (1808) for the New Theatre on Chestnut Street. About 1809 he completed his most famous work, the fountain sculpture for the Centre Square Water Works, *Water Nymph*

William Rush

Charles M. Russell

and Bittern (cast in bronze in 1854 and placed in Fairmount Park). About 1811 — by now adept in clay, and perhaps inspired by the portrait busts of Jean Antoine Houdon, who had visited Philadelphia in 1785 — Rush began to model naturalistic busts of Philadelphia luminaries in plaster and terra-cotta. Having only had access to *The Artist's Repository, or an Encyclopedia of the Fine Arts* (1808) and replicas of European masterpieces at the Pennsylvania Academy, Rush successfully made the transition from artisan to sculptor in such allegorical works as *Faith, Hope* and *Charity* (c. 1811) and *Schuylkill Chained* and *Schuylkill Freed* (c. 1828) for the Chestnut Street arch of Independence Hall.

A[dams], A[deline]. *DAB*, vol. 16, pp. 234–35.

C[raven], W[ayne]. *Britannica*, pp. 488–89.

*Craven.

Hendricks, Gordon. "Eakins's *William Rush Carving His Allegorical Statue of the Schuylkill*," *The Art Quarterly*, vol. 31, Winter 1968, pp. 382–404.

Pennsylvania Museum of Art. *William Rush 1756–1833: The First Native American Sculptor* (introduction by William Rush Dunton, Jr.; text by Henri Marceau). Philadelphia, 1937.

Charles M. Russell

Born March 19, 1864, Oak Hill, Missouri
Died October 24, 1926, Great Falls, Montana

Charles Marion Russell, a self-taught painter and sculptor who began modeling animals in clay as a child of four, came to be known as "the cowboy artist." Just before his sixteenth birthday, Russell traveled to the Montana Territory for a visit but settled there permanently, living with a trapper for two years, working as a cowboy for another eleven. Meanwhile he modeled clay animals and began painting his observations of the Wild West, the subject of his art until his death. After receiving William Niedringhaus's commission for several paintings in 1893, Russell devoted himself full-time to working as an artist. Upon his marriage three years later, his wife successfully took over the promotion and sale of his works. Usually carrying a ball of beeswax in his pocket, Russell initially made small wax or clay models only to amuse his friends, or to help him in composing his paintings. However, about 1898–99 he had his medallion *Old-Man Indian* cast in bronze for sale. Hoping to sell his paintings and illustrations, the Russells visited New York City in the winter of 1903/4. There Russell modeled *Smoking Up* — his first statue to be cast in bronze — depicting a drunken cowboy shooting up the town. While in New York City the following winter, Russell modeled three additional statuettes — *Buffalo Hunt, Counting Coup* and *Scalp Dance*. During Russell's lifetime fifty-three of his original models, all small, all of western genre and animal subjects, were cast in bronze. However, unlike his popularly reproduced paintings, very few of his sculptures were available to public viewing. Three years after his death, Russell was chosen to represent his adopted state of Montana in Statuary Hall in Washington, D.C. When John B. Weaver's portrait statue of Russell, standing with palette in hand, was finally accepted for installation in 1957, Russell was the only one of forty-two figures so memorialized by their states to have achieved his fame primarily as an artist.

*Broder.

*Los Angeles County Museum of Art. *The American West: Painters from Catlin to Russell* (by Larry Curry; foreword by Archibald Hanna). New York: The Viking Press, 1972.

McCracken, Harold. *The Charles M. Russell Book: The Life and Works of the Cowboy Artist.* Garden City, N.Y.: Doubleday and Company, 1957.

Meyer, Jane. "The Russell Gallery at Great Falls," *American Artist*, vol. 30, November 1966, pp. 26–33, 65–66.

R. W. Norton Art Gallery. *Artistry in Silver: An Exhibition of Sculpture by Charles Marion Russell (1864–1926).* Shreveport, La., 1970.

*Renner, Frederic G. *Charles M. Russell: Paintings, Drawings and Sculpture in the Amon Carter Museum* (foreword by Ruth Carter Johnson), rev. ed. New York: Harry N. Abrams in association with the Amon Carter Museum of Western Art, 1974.

Rosenstein, Harris. "Painters of the Purple Sage," *Art News*, vol. 67, Summer 1968, pp. 28–29, 62–65.

Russell, Charles M. *Paper Talk: Illustrated Letters of Charles M. Russell* (introduction and commentary by Frederic G. Renner). Fort Worth, Tex.: Amon Carter Museum of Western Art, 1962.

Augustus Saint-Gaudens

Born March 1, 1848, Dublin
Died August 3, 1907, Cornish, New Hampshire

Augustus Saint-Gaudens was brought to America as an infant by his parents, who settled in New York City. Even as a boy Saint-Gaudens was determined to become an artist: at the age of thirteen he became an apprentice to Louis Avet and in 1864 to Jules Le Brethon, both cameo cutters. While studying with LeBrethon, Saint-Gaudens also attended evening drawing classes, first at Cooper Union and later at the National Academy of Design. In 1867 he left for Paris, where he began study at the Petit Ecole and continued his training at the Ecole des Beaux-Arts under François Jouffroy. Impelled by the Franco-Prussian War, Saint-Gaudens went to Rome in 1870; there he set up his first professional studio and developed his admiration for early Renaissance sculpture. He returned to New York in 1872, obtained several commissions and went back to Rome in 1873. Two years later he was once again in New York, where he established a studio and met John LaFarge, Stanford White and Charles McKim, with all of whom he later was to work on many commissions. From this time on Saint-Gaudens's naturalistic portraits, commemorative statues and low-relief sculpture brought him continuous success and were instrumental in establishing the influence of the Beaux-Arts style in American sculpture during the final decades of the 19th century. In concert with others opposed to the policies of the National Academy of Design, Saint-Gaudens was a founder of the Society of American Artists in 1877. Upon receiving commissions for the Farragut and Randall monu-

Augustus
Saint-Gaudens

ments, Saint-Gaudens left again for Europe the following year and worked there for two years. He then returned to New York, where he established the studio he was to maintain until 1897 and completed his Adams (1886–91) and Shaw (1884–97) memorials. In 1890 Saint-Gaudens was elected an academician of the National Academy of Design. About two years earlier he had begun to teach at the Art Students League, discontinuing this affiliation when he made his last trip to Paris in 1897. During his stay, which lasted until 1900, he finished his Sherman Monument almost entirely. The completed work was awarded a *grand prix* at the Paris Exposition of 1900 and a gold medal of honor at the Pan-American Exposition, Buffalo, 1901, before it was unveiled in Central Park, New York, in 1903. After Saint-Gaudens's death four years later, Aspet — his studio and home in Cornish, New Hampshire — was maintained as a memorial and in 1964 declared a national historic site.

Cortissoz, Royal. *Augustus Saint-Gaudens*. Boston and New York: Houghton Mifflin and Company, 1907.

*Craven.

Dryfhout, John H. *Saint-Gaudens; Catalogue Raisonné*. University Press of New England, forthcoming.

Gardner.

Saint-Gaudens, Homer, ed. *The Reminiscences of Augustus Saint-Gaudens*, 2 vols. London: Andrew Melrose, 1913; New York: Garland Publishing, due 1976 (reprint).

*Smithsonian Institution, The National Portrait Gallery. *Augustus Saint-Gaudens: The Portrait Reliefs* (foreword by Marvin Sadik; introduction by John H. Dryfhout; and catalogue by John H. Dryfhout and Beverly Cox). Washington, 1969.

Tharp, Louise Hall. *Saint-Gaudens and the Gilded Era*. Boston and Toronto: Little, Brown and Company, 1969.

Lucas Samaras

Born September 14, 1936, Kastoria, Greece

Lucas Samaras settled with his family in New Jersey in 1948, bringing with him childhood memories of World War II and civil war in Macedonian Greece. He became an American citizen in 1955 and that year enrolled in Rutgers University, where he studied with Allan Kaprow, joined George Segal's sketch club and acted in plays (in 1960 he would study acting at the Stella Adler Theatre Studio). Upon receiving a B.A. and a Woodrow Wilson Fellowship, Samaras pursued graduate study in art history, specializing in Byzantine art, at Columbia University from 1959 to 1962. His early works, of the years 1958–62, include pastels, drawings, paintings and figurative sculptures made from rags dipped in plaster. During 1960–61 Samaras created roughly textured boxes, the first of many in what became his best-known three-dimensional form, and reliefs whose webbings of aluminum paint trap forks and spoons against wooden boards. Throughout the 1960s and into the '70s Samaras's imagination yielded similarly incongruous ideas in a profusion of bizarre and often sinister assemblages. He often treated ordinary objects serially, designing an array of variant, always

unusable and sometimes harmful, books, chairs, eye glasses and table settings. Samaras also performed in the Happenings of Kaprow, Robert Whitman and Claes Oldenburg. The first Happening took place in 1959 (Samaras was a participant) at the short-lived Reuben Gallery, where Samaras had his first one-man New York exhibition the same year. Although Samaras did not create his own Happenings, Kim Levin proposes that his early writings, such as "Shitman" (1961) and "Killman" (1963) can be seen as scenarios for imaginary Happenings and are verbal sources for much of his later visual imagery. He created his first environmental work in 1964 at the Green Gallery, New York — a reconstruction of his bedroom in his New Jersey home. A second environmental work, *Mirror Room*, which can be seen as an enlargement of his boxes, was fabricated commercially and exhibited at the Pace Gallery, New York, in 1966 and in Samaras's retrospective at the Whitney Museum in 1972. During the last five years much of his artistic output has consisted of polaroid self-portraits and other photographic expression.

*Alloway, Lawrence. *Samaras: Selected Works 1960–1966*. New York: The Pace Gallery, 1966.

*Chicago, Museum of Contemporary Art. *Lucas Samaras: Boxes* (essay by Joan C. Siegfried). Chicago, 1971.

*Levin, Kim. "Eros, Samaras and Recent Art," *Arts Magazine*, vol. 47, December [1972]/January 1973, pp. 51–55.

*_____. *Lucas Samaras*. New York: Harry N. Abrams, 1975.

"A Reflective Artist Takes a Peculiar Slant on the World," *Smithsonian Magazine*, vol. 3, February 1973, pp. 72–77.

Samaras, Lucas. "Autopolaroid," *Art in America*, vol. 58, November/December 1970, pp. 66–83.

_____. *Samaras Album: AutoInterview, AutoBiography, AutoPolaroid*. New York: Whitney Museum of American Art and Pace Editions, 1971. (Published in regular and deluxe editions.)

Waldman, Diane. "Samaras Reliquaries for St. Sade," *Art News*, vol. 65, October 1966, pp. 44–46.

*Whitney Museum of American Art. *Lucas Samaras* (foreword by Robert Doty; text by the artist). New York, 1972.

Lucas Samaras

Charles A. L. Sampson

Born 1825, Boston
Died January 1, 1881, Bath, Maine

Charles A. L. Sampson worked in Boston until 1848, when he moved to Bath, Maine. There he was apprenticed to G. B. McLain, a local ship carver. In 1852 Sampson opened his own carving shop in Bath, where he remained for most of his life. During the Civil War he served as a lieutenant colonel in the Third Maine Infantry, accompanied by his wife, who was an army nurse. In the years following the Civil War, the city of Bath became one of the leading centers for shipbuilding, and Sampson's business expanded. He is known to have carved many billet heads and other ship decorations and is believed to have carved almost thirty figureheads. Only four of the figureheads are known to exist today.

Morton L. Schamberg

George Segal

Copyright © Arnold Newman

Baker, William A. *A Maritime History of Bath, Maine, and the Kennebec River Region.* Bath, Me.: Marine Research Society of Bath, 1973.

*Brewington, M. V. *Ship Carvers of North America.* Barre, Mass.: Barre Publishing Company, 1962; New York: Dover Publications, 1972 (corrected republication).

*Christensen, Erwin O. *Early American Wood Carving.* Cleveland: World Publishing Company, 1952; New York: Dover Publications, 1972 (reprint).

*Lipman, Jean. *American Folk Art in Wood, Metal and Stone.* N.p.: Pantheon, 1948; New York: Dover Publications, 1972 (reprint).

*Pinckney, Pauline A. *American Figureheads and Their Carvers.* New York: W. W. Norton & Company, 1940; Port Washington, N.Y.: Kennikat Press, 1969 (reprint).

Morton L. Schamberg

Born October 15, 1881, Philadelphia
Died October 13, 1918, Philadelphia

Morton Livingston Schamberg attended the University of Pennsylvania from 1899 to 1903 and received a bachelor's degree in architecture. After graduation he began to study painting under William Merritt Chase at the Pennsylvania Academy of the Fine Arts, which he attended until 1906; during his first year there he met Charles Sheeler, another first-year student, and they remained close friends until Schamberg's death. As a member of a group of students, Schamberg traveled to Europe with Chase during the summers of 1902–4. After leaving the Pennsylvania Academy in 1906, Schamberg spent about a year in Paris, where he was impressed by European modernism. Upon his return to Philadelphia, he shared a studio with Sheeler for several years. During 1908–9 they traveled in Europe, where they studied the work of leading avant-garde artists. After returning to Philadelphia, Schamberg there had his only one-man exhibition during his lifetime, at the McClees Gallery in 1910. To help support himself, he experimented with photography in 1913; that year five of his paintings appeared in the Armory Show. In 1916, influenced by Marcel Duchamp and Francis Picabia, whom he had met in the collector Walter Arensberg's New York apartment, Schamberg began to paint Precisionist abstractions of machine forms and to experiment with assemblage. He succeeded in combining this dual interest, although not in a Precisionist manner, when he created *God* (c. 1917) — a construction of a plumbing trap set in a miter box — which is Schamberg's only known sculpture. Two days before his thirty-seventh birthday, Schamberg died in a flu epidemic.

Delaware, University of; Department of Art History and Division of Museum Studies, in cooperation with the Delaware Art Museum. *Avant-Garde Painting and Sculpture in America, 1910–25* (William Innes Homer, general ed.; text on Schamberg by Wilford Scott). Wilmington, 1975.

MacAgy, Douglas. "Five Rediscovered from the Lost Generation," *Art News,* vol. 59, Summer 1960, pp. 38–41.

*Wolf, Ben. *Morton Livingston Schamberg.* Philadelphia: University of Pennsylvania Press, 1963.

———. "Morton Livingston Schamberg," *Art in America,* vol. 52, February 1964, pp. 76–80.

George Segal

Born November 26, 1924, New York City

Raised in the Bronx, George Segal moved with his family to New Brunswick, New Jersey, in 1940. He studied at Rutgers University and Pratt Institute before entering New York University, where he received his bachelor's degree in art education in 1950. Returning to New Brunswick, Segal bought a chicken farm, where he set up his studio and made a subsistence living raising chickens, and taught in the New Jersey public schools. Originally a painter, Segal exhibited his expressionist figure paintings in his first one-man show, held in 1956, at the Hansa Gallery, an artists' cooperative in New York. His closest associations in the Hansa group were Lucas Samaras, Jan Müller, Richard Stankiewicz and Wolf Kahn, but Allan Kaprow was especially influential, introducing him to Hans Hofmann's art and teaching. In 1958 Segal began to experiment with bas-relief, creating anonymous figures in plaster, wire and burlap, which he exhibited the following year in his fourth Hansa Gallery show. By 1960 Segal began his direct casting technique with plaster-soaked bandages, using his friends and family as models, and later assembling and shaping the forms. He also began to introduce objects into his tableaux, which led some critics to place him in the Pop art movement. Segal's first sculptural situation in context, the self-portrait *Man at a Table* (1961), is his seminal work. Interested in capturing gesture, attitude and movement in his forms, Segal has become internationally famous for his natural situations (*Woman Shaving Her Leg,* 1963), environmental pieces (*Ruth in Her Kitchen,* 1964–66) and his groups or couples (*The Motel Room,* 1967). In his recent environments he has begun to incorporate sound and electrical illumination and has also begun to work with fragments of figures. Since 1965 Segal has had many one-man shows at the Sidney Janis Gallery, New York; in 1968 he had a one-man exhibition at Chicago's Museum of Contemporary Art. In 1970 Segal received an honorary doctorate from Rutgers University, where he had received his M.F.A. in 1963.

A[shton], D[ore]. *Britannica,* pp. 501–2.

The Boymans-van Beuningen Museum. *George Segal* (introduction by R. Hammacher-van den Brande; essay by Jan van der Marck; statement by the artist). Rotterdam, 1972.

*Chicago, The Museum of Contemporary Art. *George Segal: Twelve Human Situations* (introduction and text by Jan van der Marck). [Chicago, 1968].

Ontario, The Art Gallery of. *Dine, Oldenburg, Segal: Painting/Sculpture* (preface by Brydon Smith; essay on Segal by Robert Pincus-Witten). Toronto, 1967.

Perreault, John. "Plaster Caste," *Art News,* vol. 67, November 1968, pp. 54–55, 75–76.

*Seitz, William C. *Segal.* New York: Harry N. Abrams, n.d.

Tuchman, Phyllis. "George Segal," *Art International*, vol. 12, September 20, 1968, pp. 50–53.

Walker Art Center. *Eight Sculptors: The Ambiguous Image* (introduction by Martin Friedman; essay on Segal by Jan van der Marck). Minneapolis, 1966. (Introduction reprinted in *Art News*, vol. 66, March 1967, pp. 30–31, 74–76.)

Richard Serra

Born November 2, 1939, San Francisco

Richard Serra earned his way through the University of California at Berkeley and Santa Barbara by working in steel plants. In 1961 he entered Yale University, where he studied under Josef Albers and came in contact with the artists of the New York School, and during his last year accepted a position as instructor. After receiving his M.F.A. in 1964 he was awarded a Fullbright Fellowship and spent a year in Italy, where he was involved in performance pieces and the *arte povera* movement. In 1966, at the Galeria La Salita in Rome, he exhibited his Animal Habitats, startling arrangements of cages and boxes containing both live and stuffed birds and animals. Returning to the United States and settling in New York City, Serra began to experiment with new materials, and in 1968 he exhibited rubber and neon pieces in a three-man show (with Mark di Suvero and Walter De Maria) at the Noah Goldowsky Gallery. Using rubber tubing or thick sheets of vulcanized rubber, often intertwined with networks of neon lights, Serra allowed the physical properties of the rubber to interact with the force of gravity to determine the final form of the work. Gravity became a central issue in Serra's work during 1969–70, particularly in the precarious Prop series — huge plates of lead or hot-rolled steel leaning against each other and supported only by the thrust and counterthrust of their opposing weights. Since 1968 Serra has also been concerned with process art, in which the finished piece is the record of its own manufacture. In 1969, for the Whitney Museum's *Anti-Illusion* show, he made castings by splattering molten lead along the intersection of a floor and wall. Most recently Serra has worked on a larger scale in outdoor pieces that interact with the environment, such as the Skullcracker series, inspired by his experiments conducted with hot-rolled steel at the Kaiser Steel Corporation in Fontana, California, as part of the *Art and Technology* exhibition under the auspices of the Los Angeles County Museum.

Krauss, Rosalind E. "Richard Serra: Sculpture Redrawn," *Artforum*, vol. 10, May 1972, pp. 38–43.

Los Angeles County Museum of Art. *A Report on the Art and Technology Program, 1967–71* (introduction by Maurice Tuchman; essay by Jane Livingston). Los Angeles, 1971.

Müller.

Pincus-Witten, Robert. "Richard Serra: Slow Information," *Artforum*, vol. 8, September 1969, pp. 34–39.

R[atcliff], C[arter]. *Britannica*, p. 502.

Rose, Barbara. "Serra," *Vogue*, vol. 160, September 1972, pp. 252–53, 303.

Serra, Richard. "Play It Again, Sam," *Arts Magazine*, vol. 44, February 1970, pp. 24–27.

*The Solomon R. Guggenheim Museum. *Guggenheim International Exhibition 1971* (essays by Diane Waldman and Edward F. Fry). New York: The Solomon R. Guggenheim Foundation, 1971.

*Whitney.

Franklin Simmons

Born January 11, 1839, Webster, Maine
Died December 6, 1913, Rome

Raised in Maine, Simmons spent his childhood in Bath, and at the age of fifteen worked in the counting room of a cotton mill in Lewiston. After devoting much leisure time to drawing classes and modeling in clay, he created his first work, a portrait bust of Dr. Nathaniel Bowditch of Bowdoin College, for which he received local recognition. In 1856 Simmons moved to Boston for art training; studying there with John Adams Jackson, he learned more about modeling in clay and received elementary instruction in the making of plaster casts and molds. Returning to Lewiston in 1857, Simmons opened a studio of his own but soon became itinerant, working between Waterville and Brunswick. In Brunswick he completed several successful portrait busts of members of the Bowdoin College faculty and about 1859 left for Portland, where he worked on portrait busts of leading citizens and received his first commission for a life-size statue: a monument to General Hiram G. Berry for a Rockland, Maine, cemetery. The favorable reception of this work encouraged Simmons to travel to Washington, D.C., and there during 1865–66 he sculpted busts of many military and government leaders. In the fall of 1866 Simmons obtained a commission from Lewiston for one of America's first public Civil War monuments. The following year he left for Italy after securing a commission from the state of Rhode Island for a statue of Roger Williams, which he completed abroad and sent back to America for installation in Statuary Hall, Washington, D.C.; dedicated early in 1872, this statue established Simmons's national reputation. In Italy Simmons soon settled in Rome, where he lived for the rest of his life except for visits back to America. His new environment soon inspired Simmons to produce ideal sculpture, such as his marble *Penelope* (c. 1880). However, his best-known sculptures remained his portraits and public monuments, which he produced in large numbers during the 1880s and '90s. The fulfillment of his last major commission — an equestrian statue of General John A. Logan (1897–1901) — resulted in Simmons's being knighted by King Humbert of Italy. Continuing to sculpt into his seventies, he was at work on his *Hercules and Alcestis* at his death.

Cammett, Stephen. "Franklin Simmons, A Maine-Born Sculptor," *Pine Tree Magazine*, vol. 8, August 1907, pp. 92–96.

*Craven.

*R[usk], W[illiam] S[ener]. *DAB*, vol. 17, p. 169.

"The Veteran Sculptor," *Outlook*, vols. 97–98, May, 27, 1911, pp. 213–15.

Whiting, Lilian. "The Art of Franklin Simmons," *The International Studio*, vol. 25, May 1905, pp. lii–lvi.

Richard Serra

Franklin Simmons

Simeon Skillin, Sr.

Born 1716, Boston
Died 1778, Boston

John Skillin

Born 1746, Boston
Died 1800, Boston

Simeon Skillin, Jr.

Born 1756/57, Boston
Died 1806, Boston

Simeon Skillin, Sr., the founder of the Skillin family of Boston wood-carvers, was working in Boston by 1738. Referred to in various deeds and in his will as a carver, he did ship carving and figureheads (such as the *Minerva* for the brig *Hazard* in 1777) for nearly four decades. Of Simeon, Sr.'s, three sons who became ship carvers, John and Simeon, Jr., were most noted. (Another son, Samuel, although not as well known, was active in Boston from about 1780 to 1816.) Trained by their father, John and Simeon, Jr., had formed a partnership in Boston by 1780. Their shop, during their twenty-year partnership, was located on the waterfront and listed in the Boston Directory of 1796 as "Skillins Wharf." As the company prospered the Skillin brothers' carving became known in seaports from Salem to Philadelphia. They worked extensively for the wealthy Salem merchant Elias Hasket Derby, completing not only figureheads but also freestanding ornamental figures. In 1793 they billed Derby for four garden figures, which they carved for his summer residence, Oak Hill (designed by Samuel McIntire), in Danvers, Massachusetts. The brothers were involved in the furniture carving trade as well: In 1791 they completed three ornamental figures and relief carving for a chest of drawers made by Stephen Badlam of Dorchester for Elias Hasket Derby (now in the Mabel Brady Garvan Collection at Yale University). The extent of their reputation as carvers is evident from the recommendation of William Rush of Philadelphia in 1797 that John Skillin carve the figurehead *Hercules* for the frigate *Constitution* after his designs. Also involved in architectural ornamentation, the brothers carved the Corinthian capitals for the new State House in Boston after Bulfinch's design in 1797 and the fancy capitals for the pilasters of the Elias Hasket Derby mansion in Salem in 1799. The partnership ended in 1800 with the death of John Skillin, but Simeon, Jr., was active until about 1806. Most of the Skillin brothers' work has disappeared, but there are several extant pieces attributed to their workshop, including the ornament *Plenty* from the Bolles secretary (Metropolitan Museum of Art), the statue *Mercury* from the Old State House, Boston, and the garden figures *Hope* and *Justice* (at the Henry Francis du Pont Winterthur Museum).

"Add to the Skillins' Sculptures," *The Magazine Antiques*, vol. 30, July 1936, pp. 8–9.

"John Skillin as Cabinetmaker," *The Magazine Antiques*, vol. 26, July 1934, p. 7.

Keyes, Homer Eaton. "Milton, Beverly, and Salem," *The Magazine Antiques*, vol. 23, April 1933, pp. 142–43.

Swan, Mabel M. "Boston's Carvers and Joiners, Part I: Pre-Revolutionary," *The Magazine Antiques*, vol. 53, March 1948, pp. 198–201.

———. "A Revised Estimate of McIntire," *The Magazine Antiques*, vol. 20, December 1931, pp. 338–43.

———. "Simeon Skillin, Senior: The First American Sculptor," *The Magazine Antiques*, vol. 46, July 1944, p. 21.

Thwing, Leroy L. "The Ancestors of John and Simeon Skillin, Carvers, 1777–1806." Photocopy of typewritten paper, The Henry Francis du Pont Winterthur Museum, Winterthur, Del.

———. "The Four Carving Skillins," *The Magazine Antiques*, vol. 33, June 1938, pp. 326–28.

———. "The Four Skillins." Photocopy of a typewritten paper, The Henry Francis du Pont Winterthur Museum, Winterthur, Del.

David Smith

Born March 9, 1906, Decatur, Indiana
Died May 23, 1965, Albany, New York

Graduating from Paulding [Ohio] High School in 1924, David Roland Smith studied for two semesters at Ohio University. The following summer he worked at a Studebaker automobile factory in Indiana, where he welded, riveted and performed other assembly-line operations. After a job transfer to Washington, D.C., Smith moved to New York City in 1926. From then until 1932 he studied painting at the Art Students League with Richard Lahey, John Sloan and the abstract painter Jan Matulka, who strengthened Smith's interest in modern European art. Possibly as early as 1929 Smith saw for the first time, reproduced in the periodical *Cahiers d'Art*, the welded metal sculptures of Picasso (and of Julio González in issues dated 1931), revelatory encounters that made it possible for Smith to envision iron and steel as artistic mediums. By 1931 he had begun to add objects to his painting surface and during a trip (October 1931 to June 1932) to the Virgin Islands he made his first sculpture, in coral, and experimented in making constructions. Back in Brooklyn in 1932 or early 1933, he created his first welded steel sculptures and soon established a sculpture studio in the Brooklyn Terminal Iron Works. His first one-man show, of drawings and welded iron sculpture, was held at Marian Willard's East River Gallery, New York, in 1938, and two years later Smith and his wife, the painter-sculptor Dorothy Dehner (Smith would remarry in 1953), moved permanently to their summer property in Bolton Landing, New York. Throughout the 1940s and '50s Smith had at least thirty-five one-man shows, was represented in numerous group exhibitions in the United States and Europe, taught at several colleges and participated in various colloquiums on art; he was awarded Guggenheim Fellowships in 1950–51. In 1957 the Museum of Modern Art, New York, held a retrospective of Smith's sculpture and organized a one-man show of his work for the 1958 Venice Biennale. As a guest of Gian-Carlo Menotti and the Italian government, he executed twenty-six sculptures in

David Smith

thirty days for an exhibition in Spoleto, Italy, in 1962. Appointed by President Lyndon B. Johnson to the National Council on the Arts in February 1965, Smith was fatally injured less than three months later when his truck went off the road in Shaftsbury, Vermont. During the preceding thirty-odd years he had absorbed the inventions of Cubist and Constructivist sculpture, tinctured by Surrealism, and literally forged directly in metal a style that was wholly original, wholly American and still unfolding at his death.

Gray, Cleve, ed. "Feature: David Smith," *Art in America*, vol. 54, January/February 1966 (a memorial tribute with contributions by Dorothy Dehner, Marian Willard, Cleve Gray and Clement Greenberg; quotations from David Smith and others; photographs by Dan Budnik and Ugo Mulas), pp. 22–48.

*Harvard University, Fogg Art Museum. *David Smith, 1906–1965: A Retrospective Exhibition* (introduction by Jane Harrison Cone; chronology by William Berkson; with reprints of four articles by the artist and an interview with him). N.p., 1966.

*Krauss, Rosalind E. *Terminal Iron Works: The Sculpture of David Smith*. Cambridge, Mass.: The MIT Press, 1971.

*Los Angeles County Museum of Art. *David Smith: A Memorial Exhibition* (essay by Hilton Kramer, with excerpted statements by the artist.) [Los Angeles, 1965 (?)].

*McCoy, Garnett, ed. *David Smith*. New York and Washington: Praeger Publishers, 1973.

*New York, The Museum of Modern Art. *David Smith* (text by Sam Hunter). Published as *The Museum of Modern Art Bulletin*, vol. 25, no. 1, 1957, entire issue.

Smith, David. *David Smith by David Smith* (Cleve Gray, ed.). New York: Holt, Rinehart and Winston, 1968.

*The Solomon R. Guggenheim Museum. *David Smith* (essay by Edward F. Fry). New York: The Solomon R. Guggenheim Foundation, 1969.

"Special Number: David Smith," *Arts*, vol. 34, February 1960 (includes "The Sculpture of David Smith" by Hilton Kramer, pp. 22–41; "Notes on My Work" by the artist, pp. 44–49).

Tony Smith

Born 1912, South Orange, New Jersey

Recovering from tuberculosis as a child, Tony Smith made maquettes of Pueblo villages out of medicine boxes and at the age of twelve was given a copy of Jay Hambidge's *Elements of Dynamic Symmetry*. Smith worked in his family's waterworks foundry while attending the Art Students League from 1933 to 1936, and in 1937 he enrolled in Chicago's New Bauhaus. A year later he became an apprentice to Frank Lloyd Wright and spent two years assisting on such projects as Taliesin East and the Ardmore Experiment. For the next twenty years Smith painted and worked independently on architectural commissions. In 1946 he began his teaching career, first at New York University, where he remained until 1950, then at Cooper Union, Pratt Institute, Bennington College, and since 1962 at Hunter College. In the 1940s Smith was involved with the Abstract Expressionists, particularly his friends Barnett Newman, Mark Rothko, Clyfford Still and Jackson Pollock, and although he did not exhibit, he was an active member of the avant-garde. In 1960, dissatisfied with the impermanence of the houses he built, Smith turned to sculpture, based on classical proportions and the formal architectural values of geometric solids, particularly tetrahedra, octahedra and cubes. The architecture/painting/sculpture triad has remained unified throughout his career as he continues to explore "the flow of large surfaces, and the substantiality of the paced unfolding of form," as in his early sculptures, such as *Gracehoper* (1961), the cubic *Black Box* (1962) and *The Snake Is Out* (1962), a walk-through piece. Volumetric rather than planar, Smith's "presences," which are "implicit with energy," explore a classical system of modularity, while some of his later pieces, such as *Smoke* (1967) and the horizontal *Smog* (1969), are based on a space grid. For the 1970 World's Fair at Osaka, Japan, and the *Art and Technology* exhibition sponsored by the Los Angeles County Museum in cooperation with the Container Corporation of America, Smith created large-scale cavelike sculptures expressive of his philosophy of "art in a public context."

Baro, Gene. "Tony Smith: Toward Speculation in Pure Form," *Art International*, vol. 11, Summer 1967, pp. 27–31.

Burton, Scott. "Old Master at the New Frontier," *Art News*, vol. 65, December 1966, pp. 52–55, 68–70.

M. Knoedler & Co. *Tony Smith: Recent Sculpture* (foreword by Martin Friedman; interview by Lucy Lippard). New York, 1971.

*Lippard, Lucy R. *Tony Smith*. New York: Harry N. Abrams, 1972.

Maryland, University of; Art Gallery. *Tony Smith: Painting and Sculpture* (foreword by Eleanor Green). N.p., 1974.

New Jersey State Council on the Arts. *Nine Sculptures by Tony Smith* (preface by Samuel Pratt; introduction by Eugene C. Goossen). N.p., n.d.

Wadsworth Atheneum and the Institute of Contemporary Art, University of Pennsylvania. *Tony Smith: Two Exhibitions of Sculpture* (preface by Samuel Green and James Elliott; introduction by Samuel Wagstaff, Jr.; text by the artist). Hartford and Philadelphia, 1967.

Wagstaff, Sam, Jr. "Talking with Tony Smith," *Artforum*, vol. 5, December 1966, pp. 14–19.

Robert Smithson

Born January 2, 1938, Passaic, New Jersey
Died July 20, 1973, near Tecovas Lake, Texas

In 1945 Robert Smithson drew a wall-sized picture of a dinosaur in the hallway of his grammar school; as a child he collected rocks and visited reptile farms, hoping to eventually become a naturalist. While still in high school, however, Smithson won a scholarship to the Art Students League, where he studied in the evening classes. In 1956 he briefly attended the

Copyright © Arnold Newman

Tony Smith

Robert Smithson

Keith Sonnier

Brooklyn Museum Art School, spent a short time in the army reserves and hitchhiked throughout the United States and Mexico before returning to New York. Two years later his Abstract Expressionist paintings were exhibited in his first one-man show, held at the Artists' Gallery, New York. After a visit to Rome in 1961 Smithson pursued independent study in religion, psychology and Byzantine art, while maintaining a scholar's interest in ancient cultures, legends and mythologies. By the mid-1960s he had reestablished contact with the art world: In 1966 he joined the Dwan Gallery, met the major Minimalist artists and began to publish his first of many dialectical articles on entropy as it applied to sculpture and, later, to earthworks. At this time Smithson was making steel sculptures based on geometrical progressions, such as the six-module *Cryosphere*, exhibited in the Jewish Museum's *Primary Structures* show in 1966, and the spiral *Leaning Strata*, exhibited in the Museum of Modern Art's *Art of the Real* show in 1968. From 1966 to 1968 Smithson scouted quarries and urban sites with his wife, the artist Nancy Holt, and artist-friends such as Carl Andre, Robert Morris, Donald Judd and Michael Heizer. In 1968 he began his series of Sites and Non-Sites, expressive of Smithson's statement: "Instead of putting a work of art on some land, some land is put into the work of art." The Non-Sites, in which earth or rocks were displaced, put in bins and accompanied by an aerial map, were in exact proportion to the geological pattern of the Sites, following Smithson's statement that "the earth to me isn't nature, but a museum." The Non-Sites were followed by his mirror displacement pieces done in the Yucatán and similar works such as *Map of Glass* (1969, New Jersey). In the late 1960s Smithson began to apply his preoccupation with entropy to large-scale earthworks, such as his famous *Spiral Jetty* (1970, Great Salt Lake, Utah), which actualized his belief that "the artist must go into places where remote futures meet remote pasts." On a trip to his work-in-progress, *Amarillo Ramp*, Robert Smithson was killed when his plane crashed a few hundred yards from the site. The work was completed according to his plan by his wife and his friends Richard Serra and Tony Shafrazi.

*Alloway, Lawrence. "Robert Smithson's Development," *Artforum*, vol. 11, November 1972, pp. 52–61.

Coplans, John. "Robert Smithson: *The Amarillo Ramp*," *Artforum*, vol. 12, April 1974, pp. 36–45.

G[oossen], E[ugene] C. *Britannica*, pp. 527–28.

Hutchinson, Peter. "Earth in Upheaval: Earth Works and Landscapes," *Arts Magazine*, vol. 43, November 1968, pp. 19, 21.

Leider, Philip. "For Robert Smithson," *Art in America*, vol. 61, November/December 1973, pp. 80–82.

Müller.

*The New York Cultural Center. *Robert Smithson: Drawings* (preface by Mario Amaya; introduction by Susan Ginsburg). New York, 1974.

Robbin, Anthony. "Smithson's Non-Site Sights," *Art News*, vol. 67, February 1969, pp. 50–53.

Sky, Allison. "Entropy Made Visible" (interview with Robert Smithson), *On Site*, Fall 1973, pp. 26–30.

Keith Sonnier

Born 1941, Mamou, Louisiana

In 1959 Keith Sonnier entered the University of Southwestern Louisiana as an art major and studied painting there until 1963. After graduation he continued to paint during a year in France, living first in Normandy and then in Paris. In 1966 he received his M.F.A. from Rutgers University and had his first one-man exhibition at Douglass College there. While at Rutgers Sonnier met Robert Morris, Gary Kuehn and Robert Watts, who introduced him to the New York art scene and influenced his decision to shift from painting to sculpture. That same year his inflated dacron forms — soft boxes that inflated and deflated through the use of concealed motors — were shown with the work of Eva Hesse, Bruce Nauman and others in the *Eccentric Abstraction* show arranged by Lucy Lippard at the Fischbach Gallery in New York. In 1967 his first one-man show in Europe was held at the Galerie Ricke in Cologne. By 1969, when he exhibited in the Whitney Museum's *Anti-Illusion* show, Sonnier was experimenting with an expanded range of materials — neon tubing, latex, flocking, string and glass — in nonsculptural works that explored the sensuousness of the materials but transcended their inherent fragility and transparency. In a one-man show in 1970 at the Stedelijk van Abbemuseum in Eindhoven, the Netherlands, Sonnier installed three rooms, each with a different set of disorienting sensory stimuli: sound, ultraviolet light and projected mirrored fluorescence. In 1970, for the Whitney Museum Annual, Sonnier further utilized sound by amplifying street noise in disquieting high-pitched intensities from the roof of his New York studio. In recent years Sonnier has moved toward videotape and other electronic software. He has had several one-man shows at the Leo Castelli Gallery, New York, and was awarded two consecutive Guggenheim Fellowships, in 1974 and 1975.

Baker, Kenneth. "Keith Sonnier at the Modern," *Artforum*, vol. 10, October 1971, pp. 77–81.

Lippard, Lucy R. "Eccentric Abstraction," *Art International*, vol. 10, November 20, 1966, pp. 28, 34–40. (Revised version reprinted in Lippard, Lucy R. *Changing*. New York: E. P. Dutton & Co., 1971.)

Müller.

Pincus-Witten, Robert. "Keith Sonnier: Materials and Pictorialism," *Artforum*, vol. 8, October 1969, pp. 39–45.

R[atcliff], C[arter]. *Britannica*, p. 531.

Sharp, Willoughby. "Keith Sonnier at Eindhoven: An Interview," *Arts Magazine*, vol. 45, February 1971, pp. 24–27.

Sonnier, Keith and others. "Illustrated Time — Proscenium II," *Avalanche*, Fall 1972, p. 36.

*Whitney.

Edmund Stewardson

Born 1860, Philadelphia
Died July 3, 1892, Newport, Rhode Island

Edmund Austin Stewardson began his formal art training in life classes at the Pennsylvania Academy

of the Fine Arts in February 1882. Profiting from Thomas Eakins's instruction there, Stewardson was encouraged to leave for Paris in the autumn of 1887 and present himself for examination at the Ecole des Beaux-Arts. Passing first among seventy-two competitors, he was admitted to the school and the following year was chosen by Henri Chapu to study directly under him; Stewardson's other teacher in Paris was André Joseph Allar. The plaster cast of *The Bather,* Stewardson's first life-size statue, a student work, won him both an honorable mention at the Paris Salon of 1890 as well as membership (Stewardson is believed to be the youngest person ever to be admitted) in the Society of American Artists in 1891, the year that society exhibited *The Bather* in New York. Returning to America in 1890, Stewardson opened a studio in Philadelphia and during the next two years did many studies and completed four portrait busts. His increasing reputation as a sculptor resulted in his appointments as instructor at the University of Pennsylvania and the Pennsylvania Academy for the year 1892–93, positions he was unable to fill because the preceding summer he was drowned in a sailing accident off Newport, Rhode Island. Sometime after Stewardson's death, his father, Thomas Stewardson, printed a memorial album to his son in which Augustus Saint-Gaudens, Thomas Eakins, Frederick MacMonnies and others (since the contributions were signed generally only with initials, these identifications can be only presumed) universally praised Edmund Stewardson's character and attested to his artistic promise. Thomas Stewardson had *The Bather* put into marble (now in the Metropolitan Museum of Art) by a M. Léonard in Paris in 1894 and five years later endowed the Edmund Stewardson Prize for Sculpture at the Pennsylvania Academy of the Fine Arts.

Pp. 105–6 in "Correspondence: Edmund L. [*sic*] Stewardson," *The Nation,* vol. 55, August 11, 1892.

Gardner.

"In Memoriam," *Harpers Weekly,* vol. 36, November 12, 1892, p. 1101.

Taft.

Sylvia Stone

Born June 18, 1928, Toronto, Canada

Sylvia Stone attended Ontario College and studied art privately in Canada before moving permanently to New York City in 1947. In 1948 and 1951–53 she studied at the Art Students League, where she was most influenced by her teacher Vaclav Vytlacil. Stone was primarily a painter until 1965, when, "seeking a more direct way to make a shaped painting," she began to make wall reliefs from sheets of plexiglas, often painting one side in acrylics. By 1967, when her first of several one-woman shows was held at the Tibor de Nagy Gallery, New York, she had turned to freestanding or suspended geometric plexiglas constructions in smoky gray and bronze. Continuing to work exclusively in tinted plexiglas, Stone has created elegant hue contrasts through "folded" or intersecting planes, exploring perspective and illusion through the transparent and reflective qualities of the material. She has moved from essentially two-dimensional forms in the 1960s to three-dimensionality in environmental pieces such as *Crystal Palace* (1971) and *Another Place* (1972). In her recent work, she has continued to combine plexiglas rectangles with opaque acrylic surfaces, which articulate the form and add volume, as in the energetic *Manhattan Express* (1974). Stone's works have been represented in many group shows, including Whitney Museum Annuals (1968, 1970) and a Biennial (1973), *Fourteen Sculptors: The Industrial Edge* at the Walker Art Center in 1969 and *A Plastic Presence* at the Milwaukee Art Center in 1970. In 1971 she received a New York State Council on the Arts fellowship; in 1972 and 1975 she had one-woman shows at the André Emmerich Gallery, New York. Married to the artist Al Held, Stone has taught at Brooklyn College since 1960.

L[evin], K[im]. Pp. 15–16 in "Reviews and Previews," *Art News,* vol. 66, April 1967.

Mellow, James. P. 35 in "New York Letter," *Art International,* vol. 12, May 1968.

Michelson, Annette. Pp. 57–58 in "New York," *Artforum,* vol. 6, May 1968.

Rose, Barbara. "Living the Loft Life: Four Young Women with the Commitment and Grit to Blaze New Trails for Art." *Vogue,* vol. 160, August 1, 1972, pp. 72–75.

*Walker Art Center. *Fourteen Sculptors: The Industrial Edge* (essays by Barbara Rose, Christopher Finch and Martin Friedman). Minneapolis, 1969. (Friedman's essay reprinted in *Art International,* vol. 14, February 1970, pp. 31–40.)

Sylvia Stone

John Storrs

Born June 29, 1885, Chicago
Died April 22, 1956, Mer, Loire-et-Cher, France

John Henry Bradley Storrs, the son of architect and real-estate developer D. W. Storrs, traveled extensively through Europe and the Near East between 1907 and 1928, but he returned to Chicago annually to fulfill the stipulations of his father's will. During 1907–10 Storrs studied sculpture in Berlin and Paris; he also studied at the Art Institute of Chicago under Lorado Taft and others, at the Pennsylvania Academy of the Fine Arts under Charles Grafly, and briefly at the Boston Museum of Fine Arts school. Storrs attended the Académie Julian in Paris from 1910 to 1914 and was the student of Auguste Rodin during the last two years there. After Rodin's death in 1917, it was Storrs, his favorite student, who was asked to draw the death portrait of the great French sculptor. An expatriate in Paris, Storrs was one of the first American abstract sculptors and also one of the first to work in metal. His earliest sculptures, such as *Winged Horse* (1917), predate Art Deco, and by the 1920s he had assimilated the Cubist style, evident in the bronze *Gendarme Seated* (1925). He had also begun to show affinities with architecture's International Style, particularly in his architectonic *Forms in Space* series. Storr's first recorded one-man show was held at the Folsom Gallery, New York, in 1920, and was followed by frequent one-man shows during the 1920s and '30s both in the United States and France; in 1929 and 1931 he received the Logan

John Storrs

William Wetmore
Story

George Sugarman

Medal from the Art Institute of Chicago. Of his architectural commissions, Storrs is best known for the aluminum *Ceres* (1930) on top of Chicago's Board of Trade Building. Storrs worked in a variety of mediums, including stone, polychromed terra-cotta, stainless steel and marble, and for Chicago's *Century of Progress* exposition in 1933 he executed several relief panels and a monumental statue. In the late 1930s he moved permanently to his French château near Orléans. During World War II Storrs was held in a concentration camp, an ordeal that left him severely debilitated. Although he continued to work upon his release, he produced little sculpture during his remaining years. In 1965 a major exhibition of his work was held at the Downtown Gallery, New York, and in 1969 a retrospective was held at the Corcoran Gallery, Washington, D.C.

Bryant, Edward. "Rediscovery: John Storrs," *Art in America*, vol. 57, May/June 1969, pp. 66–71.

*Craven.

Davidson, Abraham A. "John Storrs, Early Sculpture of the Machine Age," *Artforum*, vol. 13, November 1974, pp. 41–45.

Kramer, Hilton. "The Rediscovery of Storrs," *The New York Times*, December 13, 1970, section 2, p. 25.

Société Anonyme, Inc. *John Storrs and Modern Sculpture* (text by André Salmon). New York, 1923.

William Wetmore Story

Born February 12, 1819, Salem, Massachusetts
Died October 7, 1895, Vallombrosa, Italy

William Wetmore Story, son of Associate Justice Joseph Story, received his undergraduate and law degrees from Harvard College in 1838 and 1840. As a lawyer and poet, Story published several legal textbooks, books of poetry and a biography of his father. Although he drew and modeled as a hobby, Story never received formal art training. Upon his father's death in 1846, however, he was commissioned to execute a memorial statue of his father, and in preparation he sailed to Italy with his wife in 1847 to study sculpture. He returned to Boston briefly, but his passion for Rome took him back to that city in 1848, where he met and became lifelong friends with the Robert Brownings. Torn between law and art, Story again returned to Boston but in 1851 sailed to Rome, where he became a sculptor in earnest (although he would not settle permanently in Rome until 1856). In 1852 he produced one of his first sculptures, the romanticized *Arcadian Shepherd Boy*, and a year later he completed the marble statue of his father. Story's studio in Rome was a literary center, which included his good friends James Russell Lowell, Nathaniel Hawthorne and Henry James (who became his biographer). Although often considered a dilettante because of his diverse interests, Story secured his reputation as a sculptor with two of his most important works, the seated *Cleopatra* (original version, 1858) and *Libyan Sibyl* (original version, c. 1861). Hawthorne immortalized *Cleopatra* by choosing it as the major work of his artist/protagonist in *The Marble Faun* (1860). In the 1860s Story was oc-cupied by literary (and some biblical) subjects, particularly from Greek tragedy, and he created *Saul* (original version, 1863), *Medea* (original version, 1864), *Delilah* (1866–67) and *Salome* (1871). Also during this period Story began his long career of executing memorial portrait statues, including the marble *Josiah Quincy* (1860) and the bronzes *Edward Everett* (1866), *Joseph Henry* (1883) and *John Marshall* (1884). Although Story never received major critical acclaim, he was a popular and internationally famous sculptor. In 1894, disconsolate over the death of his wife, Story closed his studio and retired to his daughter's home in Vallombrosa.

*Craven.

Gardner, Albert Ten Eyck. "William Story and 'Cleopatra'," *The Metropolitan Museum Bulletin*, n.s., vol. 2, December 1943, pp. 147–52.

*Gerdts.

_____. "William Wetmore Story," *The American Art Journal*, vol. 4, November 1972, pp. 16–33.

James, Henry. *William Wetmore Story and His Friends*, 2 vols. Boston: Houghton, Mifflin & Co., 1903; New York: Kennedy Galleries and Da Capo Press, 1969 (reprint).

Phillips, Mary E. *Reminiscences of William Wetmore Story: The American Sculptor and Author.* Chicago and New York: Rand McNally & Company, 1897.

Story, William Wetmore. *Conversations in a Studio*, 2 vols. Boston and New York: Houghton, Mifflin & Company, 1890.

_____. *Excursions in Art and Letters*, Boston and New York: Houghton, Mifflin & Company, 1891.

Wallace, Mrs. Lew. "William Wetmore Story: A Memory," *Cosmopolitan Magazine*, vol. 21, September 1896, pp. 464–72.

George Sugarman

Born May 11, 1912, New York City

George Sugarman began painting in 1950 after graduating from the College of the City of New York and completing his military service. Moving to Paris in 1951, he studied there on the G.I. Bill under the sculptor Ossip Zadkine during 1951–52 and at the Académie de la Grande Chaumière during 1952–53 and exhibited at the Salons de la Jeune Sculpture of 1952 and 1954. In 1955 he returned to New York City, where he experimented with polychromed wood sculpture. His first New York exhibition was held in 1958 at the Union Dime Savings Bank, followed by his first one-man gallery show in 1960 at the Widdifield Gallery, New York. Sugarman first achieved international recognition by winning second prize for sculpture at the 1961 Pittsburgh International; he has received grants from the Longview Foundation (1961–63) and the National Council on the Arts (1966). His pre-1967 sculptures consist of sprawling, baroque complexes of generally brightly colored laminated wood, cantilevered and zigzagging into space; in the early 1960s Sugarman also made lithographs, receiving a Ford Foundation grant for lithography in 1965. By 1967 he had begun to simplify and consolidate his sculptural forms and to conceive of large-scale public works. *The El Segundo Complex* was Sugarman's first metal outdoor sculp-

ture (commissioned and wood model exhibited in 1967; completed in metal in 1969). His *Square Spiral* was fabricated in steel at an earlier date and exhibited in the Whitney Museum's 1968 Sculpture Annual and in Cincinnati's Fountain Square in 1970. In 1970 Sugarman created his first metal wall sculpture, *The Venusgarden,* a large multicolored, multielemented, aluminum work. His public sculpture commissioned for the arcade of the First National Bank of St. Paul, Minnesota, was installed there permanently in 1971. Sugarman's works have also been included in group shows at the Seattle World's Fair (1962), the São Paulo Bienal (1963) and the Los Angeles County Museum's *American Sculpture of the Sixties* (1967); his more recent one-man shows have been held at the Kunsthalle, Basel (1969): Galerie Renée Ziegler, Zurich (1970); the Stedelijk Museum, Amsterdam (1970); and in New York simultaneously at the Zabriskie Gallery and, outdoors, at Dag Hammerskjöld Plaza (1974). Sugarman taught sculpture at Hunter College from 1960 to 1970 and was visiting professor at Yale University's Graduate School of Art and Architecture during 1967–68.

*Amsterdam, Stedelijk Museum. *George Sugarman* (text by Irving H. Sandler, reprinted from *Art News,* vol. 65, May 1966 pp. 34–37). Amsterdam, 1970.

Ashton, Dore. Pp. 321–22 in "New York Commentary," *Studio International,* vol. 175, June 1968.

Basel, Kunsthalle, and others. *George Sugarman: Plastiken, Collagen, Zeichnungen* (essays by Amy Goldin and Peter Althaus). Basel, 1969.

Dayton's Gallery 12. *Sugarman Sculpture Lithographs* (essay by Sidney Simon). Minneapolis, 1966.

St. Paul, The First National Bank of. *Sugarman: Sculptural Complex in an Urban Area* (essay by Irving H. Sandler). St. Paul, Minn., 1971.

*Los Angeles.

Taylor, John Lloyd. Pp. 122–23 in "Review of Exhibitions," *Art in America,* vol. 62, November/December 1974.

Lorado Taft

Born April 29, 1860, Elmwood, Illinois
Died October 30, 1931, Chicago

Following his graduation from Illinois Industrial University (later the University of Illinois) in 1879, Lorado Zadoc Taft studied in Paris at the Ecole des Beaux-Arts from 1880 to 1883. After visiting the United States in 1884 he returned to Paris for further study. In 1886 he returned permanently to the United States and became an instructor of sculpture at the Art Institute of Chicago, a position he held until 1929. In 1906 Taft relocated his studio from the Chicago Loop to a deserted barn on University of Chicago land on the Midway. He welcomed artists to this studio (which later was declared a national historic landmark) and gave them both encouragement and inspiration. All his life Taft was devoted to education and writing. He taught at the Universities of Chicago and Illinois and toured Illinois lecturing to local schools and clubs. Taft's best-known works are his monumental, often symbolic public sculptures: *Black Hawk* (1911), *Columbus*

Fountain (1912), *Fountain of the Great Lakes* (1913), *The Fountain of Time* (1922), *Young Lincoln* (1927) and, for the University of Illinois, *Alma Mater* (1929). He is better remembered, however, for his *History of American Sculpture,* first published in 1903, than for his sculpture. During his lifetime Taft received many awards: a designer's medal of the Columbian Exposition, Chicago, 1893; a gold medal at the St. Louis Exposition, 1904; and silver medals at the Pan-American Exposition, Buffalo, 1901, and Panama-Pacific Exposition, San Francisco, 1915. Taft was a member of the American Academy of Arts and Letters, the National Sculpture Society, the American Federation of Arts (director, 1914–17) and Chicago Painters and Sculptors; he was also an academician of the National Academy of Design and an honorary member of the American Institute of Architects. Taft's unfulfilled dream was to establish a museum exhibiting all the important architectural and sculptural works of all ages so that Americans who were unable to travel to Europe could be exposed to the world's great masterpieces.

Garland, Hamlin. "The Art of Lorado Taft," *The Mentor,* vol. 11, October 1923, pp. 19–34.

Mose, Ruth. "Midway Studio," *The American Magazine of Art,* vol. 19, August 1928, pp. 413–22.

Moulton, Robert, "Lorado Taft, Interpreter of the Middle West," *The Architectural Record,* vol. 36, June 1912, pp. 12–24.

*Proske.

Taft, Ada B. *Lorado Taft: Sculptor and Citizen.* Greensboro, N. C.; Mary T. Smith, 1946.

Taft, Lorado. *Modern Tendencies in Sculpture.* Chicago: University of Chicago Press, 1921.

*Williams, Lewis W., II. *DAB,* supp. 2, pp. 647–48.

Anne Truitt

Born March 16, 1921, Baltimore

Raised in Easton, Maryland, Anne Dean received her bachelor's degree in psychology from Bryn Mawr College in 1943 and subsequently did psychological research at Massachusetts General Hospital. In 1945 she enrolled in an evening sculpture class and the next year left her job at the hospital. Her marriage to James Truitt, a journalist, whose work required repeated transfer, led her to spend the following twenty years living and working as an artist throughout the United States and in Japan. In 1948 she enrolled at the Institute of Contemporary Art in Washington, D.C., and there studied sculpture under Alexander Giampietro and met Kenneth Noland, who became her good friend and later her teacher. After moving to Dallas in 1950, Truitt studied at the Dallas Museum School under Octavio Medillin. Back in Washington the following year, she opened a studio. During 1957–60 Truitt lived in San Francisco, where she maintained a studio and created clay sculptures and a large number of works on paper. In Washington again from 1960 to 1964, she worked prolifically, completing thirty-two pieces of sculpture in 1962 alone. A year later she had her first of periodic one-woman shows at the André Emmerich Gallery, New York. During her residence in Tokyo from 1964 to 1967, the Minami Gallery presented two one-woman

Lorado Taft

Anne Truitt

Richard Tuttle

Bessie Potter Vonnoh

shows of her work, which for the first time was fabricated of aluminum and then painted (Truitt has since destroyed most of these works). With almost no exception, her other sculptures have been simple geometric forms in wood, built to her specifications by cabinetmakers, then finished and painted by the artist. Since the late 1960s Truitt again has lived in Washington, D.C. She received an Artist Fellowship Program grant in 1969, a Guggenheim Fellowship in 1971 and a National Endowment for the Arts grant in 1972. In 1974 Truitt had one-woman shows at the Whitney Museum and Corcoran Gallery of Art.

Benson, Legrace. Pp. 36–40 in "The Washington Scene," *Art International*, vol. 13, December 1969.

*The Corcoran Gallery of Art. *Anne Truitt: Sculpture and Drawings 1961–1973* (introduction by Walter Hopps and biographical sketch). Washington, 1974.

Gilbert-Rolfe, Jeremy. Pp. 70–71 in "Reviews," *Artforum*, vol. 12, March 1974

Greenberg, Clement. "Changer: Anne Truitt, an American Artist Whose Painted Sculptures Helped to Change the Course of American Sculpture," *Vogue*, vol. 151, May 1968, pp. 212, 284.

——. "Recentness of Sculpture," *Art International*, vol. 11, April 20, 1967, pp. 19–21. (Reprinted in Battcock, Gregory, ed. *Minimal Art: A Critical Anthology*, pp. 180–86. New York: E. P. Dutton & Co., 1968.)

Judd, Donald. "Black, White and Gray [*sic*]," *Arts Magazine*, vol. 38, March 1964, pp. 36–38.

Prokopoff, Stephen. "Logic of Vision," *Arts Magazine*, September 1974, pp. 45–47.

Richard Tuttle

Born July 12, 1941, Rahway, New Jersey

Raised in Roselle, New Jersey, Richard Tuttle graduated in 1963 from Trinity College (Hartford, Connecticut), where he met the artist Agnes Martin, whose Minimalist aesthetic influenced his later work. In 1963 Tuttle went to New York City, where he attended Cooper Union and worked as an assistant at the Betty Parsons Gallery; a year later he began to experiment with small paper cubes. By 1965 he was making monochrome wood reliefs, essentially ideograms for aspects of the landscape, such as *Hill* and *Water*. About 1967 Tuttle began his series of dyed, crumpled canvas octagons, which could be hung on the wall (with pushpins) or spread on the floor. Stating that "I started out making thick wood pieces and they got thinner and thinner. They turned into cloth," Tuttle then turned to plain white paper for his eccentrically shaped octagonals. Applied directly to the wall, the octagonals could be read as part of the wall, but they retained a pure essence through two-dimensionality and reflection. Tuttle's painted plywood reliefs, such as *Yellow Dancer* and the gray *Ash Wednesday*, were shown in 1965 in his first of many one-man shows at the Betty Parsons Gallery; in 1969 his work was represented in the Corcoran Gallery's Biennial Exhibition and in the Whitney Museum's *Anti-Illusion* show. His freestanding sculptures, such as *Slope* and *Double Direction*, were exhibited with his cloth octagons, paper octagonals

and drawings in a one-man exhibition at the Dallas Museum of Fine Arts in 1971. A one-man exhibition at the Whitney Museum in 1975 included his Twenty-six series (metal wall reliefs comprising a conceptual alphabet), delicate wire/graphite/shadow wall pieces, white plywood wall reliefs, painted and unpainted plywood triangulars placed at floor level, and direct wall paintings. Installed by the artist and rearranged twice during its course, the exhibition could be seen as an elusive interior landscape that heightened spatial awareness and articulated Tuttle's statement that "we in our minds can make something real or can have a real experience from something that is never real."

*Dallas Museum of Fine Arts. *Richard Tuttle* (essay by R[obert] M. M[urdock]). Dallas, 1971.

Foote, Nancy. "Richard Tuttle at Betty Parsons," *Art in America*, vol. 62, May/June 1974, pp. 102–3.

Heinemann, Susan, "Richard Tuttle," *Artforum*, vol. 12, June 1974, pp. 75–76.

Pincus-Witten, Robert. "The Art of Richard Tuttle," *Artforum*, vol. 8, February 1970, pp. 62–67.

Smart, Jeffrey, P. 48 in "Artists on Their Art," *Art International*, vol. 12, May 15, 1968.

*Whitney.

*Whitney Museum of American Art. *Richard Tuttle* (text by Marcia Tucker). New York, 1976.

Bessie Potter Vonnoh

Born August 17, 1872, St. Louis
Died August 8, 1955, New York City

About 1890 Bessie Onahotema Potter began her sculpture studies at the Art Institute of Chicago under Lorado Taft. Later serving as one of Taft's female assistants, nicknamed "the White Rabbits," at the Columbian Exposition (1893) in Chicago, she modeled the figure *Art* for the Illinois State Building. At the exposition she first saw the Italian sculptor Paul Troubetskoy's portrait statuettes, which inspired her to adapt their impressionistic treatment and diminutive scale to her genre themes. Opening her own studio in 1894 she specialized in conveying "a sort of delicate domesticity," Taft quoted, in writing about her typical bronze statuette groups, often produced in multiples, of children and their mothers. Occasionally she also did portrait busts, of which one was Major General S. W. Crawford's for Fairmount Park, Philadelphia. Visiting Paris in 1895 she met Rodin, and in America the next year she produced one of her most popular statuettes, *The Young Mother*, which received a bronze medal at the Paris Exposition of 1900 and an honorable mention at the Pan-American Exposition (1901) in Buffalo. Potter married the American Impressionist painter Robert Vonnoh in 1899 and lived with him in New York City, Connecticut and southern France. In 1904 she received a gold medal at the St. Louis Exposition, and her *Enthroned* won the National Academy of Design's Shaw Prize; in 1913 her works were exhibited at the Brooklyn Museum. During the 1920s and '30s Bessie Vonnoh turned from sculpting statuettes to life-size figures, often for fountains and sometimes nude, as in her *L'Allégresse*, which received the National Academy's Watrous Gold Medal

in 1921. Elected to the National Sculpture Society and the National Institute of Arts and Letters and an academician of the National Academy of Design, Bessie Vonnoh Keyes was inactive as a sculptor after the 1930s.

Gardner.

Hoeber, Arthur. "A New Note in American Sculpture: Statuettes by Bessie Potter," *The Century Magazine*, vol. 32, May/October 1897, pp. 732–35.

Kohlman, Rena Tucker. P. 227 in "America's Women Sculptors," *The International Studio*, vol. 76, December 1922.

*McSpadden.

"Miss Bessie Potter's Figurines," *Scribner's Magazine*, vol. 19, January 1896, pp. 126–27.

*New York, The Metropolitan Museum of Art. *Nineteenth-Century America: Paintings and Sculpture* (introduction by John K. Howat and John Wilmerding; texts by John K. Howat, Natalie Spassky and others). [New York, 1970]; distributed by New York Graphic Society, n.p.

*Proske.

"A Sculptor of Statuettes," *Current Literature*, vol. 34, June 1903, pp. 699–702.

"Some Sculpture by Mrs. Vonnoh," *The International Studio*, vol. 38, August 1909, pp. 121–24.

Taft.

Peter Voulkos

Born January 29, 1924, Bozeman, Montana

Peter Voulkos was an apprentice molder in an Oregon iron foundry before he entered Montana State University to study painting. During his last year there, however, he began to work in ceramics, and in 1952 he obtained his M.F.A. from the California College of Arts and Crafts in Oakland. In 1954 he moved to Los Angeles to establish the ceramics department at the Otis (then Los Angeles County) Art Institute, serving as its chairman until 1958. Voulkos received immediate attention in Los Angeles and is credited with contributing to the revitalization of California art styles; in 1955 he was the only American to receive a gold medal at the International Exposition of Ceramics at Cannes, France. In Los Angeles Voulkos began to explore unorthodox uses of clay, applying the tenets of Abstract Expressionism to his work and abandoning pottery's traditional symmetrical vessel form. Often slab-building his pieces, Voulkos worked with stacks of thrown cylinders, often joining the seams with epoxies and glazing with bright colors. In these experiments he worked closely with his students at the Institute, notably John Mason and Kenneth Price, and together they transformed ceramics as craft into ceramics as art. In 1959, when Voulkos moved to San Francisco to teach at the University of California at Berkeley, he adopted bronze as a medium and with his colleagues built a casting foundry, where he mounted his multiform assemblages on moving platforms. By 1965, when he completed pieces such as *Hiro* and *Dunlop* (the latter for the Albany Mall, New York), Voulkos's work had become monumental in scale. In 1971 he completed a 30-foot-high sculpture for the Hall of Justice, San Francisco, and in 1972 a 70-foot-long piece for Highland Park, Illinois. His most recent work has transcended the weight and mass of his material through his use of cantilevered forms and convoluting handlebar and elbow curves. Voulkos's one-man shows include those at the Art Institute of Chicago, 1957; the Pasadena Museum of Modern Art, 1958; the Museum of Modern Art, New York, 1960; and the Los Angeles County Museum of Art, 1965.

Brown, Conrad. "Peter Voulkos," *Craft Horizons*, vol. 16, September/October 1956, pp. 12–18.

California, University of; Irvine, Art Gallery. *Abstract Expressionist Ceramics* (text by John Coplans). [Irvine, 1966]. (Text reprinted in *Artforum*, vol. 5, November 1966, pp. 34–41.)

"Ceramics: West Coast," *Craft Horizons*, vol. 26, June 1966, pp. 25–28, 97.

Coplans, John. "Voulkos: Redemption Through Ceramics," *Art News*, vol. 64, Summer 1965, pp. 38–39, 64–65.

*Los Angeles County Museum of Art. *Peter Voulkos: Sculpture*. [Los Angeles, 1965].

M[armer], N[ancy]. "Peter Voulkos: Los Angeles County Museum of Art," *Artforum*, vol. 3, June 1965, pp. 9–10.

R[atcliff], C[arter]. *Britannica*, p. 579.

*San Francisco Museum of Art. *Peter Voulkos: Bronze Sculpture* (text by Gerald Nordland). San Francisco, 1972.

Slivka, Rose. "The New Clay Drawings of Peter Voulkos," *Craft Horizons*, vol. 34, October 1974, p. 30.

John Quincy Adams Ward

Born June 29, 1830, near Urbana, Ohio
Died May 1, 1910, New York City

By 1849 John Quincy Adams Ward had moved to New York and entered the Brooklyn studio of Henry Kirke Brown, first as student and then as apprentice. Under Brown's tutelage Ward mastered all the various sculptural techniques of his day, including the preparation for casting in bronze. In 1861 Ward established his own studio in New York City. Although he traveled to Europe twice (in 1872 and 1887), he chose, unlike the expatriates, to live in America, working on themes and subjects germane to the culture and history of his native land. Ward admired classical sculpture, but the salient characteristic of his own work became a vigorous and straightforward naturalism, which may be seen even in his early ideal sculptures *Indian Hunter* (bronze cast of original statuette, 1860; enlarged statue cast in bronze, 1866) in Central Park and the statuette *Freedman* (1863). Ward's best-known works are his bronze commemorative portrait statues, which include *George Washington* (1883, Wall Street, New York), *President James A. Garfield* (1887, Washington, D.C.) and the Henry Ward Beecher Monument (1891, Brooklyn). Noted, too, for his many portrait busts in both bronze and marble, Ward also produced architectural sculpture with classical and allegorical themes, such as the *Quadriga* (or *Naval Victory*) of 1899 for the Dewey 'Arch, New York (no longer extant), and the marble pedimental figures for the New York Stock Exchange, done in collaboration with Paul Wayland Bartlett in 1903. Ward was elected an academician of the National Academy of Design in 1863 and president in 1874, the first sculptor to hold that

Peter Voulkos

John Quincy Adams
Ward

Olin Levi Warner

Max Weber

post. He also served as the first president of the National Sculpture Society from its founding in 1893 until 1905, and as a member of the original board of trustees of the Metropolitan Museum of Art, established in 1870.

A[dams], A[deline]. *DAB*, vol. 19, pp. 427–29.

Adams, Adeline. *John Quincy Adams Ward: An Appreciation.* New York: National Sculpture Society, 1912.

*Craven.

Gardner.

*Proske.

Schuyler, Montgomery. "John Quincy Adams Ward: The Work of a Veteran Sculptor," *Putnam's Monthly Magazine,* vol. 6, September 1909, pp. 643–56.

*Sharp, Lewis I. "John Quincy Adams Ward: Historical and Contemporary Influences," *The American Art Journal,* vol. 4, November 1972, pp. 71–83.

Sheldon, G. W. "An American Sculptor," *Harper's New Monthly Magazine,* vol. 57, June 1878, pp. 62–68.

Sturgis, Russell. "The Work of J. Q. A. Ward," *Scribner's Magazine,* vol. 32, October 1902, pp. 385–99.

Walton, William. "The Work of John Quincy Adams Ward, 1830–1910," *The International Studio,* vol. 40, June 1910, pp. lxxxi–lxxxviii.

Olin Levi Warner

Born April 9, 1844, Suffield, Connecticut
Died August 14, 1896, New York City

As a teenager Olin Levi Warner carved little chalk figures, and, having made a plaster bust of his father, he chose the vocation of sculptor at the age of nineteen. In 1869 he went to Paris, where he entered the Ecole des Beaux-Arts and studied under the French sculptor François Jouffroy. In addition to Augustus Saint-Gaudens, Warner's friends in Paris included the sculptors Alexandre Falguière and Antonin Mercié. Talented and industrious, Warner was offered the position of studio assistant to Jean Baptiste Carpeaux; he accepted the post and held it until political upheaval ended his employment. He returned to New York in 1872, indoctrinated in the French manner of modeling. Despite a lack of patronage and growing disillusionment following his return to America, Warner gradually gained recognition for his refined and sensitive portrait medallions. His medallion of the actor Edwin Forrest drew favorable attention at the Philadelphia Centennial Exposition of 1876; two years later his exhibition of the portrait busts of Mr. and Mrs. Plant (Mr. Plant was the president of the Southern Express Company) and then of the bust of Daniel Cottier, the New York art dealer, at Cottier's gallery led to additional commissions and commendatory reviews. Elected an academician of the National Academy of Design in 1889, Warner was also a member of the progressive group of painters and sculptors that had established the Society of American Artists in 1877. In 1880 he rented a studio in the Benedict Building, where he met and became friendly with the artists Wyatt Eaton and Julian Alden Weir, whose bust he sculpted. Warner became noted for his combination of naturalistic modeling and sensitive idealism, as seen in his *Twi-*

light (1879) and *Diana* (1883). A trip through the Northwest Territory in 1889 led to a series of Indian portrait medallions. Following his involvement as juror and sculpture exhibitor at the Columbian Exposition (for which he also designed the souvenir half-dollar) in Chicago in 1893, Warner received wide recognition and the commission to design and model two bronze doors for the Library of Congress. Basing his conception on the theme of oral tradition and writing, Warner succeeded in completing only one of the doors before his sudden death after a bicycle accident in Central Park.

*A[dams], A[deline]. *DAB*, vol. 19, pp. 467–68.

Brownell, William C. "The Sculpture of Olin Warner," *Scribner's Magazine,* vol. 20, October 1896, pp. 429–41.

Caffin.

*Craven.

De Kay, Charles [Henry Eckford, pseud.]. "Olin Warner, Sculptor," *The Century Magazine,* vol. 37. January 1889, pp. 392–401.

*Gurney, George. "Olin Levi Warner." Doctoral dissertation in progress, University of Delaware.

*Taft.

Wood, C. E. S. "Famous Indians, Portraits of Some American Chiefs," *The Century Magazine,* vol. 46, July 1893, pp. 436–45.

Max Weber

Born April 18, 1881, Bialystok, Russia
Died October 4, 1961, Great Neck, New York

At the age of ten Max Weber immigrated with his family to the United States and settled in Brooklyn, New York. There Weber attended Pratt Institute from 1898 to 1901, studying design under the formalist Arthur Wesley Dow. Saving his earnings from teaching in Virginia and Minnesota, Weber went to Paris in 1905. During his three years there he studied at the Académies Julian, de la Grande Chaumière and Colarossi, and under Matisse. Becoming friends with many of the younger artists in Paris — Picasso, Delaunay, Segonzac and Elie Nadelman — but particularly close to the much older Henri Rousseau, Weber was especially captivated by the paintings of Cézanne, which he first saw at the Salon d'Automne of 1906; Weber's own paintings were shown at the Salons d'Automne of 1907–8 and Salons des Indépendants of 1906–7. Weber returned to New York in January 1909; had his first one-man show there at the Haas Gallery three months later; and that fall met Alfred Stieglitz, who exhibited Weber's paintings at his "291" Gallery in a group show in 1910 and in a one-man exhibition the following year. Varying between minimal and total abstraction, Weber's paintings of 1909–17, assimilating the successive styles of European modernism — Fauvism, Cubism and Futurism — and aspects of primitive art, placed him in the vanguard of American art and to a corresponding degree at the mercy of most of the reviewers of his early shows. During this intense period of experimentation Weber also addressed himself to making sculpture. These small, at times miniature, plaster pieces also varied in their degrees of abstraction, from primitively handled human figures

— the earliest dated probably 1910 or 1911 — to Cubist works, such as *Spiral Rhythm* (1915), which are among America's earliest completely abstract sculptures. Weber returned to sculpture occasionally in the 1940s and increasingly in the late '50s. In the latter decade a number of his early plasters were enlarged, cast in bronze and given their first museum exhibition in his retrospective at the Newark [New Jersey] Museum in 1959. During Weber's lifetime, retrospectives of his work were also held at the Bernheim-Jeune Gallery, Paris (1924), and in New York at the Museum of Modern Art (1930), the Whitney Museum (1949) and the Jewish Museum (1956).

Cahill, Holger. *Max Weber.* New York: The Downtown Gallery, 1930.

*California, University of; Santa Barbara, The Art Galleries. *First Comprehensive Retrospective Exhibition in the West of Oils, Gouaches, Pastels, Drawings and Graphic Works by Max Weber (1881–1961)* (essay by Ala Story). Santa Barbara, 1968.

The Jewish Theological Seminary of America, The Jewish Museum. *An Exhibition of Oil and Tempera Paintings, Gouaches, Pastels, Woodcuts, Lithographs and Drawings by Max Weber* (text by Stephen S. Kayser). New York, 1956.

Max Weber. New York: American Artists Group, 1945.

New York, The Museum of Modern Art. *Max Weber: Retrospective Exhibition* (with comments on the paintings by the artist). New York, 1930.

The Newark Museum. *Max Weber: Retrospective Exhibition* (text by William H. Gerdts, Jr.). Newark, N.J., 1959.

Salpeter, Harry. "Max Weber: Artist-Scholar," *Esquire,* vol. 10, November 1958, pp. 62–65, 163–67.

Weber, Max. *Essays on Art.* N.p., 1916; printed by W. E. Rudge, New York.

*Werner, Alfred. *Max Weber.* New York: Harry N. Abrams, 1975.

*Whitney Museum of American Art. *Max Weber: Retrospective Exhibition* (text by Lloyd Goodrich; research by Rosalind Irvine). New York, 1949; New York: The Macmillan Company, 1949 (hardcover).

Adolph A. Weinman

Born December 11, 1870, Karlsruhe, Germany
Died August 8, 1952, Port Chester, New York

At the age of ten Adolph Alexander Weinman immigrated to New York City with his widowed mother. At fifteen he was apprenticed to the wood and ivory carver Frederick Kaldenberg and the next year attended evening classes in drawing and modeling at Cooper Union. He later studied at the Art Students League under Augustus Saint-Gaudens and in 1890 entered the studio of Philip Martiny, Saint-Gaudens's former assistant. In the 1890s Weinman also worked with Olin Warner on bronze doors for the Library of Congress and assisted Saint-Gaudens, Charles H. Niehaus and finally Daniel Chester French, the last with sculptural groups for the United States Custom House. In 1904 Weinman opened his own studio and produced his first important sculpture, *Destiny of the Red Men,* for which he won the silver medal at the St. Louis Exposition. Two years later he also won the competition for the memorial to General Alexander McComb, which was unveiled in Detroit in September 1908. Among his other statues are a seated *Abraham Lincoln* for Lincoln's birthplace, Hodgenville, Kentucky; a standing *Lincoln* for the state capitol in Frankfort, Kentucky; and a bronze figure of DeWitt Clinton, which was placed in front of the Museum of the City of New York in 1941. Weinman is probably best known for his architectural sculpture: In New York City these works include panels for the J. Pierpont Morgan Library; sculpture for the Municipal Building's facade (1913); the Madison Square Presbyterian Church's pediment (now at the Metropolitan Museum); and all the sculptural decoration (including the statues of Samuel Rea and Alexander Cassatt) for the interior and facade of Pennsylvania Station, before the station's reconstruction in the 1960s. Noted also for his medallic sculpture, Weinman designed the United States ten- (the Mercury dime) and fifty-cent pieces of 1916. Ten years later he received the Widener Gold Medal from the Pennsylvania Academy of the Fine Arts for his *Narcissus* and the fine arts medal of the American Institute of Architects in 1930. President and medal of honor winner of the National Sculpture Society, Weinman was a member of the American Academy of Arts and Letters (its bronze doors are another of his works) and an academician of the National Academy of Design; he served on the New York City and United States art commissions.

"Adolph Alexander Weinman," in Pan American Union *Bulletin,* vol. 45, December 1917, pp. 775–87.

*Broder.

Dorr, Charles H. "A Sculptor of Monumental Architecture," *Architectural Record,* vol. 33, June 1913, pp. 518–32.

Dyar, Clara E. "Adolph A. Weinman's Monument to Major General Alexander MacComb," *The International Studio,* vol. 39, December 1909, pp. xliv–xlv.

P. 9 in "Obituaries," *Art Digest,* vol. 26, September 15, 1952.

*Proske.

"The Sculptor Weinman and a Few Examples of His Work," *The Century Magazine,* vol. 81, March 1911, pp. 705–7.

*Taft.

Adolph A. Weinman

H. C. Westermann

Born December 11, 1922, Los Angeles

As a young man Horace Clifford Westermann worked in the logging camps of the Pacific Northwest. In 1942 he joined the marines and served in the Pacific during World War II; after the war he toured the Orient as an acrobat with a USO troupe. In 1947 Westermann began his formal training at the Art Institute of Chicago, studying there for three years while working as a handyman. Returning to the Institute after the Korean War, he studied under Paul Weighardt. In 1952 — the year he feels his artistic career began — Westermann emerged as a mature artist with his carved Death Ship series (a theme he has continued to pursue) and war-related pieces dealing with death and violence, such as the micro-

H. C. Westermann

Anne Whitney

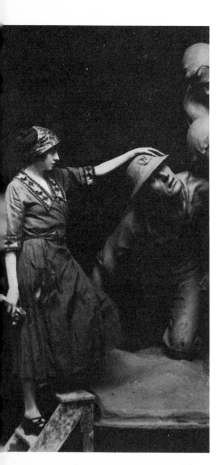

Gertrude Vanderbilt
Whitney

cosmic box construction *The Soldier's Dream* (1956). By the mid-1950s Westermann had begun constructing his first of many miniature houses in lightly varnished or painted plywood with glass, mirror, metal or found-object additions, as in *Mad House* (1957). Although Westermann's work exhibits traces of Dada/Surrealism, his style is idiosyncratic and eclectic, employing eccentric imagery in a variety of forms. Exploring the dichotomy between the verbal idea and the visual image, Westermann's work is a concatenation of visual paradoxes and puns, as in *Walnut Box* (1964), a box made of walnut and filled with walnuts. In his strictly sculptural pieces in laminated plywood, such as *A Rope Tree* (1964), the form contradicts and transcends the properties of the material. An impeccable craftsman and master carpenter, Westermann often uses power tools but is more concerned with traditional construction methods and hand-finishing, and his style evokes images of "a mad cabinetmaker," an epithet that appears in the interior of his figurative cabinet *Memorial to the Idea of Man If He Was an Idea* (1958). From 1970 to the present Westermann has shown a continued interest in the miniature house as a sculptural problem and in the glass-front box containing an arrangement of assembled objects. In 1968 a retrospective was held at the Los Angeles County Museum, and since 1958 Westermann has had many one-man shows at the Allan Frumkin Gallery in Chicago and New York.

Adrian, Dennis. "The Art of H. C. Westermann," *Artforum*, vol. 6, September 1967, pp. 16–22.

———. "Some Notes on H. C. Westermann," *Art International*, vol. 7, February 25, 1963, pp. 52–55.

*Los Angeles County Museum of Art, Contemporary Art Council. *H. C. Westermann* (essay by Max Kozloff). Los Angeles, 1968.

*———.

Perreault, John. "A Cliff in the Woods," *The Village Voice*, vol. 19, December 9, 1974, p. 100.

R[atcliff], C[arter]. *Britannica*, pp. 592–93.

Schulze, Franz. "Chicago: H. C. Westermann at Allan Frumkin," *Art in America*, vol. 61, September/October 1973, p. 122.

Smithsonian Institution, National Collection of Fine Arts; and Museum of Contemporary Art, Chicago. *Made in Chicago* (essays by Whitney Halstead and Dennis Adrian). Washington: Smithsonian Institution Press, 1974.

*Walker Art Center. *Eight Sculptors: The Ambiguous Image* (introduction by Martin Friedman; essay on Westermann by Martin Friedman). Minneapolis, 1966. (Introduction reprinted in *Art News*, vol. 66, March 1967, pp. 30–31, 74–76.)

Anne Whitney

Born September 2, 1821, Watertown, Massachusetts
Died January 23, 1915, Boston

Educated mainly by tutors, Anne Whitney first turned to poetry as her mode of artistic expression, and her *Poems,* published in 1859, achieved modest success. She did not attempt sculpture until her mid-thirties, after accidentally coming upon some clay in a neighbor's greenhouse and finding it a pleasurable material with which to work. Her first sculptures were portrait busts of her parents (1855) and friends. Self-taught at first, she later sought instruction in New York and Philadelphia, but in 1860, finding herself too advanced for classes at the Pennsylvania Academy of the Fine Arts, she drew, modeled and studied anatomy at a Brooklyn hospital. Upon returning to Massachusetts she studied anatomy with her Boston neighbor William Rimmer. She was a suffragist and abolitionist and her works were often inspired by her social ideals. Her opposition to slavery aroused her to create the colossal statue *Africa,* cast in plaster in 1864, and a statue of the Haitian leader Toussaint L'Ouverture. Later in her career the subjects of her busts and full-length portraits included many social reformers — William Lloyd Garrison, Harriet Martineau and Lucy Stone. In 1867 she made her first of three trips to Europe. While in Rome in 1869 she produced a work that especially pleased her, *Roma,* a personification of the city as a beggarwoman. She returned to America in 1871 and opened a studio in Boston. About 1873 she was commissioned to create for Statuary Hall in Washington, D.C., a marble statue of Samuel Adams, a bronze replica of which was later commissioned for Dock Square, Boston. Angered by her loss in 1875 of a commission for a statue of Charles Sumner when the judges discovered that the winning model had been submitted by a woman, she completed her statue of Sumner when she was in her early eighties; it was her last major work and was installed overlooking Harvard Square.

*A[dams], A[deline]. *DAB*, vol. 20, p. 155.

*Craven.

Payne, Elizabeth Rogers. "Anne Whitney, Art and Social Justice," *The Massachusetts Review,* vol. 12, Spring 1971, pp. 245–60.

———. "Anne Whitney, Sculptor," *The Art Quarterly,* vol. 25, Autumn 1962, pp. 244–61.

*———. *Notable,* vol. 3, pp. 600–601.

*Thorp, Margaret Farrand. *The Literary Sculptors.* Durham, N.C.: Duke University Press, 1965.

*Vassar College Art Gallery. *The White, Marmorean Flock: Nineteenth-Century American Women Neoclassical Sculptors* (introduction by William H. Gerdts, Jr.; catalogue by Nikolai Cikovsky, Jr., and others). [Poughkeepsie, N.Y.], 1972.

"Whitney, Anne," *The National Cyclopaedia of American Biography,* vol. 7, p. 72. New York: James T. White & Co., 1897.

Willard, Frances E. and Mary A. Livermore, ed. "Whitney, Miss Anne," *A Woman of the Century,* p. 769. Chicago and New York: Charles Wells Moulton, 1893; Detroit: Gale Research Company, 1974 (reprint).

Gertrude Vanderbilt Whitney

Born January 9, 1875 in New York City
Died April 18, 1942 in New York City

Trained by private tutors and at the Brearley School in New York, Gertrude Vanderbilt Whitney began her study of sculpture about 1900 under Hendrik

C. Andersen and later under James Earle Fraser and at the Art Students League; sometime before 1914 she continued her training under Andrew O'Connor in Paris, where she also received private criticisms from Rodin. At the outset of World War I she established a hospital in Juilly, France. Inspired by her experiences in the hospital, she modeled a series of sketches of its soldiers and nurses and the soldiers' wives, which she developed for her war monuments: two relief panels for the Victory Arch (1918–19), the *Washington Heights War Memorial* (1921) and the Saint-Nazaire Monument (1924), commemorating the landing of American troops on the coast of France. Some of her other commissioned works are the *Titanic Memorial* for Potomac Park, Washington, D.C., 1914; the equestrian monument Buffalo Bill for Cody, Wyoming, 1924; and the *Columbus Memorial* in Palos, Spain, dedicated in 1929. Mrs. Whitney was noted for her architectural and fountain sculpture: Early in her career (1908) she won a prize from the Architectural League of New York for her statue of Pan and the fountain in which it stands; in 1915 she won the bronze medal at the Panama-Pacific International Exposition for her *El Dorado Fountain;* in 1922 she won a medal from the New York Society of Architects for the *Washington Heights Memorial;* and in 1934 she was elected an honorary member of the American Institute of Architects. From 1907 until her death she maintained a studio in Macdougal Alley in Greenwich Village. There, also beginning in 1907, and later in a gallery called the Whitney Studio, she exhibited the works of young and liberal artists. In 1915 she formed the Friends of the Young Artists and in 1918 the Whitney Studio Club, which for ten years was the most active center for liberal art in America. In 1930 she established the Whitney Museum of American Art, and her novel *Walking the Dusk* was published under the pseudonym E. J. Webb in 1932. Three years before her death her last sculpture, *To the Morrow* (also known as *The Spirit of Flight)*, was unveiled at the New York World's Fair.

Breuning, Margaret. "Gertrude Vanderbilt Whitney's Sculpture," *Magazine of Art,* vol. 36, February 1943, pp. 62–65.

DuBois, Guy Pène. "Mrs. Whitney's Journey in Art," *The International Studio,* vol. 76, January 1923, pp. 351–54.

Friedman, B. H. A full-length biography on Mrs. Whitney is in preparation.

"Gertrude V. Whitney Memorial Exhibition," *The Art Digest,* vol. 17, February 1, 1943, p. 5.

Miller, Lillian B. *DAB,* supplement 3, pp. 818–19.

"Mrs. Whitney Exhibits Her New Sculpture," *The Art Digest,* vol. 10, April 1, 1936, p. 6.

Preston, Stuart. *Notable,* vol. 3, pp. 601–3.

*Proske.

Read, Helen Appleton. "The Art of the Whitney Museum's Founder," *Art News,* vol. 41, February 1943, p. 13.

"Sculpture of War, The Work of Gertrude V. Whitney," *Touchstone,* vol. 6, January 1920, pp. 188–94.

Whitney Museum of American Art. *Memorial Exhibition: Gertrude Vanderbilt Whitney* (foreword by Juliana Force). New York, 1943.

Harry Wickey

Born October 14, 1892, Stryker, Ohio
Died April 2, 1968, Cornwall, New York

Harry Herman Wickey grew up in a small rural town in Ohio. Discovering that he liked to draw, he moved, immediately upon graduating from high school, to Detroit, where he enrolled in John P. Wicker's art school. After 1½ years there he left for Chicago, where he studied very briefly at the Art Institute and for a longer time in the city's streets, parks and saloons. In 1914 Wickey went to New York City, where, barely sustained by a part-time job as a subway platform guard and operator, he studied for six months at the Ferrer Modern School under George Bellows, Robert Henri and Sadakichi Hartmann. Hoping to become an illustrator but lacking funds, Wickey attended the free New York School of Industrial Art, and a school in Leonia, New Jersey, under Harvey Dunn. After serving in World War I, Wickey began etching, encouraged by the artist Maria Rother, whom he had recently met and would marry in 1921. During the next fifteen years Wickey became recognized, particularly by other artists, as an outstanding etcher. Yet from 1919 to 1932 he earned his living mainly as a teacher, of his own classes until 1929 and at the Art Students League until 1932, when bad health compelled him to resign. By 1935 his eyesight had become so weakened by the nitric acid and the precise work required for etching that Wickey was forced to give up printmaking. He turned to sculpture, choosing, as in his prints, his subjects from his surroundings — farm animals in Ohio (revisited twice during 1935–36) and New York City's street life. Modeling his small single figures or groups in clay or plasteline and then casting them in bronze, he primarily aimed for the creation of vital, unified forms that emerged from and preserved the integrity of his subjects. His sculpture was shown for the first time in 1938 at the Weyhe Gallery, New York, and one-man shows followed during the next three years at the Cincinnati Museum of Art, Dayton Art Institute, Colorado Springs Fine Arts Center and Associated American Artists, New York. During 1942–46 he was artist-in-residence at Bucknell University and later taught at Orange County Community College. Remaining active as a sculptor, Wickey became curator at the Storm King Art Center, Mountainville, New York, in 1962, a position he held until his death.

Caspers, Frank. "Wickey up to Now," *Art Digest,* vol. 16, December 1, 1941, p. 27.

"Harry Wickey, Well-Known Artist, Curator Dies in Cornwall, New York," *Advance* (Stryker, Ohio), May 23, 1968, pp. 1–3.

The Weyhe Gallery. *Harry Wickey and His Work* (text by Carl Zigrosser). New York, n.d.

Wickey, Harry. *Thus Far: The Growth of an American Artist.* New York: American Artists Group, 1941.

William T. Wiley

Born October 21, 1937, Bedford, Indiana

At the age of ten William Thomas Wiley moved with his family to Richland, Washington, near Se-

Harry Wickey

William T. Wiley

Christopher Wilmarth

Mahonri M. Young

attle, where he graduated from high school in 1956. He received his B.F.A. from the San Francisco Art Institute in 1960 and his M.F.A. in 1962. That year Wiley became an art instructor at the University of California at Davis, where he is now an associate professor. A highly influential artist in the San Francisco Bay Area, Wiley is one of the leaders of Funk art. He cites diverse influences on his art, including the Pacific Northwest Indians, Dada, Clyfford Still, Giorgio de Chirico, H. C. Westermann, Frank Lobdell and his friends William Allan and Robert Hudson. By the age of twenty-one Wiley had begun to exhibit in California and soon thereafter in New York. He had one-man shows at the San Francisco Museum of Art in 1960 and at the Art Institute of Chicago and the Corcoran Gallery of Art in 1972, followed by several at the Staempfli and Allan Frumkin galleries, New York, and the Hansen Fuller Gallery, San Francisco. Working in a variety of mediums — watercolor, drawing, painting, construction, assemblage, earthwork, film, conceptual projects — Wiley often combines several mediums in one piece, as in *Enigma Doggy* (1968), a construction with wood, lead, canvas, latex, paint and chain, and *Random Remarks and Digs* (1971), an oil painting and wood construction. Wiley uses such material as feathers, twigs, rocks, leather, wax, string, felt, dust and other found objects to create highly idiosyncratic tableaux, which often combine poems or commentary with puns and other word play and evoke myth, magic and totemism, as in his sculptures *American Rope Trick* (1967–68) and *Pure Strain* (1970).

*California, University of; Art Museum. *William T. Wiley* (introduction by Brenda Richardson; notes and journal by the artist). Berkeley, Calif., 1971.

Chandler, John Noel and Albie Muldavin. "Correspondences," *Artscanada,* vol. 28, June/July 1971, pp. 44–61.

Perreault, John. "Metaphysical Funk Monk," *Art News,* vol. 67, May 1968, pp. 52–53, 66–67.

Raymond, Herbert. "Prince of Wizdumb," *Art and Artists,* vol. 8, November 1973, pp. 24–27.

Tooker, Dan. "How to Chart a Course," *Artscanada,* vol. 31, Spring 1974, pp. 82–85.

Wasserman, Emily. "William T. Wiley and William Allan: Meditating at Fort Prank," *Artforum,* vol. 9, December 1970, pp. 62–67.

Christopher Wilmarth

Born June 11, 1943, Sonoma, California

In his late teens Christopher Wilmarth worked as studio assistant to Tony Smith and in 1965 received his B.F.A. from Cooper Union. His first one-man show at New York's Graham Gallery in the fall of 1968 featured constructions of unpainted birch plywood cylinders and partial cylinders articulated by plate glass. At this time he was earning his living as a cabinetmaker and glass was not yet his primary material. In 1969 he was appointed an assistant professor at Cooper Union and received a National Endowment for the Arts grant and in 1970 a Guggenheim Fellowship. Characterizing his forms as "self-generated," Wilmarth since has exploited the light-transmitting property of glass in ways previously un-

explored in sculpture. No longer working in wood, he exhibited crayon and graphite drawings on tinted acidized glass in his summer 1970 show at French & Co., New York. The following year at the Paula Cooper Gallery, New York, he showed assemblages of bent glass sheets and wire, the latter used functionally to bind the glass and pictorially to provide lineation. He was a visiting artist at Yale University during 1971–72. About that time he worked on the problems of scale and surface posed by the addition of metal sheets to those of glass. Wilmarth's largest exhibition to date — *Nine Clearings for a Standing Man,* at the Wadsworth Atheneum and St. Louis Art Museum during 1974–75 — probed further into questions of figuration and psychological space in a series of nine rectilinear glass, steel-plate and wire-rope reliefs, supplemented by drawings and watercolors.

Ashton, Dore. "Radiance and Reserve: The Sculpture of Christopher Wilmarth," *Arts Magazine,* vol. 45, March 1971, pp. 31–33.

Glueck, Grace. P. 112 in "New York Gallery Notes: Circa 1825–2000," *Art in America,* vol. 56, September/October 1968.

———. P. 46 in "New York: Visual Riches and Recessionary Blues," *Art in America,* vol. 59, March/April 1971.

Linker, Kate. "Christopher Wilmarth: Nine Clearings for a Standing Man," *Arts Magazine,* vol. 49, April 1975, pp. 52–53 and cover.

Pincus-Witten, Robert. "Christopher Wilmarth, a Note on Pictorial Sculpture," *Artforum,* vol. 9, May 1971, pp. 54–56.

*R[atcliff], C[arter]. *Britannica,* pp. 598–99.

*Wadsworth Atheneum. *Christopher Wilmarth: Nine Clearings for a Standing Man* (essay by Joseph Masheck and statement by the artist). Hartford, 1974.

Wasserman, Emily. Pp. 59–60 in "New York," *Artforum,* vol. 7, January 1969.

Mahonri M. Young

Born August 9, 1877, Salt Lake City
Died November 2, 1957, Norwalk, Connecticut

Always knowing that he wanted to be a sculptor, Mahonri Mackintosh Young, grandson of the Mormon leader Brigham Young, began modeling in clay as a small child in Utah. After dropping out of high school Young decided that it was more practical to become an illustrator and studied drawing under James T. Harwood in Salt Lake City. Subsequently, Young's interest in becoming a sculptor was reawakened by Cyrus E. Dallin's visit to Salt Lake City to work on his Pioneer Monument, and in 1899 Young moved to New York City for further study at the Art Students League; two years later he continued his training in Paris at the Académies Julian, Colarossi and, occasionally, Delécluse. His professional career began when his first bronze statuettes, *The Shoveler* and *Man Tired,* were accepted for an American Art Association exhibition in Paris and reproduced in a Paris newspaper. Completed shortly thereafter, his small bronze figure *Bovet Arthur — A Laborer* (c. 1903–4) won for Young the National Academy of Design's Barnett Prize in 1911. In addi-

tion to workmen and boxers, his favorite subjects included western genre — cowboys, horses and Indians — and after three field trips to the Southwest he modeled the Apache, Navajo and Hopi Indian groups for the American Museum of Natural History. Young helped organize the 1913 Armory Show, in which six of his sculptures were shown, including two reliefs from his Sea Gull Monument, Salt Lake City, the work that brought him his first fame in America. About 1925 Young moved to Paris for 2½ years, a very productive period in which he sculpted most of his statues of prizefighters. Well known also for his drawings, prints and paintings, Young taught often and all subjects at the Art Students League in New York. In 1932 he won two prizes for sculpture — the gold medal for *The Knockdown* at the Los Angeles Olympic Games and the National Academy's Maynard Portrait Prize for his bust of Emil Carlsen, one of his few portraits. Seven years after the Addison Gallery of American Art's retrospective (1940) of his work in various mediums, he completed his This Is the Place Monument, a work of colossal size commemorating the Mormons' arrival in the Salt Lake valley. His last major work — a marble statue of Brigham Young installed in Statuary Hall, Washington, D.C., in 1950 — again paid tribute to Young's Mormon ancestors.

Brigham Young University and M. Knoedler & Company. *Mahonri M. Young* (essay by an unidentified child of the artist). N.p., 1969.

Du Bois, Guy Pène. "Mahonri Young — Sculptor," *Arts and Decoration*, vol. 8, February 1918, pp. 169, 188.

Gibbs, Jo. "Mahonri's Drawings," *Art Digest*, vol. 19, January 15, 1945, p. 20.

Lewine, J. Lester. "The Bronzes of Mahonri Young," *The International Studio*, vol. 47, October 1912, pp. lv–lviv.

"Mahonri Young's Sculpture Preserves his Mormon Past," *Life Magazine*, vol. 10, February 17, 1941, pp. 76, 79.

Phillips Academy, Addison Gallery of American Art. *Mahonri M. Young: Retrospective Exhibition* (essay by Frank Jewett Mather, Jr.; autobiographical remarks by the artist). Andover, Mass., 1940.

*Proske.

*[Utah State Park and Recreation Commission]. *This Is the Place: Monument and Mural* (text by Allen S. Cornwall). Salt Lake City: Wheelwright Lithographing Company, 1960.

Watson, Jane. Pp. 583–84 in "News and Comment," *Magazine of Art*, vol. 33, October 1940, pp. 582–84.

studied art in France, exhibiting paintings at the 1911 Salon d'Automne in Paris. Zorach returned to Cleveland in 1911 and had his first one-man exhibition of paintings there in 1912. At the end of the year he returned to New York and married Marguerite Thompson, an art student he had met in Paris. Settled in New York, Zorach exhibited Fauvist paintings in the Armory Show of 1913 and in the Forum Exhibition of 1916. During the summer of 1917 Zorach carved his first sculpture since childhood — a wood relief — and by 1922 he had decided to devote himself primarily to sculpture. He became a pioneer in the American revival of direct carving in stone and wood, an approach to sculpture in which the material is seen as a primary carrier of expression. Striving to monumentalize his forms, Zorach used this technique until the end of his life to interpret individual human or animal subjects and the relationships between man and woman, woman and child and child and animal. In 1924 the Kraushaar Galleries, New York, held Zorach's first one-man sculpture exhibition. He was awarded the Art Institute of Chicago's Logan Medal in 1931 and again in 1932 and in 1939 was represented at the New York World's Fair by a monumental work, *Builders of the Future*. Retrospectives of Zorach's work were held in 1950 at the Art Students League (honoring his twenty-first year of teaching there) and in 1959 at the Whitney Museum. In 1953 Zorach was elected to the National Institute of Arts and Letters, which awarded him its gold medal for sculpture in 1961.

*Baur, John I. H. *William Zorach* (bibliography by Rosalind Irvine). New York: published for the Whitney Museum of American Art by Praeger Publishers, 1959. (Longer version of the catalogue of the Whitney Museum's exhibition *William Zorach*.)

"Sculpture Lesson," *Life*, vol. 24, May 31, 1948, pp. 75–79.

*Wingert, Paul. *The Sculpture of William Zorach*. New York: Pitman Publishing, 1938.

Zorach, William. *Art Is My Life: The Autobiography of William Zorach*. Cleveland and New York: The World Publishing Company, 1967.

_____. *William Zorach*. New York: American Artists Group, 1945. (Also published as two articles in *Magazine of Art*: "Early Years," vol. 34, April 1941, pp. 162–68; "Productive Years," vol. 34, May 1941, pp. 234–39.)

_____. *Zorach Explains Sculpture: What It Means and How It Is Made*. New York: American Artists Group, 1947.

Copyright © Arnold Newman

William Zorach

William Zorach

Born 1889, Eurburg, Lithuania
Died November 15, 1966, Bath, Maine

By 1893 William Zorach and his family had immigrated to America and in 1894 settled in Cleveland, Ohio. From 1902 until 1906 Zorach was an errand boy and then an apprentice to a Cleveland lithographer while studying nights at the Cleveland School of Art. In 1907 he went to New York City and studied at the National Academy of Design under A. M. Ward and George Maynard. During 1910–11 he

Acknowledgments

THERE HAS NEVER BEEN a major survey of American sculpture associated both with a scholarly publication and a museum exhibition. There are many negative aspects to such a project which have discouraged others, particularly the cost and difficulty of assembling the objects and the reluctance of publishers to risk an unfamiliar venture. David R. Godine and his entire staff have been enthusiastic since we first encouraged them to assist us in the publication of this book and we are all convinced that our joint endeavor could not have been more pleasant or successful.

None of this effort would have been possible without the National Endowment for the Arts. At the time we were encouraged by them to proceed with plans for the exhibition and book, the Whitney Museum of American Art received what was then the largest single grant for an exhibition awarded by the Museums Program of the Endowment. With their support, the next challenge became securing a matching grant from private sources. The Chase Manhattan Bank, through the leadership of David Rockefeller, Chairman of the Board, graciously assisted us with a sense of dedication to the project equal to our own. In years to come, the Chase Manhattan Bank and the National Endowment for the Arts should be recognized as having made possible a major historic survey of an entire aspect of the visual arts, destined to become a record of aesthetic judgment at the time of the nation's Bicentennial.

The staff of the Whitney Museum is relatively small; for them to have accomplished the task of organizing this book and the associated exhibition at the Museum is a tremendous achievement for which I am particularly grateful. We are all indebted to the scholars whose contributions to this book and the exhibition greatly increase our appreciation of the subject.

To my associates at other museums, we all express our sincere thanks for their extraordinary efforts to assist us in this project. In many instances they represented our interests to trustees and others to enable us to present unusual and rare material in the context of a general survey. It is gratifying to realize and recognize the interest of other museum professionals.

The firm of Venturi and Rauch, Architects and Planners, particularly Robert Venturi, John Rauch, Steve Izenour, Tony Atkin, Gary Kneeland, Steve Kieran and J. M. Samford, were responsible for the design of the installation of the exhibition at the Whitney Museum which translated our efforts to the public and became the stimulus for further appreciation of the subject through the scholarship of this book. Interpretations of the vast range of material in the exhibition were provided to the Museum public, with special events for school children and scholars, by educational programs made possible through the generosity of The Mary Sisler Foundation.

To all the many interested and generous people who helped us, we are particularly indebted. It is a pleasure to acknowledge special recognition for the assistance of the following persons without whom this ambitious project would not have been possible:

Carolyn Adams; Richard E. Ahlborn, Chairman, Department of Cultural History, National Museum of History and Technology, Smithsonian Institution; Betty Asher, Los Angeles County Museum of Art; Elizabeth Bailey,

Registrar, Pennsylvania Academy of the Fine Arts; Amy Baker, John Weber Gallery; Bernard Barenholtz; Anthony Barnard; John I. H. Baur, Director Emeritus, Whitney Museum of American Art; Kathleen Bishop-Glover, National Museum of Man, National Museums of Canada; Mary Black, Curator, The New-York Historical Society; Doreen Bolger, The Metropolitan Museum of Art; Lee Boltin; Monique Storrs Booz; Richard Boyle, Director, Pennsylvania Academy of the Fine Arts; Peter M. Brant; Ron Brentano, Curator, Oregon Historical Society; Arthur Breton, Curator, Manuscripts, Archives of American Art; Irene Butterbaugh, Walters Art Gallery; John C. Byron, Director of South Mall Construction, Office of General Services, Albany; Emily Chapin; Margaret B. Clunie; Eugene S. Cooper; William Copley; Michelle DeAngelus; Walter De Maria; Andrew S. Dolkart; Donald Droll; Adele Earnest, Stony Point Gallery; Elizabeth Easton; Roni Feinstein; Xavier Fourcade; Doris C. Freedman, Chairman, Public Arts Council, Municipal Art Society; Linae Frei, The Eakins Press; Frederick Fried; Lisa Frigand, The Metropolitan Museum of Art; Allan Frumkin, Allan Frumkin Gallery; Diana Fuller, Hansen Fuller Galleries; Dorothy M. Fulton, The American Museum of Natural History; Henry Geldzahler, Curator, 20th-Century Art, The Metropolitan Museum of Art; Brad Gillaugh, Leo Castelli Gallery; Scott Gladden; Anne Golovin, Associate Curator, Division of Pre-Industrial History, National Museum of History and Technology, Smithsonian Institution; Frank Goodyear, Curator, Pennsylvania Academy of the Fine Arts; Nancy Graves; Mrs. Frances Archipenko Gray; Dr. William Greenspon; Arne Hansen, Director, Colorado Springs Fine Arts Center; Anne d'Harnoncourt, Curator, 20th-Century Art, Philadelphia Museum of Art; Lynda Hartigan, National Collection of Fine Arts; Harold Hayden, Art Department, University of Chicago; Flora Miller Irving; Mimi Jacobs; Suzanne Jenkins, Registrar, National Portrait Gallery; Miani Johnson, Willard Gallery; Mitchell D. Kahan; Patricia Kane, Assistant Curator, Garvan Collection, Yale University Art Gallery; Mrs. Jacob M. Kaplan; Leslie Katz, The Eakins Press; Kirsten Keen; Ellsworth Kelly; Staff of the Kendall Young Public Library, Webster City, Iowa; Mary Alice Kennedy, Assistant Curator, The New-York Historical Society; Lillian Kiesler; Mrs. Robert J. Koenig, Registrar, The Newark Museum; Carol Kurzweil, Archives of American Art; C. Stevens Laise, Curator, Ships and Ship Models, The Mariners Museum; Louise Lawler, Leo Castelli Gallery; Zachary Leader; Susan Leidy, Assistant Registrar, Pennsylvania Academy of the Fine Arts; Abram Lerner, Director, Hirshhorn Museum and Sculpture Garden; Barry Le Va; Nathan Lipfert, Assistant Curator, Bath Marine Museum; Howard Lipman; Jean Lipman; Barbara Luck, Registrar, Abby Aldrich Rockefeller Folk Art Collection; Sarah Lytle; Lois G. Marcus; Francis S. Mason, Jr., Chairman, Martha Graham Center for Contemporary Dance, Inc.; W. Barnabas McHenry; John L. Marion, President, Sotheby Parke Bernet Inc., New York; Marceline McKee, The Metropolitan Museum of Art; Randy McManus, Lincoln Center for the Performing Arts; Alexandra McPherson; Anne Meservey; George Miller; Samuel C. Miller, Director, The Newark Museum; Theodora Morgan, National Sculpture Society; John W. Myers; Pinckney Near, Curator, Virginia Museum of Fine Arts; Dr. John Neff, Curator, Modern Art, Detroit Institute of Arts; Cyril I. Nelson, E. P. Dutton and Co.; Mrs. Annalee Newman; Gerald Nordland, Director, The Frederick S. Wight Art Gallery, University of California at Los Angeles; Molly O'Donnell and the staff of the Sherman Art Library, Dartmouth College; Claes Oldenburg; Craig Owens; Joseph Papp, Producer, New York Shakespeare Festival; Elizabeth Pollock; Meyer Potamkin; Beatrice Gilman Proske, Curator of Sculpture, The Hispanic Society of America; Ora Ramat; Norman Rice, Director, Albany Institute of History and Art; Eugenia S. Robbins; Pamela Rosenthal; Beatrix T. Rumford, Director, Abby Aldrich Rockefeller Folk Art Collection; Lucas Samaras; Jeanette Schlesinger, Rockefeller Center, Inc.; Robert Schoelkopf, Robert Schoelkopf Gallery; Tom Scott, Dean of the Graduate Division, Maryland Institute, College of Art; Wilford W. Scott; Lewis Sharp, Assistant Curator, American Paintings and Sculpture, The Metropolitan Museum of Art; Ann Siegel; Harvey Simmonds, The Eakins Press; Roy Slade, Director, Corcoran Gallery of Art; Clare Stein, Executive Director, National Sculpture Society; Susan E. Strickler; Siadhal Sweeney; Dorothy Tananbaum; Dr. Joshua C. Taylor, Director, National Collection of Fine Arts; Fearn Thurlow, Curator, Paintings and Sculpture, The Newark Museum; Paul Tschinkel; Carol K. Uht, Curator, Nelson A. Rockefeller Collection; Hap Tivey; Samuel Wagstaff; John Walker, Director Emeritus, National Gallery of Art; Donald Walters, Associate Curator, Abby Aldrich Rockefeller Folk Art Collection; J. Watson Webb, Jr., President, Shelburne Museum; Angela Westwater, Sperone Westwater Fischer Inc.; Joan Whitbeck, Office of General Services, Albany; Ian McKibbin White, Director, The Fine Arts Museums of San Francisco; Mrs. Harry Wickey; Nicholas Wilder, Nicholas Wilder Gallery; William D. Wilkinson, Director, The Mariners Museum; William E. Wiltshire, III; William E. Woolfenden, Director, Archives of American Art; Timothy Yohn; Virginia Zabriskie, Zabriskie Gallery.

T. A.

List of Lenders

Abby Aldrich Rockefeller Folk Art Collection,
Williamsburg, Virginia

Addison Gallery of American Art, Phillips Academy,
Andover, Massachusetts

Albany Institute of History and Art, Albany, New York

Albright-Knox Art Gallery, Buffalo, New York

American Academy of Arts and Letters, New York

American Antiquarian Society, Worcester, Massachusetts

Museum of American Folk Art, New York

Museum of the American Indian, Heye Foundation,
New York

The American Museum of Natural History, New York

American Numismatic Society, New York

Amon Carter Museum, Fort Worth, Texas

Mr. and Mrs. Harry W. Anderson

Avery Library, Columbia University, New York

Mr. and Mrs. Alan Backstrom

Richard Brown Baker

Art Gallery, Ball State University, Muncie, Indiana

Larry Bell

Mr. and Mrs. Edwin A. Bergman

Galerie Beyeler, Basel, Switzerland

Mr. and Mrs. Michael Blankfort

Museum of Fine Arts, Boston

Louise Bourgeois

The Brooklyn Museum, New York

Daniel Brush

Mr. and Mrs. Henry M. Buchbinder

The National Gallery of Canada, Ottawa

Canadian Ethnology Service, National Museum of Man,
National Museums of Canada, Ottawa

Cincinnati Art Museum, Cincinnati, Ohio

Columbia Museum of Art, Columbia, South Carolina

Mr. and Mrs. Eugene S. Cooper

Corcoran Gallery of Art, Washington, D.C.

Delaware Art Museum, Wilmington

The Historical Society of Delaware, Wilmington

Dudley and Michael Del Balso

Walter De Maria

The Denver Art Museum, Denver, Colorado

Des Moines Art Center, Des Moines, Iowa

The Detroit Institute of Arts, Detroit, Michigan

Virginia Dwan

James Economos

Edwin Forrest Home, courtesy of the Philadelphia
Museum of Art

Empire State Plaza Art Collection, Albany, New York

Madelon Maremont Falxa

Mr. and Mrs. Richard L. Feigen

Field Museum of Natural History, Chicago

Fischbach Gallery, New York

Mr. and Mrs. Miles Q. Fiterman

Forum Gallery Inc., New York

Fourcade, Droll Inc., New York

Mr. and Mrs. Victor W. Ganz

Mr. and Mrs. Nathan Gates

Graham Gallery, New York

Dr. William Greenspon

Stewart E. Gregory

Mr. and Mrs. Edward Z. Halper

Mr. and Mrs. Richard Hankinson

Hansen Fuller Galleries, San Francisco

Heiner Friedrich, Cologne and New York

Al Held

Heritage Plantation of Sandwich, Massachusetts

Hirshhorn Museum and Sculpture Garden, Smithsonian Institution, Washington, D.C.

The Hispanic Society of America, New York

Mr. and Mrs. Leonard J. Horwich

Robert Irwin

Jasper Johns

Mr. and Mrs. George M. Kaufman

Ellsworth Kelly

Mrs. Melville J. Kolliner

Krannert Art Museum, University of Illinois, Urbana-Champaign

Lachaise Foundation, courtesy of Robert Schoelkopf Gallery, New York

Ibram Lassaw

Margo Leavin

Leo Castelli Gallery, New York

Howard and Jean Lipman

Long Island Historical Society, Brooklyn, New York

Mr. and Mrs. John McCoubrey

Galerie Maeght, Paris

Mr. and Mrs. Lewis Manilow

The Mariners Museum, Newport News, Virginia

Martha Graham Center for Contemporary Dance, Inc., New York

Flora Whitney Miller

Milwaukee Public Museum, Milwaukee, Wisconsin

Minnesota Museum of Art, St. Paul

Montclair Art Museum, Montclair, New Jersey

Mystic Seaport, Inc., Mystic, Connecticut

National Cowboy Hall of Fame, Oklahoma City, Oklahoma

The Newark Museum, Newark, New Jersey

Annalee Newman

The Metropolitan Museum of Art, New York

The Museum of Modern Art, New York

The New-York Historical Society

New York Shakespeare Festival

New York State Historical Association, Cooperstown

Nicholas Wilder Gallery, Los Angeles

North Carolina Museum of Art, Raleigh

The Oakland Museum, Oakland, California

Claes Oldenburg

Art Gallery of Ontario, Toronto

Mr. and Mrs. Al Ordover

The Pace Gallery, New York

Mr. and Mrs. Stephen D. Paine

Giuseppe Panza di Biumo

Charles Parks

Paula Cooper Gallery, New York

Peabody Museum of Archaeology and Ethnology, Harvard University, Cambridge, Massachusetts

Pennsylvania Academy of the Fine Arts, Philadelphia

Perls Galleries, New York

Philadelphia Museum of Art

Philbrook Art Center, Tulsa, Oklahoma

Portland Art Museum, Portland, Maine

The Art Museum, Princeton University, Princeton, New Jersey

Robert Rauschenberg

The Reis Family

The Rhode Island Historical Society, Providence

Museum of Art, Rhode Island School of Design, Providence

Robert Schoelkopf Gallery, New York

Roger Williams Park Museum, Providence, Rhode Island

San Francisco Museum of Art

Sara Roby Foundation, New York

Mr. and Mrs. Jack Schafer

Mrs. Joseph Halle Schaffner

Mrs. R. B. Schulhof

Shelburne Museum, Shelburne, Vermont

Estate of David Smith, courtesy of Knoedler
Contemporary Art, New York

Estate of Robert Smithson, courtesy of John Weber
Gallery, New York

National Collection of Fine Arts, Smithsonian
Institution, Washington, D.C.

National Museum of History and Technology,
Smithsonian Institution, Washington, D.C.

National Portrait Gallery, Smithsonian Institution,
Washington, D.C.

Sonnabend Gallery, New York

Sperone Westwater Fischer Inc., New York

Helen B. Stern

George Sugarman

Mr. and Mrs. James Johnson Sweeney

Taylor Museum of the Colorado Springs Fine
Arts Center

Anne Truitt

Richard Tuttle

U.S. Department of the Interior, National Park
Service; Saint-Gaudens National Historic Site,
Cornish, New Hampshire

Virginia Museum of Fine Arts, Richmond

Dorothy and Herbert Vogel

Wadsworth Atheneum, Hartford, Connecticut

Wallraf-Richartz-Museum, Cologne

Walters Art Gallery, Baltimore, Maryland

Washington University Gallery of Art, St. Louis,
Missouri

George and Wendy Waterman

Wellesley College Museum, Wellesley, Massachusetts

Mrs. C. Oliver Wellington

Whitney Museum of American Art, New York

Wilhelm-Lehmbruck-Museum der Stadt, Duisburg,
Germany

Willard Gallery, New York

Christopher Wilmarth

Mr. and Mrs. Erving Wolf

Worcester Art Museum, Worcester, Massachusetts

James Wyeth

Yale University Art Gallery, New Haven, Connecticut

Zabriskie Gallery, New York

Anonymous (7)

Index

Numbers in italics denote pages
on which illustrations appear;
bold-face numbers indicate page
references for artists' biographies.

Photograph Credits

Photographs of the works of art reproduced have been supplied, in the majority of cases, by the owners or custodians of the works, as cited in the captions. The following list applies to photographs for which an additional acknowledgment is due. Where a page reference is given, U refers to the upper photograph and L to the lower one.

Courtesy Harry N. Abrams Pl. 59

Dorothy B. Alexander p. 316U

Alt-Lee Photographers, Inc. Fig. 99

Courtesy Archives of American Art p. 257L, p. 262L, p. 265L, p. 266U & L, p. 267L, p. 272L, p. 274L, p. 278L, p. 285L, p. 286L, p. 317L, p. 318U & L, p. 319U, p. 322L

Courtesy *Art in America* Fig. 296

Oliver Baker Fig. 167

Marianne Barcellona p. 295U

Bob Benson p. 267U

E. Irving Blomstrann Fig. 347

W. L. Bowers Pls. 4, 15

Nat Boxer p. 288L

Mathew B. Brady, courtesy National Archives, U.S. Signal Corps p. 292L

Will Brown Figs. 114, 334

Rudolph Burckhardt Figs. 260, 280, 314, 319, 320, 328, 345

Hillel Burger Pl. 5; Fig. 24

Courtesy Leo Castelli Gallery Fig. 282

Courtesy Chesterwood, a Property of the National Trust for Historic Preservation p. 273L

Courtesy Chicago Historical Society p. 315U

Geoffrey Clements Pl. 61; Figs. 105, 119, 141, 163, 179, 180, 188, 189, 191, 207a, b, 211, 214, 217, 218, 236, 241, 248, 257, 269, 270, 272, 274, 281, 284, 288, 289, 301, 303, 317, 337a, b, 338, 339

Courtesy Paula Cooper Gallery Fig. 292

Criterion Photography Fig. 120

Reproduced from *Dictionary of American Portraits*, Dover Publications, 1967 p. 258U, p. 265L, p. 302U, p. 309L

eeva-inkeri photographers Fig. 169

Eliot Elisofon p. 296L

Courtesy Essex Institute p. 289L

John Evans Photography Pl. 3; Figs. 1, 2, 19, 20

Roxanne Everett p. 260U, p. 283L, p. 314L

Tom Faggi p. 270L

Charlotte Fairchild p. 320L

John A. Ferrari Figs. 190, 324

Courtesy Fourcade, Droll Inc. Fig. 246

Courtesy Frederick Fried p. 303U

Roger Fritz Figs. 275a, b

Courtesy Allan Frumkin Gallery Fig. 323

Albert E. Gallatin p. 285U

Gianfranco Gorgoni p. 256U, p. 268U, p. 293L, p. 309U, p. 311L, p. 312U

John R. Gossage p. 315L

Gray Photographer Fig. 161

Greenberg-May Prod. Inc. Fig. 212

Steve Griffin p. 257U

Pedro E. Guerrero p. 263L

Courtesy The Solomon R. Guggenheim Museum Fig. 305

Eric Hansen, Sexton Studios Pl. 11

William Harker Fig. 15

Harris and Ewing Photographers, Washington, D.C., courtesy National Portrait Gallery p. 259U, p. 260L

Helga Photo Studio, Inc. Pls. 56, 60; Fig. 242

Pinchos Horn, courtesy Archives of American Art p. 303L

Mimi Jacobs p. 274U, p. 317U

Robert Jaffe Fig. 104

Warren Jagger Figs. 25, 28

Bruce C. Jones Figs. 343a, b

Peter A. Juley & Son Figs. 91, 165, 175, 198, 204

Paul J. Kennedy Pl. 36

Bernd Kirtz BFF Fig. 267b

Joseph Klima, Jr., Detroit, courtesy Archives of American Art p. 269L

Peter A. Koszack Fig. 273

Richard Landry Pl. 64

David A. Lang p. 294L

Courtesy Janie C. Lee Gallery p. 275U

Courtesy Library of Congress p. 261U

Hans Lorenz Pl. 29

Courtesy Los Angeles County Museum of Art Fig. 234

Pirie MacDonals, courtesy The Metropolitan Museum of Art p. 259U

Eugene L. Mantie Pl. 10

Tom Mapp, Midway Studios Fig. 193

Robert Mates & Paul Katz Figs. 240, 332

Bob McCormack Photographer Fig. 9

Fred W. McDarrah p. 264U, p. 271U, p. 277U, p. 279L, p. 283U, p. 284L, p. 287L, p. 288U, p. 289U, p. 300U

Raymond Medio Fig. 130

Courtesy The Metropolitan Museum of
 Art p. 262U, p. 282U, p. 298L

Richard Merrill Fig. 145

Courtesy Minnesota Museum of Art
 p. 291L

Knox Hall Montgomery, courtesy
 Archives of American Art p. 271L

Peter Moore Pl. 50; Figs. 251, 300, 306,
 312, p. 261L

Al Mozell Figs. 244, 252

Courtesy The Municipal Museum, The
 Hague Fig. 291

Ugo Mulas p. 296U

Hans Namuth p. 264L, p. 275L, p. 282L

Courtesy National Collection of Fine Arts
 p. 302L

Courtesy National Museum of Man,
 Ottawa Fig. 22

Courtesy National Portrait Gallery
 Fig. 75, p. 304L

Courtesy National Sculpture Society
 Figs. 73, 156, p. 291U

O. E. Nelson Fig. 254

Arnold Newman p. 269U, p. 276L, p. 278U,
 p. 284U, p. 295L, p. 297U, p. 300L,
 p. 301L, p. 308L, p. 311U, p. 323

Courtesy Art Division, New York
 Public Library p. 270U

Pach Brothers, courtesy The New-York
 Historical Society Fig. 153

Thomas Palmer Figs. 94a-e, 95, 154

R. Parry Paris, courtesy Archives of
 American Art p. 280U

Courtesy Pennsylvania Academy of the
 Fine Arts Figs. 35, 36, p. 273U,
 p. 274L

Dan Perlmutter Pl. 53; Figs. 39, 86, 121,
 166, 192, 283, 313

Charles H. Phillips, courtesy *Smithsonian
 Magazine* Pl. 23

Robert Phillips, Time-Life Picture
 Agency © Time Inc. Pl. 46

Piaget, St. Louis Fig. 56

Eric Pollitzer Figs. 290, 309, 325, 336

Nathan Rabin Figs. 302, 304

Percy Rainford Figs. 178, 200

Courtesy John Rogers Studio and Museum,
 New Canaan, Conn. p. 304U

Lloyd W. Rule Pl. 16

Courtesy Israel Sack, Inc. Fig. 27

Courtesy Sandak, Inc. Figs. 7, 8, 71

Courtesy The Santa Barbara Museum of
 Art Pl. 26

Morton L. Schamberg, courtesy Ben Wolf
 p. 308U

John D. Schiff Figs. 220, 222, 223

Marvin W. Schwartz p. 272U, p. 279U

The Misses Selby Studio, courtesy The
 Metropolitan Museum of Art p. 281U

M. W. Sexton Figs. 23a, b

Robert Shaw p. 299U

Florence Sherrow Fig. 350

Shunk-Kender Fig. 307

Erik Leigh Simmons Fig. 54

David Smith Figs. 265, 267a, 276

Courtesy Sperone Westwater Fischer Inc.
 Fig. 299

Allen Stross Fig. 321

Soichi Sunami Fig. 250

William Suttle Figs. 331, 344

Joseph Szaszfai, Yale University Art
 Gallery Figs. 46, 232, 318

Frank J. Thomas Pl. 55; Fig. 279, p. 292U

Jerry L. Thompson Pls. 9, 12, 17, 18, 19,
 21, 22, 24, 28, 34, 37, 38, 40, 42, 43, 44,
 47, 51; Figs. 66, 89, 137, 205, 264

Malcolm Varon Pls. 48, 68; Fig. 263

Ron Vickers, courtesy Art Gallery of
 Ontario Fig. 308

Courtesy Virginia Museum of Fine Arts
 Fig. 43

Herbert P. Vose Fig. 55

DeWitt Clinton Ward Fig. 177, p. 306L,
 p. 319U

Courtesy John Weber Gallery Figs. 293,
 310

Virginia Weckel Fig. 87

Murray Weiss Figs. 31, 34, 42

Claire L. White Fig. 139

Susan Wilmarth p. 322U

Helen Winkler Fig. 298

A. J. Wyatt Fig. 77

Bob Zucker Figs. 92, 185

Checklist of the Exhibition

Carl Andre (b. 1935)

1. *Twelfth Copper Corner*, 1975
Copper , ¼ x 236¼ x 236¼ inches
Sperone Westwater Fischer Inc., New York

José Rafael Aragón (active 1826–1855)

2. *Christ Crucified*, 1838–51
Polychromed wood, gesso; 93½ x 68½ x
11½ inches
From the Duran Chapel, Talpa, New
Mexico
Taylor Museum of the Colorado Springs
Fine Arts Center

Alexander Archipenko (1887–1964)

3. *Turning Torso*, 1921
Bronze, 28 inches high
Inscription (rear, lower left leg): 1921/
Archipenko/ 8/8
Eighth of eight casts
Perls Galleries, New York

4. *Torso in Space*, 1936
Metalized terra-cotta, 21 x 60 x 13 inches
Smaller versions, 1935, exist in bronze and
gold-plated bronze
Whitney Museum of American Art, New
York; Gift of Mr. and Mrs. Peter Rubel

5. *Walking Woman*, 1937
Terra-cotta, 25½ x 7 x 11 inches
Inscription (lower front): Archipenko
Perls Galleries, New York

Richard Artschwager (b. 1924)

6. *Mirror-Mirror/Table-Table*, 1964
Formica on wood; 2 mirrors, each 37 x 25
x 5 inches; 2 tables, each 24 x 25 x 30
inches
Collection of Mr. and Mrs. Al Ordover

Hezekiah Augur (1791–1858)

7. *Alexander Metcalf Fisher*, 1825–27
Marble, 22⅞ inches high
Yale University Art Gallery, New Haven,
Connecticut; Gift of the Colleagues of
Alexander Metcalf Fisher, Class of 1813

Saul Baizerman (1889–1957)

8. *Barrel Roller*, c. 1920
Bronze, 4 x 3 x 2 inches
From "The City and the People" series
Collection of Mr. and Mrs. Nathan Gates

9. *Road Builder's Horse*, 1921–22
Bronze, 4 inches high
From "The City and the People" series
Whitney Museum of American Art, New
York

10. *Hod Carrier*, c. 1929
Bronze, 6¾ x 2½ x 3 inches
Inscription (founder's mark, rear, left leg;
indistinct): RBW [Roman Bronze
Works, N.Y.]
From "The City and the People" series
Zabriskie Gallery, New York

11. *Road Builder*, 1939
Hammered copper, 28½ inches high
Zabriskie Gallery, New York

Thomas Ball (1819–1911)

12. *Henry Clay*, 1858
Bronze, 30½ inches high
Inscription (rear of base): T. BALL, SCULP./
BOSTON 1858/Patent assigned to G. W.
Nichols, Founders, Chicopee, Mass.
Addison Gallery of American Art, Phillips
Academy, Andover, Massachusetts

13. *Emancipation Group*, 1865, cast 1873
Bronze, 34½ inches high
Inscriptions: (on base at right) T BALL
SCULPT/1865; (on base at left) FAUSTO
FAVI FUSE/FIRENZE 1873; (on front of
base) "And upon this act — I invoke the
considerate judgment of mankind/and
the gracious favour of Almighty God";
(on cap of slave) LIBERTY
Study for life-size monuments erected in
Washington, D.C., 1875, and Boston,
1877
Montclair Art Museum, Montclair, New
Jersey; Gift of Mrs. William Couper,
1913

George Grey Barnard (1863–1938)

14. *Grief*, n.d.
Marble, 47 x 10 x 20 inches
Inscription (front, lower left): G. Grey
Barnard
The Metropolitan Museum of Art, New
York; Gift of Mrs. Stephen C. Clark, 1967

Paul Wayland Bartlett (1865–1925)

15. *Bohemian Bear Tamer*, 1887
Bronze, 68½ inches high
Inscriptions: (right side of base) Paul. W.
Bartlett./87; (left side of base) GRUET
FONDEUR/PARIS
The Metropolitan Museum of Art, New
York; Gift of an association of gentle-
men, 1891

16. *Equestrian Lafayette*, n.d., cast 1959
Bronze, 41½ inches high
Cast by the Modern Art Foundry, New
York, from original plaster reduction of
life-size monument erected at the
Louvre, Paris, 1908
Columbia Museum of Art, Columbia,
South Carolina; Gift of Mrs. Armistead
Peter III

17. *Seated Male Figures*, n.d.
Bronze, 3½, 3½, 3¾, and 4 inches high
Inscription (one of the figures signed on
 base): Paul W. Bartlett
According to the artist's step-daughter,
 these figures were studies for the *Foun-
 tain of the Engineers* which was never
 executed
North Carolina Museum of Art, Raleigh;
 Gift of Mrs. Armistead Peter III

18. *Washington at Valley Forge*, n.d.,
 cast 1927
Bronze, 8¼ inches high
Inscriptions: (between left front and rear
 hooves) PWB; (behind right rear hoof)
 1927; (behind left rear hoof) ©
Corcoran Gallery of Art, Washington, D.C.

George Baxter (1804–1867)

19. Photographic documentation of *The
 Genius of the Great Exhibition Number
 3*, 1852
Combination of wood block and steel plates
 with oil-colored inks on paper (Baxter's
 Process); 5⁷⁄₃₂ x 9¹³⁄₁₆ inches
The Metropolitan Museum of Art, New
 York; The Elisha Whittelsey Collection,
 The Elisha Whittelsey Fund, 1955

Larry Bell (b. 1939)

20. *Talpa Fracture* from *The Iceberg*, 1975
Glass coated with quartz and metallic
 inconel; 14 panels, each 7 x 6 feet
Lent by the artist

Ronald Bladen (b. 1918)

21. Untitled, 1968
Wood, 12 x 16 x 6 feet
Fischbach Gallery, New York

Gutzon Borglum (1867–1941)

22. *Mares of Diomedes*, 1904
Bronze, 62 inches high
Inscription: Gutzon Borglum 1904
Cast by Gorham and Co., New York
The Metropolitan Museum of Art, New
 York; Gift of James Stillman, 1906

23. Photographic documentation of *Mount
 Rushmore*, begun 1927, Black Hills,
 South Dakota
Granite, 465 feet high
Postcard courtesy of James L. Lowe,
 Director, Deltiologists of America

Solon H. Borglum (1868–1922)

24. *Lassoing Wild Horses*, 1898
Bronze, 33 inches high
Inscriptions: SOLON BORGLUM; COPYRIGHTED
 BY SOLON BORGLUM; ROMAN BRONZE
 WORKS N.Y.
National Cowboy Hall of Fame, Oklahoma
 City, Oklahoma

Louise Bourgeois (b. 1911)

25. *The Blind Leading the Blind*, 1949
Painted wood, 84 x 84 x 7 inches
Inscriptions: (signed right top) LB; (back
 top) 1949
Lent by the artist, courtesy of Fourcade,
 Droll Inc., New York

26. *One and Others*, 1955
Painted and stained wood, 18¼ x 20 x
 16¾ inches
Whitney Museum of American Art,
 New York

Victor D. Brenner (1871–1924)

27. U.S. cent (Lincoln cent), 1909
Bronze, 19 millimeters in diameter
Inscription (reverse, above date): VDB
American Numismatic Society, New York

Edmond Brown (1870–1940)

28. *Carousel Rooster*, c. 1900, St. Johnsbury,
 Vermont
Polychromed wood, 39 inches high
Collection of Mrs. Joseph Halle Schaffner

Henry Kirke Brown (1814–1886)

29. *La Grazia*, 1845
Marble, 20½ inches high
The New-York Historical Society

30. *General Winfield Scott*, c. 1858, cast
 1966
Bronze, 28¾ inches high
Inscription (front of socle): Gen. Scott
Study for life-size monument erected in
 Washington, D.C., 1874
National Portrait Gallery, Smithsonian
 Institution, Washington, D.C.

A. Stirling Calder (1870–1945)

31. *The Man Cub*, c. 1901
Bronze, 44 inches high
Inscription (on base): Calder
Second of two casts
The Metropolitan Museum of Art, New
 York; Rogers Fund, 1922

32. Photographic documentation of
 Fountain of Energy, 1915
Artificial travertine
Panama-Pacific International Exposition,
 San Francisco, 1915
Glass lantern slide courtesy of Art Depart-
 ment, Dartmouth College, Hanover,
 New Hampshire

Alexander Calder (b. 1898)

33. *The Brass Family*, 1929
Brass wire, 64 x 41 x 8½ inches
Inscription (bottom of left arm of man):
 Calder
Whitney Museum of American Art, New
 York; Gift of the artist

34. *Double Cat*, 1930
Wood, 7 x 51 x 4¼ inches

Inscription (mid-section of longer cat):
 Calder
Whitney Museum of American Art, New
 York; Gift of the Howard and Jean
 Lipman Foundation, Inc.

35. *Little Ball with Counterweight*, c. 1930
Sheet metal, wood and wire, 63¾ x 12½
 x 12½ inches
Collection of Mr. and Mrs. Leonard J.
 Horwich

36. *Calderberry Bush*, 1932
Painted sheet metal, wood, wire and rod,
 84 x 56 inches
Collection of Mr. and Mrs. James Johnson
 Sweeney

37. *Thirteen Spines*, 1940
Sheet steel, aluminum, iron cable, steel
 shaft, paint; 86⅓ inches high
Wallraf-Richartz-Museum, Cologne

38. *Aspen*, 1948
Metal, 38¼ x 25 x 22 inches
Galerie Beyeler, Basel, Switzerland

39. *Big Red*, 1959
Painted sheet metal and steel wire, 74 x
 114 inches
Inscription (on stabilizer): CA/59
Whitney Museum of American Art, New
 York; Gift of the Friends of the Whitney
 Museum of American Art

40. *Snow Plow*, 1963
Steel, 74½ x 101 x 112½ inches
Inscription: CA 63
Galerie Maeght, Paris

John Chamberlain (b. 1927)

41. *Velvet White*, 1962
Welded automobile metals, 81½ x 61 x
 54½ inches
Whitney Museum of American Art, New
 York; Gift of the Albert A. List Family

Joseph Cornell (1903–1972)

42. *L'Egypte de Mlle Cléo de Mérode;
 cours élémentaire d'histoire naturelle*,
 1940
Apothecary's wooden box with bottles,
 cork and miscellaneous materials; 10⅝
 x 7¼ x 4¾ inches
Inscription (inner right corner of lid):
 Joseph Cornell 1940
Collection of Mr. and Mrs. Richard L.
 Feigen

43. *Homage to the Romantic Ballet*, 1942
Wooden box with plexiglas cubes, velvet
 and collage; 4 x 10 x 6¾ inches
Inscription (typed, rim of lower part of
 box): Joseph Cornell
Collection of Mr. and Mrs. Richard L.
 Feigen

44. *Medici Slot Machine*, 1942
Mixed media, 15½ x 12 x 4⅜ inches
Inscription (back, upper left):
 Object 1942 by Joseph Cornell
Collection of the Reis Family

45. *A Pantry Ballet (for Jacques Offen-
bach)*, 1942
Wood, paper, plastic, metal, glass and
miscellaneous materials; 10½ x 18 x 6
inches
Inscription (on front): A Pantry Ballet
(for Jacques Offenbach) Joseph Cornell
Collection of Mr. and Mrs. Richard L.
Feigen

46. *Dovecote*, 1952
Painted wood, 16¾ x 11¾ x 3⅜ inches
Inscription (back, upper left): Joseph
Cornell 1952
Collection of Mrs. R. B. Schulhof

47. *Homage to Blériot*, 1956
Box containing painted wood trapeze
supported by rusted steel spring; 18½
x 11¼ x 4¾ inches
Inscription (back, lower left corner):
Joseph Cornell
Collection of Mr. and Mrs. Edwin A.
Bergman

Thomas Crawford (1813?–1857)

48. *The Genius of Mirth*, 1843
Marble, 46 inches high
Inscription (signed on base): CRAWFORD–
FECIT–ROMAE–MDCCCXLIII
The Metropolitan Museum of Art, New
York; Gift of Mrs. Annette W. W.
Hicks-Lord, 1897

Cyrus E. Dallin (1861–1944)

49. *The Scout*, 1910
Bronze, 39 x 38 x 12 inches
Inscriptions: (top of base in front of right
hoof) © C.E.D./1910; (rear of base)
GORHAM CO. FOUNDERS
Collection of Mr. and Mrs. Erving Wolf

50. *On the Warpath*, 1915
Bronze, 21¼ x 21 x 7 inches
Inscriptions: (base, right front) C. E. Dallin
©; (base, right) GORHAM CO. FOUNDERS;
(back of base, middle) 4
Variation of a larger version of 1914
Graham Gallery, New York

Jo Davidson (1883–1952)

51. *Gertrude Stein*, 1920, cast 1954
Bronze, 31¼ x 23¼ x 24½ inches
Inscription (right side of skirt): Gertrude
Stein/Jo Davidson/Paris 1920
Cast by Roman Bronze Works, New York
Whitney Museum of American Art,
New York

José de Creeft (b. 1884)

52. *The Cloud*, 1939
Greenstone, 13½ x 12½ x 8½ inches
Whitney Museum of American Art,
New York

Walter De Maria (b. 1935)

53. *Lightning Field*, 1973–76
One of 640 stainless steel poles being

placed 200 feet apart, one per acre, on a
square mile of flat land in southwestern
United States; each pole is 18 feet high
and 2 inches in diameter
Lent by the artist

54. Photographic documentation of "test
field" for *Lightning Field*, 1973–76
35 stainless steel poles placed 208 feet
apart, one per acre on a square mile of
flat land in southwestern United States;
each pole is 18 feet high and 2 inches in
diameter

55. *Horizontal and Vertical*, 1975
Pencil on drawing boards with linen and
oak frames; horizontal, 36¼ x 45¼
inches; vertical, 45¼ x 36¼ inches
Signed and dated on backs of both frames
in upper right corners
Heiner Friedrich, Cologne and New York

José de Rivera (b. 1904)

56. *Construction #107*, 1969
Stainless steel forged rod, 21½ x 41 x 41
inches
Hirshhorn Museum and Sculpture Garden,
Smithsonian Institution, Washington,
D.C.

Mark di Suvero (b. 1933)

57. *New York Dawn (for Lorca)*, 1965
Iron, steel and wood, 78 x 74 x 50 inches
Whitney Museum of American Art, New
York; Gift of the Howard and Jean
Lipman Foundation, Inc.

57A. *Mohican*, 1967
Painted steel and wood, 15 x 9 x 30 feet
Collection of Mr. and Mrs. Lewis Manilow

Charles J. Dodge (attributed) (1806–1886)

58. *Seated Indian*, c. 1860
Painted wood, 76 inches high
From 1862 until 1930 the figure stood
outside Walter Allen's Tobacco Shop at
78 Montague Street, Brooklyn, New York
Restored for this exhibition
Long Island Historical Society, Brooklyn,
New York

Marcel Duchamp (1887–1968)

59. *In Advance of the Broken Arm*, 1945
replica of 1915 original
Wood and metal, 47¾ inches high
Inscription (on reverse of lower edge in
white paint): IN ADVANCE OF THE BROKEN
ARM MARCEL DUCHAMP [1915] replica 1945
Yale University Art Gallery, New Haven,
Connecticut; Gift of Katherine S. Dreier
to the Collection Société Anonyme

Thomas Eakins (1844–1916)

60. *Arcadia*, 1883, cast 1888 (?)
Bronze, 12 x 24 inches
Inscriptions: (upper left) EAKINS 1888;
(lower right) THOMAS EAKINS
Collection of James Wyeth

Abastenia St. Leger Eberle (1878–1942)

61. *Roller Skating*, before 1909
Bronze, 13 x 11¾ x 6¼ inches
Inscription (lower rear of base): A. St. L.
Eberle
Whitney Museum of American Art,
New York

62. *Windy Doorstep*, 1910
Bronze, 13½ x 9½ x 6½ inches
Inscription (rear, top of base): A.•St·
L•Eberle 1910
One of five casts
Worcester Art Museum, Worcester,
Massachusetts

Alfeo Faggi (1885–1966)

63. *St. Francis*, 1915, cast 1921
Bronze, 53 inches high
Inscriptions: (lower left front) A. Faggi;
(rear of base) CAST BY AMERICAN ART
BRONZE FDY CHICAGO ILL–1921
Albright-Knox Art Gallery, Buffalo, New
York; Room of Contemporary Art Fund

Herbert Ferber (b. 1906)

64. *Homage to Piranesi II*, 1962–63
Copper and brass, 90 x 46½ x 46½ inches
Inscription (incised, top surface of lower
horizontal piece of cage): Ferber 62.63
The Metropolitan Museum of Art, New
York; Gift of William Rubin, 1965

John B. Flannagan (1895–1942)

65. *Chimpanzee*, 1928
Granite, 10¾ x 8 x 6¾ inches
Whitney Museum of American Art,
New York

66. *Elephant*, 1929–30
Bluestone, 13½ x 15 x 8 inches
Whitney Museum of American Art,
New York

67. *Figure of Dignity — Irish Mountain
Goat*, c. 1932–33
Granite, horns of cast aluminum, concrete
plinth; 55¾ inches high
The Metropolitan Museum of Art, New
York; Gift of the Alexander Shilling
Fund, 1941

68. *Cobra and Mongoose*, 1938
Granite, 26 x 15½ x 15½ inches
Graham Gallery and Zabriskie Gallery,
New York

Dan Flavin (b. 1933)

69. *untitled (to the "innovator" of Wheel-
ing Peachblow)*, 1968
Daylight, pink and yellow fluorescent
light; 96 x 96 inches
Leo Castelli Gallery, New York

James Earle Fraser (1876–1953)

70. U.S. five-cent piece (Indian head and
buffalo), matte proof, 1913

Nickel (75%) and copper (25%); 21.2 millimeters in diameter
Inscription (obverse, shoulder of Indian): F
American Numismatic Society, New York

John Frazee (1790–1852)

71. *Andrew Jackson*, 1834
Plaster of Paris, 13 inches high
The Art Museum, Princeton University, Princeton, New Jersey

Daniel Chester French (1850–1931)

72. *Ralph Waldo Emerson*, 1879, cast 1901
Bronze, 22½ inches high
Inscriptions: (on front) EMERSON; (on rear shaft) D. C. FRENCH SC./1879/THE HENRY-BONNARD BRONZE C°./FOUNDERS. N.Y. 1901
National Portrait Gallery, Smithsonian Institution, Washington, D.C.

73. *The Concord Minute Man of 1775*, 1889
Bronze, 32½ inches high
Inscriptions: (back of base) D. C. French Sc.; (front of base) THE CONCORD MINVTE MAN OF 1775; (right front of base) Jno. Williams Founder-New York
Reworking of first model for over-life-size monument erected in Concord, Massachusetts, 1875
Art Gallery, Ball State University, Muncie, Indiana; Gift of F. C. Ball

74. *Standing Lincoln*, 1912
Bronze, 38 inches high
Inscriptions: (top of base) © Daniel C. French Sc 1912; (founder's mark, back of base) ROMAN BRONZE WORKS N–Y
Study for the life-size monument erected in Lincoln, Nebraska, 1912
Whitney Museum of American Art, New York

Sidney Gordin (b. 1918)

75. *Construction, Number 10*, 1955
Painted steel, 36 x 41½ x 27 inches
Whitney Museum of American Art, New York

Charles Grafly (1862–1929)

76. *Aeneas and Anchises*, 1893, probably cast between 1906 and 1929
Bronze, 27⅞ inches high
Inscriptions: (on base) GRAFLY 1893; (founder's mark) ROMAN BRONZE WORKS N Y
Delaware Art Museum, Wilmington

77. *In Much Wisdom*, 1902
Bronze, mosaic tiles; 63½ inches high
Inscriptions: (back of base) Charles Grafly, Philadelphia 1902; (founder's mark) Bureau Bros. Bronze Founders
Pennsylvania Academy of the Fine Arts, Philadelphia; Gilpin Fund Purchase, 1912

Nancy Graves (b. 1940)

78. *Camel VI*, 1968–69
Wood, steel, burlap, polyurethane, animal skin, wax and oil paint; 90 x 144 x 48 inches
The National Gallery of Canada, Ottawa

79. *Signs Exchanged Between Ireteba, Sub-Chief of the Mojave, and Major Beale, Aboard the "General Jessup," While Ferrying 16 Camels (Property of the U.S. Government) Across the Colorado River near Needles, California, January, 1858*, 1970
Ink on paper, 16¹⁵⁄₁₆ x 13¹⁵⁄₁₆ inches
Signed (lower right corner): GRAVES 1970
Private collection

Gertrude Greene (1911–1956)

80. *Space Construction*, 1942
Painted composition board and wood, 39½ x 27½ x 3 inches
Whitney Museum of American Art, New York; Gift of Balcomb Greene

Horatio Greenough (1805–1852)

81. Photographic documentation of *George Washington*, 1832–41
Marble, 136 inches high
National Collection of Fine Arts, Smithsonian Institution, Washington, D.C.

82. *Abdiel*, 1839
Marble, 40¾ inches high
Inscription (signed on back of base): HG. 1839
Yale University Art Gallery, New Haven, Connecticut; Bequest of Edward E. Salisbury

83. *Castor and Pollux*, 1847–51
Marble, 34½ x 45 inches
Museum of Fine Arts, Boston

Chaim Gross (b. 1904)

84. *Strong Woman (Acrobat)*, 1935
Lignum vitae, 48¼ x 11½ x 8 inches
Inscription (signed on front of base): CH. GROSS
Hirshhorn Museum and Sculpture Garden, Smithsonian Institution, Washington, D.C.

Robert Grosvenor (b. 1937)

85. *Untitled*, 1975
Steel pipe, 96 inches long x 12 inches in diameter
Paula Cooper Gallery, New York

James Hampton (1909–1964)

86. *Throne of the Third Heaven of the Nations Millenium General Assembly*, c. 1950–64
Furniture, light bulbs, blotters, in/out boxes, nails, pins, and other found objects, covered with gold and silver foil; 10½ feet x 26 feet, 11 inches x 14½ feet

Many of the pieces are inscribed with references to the Book of Revelation from the New Testament of the Bible
Installation for this exhibition by Lynda R. Hartigan, Art Historian, Department of 20th Century Painting and Sculpture, National Collection of Fine Arts
National Collection of Fine Arts, Smithsonian Institution, Washington, D.C.

David Hare (b. 1917)

87. *Magician's Game*, 1944
Bronze, 40¼ x 18½ x 25¼ inches
The Museum of Modern Art, New York; Given anonymously, 1969

Harris and Ewing Photographers, Washington, D.C.

88. *Paul Wayland Bartlett Standing before a Marble Sculpture*, n.d.
Photograph, 8 x 10 inches
National Portrait Gallery, Smithsonian Institution, Washington, D.C.

89. *Gutzon Borglum*, n.d.
Photograph, 8 x 10 inches
National Portrait Gallery, Smithsonian Institution, Washington, D.C.

90. *Augustus Saint-Gaudens*, n.d.
Photograph, 8 x 10 inches
National Portrait Gallery, Smithsonian Institution, Washington, D.C.

Herbert Haseltine (1877–1962)

91. *Meadowbrook Team*, 1909
Bronze, 41 x 68 x 39½ inches
Whitney Museum of American Art, New York

92. *Percheron Mare and Foal*, 1925
Bronze and onyx, 21¾ inches high x 29 inches long
Inscriptions: (back of base) HASELTINE MCMXXV; (founder's mark) ALEXIS RUDIER/Fondeur. Paris
One of first two casts
The Metropolitan Museum of Art, New York; Gift of Mrs. Florence Blumenthal, 1926

93. *Percheron Stallion (Rhum)*, 1930
Bardiglio marble, 29 x 26½ x 11 inches
Inscription (back of base): HASELTINE/MCMXXX
Field Museum of Natural History, Chicago

Michael Heizer (b. 1944)

94. *Adze Dispersal*, 1968–71
Stainless steel, ½ x 20 x 7 feet (variable)
Fourcade, Droll Inc., New York

95. Photographic documentation of *The City, Complex One*, 1972–76, central eastern Nevada
Cement, steel and earth; 23½ x 140 x 110 feet
Photograph by Gianfranco Gorgoni
Fourcade, Droll Inc., New York

José Ines Herrera (active 1890–1910)

96. *Death Cart* or *La Doña Sebastiana*, late 19th century, El Rito, New Mexico
Figure: cottonwood root, gesso, polychrome, horsehair, dog hair; cart: pine and rawhide; 54½ x 26 x 36 inches (overall)
The Denver Art Museum, Denver, Colorado; Anne Evans Collection

Eva Hesse (1936–1970)

97. *Circle Drawing*, 1968
Pencil and plastic thread on paper, 15⅛ x 15⅛ inches
Collection of Mr. and Mrs. Victor W. Ganz

98. *Horizontal Lines*, 1968
Pencil and watercolor on paper, 15⅝ x 11⅜ inches
Collection of Mr. and Mrs. Victor W. Ganz

99. *Untitled (Seven Poles)*, 1970
Fiberglass over polyethylene over aluminum wire; 7 units, each 74–111 inches high by 10–16 inches in circumference
Collection of Mr. and Mrs. Victor W. Ganz

Malvina Hoffman (1885–1966)

100. *Mask of Anna Pavlova*, 1924
Tinted wax, 15½ inches high
Inscription (scratched in wax at end of base): M HOFFMAN 1924 ©
Sixth example
The Metropolitan Museum of Art, New York; Gift of Mrs. L. Dean Holden, 1935

Harriet Hosmer (1830–1908)

101. *Daphne*, 1854
Marble, 27 inches high
Inscription (signed on back): Harriet Hosmer Sculpt. Roma.
Washington University Gallery of Art, St. Louis, Missouri

Jean Antoine Houdon (1741–1828)

102. *Benjamin Franklin*, 1779
Marble, 20⅞ inches high
Inscription (signed on socle): F. P. HOUDON EN 1779.
Loan arranged by Sotheby Parke Bernet Inc., New York

103. *George Washington*, c. 1790
Marble, 24 inches high
Inscription (signed on right shoulder): Houdon F.
Private collection

Anna Hyatt Huntington (1876–1973)

104. *Reaching Jaguar*, 1906, cast 1926
Bronze, 45 inches high
Inscriptions: COPYRIGHTED; (founder's mark) Jno. Williams Inc. N.Y. 1926
Second of three casts after small bronze study, 1906, and life-size plaster model, 1907

The Metropolitan Museum of Art, New York; Gift of Archer M. Huntington, 1925

105. *Greyhounds Playing*, 1936, remodeled c. 1945 from larger version
Latex ceramic compound, 18 x 21 x 9 inches
Cast by Louis Paul Jonas, c. 1945
About four examples of larger version cast in bronze and aluminum, 1936
The Hispanic Society of America, New York

Robert Irwin (b. 1928)

106. Untitled, 1976
Two-by-six-inch 16-inch oc construction ¾-inch dry wall, metal cornerbead on all surfaces, 17½ feet x 32 feet x 6⅝ inches
Lent by the artist

Chauncey B. Ives (1810–1894)

107. *Daniel Wadsworth*, 1841
Marble, 21 inches high
Inscriptions: (signed on back between shoulders) C. B. Ives, Sculpt.; (back of base) D. Wadsworth 1771–1848
Wadsworth Atheneum, Hartford, Connecticut; Bequest of Daniel Wadsworth

108. *Mrs. William Gage Lambert*, 1848
Marble, 28½ inches high
The New-York Historical Society

John Adams Jackson (1825–1879)

109. *Bearded Man*, n.d.
Marble, 25 inches high
Inscription (signed on back): J. A. JACKSON/ SCULPTOR
Collection of Mr. and Mrs. Edward Z. Halper

110. *Musidora*, n.d.
Marble, 25 inches high
Inscription (signed on back): J. A. JACKSON/ Sculptor
Collection of Mr. and Mrs. Edward Z. Halper

Jasper Johns (b. 1930)

111. *Painted Bronze (Savarin can with brushes)*, 1960
Painted bronze, 13½ inches high x 8 inches in diameter
Collection of the artist

112. *Painted Bronze II (Ale Cans)*, 1964
Painted bronze, 5½ x 8 x 4½ inches
Collection of the artist

Johnson, Wilson & Co., Publishers, New York

113. *Harriet Hosmer with Sculpture Bust*, 1874
Engraving, 9 x 5½ inches
Inscription (lower center): H G Hosmer [facsimile signature] Likeness from an

approved photograph from life/Johnson, Wilson & Co., Publishers, New York/Entered according to act of Congress AD 1874 by Johnson, Wilson & Co. in the office of the Librarian of Congress at Washington
National Portrait Gallery, Smithsonian Institution, Washington, D.C.

114. *Hiram Powers Standing Beside The Greek Slave*, 1874
Engraving, 8⅞ x 5⅞ inches
Inscriptions: (lower left) Painted by; (lower right) Alonzo Chapprl [sic]; (lower center) Hiram Powers [facsimile signature]/Likeness from an approved photograph finished by authority/Johnson, Wilson & Co., Publishers, New York/Entered according to act of Congress AD 1874 by Johnson, Wilson & Co. in the office of the Librarian of Congress at Washington
National Portrait Gallery, Smithsonian Institution, Washington, D.C.

Donald Judd (b. 1928)

115. Untitled, 1966
Painted cold-rolled steel; ten units, 48 x 120 x 120 inches (overall)
Whitney Museum of American Art, New York; Gift of Howard and Jean Lipman

116. Untitled, 1968
Ink on paper, 17 x 22 inches
Collection of Dudley and Michael Del Balso

Ellsworth Kelly (b. 1923)

117. *Briar*, 1963
Pencil on paper, 22⅜ x 28⅜ inches
Signed (lower right corner): E K 63
Whitney Museum of American Art, New York; Neysa McMein Purchase Award

118. *Black White*, 1968
One-half-inch steel plate, painted; 100 x 146 x 38½ inches
The Detroit Institute of Arts, Detroit, Michigan; Gift of the artist and the Founders Society

119. *Study for Green Curve, Radius 10 Feet*, 1973
Pencil on paper, 30 x 36 inches
Signed on reverse
Collection of the artist

Edward Kienholz (b. 1927)

120. *After the Ball is Over, #2*, 1963
Bronze plaque on wood and framed typewritten statement; 12⅛ x 7⅝ x 2 inches
Inscriptions: signed on bronze plaque; dated top center of typewritten statement and lower right corner of bronze plaque
Collection of Virginia Dwan

121. *The Wait*, 1964–65
Tableau: epoxy, glass, wood and found

objects; 80 x 148 x 78 inches
Whitney Museum of American Art, New
York; Gift of the Howard and Jean
Lipman Foundation, Inc.

Frederick Kiesler (1896–1965)

122. *Landscape: The Saviour Has Risen*,
cast 1962, assembled 1964
Bronze, black glass, granite and plastic;
57½ x 49 x 35½ inches
Whitney Museum of American Art, New
York; Gift of the Howard and Jean
Lipman Foundation, Inc.

J. Krans (attributed)

123. *Tinsmith*, c. 1895
Tin, 72 inches high
Trade sign for West End Sheet Metal and
Roofing Works Corp., Brooklyn, New
York, of which J. Krans was the owner
and proprietor
Collection of Mr. and Mrs. Eugene S.
Cooper

Gaston Lachaise (1882–1935)

124. *Standing Woman* (also called *Eleva-
tion*), 1912–27, cast 1937
Bronze, 70 x 28 x 16 inches
Inscriptions: (base, right of left foot)
©/1927/G. Lachaise; (founder's mark)
GARGANI FDRY N. Y./1936
Fourth of four casts
Whitney Museum of American Art,
New York

125. *Dancing Woman*, c. 1915
Bronze, 11 x 5¾ x 3¼ inches
Inscription (rear of base, right):
G. Lachaise
Collection of Mrs. C. Oliver Wellington

126. *La Force Eternelle (Eternal Force)*,
1917
Bronze, 12¾ x 6¾ x 3¼ inches
Inscriptions: (incised on plinth, rear left)
G. Lachaise/1917; (back of base)
A. KUNST/Foundry N.Y.
One of three casts
Hirshhorn Museum and Sculpture Garden,
Smithsonian Institution, Washington,
D.C.

127. *Walking Woman*, 1922
Polished bronze, 19¼ x 10½ x 7½ inches
Inscription (incised on plinth, rear right):
G. Lachaise/© 22
One of at least six casts
Hirshhorn Museum and Sculpture Garden,
Smithsonian Institution, Washington,
D.C.

128. *Dolphin Fountain*, 1924
Bronze, 17 x 39 x 25¼ inches
Inscriptions: (base, left front) G. Lachaise;
(base top) © 1924; (founder's mark)
Roman Bronze Works, N.Y.
One of two casts
Whitney Museum of American Art,
New York

129. *Georgia O'Keeffe*, 1927
Alabaster, marble pedestal; 23 inches high
Inscription (tranche of neck): G. Lachaise/
© 1927
The Metropolitan Museum of Art, New
York; The Alfred Stieglitz Collection,
Gift of Georgia O'Keeffe, 1949

130. *Torso with Arms Raised*, 1935,
cast 1973
Bronze, 37 inches high
Inscription (founder's mark): Lachaise
Estate 3/8
Third of eight casts
Lachaise Foundation, courtesy of Robert
Schoelkopf Gallery, New York

Albert Laessle (1877–1954)

131. *Turning Turtle*, 1905
Bronze, 8 x 10½ x 6½ inches
Inscriptions: (base, left front) ALBERT-
LAESSLE/PARIS/1905; (founder's mark)
QIER GORHAM CO.
One of two casts
The Metropolitan Museum of Art, New
York; Rogers Fund, 1917

Ibram Lassaw (b. 1913)

132. *Gravity Tension*, 1944
Stainless steel, cast alloy, lucite, wire; 19¼
x 11¾ x 10¼ inches
Inscription (signed at bottom): Ibram
Lassaw 1944
Collection of the artist

133. *Star Cradle*, 1949
Stainless steel and lucite, 11¼ x 16 x
11¼ inches
Inscription (signed near bottom): Ibram
Lassaw 1949
Collection of the artist

Robert Laurent (1890–1970)

134. *The Flame*, c. 1917
Wood, 18 inches high
Whitney Museum of American Art, New
York; Gift of Bartlett Arkell

135. *Duck*, c. 1921
Whitewood, 19½ inches high
Inscription (signed rear of base, top):
Laurent
The Newark Museum, Newark,
New Jersey

136. *The Awakening*, 1931
Bronze, 37¾ x 55 x 28½ inches
Inscriptions: (signed left side of base)
Laurent; (founder's mark, side of base,
rear) Roman Bronze Works
Whitney Museum of American Art,
New York

Barry Le Va (b. 1941)

137. *3 Ball Bearings, 3 Sheets Black Felt*,
1967
Ink on paper, 10 x 12½ inches
Sonnabend Gallery, New York

138. *3 Ball Bearings, 3 Sheets Black Felt*,
1967
Ball bearings and black felt, size variable
Sonnabend Gallery, New York

139. *3 Arrangements of Same Quantities
and Constants*, 1968
Colored ink on paper, 19 x 24 inches
Signed and dated, lower right corner
Sonnabend Gallery, New York

Sol LeWitt (b. 1928)

140. *Open Modular Cube*, 1966
Painted aluminum and tape, 60 x 180 x 180
inches
Art Gallery of Ontario, Toronto

Richard Lippold (b. 1915)

141. *Variation Number 7: Full Moon*,
1949–50
Brass rods, nickel-chromium and stainless
steel wire; 120 inches high
The Museum of Modern Art, New York;
Mrs. Simon Guggenheim Fund, 1950

Seymour Lipton (b. 1903)

142. *Pioneer*, 1957
Nickel-silver on Monel metal, 94 inches
high
The Metropolitan Museum of Art, New
York; Gift of Mrs. Albert A. List, 1958

James Lombard (1865–1920)

143. *Hen Weathervane*, c. 1885
Painted wood, 19¼ inches high
Found on a barn in Wells, Maine
New York State Historical Association,
Cooperstown

144. *Hen Weathervane*, 1885–90, Bridgton,
Maine
Painted wood, 17¾ inches high
New York State Historical Association,
Cooperstown

145. *Rooster Weathervane*, c. 1885–90,
Bridgton, Maine
Painted wood, 16⅛ inches high
Collection of Mr. and Mrs. Richard
Hankinson

146. *Rooster Weathervane*, c. 1888–90
Painted wood, 19¼ inches high
From the Lombard farm, Bridgton,
Maine
New York State Historical Association,
Cooperstown

Len Lye (b. 1901)

147. *Steel Fountain*, 1959
Stainless steel rods and motor, 85 inches
high
Whitney Museum of American Art, New
York; Gift under the Ford Foundation
Purchase Program

Samuel McIntire (baptized 1757–1811)

148. *Governor John Winthrop,* 1798
Wood, 16 inches high
"Winthrop" written in pencil on front of
base
American Antiquarian Society,
Worcester, Massachusetts

Edgar Alexander McKillop (1878–1950)

149. *Hippoceros,* c. 1928
Walnut body, bone teeth, leather boxing
glove tongue stuffed with cotton, taxi-
dermist eyes, bone tusks, brass hinges,
metal crank and victrola works
(originally had rhinestones set in
nostrils); 58¼ inches long
Inscription (signed on right side below
crank): HAND CARVED/MADE BY/E. A.
MCKILLOP BALFOUR NC
Abby Aldrich Rockefeller Folk Art
Collection, Williamsburg, Virginia

Frederick MacMonnies (1863–1937)

150. *Young Faun and Heron,* c. 1890
Bronze, 27¾ inches high
Inscriptions: (on base) F. MacMonnies;
(founder's mark, on base) GRUET
FONDEUR PARIS
The Metropolitan Museum of Art, New
York; Gift of Edward D. Adams, 1927

151. Photograph of *Barge of State (Tri-
umph of Columbia),* 1893
Staff material; destroyed
World's Columbian Exposition, Chicago,
1893
Photograph by C. D. Arnold
Avery Library, Columbia University, New
York

152. *Bacchante and Infant Faun,* 1894
Bronze, 34 inches high
Inscription (top of base): F. MacMonnies
1894
Reduction of life-size figure of 1893
Philadelphia Museum of Art; Gift of
Mr. and Mrs. Clarence E. Hall

Hermon Atkins MacNeil (1866–1947)

153. *The Sun Vow,* n.d., original 1898
Bronze, 73 inches high
Inscriptions: H. A. MAC NEIL Sc./R.R.S.
[Rinehart Roman Scholar] ROME. THE
SVN–VOW; (founder's mark) Roman
Bronze Works, N.Y.
Third of five casts
The Metropolitan Museum of Art, New
York; Rogers Fund, 1919

154. U.S. quarter-dollar (Standing
Liberty), 1916
Silver, 24.3 millimeters in diameter
American Numismatic Society, New York

Paul Manship (1885–1966)

155. *Centaur and Dryad,* 1913
Bronze, 21½ inches high

Inscription (top of base): PAVL MANSHIP/©/
1913
One of five casts
The Metropolitan Museum of Art, New
York; Amelia B. Lazarus Fund, 1914

156. *Dancer and Gazelles,* 1916
Bronze, 69¾ x 73 x 19 inches
Inscriptions: (top of base in front of left
foot) PAUL MANSHIP/© 1916;
(founder's mark, top of base, right rear)
Roman Bronze Works N.Y.
One of two life-size casts
Corcoran Gallery of Art, Washington, D.C.

157. *Flight of Europa,* 1925
Gilt bronze, 20½ x 31 x 7¾ inches
National Collection of Fine Arts, Smith-
sonian Institution, Washington, D.C.;
Gift of the artist

158. *Prometheus,* 1932–33, cast 1955
Gilt bronze, 6½ x 6 x 2¼ inches
Inscription (rear, lower right):
PROMETHEUS, MANSHIP
Cast from sketch for Prometheus Fountain,
Rockefeller Center, New York
Minnesota Museum of Art, St. Paul

John Mason (b. 1927)

159. *Firebrick Sculpture — Grand Rapids,*
1973
Firebrick, 25½ x 310½ x 72 inches
Hansen Fuller Galleries, San Francisco

Tompkins H. Matteson (1813–1884)

160. *Erastus Dow Palmer in His Studio,*
1857
Oil on canvas, 29¼ x 36½ inches
Signed (lower left): T. H. Matteson 1857
Albany Institute of History and Art,
Albany, New York

Clark Mills (1815–1883)

161. *Andrew Jackson,* 1855
Bronze, 24 inches high
Inscription (side of base): Patented/May
15/1855, Cornelius & Baker/Philadelphia
Reduction of life-size monument erected in
Washington, D.C., 1853
The New-York Historical Society

Bruce Moore (b. 1905)

162. *Panther,* 1929
Bronze, 14½ x 42½ x 4½ inches
Inscriptions: (base, by front paw)
BRUCE MOORE; (base, end of tail) WICHITA
1929; (founder's mark, rear, edge of
base) Roman Bronze Works N.Y.
Whitney Museum of American Art,
New York

Robert Morris (b. 1931)

163. Untitled, 1961–62
Aluminum (after plywood original);
2 pieces, each 8 x 96 x 96 inches
Leo Castelli Gallery, New York

Elie Nadelman (1882–1946)

164. *Standing Deer,* 1914, cast 1915
Bronze, 29¾ x 20 x 12 inches
Inscriptions: (back of right antler)
NADELMAN; (back of left antler) N4
Museum of Art, Rhode Island School of
Design, Providence; Bequest of Miss
Ellen D. Sharpe

165. *Standing Fawn,* c. 1914
Bronze, 19 x 16 x 9½ inches
Inscriptions: (back of right horn)
NADELMAN; (back of left horn) N4
Museum of Art, Rhode Island School of
Design, Providence; Bequest of Miss
Ellen D. Sharpe

166. *Man in the Open Air,* c. 1914–15
Bronze, 54½ inches high
Inscriptions: (top of base, behind right
foot) ELIE NADELMAN; (founder's mark,
top of base, behind tree) JNO. WILLIAMS
INC. N.Y.
The Museum of Modern Art, New York;
Gift of William S. Paley (by exchange)

167. *Ideal Head,* c. 1915
Marble, 13 x 8 x 10½ inches
Inscription (back of lower neck): ELI
NADELMAN
Museum of Art, Rhode Island School of
Design, Providence; Gift of Mrs. Gustav
Radeke

168. *Dancer,* c. 1918–21
Wood, 30 inches high
Private collection

Reuben Nakian (b. 1897)

169. *The Lap Dog,* 1927
Terra-cotta, 6½ x 10½ x 5 inches
Inscription (on cushion under head):
Nakian/–27–
Whitney Museum of American Art,
New York

Bruce Nauman (b. 1941)

170. Untitled, 1965–66
Cast fiberglass, 55 x 94 x 12 inches
Whitney Museum of American Art, New
York; Gift of Mr. and Mrs. Eugene
M. Schwartz

171. *Live Taped Video Corridor,* 1968–70
Panels and video equipment, 17½ x 40 x
3 feet (variable)
Collection of Giuseppe Panza di Biumo

172. *Rotating Glass Walls, I,* 1970
Black, red and blue pencil on paper;
23 x 29 inches
Signed (lower right corner): B. Nauman 70
Leo Castelli Gallery, New York

173. *Drawing for "3 Video/3 Film (Empty
Gesture/Empty Room/Futile Room),"*
1972
Graphite and ink wash on paper, 23 x 25
inches

Initialed and dated in lower right corner
Nicholas Wilder Gallery, Los Angeles

Louise Nevelson (b. 1900?)

174. *First Personage*, 1956
Painted wood; two pieces, 94 x 37 1/16 x
11 1/4 inches (overall)
The Brooklyn Museum, New York; Gift of
Mr. and Mrs. Nathan Berliawsky

175. *Moon Fountain*, 1957
Painted wood, 43 x 36 1/2 x 34 inches
The Pace Gallery, New York

176. *Sky Cathedral — Moon Garden + One*,
1957–60
Painted wood, 109 x 130 x 19 inches
Private collection

Barnett Newman (1905–1970)

177. *Here I (to Marcia)*, 1950, cast 1962
Bronze, 96 x 26 x 27 inches
Collection of Annalee Newman

Isamu Noguchi (b. 1904)

178. *The Queen*, 1931
Terra-cotta, 45 1/2 x 16 x 16 inches
Whitney Museum of American Art, New
York; Gift of the artist

179. *Night Land*, 1947
York fossil marble, 14 x 45 x 35 inches
Collection of Madelon Maremont Falxa

180. *Hippolytus*, 1962
Wood, canvas and metal
From set for *Phaedra*, choreographed by
Martha Graham
Collection of the Martha Graham Center
for Contemporary Dance, Inc.

181. *Shrine of Aphrodite*, 1962
Wood, canvas and metal
From set for *Phaedra*, choreographed by
Martha Graham
Collection of the Martha Graham Center
for Contemporary Dance, Inc.

Claes Oldenburg (b. 1929)

182. *Proposed Colossal Monument to
Replace the Washington Obelisk,
Washington, D.C., Scissors in Motion*,
1967
Crayon and watercolor on paper, 30 x
19 3/4 inches
Initialed and dated in lower right corner
Private collection

183. *Three Way Plug, Scale A (Soft),
Prototype in Blue*, 1971
Wood, naugahyde, rope, metal and
plexiglas; 144 x 77 x 59 inches (variable)
Des Moines Art Center, Des Moines, Iowa;
Coffin Fine Arts Trust Fund

184. *Project for a Beachhouse in the Form
of the Letter Q*, 1972
Pencil, crayon and chalk on paper; 29 x
23 inches
Signed and dated in lower right corner
Collection of Mrs. Melville J. Kolliner

185. *Proposal for a Cathedral in the Form
of a Colossal Faucet, Lake Union,
Seattle*, 1972
Pencil, crayon and watercolor on paper;
29 x 23 inches
Collection of the artist

186. *Alphabet/Good Humor, Side B*, 1974
Crayon and pencil on paper, 35 x 35 inches
Signed and dated in lower right corner
Collection of Margo Leavin

Erastus Dow Palmer (1817–1904)

187. *The Infant Flora*, 1857
Marble, 17 inches high
Inscription: E. D. PALMER SC 1857
Walters Art Gallery, Baltimore, Maryland

188. *Maquette for the White Captive*, 1857
Plaster, 19 3/4 inches high
Inscription (signed, back of support):
PALMER SC. 1857
Study for life-size marble figure of 1859
Albany Institute of History and Art,
Albany, New York

189. *Little Peasant (The First Grief)*, 1859
Marble, 47 inches high
Inscription (signed, back of support):
E. D. PALMER, SC.
Albany Institute of History and Art,
Albany, New York

Hiram Powers (1805–1873)

190. *Horatio Greenough*, 1838
Marble, 25 1/2 inches high
Inscription (signed on back of neck):
H. POWERS/Sc
Museum of Fine Arts, Boston

191. *Proserpine*, 1844
Marble, 24 15/16 inches high
Inscription (signed on acanthus leaves on
back): H. POWERS/sc. 1844
One of approximately 100 replicas carved
after original of 1839–40
Cincinnati Art Museum, Cincinnati, Ohio;
Gift of Reuben R. Springer

192. *The Greek Slave*, 1847
Marble, 65 1/2 inches high
Inscription (signed, back of base): HIRAM
POWERS SCULP. L'ANNO 1847
Third of six versions, original carved in
1843
The Newark Museum, Newark, New Jersey

193. Photographic documentation of *The
Greek Slave*, 1851
Marble, 65 1/2 inches high
Inscription (signed, rear of base): Hiram
Powers/sculp.

Fifth of six versions, original carved in
1843
Photograph by Joseph Szaszfai
Yale University Art Gallery, New Haven,
Connecticut; Olive L. Dann Fund

Bela L. Pratt (1867–1917)

194. *U.S. $2.50 gold piece (quarter eagle)*,
1908
Gold, recessed relief, 18 millimeters in
diameter
Inscription (obverse, above date): BLP
American Numismatic Society, New York

Kenneth Price (b. 1935)

195. *S. L. Green*, 1963
Painted clay, 9 1/2 x 10 1/2 x 10 1/2 inches
Whitney Museum of American Art, New
York; Gift of the Howard and Jean
Lipman Foundation, Inc.

196. Untitled, 1974
Crayon and watercolor on paper, 11 x 14
inches
Signed (lower right corner): Price
Willard Gallery, New York

A. Phimister Proctor (1860–1950)

197. *Puma*, 1909
Bronze, 11 1/2 x 12 1/2 x 3 3/4 inches
Inscription (middle of base):
A. PHIMISTER/ PROCTOR/Copw. 1909
Reduction after original life-size double
statues of 1898
The Brooklyn Museum, New York; Gift of
George D. Pratt

Robert Rauschenberg (b. 1925)

198. Untitled, 1958
Pencil and watercolor on paper, 24 1/4 x
36 1/8 inches
Whitney Museum of American Art, New
York; Gift of Mr. and Mrs. B. H.
Friedman

199. *Sketch for Monogram*, 1959
Watercolor and graphite on paper, 19 x
11 1/2 inches
Signed in lower left corner
Collection of the artist

200. Untitled, 1973
Tire tread and logs, 28 x 63 x 40 inches
Collection of the artist

Man Ray (b. 1890)

201. *Cadeau*, 1921–63
Mixed media, 5 inches high
Inscription (on handle in white):
CADEAU 1921–1963 6/10 MAN RAY
Sixth of ten examples
Collection of Mr. and Mrs. Michael
Blankfort

Frederic Remington (1861–1909)

202. *The Bronco Buster*, 1895
Bronze, 23 1/4 inches high

Inscriptions: (on base) Copyrighted/
Frederic Remington; (front of base)
A'ENRICO CARUSO/IL COMRE CELESTINO
PIVA/PRESID DELL'INSTITUTO ITALIANO DE
BENEFICENZE/NEW-YORK 18 FEBRAIO 1905;
(founder's mark, on base) ROMAN BRONZE
WORKS N.Y.
Number 40 of approximately 200 casts by
Roman Bronze Works
Amon Carter Museum, Fort Worth, Texas

203. *Comin' Through the Rye (Off the
Range),* c. 1902
Bronze, 27⅜ inches high
Inscriptions: (signed on base) Copyrighted
by/Frederic Remington; (founder's
mark, back of base) ROMAN BRONZE
WORKS N.Y.
The Metropolitan Museum of Art, New
York; Bequest of Jacob Ruppert, 1939

George Rickey (b. 1907)

204. *Omaggio a Bernini,* 1958
Stainless steel, 68 x 36 x 36 inches
Whitney Museum of American Art, New
York; Gift of Mr. and Mrs. Patrick B.
McGinnis

William Rimmer (1816–1879)

205. *The Dying Centaur,* c. 1871, cast 1906
Bronze, 21½ inches high
Inscriptions: (signed, top of base) W.
Rimmer; (founder's mark) GORHAM. CO.
FOUNDERS
The Metropolitan Museum of Art, New
York; Gift of Edward Holbrook, 1906

William Rinehart (1825–1874)

206. *Leander,* c. 1858
Marble, 42 inches high
Inscription (signed on base): W. H.
Rinehart
The Newark Museum, Newark, New
Jersey

207. *Hero,* 1869
Marble, 34 inches high
Inscription (signed on back): Wm. H.
Rinehart/Scvp.ᵗ Roma 1869
Pennsylvania Academy of the Fine Arts,
Philadelphia; Bequest of Henry C.
Gibson, 1892

Samuel Anderson Robb (1851–1928)

208. *The Baseball Player,* between 1888
and 1903
Polychromed wood, 85¼ inches high
Inscription (on base): Robb 114 CENTRE ST.
N.Y.
Heritage Plantation of Sandwich,
Massachusetts

Hugo Robus (1885–1964)

209. *Song,* 1934
Brass, 60 inches high
Inscription (impressed on right heel):
Hugo Robus

The Metropolitan Museum of Art, New
York; Rogers Fund, 1947

210. *Girl Washing Her Hair,* 1940, after
original plaster of 1933
Marble, 30½ inches long
Inscription (rear, base of torso): Hugo
Robus/Pointed in stone under supervi-
sion of artist by Joseph C. Stella
The Museum of Modern Art, New York;
Abby Aldrich Rockefeller Fund, 1939

John Rogers (1829–1904)

211. *The Fugitive's Story,* 1869
Painted plaster, 21¾ inches high
Inscription (front of base): THE FUGITIVE'S
STORY/JOHN G. WHITTIER — H. W.
BEECHER W. LLOYD GARRISON
The New-York Historical Society

Randolph Rogers (1825–1892)

212. *Nydia, the Blind Girl of Pompeii,* n.d.
Marble, 54 inches high
Inscription (signed on base): Randolph
Rogers/Rome
One of more than 50 replicas carved after
original of 1856
Pennsylvania Academy of the Fine Arts,
Philadelphia; Gift of Mrs. Bloomfield
Moore, 1895

Theodore Roszak (b. 1907)

213. *Vertical Construction,* 1942
Plastic and painted wood, 76 x 30 x 5
inches
Inscriptions: (printed on upper back) T. J.
Roszak/N.Y.C.; (written on upper
back)Theodore Roszak/NYC 1942
Whitney Museum of American Art, New
York; Gift of the artist

William Rush (attributed) (1756–1833)

214. *Benjamin Franklin,* c. 1785–90
Wood, 34 inches high
The Historical Society of Delaware,
Wilmington

William Rush (1756–1833)

215. *Eagle,* c. 1805
Gilded wood, 37 inches long
Pennsylvania Academy of the Fine Arts,
Philadelphia; Gift of B. I. de Young,
1947

216. *Tragedy,* 1808
Pine, 101¾ inches high
Edwin Forrest Home, courtesy of the
Philadelphia Museum of Art

Charles M. Russell (1864–1926)

217. *Buffalo Hunt,* 1905
Bronze, 10 inches high
Inscriptions: (on base) C M Russell/
Copyrighted (skull) 1905; (founder's
mark) Roman Bronze Works, N.Y. 1905
Amon Carter Museum, Fort Worth, Texas

Augustus Saint-Gaudens (1848–1907)

218. *Heads of Black Soldiers,* 1884–97, cast
1964/65
Bronze, 5¾, 5¾, 6 and 7½ inches high
Cast by Modern Art Foundry, New York,
from original plaster studies for *Robert
Gould Shaw Memorial* erected in Boston,
1897
U.S. Department of the Interior, National
Park Service; Saint-Gaudens National
Historic Site, Cornish, New Hampshire

219. *Head of Drummer Boy,* 1884–97, cast
between 1949 and 1959
Bronze, 6 inches high
Inscription (on back): Modern Art
Foundry NY
Study for *Robert Gould Shaw Memorial*
erected in Boston, 1897
U.S. Department of the Interior, National
Park Service; Saint-Gaudens National
Historic Site, Cornish, New Hampshire

220. *Head of Robert Gould Shaw,* 1884–97,
cast 1908
Bronze, 10 inches high
Inscriptions: (left side of base) ASTG; (back
of base) COPYRIGHT M C M V I I I/BY
A[ugusta] H[omer] SAINT-GAUDENS
Study for *Robert Gould Shaw Memorial*
erected in Boston, 1897
U.S. Department of the Interior, National
Park Service; Saint-Gaudens National
Historic Site, Cornish, New Hampshire

221. Photographic documentation of *Rob-
ert Gould Shaw Memorial,* 1884–97,
Beacon Hill, Boston
Bronze, 11 x 14 feet
Photograph by Richard Benson

222. *Standing Lincoln,* 1886, cast 1912
Bronze, 40 inches high
Inscriptions: Augustus Saint-Gaudens
MDCCCLXXXVI; Copyright 1912 A[ugusta]
H[omer] Saint-Gaudens; Gorham Co.
Founders [monogram]
Reduction of over-life-size monument
erected in Chicago, 1887
The Newark Museum, Newark, New Jersey

223. *William Merritt Chase,* 1888
Bronze, 21½ x 29½ inches
Inscription (across top): WILLIAM•MERRITT•
CHASE•IN•HIS•FORTIETH•YEAR•FROM•HIS•
FRIEND•/•AVGVSTVS• SAINT•GAVDENS•NEW—
YORK•AVGVST•M•D•C•C•C•LXXXVIII
American Academy of Arts and Letters,
New York

224. *Diana,* cast 1928
Gilt bronze, 112 inches high
Inscription: P.B. v. C.° MUNICH/MADE IN
GERMANY
Cast from cement model for 13-foot version
of 1893.
The Metropolitan Museum of Art, New
York; Purchase, Rogers Fund, 1928

225. *The Puritan,* 1899
Bronze, 31 inches high

Inscription (on base): AVGVSTVS SAINT GAVDENS/M·D·CCCXCIX/THE PVRITAN/ COPYRIGHT BY/AVGVSTVS SAINT GAVDENS
Reduction of 12-foot monument erected in Springfield, Massachusetts, 1887
The Metropolitan Museum of Art, New York; Bequest of Jacob Ruppert, 1939

226. Cast of U.S. $10 gold piece (Liberty head and standing eagle, obverse), 1905
Plaster, 13 inches in diameter
Inscription (monogram overprinted): A St G
Early high-relief model design
U.S. Department of the Interior, National Park Service; Saint-Gaudens National Historic Site, Cornish, New Hampshire

227. Cast of U.S. $20 gold piece (Standing Liberty and flying eagle, obverse), 1905–7
Plaster, 12 inches in diameter
Inscription (monogram overprinted): A St G
Early extra high relief
U.S. Department of the Interior, National Park Service; Saint-Gaudens National Historic Site, Cornish, New Hampshire

228. Cast of U.S. $20 gold piece (Standing Liberty and flying eagle, obverse), 1905–7
Plaster, 12 inches in diameter
Inscription (monogram overprinted): A St G
Final high relief
U.S. Department of the Interior, National Park Service; Saint-Gaudens National Historic Site, Cornish, New Hampshire

229. Cast of U.S. $20 gold piece (Standing Liberty and flying eagle, reverse), 1905–7
Plaster, 13¾ inches in diameter
Inscription (obverse, monogram overprinted): A St G
Model for coin as minted
U.S. Department of the Interior, National Park Service; Saint-Gaudens National Historic Site, Cornish, New Hampshire

230. Cast of U.S. $10 gold piece (Liberty head and standing eagle, reverse), 1907
Plaster, 13 inches in diameter
Inscription (obverse, monogram overprinted): A St G
Model for coin as minted
U.S. Department of the Interior, National Park Service; Saint-Gaudens National Historic Site, Cornish, New Hampshire

231. U.S. $10 gold piece (Liberty head and standing eagle), 1907
Gold, 27 millimeters in diameter
American Numismatic Society, New York

232. U.S. $20 gold piece (Standing Liberty and flying eagle), 1907
Gold, 34 millimeters in diameter
Plaster models 1906; extra high relief, high relief, low relief; coin minted from low relief model
American Numismatic Society, New York

Lucas Samaras (b. 1936)

233. *Untitled (Dripping Wedge)*, 1961
Pastel on paper, 12 x 9 inches
Signed and dated on reverse
The Pace Gallery, New York

234. Untitled, 1962
Pastel on paper, 12 x 9 inches
Signed and dated on reverse
The Pace Gallery, New York

235. *Corridor #2*, 1966–70
Mirror on wood frame, 7½ x 50 x 3½ feet
The Pace Gallery, New York

236. *Photo-Transformation*, 11/16/73
SX-70 Polaroid, 3 x 3 inches
Signed and dated on reverse
The Pace Gallery, New York

237. *Photo-Transformation*, 11/16/73
SX-70 Polaroid, 3 x 3 inches
Signed and dated on reverse
The Pace Gallery, New York

238. *Photo-Transformation*, 2/9/74
SX-70 Polaroid, 3 x 3 inches
Signed and dated on reverse
The Pace Gallery, New York

239. *Photo-Transformation*, 2/25/74
SX-70 Polaroid, 3 x 3 inches
Signed and dated on reverse
The Pace Gallery, New York

Charles A. L. Sampson (1825–1881)

240. *Belle of Oregon*, 1876
Painted carved laminated wood, 102 inches high
From the ship *Belle of Oregon*, built for the grain trade by Goss & Sawyer, Bath, Maine, in 1876
Formerly in the collection of the Webb Institute of Naval Architecture
The Mariners Museum, Newport News, Virginia

Morton L. Schamberg (1881–1918)

241. *Photograph of God*, 1917
(*God*, c. 1917; assemblage of miter box and plumbing trap, 10½ inches high; Philadelphia Museum of Art)
The Metropolitan Museum of Art, New York; Elisha Whittelsey Fund, 1973

George Segal (b. 1924)

242. *Cinema*, 1963
Plaster, illuminated plexiglas and metal; 118 x 96 x 39 inches
Albright-Knox Art Gallery, Buffalo, New York; Gift of Seymour H. Knox

Richard Serra (b. 1939)

243. *House of Cards*, 1969
Lead, 48 x 55 x 55 inches
Collection of George and Wendy Waterman

244. Untitled, 1972
Charcoal on paper, 29¾ x 41½ inches
Collection of Mr. and Mrs. Miles Q. Fiterman

Franklin Simmons (1839–1913)

245. *Penelope*, c. 1880
Marble, 36 inches high
Portland Art Museum, Portland, Maine; Gift of the City of Portland from the Estate of Franklin B. Simmons, 1921

Skillin Shop

246. *Keystone Head*, 1786–88
Painted wood, 15 inches high
The Rhode Island Historical Society, Providence

247. *Hebe*, c. 1800
Painted pine, 58 inches high
The Metropolitan Museum of Art, New York; Rogers Fund, 1967

Skillin Shop (attributed)

248. *Eagle and Snake*, c. 1790
Gilded wood, metal, glass; 73 inches long
Reportedly part of the decoration of the Boston Custom House
Formerly in the collection of Walter Randel
Collection of Dr. William Greenspon

David Smith (1906–1965)

249. *Blackburn: Song of an Irish Blacksmith*, 1949–50
Steel and bronze, 46¼ x 41 x 24 inches; stone base, 8 inches high x 7¼ inches in diameter
Inscription (on stainless steel plaque): David Smith 1949–50
Wilhelm-Lehmbruck-Museum der Stadt, Duisburg, Germany

250. *Hudson River Landscape*, 1951
Welded steel, 49½ x 75 x 16¾ inches
Inscription (on base): David Smith
Whitney Museum of American Art, New York

251. *Tanktotem V*, 1955–56
Steel, 96¾ x 52 x 15 inches
Inscription (plaque on base): David Smith/ TNKTM V/1955–56
Collection of Howard and Jean Lipman

252. *Five Spring*, 1956
Steel, stainless steel and nickel; 77⅝ x 36 x 14¾ inches
Inscription (plate on vertical fin): David Smith/.11.24.56
Estate of David Smith, courtesy of Knoedler Contemporary Art, New York

253. *Zig IV*, 1961
Painted steel, 95⅜ x 84¼ x 76 inches
Inscription (on base plane): David Smith/ July 7 1961 ZIG IV

New York Shakespeare Festival; Gift of Howard and Jean Lipman to the Vivian Beaumont Theater

254. *Voltri XIX,* 1962
Steel, 55¼ x 45 x 50 inches
Inscription (top center): David Smith 6–62/ Voltri XIX
Collection of Mr. and Mrs. Stephen D. Paine

255. *Cubi I,* 1963
Stainless steel, 124 x 34½ x 33½ inches
Inscription (on base plane): David Smith/ March 4–63/Cubi I
The Detroit Institute of Arts, Detroit, Michigan

256. *Voltron XVIII,* 1963
Steel, 110⅞ x 67⅛ x 15⅛ inches
Inscription (on base plane): David Smith/ 1/29/63 VOLTRON XVIII
On loan from the Empire State Plaza Art Collection through the auspices of Governor Hugh L. Carey. *Voltron XVIII* will be placed in its permanent location in the Empire State Plaza, Albany New York, as of October 15, 1976

Tony Smith (b. 1912)

257. *Die,* 1962
Steel, 72 x 72 x 72 inches
Fourcade, Droll Inc., New York

Robert Smithson (1938–1973)

258. *Non-Site (Palisades-Edgewater, NJ),* 1968
Enamel, painted aluminum and stone; 56 x 26 x 36 inches
Whitney Museum of American Art, New York; Gift of the Howard and Jean Lipman Foundation, Inc.

259. *Tower of Broken Glass with Pool,* 1970
Pencil on paper, 18⅞ x 24 inches
Signed and dated in lower right corner
Estate of Robert Smithson, courtesy of John Weber Gallery, New York

260. *Project for an Open Pit with Lake,* 1972
Pencil on paper, 19 x 24 inches
Signed and dated in lower right corner
Estate of Robert Smithson, courtesy of John Weber Gallery, New York

261. Photographic documentation of *Amarillo Ramp,* 1973, near Amarillo, Texas
Red sandstone shale; diameter at top, 150 feet
Photograph by Gianfranco Gorgoni
Estate of Robert Smithson, courtesy of John Weber Gallery, New York

Keith Sonnier (b. 1941)

262. *Ba-O-Ba, Number 3,* 1969
Glass and neon, 91¼ x 122¾ x 24 inches

Whitney Museum of American Art, New York; Gift of the Howard and Jean Lipman Foundation, Inc.

Stein and Goldstein
(Carousel Manufacturers)

263. *Carousel Horse,* between 1912 and 1916, Brooklyn, New York
Polychromed wood, 71 inches long
The Eleanor and Mabel Van Alstyne American Folk Art Collection; National Museum of History and Technology, Smithsonian Institution, Washington, D.C.

Edmund Stewardson (1860–1892)

264. *The Bather,* 1890
Bronze, 46 inches high
Inscription (back of base): Stewardson 1890
Pennsylvania Academy of the Fine Arts, Philadelphia; Gift of Thomas Stewardson, 1895

Sylvia Stone (b. 1928)

265. *Another Place,* 1972
Plexiglas, 80 x 204 x 338 inches
Collection of Al Held

John Storrs (1885–1956)

266. *Study for Walt Whitman Monument,* 1919
Bronze, 11½ inches high
Inscription (founder's mark, left leg of horse): VALSUANI FONDEUR CIRE PERDUE
One of three casts, after woodcut, *The Spirit of Walt Whitman,* 1917
Robert Schoelkopf Gallery, New York

267. *Forms in Space #1,* 1920–23
Marble, 76¾ inches high
Robert Schoelkopf Gallery, New York

268. *Male Nude (L'Homme nu),* 1922
Carved composition stone, 30¾ x 10½ x 10½ inches
Des Moines Art Center, Des Moines, Iowa; James D. Edmundson Fund

269. *Composition Around Two Voids,* 1932
Stainless steel, 20 x 10 x 6 inches
Inscription (incised on back near base): Storrs
Whitney Museum of American Art, New York; Gift of Monique Storrs Booz

270. *Abstract Figure,* 1934
Bronze, 33½ inches high
Robert Schoelkopf Gallery, New York

William Wetmore Story (1819–1895)

271. *Cleopatra,* 1869
Marble, 56 inches high
Inscriptions: (signed within circle) WWS [monogram]/Roma 1869; (front of base) CLEOPATRA
One of several replicas carved after original of 1858

The Metropolitan Museum of Art, New York; Gift of John Taylor Johnston, 1888

George Sugarman (b. 1912)

272. *Inscape,* 1964
Polychromed laminated wood, 24 x 144 x 108 inches
Lent by the artist

Lorado Taft (1860–1931)

273. *Fountain of Creation,* 1909
Plaster, 27 x 30 x 15 inches
Model for unrealized monument for the Midway, Chicago
Krannert Art Museum, University of Illinois, Urbana-Champaign

Anne Truitt (b. 1921)

274. *Untitled: 8 November, 1962*
Acrylic on paper, 30 x 22 inches
Signed and dated in lower right corner
Collection of Daniel Brush

275. *Untitled: 13 November, 1962*
Acrylic on paper, 22 x 30 inches
Signed and dated in lower right corner
Lent by the artist

276. *Carson,* 1963
Painted wood, 71 x 72 x 13 inches
Collection of Helen B. Stern

Richard Tuttle (b. 1941)

277. *The Fountain,* 1965
Painted wood, 1 x 40 x 40 inches
Collection of Richard Brown Baker

278. *Three Triangles and Three Colors,* 1970
Felt-tip marker on back of *2 Book Colophon;* 12 x 9 inches
Signed and dated on reverse
Collection of Dorothy and Herbert Vogel

279. *Antithesis in San Francisco: Blue,* 1973
Gouache on paper, 8 x 6 inches
Collection of the artist

280. *Curved Red Bar with Black Ends,* 1973
Gouache on paper, 8 x 6 inches
Collection of the artist

281. *1st Rendering for Yale Piece,* 1973
Watercolor and pencil on bond, 14 x 11 inches
Signed and dated on reverse
Collection of Dorothy and Herbert Vogel

Unknown artist

282. *Kent County Jail Sign,* c. 1780–1800
Polychromed wood, 34 inches high
The Rhode Island Historical Society, Providence

283. *Sternboard* (traditionally attributed to the ship *American Indian*), c. 1785, North River, Plymouth County, Massachusetts

Polychromed wood, 116½ inches long
At one time in the collection of William Randolph Hearst. Acquired by the Shelburne Museum through Edith Halpert from Robert Carlen
Shelburne Museum, Shelburne, Vermont

284. Photographic documentation of Gravestone of Polly Coombes, died 1795, Bellingham, Massachusetts

Slate
Photograph by Ann Parker

285. *Angel Gabriel Weathervane* (with original directional points), c. 1800, New England

Gilt metal, 122 inches high
Formerly in the collection of Walter Randel
Collection of Dr. William Greenspon

286. *Four Figures*, c. 1800
Wood, 25 inches high
Collection of Mr. and Mrs. George M. Kaufman

287. *Animal Toys*, c. 1850, Pennsylvania
Painted wood; giraffe 16¼ inches high
Formerly in the collection of Juliana Force, Director of the Whitney Studio Club, 1918–28, and of the Whitney Museum, 1930–48
Collection of Stewart E. Gregory

288. *Ship Chandler's Sign*, c. 1850, probably New England
Polychromed wood, 47⅞ inches high
Mystic Seaport, Inc., Mystic, Connecticut

289. *Broadside Announcing the Appearance of Hiram Powers's* Greek Slave, n.d.
Printed on paper, 9⅝ x 5½ inches
Collection of Mr. and Mrs. John McCoubrey

290. *Thin Indian Chief*, 1850–75, found in Virginia
Polychromed wood, 72¼ inches high
Formerly in the Haffenreffer Collection of Cigar-Store Indians and Other Trade Signs, sold at Parke-Bernet Galleries, Inc., New York, in 1956
Virginia Museum of Fine Arts, Richmond

291. *Harry Howard, Chief Engineer of the New York Volunteer Fire Department*, c. 1860
Polychromed wood, 91 inches high
Figure stood on top of Firemen's Hall, 155 Mercer Street, New York
Formerly in the collection of Elie Nadelman
The New-York Historical Society

292. *Father Time*, c. 1900, Mohawk Valley, New York
Painted wood, metal, hair (originally had black velvet loincloth); 48 inches high

Probably a shop sign; it was mechanized so that when shop door was opened, scythe struck bell
Museum of American Folk Art, New York

293. *Crane Decoy*, c. 1907
Wood, 51 inches high
Inscription: George Martin's Crane, Barnegat, June 1907
Private collection

Unknown artist — American Indian

294. Mortar, Wishram-Wasco, c. 1840–60
Carved oak burl, 11 x 12 x 12½ inches
Collection of Mr. and Mrs. Alan Backstrom

295. Four house posts, Tlingit, Yakutat, Alaska, early 19th century
Carved and painted wood; 92, 99, 102 and 104 inches high
Collected by Lord Clive Bossom, c. 1900
Canadian Ethnology Service, National Museum of Man, National Museums of Canada, Ottawa (cat. nos. VII–A–345, VII–A–344b, VII–A–344a, VII–A–343)

296. Shaman's grave figure guardian, Tlingit
Carved and painted wood, human hair, opercula teeth; 23½ inches high
Collected from shaman's grave house at Yakutat, Alaska, by George T. Emmons, before 1887
The American Museum of Natural History, New York (cat. no. 19/378)

297. Figure of a shaman with a shark on his back, Chilkat Tlingit
Carved and painted wood, human hair, abalone shell; 17¾ inches high
Collected by George T. Emmons, before 1887
The American Museum of Natural History, New York (cat. no. 19/308)

298. Bowl in bear form, Chilkat Tlingit
Carved and painted wood inlaid with abalone shell, opercula teeth; 15 inches wide
Collected by George T. Emmons, before 1887
The American Museum of Natural History, New York (cat. no. 19/1086)

299. Partition screen, Haida, from Howkan, Alaska
Five carved and painted cedar planks, 132 x 150 x 1½ inches (overall)
Collected by Lord Clive Bossom, c. 1900
Canadian Ethnology Service, National Museum of Man, National Museums of Canada, Ottawa (cat. no. VII–B–1527)

300. Mask, Eskimo, Lower Yukon, Alaska, 19th century
Painted wood, 23 x 21 x 2 inches
Collection of James Economos

301. Seal decoy hat, Kodiak Island, Alaska
Wood with white, red and black pigment, rawhide chin strap; 10 inches high

Collected by Edward G. Fast, 1867–68
Peabody Museum of Archaeology and Ethnology, Harvard University, Cambridge, Massachusetts (cat. no. 69–30–10/64700)

302. Dance stick, Hunkpapa Sioux, Standing Rock Reservation, North Dakota, c. 1860
Carved wood with feather, 34½ inches high
Museum of the American Indian, Heye Foundation, New York; Bequest of DeCost Smith (cat. no. 20/1295)

303. Altar carving, Zuni, possibly 19th century
Cottonwood, paint, horsehair; 10¾ x 11¼ inches
Taylor Museum of the Colorado Springs Fine Arts Center (cat. no. 1549)

304. War God, Zuni, late 19th–early 20th century
Carved wood with black, red and traces of white paint; 25⅝ inches high
The Brooklyn Museum, New York; Museum Collection Funds (cat. no. 50.1/9165)

305. Saddle, Menominee
Hide over carved wood, 23 inches long
Collected 1903
The American Museum of Natural History, New York (cat. no. 50/4848)

306. Mide doll, Ojibwa
Carved wood, 16½ inches high
Collected by C. H. Boyd, Northern Trading Post, Minocqua, Wisconsin
Milwaukee Public Museum, Milwaukee, Wisconsin (cat. no. 55324)

307. House post, Delaware, Copan, Oklahoma, c. 1874
Carved wood with traces of paint, 46 inches high
Philbrook Art Center, Tulsa, Oklahoma; Clark Field Collection (cat. no. 3296)

308. Post figure, Hawaii, probably before 1829
Carved wood, possibly sandalwood; 16 inches high
Roger Williams Park Museum, Providence, Rhode Island (cat. no. E 3099)

Bessie Potter Vonnoh (1872–1955)

309. *The Young Mother*, 1896
Bronze, 14½ inches high
Inscriptions: (rear of base) Bessie O. Potter/1896/Copyright/No. VI; (founder's mark, rear of base) Roman Bronze Works N.Y. Serial No. VI
Sixth of thirty casts
The Metropolitan Museum of Art, New York; Rogers Fund, 1906

Peter Voulkos (b. 1924)

310. *Little Big Horn*, 1959
Polychromed and underglazed stoneware, 60 x 33 x 36 inches
The Oakland Museum, Oakland, California; Gift of the Art Guild of The Oakland Museum Association

John Quincy Adams Ward (1830–1910)

311. *Indian Hunter*, 1860
Bronze, 17 inches high
Inscription (top of base): J.Q.A. WARD/1860
Study for 10-foot monument cast 1866 and erected in Central Park, New York, 1869
American Academy of Arts and Letters, New York

312. *Freedman*, 1863
Bronze, 19½ inches high
Inscriptions: (front of base) J.Q.A. WARD. SC./1863; (back of base) GORHAM CO. FOUNDERS
American Academy of Arts and Letters, New York

313. *Roscoe Conkling*, c. 1892
Bronze, 23½ inches high
Inscription (under right shoulder): J.Q.A. Ward/scult.
The New-York Historical Society

314. *Henry Ward Beecher*, n.d.
Bronze, 14¼ inches high
Inscriptions: (top of base, front) J.Q.A. Ward Sc.; (top of base, back) GORHAM Cº. FOUNDERS
Study for 8-foot monument erected in Borough Hall Park, Brooklyn, New York, 1891, and moved to Cadman Plaza, Brooklyn, 1959
Collection of Charles Parks

Olin Levi Warner (1844–1896)

315. *J. Alden Weir*, 1880
Bronze, 22½ inches high
Inscriptions: (back of neck) Alden Weir/L. Warner/1880; (founder's mark, lower back) ROMAN BRONZE WORKS N.Y.
Corcoran Gallery of Art, Washington, D.C.

Max Weber (1881–1961)

316. *Spiral Rhythm*, 1915
Gilded plaster, 24 inches high
Forum Gallery Inc., New York

Adolph A. Weinman (1870–1952)

317. U.S. dime (Mercury), 1916
Silver, 17.9 millimeters in diameter
American Numismatic Society, New York

318. U.S. half-dollar (Walking Liberty), 1916
Silver, 30.6 millimeters in diameter
American Numismatic Society, New York

319. *The Descending Night (The Setting Sun)*, n.d.
Bronze, 55¼ x 47 x 17 inches

Inscription (rear of base): ©/A A WEINMAN FECIT
Variation of 1915 plaster fountain figure for the Panama-Pacific International Exposition, San Francisco
Krannert Art Museum, University of Illinois, Urbana-Champaign

320. *The Rising Day*, n.d.
Bronze, 57½ x 53½ x 5½ inches
Inscription (rear of base): ©/A A WEINMAN FECIT
Variation of 1915 plaster fountain figure for the Panama-Pacific International Exposition, San Francisco
Krannert Art Museum, University of Illinois, Urbana-Champaign

H. C. Westermann (b. 1922)

321. *Antimobile*, 1966
Laminated plywood, 67¼ x 35½ x 27½ inches
Inscriptions: (on wheel) Antimobile; (on inside of base) "Antimobile"; (signed, rear of base) H C W
Whitney Museum of American Art, New York; Gift of the Howard and Jean Lipman Foundation, Inc.

322. *A Country Gone Nuts*, 1966
Ink, felt pen and newspaper clipping on paper; 13½ x 9¾ inches
Signed and dated in upper right corner
Private collection

323. *Study for Death Ship Run Over by a '66 Lincoln Continental*, 1966
Ink and watercolor on paper, 9¾ x 13½ inches
Signed, lower right corner; dated, upper right corner
Private collection

324. *Death Ship (Chromium Plated Bronze) of No Port*, 1967
Ink on paper, 13½ x 10½ inches
Signed and dated in lower right corner
Private collection

325. *American Death Ship on the Equator*, 1972
Copper, amaranth wood and glass; 12 x 36 x 13¾ inches
Inscription (on glass, upper left corner): H. C. Westermann 72, to little kid
Collection of Mr. and Mrs. Henry M. Buchbinder

Anne Whitney (1821–1915)

326. *Roma*, 1869, cast 1890
Bronze, 27 inches high
Inscriptions: (left rear corner of base) ANNE WHITNEY/SC./ROME 1869; (front of base) ROMA MDCCCLXIX; (right side of base) M. H. MOSMAN./FOUNDER/CHICOPEE/ MASS.; (on medallion below left hand) Quest Vante in Roma
Wellesley College Museum, Wellesley, Massachusetts

Gertrude Vanderbilt Whitney (1875–1942)

327. Bas-relief for Victory Arch (Expeditionary Force Monument), 1918–19
Bronze, 24 x 64 x 9 inches
Inscriptions: (right front) Gertrude V. Whitney; (founder's mark) Roman Bronze Works, N.Y.
Collection of Flora Whitney Miller

328. Bas-relief for Victory Arch (Expeditionary Force Monument), 1918–19
Bronze, 24 x 64 x 9 inches
Inscriptions: (left front) Gertrude V. Whitney; (founder's mark) Roman Bronze Works, N.Y.
Collection of Flora Whitney Miller

329. *Head for Titanic Memorial*, 1924
Marble, 12¾ x 7 x 9 inches
Inscription (rear, base of neck): Gertrude V. Whitney 1924
Whitney Museum of American Art, New York

330. *Mother and Child*, 1935
Marble, 34 x 10½ x 13½ inches
Inscription (rear of base): Gertrude V. Whitney
Whitney Museum of American Art, New York; Gift of Mrs. G. Macculloch Miller

Harry Wickey (1892–1968)

331. *The Old Wrestler*, 1938
Bronze, 19¾ x 6½ x 8¼ inches
Inscription (top of base, right front): WICKEY/38
Whitney Museum of American Art, New York; Gift of Mrs. Gertrude V. Whitney

William Wiley (b. 1937)

332. *Lame and Blind in Eden*, 1969
Watercolor on paper, 30 x 22 inches
Signed and dated in lower right corner
Collection of Mr. and Mrs. Harry W. Anderson

333. *Painter Baffles and Excess in California*, 1969
Watercolor on paper, 28¼ x 20¼ inches
Signed and dated under image
Collection of Mr. and Mrs. Stephen D. Paine

334. *Ship's Log*, 1969
Mixed-media construction, 82 x 78 x 54 inches
San Francisco Museum of Art

335. *Dwelling in the Pure and Infinite*, 1970
Watercolor on paper, 30 x 22 inches
Signed and dated
Collection of Mr. and Mrs. Jack Schafer

Christopher Wilmarth (b. 1943)

336. *My Divider*, 1972–73
Glass and steel, 60 x 78 x 94 inches

Inscription (top left edge of glass, facing in): CMW 73
Collection of the artist

337. *9 Clearings for a Standing Man,* 1973
Graphite and staples on paper, 22 x 31 inches
Dated in lower right corner
Collection of the artist

Mahonri M. Young (1877–1957)

338. *Man with a Pick,* 1915
Bronze, 28½ inches high
Inscriptions: (top front of base) M YOUNG; (founder's mark) Roman Bronze Works Inc. N.Y.
First of two examples
The Metropolitan Museum of Art, New York; Gift of Mrs. Edward H. Harriman, 1918

339. *Man with Wheelbarrow,* 1915
Bronze, 12 x 15¼ x 6 inches

Inscriptions: (rear, top of base, left) YOUNG/1915; (founder's mark, side of base, right) ROMAN BRONZE WORKS N–Y.
Whitney Museum of American Art, New York

340. *Groggy,* 1926
Bronze, 14¼ x 8¼ x 9½ inches
Inscriptions: (top of base, left) ©Mahonri; (founder's mark, rear, top of base) CIRE/A. VALSUANI Perdue
Whitney Museum of American Art, New York

William Zorach (1889–1966)

341. *Figure of a Child,* 1921
Mahogany, 23 x 5½ x 6¼ inches
Inscription (front of base): ZORACH/1921
Whitney Museum of American Art, New York; Gift of Dr. and Mrs. Edward J. Kempf

342. *Floating Figure,* 1922
Wood, 9 x 33 x 7 inches

Inscription (on back at right): Zorach/1922
Albright-Knox Art Gallery, Buffalo, New York; Room of Contemporary Art Fund

343. *Child with Cat,* 1926
Tennessee marble, 18 x 6½ x 10 inches
Inscription (base, under right arm): ZORACH
The Museum of Modern Art, New York; Gift of Mr. and Mrs. Sam A. Lewisohn, 1939

344. *Draped Figure,* 1927
Bronze, 13½ x 2¾ x 2¾ inches
Inscription (front of base, left of center): Zorach/1927
Whitney Museum of American Art, New York

345. *Torso,* 1932
Labrador granite, 33 x 17 x 13 inches
Collection of the Sara Roby Foundation, New York

Cover design by Tom Armstrong